Janson's History of Art

PORTABLE EDITION

Janson's History of Art

THE WESTERN TRADITION *Seventh Edition*

The Renaissance through the Rococo

PENELOPE J. E. DAVIES
The Ancient World

DAVID L. SIMON
The Middle Ages

WALTER B. DENNY
Islamic Art

ANN M. ROBERTS
The Renaissance through the Rococo

FRIMA FOX HOFRICHTER
The Renaissance through the Rococo

JOSEPH JACOBS
The Modern World

Prentice Hall
Upper Saddle River, London, Singapore, Toronto,
Sydney, Hong Kong, and Mexico City

LIBRARY OF CONGRESS CATALOGING-IN-PUBLICATION DATA

Janson, H. W. (Horst Woldemar),
 Janson's history of art: the western tradition/Penelope J. E. Davies . . . [et al.]—7th ed.
 p.cm
 Includes bibliographical references and index.
 ISBN 10: 0-205-69743-7 | ISBN 13: 978-0-205-69743-4
 1. Art—History. I. Title: History of art. II. Davies, Penelope J. E., 1964-III.
Janson, H.W. (Horst Woldemar), 1913–History of art. IV. Title

N5300.J3 2007
709—dc22 2005054647

Editor-in-Chief: **SARAH TOUBORG**
Sponsoring Editor: **HELEN RONAN**
Editor in Chief, Development: **ROCHELLE DIOGENES**
Senior Development Editor: **ROBERTA MEYER**
Development Editors: **KAREN DUBNO, CAROLYN VIOLA-JOHN**
Editorial Assistant: **JACQUELINE ZEA**
Editorial Intern: **AIZA KEESEY**
Media Project Manager: **ANITA CASTRO**
Director of Marketing: **BRANDY DAWSON**
Assistant Marketing Manager: **ANDREA MESSINEO**
Marketing Assistant: **VICTORIA DeVITA**
AVP, Director of Production and Manufacturing: **BARBARA KITTLE**
Senior Managing Editor: **LISA IARKOWSKI**
Senior Production Editor: **HARRIET TELLEM**
Production Assistant: **MARLENE GASSLER**
Manufacturing Manager: **NICK SKLITSIS**
Manufacturing Buyer: **SHERRY LEWIS**
Creative Design Director: **LESLIE OSHER**
Art Directors: **NANCY WELLS, AMY ROSEN**
Interior and Cover Design: **BTDNYC**
Design Layout: **GAIL COCKER-BOGUSZ**
Line Art Coordinator: **MARIA PIPER**
Line Art Studio: **ARGOSY PUBLISHING INC.**
Cartographer: **CARTOGRAPHICS**
Text Research and Permissions: **MARGARET GORENSTEIN**
Pearson Imaging Center
 Manager: **JOSEPH CONTI**
 Project Coordinator: **CORIN SKIDDS**
 Scanner Operators: **RON WALKO AND CORIN SKIDDS**
Picture Editing, Research and Permissions:
 LAURIE PLATT WINFREY, FAY TORRES-YAP
 MARY TERESA GIANCOLI, CRISTIAN PEÑA, CAROUSEL RESEARCH, INC.
Director, Image Resource Center: **MELINDA REO**
Manager, Rights and Permissions: **ZINA ARABIA**
Manager, Visual Research: **BETH BRENZEL**
Image Permission Coordinator: **DEBBIE LATRONICA**
Copy Editor: **STEPHEN HOPKINS**
Proofreaders: **BARBARA DEVRIES, NANCY STEVENSON, PATTI GUERRIERI**
Text Editor: **CAROL PETERS**
Composition: **PREPARÉ**
Cover Printer: **PHOENIX COLOR CORPORATION**
Printer/Binder: **RR DONNELLEY**
Portable Edition Composition & Management: **SANDRA REINHARD, BLACK DOT**
Portable Edition Production Editor: **BARBARA TAYLOR-LAINO**
Portable Edition Cover Design: **PAT SMYTHE**

COVER PHOTO: Albrecht Dürer, German, (1471-1528). Melancolia I, 1514, engraving. The
Metropolitan Museum of Art, Fletcher Fund, 1919.

Credits and acknowledgements borrowed from other sources and reproduced, with permission, in this
textbook appear on the appropriate page within text or on the credit pages in the back of this book.

Prentice Hall
is an imprint of

10 9 8 7 6 5 4 3 2 1

www.pearsonhighered.com ISBN 10: 0-205-69743-7
 ISBN 13: 978-0-205-69743-4

Contents

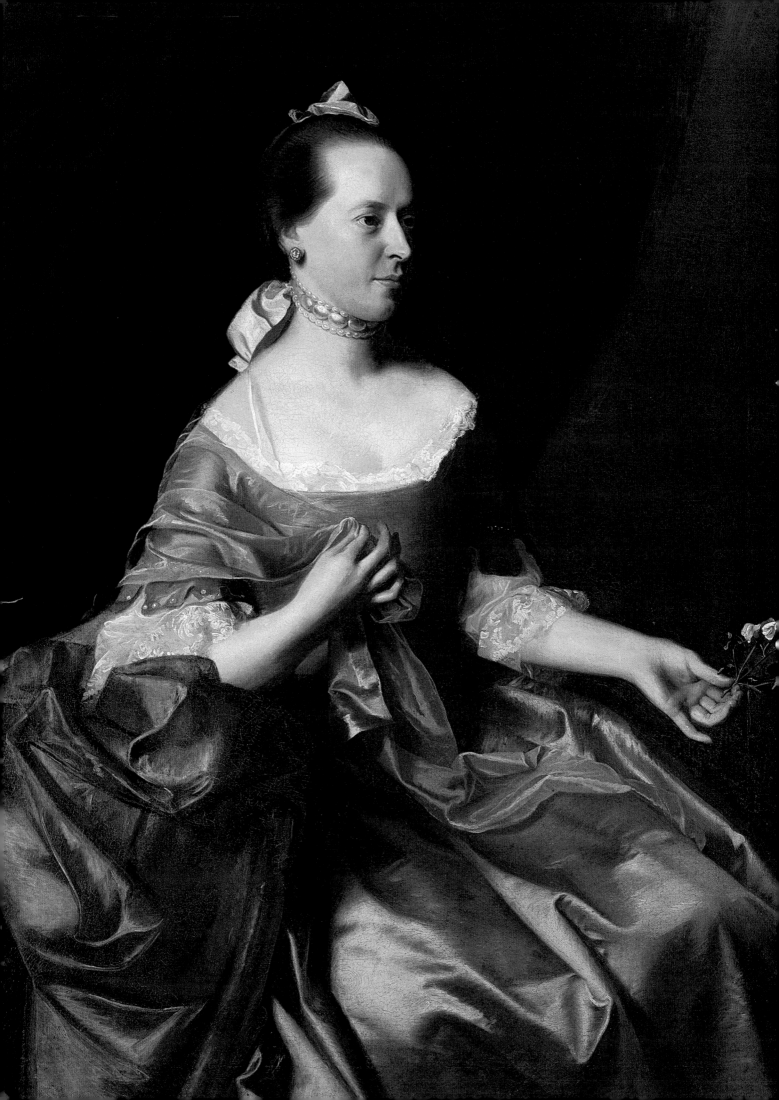

Introducing Art

WHO WAS FREELOVE OLNEY SCOTT? Her portrait (fig. I.1) shows us a refined-looking woman, born, we would guess, into an aristo-cratic family, used to servants and power. We have come to accept John Singleton Copley's portraits of colonial Bostonians, such as *Mrs. Joseph Scott,* as accurate depictions of his subjects and their lifestyles. But many, like Mrs. Scott, were not what they appear to be. Who was she? Let's take a closer look at the context in which the painting was made.

ART IN CONTEXT

Copley was one of the first American painters to make a name for himself throughout the American colonies and in England. Working in Boston from about 1754 to 1774, he became the most sought after portraitist of the period. Copley easily outstripped the competition of "face painters," as portraitists were derogato-rily called at the time, most of whom earned their living painting signs and coaches. After all, no successful British artist had any reason to come to America, for the economically struggling colonies were not a strong market for art. Only occasionally was a portrait commissioned, and typically, artists were treated like craftsmen rather than intellectuals. Like most colonial por-traitists, Copley was self-taught, learning his trade by looking at black-and-white prints of paintings by the European masters.

As we can see in *Mrs. Joseph Scott,* Copley was a master at painting textures, all the more astonishing when we realize that he had no one to teach him the tricks of the painter's trade. His illusions are so convincing, we think we are looking at real silk, ribbons, lace, pearls, skin, hair, and marble. Copley's contempo-raries also marveled at his sleight of hand. No other colonial painter attained such a level of realism.

I.1. John Singleton Copley, *Mrs. Joseph Scott.* ca. 1765.
Oil on canvas, 69½ × 39½″ (176.5 × 100 cm).
Collection of The Newark Museum, Newark, New Jersey. 48.508

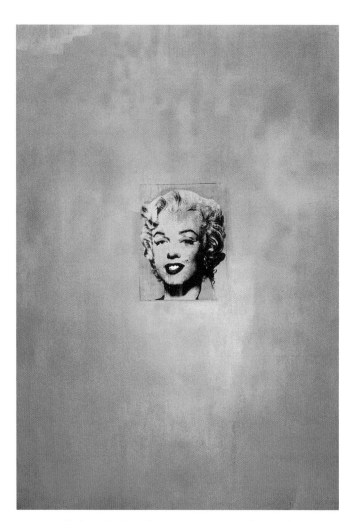

I.2. Andy Warhol. *Gold Marilyn Monroe.* 1962. Synthetic polymer paint, silk-screened, and oil on canvas, 6′11¼″ × 4′7″ (2.12 × 1.39 m). The Museum of Modern Art, New York, Gift of Philip Johnson. © 2006 Andy Warhol Foundation for the Visual Arts/© Artists Rights Society (ARS), New York, ™/© 2005 Marilyn Monroe, LLC by CMG Worldwide Inc., Indianapolis, Indiana 46256 USA.www.MarilynMonroe.com

However, Copley's job was not just to make a faithful copy of what he saw, but to project an image of Mrs. Scott as a woman of impeccable character, limitless wealth, and aristocratic status. The flowers she holds are a symbol of fertility, faithfulness, and feminine grace, indicating that she is a good mother and wife, and a charming woman. Her expensive dress was imported from London, as was her necklace. Copley may have elevated her status a bit more by giving her a pose taken from one of the prints of British or French royalty that he undoubtedly had on hand.

Not only is Mrs. Scott's pose borrowed, but most likely her dress and necklace, as well, for the necklace appears on three other women in Copley portraits. In other words, it was a studio prop. In fact, except for Mrs. Scott's face, the entire painting is a fiction designed to aggrandize the wife of a newly wealthy Boston merchant, who made a fortune selling provisions to the occupying British army. The Scotts were *nouveau riche* commoners, not titled aristocrats. By the middle of the eighteenth century, rich Bostonians wanted to distinguish themselves from their less successful neighbors. Now, after a century of trying to escape their British roots (from which many had fled to secure religious free-

dom), they sought to imitate the British aristocracy, even to the point of taking tea in the afternoon and owning English Spaniels, a breed that in England only aristocrats were permitted to own.

Mr. Scott commissioned this painting of his wife and a portrait of himself, not just to record their features, but to showcase the family's wealth. These pictures were extremely expensive and therefore status symbols, much like a Mercedes or a diamond ring from Tiffany's is today. The portraits were displayed in the public spaces of the house where they could be readily seen by visitors. Most likely they hung on either side of the mantle in the living room, or in the entrance hall. They were not intended as intimate affectionate resemblances destined for the private spaces in the home. If patrons wanted cherished images of their loved ones, they would commission miniature portraits, like the one in fig. 18.28 by Nicholas Hilliard. Miniatures captured the likeness of the sitter in amazing detail and were often so small they could be encased in a locket that a woman would wear on a chain around her neck, or a gentleman would place in the inner breast pocket of his coat, close to the heart. But the scale and lavishness of Copley's portrait add to its function as a status symbol.

If Mrs. Scott's portrait is rich with meaning, so is another image of a woman produced almost 200 years later: Andy

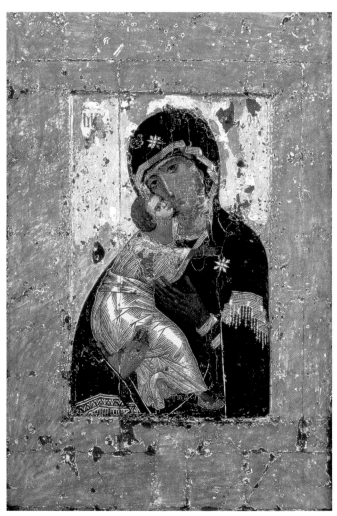

I.3. *Virgin of Vladimir.* Icon, probably from Constantinople. Faces only, 12th century; the rest has been retouched. Tempera on panel, height approx. 31″ (78 cm). Tretyakov Gallery, Moscow

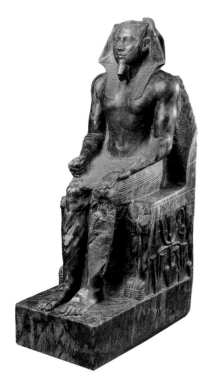

I.4. *Khafra,* from Giza. ca. 2500 BCE. Diorite, height 66″ (167.7 cm). Egyptian Museum, Cairo

Warhol's *Gold Marilyn Monroe* (fig. **I.2**) of 1962. In a sense, the painting may also be considered a portrait, because it portrays the famous 1950s film star and sex symbol. Unlike *Mrs. Joseph Scott*, however, the painting was not commissioned by Monroe or her family. Warhol chose the subject himself and made the painting to be exhibited in a commercial art gallery, where it could be purchased by a private collector for display in a home. Of course, he hoped ultimately it would end up in a museum, where a great number of people would see it—something Copley never considered because public museums did not exist in his day. In contrast to Copley, Warhol was not obliged to flatter his subject. Nor did he painstakingly paint this picture to create an illusionistic image. *Gold Marilyn Monroe* has no details and no sense of texture, as hair and flesh appear to be made of the same material— paint. Instead, the artist found a famous newspaper photograph of the film star and silkscreened it onto canvas, a process that involves first mechanically transferring the photograph onto a mesh screen and then pressing printing ink through the screen onto canvas. He then surrounded Marilyn's head with a field of broadly brushed gold paint.

Warhol's painting is a pastiche of the public image of Monroe as propagated by the mass media. He even imitates the sloppy, gritty look and feel of color newspaper reproductions of the period, for the four process colors of printing were often misregistered, that is, they did not align properly with the image. The Marilyn we are looking at is the impersonal celebrity of the media, supposedly glamorous with her lush red lipstick and bright blond hair but instead appearing pathetically tacky because of the garish color (blond hair becomes bright yellow) and grimy black ink. Her personality is impenetrable, reduced to a public smile. The painting was prompted, in part, by Monroe's recent suicide. The real Marilyn suffered from depression, despite her glamorous image. Warhol has brilliantly expressed the indifference of the mass media that glorifies celebrities by sat-

urating a celebrity-thirsty public with their likenesses, but tells us nothing meaningful about them and shows no concern for them. Marilyn Monroe's image is about promoting a product, much as the jazzy packaging of Brillo soap pads or Campbell's soup cans is designed to sell a product without telling us anything about the product itself. The packaging is just camouflage. Warhol floats Marilyn's face in a sea of gold paint, imitating icons of Christ and the Virgin Mary that traditionally surround these religious figures in a spiritual aura of golden, heavenly light (fig. **I.3**). But Warhol's revered Marilyn is sadly dwarfed in her celestial gold, adding to the poignancy of this powerful portrait, which so trenchantly comments on the enormous gulf between public image and private reality.

As we examine the circumstances in which *Mrs. Joseph Scott* and *Gold Marilyn Monroe* were created, we begin to understand how important context is to the look and meaning of works of art, and therefore, to the stories they tell. Although Copley and Warhol shared the context of being American artists, they worked in very different times, with diverse materials and techniques, and for a different type of clientele, all of which tremendously affected the look and meaning of their portraits. Because their art, like all art, served a purpose, it was impossible for either of them to make a work that did not represent a point of view and tell a story, sometimes many stories. Like great works of literature or music, memorable works of art tell powerful stories whose meanings become clearer when we explore the layers of context in which the works were made.

Many factors determine the style and meaning of a work of art and contribute to its powerful presence. For centuries, art created with a political or religious agenda had been used by the state and the church to promote an image of superiority and authority. Ancient Egyptian rulers understood art's power and used it to project their own, sometimes clothing their power in benevolence. Monumental stone sculptures typically depicted Egyptian kings and queens with one hand open for mercy, the other closed in a fist (seen in profile in fig. **I.4**). Religious images, such as Raphael's *Alba Madonna* (see fig. **I.5**), expressed the

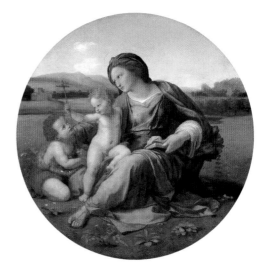

I.5. Raphael. *Alba Madonna.* ca. 1510. Oil on panel, diameter 37¼″ (94 cm). National Gallery of Art, Washington, DC. Andrew Mellon Collection

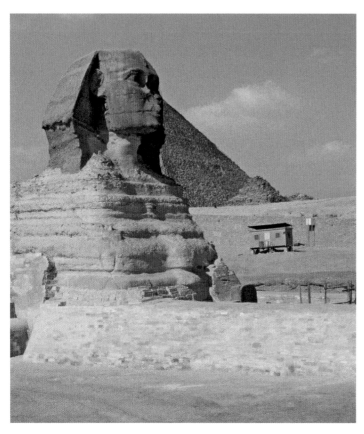

I.6. The Great Sphinx, Giza. ca 2570–2544 BCE. Sandstone, height 65′ (19.81 m)

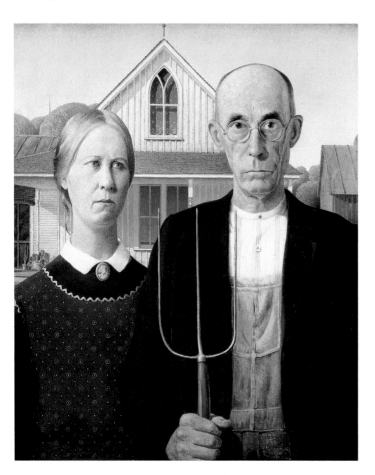

I.7. Grant Wood. *American Gothic.* 1930. Oil on board, 24⅞ × 24⅛″ (74.3 × 62.4 cm). The Art Institute of Chicago, Friends of American Art Collection. Art © Grant Wood/Licensed by VAGA, New York

idealized, perfected state of existence that its pious patron believed was attainable through Catholicism. Art meant for domestic settings, such as many landscape paintings or still lifes of fruit, dead game, or flowers, also carry many messages. Such images are far from simple attempts to capture the splendor and many moods of nature or to show off the painter's finesse at creating a convincing illusionistic image. The carefully rendered natural and man-made objects in Clara Peeters's *Still-Life of Fruit and Flowers* (fig. 20.11) remind a viewer of the pleasures of the senses, but also of their fleeting nature.

Art also has the power to evoke entire historical periods. Images of the pyramids and the Great Sphinx (fig. **I.6**), for example, conjure up the grandeur we associate with ancient Egyptian civilization. Similarly, Grant Wood's famous 1930 painting *American Gothic* (fig. **I.7**) reinforces the perception that humorless, austere, hardworking farmers populated the American Midwest at that time. In the context of popular mythology, the painting has virtually become an emblem of rural America.

Changing Contexts, Changing Meanings

American Gothic has also become a source of much sarcastic humor for later generations, which have adapted the famous pitchfork-bearing farmer and his sour-faced daughter for all kinds of agendas unrelated to the artist's message. Works of art are often appropriated by a viewer to serve in contexts that are quite different from those initially intended, and, as a result, the meanings of such works change radically. The reaction of some New Yorkers to *The Holy Virgin Mary* (fig. **I.8**) by Chris Ofili reflects the power of art to provoke and spark debate, even outrage. The work appeared in an exhibition titled *Sensation: Young British Artists from the Saatchi Collection,* presented at the Brooklyn Museum in late 1999. Ofili, who is British of African descent, made an enormous picture depicting a black Virgin Mary. He used dots of paint, glitter, map pins, and images of genitalia taken from popular magazines to suggest fertility. In African traditions, many representations of females are about fertility. In his painting, Ofili blended an African theme with Christian imagery, inadvertently offending many Westerners unfamiliar with the artist's cultural heritage. Instead of hanging on the wall, this enormous painting rested on two large wads of elephant dung, an arrangement that the artist had used many times for his large canvases since 1991. Elephant dung is held sacred in Zimbabwe, and for Ofili, a devout Catholic, the picture was about the elemental sacredness of the Virgin.

Many art historians, critics, and other viewers found the picture remarkably beautiful—glittering and shimmering with a delicate, ephemeral otherworldly aura. Many Catholic viewers, however, were repulsed by Ofili's homage to the Virgin with its so-called pornographic details. Instead of viewing the work through Ofili's eyes, they placed the painting within the context of their own experience and beliefs. Consequently, they interpreted the depiction of the dung and genitalia (and probably even a black Virgin, although this was never mentioned) as sacrilegious. Within days of the opening of the exhibition, the painting had to be put behind a large Plexiglas barrier. One artist hurled horse

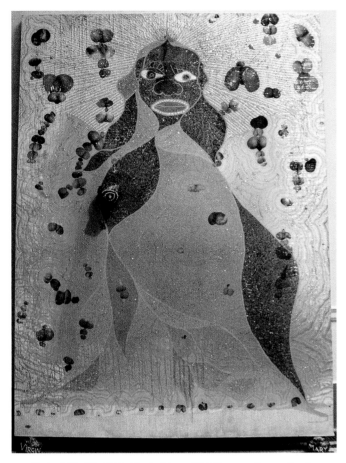

1.8. Chris Ofili. *The Holy Virgin Mary.* 1996. Paper collage, oil paint, glitter, polyester resin, map pins, and elephant dung on linen, 7′11″ × 5′11¹⁶″ (2.44 × 1.83 m). The Saatchi Gallery, London. © Chris Ofili

manure at the facade of the Brooklyn Museum, claiming "I was expressing myself creatively"; another museum visitor sneaked behind the Plexiglas barrier and smeared the Virgin with white paint in order to hide her. But the greatest attack came from New York's Mayor Rudolph Giuliani, a Catholic, who was so outraged he tried to eliminate city funding for the museum. Ultimately, he failed, but only after a lengthy lawsuit by the museum. The public outrage at Ofili's work is one episode in a long tradition that probably goes back to the beginning of image making. Throughout history, art has often provoked outrage, just as it has inspired pride, admiration, love, and respect. The reason is simple. Art is never an empty container; rather, it is a vessel loaded with meaning, subject to multiple interpretations, and always representing someone's point of view.

Social Context and Women Artists

Because the context for looking at art constantly changes, as society changes, our interpretations and insights into art and entire periods evolve as well. For example, when the first edition of this book was published in 1962, women artists were not included, which was typical for textbooks of the time. America, like most of the world, was male-dominated, and history focused on men. Women of that era were expected to be wives and mothers. If they worked, it was to add to the family's income. They were not supposed to become artists, and the few known exceptions were not

taken seriously by historians, who were mostly male. The feminist movement, beginning in the mid 1960s, overturned this restrictive perception of women's roles. As a result, in the last 40 years, art historians—many of them women—have "rediscovered" countless women artists. Many of these women were outstanding artists, held in high esteem during their lifetimes, despite having to struggle to overcome powerful social and even family resistance against women becoming professional artists.

One of these rediscovered women artists is the seventeenth-century Dutch painter Judith Leyster, a follower, if not a student, of Frans Hals. Over the centuries, all of Leyster's paintings were attributed to other artists, including Hals and Gerrit van Honthorst. Or the paintings were labeled "artist unknown." At the end of the nineteenth century, however, Leyster was rediscovered through an analysis of her signature, documents, and style, and her paintings were gradually restored to her name. It was only with the feminist movement that she was elevated from a minor figure to one of the more accomplished painters of her generation, one important enough to be included in the history of art. The feminist movement inspired a new context for evaluating art, one that had an interest in celebrating rather than denying women's achievements, and which was concerned with studying issues relating to gender and how women are portrayed in the arts.

A work like Leyster's *Self-Portrait* (fig. **I.9**), from about 1633, is especially fascinating from this point of view. Because of its size and date, this may have been the painting the artist submitted as her presentation piece for admission into the local painters' guild, the Guild of St. Luke of Haarlem. Women were not encouraged to join the guild, which was a male preserve reinforcing the

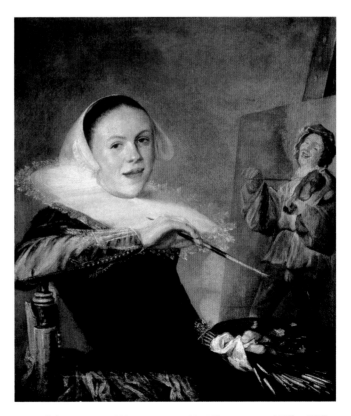

1.9. Judith Leyster. *Self-Portrait.* ca. 1633. Oil on canvas, 29¾″ × 25⅝″ National Gallery of Art, Washington, DC. (72.3 × 65.3 cm). Gift of Mr. and Mrs. Robert Woods Bliss

professional status of men. Nor did women artists generally take on students. Leyster bucked both restrictive traditions as she carved out a career for herself in a man's world. In her self-portrait, she presents herself as an artist, armed with many brushes, suggesting her deft control of the medium, which the presentation picture itself was meant to demonstrate. On the easel is a painting that is a segment of a genre scene (a glimpse of daily life), the type of painting for which she is best known. We must remember that at this time, artists rarely showed themselves working at their easels, toiling with their hands. They wanted to separate themselves from mere artisans and laborers, presenting themselves as belonging to a higher class. As a woman defying male expectations, however, Leyster needed to clearly declare that she was indeed an artist. So she cleverly elevates her status by not dressing as an artist would when painting. Instead, she appears, as her patrons do in their portraits, well dressed and well off. Her mouth is open, in what is called a "speaking likeness" portrait, giving her a casual but self-assured animated quality, as she appears to converse on equal terms with a visitor or viewer. Leyster, along with Artemisia Gentileschi and Elizabeth Vigée-Lebrun, who also appear in this book, was included in a major 1976 exhibition entitled *Women Artists 1550–1950,* which was presented in Los Angeles and Brooklyn, New York, and which played a major role in establishing the importance of women artists.

RECOGNIZING ART

Earlier generations of art historians focused almost entirely on three art forms: sculpture, architecture, and painting, together called the "fine arts." Yet recently, as artists have expanded the materials from which they make art, art historians study a wider variety of media used to express ideas. If we attempt to define art, we realize that it is not simply about a physical form. What we can see or touch in a work of art is only part of the story. The first chapter of this book discusses remarkable prehistoric paintings covering the walls of caves in Spain and France, some dating to ca. 30,000 BCE. The *Hall of the Bulls* (fig. **I.10**) appears on a wall in Lascaux Cave in the Dordogne region of France, and dates from ca. 16,000 BCE. Although we believe these works served some type of function for the people who made them, the animals they so naturalistically depicted on the walls of their caves were produced before the advent of writing, and we have no idea whether people at the time also thought of these expertly painted forms as we do—as works of art. Did they even have a concept of "art": a special category of communication in which the image played a role other than that of a simple everyday sign, such as a hiker's mark for danger carved on a tree?

In addition to its physical form, then, the question "How do we recognize art?" also depends on how we know something is art—either as an abstract idea or through our senses. The theory that art is also an intellectual product is a very old notion in Western culture. When the Italian Renaissance artist Michelangelo was carving the *David* (see fig. 16.13), he believed his role as sculptor was to use his artistic ability to "release" the form hidden with-

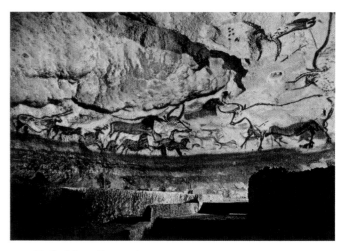

I.10. *Hall of the Bulls*, ca. 15,000–10,000 BCE. Lascaux, Dordogne, France

in the block of marble he was working on. And the twentieth-century Spanish Surrealist painter Salvador Dali once mischievously remarked that the ideas for his dreamlike paintings (see fig. 28.18) traveled down from the surrounding atmosphere through his generous handlebar moustache. Even those of us who know very little about art and its history have ideas about what art is simply because we have absorbed them through our culture. In 1919, the humorous and brilliant Parisian Marcel Duchamp took a roughly 8 by 4-inch reproduction of Leonardo da Vinci's *Mona Lisa* in the Louvre Museum in Paris and drew a mustache on the sitter's face (fig. **I.11**). Below he wrote the letters *L.H.O.O.Q.,* which when pronounced in French is *elle a chaud au cul,* which translates, "She has hot pants." With this phrase, Duchamp was poking fun at the public's fascination with the mysterious smile on the Mona Lisa, which began to intrigue everyone in the nineteenth century and had, in Duchamp's time, eluded suitable explanation. Duchamp irreverently suggests that her sexual identity is ambiguous and that she is sexually aroused. With the childish gesture of affixing a moustache to the Mona Lisa, Duchamp also attacked bourgeois reverence for Old Master painting and the notion that oil painting represented the pinnacle of art.

Art, Duchamp is saying, can be made by merely placing ink on a mass-produced reproduction. It is not strictly oil on canvas or cast bronze or chiseled marble sculpture. Artists can use any imaginable media in any way in order to express themselves. He is announcing that art is about ideas that are communicated visually, and not necessarily about the materials it is made from or how closely it corresponds to current tastes. In this deceivingly whimsical work, which is rich with ideas, Duchamp is telling us that art is anything that someone wants to call art, which is not the same as saying it is good art. Furthermore, he is proclaiming that art can be small; *L.H.O.O.Q.* is a fraction of the size of its source, the *Mona Lisa.* By appropriating Leonardo's famous picture and interpreting it very differently from traditional readings, Duchamp suggests that the answer to the question "How do we recognize art?" is not fixed forever, that it can change and be assigned by artists, viewers, writers, collectors, and museum curators, who use it for their own purposes. Lastly, and this is certainly one of Duchamp's many wonderful contributions to

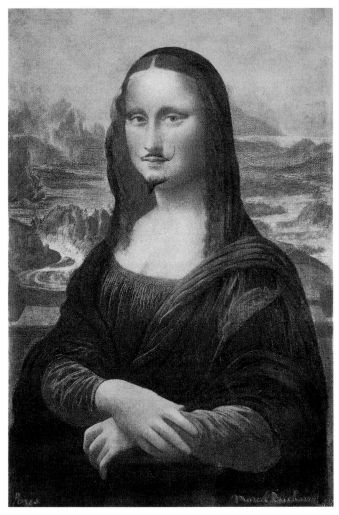

1.11. Marcel Duchamp. *Mona Lisa (L.H.O.O.Q.).* (1919) Rectified readymade; pencil on a reproduction. 7 × 4⅞″ (17.8 × 12 cm). Private collection. ©Artists Rights Society (ARS), New York/ADAGP, Paris/Succession Marcel Duchamp

art, he is telling us that art can be fun; it can defy conventional notions of beauty, and while intellectually engaging us in a most serious manner, it can also provide us with a smile, if not a good laugh.

Art and Aesthetics: Changing Ideas of Beauty

One of the reasons that Duchamp selected the *Mona Lisa* for "vandalizing" had to be that many people considered it the most beautiful painting ever made. Certainly, it was one of the most famous paintings in the world, if not the most famous. In 1919, most people who held such a view had probably never seen it and only knew it from reproductions, probably no better than the one Duchamp used in *L.H.O.O.Q.*! And yet, they would describe the original painting as beautiful, but not Duchamp's comical version. Duchamp called such altered found objects as *L.H.O.O.Q.* "assisted readymades" (for another example, see *The Fountain,* fig. 28.2). He was adamant when he claimed that these works had no aesthetic value whatsoever. They were not to be

considered beautiful, and they were selected because they were aesthetically neutral. What interested Duchamp were the ideas that these objects embodied once they were declared art.

L.H.O.O.Q. and the question of its beauty raises the issue of *aesthetics,* which is the study of beauty, its origins and its meanings, principally by philosophers. In the West, an interest in aesthetic concepts dates back to ancient Greece. The Greeks' aesthetic theories reflected ideas and tendencies of their culture. In calling a sculpture such as the *Kritios Boy* beautiful (fig. **I.12**), the Greeks meant that the statue reflected what was generally agreed to be an embodiment of the morally good or perfect: a well-proportioned young male. Even more, this idealized form, both good and beautiful, was thought to inspire positive emotions that would reinforce the character of the good citizen who admired it—an important function in the frequently turbulent city-states.

In the modern world, art historians, as well as artists, are also influenced by a variety of aesthetic theories that ultimately mirror contemporary interests about the direction of society and culture. As our world has come to appear less stable and more fragmented, aesthetic theories about what is true, good, or beautiful also have come to stress the relative nature of aesthetic concepts rather than seeing them as eternal and unchangeable. Many art historians now argue that a work of art can hold up under sever-

1.12. *Kritios Boy.* ca. 480 BCE. Marble. Height 46″ (116.7 cm). Akropolis Museum, Athens

al, often conflicting interpretations of beauty or other aesthetic concepts, if those interpretations can be reasonably defended. Thus, despite his claim, Duchamp's assisted readymades can be perceived as beautiful, in ways, of course, that are quite different from those of Leonardo's *Mona Lisa*. The beauty in Duchamp's works derives from their appeal to the intellect; if we understand his messages, his objects appear clever and witty, even profound. His wit and insights about art transformed a slightly altered cheap black-and-white reproduction into a compelling work of art, in a way that is very different from Leonardo's. The qualities that attract us to the *L.H.O.O.Q.*—its cleverness and wit—differ sharply from the skills and values that are inherent in Leonardo's *Mona Lisa*. The intriguing ideas and wit that surround the *L.H.O.O.Q.* place it above a mere youthful prank, and point to a new way of looking at art. Duchamp's innovative rethinking of the nature of art has had a profound effect on artists and aesthetic theory ever since it was made. Our appreciation of Robert Rauschenberg's *Odalisk* (fig. 29.10), created in the late 1950s out of a combination of found materials, including a pillow and a stuffed chicken, and playfully pasted with discarded materials full of sexual allusion, is unthinkable without Duchamp's work.

Quality: In the Mind or the Hand?

Terms like quality and originality are often used in discussing works of art, especially in choosing which works to include or exclude in a book like this. What is meant by these terms, however, varies from critic to critic. For example, in the long history of art, technical finesse or craft has often been viewed as the most important feature to consider in assessing quality. To debunk the myth that quality is all about technique and to begin to get at what it is about, we return to Warhol's *Gold Marilyn Monroe*. The painting is rich with stories: We can talk about how it raises issues about the meaning of art or the importance of celebrity, for example. But Warhol begs the question of the significance of technical finesse in art making, an issue raised by the fact that he may not have even touched this painting himself! We have already seen how he appropriated someone else's photograph of Marilyn Monroe, not even taking his own. Warhol then instructed his assistants to make the screens for the printing process. They also prepared the canvas, screened the image with the colors Warhol selected, and most likely painted the gold to Warhol's specifications, although we do not know this for sure.

By using assistants to make his work, Warhol is telling us that quality is not about the artist's technical finesse or even the artist's physical involvement in making the work, but about how well the artist communicates an idea using visual language. One measure of quality in art is the quality of the statement being made, or its philosophy, as well as the quality of the technical means for making the statement. Looking at *Gold Marilyn Monroe* in the flesh at New York's Museum of Modern Art is a powerful experience. Standing in front of this 6-foot-high canvas, we cannot help but feel the empty glory of America's most famous symbol of female sexuality and stardom. Because the artist's vision, and not his touch, is the relevant issue for the making of this particular work, it is of no consequence that Warhol most likely never

laid a hand to the canvas, except to sign the back. We will shortly see, however, that the artist's touch has often been seen as critical to the perception of originality in a work of art.

Warhol openly declared that his art was not about his technical ability when he called his Manhattan studio "The Factory." He was telling us that art is a commodity, and that he is manufacturing a product, even mass producing his product. The Factory churned out over a thousand, if not thousands, of paintings and prints of Marilyn Monroe, all based on the same newspaper photograph. All Warhol did, for the most part, was sign them, his signature reinforcing the importance many people place on the signature itself as being an essential part of the work. Ironically, most Old Master paintings, dating from the fourteenth through the eighteenth centuries, are not signed, and in fact, artists for centuries used assistants to help make their pictures.

Peter Paul Rubens, an Antwerp painter working in the first half of the seventeenth century and one of the most famous artists of his day, had an enormous workshop that cranked out many of his pictures, especially the large works. His assistants were often artists specializing in flowers, animals, or clothing, for example, and many went on to become successful artists in their own right. Rubens would design the painting, and then assistants, trained in his style, would execute their individual parts. Rubens would come in at the end and finish the painting as needed. The price the client was willing to pay often determined how much Rubens himself participated in the actual painting of the picture; many of his works were indeed made entirely by him. Rubens's brilliant

1.13. Pablo Picasso. Detail of *Guernica.* 1937. Oil on canvas, 11′6″ × 25′8″ (3.51 × 7.82 m). Museo Nacional Centro de Arte Reina Sofia, Madrid. On permanent loan from the Museo del Prado, Madrid. © Estate of Pablo Picasso/Artists Rights Society (ARS), New York

flashy brushwork was in many respects critical to the making of the picture. Not only was his handling of paint considered superior to that of his assistants, the very identity of his paintings, their very life so to speak, was linked to his personal way of applying paint to canvas, almost as much as it was to his dramatic compositions. For his buyers, Rubens's brushwork complemented his subject matter, even reinforced it. Despite the collaborative nature of their production, the artworks made in Rubens's workshop were often striking combinations of the ideas and the powerful visual forms used to communicate them. In that combination lies their originality.

Concepts like beauty, quality, and originality, then, do not refer only to physical objects like pretty, colorful pictures or a perfectly formed marble figure. They are ideas that reside in content and in the perception of how successfully the content is communicated visually. Some of the most famous and most memorable paintings in the history of art depict horrific scenes, such as beheadings (see fig. 19.5), crucifixions (see fig. 18.13), death and despair (see figs. 24.18 and 24.20), emotional distress (see fig.29.9), and the brutal massacre of innocent women and children (fig. **I.13**)). Duchamp's *L.H.O.O.Q.* and Warhol's *Gold Marilyn Monroe* are powerful and riveting. Some would even argue that their complex ideas and unexpected presentations make these works beautiful.

Photography as Art

The first edition of this book did not include photography among the media discussed. Now, four decades later, the artistic merit of photography seems self-evident. When photography was invented in 1839, the art world largely dismissed it as a mechanical process that objectively recorded reality. It was seen as a magical way to capture the detailed likenesses of people and objects without undergoing long artistic training. And, although some artists were intrigued by the often accidental and impersonal quality of the images it produced, the new medium was perceived by many critics as not having sufficient aesthetic merit to be seen in the lofty company of the major forms of fine art—painting and sculpture. Anyone, it seemed, could take a photograph. George Eastman's invention of the hand-held Kodak camera in 1888, allowed photography to become every man's and woman's pastime.

Photography has struggled for a long time to shed its popular, mechanical stigma. In the 1890s, some photographers, like Gertrude Käsebier, attempted to deny the hard, mechanical look of their art by making their prints appear soft, delicate, and fluid (see fig. 26.46). But at the beginning of the twentieth century, Paul Strand and others began to embrace black-and-white photography's hard-edge detail and the abstract results made possible by creative cropping. His *Wire Wheel* of 1917 (fig. 28.43) celebrates the machine age as well as the newest movements in the media of painting and sculpture. By the 1940s, black-and-white photography had gained some status as an art form, but it was not until the 1960s, when photography became an important part of the art school curriculum, that black-and-white photography began to take its place as one of the major art forms. It has taken color photography even longer to achieve serious consideration. But now,

along with video and film, both black-and-white and color photography have been elevated to an important medium. Pictures from the nineteenth and twentieth centuries that once had interested only a handful of photography insiders are intensely sought after, with many museums rushing to establish photography departments and amass significant collections. In other words, it has taken well over 100 years for people to get beyond their prejudice against a mechanical process and develop an eye for the special possibilities and beauty of the medium.

We need only look at a 1972 photograph entitled *Albuquerque* (fig. **I.14**) by Lee Friedlander to see how photography may compete with painting and sculpture in artistic merit. In *Albuquerque,* Friedlander portrays a modern America that is vacuous and lifeless, which he suggests is due to technology. How does he do this? The picture has a haunting emptiness. It has no people, and it is filled with strange empty spaces of walkway and street that appear between the numerous objects that pop up everywhere. A hard, eerie geometry prevails, as seen in the strong verticals of the poles, buildings, hydrant, and wall. Cylinders, rectangles, and circles are everywhere. (Notice the many different rectangles on the background building, or the rectangles of the pavement bricks and the foreground wall.)

Despite the stillness and emptiness, the picture is busy and restless. The vertical poles and the strong vertical elements on the house and building establish a vibrant staccato rhythm. The energy of this rhythm is reinforced by the asymmetrical composition that has no focus or center, as well as by the powerful intersecting diagonals of the street and the foreground wall. (Note how the shadow of the fire hydrant runs parallel to the street.) Disturbing features appear throughout the composition. The street sign—which cannot be seen because it is cropped at the top of the print—casts a mysterious shadow on the wall. A pole visually cuts the dog in two, and the dog has been separated from his attribute, the fire hydrant, as well as from his absent owner. The fire hydrant, in turn, appears to be mounted incorrectly, because it sticks too far out of the ground. The car on the right has been brutally cropped, and a light pole seems to sprout strangely from its hood. The telephone pole in the center of the composition is

I.14. Lee Friedlander. *Albuquerque.* 1972. Gelatin silver print, 11 × 14″. © Lee Friedlander

crooked, as though it has been tilted by the force of the cropped car entering from outside the edge of the picture (of course, the car is parked and not moving). Why do we assume this empty, frenetic quality is human-made? Because the work is dominated by the human-made and by technology. We see telephone poles, electrical wires, crosswalk signs, an ugly machinelike modular apartment building, sleek automobiles, and a fire hydrant. Cropped in the lower left foreground is the steel cover to underground electrical wiring.

Everywhere, nature has been cemented over, and besides a few scraggly trees in the middle ground and distance, only the weeds surrounding the hydrant thrive. In this brilliant print, Friedlander captures his view of the essence of modern America: the way in which technology, a love of the artificial, and a fast, fragmented lifestyle have spawned alienation and a disconnection with nature and spirituality. As important, he is telling us that modernization is making America homogeneous. The title tells us we are in Albuquerque, New Mexico, but without the title, we are otherwise in Anywhere, U.S.A.

Friedlander did not just find this composition. He very carefully selected it and he very carefully made it. He not only needed the sun, he had to wait until it was in the right position (otherwise, the shadow of the fire hydrant would not align with the street). When framing the composition, he very meticulously incorporated a fragment of the utility cover in the left lower foreground, while axing a portion of the car on the right. Nor did the geometry of the picture just happen; he made it happen. Instead of a soft focus that would create an atmospheric blurry picture, he has used a deep focus that produces a sharp crisp image filled with detail, allowing, for example, the individual rectangular bricks in the pavement to be clearly seen. The strong white tones of the vertical rectangles of the apartment building, the foreground wall, and the utility box blocking the car on the left edge of the picture were probably carefully worked up in the darkroom, as was the rectangular columned doorway on the house. Friedlander has exposed the ugliness of modern America in this hard, cold, dry image, and because of the power of its message he has produced an extraordinarily beautiful work of art.

Architecture as Art

Architecture, although basically abstract and dedicated to structuring space in a functional way, can also be a powerful communicator of ideas. For example, we see Gianlorenzo Bernini expressing complex ideas in 1656 when he was asked by Pope Alexander XVII to design a large open space, or piazza, in front of St. Peter's cathedral in Rome. Bernini obliged, creating a space that was defined by a row of columns (a colonnade) resembling arms that appear to embrace visitors, offering comfort (fig. **I.15**) and encouraging worshipers to enter the building. Bernini's design made the building seem to welcome all visitors into a universal (Catholic) church. At about the same time, the French architect Claude Perrault was commissioned to design the East facade of Louis XIV's palace, the Louvre in Paris (fig. **I.16**). The ground floor, where the day-to-day business of the court was carried out, was designed as a squat podium. The second floor,

I.15. St. Peter's, Rome. Nave and facade by Carlo Maderno, 1607–1615; colonnade by Gianlorenzo Bernini, designed 1657

where Louis lived, was much higher and served as the main floor, proclaiming Louis's grandeur. Perrault articulated this elevated second story with a design that recalled Roman temples, thus associating Louis XIV with imperial Rome and worldly power. The controlled symmetry of the design further expresses Louis's control over his court and nation.

In the modern era, an enormously wealthy businessman, Solomon R. Guggenheim, indulged his passion for modern art by commissioning architect Frank Lloyd Wright to design a museum in New York City. One of the boldest architectural statements of the mid-twentieth century, Wright's Solomon R. Guggenheim Museum is located on upper Fifth Avenue, overlooking Central Park (fig. **I.17**). The building, erected from 1956 to 1959, is radically different from the surrounding residential housing, thus immediately declaring that its function is different from theirs. Indeed, the building is radically different from most anything built up until that time. We can say that the exterior announces that it is a museum, because it looks as much like a gigantic sculpture as a functional structure.

Wright conceived the Guggenheim in 1945 to create an organic structure that deviated from the conventional static rectangular box filled with conventional static rectangular rooms. Beginning in the early twentieth century, Wright designed houses that related to the landscape and nature, both in structure and material (fig. 26.42). The structure of his buildings, whether domestic or commercial, reflects the very structure of nature, which he saw as a continuous expansion. His buildings radiate out from a central core or wrap around a central void, but in

I.16. Louis Le Vau, Claude Perrault, and Charles Le Brun. East front of the Louvre, Paris. 1667–1670

1.17. Frank Lloyd Wright. The Solomon R. Guggenheim Museum, New York. 1956–1959. David Heald © The Solomon Guggenheim Foundation, New York. © Frank Lloyd Wright Foundation, Scottsdale, AZ/Artists Rights Society (ARS), New York

1.18. Frank Lloyd Wright. Interior of the Solomon R. Guggenheim Museum, New York. 1956–59. Robert Mates © The Solomon Guggenheim R. Foundation, New York. © Frank Lloyd Wright Foundation, Scottsdale, AZ/Artists Rights Society (ARS), New York

either case, they are meant to expand or grow like a leaf or crystal, with one form opening up into another.

The Guggenheim is based on a natural form. It is designed around a spiral ramp (fig. **1.18**), which is meant to evoke a spiral shell. The structure also recalls a ceramic vase. It is closed at the bottom and open at the top, and as it rises it widens, until it is capped by a light-filled glass roof. When referring to the Guggenheim, Wright often cited an old Chinese aphorism, "The reality of the vase is the space inside." For the most part, the exhibition space is one enormous room formed by the spiral viewing ramp. Wright wanted visitors to take the elevator to the top of the ramp, and then slowly amble down its 3 percent grade, gently pulled by gravity. Because the ramp was relatively narrow, viewers could not get too far back from the works of art and were forced to have an intimate relationship with the objects. At the same time, they could look back across the open space of the room to see where they had been, comparing the work in front of them to a segment of the exhibition presented on a sweeping distant arc. Or they could look ahead as well, to get a preview of where they were going. The building has a sense of continuity and mobility that Wright viewed as an organic experience. Looking down from the

upper reaches of the ramp, we can see the undulation of the concave and convex forms that reflect the subtle eternal movement of nature. Wright even placed a pool on the ground floor, facing the light entering from the skylight high above. Regardless of their size, no other museum has succeeded in creating a sense of open space and continuous movement as Wright did in the Guggenheim. Nor does any other museum have the same sense of communal spirit; at the Guggenheim everyone is united in one big room (see fig. I.18).

EXPERIENCING ART

This book offers you an introduction to many works of art, and provides reproductions of most of them. Yet your knowledge of the objects will be enlarged when you see the works firsthand. No matter how accurate the reproductions in this book—or any other—are, they are just stand-ins for the actual objects. We hope you will visit some of the museums where the originals are displayed. But keep in mind that looking at art, absorbing its full impact takes time and repeated visits. Occasionally, you might do an in-depth reading of an individual work. This would involve carefully perusing details and questioning why they are there. Ideally, the museum will help you understand the art. Often, there are introductory text panels that tell you why the art in a particular exhibition or gallery has been presented together, and there are often labels for individual works that provide further information. Major temporary exhibitions generally have a catalogue, which adds yet another layer of information and interpretation. But text panels, labels, and catalogues generally reflect one person's reading of the work, and there are usually many other ways to approach or think about it.

Although the museum is an effective way to look at art and certainly the most efficient, art museums are relatively new. Indeed, before the nineteenth century, art was not made to be viewed in museums, but in homes, churches, or government buildings. Today we find works of art in galleries, corporate lobbies and offices, places of worship, and private homes. You may find art in public spaces, from subway stations and bus stops to plazas, from libraries and performing art centers to city halls. University and college buildings are often filled with art, and the buildings themselves are art. The chair you are sitting in and the building where you are reading this book are also works of art, maybe not great art, but art all the same, as Duchamp taught us. Even the clothes you are wearing are art. Wherever you find art, it is telling you something and making a statement.

Art is not a luxury, as many people would have us believe, but an integral part of daily life. It has a major impact on us, even when we are not aware of it; we feel better about ourselves when we are in environments that are visually enriching and exciting. Most important, art stimulates us to think. Even when it provokes and outrages us, it broadens our experience by making us question our values, attitudes, and worldview. This book is an introduction to this fascinating field that is so intertwined with our lives. After reading it, you will find that the world will not look the same.

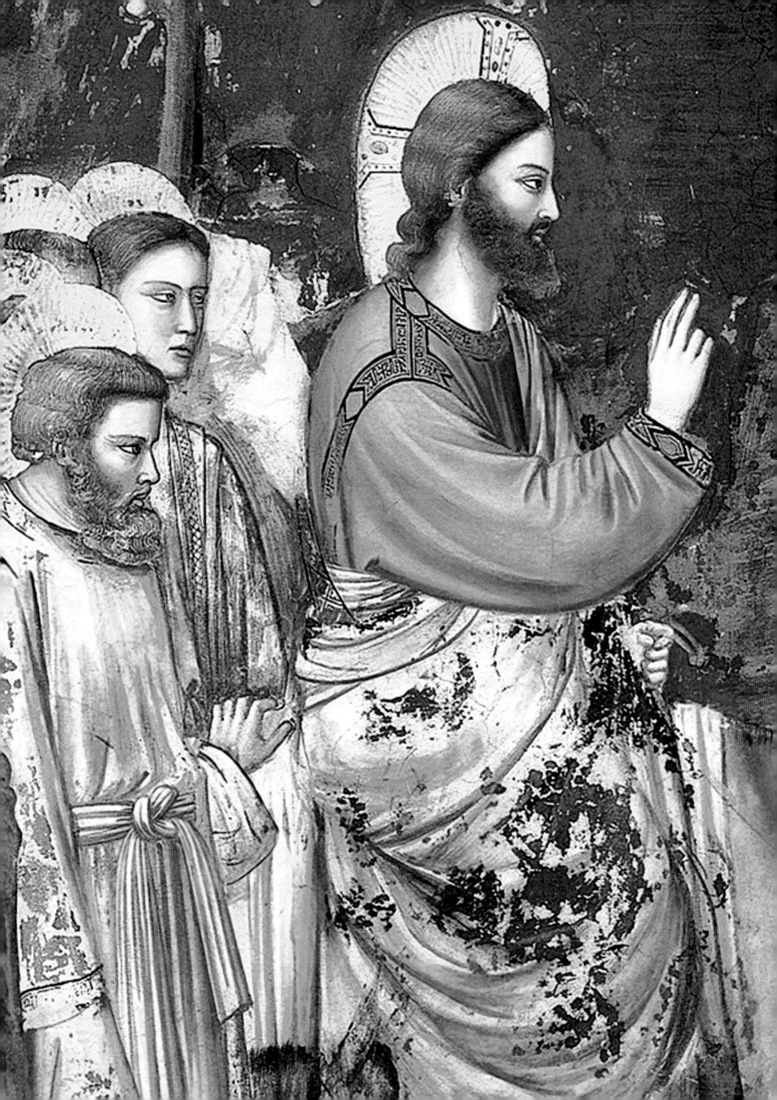

Art in Thirteenth- and Fourteenth-Century Italy

ALTHOUGH ITALIAN ARTISTS AND PATRONS SHARED CONCERNS WITH their contemporaries elsewhere in Europe, for geographic, historical, and economic reasons, the arts in Italy struck out in a different direction. Many of the innovations that would characterize the Italian Renaissance of the fifteenth and sixteenth centuries have their seeds in thirteenth and fourteenth-century Italy.

Throughout most of Europe in the thirteenth century, political and cultural power rested with landholding aristocrats. Products from their lands created wealth, and the land passed from one generation to the next. Although hereditary rulers controlled large regions, they usually owed allegiance to a king or to the Holy Roman emperor. But Italy had few viable kingdoms or strong central authorities. During most of the Middle Ages, Italian politics were dominated by the two international institutions of the Holy Roman Empire and the papacy. Usually, the emperors lived north of the Alps, and sheer distance limited their control in Italy. For much of the fourteenth century, Rome lacked a pope to command temporal power, as the papacy had moved to France. Hereditary rulers controlled southern Italy and the area around Milan, but much of Italy consisted of individual city-states, competing with each other for political influence and wealth. Among the most important of these were Florence, Siena, Pisa, and Venice.

Geography, particularly the long coastlines on the Mediterranean and Adriatic Seas, and long practice, had made Italy a trading center throughout the Middle Ages. By the thirteenth and fourteenth centuries, trade and paid labor for urban artisans had been long established. As the number of these new groups of merchants and artisans grew in the cities, their polit-ical power grew as well. The wealthiest and most influential cities, including Florence and Siena, were organized as representative republics. As a check on inherited power, some cities even excluded the landed aristocracy from participating in their political processes. Tensions erupted frequently between those who supported monarchical and aristocratic power, and thus supported the emperor, and those who supported the papacy and mercantile parties. In the cities of Florence, Venice, Pisa, and Siena, power tended to be concentrated in the hands of leading merchant families who had become wealthy through trade, manufacture, or banking. Members of these families would become the foremost patrons of artists in Italy.

Those artists developed their skills in a context that differed from the rest of Europe. Throughout the Middle Ages, Roman and Early Christian art served as an inspiration for Italian architects and sculptors, as is visible in such works as the Cathedral of Pisa (see fig. 11.33). In the mid-thirteenth century, the Holy Roman emperor Frederick II (1194–1250), who lived for a time in southern Italy, deliberately revived imperial Roman style to express his own political ambitions as heir to the Roman Empire. The other empire, Byzantium, kept a presence throughout Italy, too—through mosaics at Ravenna, Sicily, and Venice, and through the circulation of artists and icons such as the *Madonna Enthroned* (fig. 8.50). Added to these forces was the influence of the French Gothic style, introduced through the travels of artists and patrons.

Detail of figure 13.20, Giotto, *Christ Entering Jerusalem*

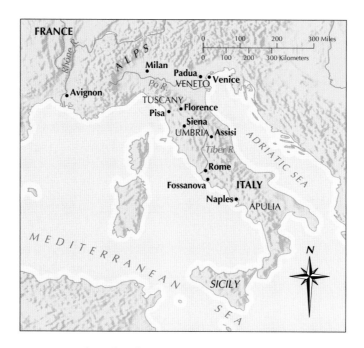

Map 13.1. Italy in the Thirteenth and Fourteenth Centuries

One of those travelers, the churchman, scholar, and poet Francesco Petrarch, exemplifies another aspect of fourteenth-century Italian culture: a growing interest in the creative works of individuals. Petrarch and his contemporaries, Dante Alighieri and Giovanni Boccaccio, belong to a generation of thinkers and writers who turned to the study of ancient works of literature, history, and art to seek out beautiful and correct forms. Petrarch also sought to improve the quality of written Latin, and thereby to emulate the works of the Roman authors Vergil and Cicero. This study of ancient thought and art led to a search for moral clarity and models of behavior, a mode of inquiry that came to be known as **humanism**. Humanists valued the works of the ancients, both in the literary and the visual arts, and they looked to the classical past for solutions to modern problems. They particularly admired Roman writers who championed civic and personal virtues, such as service to the state and stoicism in times of trouble. Humanists considered Roman forms the most authoritative, and, therefore, the most worthy of imitation, though Greek texts and ideas were also admired.

The study of the art of Rome and Greece would profoundly change the culture and the art of Europe by encouraging artists to look at nature carefully and to consider the human experience as a valid subject for art. These trends found encouragement in the ideals and theology of the mendicant orders, such as the Dominicans, who valued Classical learning, and the Franciscans, whose founder saw God in the beauty of Nature.

CHURCH ARCHITECTURE AND THE GROWTH OF THE MENDICANT ORDERS

International monastic orders, such as the Cistercians, made their presence felt in medieval Italy as in the rest of Europe. They were among the groups who helped to bring the technical and visual innovations of the French Gothic style to Italy. Italian Cistercian monasteries followed the practice, established in France, of building large, unadorned stone vaulted halls. These contrast starkly with the sumptuously adorned French Gothic cathedrals such as Reims (see fig. 12.29). Cistercians exercised control over the design of their monasteries to a great degree. The church of Fossanova, 60 miles south of Rome, represents the Cistercian plan transmitted to Italy (fig. **13.1**) from the headquarters churches in Burgundy. Consecrated in 1208, it is a vaulted basilica with somewhat abbreviated aisles that end in a squared chapel at the east end, as does the Cistercian church at Fontenay (fig. 11.23). Groin vaults cover the nave and the smaller spaces of the aisles, though the vaults are not ribbed as was the usual practice in Gothic buildings. Fossanova has no western towers and no tall spires. Interior spaces are spare and broadly proportioned rather than richly carved and narrow.

The simplicity of the architecture and the Cistercian reputation for reform made them an inspiration to the new mendicant movements that dominated Italy beginning in the thirteenth century and continuing through the Italian Renaissance. The

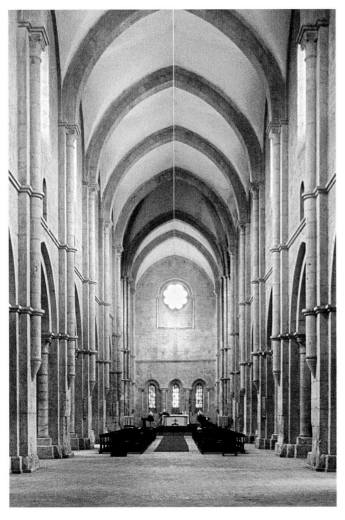

two major mendicant groups were the Franciscans and the Dominicans. They established international "orders," as did their monastic brethren, although their missions took a different form from those of traditional monks. Both orders were founded to minister to the lay populations in the rapidly expanding cities; they did not retreat from the world, but engaged with it. Each order built churches in the cities where sermons could be preached to crowds of people. The Dominicans, founded by Dominic de Guzmán in 1216, were especially concerned with combatting heresy. The Franciscan order, founded by Francis of Assisi in 1209, worked in the cities to bring deeper spirituality and comfort to the poor. Taking vows of poverty, Franciscans were committed to teaching the laity and to encouraging them to pursue spiritual growth. Toward this goal, they told stories and used images to explain and affirm the teachings of the Church. Characteristically, Franciscans urged the faithful to visualize events such as the Nativity in tangible ways, including setting up Nativity scenes (crèches) in churches as an aid to devotion.

The Franciscans at Assisi

The charismatic Francis died in 1226 and was named a saint two years later. His home town was the site of a huge basilica built in his honor. Its construction was sponsored by the pope, and was begun shortly after Francis's canonization in 1228. This multistoried structure became a pilgrimage site within a few years of its completion. The expansive walls of its simple nave (fig. 13.2) were decorated with frescoes on Old and New Testament themes and a cycle that explained and celebrated the

13.1. Nave and choir, Abbey Church of Fossanova, Italy. Consecrated 1208

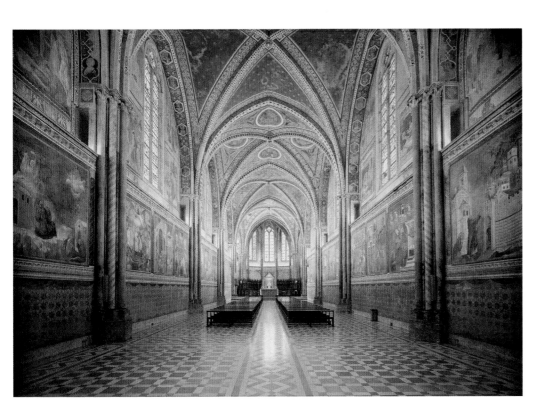

13.2. Interior of Upper Church, Basilica of San Francesco, Assisi. Begun 1228; consecrated 1253

achievements of Saint Francis. (See *Materials and Techniques*, page 442.) Scholars are still debating how many artists worked at Assisi from the 1290s to the early fourteenth century to complete this enormous cycle, but it appears that artists came here from Rome, Florence, Siena, and elsewhere. Assisi became a laboratory for the development of fourteenth-century Italian art. One of the most memorable of the many frescoes at Assisi depicts *Saint Francis Preaching to the Birds*, which was executed as part of a campaign of decoration in the church in the last decade of the thirteenth century or first part of the fourteenth century (fig. **13.3**). The whole cycle delineates Francis's life story based on a biography composed by his associates. One of the themes of Francis' life is his connection to Nature as a manifestation of God's workmanship; the story of Francis preaching to the birds exemplifies his attitude that all beings are connected. This fresco depicts Francis in his gray habit standing in a landscape and speaking to a flock of birds. To the astonished eyes of his companion, Francis appears to communicate to the birds, who gather at his feet to listen.

Trees establish the frame for the image as well as designate the location as outdoors; otherwise the background is a blue color, and little detail is provided. Francis and his companion are rendered naturalistically, as bulky figures in their

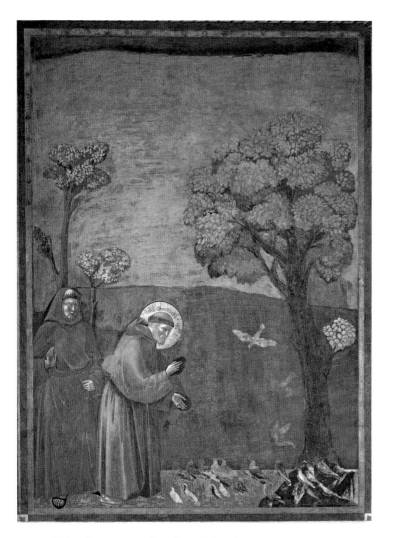

13.3. Anonymous. *Saint Francis Preaching to the Birds*. 1290s (?). Fresco from Basilica of San Francesco, Assisi

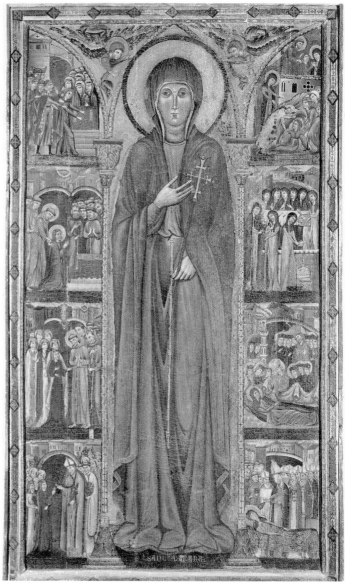

13.4. *Altarpiece of Saint Clare*. ca. 1280. Tempera on panel. 9 × 5½′ (2.73 × 1.65 m). Convent of Santa Chiara, Assisi

habits, as the artist describes light washing over their forms. Francis's figure becomes the focal point of the image, through his central position, the halo around his head, and his downward glance. His body language—the bent over stance, the movement of his hands—express his intense engagement with the birds as representatives of Nature. The simplicity of the composition makes the fresco easily legible and memorable.

The identity of the artist responsible for the frescoes in the nave of San Francesco is uncertain and controversial. One of the artists mentioned as a primary designer and painter is the Roman Pietro Cavallini, another is the Florentine Giotto di Bondone. But documentary evidence is lacking, and the opinions of connoisseurs fluctuate. Some scholars prefer to assign these frescoes to an anonymous master named for the paintings at Assisi. Whether through mutual influences or through competition with other artists, a new generation of painters comes of age at Assisi.

Franciscan women worshiped God through their vocations as nuns, though their convents and churches were less financially sound than many of the monasteries and churches of the friars. The nuns belonged to the branch of the Franciscans founded by his associate, Saint Clare, who was canonized in 1255. The church and convent she founded are still in service in Assisi, where an early example of an altarpiece to Saint Clare remains in place (fig. **13.4**). A tall rectangle of wood, painted in tempera, the altarpiece was executed around 1280. It is dominated by the figure of Saint Clare, dressed in the habit of her order, standing frontally and holding the staff of an abbess. Rather than a portrait with specific features, Clare's face has the large eyes and geometric arrangement of a Byzantine Madonna (see fig. 8.37), while her figure seems to exist in one plane. She is flanked on either side by eight tiny narratives that tell the story of her life, death, and miracles. These vignettes demonstrate her commitment to her vocation, her obedience to Francis and the Church, and her service to her fellow nuns. The narratives make little pretense at three-dimensional form or spatial structure, keeping the focus on the figures and

their actions to convey the story. Franciscan preachers wrote sermons and treatises addressed to religious women encouraging them to meditate on Scripture through visualizing the events in very physical terms. (See end of Part II, *Additional Primary Sources*.)

Churches and Their Furnishings in Urban Centers

Franciscan churches began to appear all over Italy as the friars ministered to the spiritual lives of city dwellers. A characteristic example in Florence is the church of Santa Croce (Holy Cross), begun around 1295 (fig. **13.5** and **13.6**) The architect was probably the Tuscan sculptor Arnolfo di Cambio. Santa Croce shares some features with Gothic churches in Northern Europe, but has some distinctively Italian elements. This is a basilica with a mostly rectilinear eastern end, such as those found in Cistercian churches. Its proportions are broad and expansive rather than vertical. The nave arcade uses a Gothic pointed arch, while vertical moldings pull the eye up to the

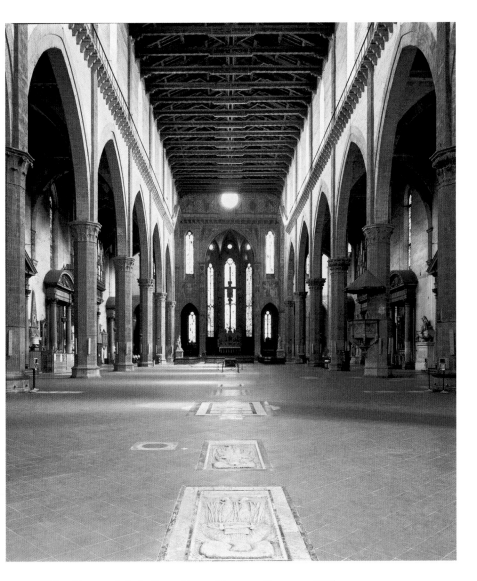

13.5. Nave and choir, Santa Croce, Florence. Begun ca. 1295

13.6. Plan of Santa Croce

Fresco Painting and Conservation

Fresco is a technique for applying paint to walls that results in an image that is both durable and brilliant. Frescoed surfaces are built up in layers: Over the rough wall goes a layer of rough lime-based plaster called *arriccio*. The artist then draws preliminary drawings onto this layer of plaster. Because they are done in red, these drawings are called *sinopie* (an Italian word derived from ancient Sinope, in Asia Minor, which was famous as a source of red brick earth pigment). Then a finer plaster called *intonaco* is applied in areas just large enough to provide for a day's worth of painting—the *giornata* (from *giorno,* the Italian word for "day"). While the plaster is still wet, the artist applies pigments suspended in lime water. As the plaster dries, the pigments bind to it, creating a *buon fresco,* literally a "good fresco." Plaster dries in a day, so only the amount of wet plaster that can be painted during that time can be applied. The work has to be done on a scaffold, so it is carried out from top to bottom, usually in horizontal strips about 4 to 6 feet long. As each horizontal level is completed, the scaffolding is lowered for the next level. To prevent chemical interactions with the lime of the plaster, some colors have to be applied *a secco* or dry; many details of images are applied this way as well. *Fresco secco* does not bond to the plaster as surely as *buon fresco* does, so it tends to flake off over time. Consequently, some frescoes have been touched up with tempera paints.

Although durability is the key reason for painting in fresco, over the centuries wars and floods have caused damage. Modern conservators have developed techniques for removing frescoes from walls and installing them elsewhere. After the River Arno flooded in 1966, many Florentine frescoes were rescued in this way, not only preserving the artworks but greatly increasing the knowledge and technology for this task. When a fresco is removed, a series of cuts are made around the image. Then a supporting canvaslike material is applied to the frescoed surface with a water-soluble glue. The surface to which the canvaslike material has been glued can then be pulled off gently and transferred to a new support to be hung elsewhere, after which the canvas can be removed.

Such removals have exposed many *sinopie*, such as the one shown here. The fresco, attributed to Francesco Traini (see fig. 13.32), was badly damaged by fire in 1944 and had to be detached from the wall in order to save what was left of it. This procedure revealed the plaster underneath, on which the composition was sketched out. These drawings, of the same size as the fresco itself, are much freer-looking in style than the actual fresco. They often reveal the artist's personal style more directly than the painted version, which was carried out with the aid of assistants.

Anonymous (Francesco Traini?). Sinopia drawing for *The Triumph of Death* (detail). Camposanto, Pisa

ceiling. Where one might expect the moldings to support a vaulted ceiling, however, Santa Croce uses wooden trusses to span the nave. The only vaults are at the apse and several chapels at the ends of the transept.

The choice to cover the nave with wood seems deliberate, as no structural reason accounts for it. There may be a regional preference for wooden ceilings, as the great Romanesque cathedral of Pisa also has a wooden roof. Santa Croce's broad nave with high arches is also reminiscent of Early Christian basilicas, such as Old Saint Peter's or Santa Maria Maggiore (see figs. 8.6 and 8.15). The wood roof at Santa Croce may have sprung from a desire to evoke the simplicity of Early Christian basilicas and thus link Franciscan poverty with the traditions of the early church.

One function of the wide spaces at Santa Croce was to hold large crowds to hear the friars' sermons. For reading Scripture at services and preaching, churchmen often commissioned

monumental pulpits with narrative or symbolic images carved onto them. Several monumental pulpits were made by members of a family of sculptors from Pisa, including Nicola Pisano (ca. 1220/25–1284) and his son Giovanni Pisano (1265–1314). Though the two men worked at various sites throughout Italy, they executed important pulpits for the cathedral and the baptistery of Pisa.

For the Pisan baptistery, Nicola Pisano carved a hexagonal marble pulpit that he finished around 1260 (fig. **13.7**) Rising to about 15 feet high, so the assembly could both see and hear the speaker, the six sides of the pulpit rest on colored marble columns supporting classically inspired capitals. Above the capitals, carved into leaf shapes, small figures symbolizing the virtues stand between scalloped shaped arches, while figures of the prophets sit in the spandrels of these arches. Surprisingly, one of these figures (fig. **13.8**) is a male nude with a lion cub on his shoulder and a lion skin over his arm. Both his form

and the lion skin identify him as Hercules, the Greek hero, who stands here for the Christian virtue of Fortitude. His anatomy, his proportions, and his stance are probably the product of Nicola Pisano's study of Roman and Early Christian sculpture. Pisano had worked for Frederick II and at Rome, so his knowledge of ancient forms was deep. The nudity is not meant to be lascivious, but serves rather to identify the figure.

Nicola's study of the Roman past informs many other elements in his pulpit, including the narratives he carved for the six rectangular sides of the pulpit itself. These scenes from the life of Christ are carved in relief. The Nativity in figure **13.9** is a densely crowded composition that combines the Annunciation with the Birth of Christ. The relief is treated as a shallow box filled with solid convex shapes in the manner of Roman sarcophagi, which Pisa's monumental cemetery preserved in good numbers. The figures could almost be copied from the

Ara Pacis procession; the Virgin has the dignity and bearing of a Roman matron (see fig. 7.22). Pisano probably knew Byzantine images of the Nativity, for his iconography reflects that tradition. As the largest and most central figure, the reclining Virgin overpowers all the other elements in the composition. Around her, the details of the narrative or setting, such as the midwives washing the child and Joseph's wondering gaze at the events, give the relief a human touch. Nicola uses broad figures, wrapped in classicizing draperies, to give the scene gravity and moral weight.

When his son Giovanni Pisano carved a pulpit about 50 years later for the Cathedral of Pisa, he chose a different emphasis. Though of the same size and material, his relief of the Nativity from the cathedral pulpit (fig. **13.10**) makes a strong contrast to his father's earlier work. Depicting the Nativity and the Annunciation to the shepherds, Giovanni Pisano dwells on the landscape and animal elements: Sheep and trees fill the right edge of

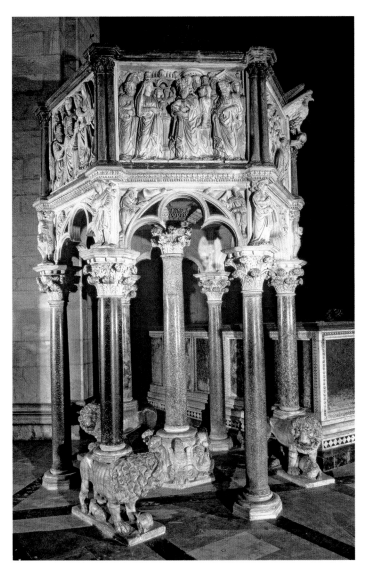

13.7. Nicola Pisano. Pulpit. 1259–1260. Marble. Height 15′ (4.6 m). Baptistery, Pisa

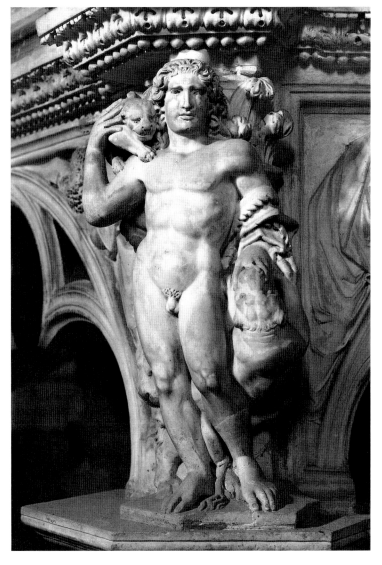

13.8. *Fortitude,* detail of the pulpit by Nicola Pisano. 1260

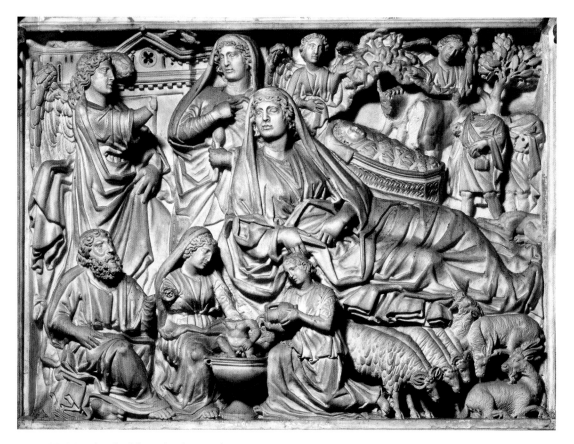

13.9. *Nativity,* detail of the pulpit by Nicola Pisano

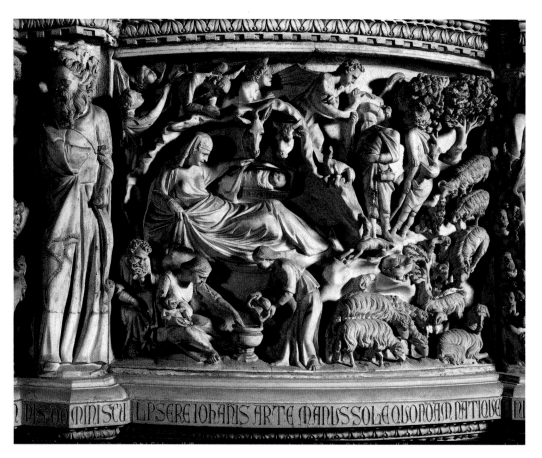

13.10. Giovanni Pisano. *The Nativity,* detail of pulpit. 1302–1310. Marble. Pisa Cathedral

the composition, while the nativity itself takes place in a shallow cave. The Virgin still dominates the composition, but she is no longer a dignified matron. Instead, she is a young mother tending to her child. Her proportions are elongated rather than sturdy. Rather than echoing Roman or Classical models, Giovanni has studied contemporary French models to bring elegance and a detailed observation of nature to the image. Each of Giovanni's figures has its own pocket of space. Where Nicola's Nativity is dominated by convex, bulging masses, Giovanni's appears to be made up of cavities and shadows. The play of lights and darks in Giovanni's relief exhibits a dynamic quality that contrasts with the serene calm of his father's work.

Expanding Florence Cathedral

East of Pisa along the Arno, the increasing wealth of Florence inspired that town to undertake major projects for its cathedral and baptistery in order to compete with its neighbors. One of Nicola Pisano's students, Arnolfo di Cambio (ca. 1245–1302) was tapped to design a new cathedral for Florence to replace a smaller church that stood on the site. The cathedral was begun in 1296 (figs. **13.11**, **13.12**, and **13.13**). Such a project took the skills and energy of several generations, and the plan was modified more than once. Revisions of the plan were undertaken in 1357 by Francesco Talenti (active 1325–1369), who took over the project

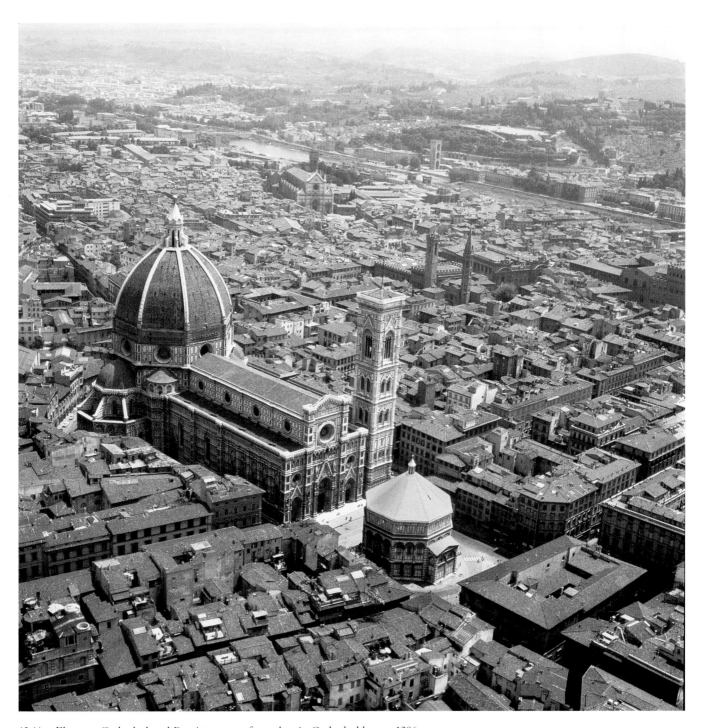

13.11. Florence Cathedral and Baptistery seen from the air. Cathedral begun 1296

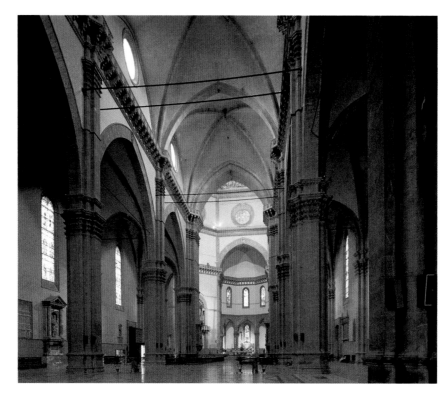

13.12. Nave and choir, Florence Cathedral

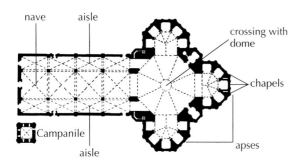

13.13. Plan of Florence Cathedral and Campanile

and dramatically extended the building to the east. By 1367, a committee of artists consulted by the overseers of the construction decided to cover the eastern zone with a high dome. The west facade and other portals continued to be adorned with sculpture throughout the Renaissance period, but the marble cladding on the building was not completed until the nineteenth century. Florence's *Duomo* was intended to be a grand structure that would not only serve as the spiritual center of the city, but as a statement of the city's wealth and importance.

Arnolfo's design was for a capacious basilica with a high arcade and broad proportions that contrast with contemporary Gothic structures in France (compare fig. 13.12 with fig. 12.26). The piers are articulated with leaf-shaped capitals and support flat moldings that rise to the clerestory level. Windows in the clerestory and aisles are relatively small, leaving much more wall surface than in French cathedrals. Although the original plan called for a trussed wooden roof in the Tuscan tradition,

by the mid-fourteenth century the plan had been altered to include ribbed groin vaults closer to the northern Gothic taste. The later plans enlarged the eastern zone to terminate in three faceted arms supporting an octagonal crossing that would be covered by a dome. (This design appears in the fresco in figure 13.33.) The scale of the proposed dome presented engineering difficulties that were not solved until the early fifteenth century. Instead of tall western towers incorporated into the facade, the cathedral has a *campanile* (bell tower) as a separate structure in the Italian tradition. The campanile is the work of the Florentine painter Giotto and his successors. If Florence's cathedral has Gothic elements in its vaults and arches, the foreign forms are tempered by local traditions.

In the heart of the city was the venerable Baptistery of Florence, built in the eleventh century on older foundations; the Florentines of the era believed it to be Roman and saw in its age the glory of their own past. Saint John the Baptist is the patron of Florence, so to be baptized in his baptistery meant that an individual not only became a Christian but also a citizen of Florence. In 1330, the overseers of the Baptistery commissioned another sculptor from Pisa, Andrea da Pisano (ca. 1295–1348; no relation to Nicola or Giovanni) to cast a new pair of bronze doors for the Baptistery. These were finished and installed in 1336 (fig. **13.14**). Cast of bronze and gilded, the project required 28 separate panels across the two panels of the door. They mostly represent scenes from the life of John the Baptist. Each vignette is framed by a Gothic quatrefoil, such as those found on the exteriors of French cathedrals. Yet within most of the four-lobed frames, Andrea provides a projecting ledge to support the figures and the landscape or architectural backgrounds. The relief of the Baptism of Christ demonstrates Andrea's clear compositional technique: Christ stands at the center, framed by

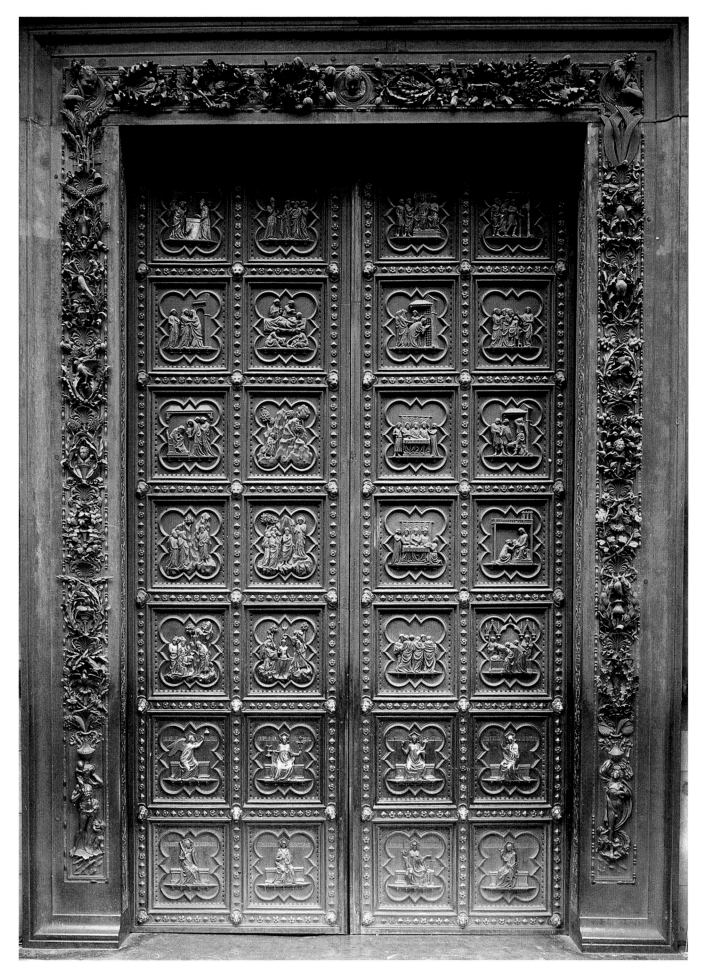

13.14. Andrea da Pisano. South doors, Baptistery of San Giovanni, Florence. 1330–1336. Gilt bronze

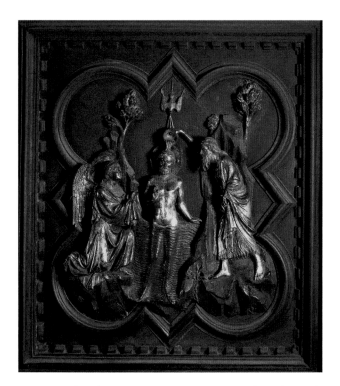

13.15. Andrea da Pisano. *The Baptism of Christ,* from the south doors, Baptistery of San Giovanni, Florence. 1330–1336. Gilt bronze

John on the right in the act of baptism and an angelic witness on the left (fig. **13.15**). The dove of the spirit appears above Christ's head. The emphasis is on the key figures, with little detail to distract from the main narrative; only a few small elements suggest the landscape context of the River Jordan.

Buildings for City Government: The Palazzo della Signoria

While the citizens of Florence were building the huge cathedral, the political faction that supported the papacy instead of the Holy Roman Empire consolidated its power in the city. The pro-papal party was largely composed of merchants who sought to contain the dynastic ambitions of aristocratic families who supported the emperor. The pro-papal group commissioned a large structure to house the governing council and serve as the symbol of the political independence of the city. The Palazzo della Signoria, also known as the *Palazzo Vecchio*, (fig. **13.16**) was probably also designed by Arnolfo di Cambio. It was begun in 1298 and completed in 1310, though it has been subject to later expansion and remodeling.

A tall, blocky, fortresslike structure, similar to fortified castles in the region, the Palazzo's stone walls are solid at the lowest level and rusticated for greater strength. The three stories of the structure are topped by heavy battlements and surmounted by a tall tower that serves not only as a symbol of civic pride, but as a defensive structure. It is slightly off-center for two reasons: The building rests on the foundations of an earlier tower, and its position makes it visible from a main street in the city. Boasting the highest tower in the city, the Palazzo della Signoria dominated the skyline of Florence and expressed the power of the communal good over powerful individual families.

PAINTING IN TUSCANY

As with other art forms in the thirteenth century, Italian painting's stylistic beginnings are different from those of the rest of Europe. Italy's ties to the Roman past and the Byzantine present would inspire Italian painters to render forms in naturalistic and monumental images. Throughout the Middle Ages, Byzantine mosaics and murals were visible to Italian artists. Venice had long-standing trading ties with the Byzantine Empire, and the Crusades had brought Italy in closer contact with Byzantium, including the diversion of the Fourth Crusade to Constantinople itself.

One result of the short-lived Latin occupation of Constantinople, from 1204 to 1261, was an infusion of Byzantine art forms and artists into Italy, which had a momentous effect on the development of Italian Gothic art. Later observers of the rapid changes that occurred in Italian painting from 1300 to 1550 described the starting point of these changes as the "Greek manner." Writing in the sixteenth century, Giorgio Vasari reported that in the mid-thirteenth century, "Some Greek painters were summoned to Florence by the government of the city for no other purpose than the revival of painting in their midst, since that art was not so much debased as altogether lost." Vasari assumes that medieval Italian painting was all but nonexistent and attributes to Byzantine art great influence over the development of Italian art in the thirteenth century. Italian artists were

13.16. Palazzo della Signoria (Palazzo Vecchio), Florence. Begun 1298

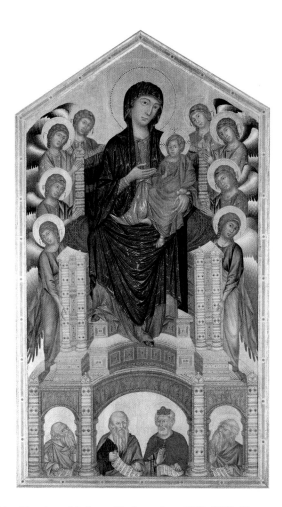

Later artists in Renaissance Italy, such as Lorenzo Ghiberti (see chapter 15) and Giorgio Vasari (see chapter 16) claimed that Cimabue was the teacher of Giotto di Bondone (ca. 1267–1336/37), one of the key figures in the history of art. If so, Giotto learned the "Greek Manner" in which Cimabue worked. Many scholars believe Giotto was one of the artists working at Assisi, so he probably also knew the work of the Roman painter Pietro Cavallini. Giotto also worked in Rome where examples of both ancient and Early Christian art were readily available for study. Equally important, however, was the influence of the Pisani—Nicolo and Giovanni—with their blend of classicism and Gothic naturalism combined in an increased emotional content. (See figs. 13.9 and 13.10.)

We can see Giotto's relationship to, but difference from, his teacher Cimabue in a tall altarpiece of the *Madonna Enthroned*, which he painted around 1310 for the Church of All Saints (Ognissanti) in Florence (fig. **13.18**). Like Cimabue's Santa Trinità Madonna, Giotto depicts the Queen of Heaven and her son

13.17. Cimabue. *Madonna Enthroned*. ca. 1280–1290. Tempera on panel, 12′7¹⁄₂″ × 7′4″ (3.9 × 2.2 m). Galleria degli Uffizi, Florence

able to absorb the Byzantine tradition far more thoroughly in the thirteenth century than ever before. When Gothic style began to influence artists working in this Byzantinizing tradition, a revolutionary synthesis of the two was accomplished by a generation of innovative and productive painters in Tuscan cities.

Cimabue and Giotto

One such artist was Cimabue of Florence (ca. 1250–after 1300), whom Vasari claimed had been apprenticed to a Greek painter. His large panel of the *Madonna Enthroned* (fig. **13.17**) was painted to sit on an altar in the Church of Santa Trinità in Florence; the large scale of the altarpiece—it is more than 12 feet high—made it the devotional focus of the church. Its composition is strongly reminiscent of Byzantine icons, such as the *Madonna Enthroned* (see fig. 8.50), but its scale and verticality are closer to the Saint Clare altarpiece (fig. 13.4) than to any Byzantine prototype. Mary and her son occupy a heavy throne of inlaid wood, which is supported by flanks of angels at either side and rests on a foundation of Old Testament prophets. The brilliant blue of the Virgin's gown against the gold leaf background makes her the focal point of the composition. Like Byzantine painters, Cimabue uses linear gold elements to enhance her dignity, but in his hands the network of gold lines follows her form more organically. The severe design and solemn expression is appropriate to the monumental scale of the painting.

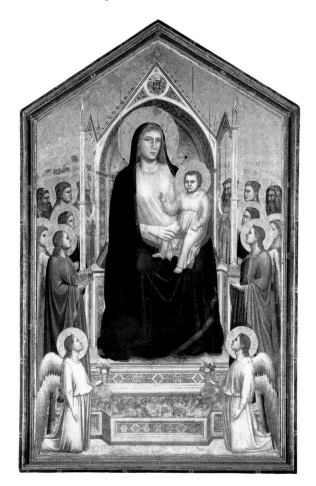

13.18. Giotto. *Madonna Enthroned*. ca. 1310. Tempera on panel, 10′8″ × 6′8″ (3.3 × 2 m). Galleria degli Uffizi, Florence

enthroned among angels against a gold background. The Virgin's deep blue robe and huge scale bring a viewer's eye directly to her and to the Christ Child on her lap. All the other figures gaze at them, both signaling and heightening their importance. Unlike his teacher, Giotto renders the figures bathed in light, so that they appear to be solid, sculptural forms. Where Cimabue turns light into a network of golden lines, Giotto renders a gradual movement from light into dark, so that the figures are molded as three-dimensional objects.

The throne itself is based on Italian Gothic architecture, though here it has become a nichelike structure. It encloses the Madonna on three sides, setting her apart from the gold background. The possibility of space is further suggested by the overlapping figures, who seem to stand behind one another instead of floating around the throne. Its lavish ornamentation includes a feature that is especially interesting: the colored marble surfaces of the base and of the quatrefoil within the gable. Such illusionistic stone textures had been highly developed by ancient painters (see fig. 7.52), and its appearance here is evidence that Giotto was familiar with whatever ancient murals could still be seen in medieval Rome.

THE SCROVEGNI CHAPEL IN PADUA Giotto's innovations in the area of light and space were accompanied by a gift for storytelling, especially in the fresco cycles he completed. Although scholars are not certain that he was among the artists who painted the nave frescoes at Assisi, his fresco cycles share formal and narrative characteristics with those images. Of

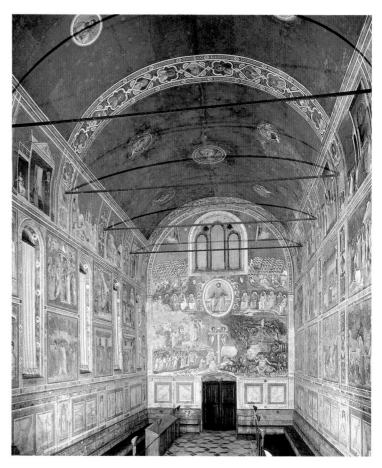

13.19. Interior, Arena (Scrovegni) Chapel. 1305–1306. Padua, Italy

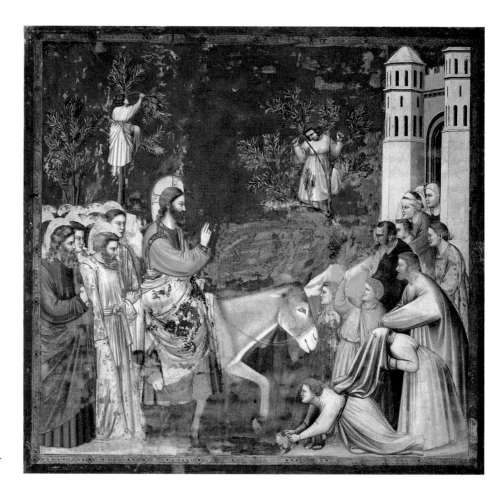

13.20. Giotto. *Christ Entering Jerusalem.* 1305–1306. Fresco. Arena (Scrovegni) Chapel. Padua, Italy

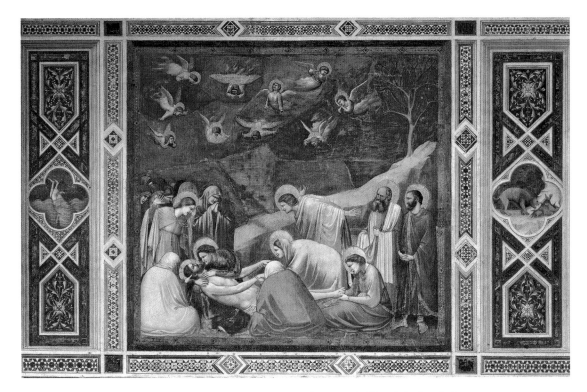

13.21. Giotto. *The Lamentation.* 1305–1306. Fresco. Arena (Scrovegni) Chapel. Padua, Italy

Giotto's surviving murals, those in the Scrovegni Chapel in Padua, painted in 1305 and 1306, are the best preserved and most famous. The chapel was built next to the palace of a Paduan banker, Enrico Scrovegni. (It is also known as the Arena Chapel because of its proximity to a Roman arena.) The structure itself is a one-room hall covered with a barrel vault. (fig. **13.19**)

Giotto and his workshop painted the whole chapel from floor to ceiling in the fresco technique. A blue field with gold stars symbolic of heaven dominates the barrel vault, below which the walls are divided into three registers or horizontal rows. Each register contains rectangular fields for narrative scenes devoted mainly to the life of Christ. The scenes begin at the altar end of the room with the Annunciation and culminate in the Last Judgment at the west end of the chapel. Along the length of the wall, the top register depicts stories of the early life of Mary and her parents; the center register focuses on stories of Christ's public life and miracles; and the lowest register depicts his Passion, Death, and Resurrection. Below the narratives the walls resemble marble panels interspersed with statues, but everything is painted.

Among the scenes from his public life is the *Christ Entering Jerusalem*, the event commemorated by Christians on Palm Sunday (fig. **13.20**). Giotto's handling of the scene makes a viewer feel so close to the event that his contemporaries must have had the sense of being a participant instead of an observer. He achieves this effect by having the entire scene take place in the foreground of his image, and by taking the viewer's position in the chapel into account as he designed the picture. Furthermore, Giotto gives his forms such a strong three-dimensional quality that they almost seem as solid as sculpture. The rounded forms create the illusion of space in which the actors exist.

Giotto gives very little attention to the setting for this event, except for the trees in which children climb and the gate of the

city on the right. His large simple forms, strong grouping of figures, and the limited depth of his stage give his scenes a remarkable coherence. The massed verticals of the block of apostles on the left contrast with the upward slope of the crowd welcoming Christ on the right; but Christ, alone in the center, bridges the gap between the two groups. His isolation and dignity, even as he rides the donkey toward the city where he will die, give the painting a solemn air.

Giotto's skill at perfectly matching composition and meaning may also be seen in the scenes on the lowest level register, which focus on the Passion. A viewer gazing at these frescoes sees them straight on, so the painter organizes these scenes to exploit that relationship. One of the most memorable of these paintings depicts the Lamentation, the moment of last farewell between Christ and his mother and friends (fig. **13.21**). Although this event does not appear in the gospels, by the end of the Middle Ages versions of this theme had appeared in both Byzantine and in Western medieval art.

The tragic mood of this Lamentation, found also in religious texts of the era, is created by the formal rhythm of the design as much as by the gestures and expressions of the participants. The low center of gravity and the hunched figures convey the somber quality of the scene as do the cool colors and bare sky. With extraordinary boldness, Giotto sets off the frozen grief of the human mourners against the frantic movement of the weeping angels among the clouds. It is as if the figures on the ground were restrained by their obligation to maintain the stability of the composition, while the angels, small and weightless as birds, are able to move—and feel—freely.

Once again the simple setting heightens the impact of the drama. The descending slope of the hill acts as a unifying element that directs attention toward the heads of Christ and the Virgin,

which are the focal point of the scene. Even the tree has a twin function. Its barrenness and isolation suggest that all of nature shares in the sorrow over Christ's death. Yet it also carries a more precise symbolic message: It refers to the Tree of Knowledge, which the sin of Adam and Eve had caused to wither and which was to be restored to life through Christ's sacrificial death.

Giotto's frescoes at the Arena Chapel established his fame among his contemporaries. In the *Divine Comedy*, written around 1315, the great Italian poet Dante Alighieri mentions the rising reputation of the young Florentine: "Once Cimabue thought to hold the field as painter, Giotto now is all the rage, dimming the luster of the other's fame." (See end of Part II, *Additional Primary Sources*.) Giotto continued to work in Florence for 30 years after completing the Arena Chapel frescoes, in 1334 being named the architect of the Florentine cathedral, for which he designed the *campanile* (bell tower) (see figs. 13.11 and 13.13). His influence over the next generation of painters was inescapable and had an effect on artists all over Italy.

Siena: Devotion to Mary in Works by Duccio and Simone

Giotto's slightly older contemporary, Duccio di Buoninsegna of Siena (ca. 1255–before 1319) directed another busy and influential workshop in the neighboring Tuscan town of Siena. The city of Siena competed with Florence on a number of fronts—military, economic, and cultural—and fostered a distinct identity and visual tradition. After a key military victory and the establishment of a republic directed by the *Nove* (the Nine), Siena took the Virgin Mary as its protector and patron, and dedicated its thirteenth-century cathedral to her. This cathedral, substantially completed by 1260, displays several features of the new style of Gothic architecture from France: Its arcade rests on compound piers like those in French cathedrals, and the ceiling was vaulted. Its facade (see fig. **13.22**) was entrusted to the sculptor Giovanni Pisano in 1284, though he left it incomplete when he departed in 1295. The facade reveals French elements, too, such as the pointed gables over tympanums defining the three portals, the blind arcades above the outer portals, and the sculpted figures of prophets and other figures who stand on platforms between the portals and on the turrets at the outer edges of the facade.

A fine example of Sienese devotion to Mary may be seen in a small panel of the *Virgin and Child* that Duccio painted around 1300 (fig. **13.23**). Still in its original frame, this wonderfully preserved painting has recently entered the Metropolitan Museum of Art in New York from a private collection. Small in scale, the painting depicts the Mother and son in a tender relationship: She supports the Christ

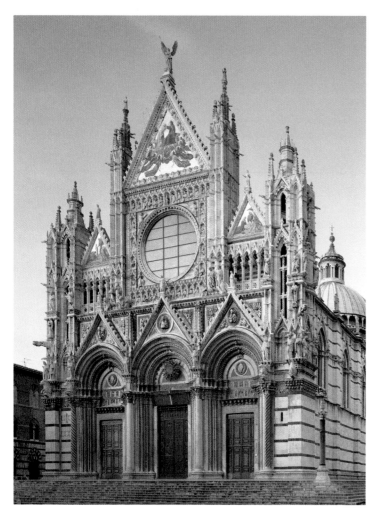

13.22. Siena Cathedral, completed ca. 1260. Facade. Lower sections ca. 1284–1299 by Giovanni Pisano

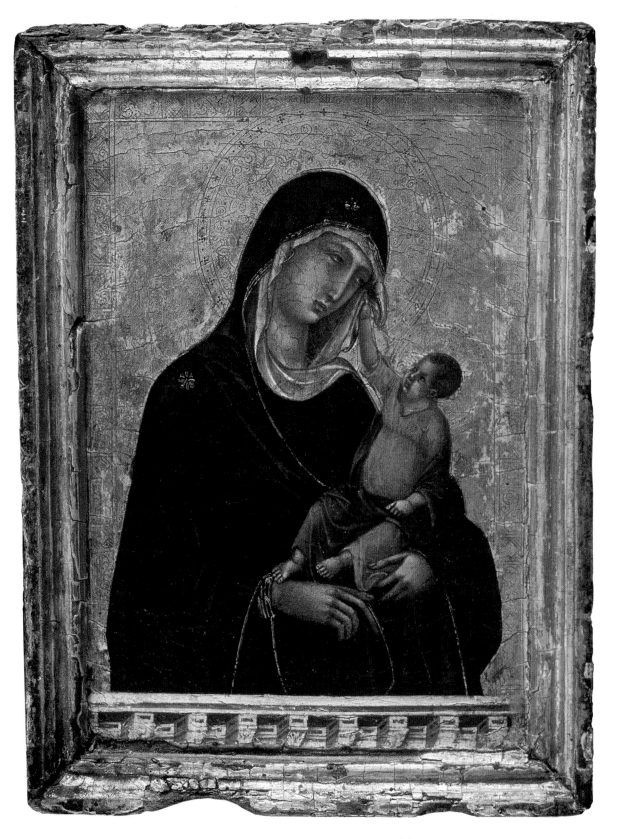

13.23. Duccio, *Virgin and Child*. ca. 1300. Tempera and gold on wood. 11 × 8¼″ (28 × 20.8 cm) Metropolitian Museum of Art, New York. Purchase Rogers Fund, Walter and Lenore Annenberg Foundation Gift, Lila Acheson Wallace Gift, Annette de la Renta Gift, Harris Brisbane Dick, Fletcher, Louis V. Bell, and Dodge Funds, Joseph Pulitzer Bequest, several members of the Chairman's Council Gifts, Elaine L. Rosenberg and Stephenson Family Foundation Gifts, 2003 Benefit Fund, and other gifts and funds from various donors, 2004. (2004.442)

The Social Work of Images

The report of the celebrations held in Siena when Duccio's *Maestà* was installed in the cathedral attests to the importance of this painting for the entire community. It was a source of pride for the citizens of Siena, but also a powerful embodiment of the Virgin's protection of the city. Although modern audiences expect to find and react to works of art hanging in museums, art historians have demonstrated that art served different purposes in late medieval Europe. Few in the West today believe that a work of art can influence events or change lives. But in fourteenth-century Europe, people thought about images in much more active terms. Art could be a path to the sacred or a helper in times of trouble.

During a drought in 1354, for example, the city fathers of Florence paraded a miracle-working image of the Virgin from the village of Impruneta through the city in hopes of improving the weather. People

with illness or health problems venerated a fresco of the Annunciation in the church of the Santissima Annunziata in Florence; they gave gifts to the image in hopes of respite from their problems. When the plague came to Florence, artists were commissioned to paint scenes depicting Saint Sebastian and other saints who were considered protectors against this deadly disease.

Images were also called upon for help outside the sacred space of the church. Continuing a tradition begun in the fourteenth century, street corners in Italy are often adorned with images of the Virgin to whom passersby may pray or show respect. Candles may be lit or gifts offered to such images in hopes of the Virgin's assistance. Art historians are also studying how works of art functioned among late medieval populations to forge bonds among social groups and encourage group identity. For example, outside the confines of monasteries, groups of citizens formed social organizations that were dedicated to a patron saint, whose image would be an important element of the group's identity.

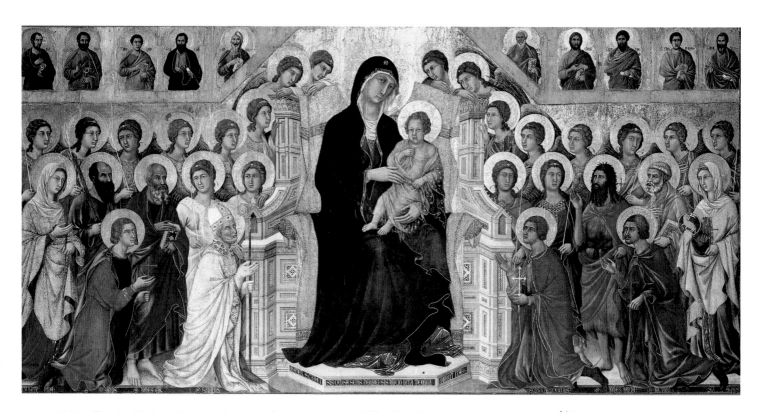

13.24. Duccio. *Madonna Enthroned,* center of the *Maestà Altar.* 1308–1311. Tempera on panel, height 6'10½" (2.1 m). Museo dell'Opera del Duomo, Siena

Child in her arms as he reaches up to pull on her veil. His small scale in relation to his mother makes him seem very vulnerable. Duccio has washed both figures in a warm light that softens the contours and suggests three-dimensional forms, but he sets these figures against a brilliant gold background that contrasts vividly with the Virgin's blue gown. Her wistful glance at her tiny child gives the painting a melancholy effect.

Duccio was commissioned by the directors of Siena's cathedral to paint the large altarpiece for the high altar, called the *Maestà* as it depicts the Virgin and Child in majesty (fig. **13.24**). Commissioned in 1308, the *Maestà* was installed in the cathedral in 1311 amidst processions and celebrations in the city. (See *Primary Source*, page 456, and *The Art Historian's Lens*, above.) Duccio's signature at the base of the throne expresses his pride in the work: "Holy Mother of God,

be the cause of peace to Siena, and of life to Duccio because he has painted you thus."

In contrast to the intimate scale of the Metropolitan's *Virgin and Child*, here Duccio creates a regal image on a large scale. Members of her court surround the enthroned Virgin and Child in the *Maestà* in a carefully balanced arrangement of saints and angels. She is by far the largest and most impressive figure, swathed in the rich blue reserved for her by contemporary practice. Siena's other patron saints kneel in the first row, each gesturing and gazing at her figure. The Virgin may seem much like Cimabue's, since both originated in the Greek manner, yet Duccio relaxes the rigid, angular draperies of that tradition so that they give way to an undulating softness. The bodies, faces, and hands of the many figures seem to swell with three-dimensional life as the painter explores the fall of light on their forms. Clearly the heritage of Hellenistic-Roman illusionism that had always been part of the Byzantine tradition, however submerged, inspired Duccio to a profound degree. Nonetheless, Duccio's work also reflects contemporary Gothic sensibilities in the fluidity of the drapery, the appealing naturalness of the figures, and the glances by which the figures communicate with each other. The chief source of this Gothic influence was probably Giovanni Pisano, who was in Siena from 1285 to 1295 as the sculptor-architect in charge of the cathedral facade, although there is evidence that Duccio may have traveled to Paris, where he would have encountered French Gothic style directly.

In addition to the principal scene, the *Maestà* included on its front and on its back numerous small scenes from the lives of Christ and the Virgin. In these panels, Duccio's synthesis of Gothic and Byzantine elements gives rise to a major new development: a new kind of picture space and, with it, a new treatment of narrative. The *Annunciation of the Death of the Virgin* (fig. **13.25**), from the front of the altarpiece, represents two figures enclosed by an architectural interior implied by foreshortened walls and ceiling beams to create and define a space that the figures may inhabit. But Duccio is not interested simply in space for its own sake. The architecture is used to integrate the figures within the drama convincingly. In a parallel scene to the Annunciation (see fig. 13.27, for comparison), this panel depicts the angel Gabriel returning to the mature Virgin to warn her of her impending death. The architecture enframes the two figures separately, but places them in the same uncluttered room. Despite sharing the space, each figure is isolated. Duccio's innovative use of architecture to enhance the narrative of his paintings inspired his younger French contemporary Jean Pucelle, who adapted this composition for the *Annunciation* in the *Hours of Jeanne d'Évreux* (fig. 12.41).

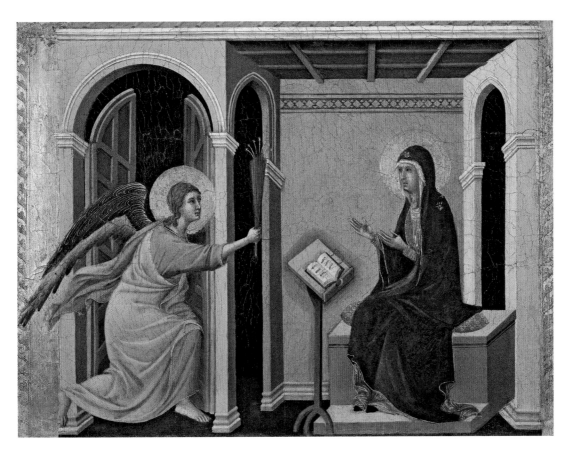

13.25. Duccio. *Annunciation of the Death of the Virgin,* from the *Maestà Altar*

Agnolo di Tura del Grasso

From his Chronicle

Duccio's Maestà *(fig. 13.24) stood on the main altar of Siena Cathedral until 1506, when it was removed to the transept. It was sawed apart in 1771, and some panels were acquired subsequently by museums in Europe and the United States. This local history of about 1350 describes the civic celebration that accompanied the installation of the altarpiece in 1311.*

These paintings [the *Maestà*] were executed by master Duccio, son of Nicolò, painter of Siena, the finest artist to be found anywere at his time. He painted the altarpiece in the house of the Muciatti outside the gate toward Stalloreggi in the suburb of Laterino. On the 9th of June [1311], at midday, the Sienese carried the altarpiece in great devotion to the cathedral in a procession, which included Bishop Roger of Casole, the entire clergy of the cathedral, all monks and nuns of the city, and the Nine Gentlemen [Nove] and officials of the city such as the podestà and the captain, and all the people. One by one the worthiest, with lighted candles in their hands, took their places near the altarpiece. Behind them came women and children with great devotion. They accompanied the painting up to the cathedral, walking in procession around the Campo, while all the bells rang joyfully. All the shops were closed out of devotion, all through Siena many alms were given to the poor with many speeches and prayers to God and to his Holy Mother, that she might help to preserve and increase the peace and well being of the city and its jurisdiction, as she was the advocate and protection of said city, and deliver it from all danger and wickedness directed against it. In this way the said altarpiece was taken into the cathedral and placed on the main altar. The altarpiece is painted on the back with scenes from the Old Testament and the Passion of Jesus Christ and in front with the Virgin Mary and her Son in her arms and many saints at the sides, the whole decorated with fine gold. The alterpiece cost 3000 gold florins.

SOURCE: TERESA G. FRISCH, *GOTHIC ART 1140–C 1450*. (ENGLEWOOD CLIFFS, NJ: PRENTICE HALL, 1971.)

The architecture keeps its space-creating function even in the outdoor scenes on the back of the *Maestà,* such as in *Christ Entering Jerusalem* (fig. **13.26**), a theme that Giotto had treated only a few years before in Padua. Where Giotto places Christ at the center of two groups of people, Duccio places him closer to the apostles and on one side of the composition. He conveys the diagonal movement into depth not by the figures, which have the same scale throughout, but by the walls on either side of the road leading to the city, by the gate that frames the welcoming crowd, and by the buildings in the background. Where Giotto reduces his treatment of the theme to a few figures and a bare backdrop, Duccio includes not only detailed architectural elements but also many children climbing trees to gather palms leaves as well

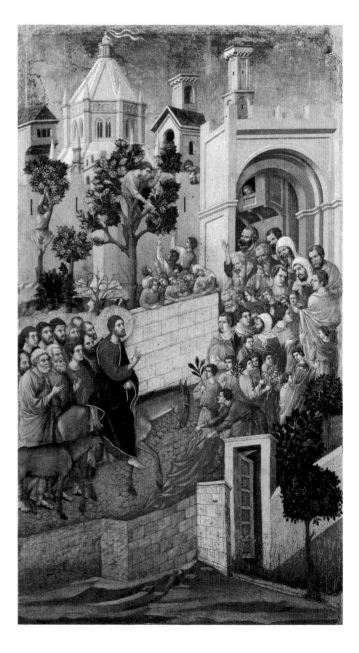

13.26. Duccio. *Christ Entering Jerusalem,* from the back of the *Maestà Altar.* 1308–1311. Tempera on panel, 40½ × 21⅛″ (103 × 53.7 cm). Museo dell'Opera del Duomo, Siena

as figures peering at the crowd in the streets from their first-floor windows. Duccio gives a viewer a more complete description of the event than Giotto, whose work stresses the doctrinal and psychological import of the moment. The goals of the two painters differ, and so do the formal means they use to achieve them.

Duccio trained the next generation of painters in Siena. One distinguished disciple was Simone Martini (ca. 1284–1344), who also worked in Assisi but spent the last years of his life in Avignon, the town in southern France that served as the residence of the popes during most of the fourteenth century. In 1333 the directors of the Siena Cathedral commissioned Simone to make another altarpiece to complement Duccio's *Maestà*. His *Annunciation* (fig. **13.27**) preserves its original pointed and cusped arch format in its restored frame and suggests what has been lost in the dismemberment of the *Maestà*, which had a similar Gothic frame. Simone's altarpiece depicts the Annunciation flanked by two local saints set against a brilliant gold ground. To connect her visually to *Maestà*, Simone's Virgin sits in a similar cloth-covered throne and wears similar garments.

The angel Gabriel approaches Mary from the left to pronounce the words "*Ave Maria Gratia Plenum Dominus Tecum*" ("Hail Mary, full of grace, the Lord is with you"). Simone renders the words in relief on the surface of his painting, covering them in the same gold leaf that transforms the scene into a heavenly vision. Simone adds an element of doubt to this narrative, as the Virgin responds to her visitor with surprise and pulls away from him. The dove of the Holy Spirit awaits her momentous decision to agree to the charge given her to become the mother of the Christ Child and begin the process of Salvation. Like Giotto, Simone has reduced the narrative to its simplest terms, but like Duccio, his figures have a lyrical elegance that lifts them out of the ordinary and into the realm of the spiritual.

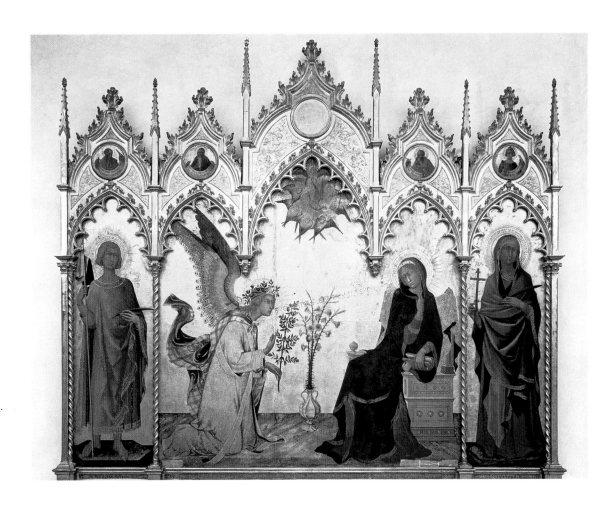

13.27. Simone Martini. *Annunciation.* ca. 1330. Tempera on panel. 10′ × 8′9″ (3 × 2.7 m). Galleria degli Uffizi, Florence.

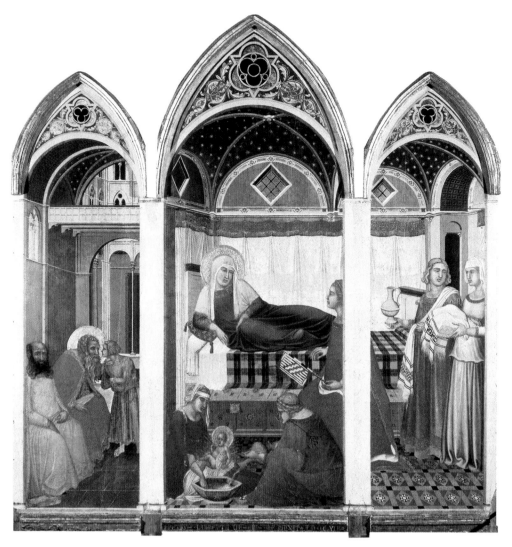

13.28. Pietro Lorenzetti. *Birth of the Virgin*. 1342. Tempera on panel, $6'1\frac{1}{2}'' \times 5'11\frac{1}{2}''$ (1.9 × 1.8 m). Museo dell'Opera del Duomo, Siena

Pietro and Ambrogio Lorenzetti

Another altarpiece commissioned for the cathedral at Siena takes a more down to earth approach. This is the *Birth of the Virgin* (fig. **13.28**) painted in 1342 by Pietro Lorenzetti (active ca. 1306–1348). Pietro and his brother Ambrogio (active ca. 1317–1348) learned their craft in Siena, though their work also shows the influence of Giotto. Pietro has been linked to work at Assisi, and Ambrogio went so far as to enroll in the painter's guild of Florence in the 1330s. Like Simone's, Pietro's altarpiece is a triptych though it has lost its original frame. In this triptych, the painted architecture has been related to the real architecture of the frame so closely that the two are seen as a single system. Moreover, the vaulted room where the birth takes place occupies two panels and continues unbroken behind the column that divides the center from the right wing. The left wing represents a small chamber leading to a Gothic courtyard. Pietro's achievement of spatial illusion here is the outcome of a development that began three decades earlier in the work of Duccio. Pietro treats

the painting surface like a transparent window *through* which— not *on* which—a viewer experiences a space comparable to the real world. Following Duccio's example, Pietro uses the architecture in his painting to carve out boxes of space that his figures may inhabit, but he is also inspired by Giotto's technique of giving his figures such mass and weight that they seem to create their own space. His innovation served the narrative and liturgical needs of Siena Cathedral by depicting another key moment in the life of the Virgin, which was also an important feast day in the Church. Saint Anne rests in her childbed, while midwives attend the newly born Virgin and other women tend to the mother. The figure of the midwife pouring water for the baby's bath seems to derive from the figure seen from the back in Giotto's *Lamentation* (fig. 13.21). The father, Joachim, waits for a report of the birth outside this room. The architectural divisions separate the sexes in the same way the architecture in Duccio's *Annunciation of the Death of the Virgin* (fig. 13.25) separates the angel from Mary.

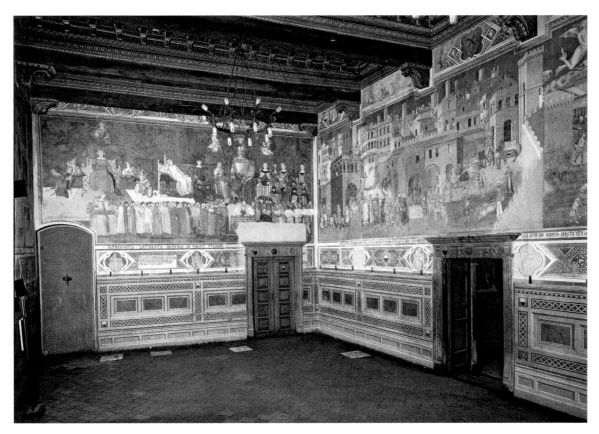

13.29. Ambrogio Lorenzetti. *The Allegory of Good Government* (left). *Good Government in the City,* and portion of *Good Government in the Country* (right). 1338–1340. Frescoes in the Sala della Pace, Palazzo Pubblico, Siena

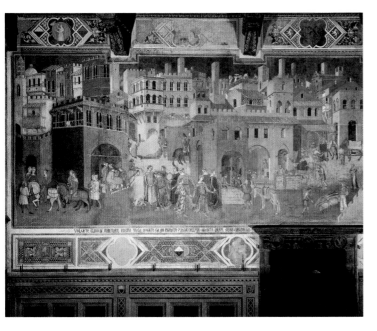

13.30. Ambrogio Lorenzetti. *Good Government in the City*

GOOD AND BAD GOVERNMENT Pietro's brother, Ambrogio Lorenzetti, combined these same influences in a major project for the city hall of Siena, executed between 1338 and 1340. The ruling Council of Nine (Nove) commissioned for their meeting hall an allegorical fresco contrasting good and bad government. The aim of this project was to be salutary, for as they deliberated, they would see in these frescoes the effects of both. While the negative example of the effects of Bad Government has been severely damaged, the frescoes that depict the positive example of Good Government are remarkably well preserved (fig. **13.29**). On the short wall of the room, Ambrogio depicted the *Allegory of Good Government* as an assembly of virtues who support the large enthroned personification of the city. To the left another enthroned figure personifies Justice, who is inspired by Wisdom. Below the virtues stand 24 members of the Sienese judiciary under the guidance of Concord. On the long wall, the fresco of *Good Government in the City* (fig. **13.30**) bears an inscription praising Justice and the many benefits that derive from her. (See *Primary Source*, page 460.) Ambrogio paints an architectural portrait of the city of Siena in this fresco. To show the life of a well-ordered city-state, the artist fills the streets and houses with teeming activity. The bustling crowd gives the architectural vista its striking reality by introducing the human scale. On the right, outside the city walls, *Good Government in the Country* provides a view of the

Inscriptions on the Frescoes in the Palazzo Pubblico, Siena

The first inscription is painted in a strip below the fresco of Good Government (see figs. 13.29 and 13.30), which is dated between 1338 and 1340. The second is held by the personification of Security, who hovers over the landscape in figure 13.28.

Turn your eyes to behold her,
you who are governing, [Justice] who is portrayed here,
crowned on account of her excellence,
who always renders to everyone his due.
Look how many goods derive from her
and how sweet and peaceful is that life

of the city where is preserved
this virtue who outshines any other.
She guards and defends
those who honor her, and nourishes and feeds them.
From her light is born
Requiting those who do good
and giving due punishment to the wicked.

Without fear every man may travel freely
and each may till and sow,
so long as this commune
shall maintain this lady [Justice] sovereign,
for she has stripped the wicked of all power.

SOURCE: RANDOLPH STARN AND LOREN PARTRIDGE, *ARTS OF POWER: THREE HALLS OF STATE IN ITALY, 1300–1600.* (BERKELEY: UNIVERSITY OF CALIFORNIA PRESS, 1992)

Sienese farmland, fringed by distant mountains (fig. **13.31**) and overseen by a personification of Security. It is a true landscape—the first since ancient Roman times (see fig. 7.55). The scene is full of sweeping depth yet differs from Classical landscapes in its orderliness, which gives it a domesticated air. The people here have taken full possession of Nature: They have terraced the hillsides with vineyards and patterned the valleys with the geometry of fields and pastures. Ambrogio observes the peasants at their seasonal labors; this scene of rural Tuscan life has hardly changed during the past 600 years.

Artists and Patrons in Times of Crisis

Ambrogio's ideal vision of the city and its surroundings offers a glimpse at how the citizens of Siena imagined their government and their city at a moment of peace and prosperity. The first three decades of the fourteenth century in Siena, as in Florence, had been a period of political stability and economic expansion, as well as of great artistic achievement. In the 1340s, however, both cities suffered a series of catastrophes whose effects were to be felt for many years.

Constant warfare led scores of banks and merchants into bankruptcy; internal upheavals shook governments, and there were repeated crop failures and famine. Then, in 1348, the pandemic of bubonic plague—the Black Death—that spread throughout Europe wiped out more than half the population of the two cities. It was spread by hungry, flea-infested rats that swarmed into cities from the barren countryside in search of food. Popular reactions to these events were mixed. Many people saw them as signs of divine wrath, warnings to a sinful humanity to forsake the pleasures of this

earth. In such people, the Black Death intensified an interest in religion and the promise of heavenly rewards. To others, such as the merry company who entertain each other by telling stories in Boccaccio's *Decameron,* the fear of death intensified the desire to enjoy life while there was still time. (See end of Part II, *Additional Primary Sources.*)

Late medieval people were confronted often with the inevitability and power of death. A series of frescoes painted on the walls of the Camposanto, the monumental cemetery building next to Pisa Cathedral, offers a variety of responses to death. Because of its somber message, the fresco was once dated after the outbreak of the plague, but recent research has pushed it closer to the 1330s. The painter of this enormous fresco is not known, though some scholars attribute the work to a Pisan artist named Francesco Traini (documented ca. 1321–1363). The huge fresco cycle, which was damaged in 1944 as a result of bombings in the Second World War, included a powerful *Last Judgment* and an image called *The Triumph of Death*, which asserts that death comes to all, rich or poor, saint or sinner. In a particularly dramatic detail (fig. **13.32**), the elegantly costumed men and women on horseback have suddenly come upon three decaying corpses in open coffins. Even the animals are terrified by the sight and smell of rotting flesh. Only the hermit Saint Macarius, having renounced all earthly pleasures, points out the lesson of the scene. His scroll reads: "If your mind be well aware, keeping here your view attentive, your vainglory will be vanquished and you will see pride eliminated. And, again, you will realize this if you observe that which is written." As the hermits in the hills above make clear, the way to salvation is through renunciation of the world in favor of the

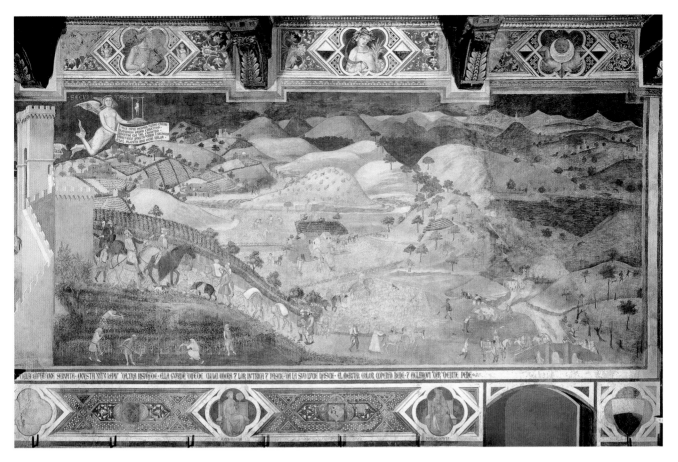

13.31. Ambrogio Lorenzetti. *Good Government in the Country*

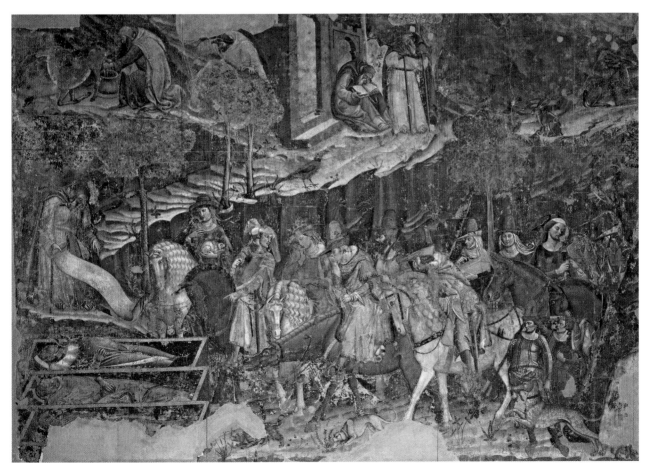

13.32. Anonymous (Francesco Traini?). *The Triumph of Death* (detail). ca. 1325–1350. Fresco. Camposanto, Pisa

spiritual life. In the center of the fresco lie dead and dying peasants who plead with Death, "the medicine for all pain, come give us our last supper." Further to the right are courtiers in a delightful landscape enjoying earthly pleasures as a figure of Death swoops down and angels and devils fight over the souls of the deceased in the sky overhead. The artist's style recalls the realism of Ambrogio Lorenzetti, although the forms are harsher and more expressive.

The Lorenzetti brothers were probably among the thousands of people throughout Tuscany who perished in the Black Death of 1348. Scholars have conjectured about the impact of the plague on the artists and patrons of works of art in the second half of the fourteenth century. We can assume that many painters died, so there weren't as many practitioners of this craft. Documentary research reveals that the number of endowed chapels, tombs, and funeral masses rose as people worried about their mortality. Many such burials and endowments were made in mendicant churches, such as the Franciscan Santa Croce and the Dominican Santa Maria Novella in Florence.

At Santa Maria Novella, a Florentine merchant named Buonamico Guidalotti, who died in 1355, provided funds in his will for a new chapter house for the Dominican community in which he could be buried. The chapel served as a meeting room for the friars and as such was painted with frescoes expressing the role of Dominicans in the struggle for salvation. A fresco on one of the walls of the Guidalotti chapel, painted by Andrea Bonaiuti (also known as Andrea da Firenze, active 1346–1379) between 1365 and 1367, depicts the actions of Dominicans to assure the access of the faithful to heaven, hence its title, *The Way of Salvation* (fig. **13.33**). In the lower section of the fresco, spiritual and temporal leaders gather before a representation of the then unfinished Cathedral of Florence. Groups of Dominicans preach to the laity and convert heretics, amidst black and white dogs (a punning reference to the order—the "Domini canes" or the dogs of the Lord). On the upper right some heedless aristocrats enjoy the pleasures of the senses, while at the center, a Dominican shows the more spiritually minded the path to heaven, whose gate is guarded by Saint Peter. Andrea's fresco reveals the influence both

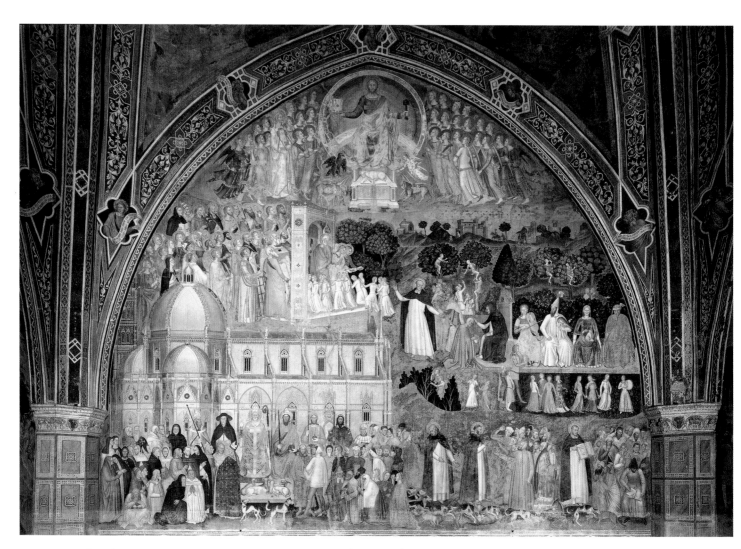

13.33. Andrea da Firenze, *Way of Salvation*. 1365–1367. Fresco. 38′ (11.6 m) wide. Guidalotti Chapel, Santa Maria Novella, Florence

of Ambrogio Lorenzetti's *Good Government* (see fig. 13.29) and the fresco on the walls of the cemetery near Pisa Cathedral (see fig. 13.32), but in its symmetry and sense of order, it seeks clarity rather than illusion and serenity rather than emotion.

Florence, however, did not complete its cathedral in the fourteenth century, and it was not to enjoy the calm atmosphere portrayed in Andrea's fresco. The plague returned in 1363, the political elite clashed with the papacy, and an uprising among the working classes created social and economic turmoil. The wealthier classes restored their power in 1381. Florence overcame these disasters to flourish in the fifteenth century as a center of economic energy, political astuteness, and cultural leadership. As the fifteenth century began, a new generation of Florentine artists would look to the art of Giotto and his contemporaries in their search for new forms of visual expression.

NORTHERN ITALY

Such political struggles did not distress the city of Venice in the fourteenth century. Unlike Florence, riven by warring factions, fourteenth-century Venice enjoyed political stability. Since 1297, the city had closed off membership in the merchant oligarchy that participated in government, and the city's leader (the Doge) was elected from this group. As a result, neither Venetian palaces nor their communal buildings required the defensive architecture seen in Florentine structures, such as the Palazzo della Signoria (fig. 13.16). A somewhat different atmosphere existed in Milan, west of Venice in Lombardy, where an aristocratic government lay in the hands of a single family with great dynastic

ART IN TIME

1305–1378—Papacy in Avignon

1307–1321—Dante composes the *Divine Comedy*

1311—Duccio's *Maestà* completed in Siena

1341—Petrarch crowned poet laureate in Rome

1347–1348—Black Death ravages Europe

ambitions. In Lombardy, the political and cultural connections were with Northern Europe, with important results for the type and the style of art produced there.

Venice: Political Stability and Sumptuous Architecture

The differing political situations in Florence and Venice affected palace design. Whereas the Florentine palace was stolid and impenetrable, the palace in Venice is airy and open, full of windows and arcades that are anything but defensible. Venetian architects borrowed from Gothic and Islamic precedents in an elegant display of the city's wealth and security. When a larger meeting space was needed for the Great Council, the city decided to enlarge the Doge's Palace near San Marco in 1340 (fig. **13.34**). Work continued here until the mid-fifteenth century. In contrast to the fortresslike Palazzo della Signoria in Florence, the Doge's Palace is open at the base, the weight of its upper stories resting on two stories of pointed arcades. The lower arcade provides a covered passageway around the building, the

13.34. Doge's Palace. Begun 1340. Venice

13.35. Milan Cathedral. Begun 1386

upper a balcony. The lavish moldings and the quatrefoils of the arcades give the structure an ornamental feel that is accented by the doubling of the rhythm of the upper arcade. The walls of the structure are ornamented with stonework in a diamond pattern, making them both visually lighter and more ornate.

Milan: The Visconti Family and Northern Influences

To the West and North of Venice, Lombardy had a different political structure and a closer relationship with Gothic France, which found expression in its visual arts. In Lombardy, the Visconti family had acquired great wealth from the products of this richly agricultural region. Besides controlling Lombardy, the Visconti positioned themselves among the great families of Europe through marriage ties to members of the Italian and European nobility. By 1395, Giangaleazzo

Visconti had been named Duke of Milan, had married the daughter of the King of France, and wed their daughter to Louis, Duke of Orleans.

Fourteenth-century projects in Milan reflect these ties to Northern Europe. The city, its archbishop, and Giangaleazzo Visconti joined together to build a new cathedral in 1386, though it required more than a century to complete. Milan Cathedral is the most striking translation of French Gothic forms in Italy (fig. **13.35**). While local architects began the project, architects from France and Germany, who were experts in raising tall Gothic structures, were consulted about the design and its implementation. Yet the local preferences for wide interior spaces and solid structure resulted in double aisles and a rejection of flying buttresses. (Compare with figs. 12.15 and 12.17.) The facade defines the interior spaces: The stepped heights of the inner and outer aisles can be clearly read, despite the profusion of vertical moldings on the exterior. The continu-

ous solid mass of the aisle walls seems hardly diminished by the mass of triangular points and turrets along the roofline. Later in the fifteenth and sixteenth centuries more antique-inspired elements such as pediments and pilasters were set into the Gothic facade.

The authoritarian nature of Visconti rule in Milan may be seen in a commission of Giangaleazzo's uncle Bernabò Visconti for his tomb (fig. **13.36**). Though now in a museum, Bernabò's Equestrian Monument originally stood over the altar of a church in Milan. Completed around 1363 by the local sculptor Bonino da Campione (active ca. 1357–1397), the marble structure includes a sarcophagus that supports a sculpted figure of Bernabò on horseback. The figure stands rather than sits on the horse, forcefully commanding the space over the high altar of the church. The idea of the equestrian image of a ruler goes back to antiquity, with the equestrian portrait of Marcus Aurelius (fig. 7.21) visible in Rome throughout the Middle Ages.

ART IN TIME

1271–1295—Marco Polo travels to China

1277—Visconti control Milan

1386—Milan Cathedral begun

13.36. Tomb of Bernabò Visconti. Before 1363. Marble. 19′8″ (6 m). Castello Sforzesco, Milan

The aristocracy of Europe claimed for themselves the prerogative of equestrian imagery. In this sculpture, Bernabò is rigid and formal in his bearing; originally the figure was covered with silver and gold leaf to further enhance its impressiveness. Yet Bonino's treatment of the horse, with its sensitive proportions and realistically observed anatomy, point to a Lombard interest in the natural depiction of form, which may be a result of Lombard contact with contemporary French art.

While promoting the building of Milan Cathedral and during his own campaign to be named duke, Giangaleazzo Visconti commissioned illuminated manuscripts, as did his French peers. His *Book of Hours* was painted around 1395 by Giovannino dei Grassi (active ca. 1380–1398) with numerous personal representations and references to the duke. The page in figure **13.37** opens one of David's Psalms with an illuminated initial D wherein King David appears. David is both the author of the text and a good biblical exemplar of a ruler. An unfurling ribbon ornamented with the French *fleur-de-lis* forms the D; shields at the corners bear the Visconti emblem of the viper. Below the text appears a portrait of Giangaleazzo in the profile arrangement that was familiar from ancient coins. Although this portrait is naturalistic, it is set into an undulating frame that supports the rays of the sun, another Visconti emblem. Around the portrait Giovannino has painted images of stags and a hunting dog, with great attention to the accurate rendering of these natural forms. Such flashes of realism set amidst the splendor of the page reflect both the patron and the artist's contribution to the developing International Gothic style. Commissioning such lavish books was an expression of the status and power that Giangaleazzo attempted to wield. His ambition to bring most of northern Italy under his control would profoundly affect the arts in Tuscany in the early fifteenth century.

13.37. Giovannino dei Grassi, *Hours of Giangaleazzo Visconti*. ca. 1395. Tempera and gold on parchment. 9³/₄″ × 6⁷/₈″ (24.7 × 17.5 cm). Banco Rari, Biblioteca Nazionale, 397 folio 115/H, Florence

SUMMARY

Thirteenth- and fourteenth-century Italian art had its roots in both Byzantine forms and Italian artists' contacts with Roman and Early Christian precedents. It is often the product of commissions by mercantile communities and urban patriciates rather than great aristocratic patrons. The activity of the mendicant orders inspired a new spirituality in these urban centers; their vivid preaching accompanied commissions of narrative imagery to speak more directly to their lay audience.

CHURCH ARCHITECTURE AND THE GROWTH OF THE MENDICANT ORDERS

One product of the mendicants' mission to preach was the building of large urban churches where sermons could be delivered. These structures took advantage of Northern Gothic innovations that allowed for large interior spaces and tall proportions, but often followed local preferences for wooden roofs, solid wall surfaces, and facades without towers. Inside these churches, sculpted forms enhanced worshipers' experience by representing sacred stories in direct and legible terms. On pulpits and on portals, sculptors in Italy made narrative scenes that drew inspiration from Roman art forms or from Northern Gothic styles. Inspired by mendicant ideas, they created memorable images of holy figures in human situations to stimulate the devotion of city dwellers.

PAINTING IN TUSCANY

For this same audience, painters developed new techniques to represent the natural world. Starting from the close study of Byzantine painting traditions that were themselves rooted in ancient styles, thirteenth- and fourteenth-century Italian painters explored ways to create images that more closely reflected nature than had earlier medieval art. This generation of artists explored techniques for consistently representing the fall of light on three-dimensional forms and for creating the illusion of space within their paintings. These techniques were used to enhance the spiritual impact of the sacred figures they painted and to tell sacred stories more effectively. The innovations of fourteenth-century painters like Giotto and Duccio provided a visual language of naturalism from which artists all over Europe could profit.

NORTHERN ITALY

The northern Italian centers of Venice and Milan developed individual forms of Gothic art. Venice's political situation and mercantile connections with the Far East and Middle East brought to that city a taste for architectural forms with sumptuous surfaces and open arcades. Ruled by an ambitious dynasty, Milan looked more to Northern Europe. Its cathedral reflects a closer study of French Gothic architecture than any other in Italy, and the artistic commissions of their rulers imitate the tastes of the French aristocracy.

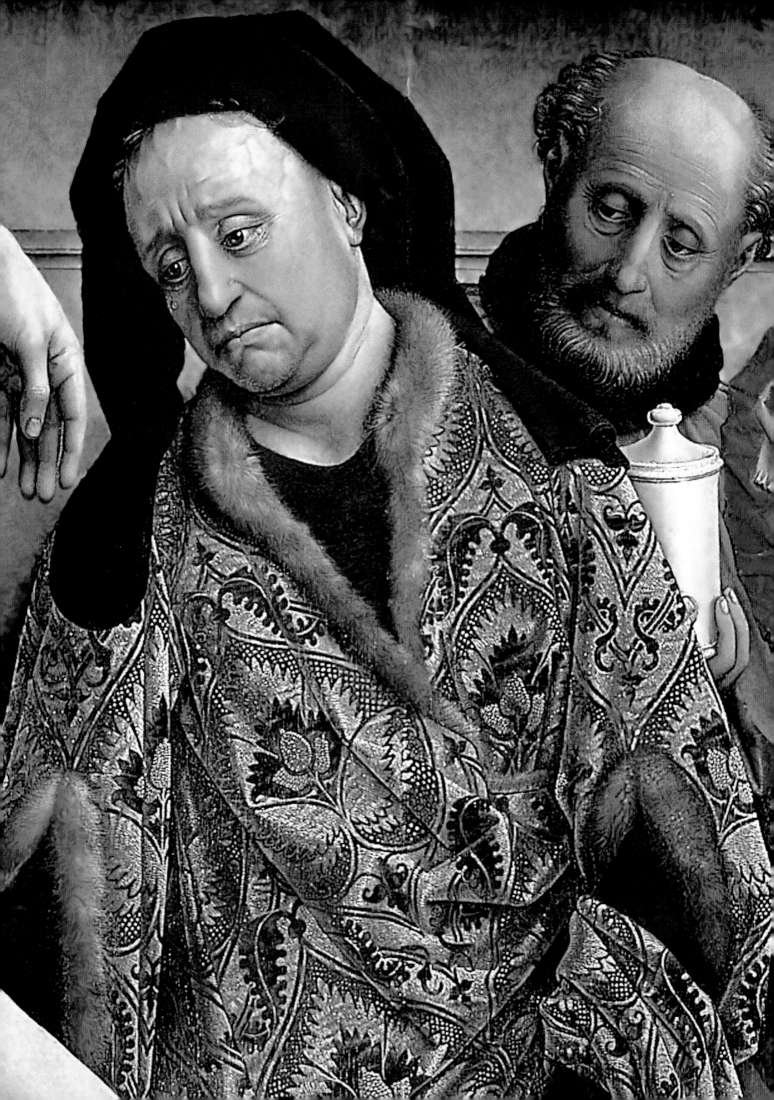

Artistic Innovations in Fifteenth-Century Northern Europe

THE GREAT CATHEDRALS OF EUROPE'S GOTHIC ERA—THE PRODUCTS OF collaboration among churchmen, rulers, and the laity—were mostly completed by 1400. As monuments of Christian faith, they exemplify the medieval outlook. But cathedrals are also monuments of cities, where major social and economic changes would set the stage for the modern world.

As the fourteenth century came to an end, the medieval agrarian economy was giving way to an economy based on manufacturing and trade, activities that took place in urban centers. A social shift accompanied this economic change. Many city dwellers belonged to the middle class, whose upper ranks enjoyed literacy, leisure, and disposible income. With these advantages, the middle classes gained greater social influence and cultural significance than they had wielded in the Middle Ages, when the clergy and aristocracy had dominated. This transformation had a profound effect on European culture, including the development of the visual arts.

Cities such as Paris, London, Prague, Bruges, Barcelona, and Basel were home to artisans, dayworkers, and merchants as well as aristocrats. Urban economies based more on money and wages than landed wealth required bankers, lawyers, and entrepreneurs. Investors seeking new products and markets encouraged technological innovations, such as the printing press, an invention that would change the world. Trade put more liquid wealth into the hands of merchants and artisans, who were emboldened to seek more autonomy from the traditional aristocracy, who sought to maintain the feudal status quo.

Two of the most far-reaching changes concerned increased literacy and changes in religious expression. During the four-

Detail of figure 14.17, Rogier van der Weyden, *Descent from the Cross*

teenth century, the removal of the papacy to Avignon and the election of two popes created a schism in the Church that ended in 1417. But the damage had already been done. Lacking confidence in the institutional Church, many lay people turned to religious movements that encouraged them to read sacred texts on their own, to meditate on Scripture, and to seek a personal relationship with God. One such movement was called the Modern Devotion, but mendicant friars and other clerics also encouraged this new lay piety. The Church was not wholly comfortable with this phenomenon, but it took hold nonetheless. These religious impulses and increasing literacy resulted in a demand for books in vernacular (local) languages, including translations of Scripture. The printing press made books more available, further stimulating the development and spread of knowledge.

In the political sphere, changes were shaping the modern boundaries of European nations. The Hundred Years' War between France and England finally ended in 1453. This allowed the French monarchy to recover, but civil war kept England politically unstable until late in the fifteenth century. French kings, however, had to contend with their Burgundian cousins, who controlled the trading hub of Northern Europe, the rich lands of Flanders in the Southern Netherlands (present-day Belgium) and the Northern Netherlands (present-day Holland). Indeed, Duke Philip the Good of Burgundy, (r. 1419–1467) was one of the most powerful men of the century.

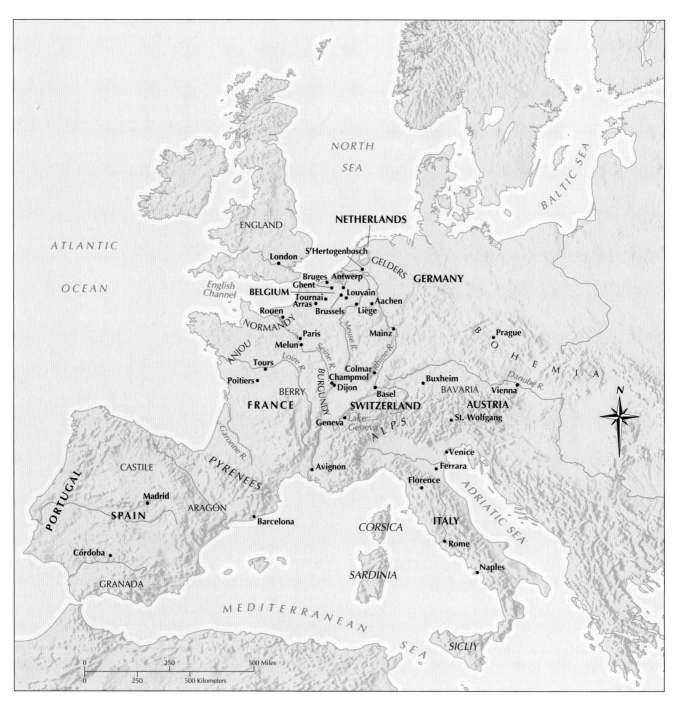

Map 14.1. Europe in the Fifteenth Century

To the east, in central Europe, the Holy Roman emperor had nominal control, but local rulers within this region often flouted his authority. On the Iberian peninsula, a crucial marriage between Queen Isabella of Castile and King Ferdinand of Aragon created a unified Spanish kingdom that became increasingly important. Competition among the powers of Europe for trade routes led to the voyages of Columbus, which would enrich the Spanish crown and change the globe.

A new style of visual art that stressed naturalism accompanied these political and social changes. Aristocrats and churchmen continued to commission works, but the new ranks of society—bureaucrats and merchants—also became

art patrons. For the merchants and middle-class patrons in urban centers, painters made images in a new medium with a new character. Using oil paints, artists in the Netherlands made paintings that still astonish viewers by their close approximation to optical reality. By mid-century, this strongly naturalistic style became the dominant visual language of Northern Europe, attracting patrons from all classes and many countries.

This period of transition out of the Middle Ages was gradual and by no means universal. Faced with a growing middle class, the traditional aristocracy attempted to maintain their privileges and status. Among the aristocratic courts of France,

the Holy Roman Empire, England, and the Burgundian Netherlands, many of which were linked by treaty or marriage, a preference emerged for a highly refined form of Gothic art, which has been termed *International Gothic*. Yet within these courtly images were the seeds of the heightened naturalism that would blossom in the fifteenth century.

COURTLY ART:
THE INTERNATIONAL GOTHIC

As the fourteenth century came to an end, aristocratic patrons throughout Europe displayed a taste for objects made of sumptuous materials with elegant forms, based on the Gothic style. As the Gothic style was associated with the rise and prestige of the French monarchy, its latest manifestation owed a great deal to the forms and traditions of France. Such cosmopolitan courts as Avignon and Paris attracted artists from different regions of Europe where they exchanged ideas. These circumstances produced the style historians call International Gothic. The artists of the International Gothic also adapted some elements from fourteenth-century Italy, including devices to imply spatial settings borrowed from Duccio and Pietro Lorenzetti and certain themes and compositions, such as aristocrats enjoying the countryside (see figs. 13.31 and 13.32). The chronological limits of this style are somewhat fluid, as some objects ascribed to the International Gothic date from the mid-fourteenth century, and other objects may date as late as the mid-fifteenth.

Artists working in this style came from Italy, France, Flanders, Germany, Spain, Bohemia, Austria, England, and elsewhere. They produced works of exquisite craftsmanship, with sometimes very complex iconographies, out of expensive materials for elite patrons. Artists used Gothic techniques, rendering forms on geometric patterns to idealize them (as we saw for example in fig. 12.21, in the work of Villard de Honnecourt), but they added touches of directly observed nature, especially in details. Many scholars see the detailed naturalism that appears in the International Gothic as a key stimulus for the more thoroughgoing naturalism of the early Flemish painters and their followers in the fifteenth century.

Sculpture for the French Royal Family

The French royal family was among the most active patrons of International Gothic, as members of this family dominated ever larger regions of France. One of King Charles V's brothers, Philip the Bold, became the Duke of Burgundy in 1363; then he added the title of Count of Flanders through his marriage to Margaret of Mâle. Through these acquisitions, the Dukes of Burgundy became powerbrokers in the military and economic struggles of the fifteenth century. Works of art helped further his status, providing an important example for his successors.

In his domain of Burgundy, Duke Philip the Bold established a Carthusian monastery, the Chartreuse de Champmol, outside Dijon. Although the monastery was almost completely destroyed in the late eighteenth century, some parts of the building survive in which Philip and his wife Margaret figure prominently. For the building of this monastery, Philip had assembled a team of artists, many of them from the Netherlands. Chief among them was the sculptor Claus Sluter from Brussels. Remnants of Sluter's work include portal sculpture and other sculptural projects.

Executed between 1385 and 1393, the portal of the Chartreuse is framed by jamb figures (fig. **14.1**) such as appear on thirteenth-century Gothic churches (see fig. 12.29). Here, however, the figures

14.1. Claus Sluter. Portal from Chartreuse de Champmol. 1385–1393. Stone. Dijon, France

have grown so large that they almost overpower their framework, as their drapery spills over the bases that support them. The figures include a portrait of Philip, with his patron, Saint John the Baptist, on the left, and a portrait of Margaret, with her patron, Saint Catherine of Alexandria. The Duke and Duchess gaze across the space to venerate the Madonna and Child, uniting all five sculptures into one entity. The Virgin, holding her son, twists into a dynamic pose as if conversing with both groups. The deeply carved folds of her garment create patterns that add weight and energy to her figure; she seems a much more substantial figure than the *Virgin of Paris* (see fig. 12.43). The portal commemorates the piety and wealth of the Duke and Duchess, presenting them in close proximity to the Queen of Heaven.

Sluter's other work for the Chartreuse de Champmol includes tombs and pulpits, but the most emblematic of the International Gothic style is *The Well of Moses* (fig. **14.2**). At one time, this hexagonal well, surrounded by statues of Old Testament prophets, was topped by a crucifix, a visual expression of the fulfillment of the New Testatment of the Old. The majestic

Moses has a long flowing beard and flowing drapery that envelops the body like an ample shell. The swelling forms seem to reach out into the surrounding space to interact directly with a viewer. The lifelike feeling created by his size and naturalistic rendering must have been enhanced greatly by the colors added to the stone by the painter Jean Malouel, which have now largely disappeared. To Moses' right stands King David, whose features have all the personality and individuality of the portraits of the duke and duchess on the portal. This attachment to the specific distinguishes Sluter's naturalistic style from that of the thirteenth century and is one of the hallmarks of the International Gothic.

THE ALTARPIECE AT CHARTREUSE DE CHAMPMOL

For the church of the Chartreuse de Champmol, Duke Philip commissioned an altarpiece that was executed between 1394 and 1399. The ensemble included an elaborately carved relief by Jacques de Baerze (showing the Adoration of the Magi, the Crucifixion, and the Entombment) for the central section and wings by the painter Melchior Broederlam (fig. **14.3**). (Their

14.2. Claus Sluter, *The Well of Moses*, from Chartreuse de Champmol. 1395–1406. Stone, height of figures approx. 6′ (1.8m)

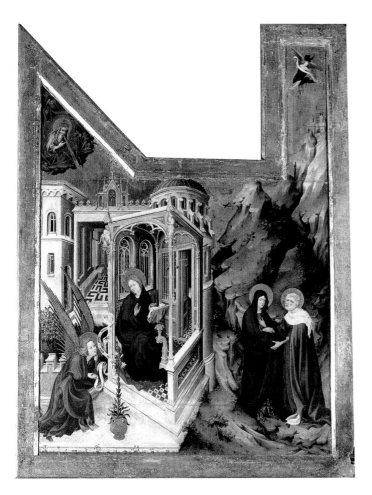
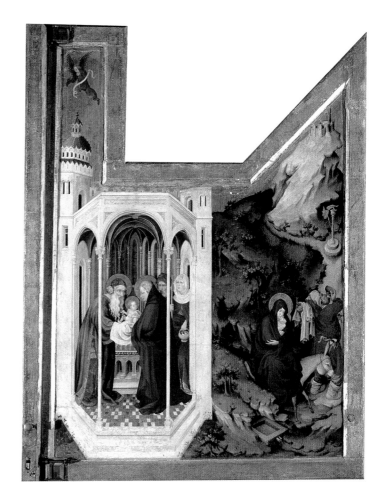

14.3. Melchior Broederlam, *Infancy of Christ* panels, wings of the altarpiece of the Chartreuse de Champmol. 1394–1399. Tempera on panel, each 65 × 49¹⁄₄ (167 × 125 cm). Musée des Beaux-Arts, Dijon, France

complex shape is the result of the format of the central section.) Each panel of the wings depicts two scenes from the infancy of Christ: The left wing depicts the Annunciation and Visitation; the right, the Presentation in the Temple and the Flight into Egypt. The painter uses landscape and architectural elements to define the narratives and to fill the odd spaces of the panel. The architecture looks like a doll's house, although it is derived from Duccio and the Lorenzetti (see figs. 13.25 and 13.28), while the details of the landscape are out of scale with the figures. Yet the panels convey a strong feeling of depth thanks to the subtlety of the modeling. The softly rounded shapes and the dark, velvety shadows create the illusion of weight, as do the ample, loosely draped garments, reminiscent of the sculpture of Sluter.

Broederlam's panels show another feature of the International Gothic style: the realistic depiction of small details. Similar realism may be seen in some Gothic sculpture (see fig. 12.30) and among some **drôleries** (small designs, often of fables or scenes from everyday life) in the margins of manuscripts such as the *Hours of Jeanne d'Évreux* (fig. 12.41). In Broederlam's Annunciation panel, such realism occurs in the carefully rendered foliage and flowers of the enclosed garden behind Gabriel at the left. In the right panel, touches of naturalistic detail

include the delightful donkey, the tiny fountain at its feet, and the rustic figure of St. Joseph, who looks like a simple peasant to contrast with the delicate, aristocratic beauty of the Virgin. This painstaking detail gives Broederlam's work the flavor of an enlarged miniature rather than of a large-scale painting, even though the panels are more than five feet tall. But these accumulated details do more than endow the image with small flashes of realism: They contribute to its meaning. In the left panel, for example, the lily signifies Mary's virginity, as does the enclosed garden next to her. The contrasting Romanesque and Gothic buildings stand for the Old and New Testaments respectively. Broederlam both enchants and instructs in this painting.

Illuminated Manuscripts: Books of Hours

Although panel painting was growing in importance, book illumination remained an important medium in northern Europe. Among the finest of the many manuscript painters employed by the French courts was the Boucicaut Master, who was named for a book of hours he painted for the aristocratic Marshal Boucicaut around 1410. (The artist may have been the Bruges artist Jacques Coene.) The book has many full-page miniatures, which are framed by gold and surrounded by a decorative spray of delicate ivy leaves, as seen in the Visitation page

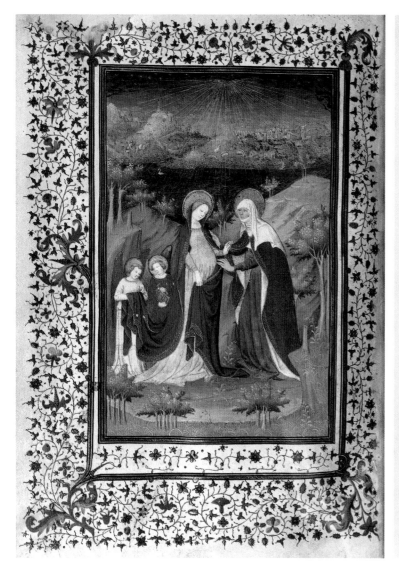

14.4. Boucicaut Master. *Hours of Marshal Boucicaut*, Visitation page. ca. 1408–1410. 10¾ × 7½″ (4.3 × 3 cm). Institut de France-Musée Jacquemart-Andre, Paris

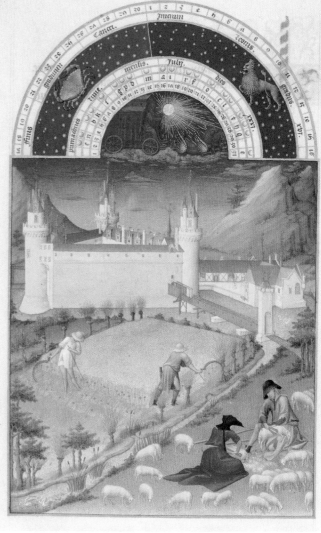

14.5. Limbourg Brothers. *Les Tres Riches Heures du Duc de Berry*, July page. 1413–1416. 8⅞ × 5⅜″ (22.5 × 3.7 cm). Musée Condé, Chantilly, France

(fig. **14.4**). In this image, the meeting between the pregnant Virgin and her cousin Elizabeth takes place in a deep, atmospheric space, defined by trees of many sizes, rising hillocks, and the distant horizon. Forms along the horizon lose clarity as atmosphere intervenes between the viewer and far-off objects. This technique is called **atmospheric perspective**. (See fig. 7.55.) The tall, elegant figures of the two women dominate the landscape; accompanied by a pair of angelic assistants, the Virgin stands in a swaying posture reminiscent of the *Virgin of Paris* (fig. 12.43), with similar drapery patterns defining her figure.

A prime example of the courtly International Gothic is the luxurious book of hours known as *Les Très Riches Heures du Duc de Berry (The Very Rich Hours of the Duke of Berry)*, produced for the brother of Philip the Bold and Charles V: Jean, Duke of Berry, the most lavish art patron of his day. The artists were Pol de Limbourg and his two brothers, Herman and Jean. The brothers were introduced to the court by their uncle, Jean Malouel, the painter who had applied the colors to Sluter's *The Well of Moses*. One or more of them must have visited Italy, for

their work includes numerous motifs and whole compositions borrowed from the artists of Tuscany and Lombardy. The brothers shared an appointment as court painters to the Duke, reflecting the high regard they enjoyed.

The *Très Riches Heures* was commissioned about 1413 and left unfinished when the Limbourg brothers died in 1416, probably of the plague. As a result, some pages were completed long after their deaths. The most famous pages in the book are devoted to the calendar and depict human activities and the cycles of nature. Such cycles, originally consisting of 12 single figures each performing an appropriate seasonal activity, were an established tradition in medieval art.

The calendar page for July (fig. **14.5**) demonstrates the Limbourgs' innovative presentation of these traditional themes. Time's passing is noted in several ways on the page: A semicircular section at the top marks the days numerically and includes the astrological signs for the month. Below this, the labor of the month is performed, as peasants harvest wheat and shear sheep in the fields, below a precisely rendered castle, Jean de

Berry's Chateau du Clain (Poitiers), now destroyed but well documented. The page depicts the orderly harvesting of a fruitful earth by the peaceful peasantry for the eyes of the man who owned the castle. This idealized view of the social order of feudalism is achieved by combining the portrait of the castle and naturalistic details of the sheep or the scythes with an artificial space that rises up the picture plane rather than receding into depth. The carefully crafted composition links the three major zones into triangular elements that fit together like a jigsaw puzzle. The jewel-like color and splashes of gold leaf in the calendar zone contribute to the sumptuous effect of the page. The prestige of the patron and the sheer innovation of the images, especially the calendar pages, in the *Très Riches Heures* inspired many later copies.

Bohemia and England

Other courts and regions in Europe shared the French taste for the International Gothic. In central Europe, the city of Prague, the capital of Bohemia, became a major cosmopolitan center thanks to Emperor Charles IV (1316–1378). Charles was educated in Paris at the court of the French King Charles IV, whose daughter he married and in whose honor he changed his name from Wenceslaus. After returning to Prague and succeeding his father as king of Bohemia, Charles was named Holy Roman emperor by the German Electors at Aachen in 1349 and crowned as such in Rome in 1355.

ART IN TIME

1348—Charles IV founds University in Prague

1385—Claus Sluter begins work at Chartreuse de Champmol, Dijon

1387—Chaucer writes *Canterbury Tales*

ca. 1413—Limbourg Brothers begin work on *Les Très Riches Heures du Duc de Berry*

Charles wanted to make Prague a center of learning, and in 1348 he established a university modeled on the one in Paris. Soon, it attracted many of the best minds in Europe. He also became a patron of the arts and founded a guild for artists. In addition to encouraging local talent, Charles brought artists from all over Europe to his city. In his castle of Karlstein, just outside of Prague, he built a chapel dedicated to the Holy Cross that imitated Louis IX's Sainte Chapelle (fig. 12.34). Instead of stained glass, the walls of this chapel were covered in paintings done by Master Theodoric, the first head of the painter's guild of Prague. The paintings were executed between 1357 and 1367.

The painting of *Saint Matthew and the Angel* in fig. **14.6** comes from this project. Here the Evangelist fingers a book while an

14.6. Master Theodoric. *Saint Matthew and the Angel*. ca. 1360–1365. Panel, 45¼ × 37″ (1.15 × 0.93 m). National Gallery, Prague. © National Heritage Institute, Prague. Inv. No. V0675/200

14.7. *The Wilton Diptych.* ca. 1400. Panel, $20^7/_8 \times 14^5/_8''$ (53 × 37 cm). National Gallery of Art, London

angel whispers in his ear. The traditional medieval symbol for the Evangelist thus becomes an active participant in the work of the saint. Matthew himself is rendered as a three-dimensional figure, whose blue garment falls across his body in softly modeled folds of drapery. This style probably derives from Theodoric's study of Italian artists, either in his native Austria or Prague.

Emperor Charles IV's daughter, Anne of Bohemia, married the English king, Richard II, in 1382. Richard, who ruled from 1377 to 1399, is the figure depicted in a painting called *The Wilton Diptych,* for the collector who once owned it (fig. **14.7**). A **diptych** is a double panel on a relatively small scale that opens on a hinge at the center like a book. This diptych represents King Richard II kneeling before his patron saints to venerate the Virgin Mary and her Child. As in Sluter's portal (fig. 14.1), the gazes of the figures connect across the panels. Angels accompany the elegant figure of the Virgin who appears like a queen surrounded by her palace guard. Her child playfully reaches out toward the king. The sumptuous colors and tall weightless figures stand in an eternal setting defined by a beautifully tooled gold background. Yet the drapery worn by the

angels is modeled in the same natural light as Master Theodoric's *Saint Matthew.* Scholars are still debating whether the artist who achieved this combination of Gothic otherworldliness and natural observation came from France, England, Bohemia, or somewhere else.

URBAN CENTERS AND THE NEW ART

Many of the artists whom the patrons in the courts preferred for their projects came from the cities of the Southern Netherlands: Bruges, Brussels, Ghent, and Tournai. The towns were centers of international commerce in whose streets many languages could be heard as merchants from all over Europe gathered to do business. These cities were very jealous of their status as independent entities with special privileges to govern themselves, set tariffs, and establish militias. Their claims for independence often clashed with the intentions of aristocratic overlords to tax and control the people and the wealth of the cities. Buildings like the Town Hall of Bruges (fig. **14.8**), built between 1376 and 1402, were designed to provide a setting for town councils and to serve as symbols of the independence and

privileges the cities claimed. Bruges' Town Hall is one of the earliest such structures in Northern Europe. Set on a major town square, it looks like an ecclesiastical structure, with its high gabled roof, traceried windows, and vaulted interior. The facade emulates Gothic churches, too, with its many sculpted figures depicting the local rulers, the Counts of Flanders. (The building was damaged during the French Revolution, and the statues on the facade today are modern.) While the interior of the structure functioned as a council hall for self-rule and issuing judgments, the exterior sculpture expressed the status quo of the nominal rule of the Counts of Flanders. Tensions between the holders of this title and the citizens of Flemish cities flared up several times in the fifteenth century. It is in the cities of Flanders that the beginnings of an artistic revolution may be seen. Working either for courts or for citizens, artists began to make images in oil painting that represent sacred figures as if they exist in the natural world, making the spiritual tangible.

Robert Campin in Tournai

An early pioneer of this naturalistic revolution is Robert Campin (1378–1444), the foremost painter of Tournai, an important trade center in southwestern Belgium. Campin ran a busy workshop, from which several other successful painters emerged, including Rogier van der Weyden.

THE *MÉRODE TRIPTYCH* The most famous work attributed to Campin is the *Mérode Triptych* (fig. **14.9**), dated on the basis of style to around 1425. The name derives from an early owner of the painting, but the subject of the central panel is the Annunciation, frequently depicted in earlier Christian art. Typically, those earlier representations of the Annunciation set the event in a church (see fig. 14.3) or other sacred space (see fig. 13.27), but Campin places the Virgin and the angel Gabriel in what appears to be the main room of a bourgeois house, complete with open shutters, well-used fireplace, and a cushioned bench. Despite the supernatural events, a viewer has the sense of actually looking through the surface of the panel into a world that mimics reality. Campin uses several devices to create this effect. He fits the objects and figures into boxes of space, sometimes uncomfortably. But he renders details in such a way as to make every object as concrete as possible in its shape, size, color, and texture. He also paints two kinds of light. One is a diffused light that creates soft shadows and delicate gradations of brightness; the other is a more direct light that enters through the two round windows, casting shadows on the wall. Campin's color scheme, with its muted tonality, unifies all three panels; his bright colors have richness and depth, and he achieves smooth transitions from lights into darks. These effects were made possible by the use of oil (see *Materials and Techniques*, page 479). Although medieval artists were

14.8. Facade of Bruges Town Hall. Begun 1376

14.9. Robert Campin. *Mérode Triptych*. ca. 1425–1430. Oil on panel. Center $25^3/_{16} \times 24^7/_8''$ (64.3 × 62.9 cm); each wing approx. $25^3/_8 \times 10^7/_8''$ (64.5 × 27.4 cm). The Metropolitan Museum of Art, New York, The Cloisters Collection, 1956

familiar with oil paints, Campin and his contemporaries expanded its possibilities for painting on panels. Its use allowed him to create a much more thorough illusion of reality than the flashes of natural detail seen in the work of court artists.

Campin was no court painter but a townsman who catered to the tastes of fellow citizens, such as the two donors piously kneeling outside the Virgin's chamber. Their identities are not known, as the coat of arms in the window of the central panel has not yet been firmly identified, but they were wealthy enough to commission this triptych, probably for their own dwelling, as it is too small for installation in a public church. One result of this may be that the artist could innovate, as he broke with tradition in several ways. This Annunciation takes place in a fully equipped domestic interior with figures that are rendered as real people, with mass and weight. The drapery of their garments falls in deep folds, anchoring the figures to the floor, as in the sculpture of Claus Sluter (see fig. 14.1). Gabriel adopts a not quite kneeling, not quite standing position as he raises his right hand to speak. Mary's red dress draws attention to her as she sits on the floor, book in hand. Between them a table supports another book, a vase of lilies, and a candle. Above and behind Gabriel, the tiny figure of a baby holding a cross, who must be Christ, floats downward toward Mary. On the left wing, the donors kneel in a garden, as though looking through the open door to witness this event. The whole effect is of time frozen: Something important is about to happen. Where Simone Martini had rendered Gabriel and the Virgin as slim, weightless figures set against an eternal gold ground (see fig. 13.27), Campin depicts their substantial bodies in a recognizably earthly setting for the eyes of the donor couple. The event takes place in their world, not in heaven.

The right wing depicts Joseph, the carpenter, at work, though just what he is making has been a subject of debate. What is the boxlike object on the ledge outside the open window? Scholars have identified it as a mousetrap, an object that the Christian theologian Saint Augustine used metaphorically to explain God's plan for salvation when he said, "The Cross of the Lord was the devil's mousetrap." The mousetrap could be a visual cue to the reason for Christ's incarnation, which is about to occur in the central panel. Equally puzzling is the object in Joseph's hand, identified by some scholars as a fire screen (like the one in the central panel) and by others as part of a press through which grapes are forced to make wine (with Eucharistic meaning).

Such carefully chosen details have persuaded many scholars that Campin used these forms as symbols to convey spiritual messages. The flowers, for example, are associated with the Virgin, as emblems of her purity and other virtues. The smoking candle next to the vase of lilies is more perplexing, and its symbolism obscure. Its glowing wick and the curl of smoke indicate that it was extinguished only moments before. But why had it been lit on a sunny day, and what snuffed out the flame? Does the arrival of the true light (Christ) extinguish mundane ones?

Panel Painting in Tempera and Oil

In the fourteenth and fifteenth centuries, painters worked with liquid pigments on wooden panels. The type of wood used varied from region to region, though oak panels were preferred in the North because they could be sawn into thin planks to serve as supports for the paint. Pine, fruitwoods, and poplar were also used. Once the panels had been formed, and often inserted into a frame by a carpenter, the flat surface would be covered with a film of gesso (a type of fine plaster) to create a smooth surface for the image. Often an underdrawing would be laid onto the gesso as a guide for the painter or his assistants.

Pigments were ground into powders that had to be mixed with some sort of liquid medium to bind them to the panel. The basic medium of medieval panel painting had been tempera, in which the finely ground pigments were mixed ("tempered") with diluted egg yolk. This produced a thin, tough, quick-drying coat that was well

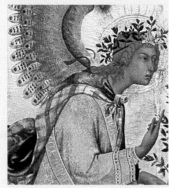

Simone Martini's "Gabriel" is painted in tempera, which dries quickly; consequently, the layers of paint do not blend, and individual strokes of the brush are visible on the surface.

suited to the medieval taste for high-keyed flat color surfaces. However, in tempera the different tones on the panel could not be blended smoothly, and the progression of values necessary for three-dimensional effects was difficult to achieve.

While medieval artists had used oil-based paints for special purposes, such as coating stone surfaces or painting on metal, artists like Jan van Eyck and Robert Campin in Flanders exploited it for panel paintings. Oil,

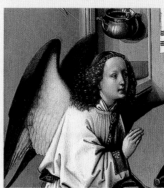

Campin's "Gabriel" is painted with oil, which dries slowly and is translucent. Each layer of color merges with the one below it to create a mirrorlike finish.

a viscous, slow-drying medium, can produce a variety of effects, from thin, translucent films (called *glazes*) to a thick layer of creamy, heavy-bodied paint (called *impasto*). The tones can also yield a continuous scale of hues, including rich, velvety dark shades. Oil painting offers another advantage over egg tempera, encaustic, and fresco: It allows artists to change their minds and rework their paintings. As the use of oil paints spread across Europe, some artists used a mixed technique, using the tempera paints to lay in base layers and covering the tempera with oil glazes. Although pigments continued to be mixed with tempera for some time, oil has been the painter's basic medium until very recently.

The appearance in Campin's picture of so many carefully delineated objects suggests that these details constitute a symbolic program, which either the artist or the patron conceived. Theologians or scholars may have provided Campin with the more learned aspects of the symbolism, but it was the artist who found the means to express these complex ideas in symbolic terms using forms observed in the visible world. Scholars are also debating the reasons why Campin and his contemporaries wanted to record the world with such fidelity. Had philosophies about nature and the natural world changed? Were pragmatic merchants demanding directly observed renderings of things they could see? Did new forms of religious practice stimulate the new style?

The Annunciation has important liturgical and theological import, but it is also a story about the conception of a child, and the couple in the left wing kneel devoutly before it. From their perspective, the triptych may be a celebration of their own desire for children or their reverence for the Holy Family as a model for their own. Such personalized approaches to holy figures and sacred dramas were an important feature of religious life at the end of the Middle Ages. Believers were encouraged in sermons, in passion plays, and in written texts to visualize the sacred in terms they could understand and to meditate on events from Christ's life in order to increase their empathy and devotion. Although monks and nuns had long practiced such contemplation, the religious movement called the Modern Devotion helped to spread these ideas among the laity. New

texts, like the *Imitation of Christ* by Thomas à Kempis, provided guidance for lay people wishing to emulate Christ. Artists like Campin may have been responding to the call to see the physical world as a mirror of divine truths and to create moving and pious images of sacred events occurring in everyday environments.

Jan van Eyck in Bruges

The visual revolution achieved in paintings such as the *Mérode Triptych* was recognized and admired not only by patrons in Flanders but also by patrons in Italy. Italian observers provide the earliest external assessments of the Flemish innovators. They recognized that the technical achievement of oil painting contributed to the striking naturalism and evocation of religious feeling in Flemish painting, and they credited the "invention" of oil painting to Jan van Eyck (1390–1441). (See end of Part III *Additional Primary Sources*.) As a result, his is one of the more famous names of fifteenth-century art, and he is a figure about whom we know a good deal.

Jan worked first for the count of Holland and then for the reigning Duke of Burgundy, Philip the Good, from 1425 until Jan's death in Bruges in 1441. Both a townsman and a court painter, Jan was highly esteemed by Philip the Good, who occasionally sent him on diplomatic errands. Unusual for his time, he signed and dated several surviving pictures, which has allowed historians to identify his artistic output and to assign unsigned works to him based on the signed ones.

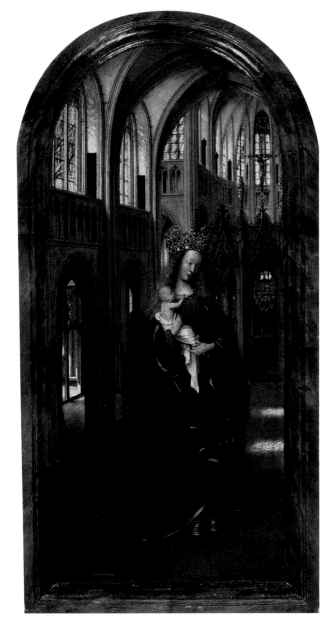

Virgin is out of proportion to everything else. She stands as tall as the triforium of this Gothic church. In another supernatural detail, the light enveloping her enters from north facing windows, a miraculous phenomenon in Northern Europe. Light both creates the form and enriches the content. An inscription on the Virgin's robe from the Song of Songs in the Old Testament confirms the symbolic meaning of the light, as it reads, "She is more beautiful than the sun . . ." Jan van Eyck uses oil painting to create images that mimic everyday reality, but which transform that reality into supernatural events. His "realism" reproduces the world selectively, so that otherwordly figures seem to inhabit human space.

THE *GHENT ALTARPIECE* Van Eyck's fame was assured when he completed the *Ghent Altarpiece* (figs. 14.11–14.14), one of the most famous of early Flemish paintings. From the moment it was installed in a chapel of the Cathedral of Saint John in Ghent (see fig. 14.14), it has drawn a crowd. Albrecht Dürer visited it in 1520, and much later artists like J. A. D. Ingres drew inspiration from it. An inscription that once

14.10. Jan van Eyck. *The Madonna in a Church*. ca. 1425–1430s. Oil on oak panel, $12\frac{1}{4} \times 5\frac{1}{2}''$ (31 × 14 cm). Gemäldegalerie, Staatliche Museen, Berlin.

One small panel attributed to Van Eyck is known as *The Madonna in a Church* (fig. **14.10**), dated by many scholars to the late 1420s. Painted in oil on panel, it is only slightly taller than this page. Despite its small scale, the panel is remarkable in its detailed recreation of the interior of a Gothic church, warmly lit by sun streaming through the clerestory windows. The Virgin herself is reminiscent of sculpted Gothic Madonnas: She is a slightly swaying, three-dimensional figure with a tiny but lively figure of Christ in her arms. In Jan's rendering, it is as if *The Virgin of Paris* had come to life (see fig. 12.43.) A sculpted Virgin appears on the choir screen of the church, and beyond the screen, angels sing from a choir book. There are hints of the miraculous: Despite the realism of the church interior, the

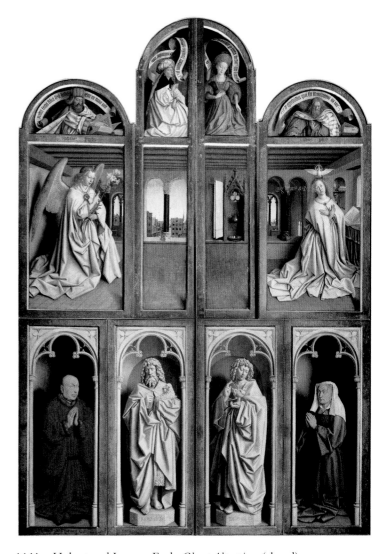

14.11. Hubert and Jan van Eyck. *Ghent Altarpiece* (closed). Completed 1432. Oil on panel, 11′5″ × 7′6″ (3.4 × 2.25 m). Church of St. Bavo, Ghent, Belgium

appeared on the frame identified Jan van Eyck as the artist who finished this multipaneled altarpiece in May 1432 and alluded to the collaboration of his older brother, Hubert, who died in 1426. The basic form of this complex altarpiece is a **triptych**—a central body with two hinged wings—the standard format of altarpieces in the Southern Netherlands, but here each of the three units consists of four panels. Since the wings are also painted on both sides, the altarpiece has a total of 20 images of various shapes and sizes. Discontinuities among the many panels suggest alterations took place as the work progressed. It appears that Jan took over a number of panels left unfinished by Hubert, completed them, added some of his own, and assembled the whole at the request of the wealthy donor, Jodicus Vijd. Vijd's portrait with that of his wife, Elizabeth Borluut, appears on the outer panels of the altar when the triptych is closed (fig. **14.11**)

Their portraits appear on the lower tier with two other figures, each in a separate niche framed by fictive Gothic tracery. Next to the donors are John the Baptist and John the Evangelist, the patrons of the Cathedral, painted in **grisaille** (a mono-

chrome to imitate the color of statues). The upper tier has two pairs of panels of different width. The artist has made a virtue of this awkward necessity by combining all four into one interior, whose foreshortened timber ceiling crosses all four panels. In addition to the continuous space, Jan heightens the illusion by painting shadows on the floor of the Virgin's chamber as if they were cast by the frames of the panels. Prophets and Sibyls occupy an upper story, their prophecies written in Gothic script in scrolls above their heads.

When the wings are opened (fig. **14.12**) the viewer sees a detailed rendering of a celestial assembly: Across the bottom tier, groups of figures converge on a central image of an altar, upon which stands a haloed Lamb. This assembly includes angels, apostles, popes, theologians, virgin martyrs, hermits, pilgrims, knights, and judges (including, possibly, a reference to Jan's employer, Duke Philip the Good). A verdant landscape provides the setting for this mystic mass, with towers of numerous churches in the skyline. Above this earthly paradise reigns an imposing Court of Heaven, with the Lord in a bright red robe at the center. Flanking him are Mary and John the

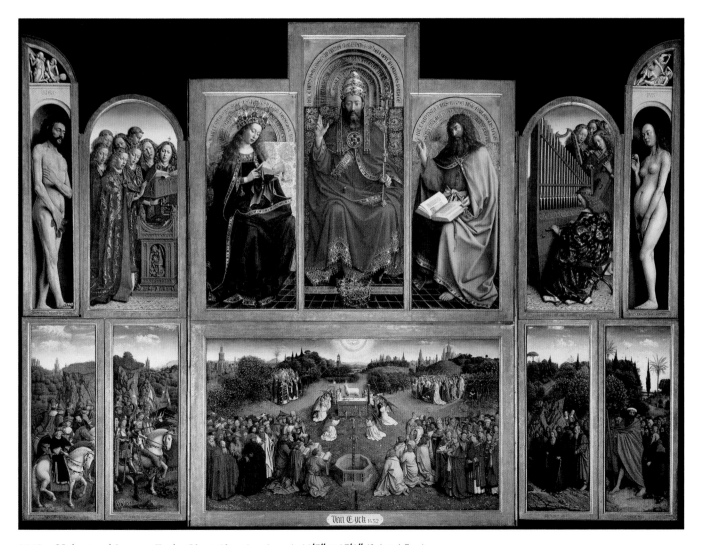

14.12. Hubert and Jan van Eyck. *Ghent Altarpiece* (open). 11′5″ × 15′1″ (3.4 × 4.5 m)

Baptist. To the left and right, choirs of angels sing and play musical instruments. At the outer edges of this upper tier stand Adam and Eve, rendered as nudes in shallow niches, below grisaille images of Abel and Cain. The almost life-size nudes are portrayed with careful attention to their anatomy and caressed by a delicate play of light and shade (fig. **14.13**).

The figures' poses are comparable to those in Gothic manuscripts, but here the artist breathes life into the forms by rendering the textures and colors of the bodies with great accuracy. Seeing this work on the altar of the Vijd Chapel in the Ghent Cathedral (fig. **14.14**), a viewer could not fail to be impressed by the scale and setting of the painting. The tone and majesty of this ensemble is very different from the domestic intimacy of the *Mérode Triptych*. The function of the altarpiece is to elucidate the liturgy performed in front of it. When open, its subject is the Mass itself, here shown in a paradisaical setting. The number of books represented and the many erudite inscriptions celebrating Christian learning suggest to many scholars that a cleric or theologian advised Jan in developing the program. But Jan accomplished the difficult task of bringing the disparate panels together and welding them into an imposing and memorable experience.

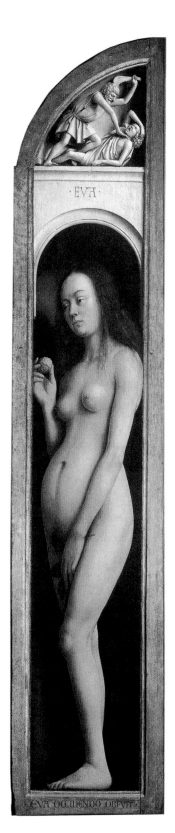

14.13. Hubert and Jan van Eyck. *Adam and Eve*, detail of *Ghent Altarpiece*. Left and right wings

14.14. Painting of *Ghent Altarpiece* in chapel. Rijksmuseum, Amsterdam

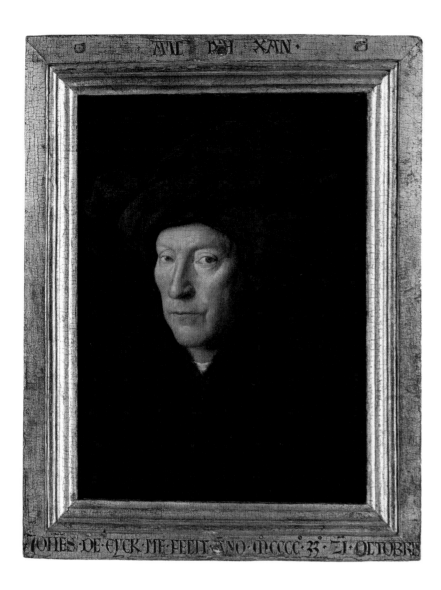

Jan's work is large in scale but full of naturally observed details and glowing color. His technique of building up color in layers of colored glazes results in the highly saturated hues, while the slow methodical application of paint blends brushstrokes to a mirrorlike finish. Jan offers a glimpse into heaven to stimulate devotion. If, as some scholars believe, the whole altarpiece was set into a Gothic architectural frame, one meaning of the image becomes the importance of the Church itself as an institution and as a pathway to the divine.

SECULAR IMAGES Jan van Eyck also made purely secular paintings, fulfilling the commissions of the court and of the middle-class citizens of Flemish towns. Jan's *Man in a Red Turban* (fig. **14.15**), signed and dated 1433, represents a middle-aged man in a three-quarters pose whose face is framed by his dramatic headgear. The distinctive face emerging from the dark background of this painting is bathed in a warm light that reveals every detail of shape and texture with almost microscopic precision. The artist does not explore the sitter's personality, yet the man gazes out of the picture to make eye contact with the viewer. This innovation, and the slight strain about the eyes which may come from gazing into a mirror, suggests

that the painting may be a self-portrait. The self-consciousness that such a project demands may relate to the text painted on the frame: An inscription reads "*ALS ICH KAN*" ("As I can," or "As best I can"). This motto appears on other works by Jan, too, perhaps challenging other artists to do better, for he has done all he can. Interestingly, the motto is written in Flemish, but transposed into Greek letters. Was Jan competing with the ancients as well as with his contemporaries? Whatever his reason may have been, we can read the motto as another sign of Jan's self-consciousness about his work as an artist and his place in history.

Jan van Eyck's signatures also challenge modern scholars to interpret his work. One of the most controversial of his surviving images represents a man and a woman standing in a richly furnished room, equipped with a brass chandelier, a mirror, and a canopied bed (fig. **14.16**). Jan signed the painting, not on the frame, as was his normal practice, but in the panel itself. Above the painted mirror in a formal script, the translated signature reads, "Jan van Eyck was here, 1434." The features of the man, if not the lady, are specific enough to be a portrait, and the image is unusual enough that scholars have used later documents to identify him as Giovanni Arnolfini, an Italian

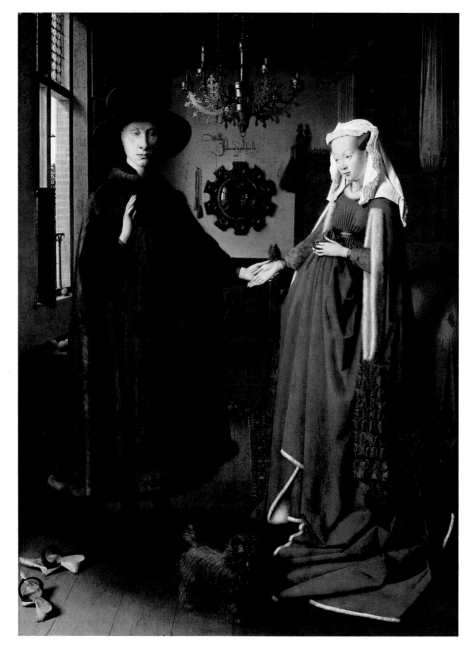

14.16. Jan van Eyck. *The "Arnolfini Portrait."* 1434. Oil on panel, 33 × 22½″ (83.7 × 57 cm). The National Gallery, London. Reproduced by Courtesy of the Trustees

merchant living in Bruges. For many years scholars believed that his companion should be identified as Giovanna Cenami, Arnolfini's wife; recent research, however, makes this doubtful, as that marriage took place much later than 1434.

Whatever their names, the painted couple are represented in the main room of a fifteenth-century house. The two join hands, with the man raising his right hand as if in a solemn oath, seemingly quite alone. In the mirror behind them, however, is the reflection of two men who have entered the room. Because the signature appears right above the mirror, many scholars believe that one of these men must be Jan van Eyck himself, perhaps the figure wearing the red headdress. The combination of the signature, with its flourishes and phrasing, and the image of the men in the mirror suggests to some that Jan acts as a witness to whatever is occurring in the room.

For many years scholars have argued that this panel represents either the wedding or the engagement of the couple represented, either of which would have required a legal and financial contract between their two families. By this reading, the painting commemorates the union of the couple. If so, the second man in the mirror may be the bride's father, who would have made the contract for the marriage of his daughter. The woman's gesture to lift her heavy gown may suggest her wish for children, as the bed behind her may suggest the consummation of the marriage. Given its secular nature, scholars have debated whether the realistic touches serve simply as an accurate record of an event and its domestic setting, or whether the details of the setting carry more symbolic weight. Has the couple taken off their shoes merely as a matter of custom, or to remind us that they are standing on "holy ground"?

(This symbol has its origins in stories of Moses removing his sandals at the burning bush on Mount Sinai, that is, in the presence of God.) Is the little dog a beloved pet, or an emblem of fidelity? (*Fides* is Latin for faithfulness, the origin of the traditional dog name, Fido.) The other furnishings of the room suggest other questions. Why does a candle in the chandelier burn in broad daylight? Why do pieces of fruit sit on the window sill? What is the function of the mirror? Tiny images of the Passion and Resurrection in the small medallions that surround the mirror sound the only unambiguously religious note. What was Jan's purpose in making this painting? For whom was it made? What function did it serve for the patron? The answers to these questions have become more controversial in recent interpretations, as scholars are now much less certain about the meaning of the image than they used to be.

Rogier van der Weyden in Brussels

As a court painter, Jan van Eyck had been exempt from the restrictions that governed other artists in Flemish towns. Regulations for the training of artists and the market for works of art came from the guilds, professional organizations of artists established to protect the interests of their members. Aspiring artists learned the trade as apprentices in the workshop of a certified master. After a fixed period, an apprentice became a journeyman (or dayworker) who could then hire out his services to others but not open his own shop. Journeymen often traveled to learn from artists other than their master. Becoming a master required completing a "masterpiece" that was evaluated by the leaders of the guild. Guilds not only controlled training but limited competition from artists outside their towns, investigated disputes among members, and saw to the social and economic needs of members, such as providing for burials, pensions, and the care of widows. Guilds were both economic and social institutions, assuring the quality of their products and seeing to the well-being of their members.

One illustrious graduate of the guild system was Rogier van der Weyden (1399/1400–1464), a painter who trained with Robert Campin in Tournai, but who certainly knew the work of Jan van Eyck. By 1435, Rogier had established a flourishing workshop in Brussels which took commissions from as far away as Italy and Spain. Perhaps his most influential work is the *Descent from the Cross* (fig. **14.17**), which dates from about 1435. It was commissioned as the center of an altarpiece by the crossbowmen's guild of Louvain (near Brussels) for a church there. For them, Rogier depicted the moment when the body of Christ is lowered from the cross in a composition of mourners crowded into a shallow box of space. His forms are carefully modeled to suggest sculptural presence, and they are detailed enough to show every nuance of texture.

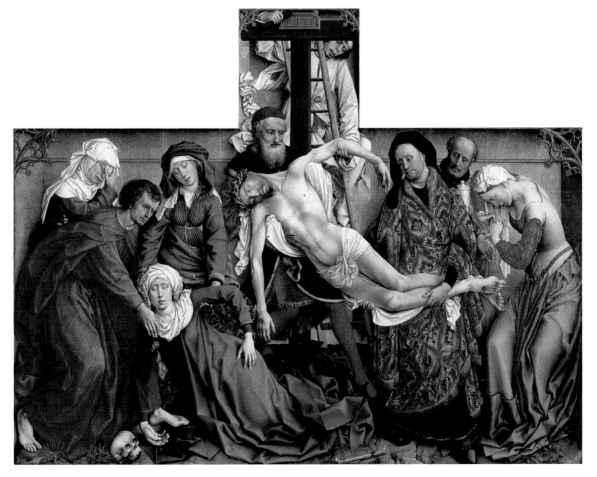

14.17. Rogier van der Weyden. *Descent from the Cross*. ca. 1435. Oil on panel, 7′2⅝″ × 8′7⅛″ (2.2 × 2.6 m). Museo del Prado, Madrid

Cyriacus of Ancona (1449)

Rogier van der Weyden probably visited Italy, and sources reveal that he made several paintings for prominent Italian patrons, including the Este family of Ferrara. One of Rogier's most discussed images in Italy drew the praise of Cyriacus of Ancona, a Humanist and diplomat who had traveled widely in the service of Italian princes.

After that famous man from Bruges, Johannes the glory of painting, Roger in Brussels is considered the outstanding painter of our time. By the hand of this most excellent painter is a magnificently wrought picture which the illustrious prince Lionello of Este showed me in Ferrara on July 8, 1449. In it one sees our first progenitors, and in a most pious image the ordeal of the Deposition of the God-Incarnate, with a large crowd of men and women standing about in deep mourning. All this is admirably depicted with what I would call divine rather than human art. There you could see those faces come alive and breathe which he wanted to show as living, and likewise the deceased as dead, and in particular, many garments, multicolored soldiers' cloaks, clothes prodigiously enhanced by purple and gold, pearls, precious stones, and everything else you would think to have been produced not by the artifice of human hands but by all-bearing nature itself.

SOURCE: *NORTHERN RENAISSANCE ART 1400–1600*: SOURCES AND DOCUMENTS, ED. WOLFGANG STECHOW. (EVANSTON, IL: NORTHWESTERN UNIVERSITY PRESS, 1989)

Rogier's goal is to increase the expressive content of his pictures. He emphasizes the emotional impact of the Descent from the Cross on its participants. Grief is etched on each figure's face, and their postures express their response to their loss. John the Evangelist on the left and Mary Magdalen on the right are bowed with grief. The Virgin's swoon echoes the pose and expression of her son. So intense are her pain and grief that they inspire the same compassion in a viewer. Rogier has staged his scene in a shallow niche or shrine, not against a landscape. This bold device focuses a viewer's attention on the foreground and allows the artist to mold the figures into a coherent group. Furthermore, the emphasis on the body of Christ at the center of the composition speaks to the celebration of the Eucharist, which takes place before the altarpiece. The source of these grief-stricken gestures and faces is in sculpture rather than in painting. These figures share the strong emotion of the mourners on the

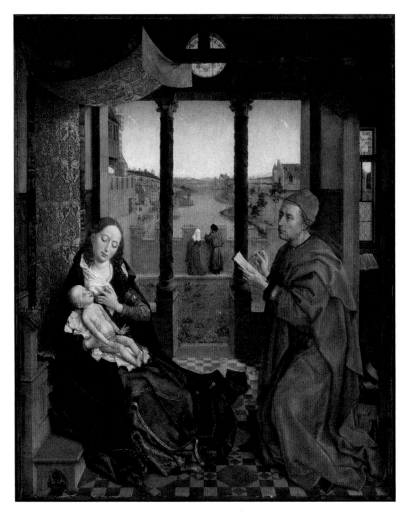

14.18. Rogier van der Weyden. *Saint Luke Painting the Virgin*. ca. 1435–1440. Oil and tempera on panel, $54^1/_8 \times 43^5/_8''$ (1.38 × 1.11 m). Museum of Fine Arts, Boston. Gift of Mr. and Mrs. Henry Lee Higginson. Photograph © 2006, Museum of Fine Arts, Boston. 93153

Naumberg choir screen (fig. 12.53) or the Virgin in the *Roettgen Pietà* (fig. 12.56). Rogier's painting inspired many copies, in both painting and sculpture.

The heightened emotion with which Rogier imbues his works was noted and admired by the Italian diplomat Cyriacus of Ancona, who saw another painting by Rogier on this theme in 1449. (See *Primary Source*, facing page.) This commentator singled out the naturalism in Rogier's work, as he admired the figures who seemed to come alive in Rogier's painting. Other Italian commentators remarked on Flemish painting's naturalism and piety as well. Viewers in Flanders would have brought their own interest in meditating on the sacrifice of Christ to their experience of Rogier's painting.

Rogier's depiction of *Saint Luke Painting the Virgin*, dated between 1435 and 1440 (fig. **14.18**), reveals his debt to earlier Flemish artists. The figure of Mary nursing her son in this image shows the continuing influence of Campin, while the composition is based on a work by Jan van Eyck. Unlike the *Descent from the Cross*, Rogier creates a deep landscape that moves into the distance. The figures inhabit a room that opens onto a garden protected by fortifications. A man and a woman peer over these battlements toward a busy Flemish city in the distance, where shopkeepers open for the day and citizens walk the street.

The painting represents Saint Luke the Evangelist in another role, as the portrayer of the Virgin and Christ Child. A Byzantine tradition explained that the Madonna appeared miraculously to Luke, so he could paint her portrait. This legend helped to account for numerous miraculous images of the Madonna in the later Middle Ages. Rogier depicts Luke drawing the features of the Virgin in silverpoint as she appears before him. (Such drawings were the starting point for most paintings of the period.) Because of this story, Saint Luke became the patron of painters' guilds throughout Europe. Rogier's painting may have been given to the Brussels Guild of Saint Luke, as later documents describe such a work in their chapel. Since this image depicts the making of an image, Rogier's painting may be a self-conscious statement about the dignity of painting and painters. It was copied numerous times in the fifteenth century, even by Rogier's own workshop. In recent years, scholars have been studying such paintings with new scientific tools that examine the techniques used by the artists. (See *The Art Historian's, Lens*, page 488.)

LATE FIFTEENTH-CENTURY ART IN THE NETHERLANDS

The paintings of Robert Campin, Jan van Eyck, and Rogier van der Weyden offered powerful examples for other artists to follow, in the Netherlands and beyond. In the later fifteenth century, court patrons continued to prefer objects made of expensive materials, particularly gold. They also commissioned illuminated manuscripts and tapestries. At the same time, patronage by the merchant class continued to grow, and painters found work in commissions from the middle class. Nonetheless, the medi-

ART IN TIME

1384—Philip the Bold of Burgundy inherits Flanders

1432—Jan van Eyck finishes the *Ghent Altarpiece*

1453—End of The Hundred Years' War between England and France

um of painting gained in prestige as the century wore on, attracting interest and patronage in aristocratic circles. Despite the increasing market for paintings, large-scale sculpture continued to find a market in the fifteenth-century Netherlands, though little has survived the ravages of war, social upheavals, and changes of taste. Even rarer are survivals of objects made in precious metals, as the very valuable raw material was easily recycled when money was scarce.

Aristocratic Tastes for Precious Objects, Personal Books, and Tapestries

Aristocratic patrons commissioned small-scale precious objects throughout the fifteenth century. One, whose brilliance makes us mourn the loss of others, is the *Statuette of Charles the Bold*, preserved in the Treasury of the Cathedral of Liège in eastern Belgium (fig. **14.19**). Commissioned from the goldsmith Gerard

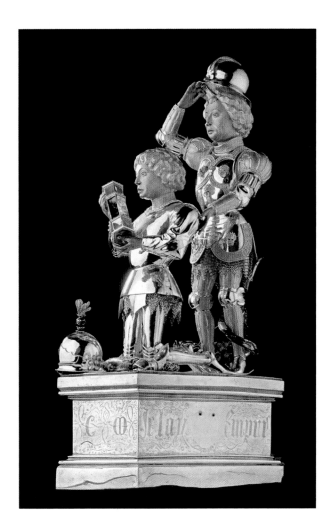

14.19. Gerard Loyet, *Statuette of Charles the Bold*. ca. 1471. 21 × 12$\frac{1}{2}$ × 7″ (53 × 32 × 17.5 cm). Cathedral Treasury, Liège

Scientific and Technical Study of Paintings

Investigative tools used in the contemporary scientific study of materials are providing new information about the practices of artists in the past. The very materiality of works of art makes them appropriate for the same sort of study as archeological discoveries. Chemical analysis of paints and pigments is providing information on the recipes for making pigments that artists used. This information can be used to examine workshop practices, to establish authenticity, and to suggest methods of conservation.

Modern scholars use a variety of techniques to investigate paintings. *X-radiographic* imaging penetrates painted surfaces and produces a photographic analysis of the use of lead in the painting process. Because lead white was used to lighten pigments, x-radiographs allow an investigator to examine how an artist modeled forms with lighter colors. X-radiographs also reveal details about an artist's brushwork or changes made

as the painting progressed. Another technique uses *infra-red light*, which can see through painted surfaces to distinguish dark marks on the white ground of a panel. Aided by special infra-red cameras (a technique called *infra-red reflectography*), analysts can photograph the underdrawings and initial paint layers below painted surfaces; computers match these photos to produce images of the preparatory layers of the painting. This information is invaluable for studying the creative process. It has also aided in determining which of the many versions of Rogier's *Saint Luke Painting the Virgin* (fig. 14.18) was executed first.

Because many Renaissance panels are painted on wood, scholars have been able to determine the number of tree rings on a particular wood panel, a technique known as *dendrochronology*. This number is then compared to a database of tree rings that have been dated to define the time when the tree was probably cut down, which can then provide additional evidence for dating the painting. Such evidence has caused some scholars to date Bosch's *Garden of Earthly Delights* (fig. 14.24) to around 1480. Scientific study is also revealing the composition of the limestone used in Gothic sculpture and the chemical makeup of ancient bronzes.

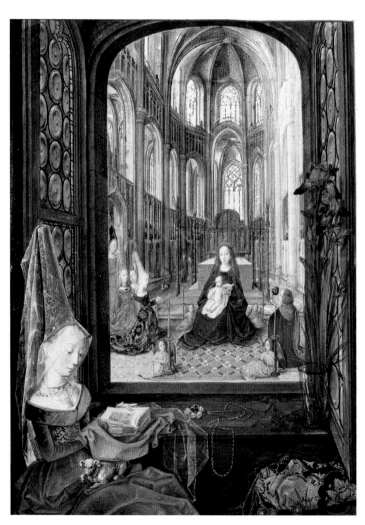

14.20. Master of Mary of Burgundy, Lady at Window, from the *Hours of Mary of Burgundy*. ca. 1480. $7^3/_8 \times 5^1/_8''$ (8.7 × 13.5 cm). Österreichisches Nationalbibliothek, Vienna

Loyet (before 1442–1500), the figure was given by Duke Charles the Bold of Burgundy to the Cathedral in 1471, perhaps to assert his control over that rebellious city. Made of gold and silver gilt with enamel details, the 21-inch high statuette represents Duke Charles holding a reliquary; behind him stands Saint George, Charles's favorite patron saint, who lifts his helmet in greeting. The Duke is dressed in armor, kneeling on a pillow to make his offering. The object demonstrates Loyet's skill and the prestige of such objects in the Burgundian court.

The taste of the court also ran to expensive books. Despite the introduction of the printing press (see pages 497–498), among the traditional elites, the manuscript book—custom-made to celebrate the purchaser's status and interests—retained its appeal. Books of hours, in which prayers were organized into cycles according to the hours of the day, appealed especially to women. A striking example of a complex and lavish illuminated book is the *Hours of Mary of Burgundy*. The book includes the coat of arms of Mary, the daughter of Charles the Bold and the last duchess of Burgundy, evidence that she was the owner of the book before her death in 1482.

Mary herself may be the woman depicted in figure **14.20**. Here the anonymous artist (named after this book of hours) depicts an elegantly dressed young woman reading from a book of hours similar to the *Hours of Mary of Burgundy*. Her costume and surroundings indicate her status: Golden brocades, transparent veils, jewelry, and flowers surround her, and a little dog rests on her lap. She sits in a private chapel, whose windows open onto a view of a light-filled Gothic church. Through the window the viewer sees the Virgin Mary with her child seated in the sanctuary, surrounded by angels. To the right of these sacred figures kneels a group of noble women, whose access to the child and his mother may be what the woman in the foreground is praying for.

The artist creates a picture within a picture here, as the glimpse into the church is completely framed by the architecture of the Lady's chapel. Where earlier manuscript artists (like the Boucicaut Master in fig. 14.4) put floral or other decorative motifs in the border and created a spatial context only for the main image, this artist treats the border as a spatial entity of its own that links the border and the main image. The artist takes care to record the tactile and sensuous quality of the dog's fur, the transparency of the glass vase, and the reflective qualities of the pearls on the ledge. The manuscript page has the impact of a painted panel.

The court was also the key market for the flourishing industry in tapestries. Major workshops practiced in Brussels, Tournai, and Arras, whose name became synonymous with the art form. Woven with colored threads of wool or silk, tapestries were often commissioned by the courtly class or their peers in the

church. The tapestry fragment of *Penelope Weaving* (fig. **14.21**), for example, was part of a series of "Famous Women" commissioned by the Bishop of Tournai around 1480. The image depicts the wife of Odysseus (or Ulysses) working at a loom. According to Homer's *Odyssey*, Penelope fended off her numerous suitors with her weaving; she insisted she would not marry again until she had completed her work, which she unwove every evening. Although a figure from the classical past, Penelope is dressed in the costume of a fifteenth-century lady. The influence of paintings is apparent, in the suggestion of space, the detailed treatment of her gems and garment, and in the figure. On the wall behind Penelope hangs a tapestry within the tapestry, in a two-dimensional pattern of repeated floral forms called *millefleurs*, which was one of the best-selling designs for tapestry in the fifteenth century. The court of Burgundy shared their Italian contemporaries' interest in stories of the ancients as exemplars for the present, but they envisioned them in familiar, not historic terms. The naturalism of the Flemish painters provided a language for the tapestry weavers to satisfy courtly taste.

Panel Paintings in Southern Netherlands

While the court collected precious objects, illuminated manuscripts, and tapestries, the middle-class demand for panel paintings continued to grow. International businessmen invested their money and their reputations in commissioning paintings from Flemish artists like Hugo van der Goes (ca. 1440–1482). Having served as dean of the painter's guild of Ghent, Hugo entered a monastery near Brussels as a lay brother in 1475, where he continued to work until his death in 1482. His best-known work is the huge altarpiece commissioned around 1474 by an agent of the Medici bank in Bruges, who shipped it to Florence (fig. **14.22**). The 10-foot wide central panel represents the Virgin, Saint Joseph, and the Shepherds adoring the newborn Christ Child in Bethlehem. In the wings, members of the donor family, including Tommaso Portinari, his wife, Maria Maddelena Baroncelli, and their children, kneel to face the central image. A spacious landscape unites all three wings as a continuous space, with the bare trees and December sky suggesting not the Holy Land but Flanders itself. Objects in the distance have turned the blue of the atmosphere; this use of atmospheric perspective infuses the panel with a cool tonality. Hugo filled this setting with figures and objects rendered with precise detail in deeply saturated colors.

Yet Hugo's realistic renderings of both landscape and figures is contradicted by variations in the sizes of the figures. The angels and kneeling members of the Portinari family are dwarfed by the other figures; the patron saints in the wings are the same size as Joseph, the Virgin Mary, and the shepherds of the Nativity in the center panel. This change of scale contradicts the pictorial space that the artist has provided for his figures. Another contrast occurs between the raucous intrusion of the shepherds and the ritual solemnity of all the other figures. These fieldhands gaze in breathless wonder at the newborn Christ Child, who is the focus of all the gazes of the figures ranged around him. Mary however,

14.21. *Tapestry of Penelope Weaving (Penelope at Her Loom)* A fragment from *The Story of Penelope and the Story of the Cimbri Women*. ca. 1480. 39³⁄₈″ × 59¹⁄₁₆″ (100 × 150 cm). Museum of Fine Arts, Boston. Maria Antoinette Evans Fund. Photograph © 2006, Museum of Fine Arts, Boston. 26.54.

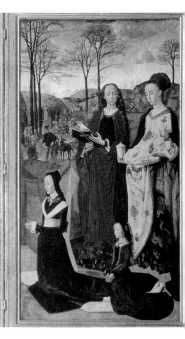

14.22. Hugo van der Goes. *The Portinari Altarpiece* (open). ca. 1474–1476. Tempera and oil on panel, center 8′3$\frac{1}{2}$″ × 10′ (2.5 × 3.1 m), wings each 8′3$\frac{1}{2}$″ × 4′7$\frac{1}{2}$″ (2.5 × 1.4 m). Galleria degli Uffizi, Florence

sits at the physical center of the composition. Such deliberate contrasts between the pictorial and psychological focal points, between the scale of the historical and the contemporary figures, and between the static and kinetic postures of the figures contribute to a viewer's unsettled reaction to the work.

The background is populated with narratives that support the main theme. Behind the figures in the left panel, Mary and Joseph travel toward Bethlehem. Behind the saints on the right wing, the Magi progress toward the center. And in the center, the movement of angels flickers across the surface, lit by both natural and supernatural light. Strategically placed at the front of the picture is a beautiful still life of flowers and a sheaf of wheat. As with so many other realistic details in Flemish paintings, these have been interpreted as symbolic references. The wheat refers to the bread of the Eucharist and the flowers to the Virgin. Portinari brought the triptych to Florence in 1483 and installed it in the family chapel attached to the hospital of Sant' Egidio. There it proclaimed the taste, wealth, and piety of the donor. Judging from their imitation of it, Italian painters who saw the work there especially admired its naturalism and its unidealized representation of the shepherds.

Triptychs were often intended for liturgical spaces. For more domestic spaces, patrons wanted smaller objects. For example, the young up and coming citizen of Bruges, Martin van Nieuwenhove, commissioned a diptych from Hans Memling in 1487 (fig. **14.23**) Born in Germany (ca. 1435–1494), Memling worked in Bruges, where his refined style based on Rogier and Jan van Eyck brought him commissions from patrons from all over Europe. Italians in Bruges especially patronized his workshop, as did local patricians like Van Nieuwenhove. An inscription on the frame of his diptych identifies the patron and gives his age, while his stylish garment and gilt-edged prayer book express his social status.

Behind him a piece of stained glass represents his patron saint, Martin. The young man focuses his gaze to the left panel, where an image of the Virgin and Child appear. Martin's family coat of arms in the window behind them implies that the Virgin and Child are visiting him in his own home. This conceit is further expressed by the reflection in the mirror behind them, where the artist has included the reflections of both the Virgin and young man. Memling has borrowed the concave mirror Jan van Eyck used in *The "Arnolfini Portrait"* (fig. 14.16) to unite the two halves of the diptych.

Memling's image demonstrates a new trend in portraiture: In addition to rendering the features, he creates a setting for the figure. Access to the divine remains a preoccupation for otherwise worldly men; in this light-filled room, Martin kneels in permanent prayer, so that the image becomes an expression of his devotion. But this object also served as a piece of self-promotion, as the many personal references to the patron display his self-assurance and social status.

The Northern Netherlands

The innovations of the early fifteenth-century painters quickly spread to the Northern Netherlands (present-day Holland), where one of the most famous paintings from the fifteenth century, Hieronymous Bosch's *Garden of Earthly Delights* (fig. **14.24**) was made. Bosch (ca. 1450–1516) came from a family of painters and spent his life in the town of 's Hertogenbosch, the seat of a Ducal residence, and from which his name derives. His work attracted the patronage of the Duke of Burgundy, and was collected by King Philip II of Spain in the sixteenth century. It was in Philip's collection that Fray José de Sigüenza encountered Bosch's painting. (See *Primary Source*, page 492.) Sigüenza's account has been an important document

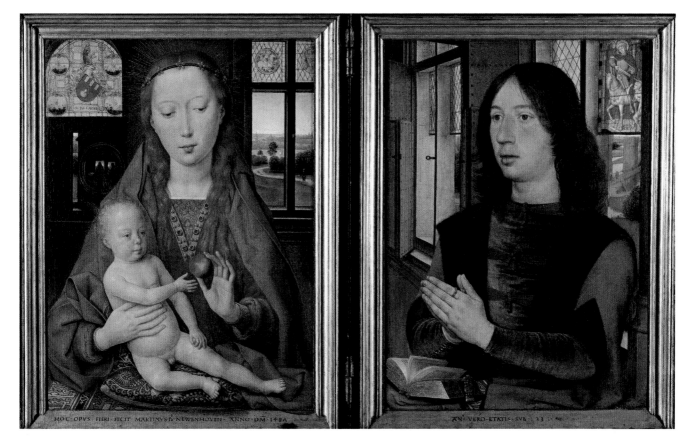

14.23. Hans Memling. *Madonna and Child*, left wing of *Diptych of Martin van Nieuwenhove*. 1487. Panel, $17^3/_8 \times 13''$ (44 × 33 cm). Hans Memling Museum, Musea Brugge, Sint-Jans Hospital, Bruges

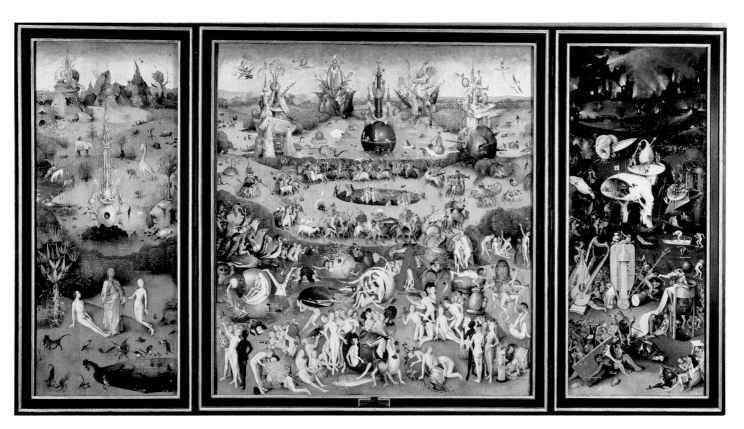

14.24. Hieronymous Bosch. *The Garden of Earthly Delights*. ca. 1480–1515. Oil on panel, center $7'2^1/_2'' \times 6'4^1/_2''$ (2.19 × 1.95 m); wings, each $7'2^1/_2'' \times 3'2''$ (2.19 × .96 m). Museo del Prado, Madrid

Fray José De Sigüenza (1544?–1606)

From *The History of the Order of St. Jerome*

The works of Hieronymus Bosch were collected by the Spanish king Philip II (r. 1556–1598) and were displayed in his Escorial Palace near Madrid, where Sigüenza was the librarian. The interpretation of Bosch's work was as difficult then as it is today and caused just as much disagreement. This passage is Sigüenza's attempt to interpret the painting that we call The Garden of Earthly Delights *(see fig. 14.24).*

Among these German and Flemish pictures ... there are distributed throughout the house many by a certain Geronimo Bosch. Of him I want to speak at somewhat greater length for various reasons: first, because his great inventiveness merits it; second, because they are commonly called the absurdities of Geronimo Bosque by people who observe little in what they look at; and third, because I think that these people consider them without reason as being tainted by heresy. ...

The difference that, to my mind, exists between the pictures of this man and those of all others is that the others try to paint man as he appears on the outside, while he alone had the audacity to paint him as he is on the inside. ...

The ... painting has as its basic theme and subject a flower and the fruit of [a] type that we call strawberries. ... In order for one to understand his idea, I will expound upon it in the same order in which he has organized it. Between two pictures is one large painting, with two doors that close over it. In the first of the panels he painted the Creation of Man, showing how God put him in paradise, a delightful place ... and how He commands him as a test of his obedience and faith not to eat from the tree,

and how later the devil deceived him in the form of a serpent. He eats and, trespassing God's rule, is exiled from that wondrous place and deprived of the high dignity for which he was created. ... This is [shown] with a thousand fantasies and observations that serve as warnings. ...

In the large painting that follows he painted the pursuits of man after he was exiled from paradise and placed in this world, and he shows him searching after the glory that is like hay or straw, like a plant without fruit, which one knows will be cast into the oven the next day, ... and thus uncovers the life, the activities, and the thoughts of these sons of sin and wrath, who, having forgotten the commands of God ... strive for and undertake the glory of the flesh. ...

In this painting we find, as if alive and vivid, an infinite number of passages from the scriptures that touch upon the evil ways of man, ... many allegories or metaphors that present them in the guise of tame, wild, fierce, lazy, sagacious, cruel, and bloodthirsty beasts of burden and riding animals. ... Here is also demonstrated the transmigration of souls that Pythagoras, Plato, and other poets ... displayed in the attempt to show us the bad customs, habits, dress, disposition, or sinister shades with which the souls of miserable men clothe themselves—that through pride they are transformed into lions; by vengefulness into tigers; through lust into mules, horses, and pigs; by tyranny into fish; by vanity into peacocks; by slyness and craft into foxes; by gluttony into apes and wolves; by callousness and evil into asses; by stupidity into sheep; because of rashness into goats. ...

One can reap great profit by observing himself thus portrayed true to life from the inside. ... And he would also see in the last panel the miserable end and goal of his pains, efforts, and preoccupations, and how ... the brief joys are transformed into eternal wrath, with no hope or grace.

SOURCE: *BOSCH IN PERSPECTIVE*, ED. JAMES SNYDER. (NY: SIMON AND SCHUSTER, 1973)

for interpreting this complex and surprising painting, whose subject and meaning has been vigorously debated.

Divided into three panels, the *Garden of Earthly Delights* represents humans in the natural world. A continuous landscape unites the three sections; the high horizon and atmospheric perpective imply a deep vista of the Earth from an omniscient vantage point. Shades of green create an undulating topography marked by thickets of trees and bodies of water. Throughout, small creatures both human and nonhuman swarm, while strange rock formations and other objects appear at intervals. The left wing appears to represent the Garden of Eden, where the Lord introduces Adam to the newly created Eve. The airy landscape is filled with animals, including such exotic creatures as an elephant and a giraffe, as well as strange hybrid monsters. The central panel reveals a world inhabited by tiny humans who frolic among giant fruits, birds, and other creatures. In the middle ground, men parade around a circular basin on the backs of all sorts of beasts. Many of the humans interact with huge birds, fruits, flowers, or marine animals. The right wing depicts an infernal zone, which may be Hell, where strange hybrid creatures torment the tiny humans with punishments appropriate to their sins. Yet the outer wings depict a crystal globe with an image of the earth emerging from a flood, with God watching over the events from above.

Despite its triptych format, this is not a traditional altarpiece but a secular work. It belonged to Count Henry III of Nassau in whose palace in Brussels it was reported to be in 1517, though recent research suggests it may have been painted as early as 1480. Many interpetations have been offered for the painting—that it represents the days of Noah, as shown by the image of a flood on the exterior; that the many swarming nudes express the views of a heretical group that promoted free love; or that the infernal landscape in the right wing demonstrates a moralizing condemnation of carnal sin.

These interpretations have suggested that Bosch was a pessimist sermonizing about the depravity of humankind. This is the way that José de Sigüenza described it, although his text also suggests several "allegories or metaphors" embedded in the painting. Yet the image itself is beautifully painted and as seductive as the sirens in the pool in the middle of the central panel. There is an innocence, even a poetic beauty, in this panorama of human activity that suggests something other than outright condemnation of the acts so carefully depicted. This ambivalence has fueled the numerous interpretations, including a recent proposal that the image depicts an alternative view of history in which the original sin of Adam and Eve does not happen, and therefore humans continue to live in a state of innocence.

Perhaps the most consistent and comprehensive interpretation of this painting links it to the practice of alchemy as an allegory of redemption. The many strangely shaped and outsized formations refer to the tools and vessels used in this medieval approach to understanding the Earth. The alchemical process required four steps: conjunction—or mixing, for which the joining of Adam and Eve is a metaphor; child's play—the slow process of cooking diverse ingredients and letting them ferment, for which the central panel would stand; putrefaction—a step in which material is burned, related to the infernal right wing; and the final cleansing of matter—represented by the exterior flood. Bosch, who had married an apothecary's daughter, consciously used the visual symbols of that science to create an unforgettable glimpse of natural processes.

REGIONAL RESPONSES TO THE EARLY NETHERLANDISH STYLE

Artists in many regions of Europe responded to the formal and technical achievements of the generation of Robert Campin and Jan van Eyck. These regional responses were influenced by local traditions and tastes, but as in the Netherlands, patrons found the naturalism of the new style useful for their religious and social purposes. France, Spain, and Central Europe produced their own variations on this style.

France

The geographic proximity, trade routes, linguistic links, and political relationships between the Burgundian Netherlands and France helped to spread the innovations in technique and

ART IN TIME

1455—Wars of the Roses begin in England

1477—Charles the Bold of Burgundy dies in battle

1483—*Portinari Altarpiece* arrives in Florence

1488—Flemish towns revolt against Maximilian I

style throughout France. Artists either traveled to Flemish cities or developed their own brand of naturalism in imitation of the effects that Rogier or Hugo had achieved (see figs. 14.18 and 14.22). Yet French art has distinctive features and traditions. In the first half of the fifteenth century, the troubles of the Hundred Years' War limited expenditures on art. Citizens of the war-torn cities commissioned very little, but members of the church and the court continued earlier forms of patronage.

After establishing his rule at the close of the Hundred Years' War, the king of France, Charles VII, appointed Jean Fouquet (ca. 1420–1481) of Tours as his court painter. Both a book illuminator and a panel painter, Fouquet traveled to Italy around 1445, where he learned some of the innovations of contemporary Italian art. His work, however, owes much to Netherlandish style in technique, color, and approach. Charles VII's treasurer, Étienne Chevalier, commissioned Fouquet around 1450 to paint a diptych representing the treasurer and his patron saint, Stephen, in proximity to the Virgin and Child, the so-called *Melun Diptych* (figs. **14.25** and **14.26**). Like his

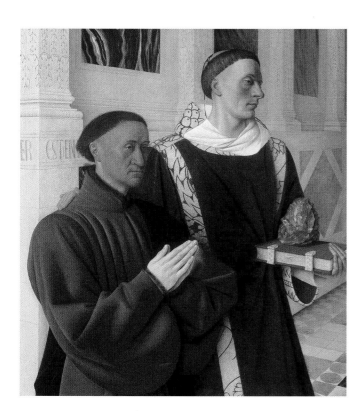

14.25. Jean Fouquet. *Étienne Chevalier and St. Stephen*, left wing of the *Melun Diptych*. ca. 1450. Oil on panel, $36\frac{1}{2} \times 33\frac{1}{2}''$ (92.7 × 85 cm). Staatliche Museen zu Berlin, Gemäldegalerie

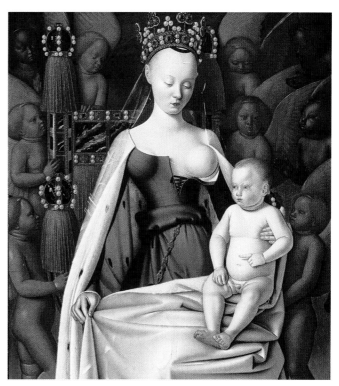

14.26. Jean Fouquet. *Madonna and Child*, right wing of the *Melun Diptych*. ca. 1450. Oil on panel, $36\frac{5}{8} \times 33\frac{1}{2}''$ (94.5 × 85.5 cm). Koninklijk Museum Voor Schone Kunsten, Antwerpen Belgie (Musée Royal des Beaux-Arts, Antwerp, Belgium)

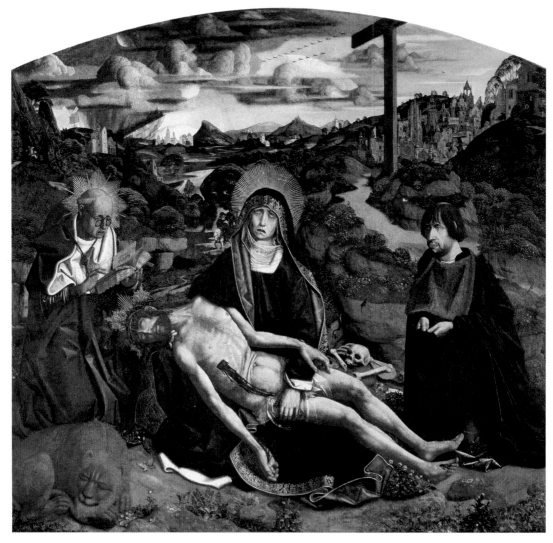

14.27. Bartolome Bermejo. *Pietà*. 1490. Panel, $74^3/_8 \times 68^7/_8''$ (189 × 175 cm). Cathedral, Barcelona

Flemish contemporaries, Fouquet records the specific physiognomy of the patron in his fur-lined garment. The head of the saint who carries a book and the stone of his martyrdom seems as individual as that of the donor.

They stand in a room with marbled floors and marble panels on the walls, framed by antique-inspired pilasters that recede to suggest space. The two men gaze across the frame toward an image of the enthroned Virgin and Child. According to an old tradition, the Madonna is also a portrait: of Agnès Sorel, Charles VII's mistress. If so, the panel presents an image of courtly beauty, as befits the Queen of Heaven, seen wearing a crown amid a choir of angels. Fouquet deliberately contrasts the earthly and divine realms. The deep space in the left panel differs vividly from the right panel, organized as a rising triangle, with the cool colors of the Virgin and Child set against the vivid reds and blues of the angels. In contrast to his Flemish counterparts, Fouquet is not interested in suggesting specific textures, and he subordinates details to the overall design. Fouquet does not appeal to the emotions. His images are geometrically ordered and rational rather than expressive.

Spain

Netherlandish naturalism reverberated strongly on the Iberian peninsula in the fifteenth century. Artists traveled between Flanders and Spain, and trade, diplomacy, and a dynastic marriage brought the united kingdoms of Castile and Aragon into increasingly close contact with Flanders. These contacts were echoed in the works of art imported into Spain from Flanders and in works of art produced in Spain by local artists.

A powerful example of the Spanish interpretation of Flemish naturalism is the *Pietà* painted in 1490 by Bartolome Bermejo (ca. 1440–1500) for a deacon of the Cathedral of Barcelona (fig. **14.27**). Bermejo was born in Córdoba, but he worked in many regions of Spain, and may have been trained in Bruges. His *Pietà* sets the image of the Virgin grieving for her dead son in a dark and atmospheric landscape dominated by an empty cross. Instead of the historical mourners called for by the narrative, and included by Giotto (see fig. 13.21), Mary and Christ are flanked by Saint Jerome to a viewer's left (the lion is his attribute) and a portrait of the deacon to the right.

This removes the theme from a strict narrative context and makes the painting function as an image of devotion similar to the *Roettgen Pietà* (fig. 12.56), though the precise detail of the figures and the landscape derive from Flemish models. In contrast to the cool rationality of Fouquet, Bermejo's work is highly emotional and expressive.

Central Europe

Linked by trade and political ties to the Netherlands, artists and patrons in Central Europe were also receptive to the new style, especially in cities along the Rhine (see map 14.1). One such artist, Conrad Witz (1400/10–1445/46) became a citizen of Basel, Switzerland, and a master in the city's guild of painters at just the moment that the Church's Council of Basel concluded. This Church council, or synod, had met from 1431 to 1434 to debate whether the pope alone or councils of bishops had the right to determine doctrine. These controversial issues inform the paintings Witz made in 1444

for the bishop of Geneva, which were destined for the Cathedral of Saint Peter.

The panels represent scenes from the life of Saint Peter, including *The Miraculous Draught of Fishes* (fig. **14.28**). The painting depicts Christ calling Saint Peter to walk across the Sea of Galilee to join him. The solidly modeled figure of Christ dominates the right side of the composition, in part because his red garment contrasts vividly with the green tones of the painting. Saint Peter appears twice, once in the boat among other apostles, who are called to be "fishers of men," and again sinking into the waters upon which Christ seems to float. The technique and style owe much to the Flemings, but Witz devotes his attention to the landscape. In place of the Sea of Galilee, Witz substitutes Lake Geneva, emphasizing local topography, such as the distinctive mountain above Christ's head. He accurately depicts every reflection on the water, so that we can see the bottom of the lake in the foreground and the variety of textures of the water's surface in the background. Witz places the events of the historical past in the setting of the present. Peter's

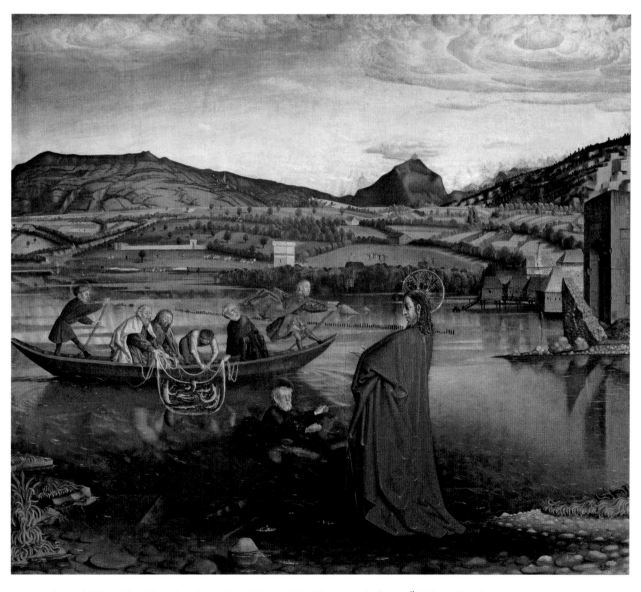

14.28. Conrad Witz. *The Miraculous Draught of Fishes*. 1444. Oil on panel, 51 × 61″ (132 × 154 cm). © Musée d'Art et d'Histoire, Geneva, Switzerland. 1843.11

From the Contract for the St. Wolfgang Altarpiece

It took Michael Pacher ten years (1471–1481) to complete this elaborate altarpiece for the pilgrimage church of St. Wolfgang. The altarpiece is still in its original location.

Here is recorded the pact and contract concerning the altar at St. Wolfgang, concluded between the very Reverend, Reverend Benedict, Abbot of Mondsee and of his monastery there, and Master Michael, painter of Bruneck, on St. Lucy's day of the year 1471.

ITEM, it is first to be recorded that the altar shall be made conforming to the elevation and design which the painter has brought to us at Mondsee, and to its exact measurements.

ITEM, the predella shrine shall be guilded on the inside and it shall show Mary seated with the Christ Child, Joseph, and the Three Kings with their gifts; and if these should not completely fill the predella shrine he shall make more figures or armored men, all gilt.

ITEM, the main shrine shall show the Coronation of Mary with angels and gilt drapery—the most precious and the best he can make.

ITEM, on one side St. Wolfgang with mitre, crozier, church, and hatchet; on the other St. Benedict with cap, crozier, and a tumbler, entirely gilded and silvered where needed.

ITEM, to the sides of the altar shall stand St. Florian and St. George, fine armored men, silvered and gilded where needed.

ITEM, the inner wings of the altar shall be provided with good paintings, the panels gilded and equipped with gables and pinnacles, representing four subjects, one each....

ITEM, the outer wings—when the altar is closed—shall be done with good pigments and with gold added to the colors; the subject from the life of St. Wolfgang....

ITEM, at St. Wolfgang, while he completes and sets up the altar, we shall provide his meals and drink, and also the iron work necessary for setting up the altar, as well as help with loading wherever necessary.

ITEM, the contract is made for the sum of one thousand two hundred Hungarian guilders or ducats....

ITEM, if the altar is either not worth this sum or of higher value, and there should be some difference of opinion between us, both parties shall appoint equal numbers of experts to decide the matter.

SOURCE: *NORTHERN RENAISSANCE ART 1400–1600: SOURCES AND DOCUMENTS*, ED. WOLFGANG STECHOW. (EVANSTON, IL: NORTHWESTERN UNIVERSITY PRESS, 1989)

sinking into the water, suggesting his need for assistance, may be evidence of the bishop's support of the Council's role to advise the pope.

AN ALTARPIECE IN ITS ORIGINAL SETTING Witz's panels were originally the wings of an altarpiece, many of which had sculptures as their central elements or *corpus*. In German speaking regions, altarpieces were usually made of wood, often large and intricately carved. Protestant reformers in the sixteenth century destroyed many sculpted religious images, so surviving examples are rare. The *St. Wolfgang Altarpiece* (fig. **14.29**) by the Tyrolean sculptor and painter Michael Pacher (ca. 1435–1498) is impressive both because of its scale and because it remains in its original setting.

The surviving contract between the abbot who commissioned it and the painter specifies both the subject matter and the quality of the materials and workmanship (see *Primary Source*, above). This was the normal pattern for contracts given to artists for expensive projects in the period.

Much as Jan van Eyck did in the Ghent Altarpiece, Pacher creates a vision of heaven: The *corpus* depicts the Coronation of the Virgin as Queen of Heaven flanked by the patron saints of the monastery. Carved of soft wood that permits the sculptor to create deep folds and sharp edges, the lavishly gilt and colored forms make a dazzling spectacle as they emerge from the shadows under Flamboyant Gothic canopies. The figures and setting in the central panel seem to melt into a pattern of twisting lines that permits only the heads to stand out as separate elements.

The complexity and surface ornamentation that dominates the *corpus* contrast with the paintings of scenes from the life of the Virgin on the interior of the wings. Here the artist represents large figures, strongly modeled by clear light, and he suggests a deep space for them. He takes a viewer's vantage point into account, so that the upper panels are represented as if seen from below. This kind of perspective must have been inspired by developments in contemporary Italian painting. Pacher almost certainly crossed the Alps and visited northern Italy, where some of his works were commissioned, so he had learned to use the new technique for projecting space. (Compare his perspective to Mantegna's in figure 15.53.) This perspective appears only in the wings, however, where scenes from the past are set into spaces that look like the Austrian present. The interior of the temple where the circumcision takes place, for example, has a vault much like ones in late Gothic churches. Pacher makes the historical scenes in the wings much more down to earth than the spectacle of heaven in the center.

PRINTING AND THE GRAPHIC ARTS

Along with the new techniques of painting, fifteenth-century Europe saw the development of a new medium: printmaking. The invention of movable type and the printed page would have enormous consequences for Western civilization. Tradition has credited Johann Gutenberg (ca. 1397–1468) with inventing movable type, but the roots of printing actually lie in the ancient Near East 5,000 years ago. The Sumerians were the earliest "printers," for their relief impressions on clay, from stone seals, were carved with both pictures and inscriptions (fig. 2.11). From Mesopotamia the use of seals spread to India and eventually to China. The Chinese applied ink to their seals in order to impress them on wood or silk, and in the second century CE they invented paper. By the ninth century they were printing pictures and books from wooden blocks carved in

14.29. Michael Pacher. *St. Wolfgang Altarpiece*. 1471–1481. Carved wood, figures about lifesize; wings, oil on panel. Church of St. Wolfgang, Austria

Printmaking

Printmaking is a technique for making multiple copies of the same image. In the fifteenth century, most prints used dark black ink on paper (though some are printed on parchment). Printmakers used one of several techniques to make these images; the two broad categories are **relief** prints (in which the lines to be printed are raised from the block) and **intaglio** (in which the lines to be printed are cut into a plate). Designs (and text) will print as reversed images as they are transferred to the paper by the force of a press. By 1500, printing technology allowed for the reproduction of pictures by several methods, all developed at the same time as the printing of type.

WOODCUT In a woodcut the design is cut into a wood block so that raised ridges will print. The thinner the ridges are, the more difficult they are to carve, so specialists took over this phase of the work. Early woodcuts often include inscriptions, but to carve lines of text backward in relief on a wooden block must have been risky—a single slip could ruin an entire page. It is little wonder, then, that printers soon had the idea of putting each letter on its own small block. Wooden movable type carved by hand worked well for large letters but

Detail of Schongauer's *The Temptation of St. Anthony.* Engraving, see fig. 14.32

not for small ones, and the technique proved cumbersome for printing long texts such as the Bible. By 1450 this problem had been solved through the introduction of metal type cast from molds, and the stage was set for book production as it was practiced until the late twentieth century. Because the text was carved in relief, it became apparent that accompanying pictures should be carved in relief as well, so that an entire page could be printed with one run of the press over the **matrix**—or form—which held all the information to be printed.

ENGRAVING The technique of engraving—embellishing metal surfaces with incised pictures—had developed in Classical antiquity (see fig. 6.20) and continued to be practiced throughout the Middle Ages (see fig. 10.2). Goldsmiths and designers of armor, in particular, were experts in incising designs on metal surfaces. These skills allowed goldsmiths to engrave a plate that could serve as the matrix for a paper print. Because the lines themselves were incised into the plate, more linear information could be included in the design. In an engraving, lines are V-shaped grooves cut with a special tool, called a **burin**, into a metal plate, usually copper, which is relatively soft and easy to work with. Ink is forced into the grooves made by the burin, the plate is wiped clean of excess ink, and a damp sheet of paper is placed on top of the inked plate; the force of a press tranfers the ink—and the design—to the paper.

relief, and 200 years later, they developed movable type. Some of the products of Chinese printing may have reached the medieval West—perhaps through Islamic intermediaries.

The technique of manufacturing paper, too, came to Europe from contact with Islamic regions, though it gained ground as a cheap alternative to parchment very slowly. While printing on wood blocks was known in the late Middle Ages, it was used only for ornamental patterns on cloth. All the more astonishing, then, is the development, over the course of a century, of a printing technology capable of producing editions of several hundred copies of relatively inexpensive books. The new technology quickly spread across Europe, spawning the new industry of bookmaking. Printed books were far less expensive than hand made volumes, but they were useless to those who could not read. Literacy began to rise among the lower classes, a consequence that would have profound effects on Western civilization. To compete with illuminated manuscripts, printed books included printed images, which were often hand colored to imitate the more expensive manuscripts. Ultimately, the printed book almost completely replaced the illuminated manuscript.

The pictorial and the literary aspects of printing were closely linked from the start. The practice of inking pictorial designs carved on wooden blocks and then printing those designs on paper began in Europe late in the fourteenth century. Early surviving examples of such prints, called **woodcuts**, come from France, the Netherlands, and Germany. The designs were

14.30. *Buxheim Saint Christopher.* 1423. Woodcut, $11\frac{3}{8} \times 8\frac{1}{8}''$ (28.8 × 20.6 cm). John Rylands University Library. Courtesy of the Director and the Librarian. The John Rylands University Library of Manchester

14.31. *Woodcut of St. Christopher,* detail from the *Annunciation* by Robert Campin (?) ca. 1435. Musées Royaux de Beaux-Arts de Belgique. Inv. 3937

ART IN TIME

1444—Witz's *The Miraculous Draught of Fishes*
1469—Marriage of Ferdinand of Aragon and Isabella of Castile
1486—Maximilian of Habsburg becomes Holy Roman Emperor
1492—Muslim kingdom of Granada conquered by Spain

engravings, and engravers included initials and dates in their prints. Consequently, many engravers of the late fifteenth century are known to us by name.

Printing Centers in Colmar and Basel

Martin Schongauer of Colmar, Germany (ca. 1435/50–1491) learned the goldsmith's craft from his father, but he became a printmaker and a painter. He studied the paintings of Rogier van der Weyden, which may have influenced the style of his engravings. Their complex designs, spatial depth, and rich textures make them competitors to panel paintings. Some artists found inspiration in them for large-scale pictures. They were also copied by other printmakers. *The Temptation of St. Anthony* (fig. **14.32**) is one of Schongauer's most famous works—known

probably furnished by painters or sculptors, but the actual carving of the wood blocks was done by specialists. (For the various techniques of printing, for pictures as well as books, see *Materials and Techniques*, facing page.)

An early dated example of a woodcut is the *Buxheim Saint Christopher* (fig. **14.30**), so called because it came from a monastery in that south German town. This single sheet, hand-colored woodcut bears the date 1423 and a prayer to the saint; woodcuts combining image and text like this were sometimes assembled into popular picture books called *block books*. Simple, heavy lines define the forms in the print, including the fall of the garment around the figures and the contours of objects. Vertical lines in parallel rows—called **hatching**—denote shadows or textures of objects, but the composition is strictly two-dimensional, as the landscape forms rise along the picture plane to surround the figures. According to legend, Christopher was a giant who ferried people across a river; he was surprised one day at the weight of a child, who turned out to be Christ. (The saint's name derives from this encounter.)

The forms in the *Buxheim Saint Christopher* owe a great deal to late Gothic style, but the audience for prints were not the aristocrats of the Middle Ages. Fifteenth-century woodcuts were popular art. A single wood block yielded thousands of copies, to be sold for pennies apiece, so that for the first time in history almost anyone could own pictures. A detail from a Flemish *Annunciation* panel of about 1435 in figure **14.31** reveals one use to which people put such prints. A print much like the *Buxheim Saint Christopher* is pinned on the wall in a middle-class household.

From the start, **engravings** appealed to a smaller and more sophisticated public. The oldest surviving examples, from about 1430, already show the influence of Flemish painters. Early engravers were usually trained as goldsmiths, but their prints reflect local painting styles. Their forms are systematically modeled with fine hatched lines and often convincingly foreshortened. Distinctive styles appear even in the earliest

14.32. Martin Schongauer. *The Temptation of St. Anthony.* ca. 1480–1490. Engraving, $11\frac{1}{2} \times 8\frac{5}{8}''$ (29.2 × 21.8 cm). The Metropolitan Museum of Art, New York Rogers Fund, 1920

and admired in sixteenth-century Italy. The print represents the climax of Saint Anthony's resistance to the devil. Unable to tempt him to sin, the devil sent demons to torment him. The engraving displays a wide range of tonal values, a rhythmic quality of line, and the rendering of every conceivable kind of surface—spiky, scaly, leathery, furry—achieved by varying the type of mark made on the plate.

Since the time of Witz, the Swiss city of Basel had embraced the new technology for printing books to become a major center for publishing. A group of reform-minded intellectuals and authors contributed texts for publication, which graphic artists illustrated with woodcuts. One of the best sellers of the period was a satiric text by Sebastian Brant called the *Ship of Fools*, published in Basel in 1494. Brant's text poked fun at many of the ills he perceived in contemporary society, which, as the title implies, he characterized as a boat piloted by Folly. One important theme his text addresses is contemporary dissatisfaction with the Church. This tide of anticlerical feeling was already rising when Luther's critique of the Church was posted in 1517 in Wittenberg (see page 632). But Brant's satirical eye also fell on his own peers, as the woodcut in figure **14.33** reveals. The image depicts a scholar in his study surrounded by books, but rather than read them, he holds a duster to clean them. The man's costume, including a hood with bells on it, identifies him as a fool. Compared with the *Buxheim Saint Christopher*, the unnamed artist who produced this woodcut increases the density of hatching that implies texture and volume and attempts a spatial context for the forms. The practice of coloring prints fell by the wayside as the medium developed its own aesthetic and appeal.

14.33. Woodcut of Scholar in Study, from Sebastian Brant, *Ship of Fools*. Published Basel, 1494

SUMMARY

For all that it depends on the past, the art of Northern Europe in the fifteenth century differs profoundly from the art of previous centuries. Out of the lingering Gothic forms preferred by the aristocracy for its books and precious objects grew a new form of art in the medium of oil painting. The paintings of Robert Campin, Jan van Eyck, and Rogier van der Weyden are exceptional not for the expense of their raw materials, but for the skill with which each painter records the natural world to enhance the spiritual experience of a viewer. The revolution in the visual arts that these artists pioneered spread all over Northern Europe and affected many different media. If we consider the fifteenth century in Northern Europe as a period of artistic and cultural flowering with great implications for the future, then this era must be called a renaissance.

COURTLY ART: THE INTERNATIONAL GOTHIC

Growing out of French Gothic styles, but also incorporating stylistic features from other parts of Europe, the International Gothic style appealed mostly to patrons in the royal courts. These aristocratic patrons commissioned luxury products based on the traditions of Gothic art, but embellished with naturalistic details. Made for elite viewers, these works often have complex and erudite imagery. The international ties among the patrons spread the style to the courts of Europe.

URBAN CENTERS AND THE NEW ART

By contrast, artists in the urban centers of the Southern Netherlands developed techniques and styles to record the natural world and create religious images that spoke directly to the middle-class patrons who commissioned them. In these images made only of wood and oil paint, sacred figures resembled real people, who had bodies with weight and texture and who expressed human emotion vividly. Portraits recorded the features of patrons with great accuracy. Details of settings or garments contribute to the realistic effect of these images, while adding symbolic meaning.

LATE FIFTEENTH-CENTURY ART IN THE NETHERLANDS

The new style of painting spread throughout the Netherlands and by 1500 had an impact on artists working in other art forms, such as manuscripts, tapestries, and sculpture. Although the courts continued to prefer these luxury arts, painting increased in stature and in patronage. International merchants purchased paintings that depicted the patrons in close contact with sacred figures. These works expressed the piety of their patrons, but also served their social ambitions.

REGIONAL RESPONSES TO THE EARLY NETHERLANDISH STYLE

Artists in other regions throughout Europe adapted the technical and stylistic innovations of the Netherlands. The French preference for geometric order and clear design combined with this naturalistic style to produce somber and meditative images, while Spanish artists made more dramatic and expressive images. In Central Europe, artists extended the naturalistic style to include specific local settings for sacred stories, bringing the religious lessons ever closer to a viewer.

PRINTING AND THE GRAPHIC ARTS

Born in Northern Europe, the new technology of printmaking contributed to the spread of these variations on Netherlandish naturalism. Early prints in woodcut and engraving borrowed motifs and compositions from painters, which they had to translate into strictly linear elements. By the end of the century, however, printmakers made original compositions with great skill that competed with the naturalism of painting.

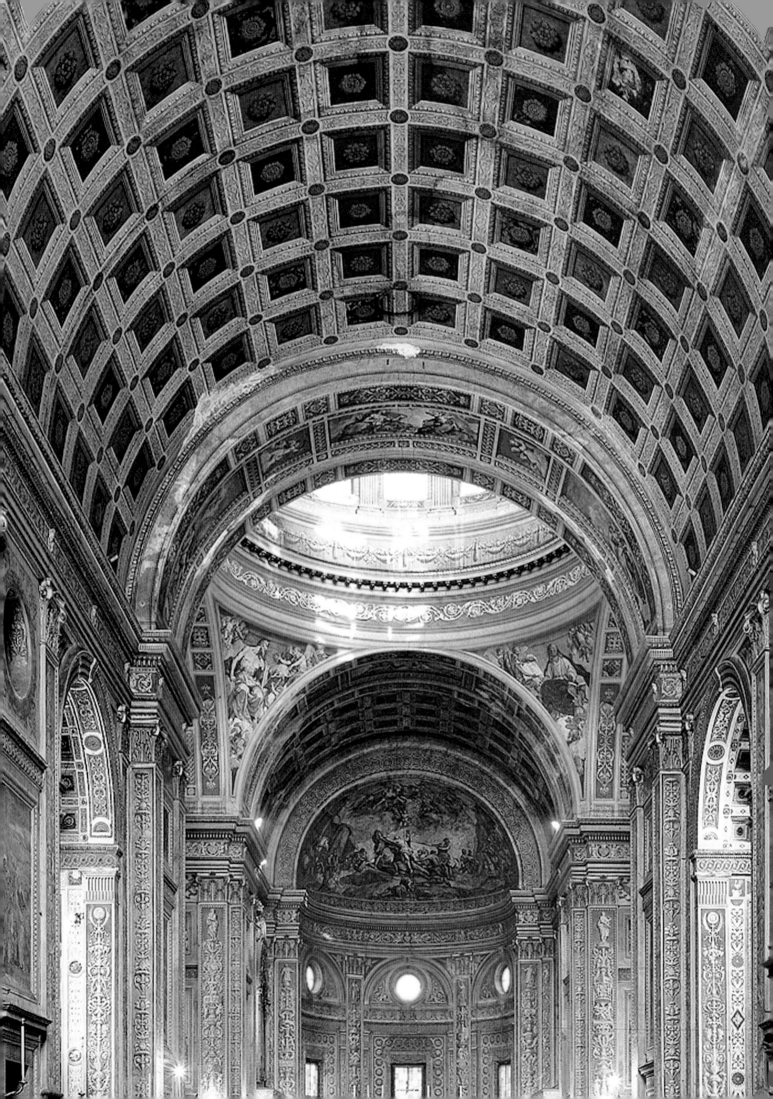

The Early Renaissance in Fifteenth-Century Italy

NEITHER A SCHOLAR WRITING A HISTORY OF FRANCE IN THIRTEENTH-century Paris nor a notary writing a contract in fourteenth-century Bruges could have imagined that he was living in a "middle" age; he only knew that his age followed the eras of the past. But intellectuals in fifteenth-century Italy thought of themselves as living in a *new* age, one that

was distinct from the immediate past. This consciousness of historical difference separates the thinkers of the fifteenth and sixteenth centuries from their medieval forebears. These thinkers devalued the post-Roman, or medieval world, and believed they could improve their culture by reviving the best features of antiquity, that is, Roman and Greek culture. Their efforts, beginning in the fifteenth century in Italy, sparked a cultural flowering of great significance for the history of Europe.

First called the *rinascimento,* Italian for "rebirth," the period came to be known by its French name, the *Renaissance*. Its original users defined it as the rebirth of classical learning, literature, and art. Modern historians have divided the Italian Renaissance into stages: an early phase in the fifteenth century, the High Renaissance denoting a period of exceptional achievement, and the Late Renaissance, which is primarily a chronological term. Neither the definition of the Renaissance as the revival of Classical forms nor the chronological limits apply easily outside of Italy, but the broader definition of a Renaissance as a cultural or artistic renewal has come to apply elsewhere. In Northern Europe, as we have seen in Chapter 14, scholars and artists did not have the same dedication to reviv-

ing the ancients, though they did study the past. More significant was an economic and cultural expansion that resulted in far-reaching technical and cultural achievements.

The causes of the cultural flowering in Italy are complex, as events, people, ideas, and social shifts came together in a revolution that produced many of the characteristics of modern European civilization. (For this reason, some scholars refer to this era as the "early modern period.") This cultural shift was fundamentally an intellectual one. The followers of the fourteenth-century author Petrarch began to study texts from Greece and Rome both for their moral content and their style. They committed themselves to the *studia humanitatis*—the study of human works, emphasizing rhetoric, literature, history, moral philosophy, and art forms. Although its roots lay in the medieval university, which prized theology, this educational approach, called **humanism**, aimed to create knowledge for practical use in the world—for lawyers, bureaucrats, politicians, diplomats, and merchants. Humanist education shifted intellectual activity out of Church control.

Humanist scrutiny of ancient texts not only deepened their knowledge of Latin authors, but also stimulated the study of the great Greek thinkers such as Aristotle, Plato, Euclid, and Ptolemy. Humanists' analytical approach and empirical observations encouraged new thinking in many fields, including mathematics and natural science. Studying history taught the importance of individuals acting in the world to assure their

Detail of figure 15.50, Leon Battista Alberti, *Interior of Sant' Andrea*

Map 15.1. Italy in the Renaissance

personal fame, yet also encouraged educated people to serve the common good by participating in civic life. Humanist educational ideas spread quickly throughout Italy, aided by the introduction into Italy of the printing press in 1464, which made books more widely available. Governing parties throughout Italy, whether princes, popes, or elected councils, used humanists in their bureaucracies and courts to conduct their business.

Humanist ideas affected artists as well as the patrons who hired them. As humanists studied ancient texts, artists studied ancient artworks, not just to imitate details or motifs, but to understand the principles by which ancient buildings were designed and ancient sculptures achieved their naturalism. Renaissance artists took up the ancient ideal of rivaling nature in their art, but they brought their practical skills to this intellectual aim. They devised techniques such as perspective and mastered new technologies like oil painting and printmaking to further their goal of reproducing the natural world and to spread their ideas.

Artists used these ideas and techniques to make art that served spiritual and dynastic functions for their patrons. Medieval institutions—religious orders, guilds, and the Church—commissioned churches, architectural sculpture, wall paintings, altar furnishings, and other objects as they had in earlier centuries, though secular patronage increased. The artists earned personal glory along the way, so that by the end of the century the status of the artist had changed. Through much of the Middle Ages, the social and economic position of artists in society was comparable to any other artisan. They were respected for the skill of their hands, but not considered intellectuals. Many artists in fifteenth-century Italy behaved like intellectuals, investigating the past and solving problems scientifically, so the status of the artist rose as a result.

During this period, there was no single political entity called Italy. Regions of different size and political organization competed with each other economically and often on the battlefield. The Kingdom of Naples in the south was a monarchy. Dukes, princes, and despots carved up northern Italy into city-states, including Milan, Mantua, and Urbino. The pope returned to Rome from Avignon to reclaim control of the papal states. And the major trading cities of Venice and Florence formed republics, where mercantile elites controlled political power. Though the cultural flowering we call the Renaissance occurred throughout Italy, for many modern scholars the city of Florence was its birthplace.

In Praise of the City of Florence (c. 1403–1404) by Leonardo Bruni

Though born in Arezzo, Leonardo Bruni (1370–1444) moved to Florence to take up law and humanistic studies. His mentor, Coluccio Salutati, was the Chancellor of Florence, to which post Bruni succeeded in 1406 . An ardent student of Classical literature, he modeled his own writings on those of Greek and Roman authors. He wrote this panegyric to Florence after the death of Giangaleazzo Visconti, which ended the threat to the city from Milan.

Therefore, what ornament does this city lack? What category of endeavor is not fully worthy of praises and grandeur? What about the quality of the forebears? Why are they not the descendants of the Roman people? What about glory? Florence has done and daily continues to do great deeds of honor and virtue both at home and abroad. What about the splendor of the architecture, the buildings, the cleanliness, the wealth, the great population, the healthfulness and pleasantness of the site? What more can a city desire? Nothing at all. What, therefore, should we say now? What remains to be done? Nothing other than to venerate God on account of His great beneficence and to offer our prayers to God. Therefore, our Almighty and Everlasting God, in whose churches and at whose altars your Florentines worship most devoutly; and you, Most Holy Mother, to whom this city has erected a great temple of fine and glimmering marble, where you are at once mother and purest virgin tending your most sweet son; and you, John the Baptist, whom this city has adopted as its patron saint—all of you, defend this most beautiful and distinguished city from every adversity and from every evil.

SOURCE: "PANEGYRIC TO THE CITY OF FLORENCE," TR. BENJAMIN G. KOHL IN *THE EARTHLY REPUBLIC: ITALIAN HUMANISTS ON GOVERNMENT AND SOCIETY*. (PHILADELPHIA: UNIVERSITY OF PENNSYLVANIA PRESS, 1978)

FLORENCE, CA. 1400–1430, ANCIENT INSPIRATIONS FOR ARCHITECTURE AND ARCHITECTURAL SCULPTURE

One reason for the prominence of Florence in histories of the Renaissance is that many early humanists were Florentines who patriotically praised their hometown. Florence was an important manufacturing center, a key center for trade, and a major center for international banking, whose wealth and social dynamism attracted talented individuals. Instead of hereditary aristocrats, bankers and merchants controlled the government. Groups of merchants and artisans banded together in guilds (economic and social organizations) to strengthen their positions. The governing council, called the *Signoria*, consisted of officials elected from members of the guilds and prominent mercantile families. The government was a republic, a word that for Florentines signaled their identity as the heirs of the ancient Roman Republic.

Florentine politicians, such as Coluccio Salutati and Leonardo Bruni, chancellors in succession to the *Signoria,* gave eloquent voice to Florentine aspirations. Urging the city to defy the Duke of Milan as he threatened to invade in 1401–1402, Salutati called on the city's Roman history as a model to follow. After this threat had passed, Leonardo Bruni declared that Florence had been able to defy Milan because of her republican institutions, her cultural achievements, and the origins of her people. In his *In Praise of the City of Florence* (1403–1404), he compared Florence's virtues to those of fifth-century Athens, which had defied the invading Persians. Yet he also praised Florentine piety and devotion, expressed in the building of churches. (See *Primary Source,* above.) Renaissance humanists wished to reconcile the lessons of antiquity with their Christian faith.

Bruni's words may explain why practical Florentines invested so much of their wealth on cultural activity. The *Signoria* and groups delegated by it commissioned numerous public projects to beautify and improve their city. Not only did individuals or families sponsor public projects, but so did merchant guilds who held competitions among artists for their commissions. The successful accomplishment of projects of great visibility enhanced the prestige of sponsoring individuals and groups and drew artists to the city. Many native sons (daughters were forbidden entry to the guilds, so few women became artists) became sculptors, painters, and goldsmiths. In addition to the competitions for work at the Baptistery and Duomo, awarded to Lorenzo Ghiberti and Filippo Brunelleschi, the guilds commissioned sculptures of their patron saints for the exterior niches of the centrally placed structure called Or San Michele. Among the artists who filled the niches were Donatello and Nanni di Banco.

The Baptistery Competition

Andrea Pisano's bronze doors for the Baptistery (fig. 13.14), completed in 1360, were an impressive example of Florentine taste and piety. Their success inspired the overseers of the works at the Baptistery, The Guild of Wool Merchants, to open another competition for a second set of bronze doors. Each competitor was asked to make a design on the theme of the Sacrifice of Isaac; six artists made trial reliefs for this competition, though only two of them survive. One is by Filippo Brunelleschi; the other is by Lorenzo Ghiberti (1381–1455), whom the Guild ultimately chose to execute the second doors of the Baptistery (fig. **15.1**). Ghiberti left a description of the competition, and his acclaim as the victor in his *Commentaries*, written late in his life. (See *Primary Source*, page 506).

Ghiberti's trial relief reveals the strength of his composition, his skill at rendering the human form, and his observation of natural details. The Gothic quatrefoil shape was inherited from Andrea Pisano's first doors for the Baptistery (see fig. 13.15). and presented certain design challenges. How could he fill the four lobes of the quatrefoil, yet convey the narrative succinctly and naturalistically? Ghiberti solved the problem by placing narrative details in the margins and the focal point at the center. Thus, the ram on the mountain

Lorenzo Ghiberti (ca. 1381–1455)

The Commentaries, from Book 2

Ghiberti's incomplete Commentaries *is an important early document of art history. The first book consists largely of extracts from Pliny and Vitruvius; the second is about art in Italy in the thirteenth and fourteenth centuries and ends with an account of Ghiberti's own work (fig. 15.1).*

Whereas all gifts of fortune are given and as easily taken back, but disciplines attached to the mind never fail, but remain fixed to the very end, . . . I give greatest and infinite thanks to my parents, who . . . were careful to teach me the art, and the one that cannot be tried without the discipline of letters. . . . Whereas therefore through parents' care and the learning of rules I have gone far in the subject of letters or learning in philology, and love the writing of commentaries. I have furnished my mind with these possessions, of which the final fruit is this, not to need any property or riches, and most of all to desire nothing. . . . I have tried to inquire how nature proceeds . . . and how I can get near her, how things seen reach the eye and how the power of vision works, and how visual . . . works, and how visual things move, and how the theory of sculpture and painting ought to be pursued.

In my youth, in the year of Our Lord 1400, I left Florence because of both the bad air and the bad state of the country. . . . My mind was largely directed to painting. . . . Nevertheless . . . I was written to by my friends how the board of the temple of St. John the Baptist was sending for well-versed masters, of whom they wanted to see a test piece. A great many very well qualified masters came through all the lands of Italy to put themselves to this test. . . . Each one was given four bronze plates. As the demonstration, the board of the temple wanted each one to make a scene . . . [of] the sacrifice of Isaac. . . . These tests were to be carried out in a year. . . . The competitors were . . . : Filippo di ser Brunellesco, Simone da Colle, Niccolo D'Arezzo, Jacopo della Quercia from Siena, Francesco da Valdambrino, Nicolo Lamberti. . . . The palm of victory was conceded to me by all the expects and by all those who took the test with me. The glory was conceded to me universally, without exception. Everyone felt I had gone beyond the others in that time, without a single exception, with a great consultation and examination by learned men.

. . . The judges were thirty-four, counting those of the city and the surrounding areas: the endorsement in my favor of the victory was given by all, and the by the consuls and board and the whole body of the merchants guild, which has the temple of St. John the Baptist in its charge. It was . . . determined that I should do this bronze door for this temple, and I executed it with great diligence. And this is the first work; with the frame around it, it added up to about twenty-two thousand florins.

SOURCE: CREIGHTON GILBERT, *ITALIAN ART 1400-1500: SOURCES AND DOCUMENTS.* (EVANSTON, IL: NORTHWESTERN UNIVERSITY PRESS, 1992)

15.1. Lorenzo Ghiberti. *The Sacrifice of Isaac.* 1401–1403. Panel, gilt bronze relief. 21 × 17″ (53.3 × 43.2 cm). Museo Nazionale del Bargello, Florence

appears in the upper left and the foreshortened angel on the right. At the center, Abraham gestures dramatically as he moves to sacrifice his son, bound and naked on an altar. Isaac twists to face the spectator, his beautifully formed torso contrasting with the cascade of drapery worn by his father. A wedge of mountain keeps other figures away from the main scene. Ghiberti's design successfully combines movement, focus, and narrative. At the same time, his interest in the lyrical patterning of the International Gothic tempers the brutality of the scene. Abraham's drapery falls in cascades similar to those of the figure of Moses in Sluter's *Well of Moses* (fig. 14.2). In addition to the design, Ghiberti's entry demonstrated a technical finesse that may have persuaded the judges to select him: Unlike Brunelleschi, he cast his entry in one piece. The casting of the doors kept Ghiberti's workshop busy for 20 years. Many of the most sought-after artists of the next generation spent time in his shop, as he completed the doors.

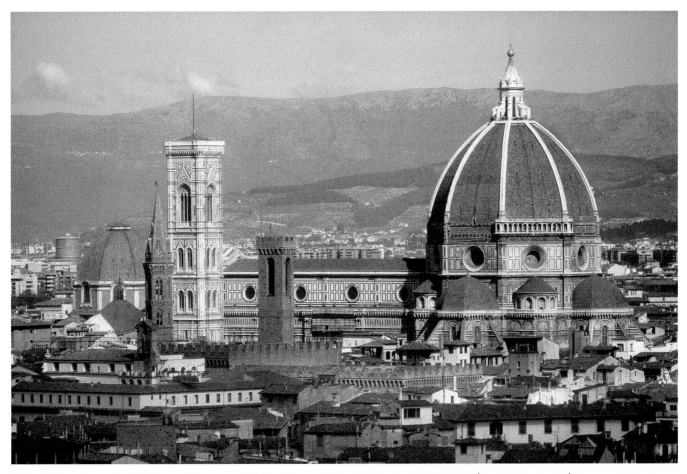

15.2. Filippo Brunelleschi. Dome of Florence Cathedral (Santa Maria del Fiore). 1420–1436. 100' high (35.5 m), 459' diameter (140 m)

Brunelleschi and The Dome of the Florence Cathedral

After losing the competition for the Baptistery doors, Filippo Brunelleschi (1377–1446) changed his artistic focus. He went to Rome with his friend, the sculptor Donatello. There he studied ancient structures and reportedly took exact measurements of them. His discovery of linear perspective (discussed later in this chapter), may well have grown out of his search for an accurate way of recording the appearance of those ancient buildings. We do not know what else he did during this period, but between 1417 and 1419 he again competed with Ghiberti, this time for the job of building the dome for the Florence Cathedral (see fig. **15.2**). The dome had been planned half a century earlier, so only details could be changed, and its vast size posed a difficult problem of construction. Brunelleschi's proposals were the fruit of his study of Gothic, Roman, Byzantine, and maybe even Persian buildings, but the building of the dome was as much a feat of engineering as of style. (See *Materials and Techniques*, page 508.) The project occupied him for most of the rest of his life. It would come to symbolize Florentine inventiveness, piety, ambition, and skill.

Soaring hundreds of feet above street level, the dome dwarfs all other structures in Florence. Resting visually on the smaller semidomes that surround the cathedral's eastern end, the ribs of the dome rise upward dramatically, terminating at a small marble cupola or lantern. Brunelleschi designed this lantern to tie the eight exterior ribs together, but it also marks the crescendo of that upward movement. When the cathedral was dedicated on March 25, 1436, the city rejoiced. Florence had demonstrated its devotion to the Virgin Mary, as well as its ambition to overawe its neighbors culturally. Florentines were justifiably proud that a native son had so cleverly accomplished what previous generations had not. Brunelleschi's forms would influence architecture far beyond Tuscany.

Donatello and Nanni di Banco at Or San Michele

While work continued on the dome of Florence Cathedral, another competition played out nearby at Or San Michele. Begun in 1337, this structure served both as a granary and a shrine holding a locally venerated image of the Virgin and Child. The guilds of Florence oversaw the building, with each one taking responsibility for filling a niche on the exterior with sculpture. In 1406, the city set a deadline to complete this work within 10 years. In the decades that followed, the guilds and the sculptors they commissioned competed intensely to create impressive statues of their patron saints. The major guilds commissioned Lorenzo Ghiberti to execute several statues for Or San Michele, while some younger sculptors won commissions from less-powerful guilds.

Brunelleschi's Dome

As the basic dimensions and plans for the Cathedral of Florence had been established in the fourteenth century, Brunelleschi first determined to lift the dome on a drum above the level of the nave in order to reduce the weight on the walls. Brunelleschi proposed to build the dome in two separate shells, which was a method more common in Islamic than Italian architecture, especially employed in Persia. Compare the fourteenth-century tomb of the Il-Khan Oljeytu in Sultaniya, Iran (fig. 9.21). These two shells were supported by a series of ribs, eight of them visible on the exterior but others hidden; the vertical ribs were themselves linked by rows of horizontal ribs, a system which may have been inspired by the coffered dome of the Pantheon (see fig. 7.43). Both the use of ribs and the pointed profile reflect Gothic practice. The dual shells of the dome lighten the whole mass since their walls are thin relative to their size. Brunelleschi's brickwork in a herringbone pattern serves both to resist cracks caused by settling and to lessen the weight as the courses of brick get thinner as they rise.

Along with these design features, Brunelleschi proposed innovations in the construction process. The traditional practice had been to construct a wooden centering across the span of the dome to support it during construction, but this required huge pieces of timber. Instead of a centering, Brunelleschi designed new a system by which temporary scaffolding was cantilevered out from the walls of the drum, thereby reducing the size and

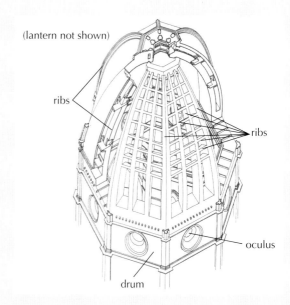

Isometric view of Brunelleschi's dome. (Drawing by P. Sanpaolesi)

amount of timber needed during building. And instead of having building materials carried up on ramps to the required level, he designed new hoisting machines. Brunelleschi's entire scheme reflects a bold, analytical mind that was willing to discard conventional solutions if better ones could be devised.

Among them was Ghiberti's former assistant Donatello (1389–1466). Between 1410 and 1417, Donatello carved the *St. George Tabernacle* (fig. **15.3**) for the Guild of Armorers. The niche for the figure is so shallow that the figure seems poised to step out of it. Although dressed in armor, he appears able to move his limbs easily. His stance, with the weight placed on the forward leg, suggests he is ready for combat. (Originally, the right hand held a real sword or lance, and he wore a real helmet, effectively showcasing the guild's wares.) The controlled energy of his body is reflected in his eyes, which seem to scan the horizon for the enemy. St. George is portrayed as the Christian soldier spiritually akin to the St. Theodore at Chartres (see fig. 12.24) and to other figures of chivalry.

Below *St. George's* niche a relief panel shows the hero's best-known exploit, the slaying of a dragon. (The woman on the right is the princess whom he had come to free.) Here Donatello devised a new kind of relief that is shallow (called **schiacciato**, meaning "flattened-out"), yet he created an illusion of almost infinite depth. In this relief, the landscape behind the figures consists of delicate surface modulations that catch light from varying angles. Every tiny ripple has a descriptive power that is greater than its real depth. The sculptor's chisel, like a painter's brush, becomes a tool for creating shades of light and dark. The energetic figure of the saint on horseback, battling the dragon in the foreground, protrudes from this atmospheric background, while the princess watches. The whole work becomes an image of watchfulness and preparedness for danger.

The Linen Weaver's guild also turned to Donatello to fill their niche with a figure probably completed in 1413 (fig. **15.4**). Their patron, *St. Mark*, stands almost 8 feet high, but that is only one of the features that makes him so imposing. His large, powerful hands grip a book, most likely his Gospel. His body stands in a pose Donatello learned from studying the art of the ancients: One leg is flexed while the other holds the body's weight in a *contrapposto* stance (see fig. 5.29, the *Kritios Boy*). St. Mark's drapery falls in deep folds to reveal and emphasize his posture.

Donatello treats the human body as an articulated structure, capable of movement, and its drapery as a separate element that is based on the shapes underneath rather than on patterns and shapes imposed from outside. Following Classical precedents such as the *Doryphoros* (see fig. 5.33), Donatello carefully balances the composition, so the elements on the left (as a viewer sees it) stress the vertical and the static, while those on the right emphasize the diagonal and kinetic. The deeply carved eyes and undulating beard of the saint maintain control over the whole figure, while the mass of drapery reminds the viewer of the Linen Weavers' products. This work reflects Donatello's deep understanding of the principles that guided the artists of antiquity and his commitment to them. St. Mark reveals what Donatello learned from studying ancient works of sculpture: an emphasis on naturalistic form, the independence of body and drapery, a balanced but contrasting composition, the potential for movement, and psychological presence.

Not only did the guilds compete through these projects, but the artists themselves stimulated each other to new efforts. Donatello's work must have been a revelation to his contemporaries. The Guild of Wood and Stone Carvers hired Nanni di Banco (ca. 1380–1421) to fill their niche at Or San Michele with an image of the Four Crowned Saints, called the *Quattro Coronati* (fig. **15.5**). Carved between 1409 and 1416/17, these figures represent four Christian sculptors who were executed for refusing to carve a pagan statue ordered by the Roman emperor Diocletian. The life-sized saints stand in a Gothic niche as if discussing their impending fate. Their bodies seem to spill out

15.3. Donatello. *St. George Tabernacle,* from Or San Michele, Florence. ca. 1410–1417. Marble, height of statue 6′10″ (2.1 m). Relief 15 ¼ × 47¼″ (39 × 120 cm). Museo Nazionale del Bargello, Florence

15.4. Donatello. *St. Mark.* ca. 1411–1413. Marble, 7′9″ (2.4 m). Or San Michele, Florence (now Museo di Or San Michele, Florence)

ART IN TIME

1401—Ghiberti wins commission to sculpt northern doors of
 the Baptistery of Florence
1402—Gian Galeozzo Visconti dies, ending threat to Florence
1406—Florence conquers Pisa
1420—Brunelleschi's dome for Florence Cathedral begun

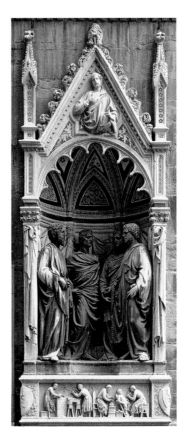

of the confines of the niche, draped as they are in the heavy folds of their togas. These garments and the heads of the second and third of the *Coronati* directly recall Roman portrait sculpture of the first century CE (see fig. 7.12). It is as if Nanni were situating the martyrs in their historical moment. His figures emulate the Roman veristic style (fig. 7.11) and monumentality. The relief below the saints represents sculptors at work, both explaining the story of the martyrs and advertising the skills of the patrons who commissioned the work.

Brunelleschi's Ospedale degli Innocenti

Another guild in Florence sponsored a different sort of public work for the city, intended to address a social problem. The Guild of Silk Manufacturers and Goldsmiths hired Filippo Brunelleschi to design a hospital for abandoned children near the church of Santissima Annunziata. In 1421, construction began on the Ospedale degli Innocenti (Hospital of the Innocents), although building continued long after Brunelleschi's death. The facade of the hospital (fig. **15.6**) consists of a covered walkway, or **loggia**, defined by an arcade raised slightly above ground level. A strong horizontal molding sits above the arcade, and above that is a simple arrangement of pedimented windows.

15.5. Nanni di Banco. *Quattro Coronati (Four Saints)*. ca. 1409–1416/17. Marble, 6′ (1.83 m). Or San Michele, Florence (now Museo di Or San Michele, Florence)

In designing this structure, Brunelleschi revived the architectural forms of the ancients, as seen in the columns, their capitals, the arches, and the entablatures. Doing so demanded that he work within rigid rules for designing these elements. Unlike a medieval column, a Classical column is strictly defined; its details and

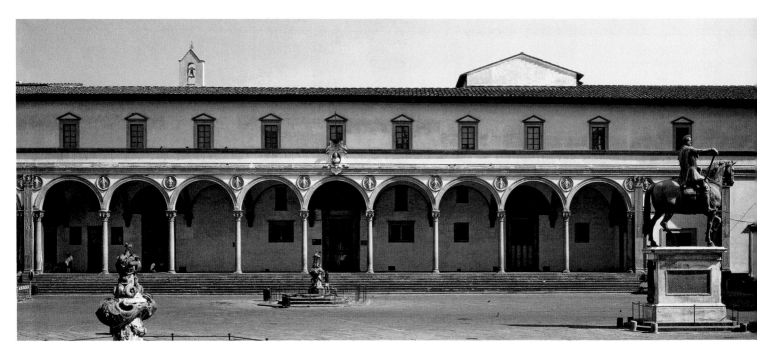

15.6. Filippo Brunelleschi. Ospedale degli Innocenti (Hospital of the Innocents) Florence. Begun 1421

Leon Battista Alberti

From *Treatise on Architecture, 1452*

Modeled on Vitruvius' treatise on architecture from the first century CE,
Treatise on Architecture *was completed in 1452 but not published until
1485, after Alberti's death.*

The most expert Artists among the Ancients were of [the] opinion
that an Edifice was like an Animal, so that in the formation of it
we ought to imitate Nature. It is manifest that in those [animals]
which are esteemed beautiful, the parts or members are not constantly
all the same, but we find that even in those parts wherein they vary
most, there is something inherent and implanted which tho' they dif-
fer extremely from each other, makes each of them be beautiful. But
the judgment which you make that a thing is beautiful, does not pro-
ceed from mere opinion, but from a secret argument and discourse
implanted in the mind itself. There is a certain excellence and natural
beauty in the figures and forms of buildings, which immediately
strike the mind with pleasure and admiration. It is my opinion that
beauty, majesty, gracefulness and the like charms, consist in those par-
ticulars which if you alter or take away, the whole wou'd be made
homely and disagreeable. There is something which arises from the
conjunction and connection of these other parts, and gives the beauty
and grace to the whole: which we will call Congruity, which we may
consider as the original, of all that is graceful and handsome. Wherev-
er such a composition offers itself to the mind either by the con-
veyance of the sight, hearing, or any of the other senses, we
immediately perceive this Congruity: for by Nature we desire things
perfect, and adhere to them with pleasure when they are offered to us;
nor does this Congruity arise so much from the body in which it is
found, or any of its members, as from itself and from Nature, so that
its true Seat is in the mind and in reason. This is what Architecture
chiefly aims at, and by this she obtains her beauty, dignity and value.

SOURCE: *A DOCUMENTARY HISTORY OF ART*, VOL. I, ED. ELIZABETH GILMORE HOLT, P. 235–237

proportions can vary only within narrow limits. Unlike any other
arch (horseshoe, pointed, and so forth), the Classical round arch
has only one possible shape, a semicircle. The Classical architrave,
profiles, and ornaments must all follow similarly strict rules. This
is not to say that Classical forms are completely inflexible. But the
discipline of the Greek orders, which can be felt even in the most
original Roman buildings, demands regularity and discourages
arbitrary departures from the norm. Using such "standardized"
forms, Brunelleschi designed the facade of this hospital as a series
of blocks of space of the same size, defined by the bays of the
arcade. Each bay establishes a square of space that is covered by a
dome resting on pendentives. Transverse arches divide the domes
inside the arcade. Using contrasting colors of stone, Brunelleschi
emphasizes the edges of these units of space without disrupting
their rhythmic sequence.

One other principle accounts for the balanced nature of the
design. For Brunelleschi, the secret of good architecture lay in
choosing the "right" proportions—that is, proportional ratios
expressed in simple whole numbers—for all the major measure-
ments of a building. For example, the entablature over the
columns sits at twice the height of a column for a ratio of 2:1. The
ancients had possessed this secret, he believed, and he tried to dis-
cover it when he measured their monuments. What he found, and
exactly how he applied it, is uncertain, but his knowledge may
have been passed to Leon Battista Alberti. In his *Treatise on Archi-
tecture*, Alberti argues that the mathematical ratios that determine
musical harmony must also govern architecture, for they recur
throughout the universe and thus are divine in origin. (*See Prima-
ry Source*, above.) Similar ideas, derived from the theories of the
Greek philosopher Pythagoras, had been current during the Mid-
dle Ages, but they had never before been expressed so directly and
simply. At the Innocenti, Brunelleschi used ratios to dictate rela-
tionships: The windows are centered between the columns, the
intervals between columns equal the height of the columns,
the span between the columns is the distance from the column to
the wall. Proportion locks the composition into a balanced whole.
The arcade, with its beautifully proportioned columns supporting
arches, made of a dark local sandstone called *pietra serena* (literally,
"peaceful stone"), gives the facade a graceful rhythm.

Above the spandrels of the arches, terra-cotta reliefs in
roundels from the della Robbia workshop depict babies, the
"innocents" for whom the structure was named. Brunelleschi's
Innocenti not only served Florence's poor, it defined a public
square. This loggia establishes one side of a piazza perpendicu-
lar to the Church of the Annunziata; it was ultimately closed by
the facades of other buildings on the square. Such public spaces
were used for social, religious, and political functions, and by
echoing the design of the Roman forum, they expressed the
Florentine sense of themselves as the heirs to Rome.

In the revival of classical forms, Renaissance architecture
found a standard vocabulary. The theory of harmonious pro-
portions gave it a syntax that had been mostly absent in
medieval architecture. Similarly, the revival of Classical forms
and proportions enabled Brunelleschi to transform the archi-
tectural "vernacular" of his region into a stable, precise, and
coherent system. Brunelleschi's achievement placed architec-
ture on a firm footing and applied the lessons of Classical antiq-
uity for modern Christian ends. Furthermore, his study of the
ancients and his practical application of Classical geometric
proportions probably stimulated his discovery of a system for
rendering forms in three dimensions. This technique became
known as linear or scientific perspective. (See *Materials and
Techniques*, page 513.)

CHAPELS AND CHURCHES
FOR FLORENTINE FAMILIES, 1420–1430

The building projects in Florence went beyond the cathedral
and civic institutions such as the Innocenti. Private patrons and
elite families contributed to the flowering of architecture and

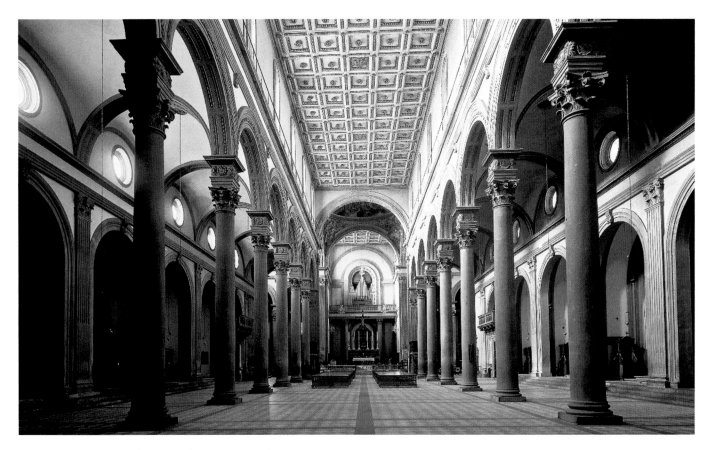

15.7. Filippo Brunelleschi. Nave of San Lorenzo, Florence. ca. 1421–1469

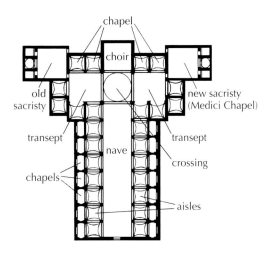

15.8. Plan of San Lorenzo.

other arts in Florence by sponsoring churches and chapels throughout the city. Donors often made such commissions for pious reasons, as endowing funerary chapels assured perpetual masses for the souls of deceased family members. But making substantial gifts to neighborhood churches elevated the donor's social prestige as well. The fortunes of Florentine families may be mapped by their sponsorship of such projects. (See *The Art Historian's Lens*, page 518.)

The Medici family's interest in their parish church, San Lorenzo, led to Brunelleschi's transformation of that structure. The family's bitter rivals, the Pazzi, hired the same architect to build at the Franciscan church of Santa Croce. The Strozzi family built their chapel at Santa Trinità, and turned to Gentile da Fabriano to provide an altarpiece. At both Santa Maria Novella and at the Church of Santa Maria delle Carmine, the young Masaccio found employment in painting frescoes for other prominent families. These artists contributed to the remaking of Florence in the early fifteenth century, and to the revolutionary new style of art that was born there.

Brunelleschi at San Lorenzo

Early in the fifteenth century, the Medici were involved in a project to rebuild their parish church. In 1419, Giovanni di Bicci de' Medici commissioned Brunelleschi to add a sacristy to the Romanesque church of San Lorenzo. The structure would also serve as a burial chapel for the Medici. The family was so pleased with his plans for this sacristy that they asked Brunelleschi to develop a new design for the entire church. Brunelleschi's work began in the 1420s, but construction proceeded in fits and starts; the nave was not completed until 1469, more than 20 years after the architect's death. (The exterior remains unfinished to this day.) Nevertheless, the building in its present form is essentially what Brunelleschi had envisioned about 1420, and it represents the first full statement of his architectural aims (figs. **15.7** and **15.8**).

Perspective

One of the transformative inventions of the Renaissance was linear, or scientific, perspective, sometimes called one-point or center-point perspective. The system is a geometric procedure for projecting the illusion of space onto a two-dimensional surface. Its central feature is the **vanishing point**, a single point toward which any set of parallel lines will seem to converge. If these lines are perpendicular to the picture plane, their vanishing point will be on the horizon. (Such lines are called **orthogonals**.) To further clarify the space, lines parallel to the picture plane, called **transversals** (not shown), are laid in at regular intervals, derived geometrically.

how the forms looked to them, sometimes with excellent results, as in Van Eyck's The "Arnolfini" Portrait (fig 14.16).

In Early Renaissance Italy, **scientific perspective** systematized the projection of space using mathematics and geometry, overturning the intuitive perspective practices of the past. This "scientific" approach to making images (whether paintings, prints, drawings, or reliefs) became an argument for upgrading the fine arts to become one of the liberal arts. In 1435, Brunelleschi's discovery was described in On Painting by Leon Battista Alberti, the first Renaissance treatise on painting. It is a standard element of drawing instruction to this day.

One advantage of this technique is that the artist can adjust the perspectival system to account for the presence of a spectator. The method presupposes that a beholder's eye occupies a fixed point in space, so that

After Pietro Perugino, *The Delivery of the Keys*, Fresco in the Sistine Chapel, Rome. See fig 15.59

Brunelleschi is said to have developed this tool, but at least since the time of the ancients, artists had experimented with techniques to create the illusion of depth on a flat surface. At Pompeii, wall painters sometimes used color to suggest deep space (see fig. 7.55), a technique known as atmospheric or aerial perspective. This method recognizes the eye's inability to perceive color at great distances, and that specific colors become light blue or gray at the horizon line. In addition, the forms themselves often become less clear. (See the lower section of Van Eyck's Ghent Altarpiece, fig. 14.11.) Artists also adjusted spatial elements according to

a perspective picture dictates where the viewer must stand to see it properly. Thus the artist who knows in advance that the image will be seen from above or below, rather than at ordinary eye level, can make the perspective construction correspond to these conditions. (See, for example, fig. 15.59.) Sometimes, however, these vantage points are so abnormal (as when a viewer is looking up at an image on the ceiling) that the design must be foreshortened to an extreme degree. In such cases, the artist may create an "ideal beholder" for the image, regardless of a spectator's actual viewpoint.

At first glance, the plan may not seem very novel. Like Cistercian Gothic churches, it terminates in a square east end and eschews ornament (see fig. 13.1), while the unvaulted nave and transept recall Franciscan churches like Santa Croce (see fig. 13.6). Brunelleschi was constrained by the just completed sacristy and the preexisting church. But a new emphasis on symmetry and regularity distinguishes his design for San Lorenzo, accompanied by architectural elements inspired by

the past but organized by attention to proportion, as he had done at the Innocenti. The ground plan demonstrates Brunelleschi's technique of composing with units of space in regular square blocks, so that each bay of the nave is twice as wide as its side aisles, and the crossing and apse are each four times the size of each aisle.

Inside, static order has replaced the flowing spatial movement of Gothic church interiors, such as Chartres (fig. 12.12).

The Theoretical Treatise

The humanist ideal of studying the past to inform the present inspired the writing of treatises on many subjects during the Renaissance. Such primary documents articulate the theoretical concerns shared by artists and Humanists and assist art historians in interpreting works of art from the period. One such treatise provided painters of Masaccio's generation with a theoretical and practical guide to the new techniques of painting. Its author, Leon Battista Alberti (1404–1472), was both a priest and a man of the world. The son of a powerful Florentine family that had been exiled from the city, he was born and raised in Genoa. After studying law, he entered the papal court in Rome and spent the rest of his career in the Church. Alberti was interested in many subjects, including moral philosophy (his treatise "On the Family" was begun 1432) and geography. A treatise he finished around 1435 lays out rules for surveying and mapping that were widely used during the Renaissance.

During a visit to Florence in the 1430s, Alberti became acquainted with the leading artists of his day. As a result, he authored the first Renaissance treatises on sculpture (ca. 1433) and painting (ca. 1435). *On Painting* (which is dedicated to Brunelleschi, refers to "our dear friend" Donatello, and praises Masaccio) includes the first systematic treatment of linear perspective. During a stay at the court of Ferrara in 1438, Alberti was asked to restore Vitruvius' treatise on architecture, then known in various manuscripts. Upon his return to Rome five years later, he began a systematic study of the monuments of ancient Rome that led to the *Ten Books on Architecture* (finished 1452 and published 1485)—the first book of its kind since Vitruvius' treatise, on which it is modeled. (See *Primary Source*, page 511.) Alberti's writings helped to spread Florentine innovations through Italy and increased the prestige of Florentine artists as well. It brought him important commissions as an architect.

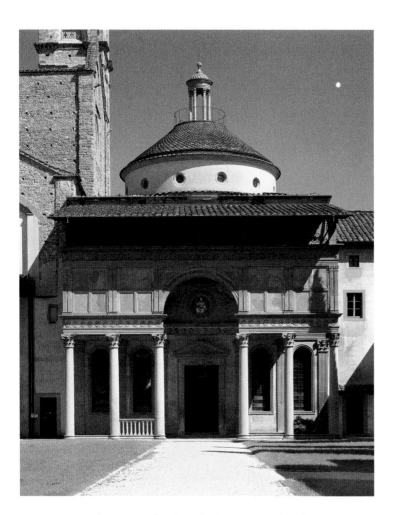

15.9. Filippo Brunelleschi and others. Pazzi Chapel, Santa Croce, Florence. Begun 1442–1465

From the portal, a viewer can clearly see the entire structure, almost as if looking at a demonstration of scientific perspective. The effect recalls the "old-fashioned" Tuscan Romanesque, such as Pisa Cathedral (see fig. 11.34), as well as Early Christian basilicas like Santa Maria Maggiore in Rome (compare with fig. 8.15). To Brunelleschi, these monuments exemplified the church architecture of antiquity. They inspired his use of round arches and columns, rather than piers, in the nave arcade. Yet these earlier buildings lack the lightness and clarity of San Lorenzo; their columns are larger and more closely spaced, so that they tend to screen off the aisles from the nave.

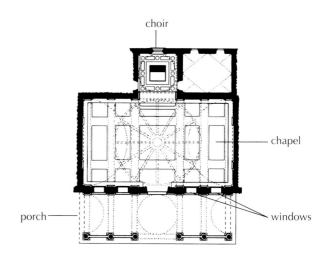

15.10. Plan of the Pazzi Chapel

Only the blind arcade on the exterior of the Florentine Baptistery is as graceful in its proportions as San Lorenzo's, but it has no supporting function (see fig. 11.35). Since the Baptistery was thought to have once been a Classical temple, it was an appropriate source of inspiration for Brunelleschi and for the new generation of Medici patrons.

Brunelleschi at Santa Croce: The Pazzi Chapel

Other families in Florence tapped Brunelleschi for architectural projects, including the aristocratic Pazzi. This family hired Brunelleschi to design a chapel adjacent to the Franciscan church of Santa Croce. Construction began on this chapel (fig. **15.9**) around 1442 and continued until 1465, so the extent of Brunelleschi's participation in the final elements has been controversial. For example, neither the portico nor

the facade in their present form may reflect his design. The plan (fig. **15.10**) shows us that the porch has two barrel vaults, which help to support a small dome, an arrangement that echoes the interior. But the porch blocks light from entering the four windows that Brunelleschi designed for the entry wall of the chapel, suggesting that a later architect altered his original plan.

The interior of the chapel, however, seems to be pure Brunelleschi. The rectangular space is roofed with two barrel vaults on either side of a dome on pendentives. On the interior, this dome sports 12 ribs articulated in Brunelleschi's favorite gray stone, *pietra serena*. The same stone marks each intersection of planes, the roundels that now hold sculpture, the square panels that define the barrel vaults, and the Corinthian pilasters that divide the wall surfaces (fig. **15.11**). Brunelleschi chose capitals and pilasters of a strong Roman character. A second dome on pendentives, half the diameter of the first, covers the square space housing the altar. As in the Ospedale degli Innocenti, proportion controls the design elements. The aim here seems to be to create a centrally planned space out of what is a fundamentally longtitudinal plan, and the intersections of circles and squares are carefully orchestrated by Brunelleschi to combine them into a rational and calm interior.

The restrained use of color and sculpture in the chapel add to the stable effect. The most colorful elements in the room are the large roundels with terra-cotta reliefs of the evangelists in the pendentives of the central dome. These may have been designed by Brunelleschi himself. On the walls are 12 smaller reliefs of the apostles, which Vasari attributed to Luca della Robbia and his shop (see fig. 15.24). Yet the sculptural elements are totally subordinate to the architecture.

The Strozzi Family, Santa Trinità, and Gentile da Fabriano

Building chapels was the mark of a great family. In addition to mendicant churches, chapels were commissioned for parish churches, such as the Gothic church of Santa Trinità. Here the sacristy was endowed by the Strozzi, one of the wealthiest families in Florence. To complete the program, Palla Strozzi commissioned Gentile da Fabriano to paint the altarpiece, *The Adoration of the Magi*, which Gentile signed and dated in 1423

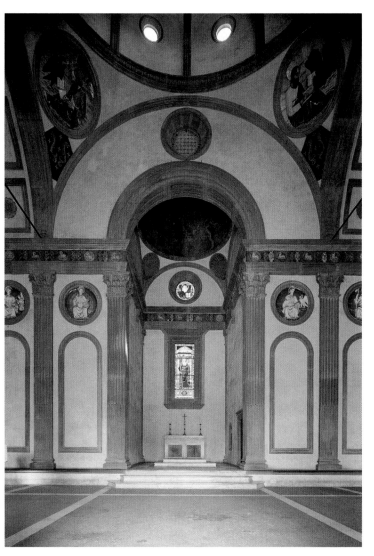

15.11. Filippo Brunelleschi and others. Interior of the Pazzi Chapel

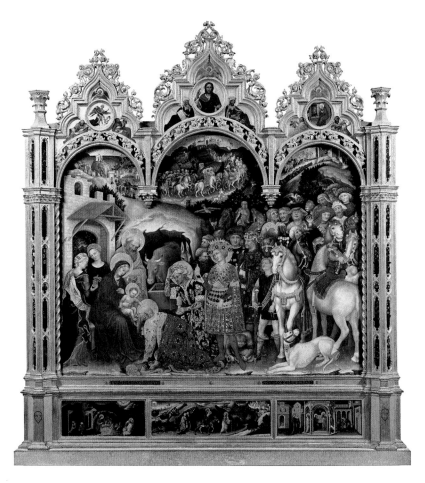

15.12. Gentile da Fabriano. *Adoration of the Magi*. 1423. Tempera on panel, 9'10" × 9'3" (3 × 2.82 m).Galleria degli Uffizi, Florence

(fig. **15.12**). Gentile (ca. 1385–1427) worked throughout Northern Italy in a style informed by some of the same characteristics as the International Gothic in Northern Europe. The lavish, triple-arched gilt frame of the altarpiece, with a **predella** (the base of the altarpiece) and gable figures, encloses a single scene in the central panel: the visit of the Magi to Bethlehem to acknowledge the newborn Jesus as King. A cavalcade of richly dressed people, as well as horses, dogs, and exotic animals (monkeys, leopards, and camels) fills the front plane of the picture as the three kings advance to venerate the child, who sits in his mother's lap to the left. Behind the stable and rock formations that define the frontal plane, the landscape winds upward into the arches of the frame. And in those distant vistas appear the Magi wending their way to Bethlehem; towns and castles mark their route. So despite the apparently unified landscape, several episodes of the narrative appear in the center panel. Other moments in the story—the Nativity, the Flight into Egypt, the Presentation in the Temple—appear in the predella. Small images in the gable above the center panel start the story off with images of the Annunciation.

Gentile's altarpiece imagines the events of the Magi's visit in courtly and sumptuous terms. Not only is the image full of elegant figures, garbed in brilliant brocades and surrounded by colorful retainers, but the panel also shines with gold leaf and tooled surfaces. (The haloes of the Virgin and St. Joseph bear pseudo-kufic inscriptions, attesting to Gentile's contact with Islamic works, probably in Venice.) The kings, also given halos, stand not only for the international acknowledgement of Christ's divinity, but for the three ages of man: youth, middle age, and old age. The artist crowds the space—the festive pageant almost overwhelms the Holy Family on the left—with men and beasts, including some marvelously rendered horses. Despite this crowding, a golden light unites the whole image, illuminating the bodies of the animals, the faces of the humans, and parts of the landscape. These forms are softly modeled to suggest volume for the figures and to counteract the strong flattening effect of all the gold. The predella scene of the Nativity (fig. **15.13**) demonstrates this aspect of Gentile's art further, as it stresses the function of light over line to delineate the forms. What is more, the source for the light that models the figures and the shed in the predella is the mystical light emanating from the Child himself. Gentile's picture reveals his awareness of light as a carrier of meaning.

Masaccio at Santa Maria Novella

Gentile's refined style made him very popular among aristocratic patrons throughout Italy, but it was his approach to light that would strongly influence younger painters. One such artist was Masaccio (Tommaso di Ser Giovanni di Mone

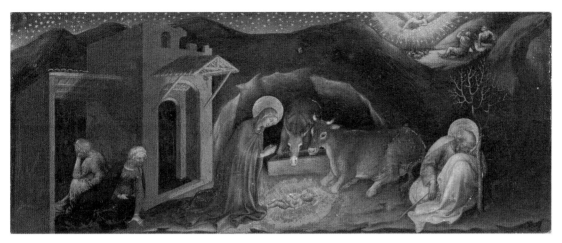

15.13. Gentile da Fabriano, *The Nativity*. Detail of *Adoration of the Magi*, from the predella. 1423. Tempera on panel, 12¼ × 29½" (31 × 75 cm)

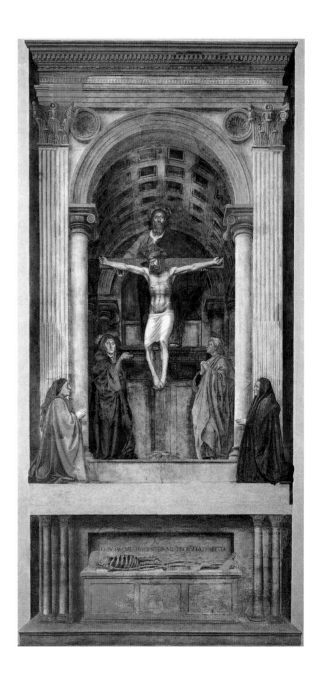

Cassai, 1401–1428). Leon Battista Alberti, a contemporary of Massaccio, celebrated the young painter's work in his treatise "On Painting," finished around 1435. (See *The Art Historian's Lens*, page 514.) Vasari noted that many sixteenth-century artists admired Masaccio, but nonetheless, in the 1560s, he covered up one of Masaccio's most famous works in Santa Maria Novella (fig. **15.14**) when he remodeled the church. Ultimately, this action probably saved Masaccio's work, but much about its commissioning and meaning are still hidden.

Because the fresco originally stood in front of a tomb slab for the Lenzi family, many scholars have concluded that this was the family who commissioned Masaccio to paint the fresco depicting the Holy Trinity in the company of the Virgin, St. John the Evangelist, and the two donors. The lowest section, linked with a tomb below, depicts a skeleton lying on a sarcophagus. The inscription (in Italian) reads, "What I once was, you are; what I am, you will become." With its large scale, balanced composition, and sculptural volume, the style suggests the art of Giotto (figs. 13.20–13.21). Giotto's art was a starting point for Masaccio, though in Giotto's work, body and drapery form a single unit, where Masaccio's figures, like Donatello's, are "clothed nudes," whose drapery falls in response to the body wearing it.

The setting reveals the artist's awareness of Brunelleschi's new architecture and of his system of perspective. (See *Materials and Techniques*, page 513.) The tall pilasters next to the painted columns recall the pilasters Brunelleschi designed for the Pazzi chapel, as do the simple moldings that define the arch and the entablature of this fictive chapel. Masaccio's use of perspective gives the spectator all the data needed to measure

15.14. Masaccio. *The Holy Trinity with the Virgin, St. John, and Two Donors.* ca. 1425. Fresco, detached from wall. 21'10⅝" × 10'4¾" (6.67 × 3.17 m) Santa Maria Novella, Florence

Patronage Studies

Seeing a work of art in a museum, a modern viewer may not be aware of its original function or context, nor of the circumstances that brought it into creation. Many art historians find that an important way to investigate these circumstances is to focus on the patronage of artwork. Such studies may include finding evidence in documents indicating who paid the artist for the work; considering what role the patron may have had in determining style or subject matter; evaluating the relationship between the artist and the patron; and drawing conclusions about what the patron wanted the work of art to do.

The relationships between patron and artist in the Renaissance were varied: In princely courts, an artist could be considered a member of the household staff, with many rather mundane tasks to do, or an esteemed member of the prince's circle, with special status and prestige. In urban centers artists may have interacted with patrons on a more socially equal level, but the person buying the work of art still had a great deal to say about the finished product. In gifts made to churches, patrons might want their portraits painted into the work of art or their coat of arms prominently displayed to remind a viewer of the identity of the donor, a practice that was widespread by the end of the Middle Ages. The system of patronage in Italy was part of a larger social network. In Florence, the great families of a neighborhood were often the major patrons of large projects for the entire neighborhood (for example the Medici at San Lorenzo; the Rucellai at Santa Maria Novella). Other families or groups often allied themselves with the great families for political, social, or commercial reasons. In some cases, this resulted in works of art that represented or made reference to the great families. Artists favored by the major patrons could gain other clients among the followers of those patrons. The investigation of these issues has enhanced our understanding of the way works of art functioned in their time.

the depth of this painted interior, to draw its plan, and to envision the structure in three dimensions. This barrel-vaulted chamber is not a shallow niche, but a deep space in which the figures could move freely. The picture space is independent of the figures; they inhabit the space, but they do not create it. Masaccio used Brunelleschi's invention to create an illusion of space where none exists.

To the spectator conversant with perspective, all the lines perpendicular to the picture plane converge toward a point below the foot of the Cross, on the platform that supports the kneeling donors. To see the fresco correctly, we must face this point, which is at an eye level somewhat more than 5 feet above the floor of the church. The figures within the chamber are 5 feet tall, slightly less than life-size, while the donors, who are closer to the viewer, are fully life-size. The framework therefore is "life-size," too, since it is directly behind the donors. The chapel that opens out behind them seems to belong to the same scale: It moves backwards into space, covered by a barrel vault. That vault is subdivided by eight square coffers, an echo of the dome of the Pantheon. The space seems measurable, palpable. However, the position of God the Father is puzzling. His arms support the Cross, close to the front plane, while his feet rest on a ledge attached to a wall. How far back is this structure? If it is against the back wall, then the figure of God destroys the spatial effect. But why should the laws of perspective constrain God? Another possibility is that Masaccio intended to locate the ledge directly behind the Cross, as we can tell by the strong shadow that St. John casts on the wall below. What, then, is God standing on? Again, must natural laws apply to the Creator?

God the Father holds his son while the dove of the Holy Spirit is a further link between them. Masaccio expresses the theme of the Trinity by the triangular composition that begins with the donors and rises to the halo of God. The composition is carefully balanced by colors, too, as opposing reds and blues unite in the garment worn by God. The whole scene has a trag-

ic air, made more solemn by the calm gesture of the Virgin, as she points to the Crucifixion, and by the understated grief of John the Evangelist. The reality of death but promise of resurrection is appropriate for a funerary commemoration.

The Brancacci Chapel

Even if we are uncertain about the identity of the donors for the *Trinity* fresco, we do know who paid for the largest group of Masaccio's surviving works. To fulfill a bequest from his uncle Pietro, Felice Brancacci underwrote the frescoes in the Brancacci Chapel in Santa Maria del Carmine (figs. **15.15–15.18**), which depict the life of St. Peter. Work began in the chapel around 1425, when Masaccio collaborated with a slightly older painter named Masolino (1383–ca.1440). The project was left incomplete when both artists were called away to work on other commissions. Masaccio went to Rome, where he died in 1428. The chapel was finally completed by the Florentine painter Filippino Lippi (1457/58–1504), who finished the lower tier on either side in the 1480s. These frescoes transform the space of the chapel into a display of narratives from Scripture.

The most famous of the frescoes is *The Tribute Money* by Masaccio, located in the upper tier (fig. 15.17). It depicts the story in the Gospel of Matthew (17:24–27) as a continuous narrative. In the center, Christ instructs Peter to catch a fish, whose mouth will contain money for the tax collector. On the far left, in the distance, Peter takes the coin from the fish's mouth, and on the right he gives it to the tax collector. Masaccio uses perspective to create a deep space for the narrative, but to link the painting's space to the space of a viewer, Masaccio models the forms in the picture with light that seems to have its source in the real window of the chapel. He also uses atmospheric perspective in the subtle tones of the landscape to make the forms somewhat hazy, seen as well in the *Ghent Altarpiece* by Jan van Eyck (fig. 14.11). The effect also recalls the setting

a decade earlier in Donatello's small relief of St. George (compare with fig. 15.3).

The figures in *The Tribute Money,* even more than those in the *Trinity* fresco, show Masaccio's ability to merge the weight and volume of Giotto's figures with the new functional view of body and drapery. All stand in balanced contrapposto. Fine vertical lines scratched in the plaster establish the axis of each figure from the head to the heel of the engaged leg. In accord with this dignified approach, the figures seem rather static. Instead of employing violent physical movement, Masaccio's figures convey the narrative by their intense glances and a few strong gestures. But in *The Expulsion from Paradise* just to the left (fig. 15.18), Masaccio shows the human body in motion. The tall, narrow format leaves little room for a spatial setting. The gate of Paradise is barely indicated, and in the background are a few shadowy, barren slopes. Yet the soft, atmospheric modeling, and especially the boldly foreshortened angel, convey a sense of unlimited space. Masaccio's grief-stricken Adam and Eve are striking representations of the beauty and power of the nude human form.

In contrast to the fluid grace of Gentile da Fabriano's painting (figs. 15.12 and 15.13), Masaccio's paintings represent a less beautiful reality. Nonetheless, at the Brancacci Chapel and elsewhere, Masaccio worked alongside Masolino, who had been strongly influenced by Gentile. The two painters worked well together and even collaborated on some of the frescoes. (The head of Christ in *The Tribute Money* may be by Masolino.) Nowhere is the contrast between the two artists' styles more striking than in *The Temptation* by Masolino (visible in the

ART IN TIME

1417—Great Schism in Catholic Church ends

1420—Papacy returns to Rome from Avignon

ca.1425—Masaccio's *Trinity* fresco in Santa Maria Novella

1439—Council of Florence attempts to reunite Roman and Byzantine churches

upper right of fig. 15.16). Where Masolino's figures of Adam and Eve are serenely beautiful nudes bathed in a diffuse natural light, Masaccio's figures express powerful emotion through their sheer physicality. Before he could finish the Brancacci Chapel, Masaccio left for Rome to work on another commission; he died there at a very young age, but his work stimulated other painters to experiment with perspectival space.

THE FLORENTINE STYLE SPREADS, 1425–1450

The building of the Florence Cathedral's dome, the work on Or San Michele, and the numerous chapels being rebuilt made Florence a busy place for artists in the second quarter of the fifteenth century. The innovative works made by Brunelleschi, Donatello, and Masaccio profoundly impressed visitors from other cities by their power and authority. Through the travels of patrons and artists the new style born in Florence spread to other cities in

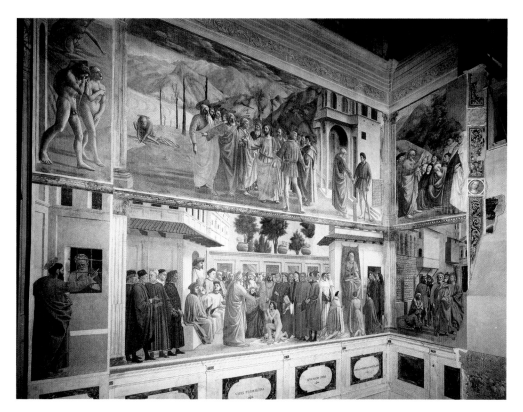

15.15. Left wall of Brancacci Chapel, with frescoes by Masaccio and others. Santa Maria del Carmine, Florence

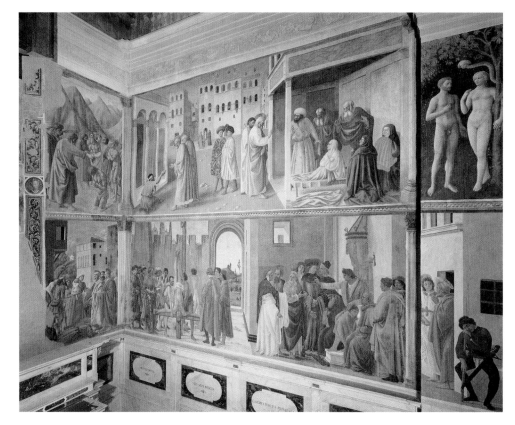

15.16. Right wall of Brancacci Chapel, with frescoes by Masaccio, Masolino, and Filippino Lippi. Santa Maria del Carmine, Florence

Italy. At first, patrons in nearby centers like Pisa and Siena hired Masaccio and Donatello, but soon patrons in more distant centers, such as Padua and Rome, sought their services.

Pisa

Little of Masaccio's work in Rome survives, but he also worked for other patrons outside of Florence. In Pisa, a nearby Tuscan city, he completed an altarpiece in many panels (a **polyptych**) in 1426 for a chapel in the Carmelite church. The surviving panels are now dispersed among various collections. The center panel (fig. **15.19**) represents the *Madonna Enthroned* in a monumental Florentine composition, first introduced by Cimabue and then reshaped by Giotto (see figs. 13.17 and 13.18). Like these earlier paintings, Masaccio's picture includes a gold ground and a large, high-backed throne with angels on each side (here only two appear). Despite these traditional elements, the painting is revolutionary in several respects. The kneeling angels in Giotto's *Madonna* have become lute players seated on the lowest step

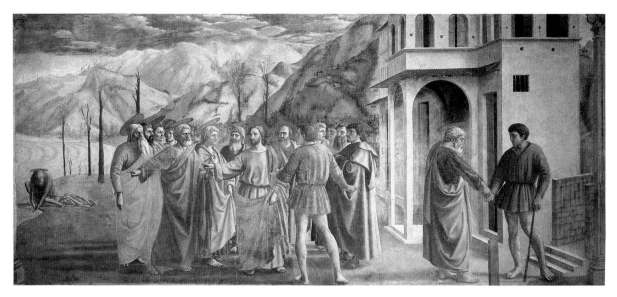

15.17. Masaccio. *The Tribute Money*. ca. 1425. Fresco. 8′1″ × 19′7″ (1.87 × 1.57 m) Brancacci Chapel

of half-shadows results in a rich scale of transitional hues. This light illuminates the forms, all but eliminating contour lines in the painting. As a result the figures seem like sculpture. Masaccio was only 25 when he executed this picture. His death only three years later cut short the revolutionary direction his painting was taking.

Siena

Elsewhere in Tuscany, too, Florentine artists were being noticed and were earning commissions. In 1416, Lorenzo Ghiberti assembled a group of artists to execute a new baptismal font for the Baptistery of Siena, San Giovanni. One of the panels for the sides of the hexagonal basin was assigned to

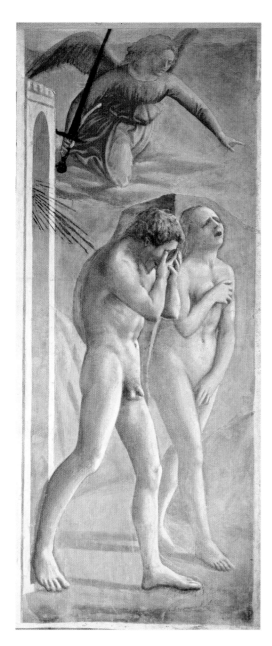

15.18. Masaccio. *The Expulsion from Paradise.* ca. 1425. Fresco. 84¼ × 10′35½″ (214 × 90 cm) Brancacci Chapel

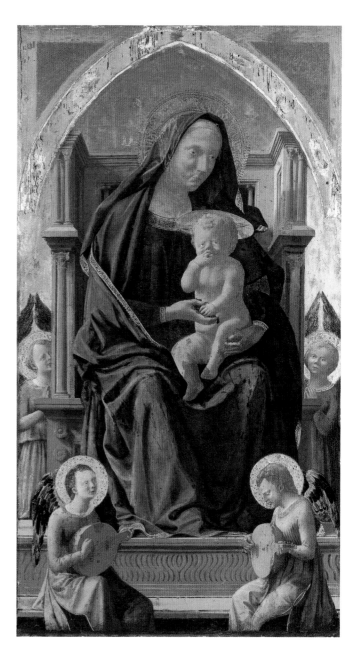

15.19. Masaccio. *Madonna Enthroned.* ca. 1426. Tempera on panel, 56 × 29″ (135 × 73 cm). The National Gallery, London
Reproduced by courtesy of the Trustees

of the throne. The garments of the solidly formed Madonna fall not in graceful cascades, but wrap around her figure like the garments of Donatello's *St. Mark.* Instead of offering a blessing, the childlike Jesus eats a bunch of grapes, referring to wine and the sacrament of the Eucharist. Above all, the powerful proportions of the figures make them much more concrete and impressive even than Giotto's. This is a convincingly human Christ Child. In light of the architecture of the *Trinity* fresco, it is no surprise that Masaccio replaces Giotto's ornate but frail Gothic throne with a solid and plain stone seat in the style of Brunelleschi, or that he makes expert use of perspective. (Note especially the two lutes.)

Adding to these elements is Masaccio's delicate yet precise rendering of the light on the surfaces. Within the picture, sunlight enters from the left, like the glow of the setting sun. He avoids harsh contrasts between light and shade; instead the use

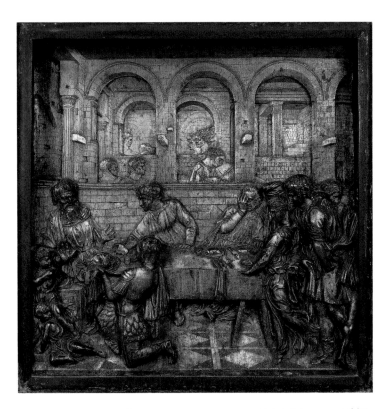

15.20. Donatello. *The Feast of Herod.* ca. 1425. Gilt bronze, 23½″ (59.7 cm) square. Baptismal font, Siena Cathedral

Padua

Donatello's successes in Tuscany led to a commission from the Republic of Venice in 1443. The commander of the Venetian armies, Erasmo da Narni (nicknamed "Gattamelata") had recently died, and Venice sought to honor him with a statue. Donatello produced his largest free-standing work in bronze: the *Equestrian Monument of Gattamelata* (fig. **15.21**), which still stands in its original position on a tall pedestal near the church of St. Anthony in Padua. Having visited Rome, Donatello certainly knew the tradition of equestrian statues exemplified by the *Marcus Aurelius* (fig. 7.23), but he also knew the medieval tradition seen in the monument of Bernabò Visconti in Milan, (fig. 13.36). Like the *Marcus Aurelius*, the *Gattamelata* is impressive in scale and creates a sense of balance and dignity. The horse, a heavy-set animal fit to carry a man in full armor, is so large that the rider must dominate it by force of personality rather than by size. Like the Visconti monument, it belongs to a tradition of representations of military leaders on horseback as funerary monuments. In this vivid portrait of a general, Donatello reenergizes this tradition by the carefully realistic depiction of the armor and fittings and the powerful characterization of Gattamelata's features.

FLORENCE DURING THE ERA OF THE MEDICI, 1430–1494

From 1434 to 1494 the Medici dominated the city of Florence. Across four generations, Medici men were active in government and in business, while Medici women contributed to the social and religious life in the city. The family's wealth came from their mercantile and banking interests and the wise political alliances they struck both within Florence and in other Italian centers. As bankers to the pope, the Medici became leaders in the Florentine pro-papal party, and ultimately became the *de facto* rulers of the city.

Their fortunes were made at the end of the fourteenth century by the shrewd investments of Giovanni di Bicci de' Medici (1360–1429). His son Cosimo (1389–1464) was involved in the factional disputes of the 1430s, resulting in his exile from the city in 1433. But in 1434 his party triumphed, and Cosimo returned as the leader of the Florentine government. Cosimo's sons Piero (1416–1469) and Giovanni followed their father's example; and Piero's son, Lorenzo, called "The Magnificent" (1449–1492), became one of the most celebrated and well-connected men of the century. In addition to creating links to other prominent families in Florence and beyond, the Medici family promoted the literary and educational innovations of Florentine humanists, and actively used works of art to express their political and social status.

Other families either allied themselves with the Medici or competed with them commercially and politically, as well as in the arena of the arts. During this time, too, the city continued to commission artistic projects to add to its luster. This period of Medici domination saw the continued development of the

Donatello, who had worked in Ghiberti's shop. He finished *The Feast of Herod* (fig. **15.20**) about 1425. This gilt bronze relief has the same exquisite surface finish as Ghiberti's panels (see fig. 15.1) but is much more expressive. The focus of the drama—the executioner presenting the head of St. John the Baptist to Herod—is far to the left, while the dancing Salome and most of the spectators are massed on the right. Yet the center is empty. Donatello created this gaping hole to add to the impact of the shocking sight, along with the witnesses' gestures and expressions. Moreover, the centrifugal movement of the figures suggests that the picture space does not end within the panel but continues in every direction. The frame thus becomes a window through which is seen a segment of deepening space. The arched openings within the panel frame additional segments of the same reality, luring the viewer farther into the space.

This architecture, with its round arches, its fluted columns and pilasters, reflects the designs of Filippo Brunelleschi. More importantly, *The Feast of Herod* is an example of a picture space using Brunelleschi's linear perspective. A series of arches set at different depths provides the setting for different figures and moments in the biblical story: In the background, we see the servant carrying the head of the Baptist which he then presents to Herod in the foreground. Donatello used perspective to organize the action as a continuous narrative, unfolding through space as well as time.

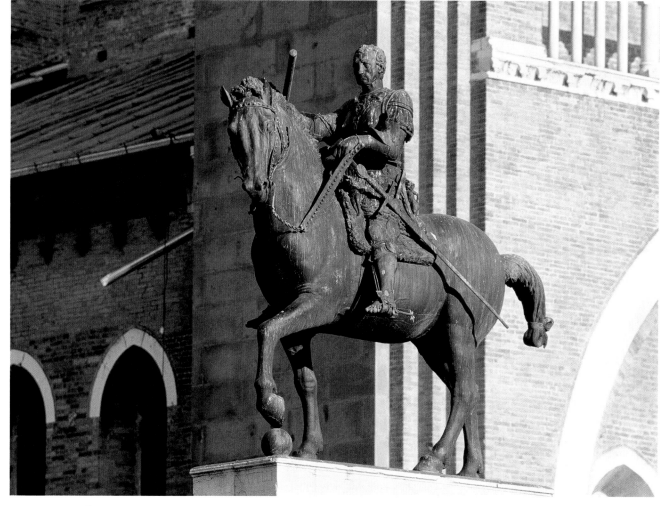

15.21. Donatello. *The Equestrian Monument of Gattamelata*. 1445–1450. Bronze, approx. 11 × 13′ (3.35 × 3.96 m). Piazza del Santo, Padua

stylistic innovations of the early fifteenth century along with new themes in art. Brunelleschian forms dominated Florentine architecture, along with the ideas and designs of Leon Battista Alberti. Sculptors of the first part of the century, including Ghiberti and Donatello, had a strong influence on younger sculptors such as Luca della Robbia, Bernardo Rossellino, Antonio Pollaiuolo, and Andrea del Verrocchio. Religious communities and churches acquired paintings for wall spaces or for altars by painters strongly influenced by the classicism and naturalism of Masaccio and the elegance of Gentile da Fabriano. For wealthy patrons with broad cultural and intellectual interests, artists developed new forms and subjects for painting and sculpture.

Sculpture and Architectural Sculpture

Ghiberti's first set of bronze doors for the Baptistery so impressed the Guild of Wool Merchants, who oversaw the building, that they commissioned him to execute a second pair. These doors, begun in 1425 but not completed until 1452, were ultimately installed in the east entry of the Baptistery, facing the cathedral; this area is called the Paradise, so the doors were

termed the "Gates of Paradise" (fig. **15.22**). The two doors each contain five large panels in simple square frames; these create a larger field than the 28 small panels in quatrefoil frames of the earlier doors. The panels depict scenes from the Old Testament, completing the program of all three doors: One door is devoted to the Life of John the Baptist, one to the Life of Christ, and one to the Old Testament. The program for these doors may have been planned by the humanist Ambrogio Traversari (1386–1439), with the input of the chancellor, Leonardo Bruni (see page 505), who prescribed that the doors should be both significant and splendid. To achieve splendor, Ghiberti completely gilded the bronze and framed the panels with figures in niches, portrait heads in roundels, and foliate decorations. Significance was achieved through the selection of themes and the clarity of the narratives.

In designing these reliefs, Ghiberti drew on the new devices for pictorial imagery he and his rivals had pioneered, including the *schiacciato* relief devised by Donatello for the St. George at Or San Michele and the linear perspective developed by Brunelleschi and employed by Masaccio. The graceful proportions, elegant stances, and fluid drapery of the figures bespeak

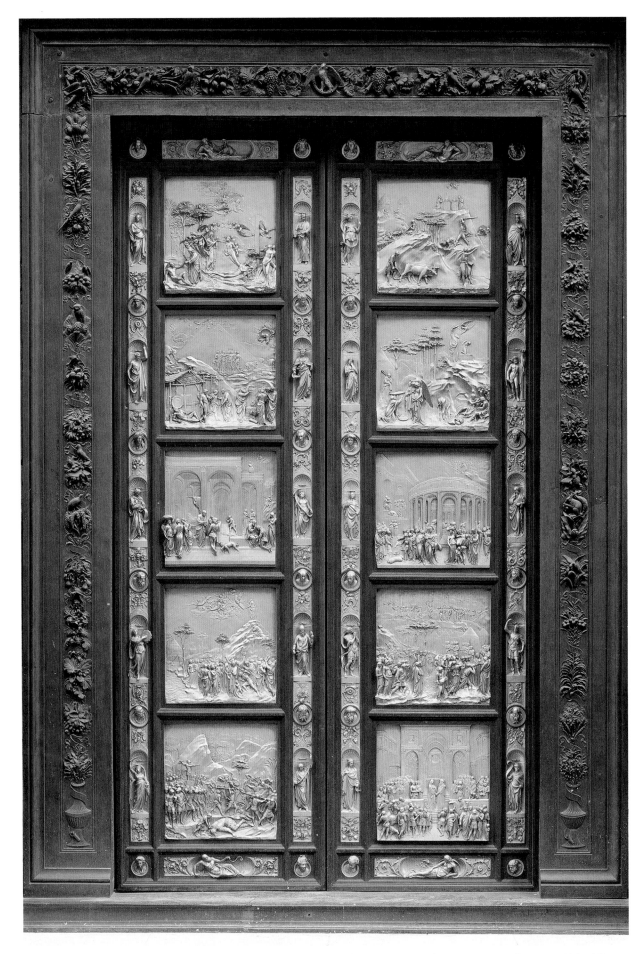

15.22. Lorenzo Ghiberti. "*Gates of Paradise.*" Replica of east doors of the Baptistery of San Giovanni, Florence. 1425–1452. Gilt bronze, height 15′ (4.57 m)

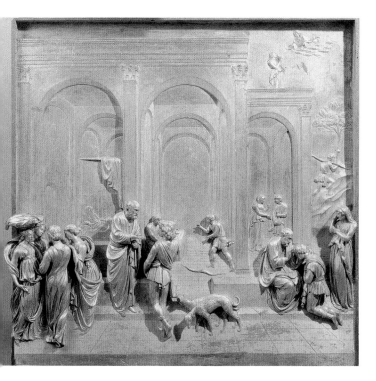

15.23. Lorenzo Ghiberti. *The Story of Jacob and Esau*, panel of the "*Gates of Paradise*." ca. 1435. Gilt bronze, 31¼″ (79.5 cm) square. Baptistery of San Giovanni

ART IN TIME

1431—Joan of Arc executed at Rouen

1437—Ca' d'Oro completed in Venice

1445—Donatello's *Equestrian Monument of Gattamelata*

Ghiberti's own allegiance to the International Gothic style. The hint of depth seen in *The Sacrifice of Isaac* (see fig. 15.1) has grown in *The Story of Jacob and Esau* (fig. **15.23**) into a deeper space defined by the arches of a building planned to accommodate the figures as they appear and reappear throughout the structure in a continuous narrative. The relief tells the story of Isaac blessing his younger son, Jacob, instead of the elder Esau. The blind Isaac sends Esau off to hunt on the left, but confers his blessing to the disguised Jacob on the right. Isaac's preferring the younger Jacob over the older Esau foreshadowed Christianity replacing Judaism for medieval theologians. Ghiberti's spacious hall is a fine example of Early Renaissance architectural design.

The expense of the *Gates of Paradise* could not be matched for every project in the city, but the terra-cotta sculptures of Luca della Robbia (1400–1482) were an appealing and cheaper alternative. Luca covered the earth-colored clay with enamel-like glazes to mask its surface and protect it from the weather. His finest works in this technique, which include *The Resurrection,* executed to go above a door at the Duomo (fig. **15.24**), demonstrate his ambition to create legible narratives of sacred themes in the new language of antique forms. The figure of Christ dominates this composition as he floats above the sarcophagus that parallels the base of this lunette. Around the sarcophagus Luca places Roman soldiers in

15.24. Luca della Robbia. *The Resurrection.* 1442–1445. Glazed terra cotta, 5′3″ × 7′3½″ (1.6 × 2.22 m). Museo Nazionale del Bargello, Florence

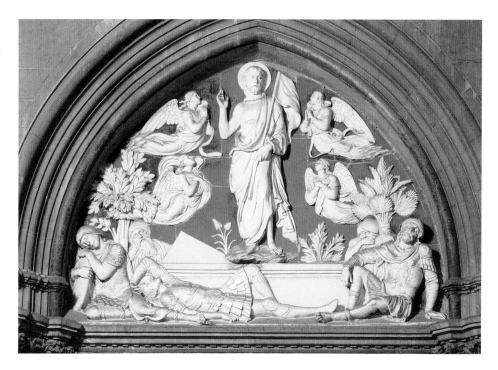

armor inspired by ancient models. The white glaze creates the effect of marble against the deep blue background of the lunette and adds to the legibility of the composition. Such inexpensive substitutes for marble and bronze carvings attracted many buyers, and the della Robbia workshop became a factory, turning out scores of small Madonna panels, altarpieces, and architectural sculpture, still visible throughout Florence and surrounding villages.

Even the most famous artists worked in less expensive materials. Although the circumstances of its commission are unclear, a powerful figure of *Mary Magdalen* by Donatello was carved sometime in mid-century. This life-sized figure (fig. **15.25**) was carved in poplar wood, painted, and gilded.

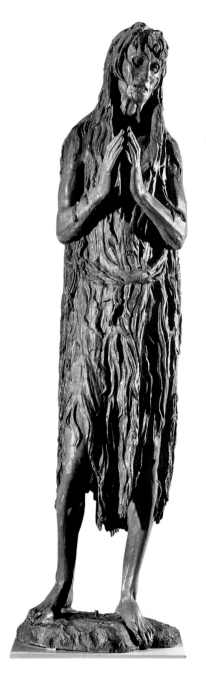

15.25. Donatello. *Mary Magdalen*. ca. 1430–1450. Polychrome and gold on wood, height 6′1″ (1.85 m). Museo dell'Opera del Duomo, Florence

Late medieval enhancements of Mary of Magdala's biography reported that she spent the last years of her life in the desert as a hermit in penitence. In his image of her, Donatello carves the soft wood into complex textures to render her rough garment and her hair, and to give her figure a gaunt, emaciated look. Her limbs and face are painted the ruddy color of someone who lives in the desert, while her hair was originally gilded. The figure has been dated from the 1430s to the 1450s. Many scholars see the *Magdalen* as a work of Donatello's old age, and thus in its spiritual intensity they chart a change of mood for the artist. In any case, the *Magdalen* demonstrates Donatello's range as a sculptor, as he explores the expressive possibilities of another sculpted medium.

A HUMANIST'S TOMB On the death of its illustrious chancellor Leonardo Bruni, the city of Florence honored him with a monument installed in Santa Croce (fig. **15.26**). This humanist and statesman had played a vital part in the city's affairs since the beginning of the century, and when he died in 1444, he received a grand funeral "in the manner of the ancients." The tomb was executed by Bernardo Rossellino (1409–1464), a sculptor from the countryside around Florence. Since Bruni had been born in Arezzo, his native town probably contributed to the project and perhaps favored another former resident, Rossellino, for the commission.

Bruni's contributions to the city as politician, historian, and literary figure forged Florentines' notions of themselves as the heirs to Roman culture, and Rossellino's design paid homage to this theme. The tomb's imagery contains many echoes of Bruni's funeral: His effigy lies on a bier supported by Roman eagles, his head wreathed in laurel and his right hand resting on a book (perhaps his own *History of Florence*). On the sarcophagus, two figures with wings hold an inscription. The only religious element appears in the lunette, where in a roundel the Madonna and Child look down at the effigy. Above the arch a heraldic lion appears in a wreath supported by angels. This symbol of Florence associates Bruni with the city he served and links the city to his goal of reviving Roman virtues.

VERROCCHIO AT OR SAN MICHELE More sculptural commissions were given at Or San Michele in the second half of the century. Sometime after 1462, a sculpture by Donatello was removed and the niche reassigned to the judges of the merchant's guild. This group hired Andrea del Verrocchio (1435–1488) to fill the niche with an image reflecting their activities, using a theme traditionally associated with justice. The architecture of the niche remained as Donatello had designed it, so Verrocchio executed the figures of *The Doubting of Thomas* (fig. **15.27**) without backs to squeeze them into the shallow space. The bronze figures stand close together, as the apostle Thomas seeks proof of the miracle of the Resurrection by probing the wound in Christ's side. Verrocchio was a painter as well as sculptor, and this sculpture shares with contemporary paintings an interest in textures, the play of light and dark in massive drapery folds, and illusionism. The niche can barely

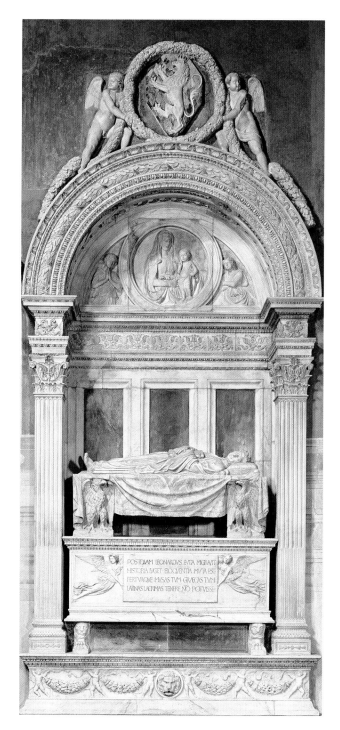

15.26. Bernardo Rossellino. *Tomb of Leonardo Bruni.*
ca. 1445–1450. Marble, height 20′ (6.1 m to top of arch).
Santa Croce, Florence

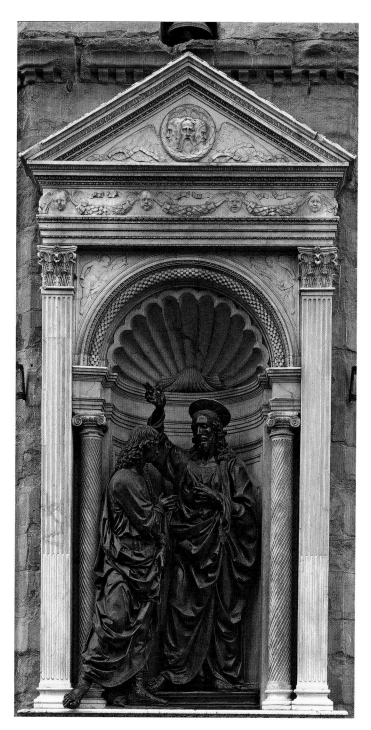

15.27. Andrea del Verrocchio. *The Doubting of Thomas.*
1467–1483. Bronze, Christ 7′6½″ (2.28 m) Thomas 6′6¾″ (2m).
Or San Michele, Florence (Copy in niche)

contain the oversized figures, so Thomas's foot projects beyond the limits of the frame, linking the passerby to the scene. His body twists into the composition, leading the viewer to the gentle features of Christ. The eloquent poses and bold exchange of gestures between Christ and Thomas convey the drama of the scene. Verrocchio lets the active drapery, with its deep folds, suggest the calm of Christ and the disturbance in Thomas's mind. Michelangelo admired the *The Doubting of Thomas* for the beauty of the figures; and Leonardo da Vinci learned from his teacher, Verrocchio, to create figures whose actions express the passions of the mind.

Florentine Churches and Convents at Mid-Century

The work at the Cathedral, the Baptistery, and Or San Michele was accompanied by construction and renewal elsewhere in Florence. Throughout the city, churches and convents were rebuilt or enlarged, often with corresponding commissions for their decoration. One important feature of fifteenth-century religious life was a call to restore the practices in monasteries and convents to a stricter observance of the ancient rules of such institutions. The leaders of these observant movements often gained the admiration

and support of private citizens. Renaissance artists and their patrons wished to put the new style to work for their faith. The naturalism and spatial effects now possible could create images that spoke powerfully to believers. Perspective and other devices could connect viewers to religious stories to evoke their empathy. New ideas about proper decorum for pictures coming from the study of the classics inspired artists to create balanced compositions peopled with dignified characters. Yet not all churchmen approved of the increasingly naturalistic and classicizing forms found in religious art in the fifteenth century. The tension between Christian and Classical forms erupted at the end of the century with the condemnation of "pagan" images by the Dominican preacher Girolamo Savonarola.

FRA ANGELICO AT SAN MARCO With the support of Cosimo de' Medici, the Dominicans built a second Dominican convent for friars in Florence in 1436. Among the members of this community was a talented painter from the Florentine countryside, Fra (Brother) Giovanni da Fiesole, called Fra Angelico (ca. 1400–1455). For this new community, Angelico painted altarpieces, books, and many frescoes in the living quarters for the friars. His fresco of the *Annunciation*, executed between 1440 and 1445, is placed prominently at the entry to the dormitory (fig. **15.28**). Angelico sets the two protagonists of this important event into a vaulted space very similar to the real architecture of the convent. A perspectival scheme defines the space, although the figures are too large to stand comfortably in it. The Virgin and the angel Gabriel glance at each other across the space; they humbly fold their hands, expressing their submission to divine will. The forms are graceful, and the overall scene is spare, rather than extravagant. The colors are pale, the composition has been pared to the minimum, the light bathes all the forms in a soft glow. Angelico's composition has the

simplicity and spatial sophistication of Masaccio (see fig. 15.17), though his figures are as graceful as Gentile da Fabriano's (see fig. 15.12). An inscription at the base of the fresco calls on the friars who pass by to say an Ave Maria. The fresco surely enhanced their life of prayer and contemplation, as was the goal of such imagery in religious communities.

CASTAGNO AT SANT' APOLLONIA Florence abounded in convents of women who wished to adorn their establishments too, though few painters in nunneries had the chance to become as skilled at painting as Angelico. Thus professional painters like Andrea del Castagno (ca. 1423–1457) were hired to decorate convent spaces with appropriate imagery. For the Benedictine convent of Sant' Apollonia, Castagno painted his most famous fresco, *The Last Supper* (fig. **15.29**) around 1447. This fresco is the best preserved of a set he painted in the refectory (dining hall) of the convent. He sets the event in a richly paneled alcove framed by classicizing pilasters and other antique decorative elements. By skillfully using perspective, Castagno creates a stagelike space for the event. Strong contrasts of light and dark define sculpturally imagined figures seated around the table. As in medieval representations of the subject, Judas sits alone on the near side of the table. The symmetry of the architecture, emphasized by the colorful inlays, imposes a similar order among the figures and threatens to imprison them. There is little communication among the apostles—only a glance here, a gesture there—so that a brooding silence hovers over the scene. Breaking with the demands of tradition and perspective, Castagno used a daring device to disrupt the symmetry and focus the drama of the scene. Five of the six marble panels on the wall behind the table are filled with subdued colored marble, but above the heads of St. Peter, Judas, and Jesus, the marble's veining is so garish and explosive

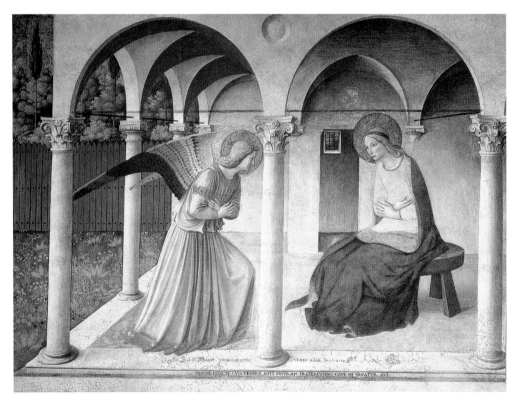

15.28. Fra Angelico. *Annunciation.* ca. 1440–1445. Fresco on dormitory level of the Convent of San Marco, 7′1″ × 10′6″ (2.1 × 3.2 m). Museo di San Marco, Florence

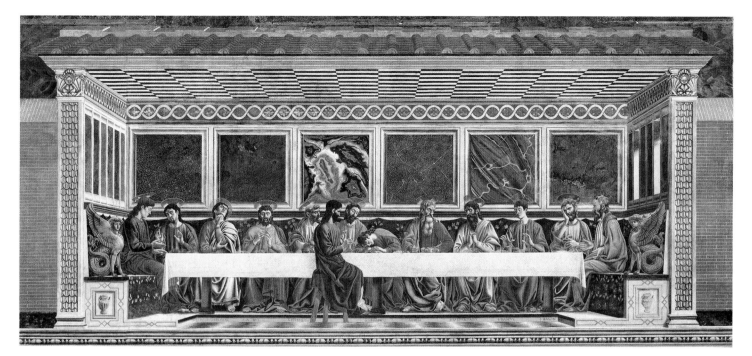

15.29. Andrea del Castagno. *The Last Supper.* ca. 1445–1450. Fresco. Sant' Apollonia, Florence

that a bolt of lightning seems to descend on Judas' head to focus attention on these key figures. The sisters who dined in front of this fresco could see in it examples to follow and to avoid.

DOMENICO VENEZIANO AT SANTA LUCIA DEI MAGNOLI Religious imagery was also needed by the laity to adorn the altars of parish churches. An important shift occurred in the design of altar panels in the 1440s, perhaps at the hands of

Fra Angelico, that was soon adopted by many painters. Earlier altarpieces, like Gentile's *The Adoration of the Magi* (fig. 15.12), were complex ensembles with elaborately carved frames, but the newer altarpieces emphasized gilded carpentry less and geometric clarity more. For the main altar of the church of Santa Lucia dei Magnoli in Florence, the painter Domenico Veneziano (ca. 1410–1461) executed the *Madonna and Child with Saints* around 1445 (fig. **15.30**). As his name suggests, Domenico was

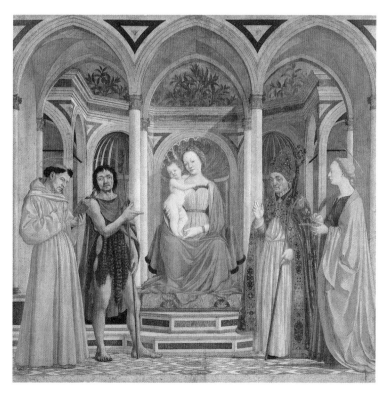

15.30. Domenico Veneziano. *Madonna and Child with Saints.* ca. 1445. Tempera on panel, 6′10″ × 7′ (2.08 × 2.13 m). Galleria degli Uffizi, Florence

from Venice, though he came to Florence in search of work in 1439. A letter he addressed to the son of Cosimo de' Medici in 1438 reveals that he knew a lot about the commissions being awarded there (see *Primary Source*, page 532), and his work shows his study of Florentine artists. The altarpiece he painted for Santa Lucia depicts an enthroned Madonna and Child framed by architecture and surrounded by saints, including Zenobius, a patron saint of Florence, and Lucy, an early Christian martyr, who holds a dish containing her eyes.

The theme of the central Madonna surrounded by saints and sometimes angels is often termed a *sacra conversazione* (sacred conversation), which suggests that the image is not a narrative, but a glimpse of a heavenly court peopled by dignified and decorous courtiers. Domenico imagines this gathering in a light-filled loggia articulated with pink and green marble. The architecture is clear and convincing, yet the space it defines is an ideal one elevated above the everyday world. Domenico may have modeled this space on Masaccio's *Holy Trinity* fresco (fig. 15.14), for his St. John (second from left) looks at us while pointing toward the Madonna, repeating the glance and gesture of Masaccio's Virgin. Domenico's perspective setting is worthy of Masaccio's, although his architectural forms have Gothic proportions and arches. The slim, sinewy bodies of the male saints, with their highly individualized, expressive faces, show Donatello's influence (see fig. 15.3).

Domenico treats color as an integral part of his work, and the *sacra conversazione* is as noteworthy for its palette as for its composition. The blond tonality—its harmony of pink, light green, and white set off by spots of red, blue, and yellow—reconciles the brightness of Gothic panel painting with natural light and perspectival space. The sunlight streams in from the right, as revealed by the cast shadow behind the Madonna. The surfaces reflect the light so strongly that even the shadowed areas glow with color. Color, light, and space come together in this painting to make a heavenly vision in which the faithful may take comfort.

ALBERTI'S FACADE FOR SANTA MARIA NOVELLA

The marbled surfaces of the fictive architecture in Domenico's *Madonna and Child with Saints* is an idealized version of a Florentine church facade. But many important churches in Florence still lacked facades in the fifteenth century, including Santa Maria Novella. The exterior of this Dominican church, built largely between 1278 and 1350, had been left unfinished above the row of polychromed Gothic niches with their Gothic portals. (These were extended by walls on either side.)

Repairing and improving a church was an act of piety—motivation enough for a parish member, Giovanni Rucellai, to have this facade completed around 1458 (fig. **15.31**). Rucellai hired Leon Battista Alberti to design and install a marble skin over the facade. Multicolored marble facades were traditional in Tuscany. Alberti's models for this project included the Cathedral (fig. 15.2) and other churches in Florence, including the Baptistery (fig. 11.35) and San Miniato al Monte (fig. 11.36) from which the emphatic arcades may derive.

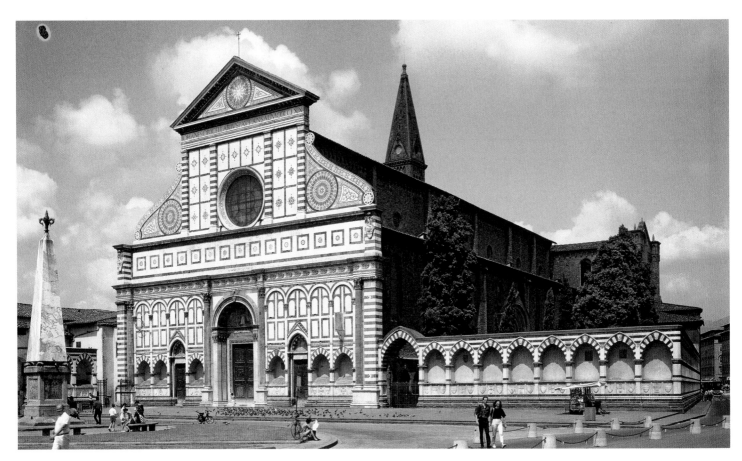

15.31. Leon Battista Alberti. Facade of Santa Maria Novella, Florence. 1458–1470

Other than the doorways and giant *oculus*, which were fixed, Alberti's facade masks its relationship to the rest of the church. Deciding not to be limited by the internal structure of the church, the architect was free to design the facade as a system of squares. Three main squares divide the facade: Two on the lower story flank the extraordinarily classicizing main portal; likewise, the "temple" atop the frieze fits within a square. Mathematical ratios lock these squares into relationships with the whole facade and with the other elements of the composition. Alberti's use of graceful scrolls to bridge the gap between the temple and the frieze was truly innovative and was to prove extremely influential (compare with fig. 17.21). It also helps to disguise the loose fit of the facade with the main body of the church by hiding the clerestory. Just below the pediment on the frieze level of the "temple," Alberti includes an inscription that credits Giovanni Rucellai for bringing the work to completion. It is the patron, not the artist, who gains the glory for the work.

ART IN TIME

1434—Cosimo de' Medici becomes leader of Florentine government

1450—Francisco Sforza seizes control of Milan

1452—Ghiberti's *Gates of Paradise* (east doors) of Baptistery completed

1453—Constantinople falls to the Ottoman Turks; the Ottoman Empire begins

vertical balance to the horizontality. What is more, the weight of those pilasters lightens both literally, as the pilasters project further at the first floor than at the third, and figuratively, as a Doric order supports the lower story while a Corinthian order supports the top. Alberti treats each element—pilaster, entablature, arch—equally to unify the design. The result is a network of linear forms that emphasizes the wall surface and

DOMESTIC LIFE: PALACES, FURNISHINGS, AND PAINTINGS, CA. 1440–1490

Patrons like Giovanni Rucellai or Cosimo de' Medici asked artists to create works of art for their families as well as for the Church. As family fortunes rose, palaces needed building or remodeling to provide an appropriate setting for family life and civic display. Furnishings within the home had to express the status of the family. Sculptures and paintings of new sorts, like cassone paintings, proclaimed the alliances between families. Works of art depicted new subjects, many of them inspired by Classical antique art, that displayed the humanist educations of both artists and patrons. In sculpture, the long-lived Donatello was an inspiration for younger sculptors like Pollaiuolo. Painters tacked between the grave simplicity of Masaccio and the idealized elegance of Gentile da Fabriano to find the right language to depict imagery drawn from the ancient world. Architects like Alberti and Michelozzo built family homes endowed with great dignity by their use of Classical forms.

Patrician Palaces

Even before his work at Santa Maria Novella, the Rucellai family had commissioned Alberti to create the design for their Palazzo (fig. **15.32**). Again, Alberti was responsible only for the exterior of the building (perhaps with the assistance of Bernardo Rossellino), which united three medieval structures into one palace. The stone facade attempts to regularize and rationalize the structure across three stories. It consists of three rows of pilasters, separated by wide architraves, in imitation of the Colosseum (see fig. 7.40). Yet the pilasters are so flat that they remain part of the wall, while the facade seems to be one surface onto which the artist projects a linear diagram of the Colosseum exterior.

Here Alberti was trying to resolve what became a fundamental issue of Renaissance architecture: How to apply a Classical system to the exterior of a non-Classical structure. Strong horizontals in the entablatures divide the three stories, but the repetition of pilasters raised slightly above the surface creates a

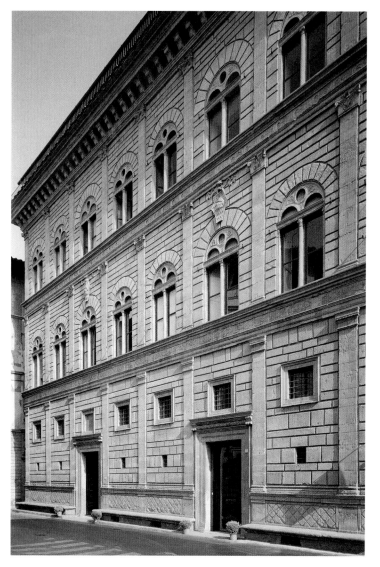

15.32. Leon Battista Alberti. Facade of Palazzo Rucellai, Florence. 1446–1451

Domenico Veneziano Solicits Work

The Venetian painter wrote to Piero de' Medici in 1438 requesting that he be considered for a commission that the family was about to award. The letter reveals Domenico's knowledge of the work to be done, and his arguments for why he should do it.

To the honorable and generous man Piero di Cosimo de' Medici of Florence....

Honorable and generous sir. After the due salutations. I inform you that by God's grace I am well. And I wish to see you well and happy. Many, many times I have asked about you.... and having first learned where you were, I would have written to you for my comfort and duty. Considering that my low condition does not deserve to write to your nobility, only the perfect and good love I have for you and all your people gives me the daring to write, considering how duty-bound I am to do so.

Just now I have heard that Cosimo [Piero's father] has decided to have an altarpiece made, in other words painted, and wants a magnifi-

cent work, which pleases me very much. And it would please me more if through your generosity I could paint it. And if that happens, I am in hopes with God's help to do marvelous things, although there are good masters like Fra Filippo [Lippi] and Fra Giovanni [Angelico] who have much work to do. Fra Filippo in particular has a panel going to Santo Spirito which he won't finish in five years working day and night, it's so big. But however that may be, my great good will to serve you makes me presume to offer myself. And in case I should do less well than anyone at all, I wish to be obligated to any merited punishment, and to provide any test sample needed, doing honor to everyone. And if the work were so large that Cosimo decided to give it to several masters, or else more to one than to another, I beg you as far as a servant may beg a master that you may be pleased to enlist your strength favorably and helpfully to me in arranging that I may have some little part of it ... and I promise you my work will bring you honor...

By your most faithful servant Domenico da Veneziano painter, commending himself to you, in Perugia, 1438, first of April.

SOURCE: CREIGHTON GILBERT, *ITALIAN ART 1400–1500*: SOURCES AND DOCUMENTS. (EVANSTON, IL: NORTHWESTERN UNIVERSITY PRESS, 1992)

successfully modifies the Classical forms for domestic use. Without great expense, the palace becomes a statement of the dignity of the Rucellai family.

Given their status in Florence, the Medici required a more lavish palace that would house the family and accommodate political and diplomatic functions as well. Nevertheless, Cosimo de' Medici turned down a design by Brunelleschi for this project, perhaps because he found it ostentatious. The commission went to a younger architect, Michelozzo di Bartolomeo (1396–1472), who had worked as a sculptor with both Ghiberti and Donatello. His design (fig. **15.33**) recalls the fortresslike Florentine palaces of old, and it may have been this conservatism that appealed to Cosimo. (The windows on the ground floor were added by Michelangelo in 1516–1517, and the whole was extended by the Riccardi family in the seventeenth century.)

Michelozzo borrowed the rustication and some of the window design from the Palazzo della Signoria (compare with fig. 13.16), but he lightened the forms significantly. The three stories form a graded sequence: The lowest story features rough-hewn, "rusticated" masonry; the second has smooth-surfaced blocks; and the third has an unbroken surface. On top of the structure rests, like a lid, a strongly projecting cornice such as those found on Roman temples. Inside, the spaces of the palace open to a central courtyard defined by an arcade resting on Brunelleschian classicizing columns (fig. **15.34**). (See figs. 15.6 and 15.7.) The arcade supports a frieze with carved medallions featuring symbols favored by the Medici (the seven balls are on the Medici coat of arms) and **sgraffito ornament** (incised decorative designs). The double-lancet windows of the facade reappear here. The effect of the whole is to provide a splendid setting for Medici affairs: familial, social, commercial, and governmental. Thus the large courtyard that dominates the interior is ceremonial as well as practical.

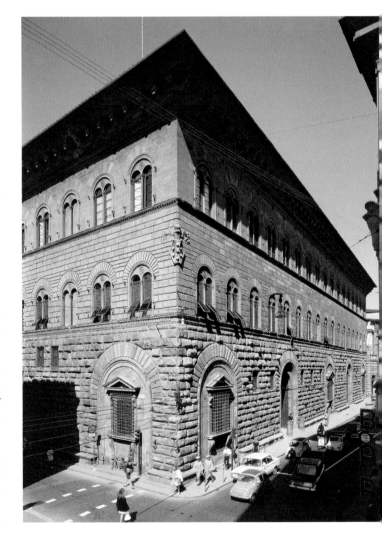

15.33. Michelozzo di Bartolomeo. Palazzo Medici-Riccardi, Florence. Begun 1444

Heroic Images for Florentine Collectors

DONATELLO'S *DAVID* One of the most debated works of the Renaissance, Donatello's bronze *David* (fig. **15.35**) once stood on a high pedestal in the courtyard of the Medici palace. The *David* may be the first free-standing, life-sized nude statue since antiquity. The sheer expense of casting a whole figure of this sort in bronze, with parts gilt as well, required a patron with the wealth of the Medici to pay for it. Using the lost wax method of casting (see *Materials and Techniques*, page 124), Donatello composed the figure to be seen from every side, as the contrapposto stance and high finish of the work demand that a viewer walk around it.

Both the date of the *David,* between the 1420s and the 1460s, and its meaning have sparked controversy. Much in the figure is difficult to square with the biblical story. The young David stands with his left foot atop the severed head of the giant Goliath, whom he has miraculously defeated. But if David has already defeated Goliath, why does he hold a stone? Most untraditionally, Donatello depicts David nude, which may be intended to suggest his status as a hero in the ancient mode. But instead of depicting him as a full-grown youth like the athletes of Greece, Donatello chose to model an adolescent boy with a softly sensuous torso, like Isaac in Ghiberti's competition panel (fig. 15.1). *David*'s contrapposto alludes to ancient sources, but it also creates a languid pose for the nude youth, which some critics have seen as sexually suggestive. The broad-brimmed hat and knee-high boots seem to accent his nudity. David wields Goliath's sword, which is too large for him, and his gaze seems impassive if we consider the terror he has just confronted.

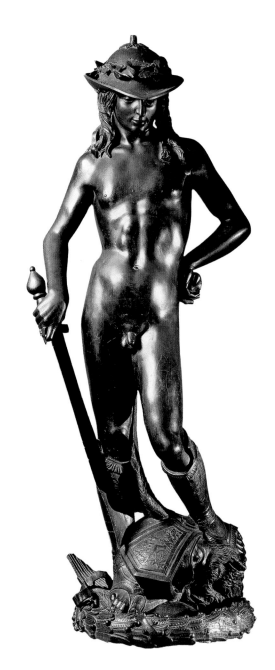

15.35. Donatello. *David.* ca. 1420s–1460s. Bronze, height $62\frac{1}{4}''$ (158 cm). Museo Nazionale del Bargello, Florence

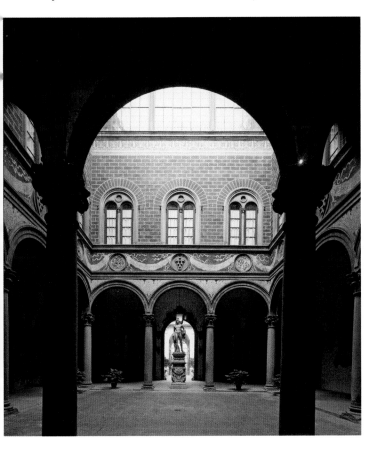

15.34. Michelozzo di Bartolomeo. Courtyard of Palazzo Medici-Riccardi

One key to the meaning of the *David* may be an inscription once written on its base that identified David as the defender of the fatherland. Since David had been venerated as a patron of the city, the Medici appropriated this symbol of Florentine civic virtue and installed it in their residence. (Donatello had earlier sculpted a marble image of David that stood in the Palazzo della Signoria, so even the choice of sculptor may be significant.) But scholars have debated the specific associations of the statue: Does the *David* celebrate a specific Florentine victory? Does it celebrate a Medici political victory? Does it represent Florentine vigilance? Is the *David* a symbol of Republican victory over tyranny? Or does its presence in the Medici palace turn it into a symbol of dynastic power? How does David's youth and nudity affect its meaning? Our understanding of how fifteenth-century Florentines viewed the sculpture is still developing.

HERCULEAN IMAGES The Medici family appears to have made a habit of borrowing Florentine civic imagery for their palace. Sometime around 1475, Antonio del Pollaiuolo (1431–1498) executed the *Hercules and Antaeus* (fig. **15.36**) for the family. This is a table statue, only about 18 inches high, but

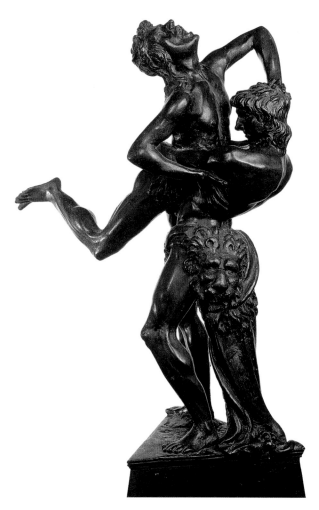

15.36. Antonio del Pollaiuolo. *Hercules and Antaeus.* ca. 1475. Bronze, height with base 17³⁄₄″ (45.8 cm). Museo Nazionale del Bargello, Florence

it has the force of a much larger object. It represents Hercules—another local patron—battling Antaeus, the son of an Earth goddess. Hercules' foe gains strength from contact with the Earth, so Hercules must lift him off the ground to defeat him. Pollaiuolo had been trained as a goldsmith and metalworker, probably in the Ghiberti workshop, but was deeply impressed by the work of Donatello and Andrea del Castagno, as well as by ancient art. These sources influence the distinctive style that appears in the statuette.

To create a free-standing group of two struggling figures, even on a small scale, was a daring idea. There is no precedent for this design among earlier statuary groups, ancient or Renaissance. Even bolder is the centrifugal force of the composition. Limbs seem to move outward in every direction, so the viewer must examine the statuette from all sides. Despite its violent action, the group is in perfect balance. To stress the central axis, Pollaiuolo in effect grafted the upper part of Antaeus onto the lower part of Hercules as he lifts him in a stranglehold. Pollaiuolo was a painter and engraver as well as a bronze sculptor, and we know that about 1465 he did a closely related painting of Hercules and Antaeus for the Medici.

Few of Pollaiuolo's paintings have survived, and only one engraving, the *Battle of the Ten Naked Men* (fig. **15.37**). As far as we know, this print is Pollaiuolo's most elaborate design. Its subject is not known, though it may derive from an ancient text. One purpose the engraving serves is to display the artist's mastery of the nude body in action and thus to advertise his skill. This may account for the prominent signature in the print; he signs it *Opus Antonii Pollaioli Florentini (The Work of Antonio Pollaiuolo of Florence)*. Between 1465 and 1470, when the print must have been produced, depicting the nude in action was still a novel problem, and Pollaiuolo explored it in his paintings, sculptures, and prints. He realized that a full understanding of movement demands a detailed knowledge of anatomy, down to the last muscle and sinew. These naked men look almost as if their skin had been stripped off to reveal the play of muscles underneath. So, to a lesser extent, do the two figures of Pollaiuolo's statuette *Hercules and Antaeus*.

Paintings for Palaces

The interiors of patrician palaces served not only as private quarters and settings for family life, but as public spaces where family members performed civic roles. A visitor would be likely to find paintings and perhaps sculptures, many on religious subjects, in these places. Indeed, early in the fifteenth century, one of the leading clerics of Tuscany urged that religious images be displayed in private homes. In a treatise written in 1403, Cardinal Giovanni Dominici counseled that images of Christ, Mary, or saints in the home would encourage children to emulate those holy figures. (See *Primary Source*, page 536.)

Patrician homes also showcased **cassoni**, carved or painted chests for storing valuables. The product of collaboration between skilled carpenters, woodworkers, and painters, such

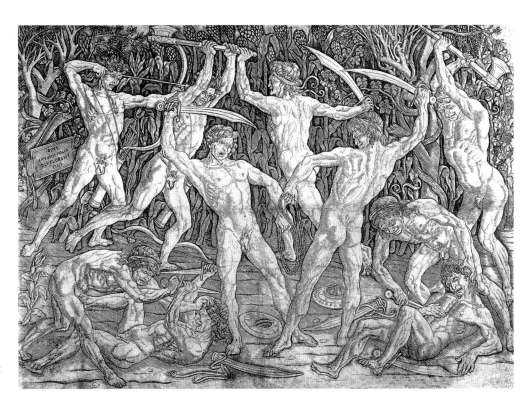

15.37. Antonio del Pollaiuolo. *Battle of the Ten Naked Men.* ca. 1465–1470. Engraving, 15$\frac{1}{8}$″ × 23$\frac{1}{4}$″ (38.3 × 59 cm). Cincinnati Art Museum, Ohio. Bequest of Herbert Greer French. 1943.118

chests were usually decorated, sometimes with chivalric imagery, like the one in fig. **15.38**, which depicts a tournament taking place on the Piazza Santa Croce. Cassoni were also adorned with mythological scenes, histories, or romances. Pairs of cassoni were usually given to a bride on her wedding; Cassoni mark the union of two families, and thus reflect family status as much as nuptial concerns. Edifying or learned stories on cassoni often derived from studies of ancient authors such as Plutarch, Ovid, or Vergil. Thus cassone panels displayed a family's wealth, their learning and interest in humanism, sometimes their patriotism, and very often lessons for a bride to take with her to her new home.

Another type of domestic imagery was the circular painting, or **tondo**, which was something of a special taste in Florence. Many of the leading painters of the latter decades of the fifteenth century produced tondi, including Fra Filippo Lippi

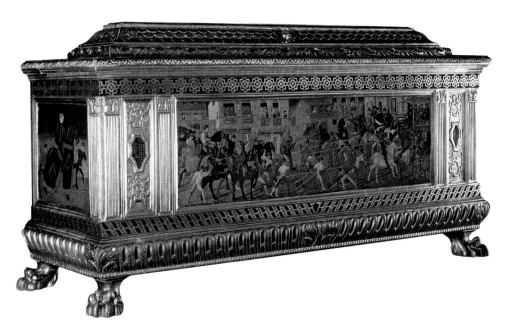

15.38. *Cassone* with tournament scene. ca. 1460. Tempera on panel, chest 40 × 80 × 14″ (103 × 203 × 66 cm); panel 15 × 51″ (38 × 130 cm). National Gallery, London

Giovanni Dominici Urges Parents to Put Religious Images in Their Homes

Florentine by birth, Dominici entered the Dominican order, where he became involved with reform. Among his writings was the Regola del governo di cura familiare (Rule for the Management of Family Care) *of 1403, from which this excerpt is taken.*

Part IV [on the management of children]. In the first consideration, which is to bring them up for God. . .you should observe five little rules. . . .The first is to have paintings in the house, of holy little boys or young virgins, in which your child when still in swaddling clothes may delight, as being like himself, and may be seized upon by the like thing, with actions and signs attractive to infancy. And as I say for painting, so I say of sculptures. The Virgin Mary is good to have, with the child on her arm, and the little bird or the pomegranate in his fist. A good figure would be Jesus suckling, Jesus sleeping on his mother's lap, Jesus standing politely before her, Jesus making a hem and the mother sewing that hem. In the same way he may mirror himself in the holy Baptist, dressed in camel skin, a small

boy entering the desert, playing with birds, sucking on the sweet leaves, sleeping on the ground. It would do no harm if he saw Jesus and the Baptist, the little Jesus and the Evangelist grouped together, and the murdered innocents, so that fear of arms and armed men would come over him. And so too little girls should be brought up in the sight of the eleven thousand virgins, discussing, fighting and praying. I would like them to see Agnes with the fat lamb, Cecilia crowned with roses, Elizabeth with many roses, Catherine on the wheel, with other figures that would give them love of virginity with their mothers' milk, desire for Christ, hatred of sins, disgust at vanity, shrinking from bad companions, and a beginning, through considering the saints, of contemplating the supreme saint of saints. . . . I warn you if you have paintings in your house for this purpose, avoid frames of gold and silver, lest they become more idolatrous than faithful, since, if they see more candles lit and more hats removed and more kneeling to figures that are gilded and adorned with precious stones than to the old smoky ones, they will only learn to revere gold and jewels, and not the figures, or rather, the truths represented by those figures.

SOURCE: CREIGHTON GILBERT, *ITALIAN ART 1400–1500: SOURCES AND DOCUMENTS.* (EVANSTON, IL: NORTHWESTERN UNIVERSITY PRESS, 1992)

(ca. 1406–1469), to whom has been attributed the *Madonna and Child with the Birth of the Virgin* (fig. **15.39**). The Florentine banker Lionardo Bartolini Salimbeni may have commissioned this panel to celebrate a birth in his family. Lippi presents the Madonna and infant Jesus as an ideal mother and child. They recall Masaccio's *Madonna* (fig. 15.19) in several ways, but Fra Filippo's youthful Mary has a slender elegance and gentle

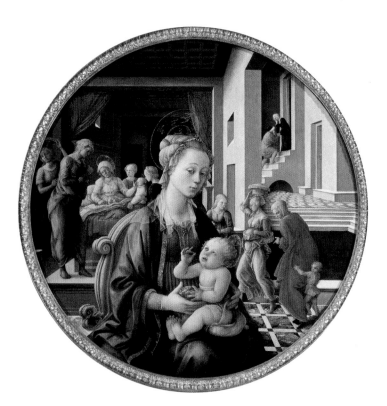

15.39. Fra Filippo Lippi. *Madonna and Child with the Birth of the Virgin.* (The Bartolini Tondo) 1452–1453. Tempera on panel, diameter 53″ (134.6 cm) Palazzo Pitti, Florence

sweetness. The curly edge of the Virgin's headdress and the curved folds of her mantle streaming to the left, which accentuate her turn to the right, add a lyrical quality to her figure. The child Jesus picks seeds out of a pomegranate, an emblem of eternal life. At the same time, the seeds may symbolize fertility, since the secondary theme is St. Anne giving birth to the Virgin.

Behind the Virgin is a stagelike scene that is surprisingly cluttered, created by a perspective scheme with several vanishing points. Different parts of the narrative appear in different sections of the tondo. In the background to the left is a domestic interior showing the Virgin's birth, with St. Anne in childbed. To the right is the meeting of St. Anne and her husband St. Joachim at the Golden Gate of Jerusalem after the angel of the Lord had appeared to them separately and promised them a child. In contrast to all other depictions of this legend, the event in this painting is presented as if it were taking place before the entrance to a private house.

Most likely Lippi learned to use this kind of continuous narrative from reliefs of Donatello and Ghiberti: Compare *The Feast of Herod* (fig. 15.20) and *The Story of Jacob and Esau* (fig. 15.23), which incorporate similarly complex spaces to tell their stories. Lippi quotes from Ghiberti's relief in this tondo in the figure of the maidservant to the Virgin's right. After Masaccio's death, the age, experience, and prestige of Donatello and Ghiberti gave them an authority unmatched by any other painter active at the time. Their influence, and that of the Flemish masters, on Fra Filippo's outlook was of great importance, since he played a vital role in setting the course of Florentine painting during the second half of the century.

UCCELLO'S *BATTLE OF SAN ROMANO* The same family who may have commissioned Lippi's tondo commissioned another set of wall paintings that have a fascinating history.

The Florentine artist Paolo Uccello (1397–1475) painted the *Battle of San Romano* (fig. **15.40**) as one of three panels depicting a battle between Florence and Lucca in 1432. Florence's victory in this battle was one of the factors that led to Cosimo de' Medici's consolidation of power. Uccello depicts the charge of the Florentine forces led by Cosimo's ally, Niccolò da Tolentino, the man on the white horse wielding a general's baton at the center of the painting. Because of the importance of this subject to the Medici, scholars have long believed that they commissioned this painting. The series was identified as one described in Lorenzo de' Medici's bedroom in a document of 1492. Recent research, however, shows that Lionardo Bartolini Salimbeni, who had been a member of the governing council of Florence during the battle, commissioned Uccello to paint these panels for his townhouse in Florence around 1438. After his death, Lorenzo de' Medici sought to obtain them, first by purchase and, when that failed, by force. The sons of the original owner filed a lawsuit for their return. These circumstances suggest the importance of the paintings for both families.

Rather than the violence of war, Uccello's painting creates a ceremonial effect, as the plastic shapes of the figures and horses march across a grid formed by discarded weapons and pieces of armor. These objects form the orthogonals of a perspective scheme that is neatly arranged to include a fallen soldier. A thick hedge of bushes defines this foreground plane, beyond which appears a landscape that rises up the picture plane rather than deeply into space. The surface pattern is reinforced by spots of brilliant color and lavish use of gold, which would have been more brilliant originally, as some of the armor was covered in silver foil that has now tarnished. Such splendid surfaces remind us of the paintings of Gentile da Fabriano (see fig. 15.12). Uccello's work owes much to International Gothic displays of lavish materials and flashes of natural observation, with the added element of perspectival renderings of forms and space.

PAINTINGS FOR THE MEDICI PALACE: BOTTICELLI

In addition to acquiring paintings in Florence through commission, purchase, or force, the Medici had numerous contacts with Northern Europe, not only through diplomatic exchanges, but

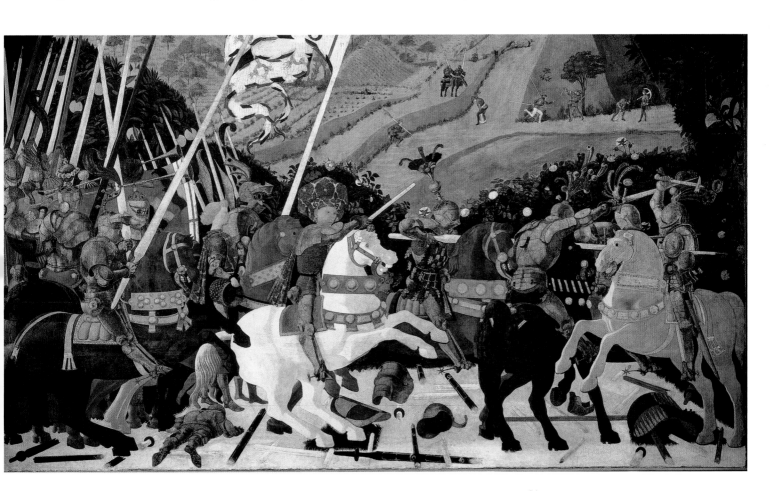

15.40. Paolo Uccello. *Battle of San Romano.* ca. 1438. Tempera and silver foil on wood panel, 6′ × 10′5¾″ (1.8 × 3.2 m). The National Gallery, London. Reproduced by courtesy of the Trustees

through their banking business. Medici agents in Bruges sent many works of art to Florence, as inventories confirm. In this, the Medici behaved as did many of the ruling families of Italy, for Flemish art was widely admired in places as disparate as Naples, Venice, Ferrara, and Milan. Through such acquisitions, the Medici palace was filled with panel paintings and tapestries from the North. These objects made a profound impression on Florentine artists like Uccello, Filippo Lippi, Ghirlandaio, and the young Sandro Botticelli.

Botticelli (1445–1510), who had trained with Verrocchio, became one of the favorite painters of the Medici circle—the group of nobles, scholars, and poets surrounding Lorenzo the Magnificent, the head of the Medici family and, for all practical purposes, the real ruler of the city from 1469 until 1492. The *Primavera (Spring)* (fig. **15.41**) was probably painted for a cousin who grew up in the household of Lorenzo the Magnificent. This work, and two others on the theme of love, may have been commissioned for the young man's wedding, which took place in 1482, the date often proposed for the painting.

Scholars have suggested numerous interpretations for this image. The painting depicts Venus in her sacred grove, with Eros flying overhead. Her companions, the Three Graces and Hermes (the Roman god Mercury), stand on the left; to the

right, Zephyr grasps for the nymph Chloris, whom he then transforms into Flora, the goddess of flowers. One interpretation links the *Primavera* to the writings of the Neo-Platonist philosopher Marsilio Ficino (1433–1499), who was widely read and admired at the Medici court. By this reading, the painting is an allegory about Platonic love between two friends: Mercury points the way to divine love in the guise of Venus, who is born of the Three Graces, symbolizing beauty. In contrast is physical love, represented by Flora, whom Zephyr had raped. Other readings of the *Primavera* see it as an allegory about the immortality of the soul (drawing a parallel between the story of Chloris and the Rape of Persephone) or an allegory in which Venus is likened to Mary and the other characters to Christian figures participating in the Last Judgment. Yet, given that the painting was made in connection with a wedding, it may be a celebration of marriage and fertility, as the dense thicket of orange trees and carpet of flowers suggests. The painting inspires different readings, depending on the audience before it.

Often paired with the *Primavera* in the public imagination is Botticelli's most famous image, *The Birth of Venus* (fig. **15.42**). It, too, once hung in a Medici villa, though it may have been painted several years later than the *Primavera*. In this painting, too, the central figure in the composition is Venus, though here

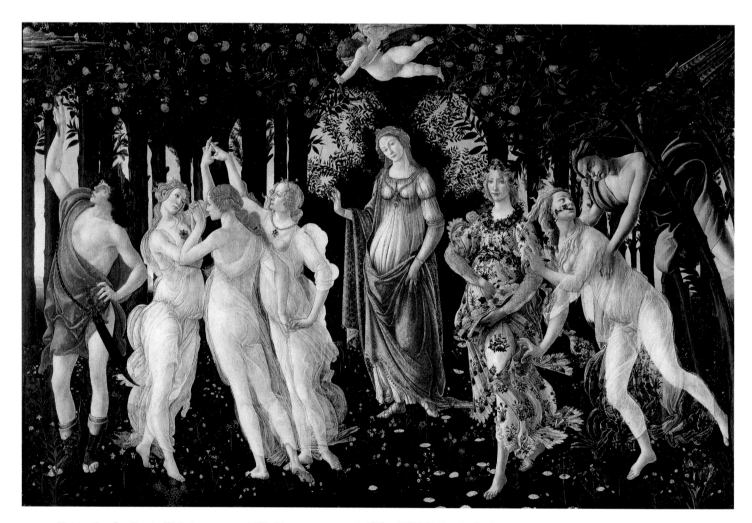

15.41. Sandro Botticelli. *Primavera.* ca. 1482. Tempera on panel. 6′8″ × 10′4″ (2.03 × 3.15 m). Galleria degli Uffizi, Florence

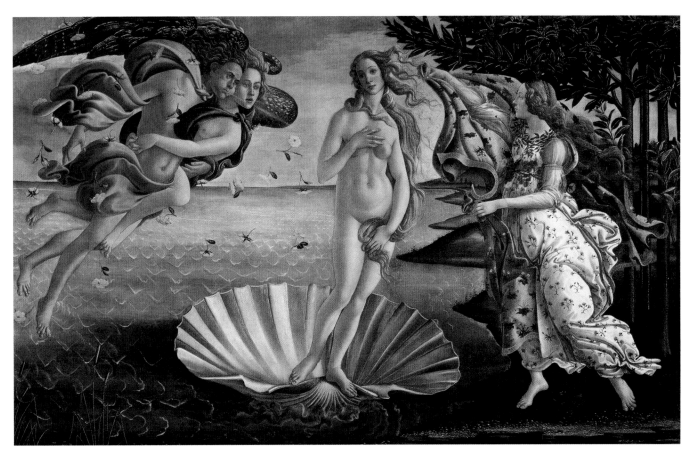

15.42. Sandro Botticelli. *The Birth of Venus*. ca. 1485. Tempera on panel. $5'8\frac{7}{8}'' \times 9'1\frac{7}{8}''$ (1.8 × 2.8 m). Galleria degli Uffizi, Florence

she floats slowly toward the seashore, where a flower-clad woman waits to enfold her in a flowered robe. Her movement is aided by Zephyr accompanied by Chloris (Flora). Unlike the *Primavera,* here the space behind the figures seems to open out into the distance, with the sky and water creating a light, cool tonality for the painting. In the figures, though, the shallow modeling and emphasis on outline produce an effect of low relief rather than of solid, three-dimensional shapes. The bodies seem to be drained of all weight, so that they float even when they touch the ground.

These ethereal figures recreate ancient forms. Botticelli's figure of *Venus* depends on a variant of the *Knidian Aphrodite* by Praxiteles (see fig. 5.60). The subject itself seems related to the Homeric *Hymn to Aphrodite,* which begins: "I shall sing of beautiful Aphrodite ... who is obeyed by the flowery sea-girt land of Cyprus, whither soft Zephyr and the breeze wafted her in soft foam over the waves. Gently the golden-filleted Horae received her, and clad her in divine garments." Still, no single literary source accounts for the pictorial conception. It may owe something to Ovid and the poet Poliziano, who was, like Botticelli, a member of the Medici circle. But again, the thinking of Marsilio Ficino may play a role here. Among the Neo-Platonists, Venus appears in two guises, a celestial Venus and a mundane Venus; the former was the source of divine love, the latter of physical love. *The Birth of Venus* may be an allegory of the origin of the celestial Venus for an audience attuned to the

nuances of Neo-Platonic philosophy. The elegant forms and high finish of the painting by Botticelli, combined with the erudite subject matter based on ancient thought, exemplify the taste of the Medici court.

Portraiture

Images of history, of contemporary events, or of ancient myths demonstrate the increasing interest in secular themes in the art of the Renaissance. Another genre of image in great demand was the portrait. In addition to dynastic images for kings, or monuments to war heroes, the second half of the fifteenth century saw the spread of portraits of merchants, brides, and artists.

The idea of recording specific likenesses was inspired by the fifteenth century's increasing awareness of the individual, but also by the study of Roman art, where portraits abound. Artists were already making donor portraits like Masaccio's *Trinity* fresco (fig. 15.14), funerary monuments like Bruni's tomb (fig. 15.26), and commemorations of public figures like Donatello's *Gattamelata* (fig. 15.21), but new forms of portraiture developed in the fifteenth century.

Donor portraits had a long history in Italian art, going back to the Early Christian period. But in the fifteenth century they gained new prominence. In a fresco cycle in Santa Maria Novella, the Florentine painter Domenico Ghirlandaio (1449–1494) places portraits of many members of the Tornabuoni family, who sponsored the cycle, in very visible positions. In the *Birth of the Virgin*

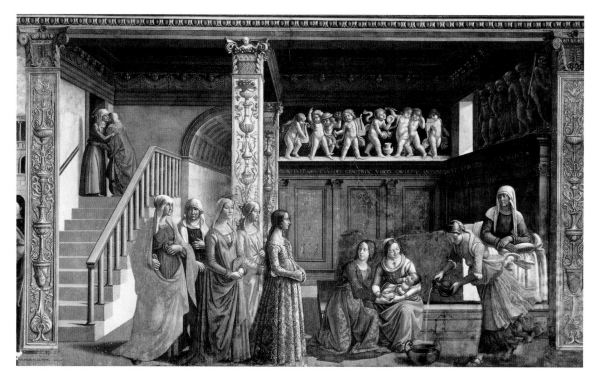

15.43. Domenico Ghirlandaio. *Birth of the Virgin*. ca. 1485–1490. Fresco. Cappella Maggiore, Santa Maria Novella, Florence

(fig. **15.43**), Ghirlandaio uses perspective to construct a doll's house view of an elaborately decorated bedchamber where Saint Anne watches the midwives wash her newborn child. The room is adorned with ornamental pilasters and panels, while a carved frieze of *putti* (little boys), reminiscent of works by Donatello and Luca della Robbia, seems to celebrate the birth. Inscriptions below this frieze praise the birth of the Mother of God, and other writings on the wall below identify Ghirlandaio as the author. (His family name was Bigordi, but his father was a garland maker, and this nickname passed on to his son.) In the 1480s and 1490s, his shop was one of the busiest in Florence, and it was there that the young Michelangelo learned the techniques of fresco.

Ghirlandaio sets contemporary figures into this sacred drama who upstage the historical characters: A group of women in expensive dress and decorous poses witness the birth of the Virgin. The young lady depicted in profile at the center of the composition is the daughter of the patron, Ludovica Tornabuoni. The tall woman in a blue robe at the back of this group is Lucrezia Tornabuoni, who had married into the Medici family (her son was Lorenzo de' Medici). As the *Birth of the Virgin* fresco demonstrates, Ghirlandaio was an accomplished portraitist as well as storyteller. His use of the profile portrait for Ludovica, the central figure, reflects the preference for the profile among Italian artists and patrons in the middle years of the fifteenth century. The profile portrait had been adopted from Roman coins, which always showed emperors from the side. But around 1480, both Ghirlandaio and his younger colleague, Botticelli, began to adopt the three-quarter view in their portraits, and the practice soon became widespread.

Among Ghirlandaio's most touching individual portraits is the panel of *An Old Man and a Young Boy* (fig. **15.44**), usually dated around 1480. Despite the very specific physiognomy of the old man, whose nose has been disfigured by rosacea (a skin disorder), the sitters and their relationship to each other are unknown. The familiarity of their gestures suggest that they depict two generations of one family; if so, the painting represents the continuity of the family line. Even though the textures are somewhat generalized and the composition geometrically ordered, Ghirlandaio's attention to detail may reflect his acquaintance with Netherlandish art. The landscape view through the window that breaks up the picture plane was also a Northern European idea. (See Memling's *Portrait of Martin van Niewenhove*, fig. 14.23.) But the most important contribution was the three-quarter view of the human face, which had been used in Flanders since the 1420s.

Leading families like the Tornabuoni included portraits of the Medici family in their commissions as a statement of their alliance with the ruling party. The Medici themselves commissioned numerous family likenesses for their palaces and for their friends. They preferred the **portrait bust**, a shoulder length sculptural likeness, most likely to draw parallels between themselves and Roman families who owned numerous busts of their ancestors (see fig. 7.13). The Florentine busts celebrated the living, however, not the dead, and were made of marble, bronze, or terra cotta by some of the leading sculptors of the century. Around 1480, Andrea del Verrocchio (or his shop) executed such a bust of Lorenzo de' Medici. (fig. **15.45**). The image captures his physical likeness, but the concentrated gaze and drawn mouth give him an intensity that is meant to express his personality. Lorenzo was young to be the head of the ruling political faction, and the bust portrays him with the dignity and gravitas of a Roman elder as if to compensate for his youth.

The court around Lorenzo the Magnificent was learned, ambitious, and very cultivated. Lorenzo was the patron of

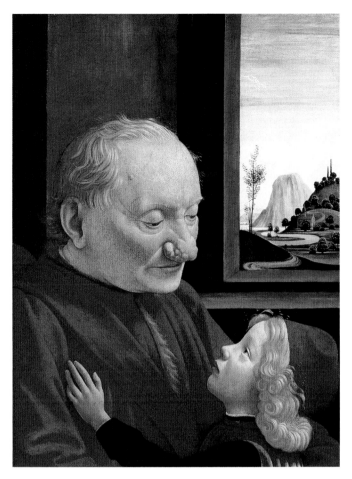

15.44. Domenico Ghirlandaio. *An Old Man and a Young Boy.* ca. 1480. Tempera and oil on wood panel, 24¹⁄₈ × 18″ (61.2 × 45.5 cm). Musée du Louvre, Paris

numerous humanists, philosphers, poets, and artists, including the young Michelangelo. Yet this brilliant court did not outlast Lorenzo's death in 1492. His heir, Piero de' Medici, did not share his father's diplomatic gifts. What is more, he faced an increasingly unstable economy (the bank failed in 1494) and invading armies from France and Spain. Piero's inept handling of these crises encouraged an uprising in Florence in 1494, which expelled the Medici faction and sought to restore Republican government. A vacuum of power was filled for a time by the Dominican friar Girolamo Savonarola, who attacked the "cult of paganism" and the materialism he saw in Florentine culture. Savonarola's exhortations to repentence and his strong criticism of corruption not only in Florence but in the Church hierarchy made him many enemies, and he was executed in 1498. As the fifteenth century came to an end, Florence was battling for its life against the stronger powers of the papacy, Spain, and France.

THE RENAISSANCE STYLE REVERBERATES, 1450–1500

Artists from all over Italy and beyond found the innovations being explored in Florence a stimulation to their own work, though they responded to the new styles in individual ways.

Additionally, patrons throughout Italy saw the advantages of expressing their authority through visual and textual references to antiquity. By mid-century, linear perspective was in widespread use, and Florentine techniques for rendering form through light were being practiced by many artists. Piero della Francesca blended his own fascination with mathematics, the ancient world, and Flemish painting to create a personal style that found favor in several Italian courts. The Florentine humanist and architect Leon Battista Alberti designed influential buildings in northern Italy, including one for the Marquis of Mantua, who had also attracted the services of the painter-archeologist Andrea Mantegna. The city of Venice commissioned Florentine artists, such as Andrea del Verrocchio, for major projects, but their local traditions in architecture and painting remained strong. Venetian painters like Giovanni Bellini developed an influential school of Renaissance painting that rivaled Florentine style. As the papacy regained its control in Rome, Perugino and Luca Signorelli joined local painters like Melozzo da Forlì in projects designed to celebrate papal power.

Piero della Francesca in Central Italy

One of the most distinctive and original artists of the second half of the fifteenth century was Piero della Francesca (ca. 1420–1492), who visited Florence while training with Domenico Veneziano (see fig. 15.30). Piero came from Borgo San Sepolcro in southeastern Tuscany, where he completed

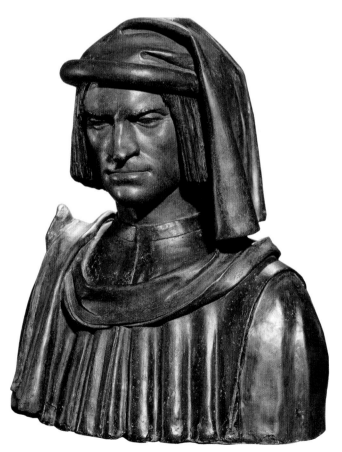

15.45. Andrea del Verrocchio. *Bust of Lorenzo de' Medici.* ca. 1480. Painted terra cotta. Samuel A. Kress Collection, National Gallery of Art, Washington, DC. 1943.4.92

some of his important early commissions. He worked for patrons in Tuscany, Rimini, and Ferrara, and executed several important works for Federico da Montefeltro, a *condottiere* (mercenary general) turned prince of Urbino (southeast of Tuscany) around 1470. Piero's early training with Domenico Veneziano may be seen in his colors, while his experience of Masaccio is apparent in the solidity and simplicity of his forms and the solemn character of his compositions. The early fifteenth-century systemization of perspective was critical for Piero, who became such an expert at mathematically determining perspective for space and for rendering figures in space that he wrote a treatise about it. It is likely that Piero made contact with Leon Battista Alberti, with whom he shared patrons, as well as an interest in art theory.

A work that Piero made for his hometown reflects this combination of influences on his art. The city of Borgo San Sepolcro commissioned him to paint a fresco for the Palazzo Comunale of the town, probably around 1460. Befitting the name of the town, which means the "Holy Sepulchre," Piero's theme is Christ Resurrected stepping out of his tomb (fig. **15.46**). The figure of Christ dominates the composition: His frontality and the triangular composition may derive from the *Trinity* fresco by Masaccio (fig. 15.14), but the light of sunrise and the pale colors reflect the art of Domenico Veneziano. Piero pays special attention to the arrangement of the Roman soldiers asleep in front of the sepulchre; they are variations on a theme of bodies in space. The spectator must look up to see the glorified body of Christ, so perfect in his anatomy and so serene in his aspect as he triumphs over death.

Piero's art brought him to the attention of the cultivated Duke Federico da Montefeltro, who had assembled a team of artists from all over Europe for his court at Urbino. There, Piero della Francesca came into contact, and perhaps into competition, with artists not only from Italy but also from Spain and Flanders. From them, Piero learned the new technique of painting with oil glazes and became an early practitioner of this technique in central Italy.

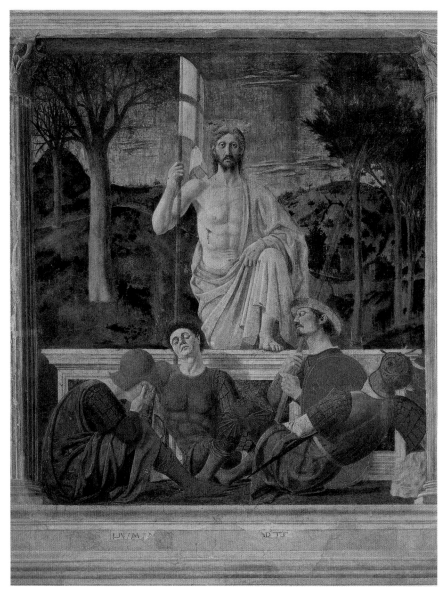

15.46. Piero della Francesca. *Resurrection*. ca. 1463. Fresco, 7'5" × 6'6½" (2.25 × 1.99 m). Palazzo Comunale, Borgo San Sepolcro

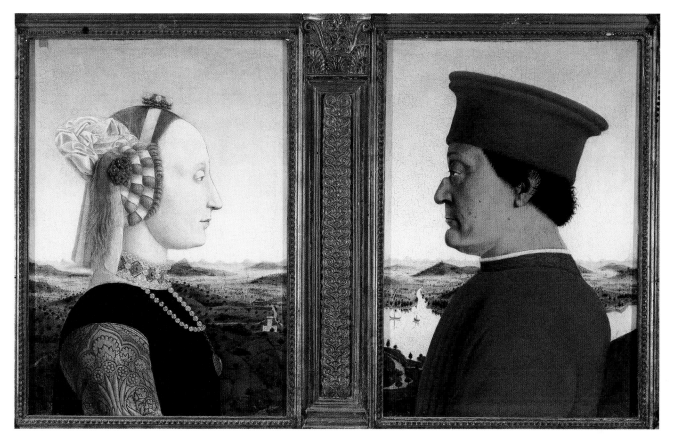

15.47. Piero della Francesca. *Double Portrait of Battista Sforza and Federico da Montefeltro.* ca. 1472. Oil and tempera on panel, each panel 18½" × 13" (47 × 33 cm). Galleria degli Uffizi, Florence

Piero's quiet, spatially complex paintings were thus enriched with more brilliant colors and surface textures in the style of Flemish art. The double portrait of Battista Sforza and Federico da Montefeltro that Piero painted around 1472 (fig. **15.47**) demonstrates his mastery of spacial representation and clarity of form by using the rich hues and varied textures made possible by oil painting. This diptych portrays both the count and his wife in profile facing each other in front of a deep continuous landscape. Federico, whose face had been disfigured in a tournament, shows his good side on the viewer's right. His wife, Battista, had recently died from a fever; Piero gives her the place of honor to the viewer's left. Her pale features are framed by her complicated hairstyle and her gems and brocades. A shadow falls over the landscape behind her, while the landscape behind her husband is well-lit and busy.

At about the same time, Federico called on Piero to execute a larger image that ultimately became the memorial over his tomb (fig. **15.48**). For this painting, Piero drew on the theme of the *sacra conversazione*; here, the Virgin and her sleeping child are surrounded by saints and angels while the patron, Duke Federico, kneels before her. The figures stand as vertically and as still as the pilasters on the wall behind them. Strong light enters from the left, casting broad shadows that fall to the right and define the depth of the apse. Framed by the marble panel

15.48. Piero della Francesca, *Enthroned Madonna and Saints with Federico da Montefeltro.* ca. 1472–1474. Oil on panel, 8'2" × 5'7" (2.48 × 1.7 m). Pinacoteca di Brera, Milan

on the far wall, the Virgin's head is as ovoid as the egg that hangs from the shell at the curve of the apse. The architecture of the church has a monumental character, with its marble paneling, classicizing pilasters, and barrel-vaulted apse. Using the oil technique, Piero describes the veining of the marble, the soft texture of the carpet, and the gleam of Federico's armor.

The meaning of this painting is unclear. A viewer looks for Federico's wife, Battista, to complement his kneeling figure, but even though her patron saint, John the Baptist, stands at the left, Battista herself is missing. She died in 1472, which helps to date the painting, and her conspicuous absence may be part of the picture's meaning. Piero depicts Federico venerating the Christ Child, who wears a piece of coral to ward off illness, as if in thanks for the birth of his heir, despite the loss of his wife. Yet the sleeping Child refers to the eventual death of Christ—and his Resurrection—so the funereal theme is maintained. Piero's gift was for making images that convey dignity and melancholy in carefully balanced and spacious compositions.

Alberti and Mantegna in Mantua

Mantua, in the northern Po Valley, had been dominated for more than a century by the Gonzaga family. They created a brilliant court, peopled with humanists, educators, and artists. Marquis Ludovico Gonzaga had married a German princess, Barbara of Brandenburg, and the court was very cosmopolitan. Works such as the *Ten Books on Architecture* (ca. 1452) brought Leon Battista Alberti great prominence and the Gonzaga lured him to their service.

15.49. Leon Battista Alberti. Sant' Andrea, Mantua. Designed 1470

15.50. Leon Battista Alberti. Interior of Sant' Andrea

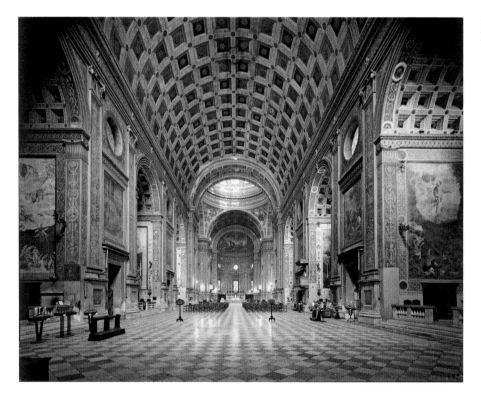

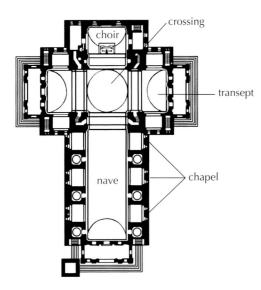

15.51. Plan of Sant' Andrea (transept, dome, and choir are later additions)

By 1470, Alberti had designed the church of Sant' Andrea in Mantua, his last work (fig. **15.49**). The majestic facade expresses Alberti's ultimate goal of merging Classical temple forms with the traditional basilican church. Here, he interwove a triumphal arch motif, now with a huge recessed center niche to serve as the portal, with a Classical temple front. As on the exterior of the Palazzo Rucellai (fig. 15.32), he used flat pilasters that stress the primacy of the wall surface to keep the two competing forms in balance. He used two sizes of pilaster to achieve this balance: The smaller pilasters support the arch over the huge central niche, and the larger ones support the unbroken architrave and the strongly outlined pediment. The larger pilasters form what is known as a **colossal order**, meaning that it is more than one story high. These tall pilasters balance the horizontal and vertical elements of the design.

To further unify the facade, Alberti inscribed the entire design within a square, even though it made the facade much lower than the height of the nave. (The effect of the west wall protruding above the pediment is more disturbing in photographs than at street level, where it can hardly be seen.) While the facade is distinct from the main body of the structure, it offers a "preview" of the interior, where the same colossal order, the same proportions, and the same triumphal-arch motif reappear on the walls of the nave (fig. **15.50**).

Compared with Brunelleschi's San Lorenzo (fig. 15.8), the plan (fig. **15.51**) is extraordinarily compact. Had the church been completed as planned, the difference would be even stronger. Alberti's design had no transept, dome, or choir, all of which were added in the mid-eighteenth century; he planned only a nave ending in an apse. Following the example of the Basilica of Constantine (see figs. 7.68 and 7.69), Alberti replaced the aisles with alternating large and small vaulted chapels and eliminated the clerestory. The colossal pilasters and the arches of the large chapels support a coffered barrel vault of impressive size. (The nave is as wide as the facade.) Here, Alberti has drawn upon his study of the massive vaulted halls in ancient

Roman baths and basilicas, but he interprets these models freely to create a structure that can truly be called a "Christian temple." Such a synthesis of ancient forms and Christian uses was a primary goal of fifteenth-century humanists and their patrician sponsors. Alberti's accomplishment of this goal at Sant'Andrea would inspire many other architects to do the same.

The humanist court at Mantua played host for many years to one of the most intellectually inclined artists of the century, Andrea del Mantegna (1431–1506). Trained in Padua, but aware of artistic currents in Venice, Florence, and Rome, Mantegna became court painter to the Gonzaga in 1460, a position he held until his death at age 75. His interests as a painter, a humanist, and an archeologist can be seen in the panel depicting *St. Sebastian* (fig. **15.52**), probably painted in the 1450s.

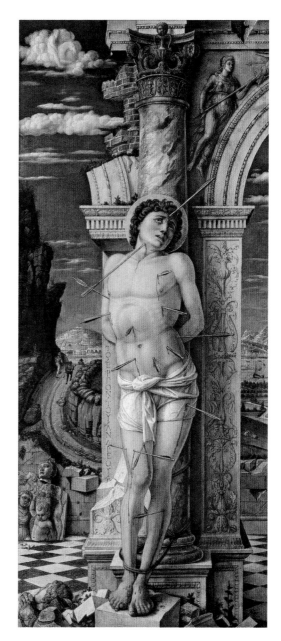

15.52. Andrea Mantegna. *St. Sebastian*. ca. 1450s. Tempera on panel, $26\frac{3}{4} \times 11\frac{7}{8}$″ (68 × 30.6 cm). Kunsthistorisches Museum, Vienna

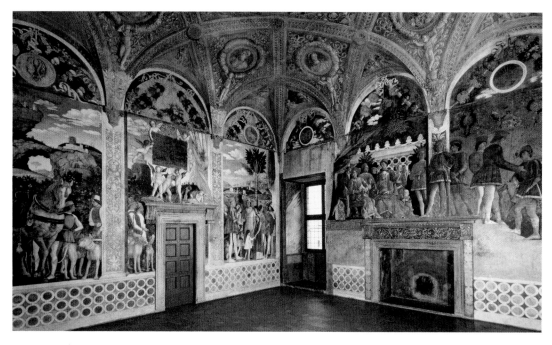

15.53. Andrea Mantegna. *Camera Picta*. 1465–1474. Fresco. Ducal Palace, Mantua

Sebastian was an early Christian martyr who was condemned to be executed by archers. (He recovered from these wounds, which may explain why he was invoked so often against the plague.) Mantegna depicts the anatomically precise and carefully proportioned body of the saint tied to a Classical column. These forms are crisply drawn and modeled to resemble sculpture. Architectural and sculptural Classical ruins lie at his feet and behind him, and next to him, on the left, is the artist's signature in Greek. A road leads into the distance, traversed by the archers who have just shot the saint; through this device, Mantegna lets the perspectively constructed space denote the passage of time. Beyond these men is an atmospheric landscape and a deep blue sky dotted with soft white clouds. The scene is bathed in warm late-afternoon sunlight, which creates a melancholy mood. The light-filled landscape in the background shows Mantegna's study of Flemish paintings, which had reached Florence as well as Venice by 1450, where Mantegna would have encountered them.

Mantegna's patron for the St. Sebastian is unknown, but as a court painter, he served the Marquis of Mantua by painting his villas and palaces. For the Marquis' palace in Mantua, he began painting in 1465 a room that has come to be called the *Camera Picta*, or painted room (fig. **15.53**). This was a multipurpose vaulted room—sometimes bedroom, sometimes reception hall—that Mantegna finished in 1474. On the walls Mantegna painted portraits of the Gonzaga family, their retainers, their children, and their possessions. This room celebrates the Marquis's brilliant court, his dynastic accomplishments, and his wealth, all in a witty display that became an attraction for visiting humanists, politicians, artists, and princes. In such ways, princes used art to improve their social and political positions. The *Camera Picta* also celebrates Mantegna's skill and brought him fame among his contemporaries.

Mantegna used the actual architecture of the room—the corbels supporting the vaults, the mantel over the fireplace—to create an illusionistic glimpse of the Gonzaga family at home. Fictive pilasters serve as window frames through which a viewer sees members of the family out-of-doors; the figures of Ludovico and his son Francesco, recently made a cardinal, are observed by servants with a horse and dogs on the other side of the main door. In addition to the specific features of the people and the naturalism of the details, Mantegna's mastery of perspective allows him to connect the painted world to the real world of the spectator. The centerpiece of this illusion occurs at the crown of the vault, where Mantegna paints a fictive oculus through which a spectator sees the sky. Mantegna uses many devices to suggest illusions here, including drapery that appears to be fluttering in the outside breeze and fictive reliefs of Roman emperors on the vaults. Above the mantel, Ludovico appears again, this time in a more formal setting, surrounded by family and courtiers. The brilliance of the court is wonderfully captured by Mantegna's splendid frescoes.

Venice

While it competed with its neighbors for territory, trade routes, and influence, Venice had a stable republican government throughout the fifteenth century. It was ruled by a merchant aristocracy so firmly established that there was little internal conflict and the Doge's Palace (fig. 13.34) could forgo any fortifications. Similarly, the houses of Venetian patricians were not required to serve as fortresses, so they developed into graceful, ornate structures. The Ca' d'Oro (fig. **15.54**) was built beginning in 1421 for Marino Contarini, whose family had long prospered from trade. To assert his family's status, Contarini spared no expense on his dwelling on the Grand Canal. It received its name ("house of gold") from the lavish gold leaf that once adorned the facade.

The design in part reflects the different functions of the building. The ground floor was used as a shipping center and warehouse, while the second story is devoted mainly to a large reception hall, with several smaller rooms to the right. Private quarters are found mainly on the upper floor. The intersecting ribs of arches form a delicate latticework on the facade, which combine with the brilliant colors and the use of gold to express the family's wealth, position, and ambition.

ECHOES OF DONATELLO'S *GATTAMELATA* The tradi-tions of Venice gave way slowly to the interest in ancient art coming from Florence. Several Florentine artists, including Donatello and Andrea del Castagno, were called to Venice to execute important commissions in the fifteenth century. Flem-ish painting was admired and collected in Venice, which as a center for international trade housed colonies of merchants from Northern Europe. By the end of the century, Venice had also found the new techniques and references to ancient art use-ful tools for expressing itself. A good example of this is the com-mission given by the Republic of Venice to Verrocchio to execute a large bronze equestrian statue commemorating a Venetian army commander, the *condottiere* Bartolommeo Colleoni (fig. **15.55**). Colleoni had requested such a statue in his will, in which he left a large fortune to the Republic of Venice. Colleoni obviously knew the *Gattamelata* statue (fig. 15.21) by Donatello, and wanted the same honor for himself. Verrocchio likely viewed Donatello's work as the model for his statue, yet

15.55. Andrea del Verrocchio. *Equestrian Monument of Colleoni.* ca. 1483–1488. Bronze, height 13′ (3.9 m). Campo Santissimi Giovanni e Paolo, Venice

he did not simply imitate it. He brought his painter's skill to the rendering of the textures and details of the monument.

Colleoni's horse is graceful and spirited rather than robust and placid; its thin hide reveals veins, muscles, and sinews, in contrast to the rigid surfaces of the armored figure bestriding it. Since the horse is also smaller in relation to the rider than in the *Gattamelata* statue, Colleoni looms in the saddle as the very image of forceful dominance. Legs straight, one shoulder thrust forward, he surveys the scene before him with the same concentration we saw in Donatello's *St. George* (see fig. 15.3). Like Donatello's work, the Colleoni statue also reflects the funereal tradition reflected in the *Tomb of Bernarbò Visconti* (fig. 13.36) and reminds a viewer of the contributions the *condottiere* made to the Republic of Venice.

BELLINI AND OIL PAINTING In addition to the revival of Roman forms, the traditions of Venice were further enhanced late in the fifteenth century by the Venetian explo-ration of the new medium of oil painting. A crucial intermedi-ary in introducing this technique to Venice was probably Antonello da Messina, a painter from southern Italy who may have traveled to Flanders to learn the technique; he is docu-mented in Venice in the 1470s. In the painting of Giovanni

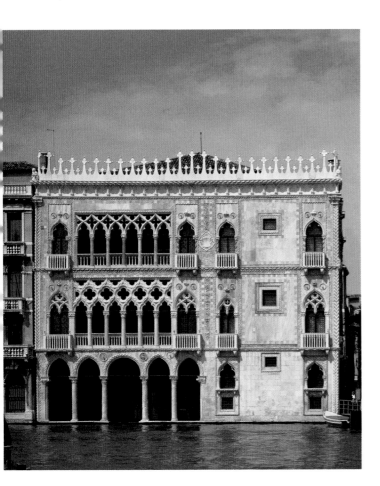

15.54. Ca'd'Oro, Venice. 1421–1440

Bellini (ca. 1430–1507), Mantegna's brother-in-law and a member of a family of painters, the technique of painting in oil pioneered by the Flemish is combined with Florentine spatial systems and Venetian light and color.

Bellini's *St. Francis in Ecstasy* (fig. **15.56**), dating from about 1480, displays the artist's synthesis of these elements to create a wholly original image. In this painting, St. Francis has just stepped out of his hermit's cell, fitted out with a desk under an arbor. He has left his wooden sandals behind and looks up ecstatically to the sky. Some scholars believe the painting shows Francis receiving the stigmata (the wounds of Christ) on the Feast of the Holy Cross in 1224, when a crucified seraph appeared to him on Mount La Verna, in Tuscany. Others have argued that the scene "illustrates" the *Hymn of the Sun*, which Francis composed the next year, after his annual fast at a her-

mitage near his hometown of Assisi. Whichever narrative moment is depicted, the painting expresses Franciscan ideals. For St. Francis, "Brother Sun, who gives the day . . . and . . . is beautiful and radiant with great splendor," was a symbol of the Lord. What he sees in the painting is not the sun itself, which is obscured by a cloud, but God revealed as the light divine. This miraculous light is so intense that it illuminates the entire scene.

In the background is a magnificent expanse of Italian countryside. St. Francis is so small compared to the setting that he seems almost incidental. Yet his mystic rapture before the beauty of the visible world guides a viewer's response to the vista that is displayed, which is ample and intimate at the same time. St. Francis believed that God had created Nature for the benefit of humanity, and Bellini uses the tools of the Renaissance artist to recreate a vision of natural beauty. In this deep space,

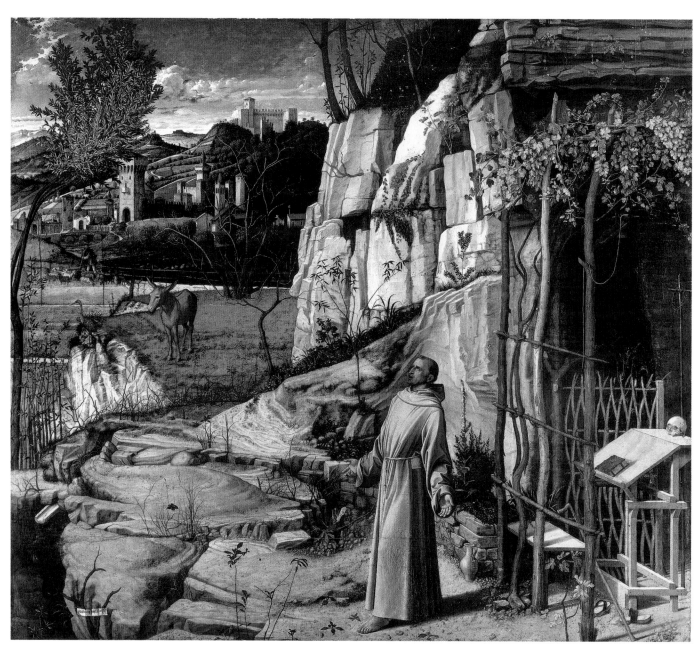

15.56. Giovanni Bellini. *St. Francis in Ecstasy.* ca. 1480. Oil and tempera on panel, 49 × 55⅞″ (124 × 141.7 cm). The Frick Collection, New York. © copyright the Frick Collection

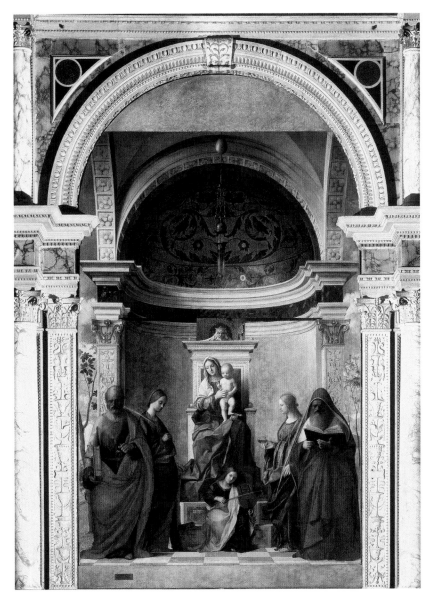

15.57. Giovanni Bellini. *Madonna and Saints.* 1505. Oil on panel, 16′5¹/₈″ × 7′9″ (5 × 2.4 m). San Zaccaria, Venice

derived using the rules of perspective, he depicts detailed textures and forms to populate the landscape. Some of these forms may express other Franciscan values. For Francis, the road to salvation lay in the ascetic life of the hermit, symbolized by the cave. The donkey may stand for St. Francis himself, who referred to his body as Brother Ass, which must be disciplined. The other animals—the heron, bittern, and rabbit—are, like monks, solitary creatures in Christian lore. Yet Bellini's soft colors and glowing light infuse the painting with a warmth that makes such a solitary life not only bearable, but enviable.

As the foremost artist of Venice, Bellini produced a number of altarpieces of the *sacra conversazione* type. The latest and most monumental is the *Madonna and Saints* (fig. **15.57**), done in 1505 for the venerable Benedictine convent of San Zaccaria. This Queen of Heaven is raised up on a throne with her Child, while saints Peter, Catherine, Lucy, and Jerome stand before her. The placement of the female saints may reflect the interests of the nuns for whom the altarpiece was made. (When the painting

was fitted with its present frame a decade later, it was cut at the sides, and a piece, since removed, was added at the top.) Compared with Domenico's *sacra conversazione* of 60 years earlier (fig. 15.30), the setting is simpler but even more impressive. Instead of a Gothic canopy, the saints are gathered below a semi-dome covered with mosaic in the Venetian medieval tradition (see San Marco, fig. 8.48). Piero's Urbino Madonna (fig. 15.48) provides a closer model for this painting, but Bellini's figures are more comfortably inserted into the apse and the pyramid composition is more stable. The structure is obviously not a real church, for its sides are open and the scene is flooded with sunlight. The Madonna's high-backed throne and the music-making angel on its lowest step may be compared to those in Masaccio's *Madonna Enthroned* of 1426 (see fig. 15.19).

What distinguishes this altar from earlier Florentine examples is not only the spaciousness of the design but its calm, meditative mood. Instead of "conversation," the figures seem deep in thought, so gestures are unnecessary. The silence is enhanced

by the way the artist has bathed the scene in a delicate haze. There are no harsh contrasts. Light and shadow blend in almost imperceptible gradations, and colors glow with a new richness. Bellini creates a glimpse into a heavenly court peopled by ideal figures in an ideal space.

Rome and the Papal States

Long neglected during the papal exile in Avignon (see page 457), Rome once more became a major artistic center in the late fifteenth century. As the papacy regained power on Italian soil, the popes began to beautify both the Vatican and the city. They also reasserted their power as temporal lords over Rome and the Papal States. These Popes believed that the monuments of Christian Rome must outshine those of the pagan past. To achieve this goal, they called many artists from Florence and the surrounding areas to Rome in the fifteenth century, including Gentile da Fabriano, Masaccio, Fra Angelico, Piero della Francesca, and Sandro Botticelli. Like the other courts of Italy, the papacy saw the value of spending money on adorning both ecclesiastical and domestic structures.

Pope Sixtus IV della Rovere (1471–1484) sponsored several important projects in the last quarter of the century, including the building of the Vatican library. To commemorate this project, Sixtus hired a local painter, Melozzo da Forlì (1438–1498), to paint a fresco depicting himself and his court at the confirmation of Bartolomeo Platina as the official Vatican librarian (fig. **15.58**). The pope sits enthroned, surrounded by his nephews. (Awarding offices to members of one's family was a widespread practice called *nepotism*, from the Italian word for "nephew.") The standing figure at the center is Giuliano delle Rovere, Sixtus's nephew and the future Pope Julius II. Melozzo designed the fresco to illusionistically continue the space of the real structure (now destroyed). A viewer looks up to see the ceilings, the pillars, the windows of the room. Furthermore, the surfaces are very luxurious: Melozzo depicts lots of veining in the marble, elaborate moldings, and decorative forms in the framing elements. (The oak leaves with acorns in the framing pilasters are a reference to the pope's family name: Rovere means "oak.") Platina points to an inscription which lauds Sixtus for his improvements to Rome.

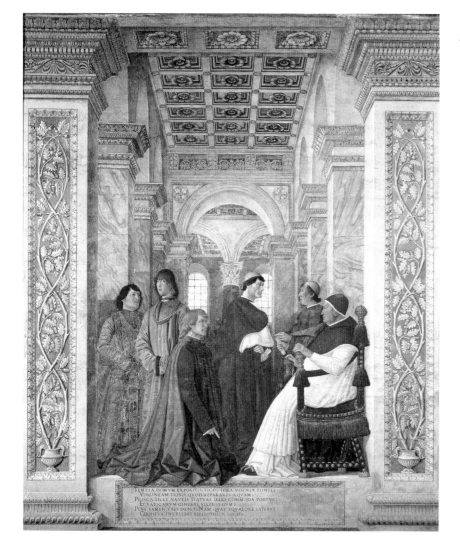

15.58. Melozzo da Forli. *Sixtus IV Confirming the Papal Librarian*. ca. 1480. Detached fresco, 12′ × 10′4″ (3.7 × 3.15 m). Musei Vaticani, Rome

THE SISTINE CHAPEL One of those improvements was the building at the Vatican of a new chapel for the pope, called the Sistine Chapel after Sixtus IV. Around 1481–1482, Sixtus commissioned a cycle of frescoes for the walls of the chapel depicting events from the life of Moses (on the left wall) and Christ (on the right wall), representing the Old and New Testaments. To execute them, he hired most of the important painters of central Italy, among them Botticelli, Ghirlandaio, and Pietro Vanucci, called Perugino (ca. 1450–1523). Born near Perugia in Umbria (the region southeast of Tuscany), Perugino maintained close ties with Florence. He completed the fresco of *The Delivery of the Keys* (fig. **15.59**) in 1482.

The gravely symmetrical design of the fresco conveys the special importance of the subject in this particular setting: The authority of St. Peter as the first pope, as well as of all those who followed him, rests on his having received the keys to the Kingdom of Heaven from Christ himself. The figures have the crackling drapery and idealized features of Verrocchio (see fig. 15.27) in whose shop Perugino spent some time. Along with the other apostles, a number of bystanders with highly individualized features witness the solemn event.

In the vast expanse of the background, two further narratives appear: To the left, in the middle distance, is the story of the Tribute Money; to the right, the attempted ston-

ing of Christ. The inscriptions on the two Roman triumphal arches (modeled on the Arch of Constantine; see fig. 7.63) favorably compare Sixtus IV to Solomon, who built the Temple of Jerusalem. These arches flank a domed structure seemingly inspired by the ideal church of Alberti's *Treatise on Architecture*. Also Albertian is the mathematically exact perspective, which lends the view its spatial clarity. The symmetry and clear space of the image express the character of the rule of the Sixtus IV, not only in spirtual, but in temporal terms.

SIGNORELLI, THE CHAPEL OF SAN BRIZIO Sixtus's claims over the Papal States were taken up by his successor, Alexander VI, who pursued temporal power with armies as well

ART IN TIME

- 1464—First printing press in Italy set up near Rome
- **1470—Alberti's Sant' Andrea in Mantua begun**
- 1471—Sixtus IV elected pope
- **ca. 1480—Bellini's *St. Francis***
- 1492—Columbus sails west

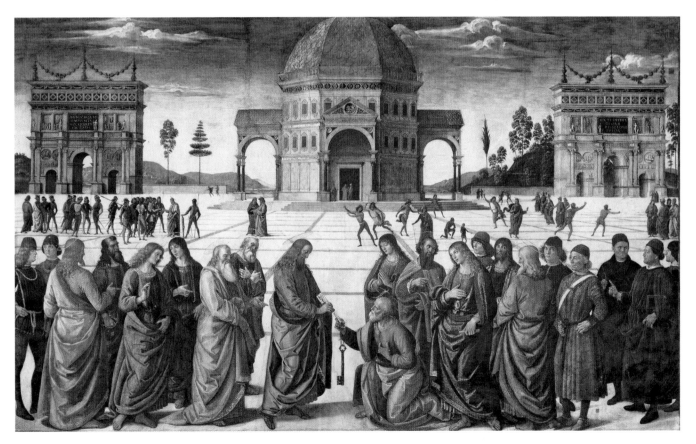

15.59. Pietro Perugino. *The Delivery of the Keys*. 1482. Fresco, 11'5½" × 18'8½" (3.5 × 5.7 m). Sistine Chapel, Vatican Palace, Rome

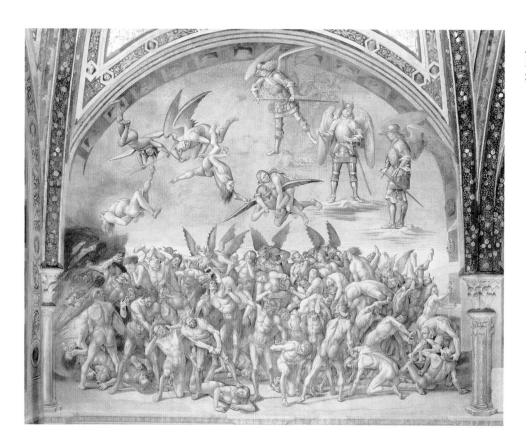

15.60. Luca Signorelli. *The Damned Cast into Hell.* 1499–1500. Fresco, approx. 23′ (7 m) wide. San Brizio Chapel, Orvieto

as spiritual weapons. (Such activities drew the censure of other Christians, both in Italy and elsewhere, fueling the anticlerical feelings of the next century.) The city of Orvieto had shown great allegiance to the papacy, and in return, the pope adorned the Chapel of San Brizio in the cathedral of that Umbrian city with a series of frescoes beginning in 1499. The commission for the project went to Luca Signorelli (1445/50–1523), a Tuscan painter who had studied with Piero della Francesca. The theme chosen for the frescoes is the end of the world, as predicted in the book of Revelation, but further elaborated by St. Augustine, Thomas Aquinas, and Dante, as well as the fifteenth-century Dominican preacher Vincent Ferrer. One of the most memorable of these frescoes is *The Damned Cast into Hell* (fig. **15.60**). Signorelli envisions the scene as a mass of bodies pressed forcefully downward to be tormented by devils and licked by the flames of Hell, while the Archangel Michael oversees the punishment. Inspired by the muscular forms of Pollaiuolo, Signorelli uses the nude body as an expressive instrument: The damned twist and turn, their bodies expressing the torments they face. The chaotic composition and compressed space contrasts strikingly with the rational calm of Perugino's *The Delivery of the Keys* (see fig. 15.59). Signorelli's frightening image of the end of time was painted as the year 1500 approached, a date which many believed would signal the end of days.

The late 1490s were a time of great uncertainty in Italy. The Medici were expelled from Florence; the French invaded in 1494; the plague returned to ravage cities; and the Turks continued their incursions into Europe. (The Turks had crushed the Christian forces at Lepanto, Greece, in 1499, a defeat that would be avenged in a second, more famous battle at the same site in 1571.) Fears that the "end of days" were coming were fanned by the sermons of Savonarola and other preachers.

SUMMARY

The world had changed a great deal over the fifteenth century. The printing press spread the new learning of the humanists and allowed philosophers and scientists to build on the wisdom of their predecessors in powerful new ways. The conquest of the eastern Mediterranean by the Turks spurred the Atlantic nations of Portugal and Spain to investigate other routes for trade with Asia, leading to the circumnavigation of Africa and the discovery of the Americas. The schism in the papacy and the worldly character of late fifteenth-century popes continued a process of disaffection

with religious institutions and increased secularity in the culture. Competition and trade spread an economy that became based on capital and money, thereby changing the face of society by expanding the middle class.

Artists of fifteenth-century Italy participated in these changes by developing new means to render the world in their images. Beginning with a study of the past embodied in Rome and its art, the sculptors, painters, and architects of Italy created works of art that united ancient forms with contemporary content. Under the influence of the ancients and their humanist contemporaries, these artists wrote theoretical treatises as if they themselves were scholars, increasing the status of the arts in their culture. Their creation of systems for representing the world through perspective, through naturalism and through the human form, became normative for not only themselves but for most Europeans in subsequent centuries. The Early Renaissance revolutionized the way people in Europe looked at works of art and at the work of artists.

ANCIENT INSPIRATIONS FOR ARCHITECTURE AND ARCHITECTURAL SCULPTURE

The city of Florence placed great value on commissioning public buildings and embellishing them with significant works of art. Competition among artists and among patrons resulted in a series of impressive and innovative monuments, many of them inspired by the study of ancient art. Combining his study of Roman buildings with Gothic building techniques, Brunelleschi transformed the city with his classicizing architecture. His architecture uses Roman forms organized by geometry and proportion to create spaces that are harmonious and rational. The young Donatello modeled his sculpture after ancient works to give his figures great naturalism, but also dignity and the potential for movement.

CHURCHES AND CHAPELS FOR FLORENTINE FAMILIES, 1420 – 1430

Prominent Florentine families paid for the construction and adornment of churches to express piety and social standing. Brunelleschi designed whole churches and individual chapels for the leading families of Florence, while his invention of linear perspective provided a means for artists to create the illusion of space in their pictures. Painters made altarpieces and frescoes to adorn family chapels. Masaccio's religious frescoes take full advantage of perspective, but also display his innovations in modeling forms in light and in the expressive possibilities of the human body.

SPREAD OF FLORENTINE STYLE, 1425–1450

The innovations of Florentine artists spread quickly through Italy. Patrons such as the Bishop of Siena or the Carmelite friars of Pisa probably took advice from their Florentine peers when looking for artists to hire. The artists themselves traveled throughout Tuscany to execute important commissions, bringing their expertise in perspective, modeling, and expressive form along with them. Patrons in other cities, such as Rome and Venice, also sought the talents of Masaccio and Donatello for artistic projects.

FLORENCE DURING THE ERA OF THE MEDICI, 1430–1494

In the middle years of the fifteenth century, Florentine artists continued to explore the lessons of antiquity and the potential for spatial illusion pioneered by Donatello, Ghiberti, Masaccio, and Brunelleschi. Ghiberti worked on a second pair of doors for the Baptistery, which focused on complex narratives from the Old Testament in illusionistic spaces, while Donatello explored many sculptural media. Their influence may be seen on the next generation of sculptors and painters. These artists were commissioned by convents, monasteries, and prominent families to make religious images or to adorn churches. Leon Battista Alberti fused local tradition and Classical architectural theory in his facade for Santa Maria Novella.

DOMESTIC LIFE: PALACES, FURNISHINGS, AND PAINTINGS, CA. 1440–1490

The private dwellings of Florentine families displayed their social rank and civic virtue, which found visual expression in classicizing forms. Adapting elements from Roman structures, Alberti and Michelozzo created palaces that served as stages for family life and public events. These buildings were adorned with furnishings, paintings, and sculptures of both religious and secular themes. The Medici populated their palace with images of Florentine civic patrons, like Donatello's *David* and Pollaiuolo's *Hercules and Antaeus*. Both sculptors made images of nudes, a practice clearly inspired by ancient statues, for these domestic settings. Palaces were also adorned with paintings on painted chests (cassoni) or on circular panels (tondi). Themes from contemporary history and Greek mythology were treated in paintings for palace walls. Portraits of individuals and of families appeared not only as donors in religious commissions or tombs, but as actors in sacred narratives and as separate paintings and portrait busts.

THE RENAISSANCE STYLE REVERBERATES, 1450–1500

The authority of antiquity and the impressiveness of Florentine style inspired artists outside of Florence to emulate and interpret the new styles. Piero della Francesca spent time in Florence, but developed his own style informed by perspective, antiquity, and Masaccio, to which he added the new technique of oil painting. Alberti accepted commissions in the courts of northern Italy, thus bringing his classicizing architecture to other regions of Italy. In Mantua, the artist and humanist Mantegna made paintings inspired by his interest in archeology, while his work as a court painter produced illusionistic frescoes that flattered his employer. Venice adhered to its local traditions in architecture, but hired Verrocchio to sculpt an equestrian portrait of a general that emulated the ancients. Venetian painters were interested in the possibilities for naturalism suggested by the new styles emanating from Florence, but they were also open to the nuances of color and light made possible by oil paints. As the popes rebuilt the city of Rome, they hired artists from Florence and elsewhere to create images that expressed their legitimacy as the heirs of St. Peter and their political power as rulers of the Papal States. Renaissance Naturalism and Classicism proved adaptable to many needs.

The High Renaissance in Italy, 1495–1520

LOOKING BACK AT THE ARTISTS OF THE FIFTEENTH CENTURY, THE ARTIST and art historian Giorgio Vasari wrote in 1550, "Truly great was the advancement conferred on the arts of architecture, painting, and sculpture by those excellent masters...." From Vasari's perspective, the earlier generation had provided artists the groundwork that enabled sixteenth-century

artists to "surpass the age of the ancients." Later artists and critics agreed with Vasari's judgment that the artists who worked in the decades just before and after 1500 attained a perfection in their art worthy of admiration and emulation.

For Vasari, the artists of this generation were paragons of their profession. Following Vasari, artists and art teachers of subsequent centuries have used the works of this 25-year period between 1495 and 1520, known as the *High Renaissance*, as a benchmark against which to measure their own. Yet the idea of a "High" Renaissance presupposes that it follows something "lower," which seems an odd way to characterize the Italian art of the inventive and dynamic fifteenth century. For this and other reasons, this valuation has been reconsidered in the past few decades. Nonetheless, this brief period saw the creation of what are still some of the most revered works of European art in the world. These works were created by the most celebrated names in the history of art, as chronicled in Vasari's book *The Lives of the Most Eminent Painters, Sculptors and Architects of Italy*. Vasari's book placed the biography of the artist at the center of the study of art, and his *Lives* became a model of art historical writing. Indeed, the celebrity of artists is a distinctive characteristic of the early sixteenth century.

Leonardo, Bramante, Michelangelo, Raphael, Giorgione, and Titian were all sought after in early sixteenth-century Italy, and the two who lived beyond 1520, Michelangelo and Titian, were internationally celebrated during their lifetimes. This fame was part of a wholesale change in the status of artists that had been occurring gradually during the course of the fifteenth century and which gained strength with these artists. Despite the qualities of their births, or the variations in their styles or their personalities, these artists were given the respect due to intellectuals and Humanists. Their social status was on a par with members of the great royal courts. In some cases, they were called "genius" or "divine." Some among them were raised to the nobility.

Part of this cult of fame was due to the patrons who commissioned this small number of gifted and ambitious men to make works of art for them. This period saw the coming together of demanding patrons—rulers, popes, princes—and innovative artists. Patrons competed for works by these artists and set the artists in competition with each other, a pattern that had already begun in early fifteenth-century Florence; the skills of the artists were tested against each other to inspire them to produce innovations in technique and in expression. The prestige of the patrons contributed to the mystique that developed around the artists, and the reputations of the artists enriched the prestige of the patrons. What is truly remarkable about this group of artists is their mastery of technique in their

Detail of figure 16.16, Michelangelo, *Awakening Prisoner*

chosen media and in their styles of expression. Each of these artists developed a distinctive visual style that grew out of the ideas of the fifteenth century, but which, through their personal vision, their awareness of intellectual trends of their times, and their hard work, created works of art that their contemporaries claimed surpassed both Nature and the ancients. Their pictorial works share certain features: an approach to the imitation of Nature that idealizes forms even as they are rendered to replicate Nature; an understanding of and reliance on the forms of antiquity; a balance and clarity in their compositions; and an emotional power.

Also remarkable is that works of such authority and harmony were produced during a quarter century of crisis and instability. During this period, Italy was threatened by the Turkish expansion from Istanbul, invaded by the French, and torn apart by internal wars. Florence saw the exile of the Medici, the rise of Girolamo Savonarola, the establishment of a republic, and the return of the Medici. Venice saw its territories stripped away by its rivals. Milan was ruled by a despot, then conquered by the French. The papacy began a program of territorial reclamation and expansion that brought it into conflict with its neighbors; the Roman Church also had to contend with the shock of a theological challenge offered by Martin Luther's critique of Catholic dogma and practice. All of Europe was shocked by reports of new lands and new peoples across the ocean, which challenged their notion of the world itself.

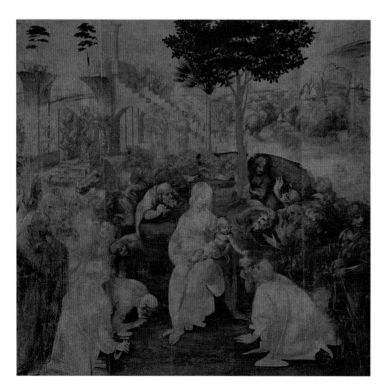

16.1. Leonardo da Vinci. *Adoration of the Magi*. 1481–1482. Monochrome on panel, 8′ × 8′1″ (2.43 × 2.46 m). Galleria degli Uffizi, Florence

THE HIGH RENAISSANCE IN FLORENCE AND MILAN

Florence's reputation as a center for the arts made it a magnet for artists and patrons as the fifteenth century came to a close. The brilliance of the court around Lorenzo de' Medici came to an end with his death in 1492 and the subsequent failure of his son as the leader of the city. Many Florentines heeded the warnings of the preacher Girolamo Savonarola, who encouraged them to reform their faith and their lives; in response, they rejected the worldly culture of the Medici court. Under his influence, "pagan" texts and works of art were burned in bonfires in the Piazza della Signoria; the painter Sandro Botticelli destroyed several of his paintings at these bonfires. Yet the penitential furor that Savonarola urged did not outlive the preacher's execution in 1498. Florence restored its republican form of government, which lasted only until the next generation of Medici politicians took the reins of government in 1512. The political ferment seems to have inspired tremendous artistic innovation, as witnessed in the works of Leonardo da Vinci and Michelangelo Buonarotti.

Leonardo da Vinci in Florence

Leonardo da Vinci was at once a scientist, painter, sculptor, musician, architect, and engineer. The son of a notary, Leonardo was born in the little Tuscan town of Vinci in 1452 and trained as a painter in Florence in Verrocchio's busy workshop. He left Florence around 1482 to work for Ludovico Sforza, the duke of Milan, primarily as a military engineer and only secondarily as an artist. On Sforza's removal by the French in 1499, Leonardo made his way to Venice, Rome, and Florence, where he executed several commissions between 1503 and 1505. From 1506 through 1516 he worked in Rome and Florence and again in Milan, whose French overlord, Francis I, invited him to retire to a chateau in the Loire Valley. Leonardo died there in 1519.

When he left Florence in 1482, Leonardo had been working on an ambitious panel of the *Adoration of the Magi* (fig. **16.1**), commissioned by a group of Florentine monks; but he left it unfinished except for the ground and the underdrawing. While the theme is traditional, the panel otherwise displays Leonardo's inventive approach to rendering form. For the background structures, he deploys an exact perspective and a geometric order that recall Masaccio (see fig. 15.14). He then installs the main figures in a pyramidal arrangement that places the Virgin's head at the apex, surrounded by a sweeping arc of onlookers. There seems little connection between these foreground figures and the background elements, though the tree at the center bridges them. The gracefulness of the Madonna and Child reflects Florentine style in about the year 1480, though much else about the panel is revolutionary.

This is especially true in its execution. Although Leonardo had completed only some of the initial layers of the painting, the forms in the panel seem to materialize softly and gradually, never quite detaching themselves from the dusky atmosphere.

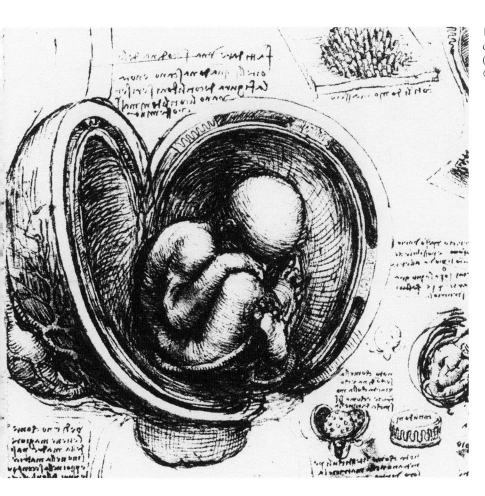

16.2. Leonardo da Vinci. *Embryo in the Womb.* ca. 1510. Detail of pen drawing, $11^{7}/_{8} \times 8^{3}/_{8}''$ (30.4 × 21.5 cm). Windsor Castle, Royal Library. © 1991 Her Majesty Queen Elizabeth II

Leonardo, unlike Filippo Lippi or Botticelli, thought not in terms of outlines but of three-dimensional bodies made visible in varying degrees by the fall of light (compare with figs. 15.39 and 15.42). This method of modeling is called **chiaroscuro**, the Italian word for "light and dark." Starting from a middle tone laid all over the panel, Leonardo renders deep shadows and bright highlights for his forms. Instead of standing side by side in a vacuum, forms share in a new pictorial unity created by the softening of contours in an envelope of atmosphere.

Leonardo seeks emotional continuity as well. Instead of the distracting profusion of people, animals, and things in Gentile da Fabriano's *Adoration of the Magi* of 1423 (fig. 15.12), Leonardo arranges his figures so that all gaze at the Mother and Child at the center of the picture. The figures are remarkable for the expression of emotion through gestures and faces, which Leonardo learned from his study of both Pollaiuollo and Verrocchio (see figs. 15.36 and 15.27). Despite its unfinished state, the panel suggests the direction that Leonardo's art would take, in its technical daring and its emotional depth.

Leonardo in Milan

Instead of completing this panel, Leonardo left Florence for Milan, where he entered the employ of Ludovico Sforza, Duke of Milan. He stayed there until 1499, working as an engineer, court artist, and military designer. As had Brunelleschi before

him, Leonardo turned to analysis and research to solve a variety of problems, both artistic and scientific. He believed the world to be intelligible through mathematics, which formed the basis for his investigations. Thus the artist must know not only the rules of perspective, but all the laws of Nature. To him the eye was the perfect means of gaining such knowledge. The extraordinary range of his inquiries can be seen in the hundreds of drawings and notes that he hoped to turn into an encyclopedic set of treatises. He was fascinated by all elements of Nature: animals, water, anatomy, and the workings of the mind. How original he was as a scientist is still a matter of debate, but he created modern scientific illustration, an essential tool for anatomists and biologists. His drawings, such as the *Embryo in the Womb* (fig. **16.2**), combine his own vivid observations with the analytic clarity of diagrams—or, to paraphrase Leonardo's own words, sight and insight. The sheet of studies shown in figure 16.2 depends on his skill at rendering what he saw, and on his dispassionate recording of details both in visual terms and in his notes, written backwards in mirror writing.

Like other fifteenth-century scholars, he read ancient authorities to assist his inquiries. To prepare himself for human dissections, Leonardo read the works of the Greek physician Galen. His interest in architecture and engineering led him to the works of the Roman architect Vitruvius, whose treatise had

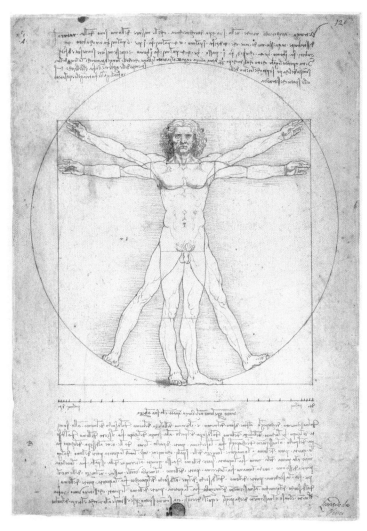

16.3. Leonardo da Vinci. *Vitruvian Man.* ca. 1487. Pen and ink, 13½ × 9½″ (34.3 × 24.5 cm). Gallerie dell'Accademia, Venice

Soon after arriving in Milan, Leonardo painted *The Virgin of the Rocks* (fig. **16.5**) for a Confraternity of the Immaculate Conception, which maintained a chapel in San Francesco Grande. The subject—the infant St. John adoring Jesus in the presence of the Virgin—enjoyed a certain popularity in Florence in the late fifteenth century. Speculation on the early life of Jesus and his cousin, the Baptist, led to stories about their meeting as children. Franciscan preachers encouraged believers to meditate on the "human" side of Jesus' life and stories like this were the result. Such tales report the young Baptist spending his life as a hermit, and he is sometimes represented wearing a hair shirt. Leonardo imagines this meeting almost as a vision of Christ appearing to the infant Baptist in the wilderness. The young Baptist kneels on the left and looks toward Jesus, who blesses him. The Virgin Mary is the link between the two boys, as she protectively reaches for the Baptist with one hand and holds an open palm over her son with the other. An angel with a billowing red cloak steadies Jesus and points toward the Baptist, while looking out at the viewer.

The scene is mysterious in many ways. The secluded rocky setting, the pool in the foreground, and the carefully rendered plant life suggest symbolic meanings, but scholars are still

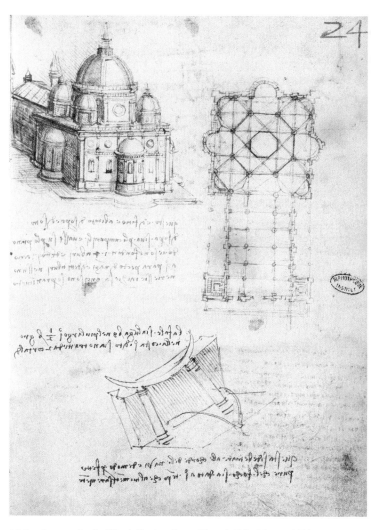

16.4. Leonardo da Vinci. *Project for a Church* (Ms. B). ca. 1490. Pen drawing, 9⅛ × 6¾″ (23 × 17 cm). Bibliothèque de l'Arsenal, Paris

inspired Alberti earlier in the century. A drawing from the late 1480s (fig. **16.3**) visualizes Vitruvius' notion that the human body may be used to derive the perfect geometrical forms of the circle and the square. This is a powerful image of the value that humanists and architects placed on these geometric elements, as carriers of profound meaning as well as visual forms. Like other humanists, Leonardo was interested in the place of man in the world.

Leonardo himself was esteemed as an architect. He seems, however, to have been less concerned with actual building than with tackling problems of structure and design. For the most part, the many architectural projects in his drawings were intended to remain on paper. Yet these sketches, especially those of his Milanese period, reveal Leonardo's probing of the design problems faced by his forebears, Brunelleschi and Alberti, and his contemporaries. The domed central-plan churches of the type shown in figure **16.4** hold particular interest to architectural history. In this drawing Leonardo imagines a union of circle and square, controlled by proportion, and articulated by Classical orders. In conception, this design stands halfway between the dome of Florence Cathedral and the most ambitious structure of the sixteenth century, the new basilica of St. Peter's in Rome.

debating the details. The figures emerge from the semidarkness of the grotto, enveloped in a moist atmosphere that delicately veils their forms. This fine haze, called **sfumato** (smokiness), lends an unusual warmth and intimacy to the scene. The light draws attention to the finely realized bodies of the children and the beautiful heads of the grownups. Leonardo arranges the figures into a pyramid of form, so the composition is stable and balanced, but the gestures lead the eye back and forth to suggest the relationships among the figures. The selective light, quiet mood, and tender gestures create a remote, dreamlike quality, and make the picture seem a poetic vision rather than an image of reality.

Leonardo had much to say about the relation between poetry and painting. He thought sight was the superior sense and that painters were best equipped to represent what the eye could see or imagine. His notebooks include many comments on the *paragone*, or comparison, between painting and poetry. This competition between art forms was rooted in the Roman

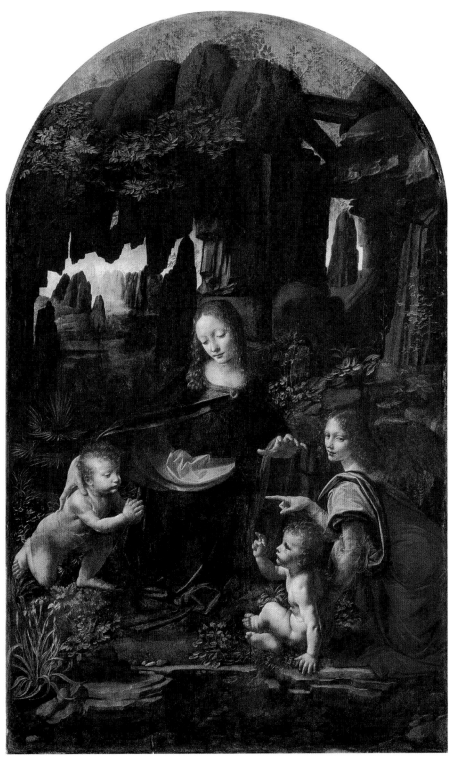

16.5. Leonardo da Vinci. *The Virgin of the Rocks*. ca. 1485. Oil on panel transferred to canvas, 6'6" × 4' (1.9 × 1.2 m). Musée du Louvre, Paris

Leonardo Da Vinci (1452–1519)

From his undated manuscripts

Leonardo, the consummate High Renaissance man, wrote on a variety of topics. The comparison of the arts, or paragone*, was a common subject in High Renaissance scholarship.*

He Who Depreciates Painting Loves Neither Philosophy nor Nature

If you despise painting, which is the sole imitator of all visible works of nature, you certainly will be despising a subtle invention which brings philosophy and subtle speculation to bear on the nature of all forms—sea and land, plants and animals, grasses and flowers—which are enveloped in shade and light. Truly painting is a science, the true-born child of nature. For painting is born of nature; to be more correct we should call it the grandchild of nature, since all visible things were brought forth by nature and these, her children, have given birth to painting. Therefore we may justly speak of it as the grandchild of nature and as related to God.

A Comparison Between Poetry and Painting

The imagination cannot visualize such beauty as is seen by the eye, because the eye receives the actual semblances or images of objects and transmits them through the sense organ to the understanding where they are judged. But the imagination never gets outside the understanding; . . . it reaches the memory and stops and dies there if the imagined object is not of great beauty; thus poetry is born in the mind or rather in the imagination of the poet who, because he describes the same things as the painter, claims to be the painter's equal! . . .

The object of the imagination does not come from without but is born in the darkness of the mind's eye. What a difference between forming a mental image of such light in the darkness of the mind's eye and actually perceiving it outside the darkness!

If you, poet, had to represent a murderous battle you would have to describe the air obscured and darkened by fumes from frightful and deadly engines mixed with thick clouds of dust polluting the atmosphere, and the panicky flight of wretches fearful of horrible death. In that case the painter will be your superior, because your pen will be worn out before you can fully describe what the painter can demonstrate forthwith by the aid of his science, and your tongue will be parched with thirst and your body overcome by sleep and hunger before you can describe with words what a painter is able to show you in an instant.

Of the Sculptor and Painter

The sculptor's art requires more physical exertion than the painter's, that is to say, his work is mechanical and entails less mental effort. Compared with painting, there is little scientific research; for the sculptor's work consists in only taking off and the painter's in always putting on. The sculptor is always taking off from the same material, while the painter is always putting on a variety of materials. The sculptor gives all his attention to the lines that circumscribe the material which he is carving, and the painter studies these same lines, but he has besides to study the shade and light, the color and the foreshortening. With respect to these the sculptor is helped throughout by nature, which supplies the shade and light and the perspective. While the painter has to acquire these by dint of his ingenuity and has himself to play the part of nature, the sculptor always finds them ready made.

SOURCE: *THE LITERARY WORKS OF LEONARDO DA VINCI*, ED. JEAN PAUL RICHTER. (LONDON:PHAIDON PRESS LTD., 1975)

poet Horace's statement that poetry is like painting (*ut pictura poesis*), which artists of the High Renaissance reinterpreted to mean that painting ought to conform to poetry. (See *Primary Source*, above.) Leonardo's musings on the competition between poetry and painting further extended to the competition between painting and sculpture. He argued that painting was superior to sculpture primarily because it provided the possibility for creating the sort of illusionary spaces and textures seen in the *Virgin of the Rocks*. Additionally, the painter could dress elegantly while he worked, and not subject himself to the clouds of dust or the brute force needed to make sculpture. Not all of his contemporaries agreed. Michelangelo, for one, defended the art of sculpture as superior to painting, precisely because it created fully three-dimensional forms while painting merely created illusions.

Leonardo's skill at creating such illusions and his experimental approach to achieving them is apparent in *The Last Supper* (fig. **16.6**), executed between 1495 and 1498. Leonardo's patron, Duke Ludovico, commissioned him to decorate the refectory (dining hall) of the Dominican monastery of Santa Maria delle Grazie, which housed the Duke's family

chapel. The resulting painting was instantly famous and copied numerous times by other artists, but a modern viewer can only imagine its original splendor, even though the painting was recently restored. Dissatisfied with the limitations of the traditional fresco technique, Leonardo experimented with an oil-tempera medium on dry plaster that did not adhere well to the wall in the humidity of Milan. What is more, the painting has been diminished by renovations and damage done to the wall. Yet what remains is more than adequate to account for its tremendous impact.

The theme of the Last Supper was conventional for monastic refectories, as a comparison with Castagno's *Last Supper* (see fig. 15.29), painted half a century before, reveals. Monks or nuns dined in silence before images of the apostles and Christ at table. Like Castagno, Leonardo creates a spatial setting that seems like an annex to the real interior of the room, though deeper and more atmospheric than the earlier fresco. The central vanishing point of the perspective system is located behind the head of Jesus in the exact middle of the fresco; it thus becomes charged with symbolic significance. Equally symbolic is the opening in the wall behind Jesus: It

acts as the architectural equivalent of a halo. Rather than Castagno's explosion of marble veining or an artificial disk of gold, Leonardo lets natural light enframe Jesus. All elements of the picture—light, composition, colors, setting—focus the attention on Jesus.

He has presumably just spoken the fateful words, "One of you shall betray me." The disciples ask, "Lord, is it I?" The apostles who flank Jesus do not simply react to these words. Each reveals his own personality, his own relationship to Jesus. In the group to his right, Peter impulsively grabs a knife, next to him John seems lost in thought; and Judas (the figure leaning on the table in the group to Jesus' right) recoils from Jesus into shadow. Leonardo has carefully calculated each pose and expression so that the drama unfolds across the picture plane. The figures exemplify what the artist wrote in one of his notebooks—that the highest and most difficult aim of painting is to depict "the intention of man's soul" through gestures and movements of the limbs.

But to view this scene as just one moment in a psychological drama does not do justice to Leonardo's aims, which went well beyond a literal rendering of the biblical narrative. He clearly wanted to condense his subject, both physically (by the compact, monumental grouping of the figures) and spiritually (by presenting many levels of meaning at one time). Thus Jesus' gesture is both one of submission to the divine will and of offering. His calm presence at the center of the table suggests that in

ART IN TIME

1498—Execution of Savonarola in Florence

1499—France conquers Milan

ca. 1503—Leonardo's *Mona Lisa*

1512—Florentine Republic is dismantled and the Medici family comes back to power

addition to the drama of the announcement, Jesus also institutes the Eucharist, in which bread and wine become his body and blood. Such multiple meanings would serve as spiritual food for the Dominican friars who lived in the presence of this image.

In 1499, the duchy of Milan fell to the French, and Leonardo returned to Florence after brief trips to Mantua and Venice. He must have found the climate very different from what he remembered. Florentines had become unhappy with the rule of Lorenzo de' Medici's son, Piero, and expelled the Medici, and until their return in 1512, the city was briefly a republic again. For a while, Leonardo seems to have been active mainly as an engineer and surveyor. Then in 1503 the city commissioned him to do a mural for the council chamber of the Palazzo della Signoria, but in 1506 he abandoned the commission and returned to Milan.

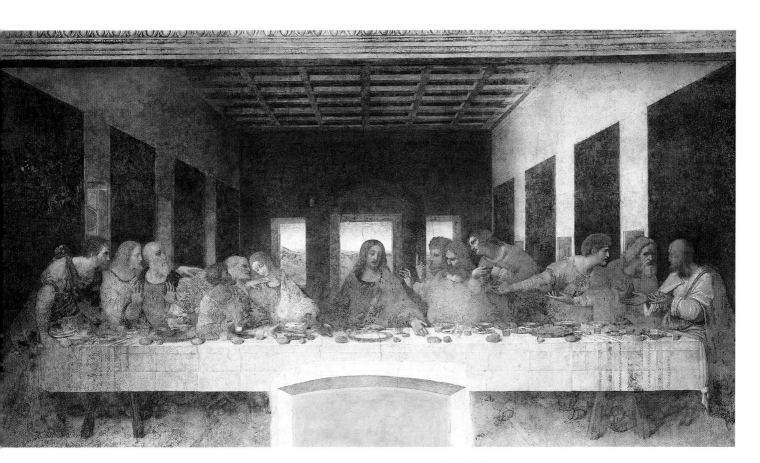

16.6. Leonardo da Vinci. *The Last Supper.* ca. 1495–1498. Tempera wall mural, 15'2" × 28'10" (4.6 × 8.8 m). Santa Maria delle Grazie, Milan

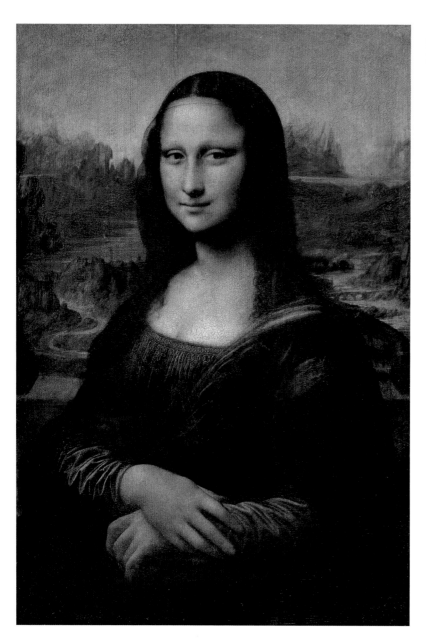

16.7. Leonardo da Vinci. *Mona Lisa*. ca. 1503–1505. Oil on panel, $30\frac{1}{4} \times 21''$ (77 × 53.5 cm). Musée du Louvre, Paris

Reinventing the Female Portrait

While working on the mural, Leonardo also painted the portrait of a woman, whom Vasari identified as Lisa di Gherardo, wife of Francesco del Giocondo, the so-called *Mona Lisa* (fig. **16.7**). If it is indeed Ma[don]na (Lady) Lisa, which is not universally acknowledged, she was about 25 when the portrait was made. For reasons that are unclear, Leonardo kept this painting, and after his death in France, the portrait entered the collection of Francis I. From the royal collection, it became a key possession of the Musée du Louvre. To some extent its fame is a product of its ownership.

But it is also famous for its formal qualities, as Leonardo reinvents the female portrait in this image. In the fifteenth century, portraits were made of women at their marriages, often in a profile format that stressed the woman's expensive garments over her personality or features. Here, Leonardo adopts the Northern European device of the three-quarter pose and

represents the lady at half-length, so that her hands are included in the image and the whole composition forms a stable pyramid. Light washes over her, drawing attention to her features. The forms are built from layers of glazes so thin that the panel appears to glow with a gentle light from within, despite the dirty varnish that obscures the painting. The lady sits before an evocative landscape, whose mountainous elements emerge from a cool *sfumato* backdrop, while the rivers and bridges winding through it echo the highlights on her drapery. Where earlier portraits paid as much attention to a woman's jewels as her person, Leonardo concentrates on the fashionably plucked high forehead. The skill with which he renders the lady's veil and the hands give her as much character as the famous smile. Vasari helped to spread the fame of the painting, for he claimed the portrait exemplified "how faithfully art can imitate nature." This skill, for Vasari, was the root of Leonardo's genius. (See end of Part II, *Additional Primary Sources*.)

ROME RESURGENT

By the end of the fifteenth century, the papacy had firmly established itself back in Rome. Along with their spiritual control of the Church, the popes reasserted political and military control over the Papal States in the area around Rome. Rebuilding the city of Rome was an expression of the papal intentions to rule there, as Sixtus IV had demonstrated with his building of the Sistine Chapel, among other projects. Alexander VI, who became pope in 1492, used his papacy to enlarge papal domains through military exploits undertaken by his son Cesare Borgia, and he also made the papal court the peer of any princely court in Italy. On his death, the new pope Julius II (1503–1513) made his aim the physical renewal of the city of Rome, hoping that it would rival the glory of the ancient city. Julius invested vast sums in large-scale projects of architecture, sculpture, and painting, and he called numerous artists to work for him. Under Julius, Rome became the crucible of the High Renaissance.

Bramante in Rome

The most important architect in Julius's Rome was Donato Bramante (1444–1514). A native of Urbino, he began his career as a fresco painter. Influenced by Piero della Francesca and Andrea Mantegna, Bramante became skilled at rendering architectural settings in correct perspective. Leonardo may have had some influence on Bramante too, as both men were colleagues at the court of Milan. Bramante's architectural works take Brunelleschi and Alberti as their main points of departure.

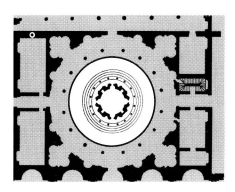

16.9. Plan of Bramante's Tempietto (after Serlio, in *Regole generali di architettura*).

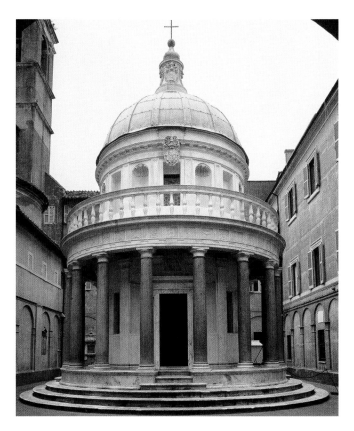

16.8. Donato Bramante. The Tempietto, San Pietro in Montorio, Rome. 1502–1511

After Milan fell to the French in 1499, Bramante went to Rome, where he experienced Roman buildings firsthand. There, the Spanish-born Pope Alexander VI had begun the process of enlarging and enhancing papal holdings, in which he had the support of the powerful Spanish monarchs, Ferdinand and Isabella. The Spanish kings commissioned Bramante around 1500 to build a structure to mark the supposed site of St. Peter's crucifixion, attached to the church of San Pietro in Montorio (fig. **16.8**). Because of its powerful evocation of Roman circular temples, it was called the Tempietto, or "little temple." This structure serves as a martyrium, a special chapel associated with a martyr.

In early Christian Rome, such structures were often centralized in plan. Bramante, however, seems as much inspired by the precepts of Alberti and the experiments of Leonardo as he is by the experience of Rome itself. A contemporary, Sebastiano Serlio, recorded Bramante's design in an architectural treatise that was published in the 1540s. According to this plan, Bramante intended for the Tempietto to be surrounded by a circular, colonnaded courtyard that entirely responds to the structure. This conception was as bold and novel as the design of the chapel itself (fig. **16.9**), for not only does the chapel's colonnade dictate the courtyard's colonnade, the walls of the courtyard opened into concave niches that echo the facade of the chapel.

This facade, with its three-step platform and the plain Tuscan Doric order, recalls Roman temple architecture more directly than does any fifteenth-century building (compare fig. 7.46). Moreover, the entire design is based on the module of the columns: For example, the distance between the columns is four times their diameter, and they are placed two diameters from the wall. This insistent logic follows the rules of temple design established by Vitruvius. Equally striking is Bramante's use of the "sculptured wall" in the Tempietto itself and the courtyard, as shown in the plan. Deeply recessed niches in the upper story are counterbalanced by the convex shape of the dome and by strongly projecting moldings and cornices. As a result, the Tempietto has a monumentality that belies its modest size. The building, including the sculptural decoration in the metopes and frieze around the base, is a brilliant example of papal propaganda.

16.10. Donato Bramante. Original plan for St. Peter's, Rome. 1506 (after Geymuller)

The Tempietto proclaims Christ and the popes (considered the successors of St. Peter) as the direct heirs of Rome. Bramante used the language of ancient Rome to express the claims of the modern pope. The publication of the design by Serlio helped spread the specific elements and the underlying design concepts of this building, and it became a very influential structure.

Such work brought Bramante to the notice of Alexander VI's successor, Julius II, who was pope between 1503 and 1513. The nephew of Sixtus IV, represented in the fresco by Melozzo da Forli in the Vatican (fig. 15.58), Giuliano delle Rovere, as Pope Julius II, was probably the most worldly and ambitious

pope of the Renaissance. He used art and artists as tools in his goal of restoring papal authority over Christendom. This is nowhere more evident than in Julius's decision to replace the Constantinian basilica of St. Peter's, which was in poor condition, with a church so magnificent that it would overshadow all the monuments of imperial Rome. He gave the commission to Bramante and laid the cornerstone in 1506. Bramante's original design is known mostly from a plan (fig. **16.10**) and from the medal commemorating the start of the building campaign (fig. **16.11**), which shows the exterior in general terms. These reveal the innovative approach that Bramante took in this project, which was grand both in scale and in conception.

The plan and commemorative medal indicate that Bramante planned a huge round dome, similar to the Pantheon's, to crown the crossing of the barrel-vaulted arms of a Greek cross. Four lesser domes, each surmounting a chapel that echoes the main space, and tall corner towers were planned around the central dome. As Alberti prescribed and Leonardo proposed, Bramante's plan is based on the circle and the square. These perfect forms were revered by the ancients and chosen as appropriate symbols for the Christian empire that Julius planned. Bramante envisioned four identical facades dominated by classical forms: domes, half-domes, colonnades, and pediments. The principal dome would have been encircled by a colonnade as well. The whole facade would have been a unified, symmetrical sculptural form, united by proportion and the interplay of geometric elements.

But this logical interlocking of forms would have been accompanied by the structure's huge scale, for Julius's church was intended to be more than 500 feet long. Such a monumental undertaking required vast sums of money, and the construction of St. Peter's progressed so slowly that in 1514, when Bramante died, only the four crossing piers had been built. For the next three decades the project was carried on by architects trained under Bramante, who altered his design in a number of ways. A new and decisive phase in the history of St. Peter's began in 1546, when Michelangelo took charge. It was then altered again in the seventeenth century. Nevertheless, Bramante's original plan for St. Peter's was to put Roman imperial and Early Christian forms at the service of a Renaissance pope's spiritual and temporal ambitions.

Michelangelo in Rome and Florence

Julius's ambitions were also the spur for one of the crucial figures in the history of art, Michelangelo di Lodovico Buonarroti Simoni (1475–1564). Acclaimed by his contemporaries, admired by his successors, hailed as "divine" by Vasari, Michelangelo is one of the most influential and imitated artists in history. Gifted, driven, he has become the archetype of the genius, whose intellect and talents enabled him to work in many media; he was a sculptor, architect, painter, and poet. In his ambition to outdo the artists of antiquity he was encouraged by Pope Julius II, who gave him the opportunities for some of his most inspired and famous works.

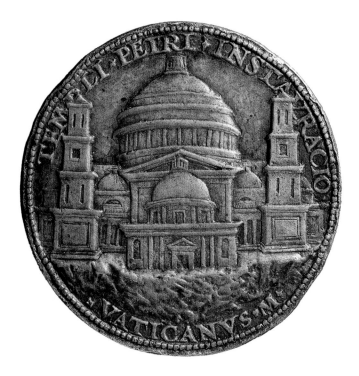

16.11. Cristoforo Foppa Caradosso. Bronze medal showing Bramante's design for St. Peter's. 1506. The British Museum, London

PRIMARY SOURCE

Michelangelo Interprets the Vatican Pietà

The Pietà *for Cardinal Jean de Villiers de la Groslaye, now in St. Peter's, helped to establish Michelangelo's reputation as a sculptor. In his* Life of Michelangelo Buonarotti, *first published in 1553, Michelangelo's friend and biographer, Ascanio Condivi, quotes the sculptor explaining features of the work.*

A little later on, the Cardinal of Saint-Denis . . . commissioned him to make from one piece of marble that marvelous statue of Our Lady . . . [she] is positioned seated on the rock, in which the cross was sunk, with her dead Son on her lap, and of such and so rare a beauty, that no one sees her without being inwardly moved to pity. An image truly worthy of the humanity which belongs properly to the Son of God and to such a mother; although there are some who make the reproach that the mother is shown as too young, in relation to her Son. But when I was discussing this with Michelangelo one day, he replied to me: "Don't you know that chaste women remain far fresher than those who are not chaste? So much more the Virgin, in whom never has the least lascivious desire ever arisen that might alter her body.

Moreover, let me add this, that besides such freshness and flower of youth being maintained in her in this natural way it may be believed to have been assisted by divine power to prove to the world the virginity and perpetual purity of the mother. This was not necessary in the Son; rather completely the opposite; because to show that, as He did, the Son of God took a truly human body, and was subjected to all that an ordinary man endures, except sin, there was no need for the divine to hold back the human, but to leave it to its order and course, so that the time of life He showed was exactly what it was. Consequently you are not to wonder if for these reasons I have made the most Holy Virgin, mother of God, far younger in comparison with her Son than her age would ordinarily require, and that I left the Son at his own age."

This reflection would be worthy of any theologian . . . When he made this work, Michelangelo would have been 24 or 25 years old. He acquired great fame and reputation from this effort, and indeed it was already everyone's opinion that he had not only surpassed all his contemporaries, and those who came before him, but that he also contended with the ancients.

SOURCE: *MICHELANGELO, LIFE, LETTERS AND POETRY.* ED. AND TR. GEORGE BULL. (OXFORD: OXFORD UNIVERSITY PRESS, 1987)

Unlike Leonardo, for whom painting was the noblest of the arts because it embraced every visible aspect of the world, Michelangelo was a sculptor to the core. More specifically, he was a carver of marble statues. The limitations of sculpture, which Leonardo condemned as mechanical, unimaginative, and dirty, were virtues in Michelangelo's eyes. Only the "liberation" of real, three-dimensional bodies from recalcitrant matter would satisfy Michelangelo. Painting, for him, should imitate the roundness of sculptured forms. Architecture, too, ought to share the organic qualities of the human figure.

Michelangelo's belief in the human image as the supreme vehicle of expression gave him a sense of kinship with ancient sculpture, more so than with any other Renaissance artist. Among Italian masters, he admired Giotto, Masaccio, and Donatello more than his contemporaries. Although his family came from the nobility, and therefore initially opposed his desire to become an artist, Michelangelo was apprenticed to Ghirlandaio, from whom he learned techniques of painting. He came to the attention of Lorenzo de' Medici, who invited him to study the antique statues in the garden of one of the Medici houses. This collection was overseen by Bertoldo di Giovanni (ca. 1420–1491), a pupil of Donatello, who may have taught Michelangelo the rudiments of sculpture. From the beginning, however, Michelangelo was a carver rather than a modeler. He rarely worked in clay, except for sketches; he preferred harder materials, especially marble, which he shaped with his chisel.

The young artist's mind was decisively shaped by the cultural climate of Florence during the 1480s and 1490s, even though the troubled times led him to flee the city for Rome in 1496. Lorenzo de' Medici's death in 1492 put an end to the intellectual climate he had fostered. The subsequent expulsion

of the Medici, and the rise to power of the fiery preacher Girolamo Savonarola, brought calls for a spiritual awakening and a rejection of "paganism" and materialism. Both the Neo-Platonism of Marsilio Ficino and the religious reforms of Savonarola affected Michelangelo profoundly. These conflicting influences reinforced the tensions in his personality, including violent mood changes and his sense of being at odds with himself and with the world. Just as he conceived his statues as human bodies released from their marble prisons, so he saw the body as the earthly prison of the soul—noble perhaps, but a prison nonetheless. This dualism of body and spirit endows his figures with extraordinary pathos. Although outwardly calm, they seem stirred by an overwhelming psychic energy that finds no release in physical action.

PIETÀ Having left Florence after the Medici were exiled, Michelangelo worked in Bologna and then Rome, where he was commissioned in 1498 by a French cardinal to carve a *Pietà* for his tomb chapel attached to St. Peter's (fig. **16.12**). In the contract, Michelangelo promised to carve "the most beautiful work of marble in Rome." The subject of the *Pietà* was more familiar in Northern Europe than in Italy, appearing in such works as the *Roettgen Pietà* (fig. 12.56), although the theme of the Virgin's Lamentation for her dead son had appeared in works such as Giotto's Arena Chapel frescoes (see fig. 13.21). Michelangelo, however, imagines the farewell between Mother and Son as a calm and transcendent moment rather than a tortured or hopeless one. The composition is stable; the overlarge figure of the Virgin with her deeply carved robe easily supports her dead son.

The figures are beautiful rather than tormented. The Virgin is far too young to be holding her grown son, so perhaps

the image is an echo of the Madonna and Child, as well as the Pietà itself. Michelangelo himself intended her youth to express her perpetual Virginity, according to his friend and biographer, Ascanio Condivi (see *Primary Source*, page 565). Michelangelo doesn't merely tell a story, but offers viewers the opportunity to contemplate the central mystery of Christian faith—Christ as God in human form who sacrificed himself to redeem original sin—with the same serenity as Mary herself. When the *Pietà* was first displayed in 1499 some controversy surrounded its authorship; Michelangelo put it to rest by carving his name on the Virgin's sash. The inscription proudly asserts his authorship and his origin in Florence. At 24, his fame was assured.

DAVID When this project was completed, Michelangelo returned to Florence, which had reestablished a republican form of government. There, in 1501, directors of the works for Florence Cathedral a commissioned him to execute a figure to be placed on one of the buttresses. The 18-foot high block of marble for this project had been partly carved by an earlier

sculptor, but Michelangelo accepted the challenge to create something memorable from it. The result was the gigantic figure of the *David* (fig. **16.13**). When it was completed in 1504, a committee of civic leaders and artists decided instead to put it in front of the Palazzo della Signoria, the seat of the Florentine government. They placed a circlet of gilt bronze leaves around the statue's hips and put a gilt bronze wreath on David's head. The city of Florence claimed the figure as an emblem of its own republican virtues.

Michelangelo treated the biblical figure not as a victorious hero, but as the ever vigilant guardian of the city. Unlike Donatello in his bronze *David* for the Medici (fig. 15.35), Michelangelo omits the head of Goliath; instead David nervously fingers a slingshot, as his eyes focus on an opponent in the distance. Although both Donatello and Michelangelo rendered David as nudes, the style of the later sculpture proclaims an ideal very different from the wiry slenderness of Donatello's youth. Michelangelo had just spent several years in Rome, where he had been deeply impressed with the emotion-charged, muscular bodies of Hellenistic sculpture, which

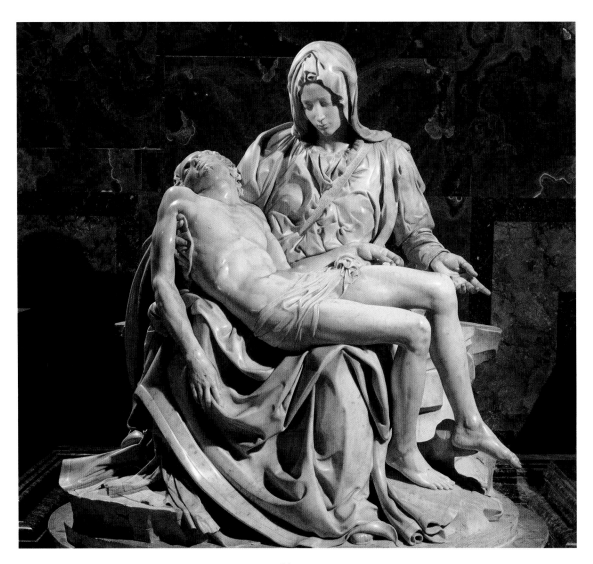

16.12. Michelangelo. *Pietà*. ca. 1498. Marble, height 68$\frac{1}{2}$″ (173.9 cm). St. Peter's, Rome

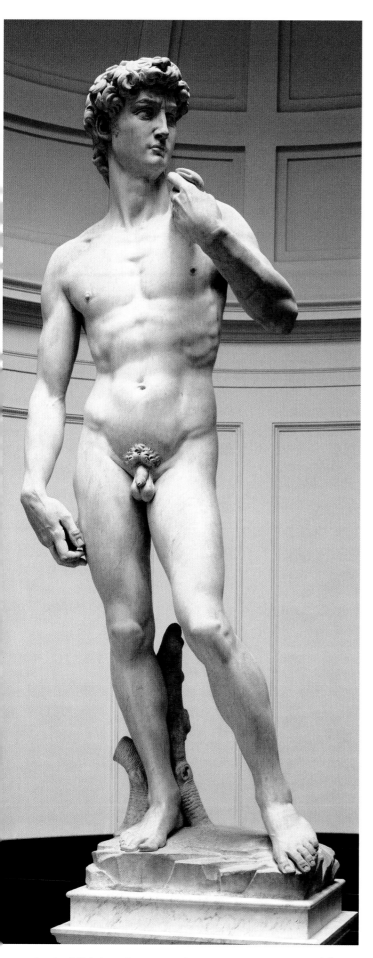

were being avidly collected there (see *The Art Historian's Lens*, page 156). Their heroic scale, their superhuman beauty and power, and the swelling volume of their forms became part of Michelangelo's own style and, through him, of Renaissance art in general. In the *David*, Michelangelo competes with antiquity on equal terms and replaces its authority with his own. Instead of the emotionally wrought figures he saw in Hellenistic works, Michelangelo crafted the *David* to be at once calm and tense, active yet static, full of the potential for movement rather than its actual expression.

Michelangelo in the Service of Pope Julius II

The ambition to create powerful works of art is a hallmark of Michelangelo's career. It is seen again in the project he undertook for the Tomb of Julius II, planned for the new St. Peter's. The commission was given in 1505, but Julius interrupted it, then died in 1513, leaving the project incomplete. His heirs negotiated with Michelangelo over the next 30 years to produce a reduced version of the original plan. The initial plan, reconstructed in figure **16.14**, combined sculpture and architecture into a grand statement of the glory of the pope. Julius's sarcophagus was to sit at the apex of this architectural mass, intended in the first plan to enclose a burial chamber.

16.13. Michelangelo. *David*. 1501–1504. Marble. Height 13′5″ (4.08 m). Galleria dell'Accademia, Florence

16.14. Reconstruction of Michelangelo's plan (ca. 1505) of the Tomb of Pope Julius II (after Tolnay).

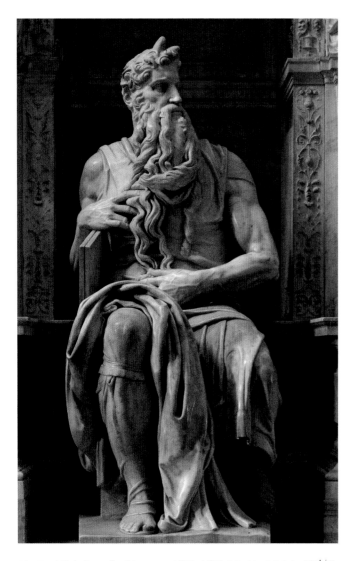

16.15. Michelangelo. *Moses.* ca. 1513–1515. Marble. Height 7′8¹/₂″ (2.35 m). S. Pietro in Vincoli, Rome

On lower levels of the structure Michelangelo planned a figure of St. Paul and an installation of the *Moses* (fig. **16.15**), which was completed about 10 years later. The *Moses,* meant to be seen from below, has the awesome force Vasari called *terribilità*—a concept similar to the "sublime." His pose, both watchful and meditative, suggests a man capable of wise leadership as well as towering wrath. Moses has just received the Ten Commandments, which he holds close to his massive torso. The horns, a traditional attribute based on a mistranslation of the Hebrew word for *light* in the Vulgate (Latin Bible), which is also seen in Sluter's *Well of Moses* (see fig. 14.2), signify the divine favor bestowed on Moses, whose face shone after he came down from Mount Sinai (Exodus 34). The powerful figure of the Moses was to be accompanied by figures of bound men, whose meaning is still obscure, and figures personifying the active and contemplative life. Some of these figures, including the *Moses*, were assembled into the monument for Julius installed in the church of San Pietro in Vincoli in Rome, on a scale much reduced from the initial plan.

One later figure for the tomb, the unfinished *Awakening Prisoner* (fig. **16.16**), provides invaluable insights into Michelangelo's artistic personality and working methods. For him, the

making of a work of art was both joyous and painful, full of surprises, and not mechanical in any way. It appears that he started the process of carving a statue by trying to perceive a figure in the block as it came to him from the quarry. (At times he may even have visualized figures while picking out his material on the spot.) He may have believed that he could see "signs of life" within the marble—a knee or an elbow pressing against the surface. This attitude is expressed in one of his most famous sonnets, written around 1540:

> Not even the best of artists has any conception
> That a single marble block does not contain
> within its excess, and *that* is only attained
> by the hand that obeys the intellect.

> Source: James Saslow's translation, from *The Poetry of Michelangelo*. New Haven, CT: Yale University Press, 1991, p. 302.

16.16. Michelangelo. *Awakening Prisoner.* ca. 1525. Marble. Height 8′11″ (2.7 m). Galleria dell'Accademia, Florence

To get a firmer grip on this dimly felt image that he believed was inside the stone, Michelangelo made numerous drawings, and sometimes small models in wax or clay, before he dared to assault the marble itself. His practice was to draw the main view on the front of the block. Once he started carving, every stroke of the chisel would commit him more and more to a specific conception of the figure hidden in the block. The marble would permit him to free the figure only if his guess about its shape was correct. Sometimes the stone refused to give up some essential part of the figure within it, and he left the work unfinished. Michelangelo himself may have appreciated the expressive qualities of incomplete works. Although he abandoned *Awakening Prisoner* for other reasons, every gesture seems to record the struggle for the liberation of the figure.

Pope Julius interrupted Michelangelo's work on the tomb at an early stage. The pope's decision to enlarge St. Peter's, a commission he gave to Bramante in 1506, altered his patronage priorities, and this so angered Michelangelo that he left Rome. Two years later, the pope half forced, half coaxed him to return to paint frescoes on the ceiling of the Sistine Chapel in the Vatican.

FRESCOES FOR THE SISTINE CHAPEL CEILING

The Sistine Chapel takes its name from Pope Sixtus IV, Julius's uncle, who had it built and adorned between 1477 and 1482. Driven by his desire to resume work on the tomb, Michelangelo finished the ceiling in only four years, between 1508 and 1512 (fig. **16.17**). In this brief period of intense creation in a medium that he never felt was his own, Michelangelo produced a work of truly epochal importance.

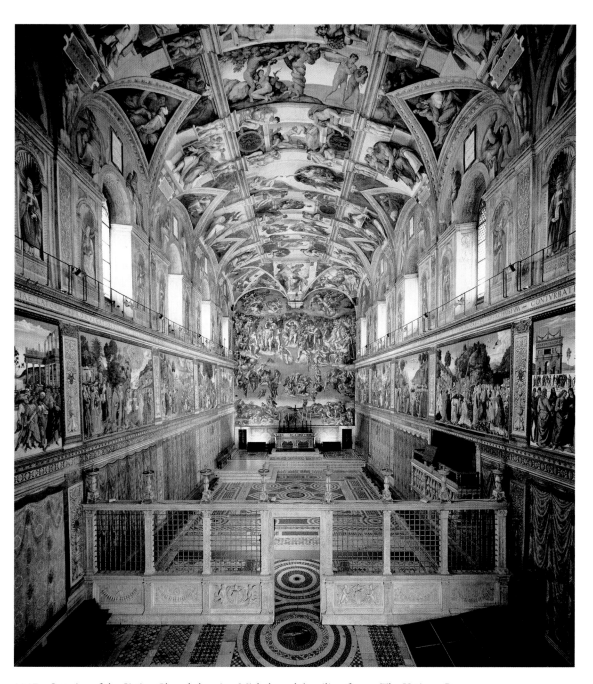

16.17. Interior of the Sistine Chapel showing Michelangelo's ceiling fresco. The Vatican, Rome

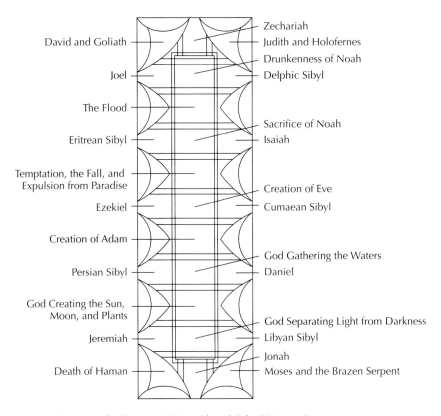

David and Goliath — — Zechariah
— Judith and Holofernes
— Drunkenness of Noah
Joel — — Delphic Sibyl

The Flood —

Eritrean Sibyl — — Sacrifice of Noah
— Isaiah

Temptation, the Fall, and — — Creation of Eve
Expulsion from Paradise
Ezekiel — — Cumaean Sibyl

Creation of Adam —

— God Gathering the Waters
Persian Sibyl — — Daniel

God Creating the Sun, — — God Separating Light from Darkness
Moon, and Plants
Jeremiah — — Libyan Sibyl
— Jonah
Death of Haman — — Moses and the Brazen Serpent

16.18. Diagram of subjects in Sistine Chapel. The Vatican, Rome

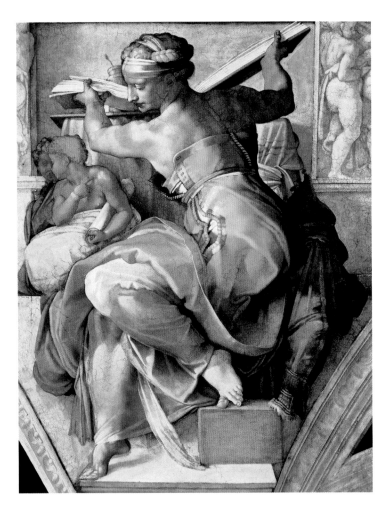

16.19. *Libyan Sibyl* portion of the Sistine Chapel ceiling

The ceiling is a shallow barrel vault interrupted over the windows by the triangular spandrels that support it. Michelangelo treated this surface as a single entity, with hundreds of figures distributed rhythmically within a painted architectural framework. Several different themes intersect throughout this complex structure (see figure **16.18**). In the center, subdivided by ten illusionistic transverse arches, are nine scenes from the book of Genesis, from the Creation of the World (at the altar end) to the Drunkenness of Noah (near the entry door); large figures of prophets and sibyls flank these narratives. In the triangular spandrels sit the ancestors of Christ, who also appear in the lunettes flanking the windows. Further narrative scenes occur at the corner pendentives, focusing on the Old Testament heroes and prophets who prefigured Christ. Scholars are still debating the theological import of the whole program and whether Michelangelo consulted with advisors in the development of the themes. While the Creation and Fall of Man occur at the center of the ceiling, the prophets and ancestors predict the salvation of humanity in Christ. Except for the architecture, these themes are expressed almost entirely by the human figure.

The Sistine Chapel ceiling swarms with figures, most of them in the restless postures seen in the Moses. For example, as seen in figure **16.19**, the *Libyan Sibyl* (a sibyl was a pagan prophetess, in whose prophecies Christians saw evidence for the coming of Christ) barely sits on her throne, but twists backwards to hold her book. Her muscular forms derive from Michelangelo's model drawing of young men. (See *Materials and Techniques*, page 571.) These figures also stem from

Drawings

Medieval artists had used the technique of drawing to record monuments they had seen or to preserve compositions for future use. These drawings were usually made with pen and ink on parchment. During the Renaissance, the increasing availability of paper expanded the uses of drawings and encouraged artists to use a variety of media in making them.

Pen and ink on paper were used most often, as the liquid ink could be transferred to the paper using a sharp quill pen or stylus. Sometimes the forms drawn with ink were further elaborated with a wash (usually diluted ink) applied with a brush. Some artists preferred to work with liquid media and thin brushes to render all the forms.

Artists also drew on the relatively rough surface of paper using charcoal or chalk. These naturally occurring materials are both dry and crumbly enough to leave traces when the artist applies them to the paper. The lines they leave can be thick or thin, rendered with carefully descriptive marks, or with quick evocative strokes. Artists could smudge these soft media to soften contours and fill in shadows, or to produce parallel lines called hatching to describe shadows. See, for example, the variety of strokes Michelangelo used to make the red chalk study for the *Libyan Sibyl* on the Sistine Chapel ceiling.

More difficult to master was the technique of *silverpoint*. This entailed using a metal stylus to leave marks on a surface. Silver was the most prized metal for this technique, though lead was also used. Mistakes could not be undone, so it took great skill to work in silverpoint. To make silver leave traces on paper, the paper had to be stiffened up by coating it with a mixture of finely ground bone and *size* (a gluelike substance). Such coatings were sometimes tinted. When the silver stylus is applied, thin delicate lines are left behind that darken with age.

Renaissance artists also expanded the uses of drawings. Apprentices learned how to render forms using drawings; artists worked out solutions to visual problems with drawings. Drawings were also used to enable artists to negotiate contracts and to record finished works as a kind of diary or model book.

Artists also made cartoons, or full-scale patterns, for larger works such as frescoes or tapestries (see fig. 16.27). Transferring designs from drawings onto larger surfaces could be achieved in a number of ways. A grid could be placed over the design to serve as a guide for replicating the image on a larger scale. Or cartoons for frescoes could be pricked along the main lines of the design; through these tiny holes a powder was forced to reproduce the design on the wall. This is called *pouncing*.

In the sixteenth century, drawings became prized in their own right and were collected by artists, patrons, and connoisseurs. The drawing was thought to reveal something that a finished work could not: the artist's process, the artist's personality, and ultimately, the artist's genius.

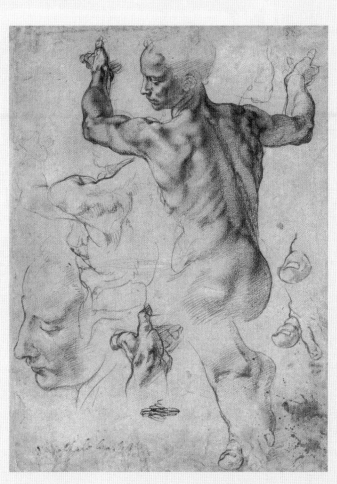

Michelangelo. *Studies for the Libyan Sibyl*. Red chalk, $11\frac{3}{8} \times 8\frac{7}{16}''$ (28.9 × 21.4 cm). The Metropolitan Museum of Art, New York. The Purchase, Joseph Pulitzer Bequest, 1924 (24.197.2)

Michelangelo's deep study of ancient sculpture, which he hoped to surpass. Since the cleaning of the frescoes in the 1980s, scholars have come to appreciate the brilliance of Michelangelo's colors, and the pairing of complementary colors he used in the draperies. (See *The Art Historian's Lens*, page 573.)

A similar energy pervades the center narratives. *The Fall of Man* and *The Expulsion from the Garden of Eden* (fig. **16.20**) show the bold, intense hues and expressive body language that characterize the whole ceiling. Michelangelo's figures are full of life, acting out their epic roles in sparse landscape settings. To the left of the Tree of Knowledge, Adam and Eve form a spiral composition as they reach toward the forbidden fruit, while the composition of *The Expulsion from the Garden of Eden* is particularly close to Masaccio's (see fig. 15.18) in its intense drama. The nude youths (*ignudi*) flanking the main sections of the ceiling play an important visual role in Michelangelo's design. They are found at regular intervals, forming a kind of chain linking the narratives. Yet their meaning remains uncertain. Do they represent the world of pagan antiquity? Are they angels or images of human souls? They hold acorns, a reference to the pope's family name, delle Rovere (Rovere means "oak"). The ignudi also support bronze medallions that look like trophies, reminding the viewer of Julius's military campaigns throughout Italy.

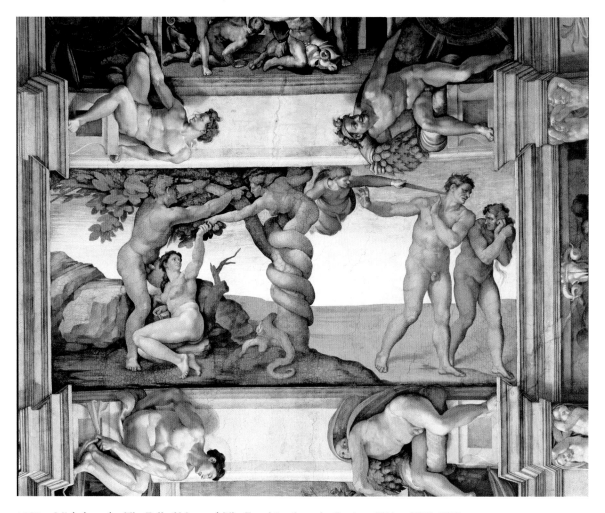

16.20. Michelangelo. *The Fall of Man* and *The Expulsion from the Garden of Eden*. 1508–1512.
Portion of the Sistine Chapel ceiling. The Vatican, Rome

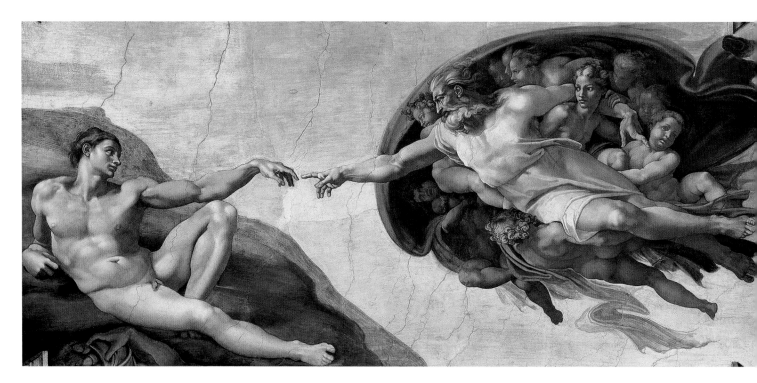

16.21. Michelangelo. *The Creation of Adam*. 1508–1512. Portion of the Sistine Chapel ceiling

Cleaning and Restoring Works of Art

One of the most controversial topics in contemporary art history is whether and how to clean venerable but soiled works of art. Heated exchanges, accusations, and lawsuits regularly accompany cleaning and restoration projects. Cleaning means just that—removing soot, grime, pollutants, and sometimes layers of varnish or other protective materials earlier generations of owners put on a work. Restoration sometimes involves replacing missing elements in a work to suggest to the viewer what an object looked like on its completion. Both processes are being debated today.

Many of the most famous images from the Renaissance have been at the center of these controversies: Masaccio's Brancacci Chapel, Leonardo's *Last Supper*, Michelangelo's frescoes at the Sistine Chapel, and most recently (in 2004) Michelangelo's *David*. Questions arise because of the jarring outcomes that can result from cleaning projects. For example, when the Sistine Chapel ceiling was cleaned in the 1980s, critics complained that the cleaning process removed the top layer of the paint, leaving only "garish" underpainting. Michelangelo's reputation as a colorist has been permanently changed by the cleaning of the ceiling frescoes.

The techniques of cleaning vary according to the medium and condition of the work, but conservators try to use the least damaging solvents possible, and they document every step they take. Work can be very slow, as in the case of the *Last Supper*. The project took 20 years, as clean-

ers had to contend with the work of earlier "restorers," who had filled in missing sections of the image with new paint. Current cleaning removed overpaints, and filled in missing areas with removable water-based pigment. Modern restorers are careful to add only materials that can be removed without damaging the original object.

Museums routinely clean objects in their care to conserve them. Major museums keep large conservation laboratories to treat works of art. Often the impetus and funding for such projects comes when an object is requested for an important exhibition. In the case of the Sistine Chapel ceiling, a corporation underwrote the cleaning of the ceiling in exchange for the rights to make a film about the process. Philanthropic and corporate donors have supported many recent cleaning projects.

The *David* offers a good example of why objects need cleaning. The statue stood in the Piazza della Signoria for almost four centuries, subjected to pollutants and humidity, until it was removed to the Galleria dell'Accademia in Florence in 1873. (A copy now stands in the Piazza.) In 2003, a cleaning program was undertaken, again amidst protests: Critics wanted a minimally invasive dry cleaning (like a careful dusting), but the curators used a distilled water, clay, and cellulose paste to draw pollutants out of the marble. Mineral sprits were used to remove wax on the marble.

Perhaps the one object from the High Renaissance most in need of cleaning today—but unlikely to receive it—is Leonardo's *Mona Lisa*. The directors of the Louvre have said that no such cleaning will ever be done.

The most memorable of the center narratives is *The Creation of Adam* (fig. **16.21**). The fresco depicts not the physical molding of Adam's body, but the passage of the divine spark— the soul—and thus achieves a dramatic relationship unrivaled by any other artist. Michelangelo's design contrasts the earthbound Adam, who has been likened to an awakening river god, with the dynamic figure of God rushing through the sky. Adam gazes not only toward his Creator, but toward the figures in the shelter of God's left arm. The identity of these figures has been vigorously debated: The female may be Eve, awaiting her creation in the next panel; another proposal is that she may be Mary, with Jesus at her knee, foreordained to redeem fallen humanity. The entire image has come to be seen as the perfect expression of Michelangelo's view of his own artistic creativity.

After the death of Julius II in 1513, Michelangelo returned to his work on the pope's tomb. But when Leo X (the son of Lorenzo de' Medici) acceded to the papacy, he sent Michelangelo back to Florence, to work on projects for the Medici family, which had been restored to power. There his style developed and changed, until his eventual return to Rome in the 1530s.

Raphael in Florence and Rome

If Michelangelo represents the solitary genius, Raphael of Urbino (Raffaello Sanzio, 1483–1520) belongs to the opposite type: the artist as a man of the world. The contrast between

them was clear to their contemporaries, and both enjoyed great fame. Vasari's book, with its championing of Michelangelo, helped to inspire later generations' veneration of Michelangelo over Raphael, in part because of the two men's biographies. Where Michelangelo's dramatic conflicts with his art and with his patrons made good stories, Raphael's career seems too much a success story, his work too marked by effortless grace, to match the tragic heroism of Michelangelo. Raphael's gifts were in his technical brilliance, his intelligent approach to composing pictures, and his dialogue with the other artists of his time. He is the central painter of the High Renaissance. During his relatively brief career he created the largest body of Renaissance pictorial work outside of Titian's, one that is notable for its variety and power. He also oversaw a lively and large workshop, from which many artists of the next generation emerged, effectively putting his stamp on the whole period.

RAPHAEL'S EARLY MADONNAS Raphael had a genius for synthesis that enabled him to merge the qualities of Leonardo and Michelangelo. His art is lyrical and dramatic, pictorially rich and sculpturally solid. These qualities are already present in the Madonnas he painted in Florence (1504–1508) after his apprenticeship with Perugino. The meditative calm of the so-called *La Belle Jardinière (Beautiful Gardener)* (fig. **16.22**) still reflects the style of his teacher; the forms are, however,

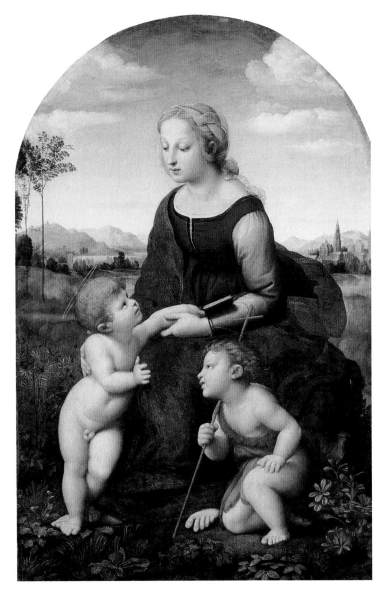

16.22. Raphael. *La Belle Jardinière*. 1507. Oil on panel, 48 × 31½″ (122 × 80 cm). Musée du Louvre, Paris

more ample and the chiaroscuro expertly rendered. The young Jesus and John the Baptist have perfect little bodies, posed in graceful postures to interact with each other and the Virgin. For this image, Raphael reworks a composition by Leonardo, but he replaces the enigmatic gestures in *The Virgin of the Rocks* by a gentle, rhythmic interplay. Raphael replaces the intricate grouping with a stable pyramid whose severity is relieved by Mary's billowing cape. Equally striking is the carefully observed landscape, whose bright light and natural beauty provides an appropriate setting for the figure group.

One of the reasons *La Belle Jardinière* looks different from *The Virgin of the Rocks,* to which it is otherwise so clearly indebted, is Michelangelo's influence, which is seen in the figural composition. The full force of this influence can be felt only in Raphael's Roman works, however. In 1508, at the time

Michelangelo began to paint the Sistine Chapel ceiling, Julius II summoned Raphael from Florence at the suggestion of Bramante, who also came from Urbino. At first Raphael mined ideas he had developed under his teacher Perugino, but Rome utterly transformed him as an artist, just as it had Bramante, and he underwent an astonishing growth.

FRESCOES FOR THE STANZA DELLA SEGNATURA

The results can be seen in the Stanza della Segnatura (Room of the Signature, fig. **16.23**), the first in a series of rooms he was called on to decorate at the Vatican Palace. The frescoes painted by Raphael in this room show an almost endless fertility in the creation of daring narrative compositions. The "Room of the Signature" derives its name from its later function as the place where papal bulls were signed, though originally it housed Julius II's personal library. Beginning in 1508, Raphael painted a cycle of frescoes on its walls and ceiling that refer to the four domains of learning: theology, philosophy, law, and the arts. In general, the Stanza represents a summation of High Renaissance humanism, for it attempts to represent the unity of knowledge in one grand scheme. Raphael probably had a team of scholars and theologians as advisors, yet the design is his alone.

Theology is the subject of the earliest wall fresco in the room (fig. **16.24**). Since the seventeenth century it has been called *The Disputà,* or *The Disputation Over the Sacrament.* The subject of the discussion is the doctrine of the Transubstantiation, which states that the wine and host of the Eucharist become the body and blood of Christ. Raphael divides the lunette into two regions, one earthly where theologians are gathered around an altar, and one heavenly. In the upper zone, Christ sits enthroned in heaven between the Virgin and St. John the Baptist. God the Father is above him, with saints and prophets to either side. The dove of the Holy Spirit hovers over the Eucharist below. Around the altar in the lower zone are doctors of the church, popes, artists, poets (Dante is represented), and other personages.

The participants are not so much disputing, however, as bearing witness to the Eucharist and its central place in the Catholic faith. The host in its monstrance on the altar is the fulcrum of the composition, dictating the arrangement of figures in both the earthly and heavenly zones. The round form of the monstrance is echoed in the halo around the dove, and in the mandorla around Christ in the vertical center of the composition. The presence of God the father above Christ adds a Trinitarian element to the meaning. And the curving arrangement of the heavenly court echoes the curve of the lunette. On the earthly realm, Raphael creates a space like that in Perugino's *Delivery of the Keys* nearby in the Vatican (see fig. 15.59), while the landscape makes subtle use of atmospheric perspective to emphasize the host. Through both heaven and Earth, books and the written word are featured, appropriately for a room intended as a library.

In the lunette over the door to the left are personifications of *The Three Legal Virtues*—Fortitude, Prudence, and Temperance. Beneath are *The Granting of Civil Law* (left) and

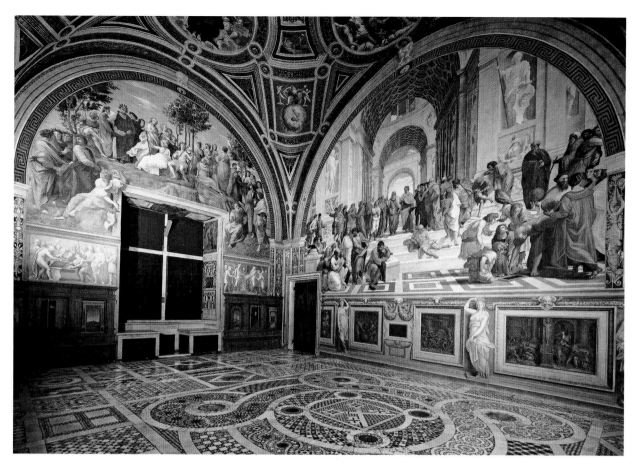

16.23. Raphael. Frescoes of the Stanza della Segnatura. 1508–1511. Vatican Palace, Rome

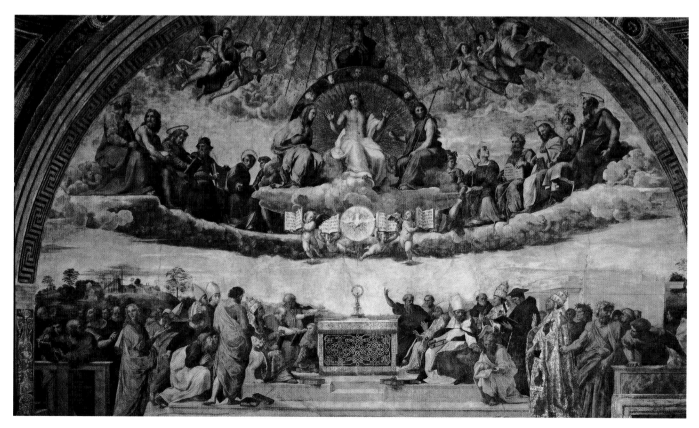

16.24. Raphael. *Disputà*. 1508–1511. Fresco, height 19′ (5.79 m). Portion of the Stanza della Segnatura

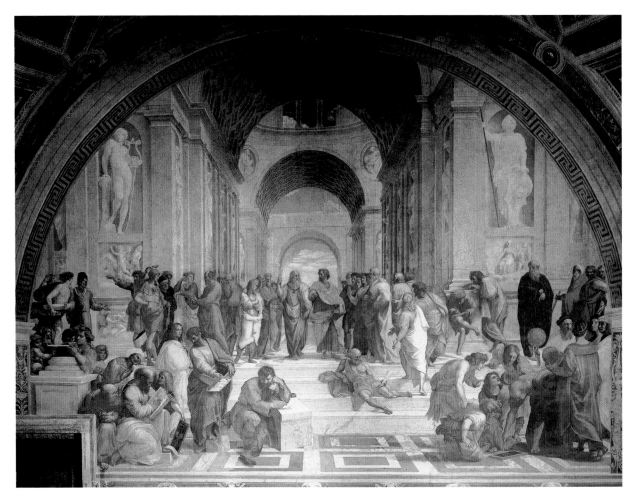

16.25. Raphael. *The School of Athens.* 1508–1511. Fresco. Stanza della Segnatura. Vatican Palace, Rome

The Granting of Canon Law (right), representing legal learning. The opposite doorway depicts *Parnassus,* the sacred mountain of Apollo. The Muses appear in the company of the great poets from antiquity to the artist's own time, for Humanists had regarded artistic inspiration as a means of revelation since the time of Dante and Petrarch. The painting reflects the papal court's dream of a Golden Age under Julius II, in which the Vatican Hill would become the new Parnassus. The message of the Stanza della Segnatura is that the philosophy of antiquity, along with knowledge and the arts, are forms of revelation that emanate from God. They lead to religious truth but are subordinate to it.

Of all the frescoes in the Stanza della Segnatura, *The School of Athens* (fig. **16.25**), facing the *Disputà,* has long been acknowledged as Raphael's masterpiece and the embodiment of the Classical spirit of the High Renaissance. Like the *Disputà*, this title was assigned later, and the subject has been much debated. The fresco seems to represent a group of famous Greek philosophers gathered around Plato and Aristotle, each in a characteristic pose or activity. Raphael may have already studied parts of the Sistine Chapel ceiling, then nearing completion. He owes to Michelangelo the expressive energy, the physical power, and dramatic grouping of his figures. Yet

Raphael has not simply borrowed Michelangelo's gestures and poses. He has absorbed them into his own style and thus given them a different meaning. Body and spirit, action and emotion are balanced harmoniously, and all members of this great assembly play their roles with magnificent, purposeful clarity.

The conception of *The School of Athens* suggests the spirit of Leonardo's *The Last Supper*, as Raphael organizes his figures into groups like Leonardo's. He further distinguishes the relations among individuals and groups, and links them in a formal rhythm. (The artist worked out the poses in a series of drawings, many from life.) Also in the spirit of Leonardo is the symmetrical design, as well as the interdependence seen between the figures and their architectural setting. Like Leonardo's work, an opening in the building serves as a frame for the key figures. But Raphael's building plays a greater role in the composition than the hall does in *The Last Supper*. With its lofty dome, barrel vault, and colossal statuary, it is Classical in spirit, yet Christian in meaning. Inspired by Bramante, who, Vasari informs us, helped Raphael with the architecture, the building seems like an advance view of the new St. Peter's, then being constructed. Capacious, luxurious, overpowering, the building is more inspired by Roman structures, such as the Basilica of Maxentius and Constantine (see fig. 7.68), than by

anything Greek. Yet two fictive sculptures of Greek divinities preside over this gathering of learned men of the Greek past: Apollo, patron of the arts with his lyre to the left, and Athena, in her guise as Minerva, goddess of wisdom, on the right.

The program of *The School of Athens* reflects the most learned Humanism of the day, which is still being elucidated by scholars. Since Vasari's time, historians have attempted to identify the figures inhabiting this imposing space. At center stage, Plato (whose face resembles Leonardo's) holds his book of cosmology and numerology, *Timaeus,* which provided the basis for much of the Neo-Platonism that came to pervade Christianity. To Plato's left (a viewer's right), his pupil Aristotle grasps a volume of his *Ethics,* which, like his science, is grounded in what is knowable in the material world. The tomes explain why Plato is pointing rhetorically to the heavens, Aristotle to the earth. The figures represent the two most important Greek philosophers, whose approaches, although seemingly opposite, were deemed complementary by many Renaissance Humanists. In this composition, the two schools of philosophy come together.

Some scholars believe that Raphael organized the array of philosophers to reflect the two camps: the idealists and the empiricists. To Plato's right is his mentor, Socrates, who addresses a group of disciples by counting out his arguments on his fingers. Standing before the steps are figures representing mathematics and physics (the lower branches of philosophy that are the gateway to higher knowledge). Here appears the bearded Pythagoras, for whom the truth of all things is to be found in numbers. He has his sets of numbers and harmonic ratios arranged on a pair of inverted tables that each achieve a total of the divine number ten. On the other side of the same plane, Raphael borrowed the features of Bramante for the head of Euclid, seen drawing or measuring two overlapping triangles with a pair of compasses in the foreground to the lower right. Behind him, two men holding globes may represent Zoroaster the astonomer and Ptolemy the geographer. Vasari tells us that the man wearing a black hat behind these scientists is a self-portrait of Raphael, who places himself in the Aristotelian camp.

Despite the competition between them, Raphael added Michelangelo at the last minute (as revealed by his insertion of a layer of fresh plaster or *intonaco* on which to paint the new figure), whom he has cast as Heraclitus, a sixth century BCE philosopher, shown deep in thought sitting on the steps in the Platonic camp. (Heraclitus was often paired with Diogenes the Cynic, shown lying at the feet of Plato and Aristotle.) Scholars have remarked that this figure is not only a portrait of the sculptor, but is rendered in the style of the figures on the nearby Sistine Chapel ceiling. The inclusion of so many artists among, as well as in the guise of, famous philosophers is testimony to their recently acquired—and hard-won—status as members of the learned community.

PAPAL AND PRIVATE COMMISSIONS After Julius II died in 1513, Raphael was hired by his successor, Leo X, who ordered Raphael to finish painting the Stanze for the papal

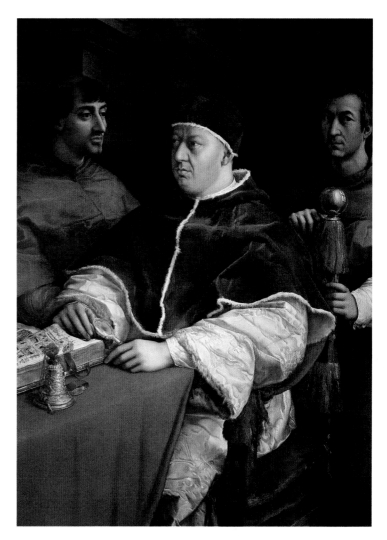

16.26. Raphael. *Portrait of Pope Leo X with Cardinals Giulio de' Medici and Luigi de' Rossi.* ca. 1517. Oil on panel, $60^5/_8 \times 46^7/_8$″ (154 × 119 cm). Galleria degli Uffizi, Florence

apartments. The Pope also sat for portraits. In the *Portrait of Pope Leo X with Cardinals Giulio de' Medici and Luigi de' Rossi* (fig. **16.26**), painted about 1517, Raphael did little to improve the heavy-jowled features of the pope, or the faces of his associates. (Giulio de' Medici, on the left, became pope himself in 1523, as Clement VII.) The three men are gathered around a table, on which rests a beautifully worked bell and an illuminated manuscript. Rather than a spiritual being or a warrior, the pope is represented as a collector and connoisseur, shown examining a precious object. The textures of the brocades and fur-lined garment only add to the sensual experience. Light enters this space from a window on the right whose shape is reflected in the brass ball of the chair's finial. This meditation on the sense of sight owes a debt to Netherlandish art.

Raphael's work clearly pleased the new pope. After Bramante's death in 1514, Raphael was named the architect of Saint Peter's and subsequently superintendent of antiquities in Rome. In 1516, Pope Leo X sent Michelangelo to Florence to work on the Medici Chapel, leaving Raphael as the leading artist in Rome. Now he was flooded with commissions, and of necessity depended increasingly on his growing workshop.

In 1515–1516, the pope commissioned Raphael to design a set of tapestries on the theme of the Acts of the Apostles for the Sistine Chapel. The commission placed him in direct competition with Michelangelo, and consequently Raphael designed and executed the ten huge cartoons (See *Materials and Techniques*, page 571) for this series with great care and enthusiasm. The cartoons were sent to Flanders to be woven, and thus they spread High Renaissance ideas from Italy to Northern Europe. One of the most influential of these cartoons is the *Saint Paul Preaching at Athens* (fig. **16.27**), which demonstrates Raphael's synthesizing genius. For the imposing figure of St. Paul, Raphael has adapted the severity and simplicity of Masaccio's Brancacci Chapel frescoes (see figs. 15.16, 15.17). The power of the saint's words is expressed not only by his gestures, but by the responses of the voluminously clad audience. The architecture that defines the space is inspired by Bramante; the plain Tuscan order of the columns in the round temple in the background recall the Tempietto (fig. 16.8). Instead of allowing the eye to wander deeply into the distance, Raphael limits the space to a foreground plane, into which a viewer is invited by the steps in the foreground. The simplicity and grandeur of the

conception conveys the narrative in bold, clear terms that are only enhanced by the large scale of the figures.

Raphael's busy workshop was engaged by the powerful Sienese banker, Agostino Chigi, for his new villa in Rome, now called the Villa Farnesina after a later owner. The building was a celebration of Chigi's interests: in the antique, in conspicuous display, and in love. Throughout the villa he commissioned frescoes on themes from the pagan past. For this setting, Raphael painted the *Galatea* around 1513 (fig. **16.28**). The beautiful nymph Galatea, vainly pursued by the giant Polyphemus, belongs to Greek mythology, known to the Renaissance through the verses of Ovid. Raphael's *Galatea* celebrates the sensuality of pagan spirit as if it were a living force. Although the composition of the nude female riding a seashell recalls Botticelli's *The Birth of Venus* (see fig. 15.42), a painting Raphael may have known in Florence, the very resemblance emphasizes their profound differences. Raphael's figures are vigorously sculptural and arranged in a dynamic spiral movement around the twisting Galatea. In Botticelli's picture, the movement is not generated by the figures but imposed on them by the decorative, linear design that places all the figures on the

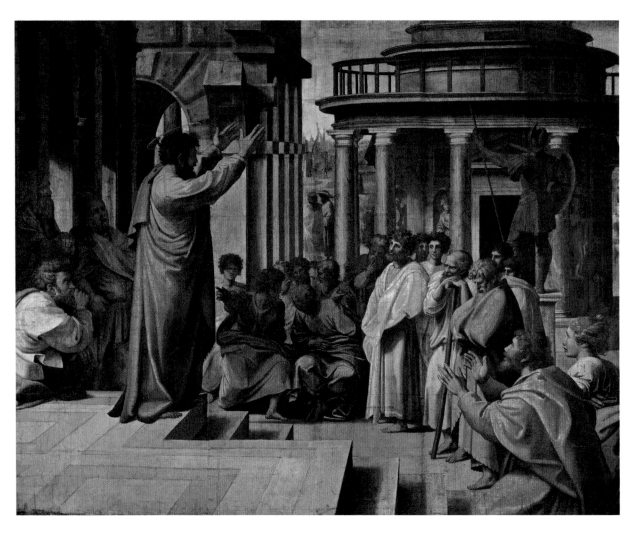

16.27. Raphael. *Saint Paul Preaching at Athens.* 1515–1516. Cartoon, gouache on paper, 11′3″ × 14′6″ (3.4 × 4.4 m). Victoria & Albert Museum, London

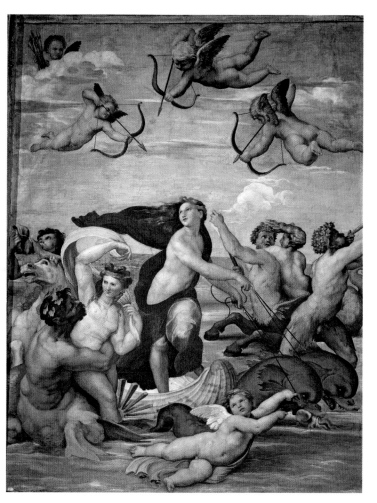

16.28. Raphael. *Galatea*. ca.1513. Fresco, 9'8¹⁄₈" × 7'4" (3 × 2.2 m).
Villa Farnesina, Rome

ART IN TIME

1503—Pope Julius II assumes papal throne. Rome and the papacy
prosper during his reign.

**1508—Michelangelo begins painting the ceiling of the
Sistine Chapel.**

ca. **1510—Raphael's** *The School of Athens*

1517—Luther posts his *Ninety-five Theses*, sparking the
Reformation

same plane. Like Michelangelo, Raphael uses the arrangement
of figures, rather than any detailed perspective scheme, to call
up an illusion of space and to create a vortex of movement.

Raphael's statuesque, full-bodied figures suggest his careful
study of ancient Roman sculpture which, like Michelangelo, he
wanted to surpass. An even more direct example of his use of
antique sources is his design for the engraving of *The Judgment
of Paris* by Marcantonio Raimondi, executed about 1520 (fig.
16.29). Collectors increasingly desired to own Raphael's draw-
ings, so he used the skills of the engraver to record and to
spread his designs. This design is based on a Roman sarcopha-
gus panel then in a Roman collection, which Raphael has inter-
preted rather than copied. The engraving depicts the Judgment
of Paris witnessed by the Olympian gods in heaven and a
group of river gods on the lower right. The statuesque figures
are firmly defined in the engravings through the strong
contours and *chiaroscuro*, and they occupy a frontal plane across
the images. In images like this, Raphael translated the art of
antiquity for generations of artists to come.

16.29. Marcantonio Raimondi, after Raphael. *The Judgment of Paris*. ca. 1520. Engraving.
The Metropolitan Museum of Art, New York. Rogers Fund, 1919. (19.74.1)

On Raphael's Death

Raphael died in Rome in April of 1520. In a letter to Isabella d'Este, the Duchess of Mantua, the Humanist Pandolfo Pico della Mirandola tells her about the artist's death and the reaction of Rome to his loss.

. . . now I shall inform you of . . . the death of Raphael of Urbino, who died last night, that is, on Good Friday, leaving this court in the greatest and most universal distress because of the loss of hope for the very great things one expected of him that would have given glory to our time. And indeed it is said about this that he gave promise for everything great, through what one could already see of his works and through the grander ones he had begun. . . . Here one speaks of nothing else but of the death of this good man, who at thirty-three years of age has finished his first life; his second one, however, that of fame which is not subject to time and death, will be eternal, both through his works and through the men of learning that will write in his praise. . .

SOURCE: KONRAD OBERHUBER, *RAPHAEL. THE PAINTINGS.* (MUNICH AND NEW YORK: PRESTEL: 1999, P. 9.)

Raphael's life was cut short in 1520, when he died after a brief illness. Roman society mourned him bitterly, according to the reports of witnesses. (See *Primary Source,* above.) Befitting the new status assigned to artists, he was buried in the Pantheon. Significantly, many of the leading artists of the next generation emerged from Raphael's workshop and took his style as their point of departure.

VENICE

While Rome became the center of an imperial papal vocabulary of art, Venice endured the enmity of its neighbors and the dismantling of its northern Italian empire. Having gradually expanded its influence over northeastern Italy, the Republic of Venice was threatened by the League of Cambrai, an international military alliance aimed against it in 1509. Yet, by 1529 Venice had outlasted this threat and reclaimed most of its lost territory. Resisting the invasions of Europe by the Turks, Venice's navy fought determinedly in the eastern Mediterranean to hold off this threat. In the midst of this turmoil, artists in Venice built on the traditions of the fifteenth century and the innovations of Giovanni Bellini to create a distinct visual language. Two artists in particular, Giorgione and Titian, created new subject matters, approaches to images, and techniques.

Giorgione

Giorgione da Castelfranco (1478–1510) left the orbit of Giovanni Bellini (see fig. 15.57) to create some of the most mysterious and beguiling paintings of the Renaissance. Although he painted some religious works, he seems to have specialized in smaller scale paintings on secular themes for the homes of wealthy

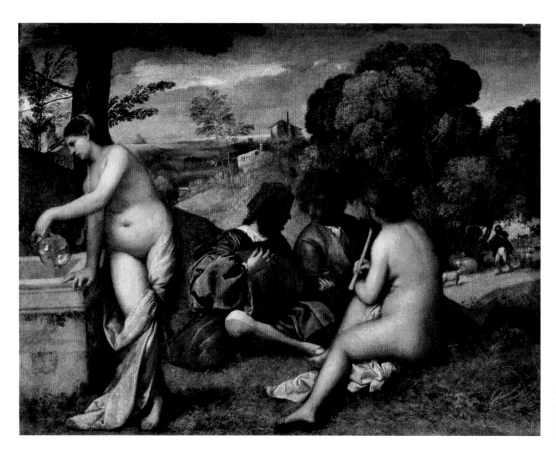

16.30. Giorgione (and Titian?). *Fête Champêtre (Pastoral Concert).* ca. 1509–1510. Oil on canvas, 43¼ × 54⅜" (105 × 136.5 cm). Musée du Louvre, Paris

collectors. His death at a young age, probably from the plague, left the field open for his young colleague, Titian, who worked in his shop for some time. Some of the works traditionally ascribed to Giorgione have, in fact, been argued for Titian in recent years.

One such work, the so-called *Fête Champêtre* or *Pastoral Concert*, (fig. **16.30**) has been on display in the Louvre since the nineteenth century, where it had arrived from the French royal collection. The painting depicts a group of young people gathered in a lush landscape to make music when a shepherd and his flock come upon them. Attempts to find a narrative subject to attach to this image have proven fruitless: No single literary source seems to account for it. Most puzzling are the nude women, one of whom is about to play a recorder, while another dips water from a fountain. They have been identified as the Muses, ancient female divinities who inspire the arts. The forms are rendered in a soft chiaroscuro technique so that they emerge from the atmospheric landscape as soft round shapes. The landscape moves from dark to light to dark passages, receding into the atmospheric distance. Instead of telling a story, the painting seems designed to evoke a mood.

Giorgione's *The Tempest* (fig. **16.31**) is equally unusual and enigmatic. The picture was first recorded in the collection of the merchant Gabriele Vendramin, one of Venice's greatest patrons of the arts. Scholars have offered many proposals to explain this image, which depicts a stormy landscape inhabited by a shepherd on the left and a nursing mother on the right. It is the landscape, rather than Giorgione's figures, that is the key to interpretation. The scene is like an enchanted idyll, a dream

ART IN TIME

ca. 1505—Giorgione's *The Tempest*
- 1509—League of Cambrai formed against Venice
- 1513—Machiavelli writes *The Prince.*
- 1521—Hernan Cortez captures Mexico for Spain
- **1526—Titian's *Madonna with the Members of the Pesaro Family***

of pastoral beauty soon to be swept away. In the past, only poets had captured this air of nostalgic reverie. Now it entered the repertory of the artist. Indeed, the painting is very similar in mood to *Arcadia* by Jacopo Sannazaro, a poem about unrequited love that was popular in Giorgione's day. Thus *The Tempest* initiates what was to become an important new tradition in art, the making of pictorial equivalents to poetry (*Poesie*) instead of narratives.

Vasari criticized Giorgione for not making drawings as part of his process of painting (see end of Part II, *Additional Primary Sources*.) Steeped in the Florentine tradition of Leonardo, Michelangelo, and Raphael, Vasari argued that drawing or *disegno* was fundamental to good painting. The Venetians, however, valued light and color above all to create their sensual images. Vasari dismissed this as *colore*, which he argued was secondary to the process of drawing. This competition between *disegno* and *colore* provided the grounds for criticizing or praising paintings well beyond the sixteenth century.

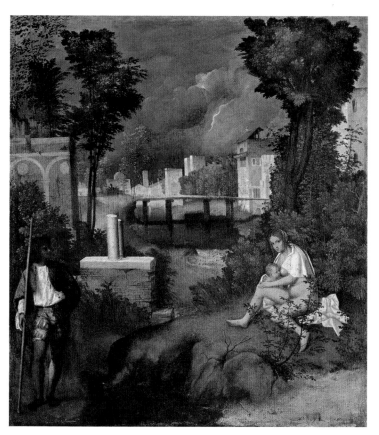

16.31. Giorgione. *The Tempest.*
ca. 1505. Oil on canvas,
31¼ × 28¾″ (79.5 × 73 cm).
Galleria dell'Accademia, Venice

Titian

Giorgione died before he could fully explore the sensuous, lyrical world he had created in *The Tempest*. This task was taken up by Titian (Tiziano Vecellio, 1488/90–1576), who trained with Bellini and then with Giorgione and even repainted some of their works. Titian would dominate Venetian painting for the next half-century. Throughout his long life, he earned commissions from the most illustrious patrons in Europe; he trained many of the Venetian artists of the century.

Titian's interpretation of the legacy of Giorgione may be seen in the *Bacchanal* (fig. **16.32**), commissioned around 1518 by Alfonso d'Este, the duke of Ferrara, for his Camerino d'Alabastro (little room of alabaster). In this painting Titian attempted to remake a Roman painting known only from descriptions by the Roman author Philostratus. The theme is the effect of a river of wine on the inhabitants of the island of Andros. Titian depicts a crowd of figures in various stages of undress hoisting jugs of wine and generally misbehaving. He thus competed both with antique art and with literature. Titian's landscape, rich in contrasts of cool and warm tones, has all the poetry of Giorgione, but the figures are of another breed.

Active and muscular, they move with a joyous freedom that recalls Raphael's *Galatea* (fig. 16.28).

By this time, many of Michelangelo's and Raphael's compositions had been engraved, and from these reproductions Titian became familiar with the Roman High Renaissance. At least one figure, the man bending over to fill his jug in the river, may be copied from Michelangelo. A number of the figures in his *Bacchanal* also reflect the influence of Classical art. Titian's approach to antiquity, however, is very different from Raphael's. He visualizes the realm of ancient myths as part of the natural world, inhabited not by animated statues but by beings of flesh and blood. The nude young woman who has passed out in the lower right corner is posed to show off her beautiful young body for the viewer's pleasure. The figures of the *Bacchanal* are idealized just enough to persuade us that they belong to a long-lost Golden Age. They invite us to share their blissful state in a way that makes the *Galatea* seem cold and remote by comparison.

Titian's ability to transform older traditions can also be seen in his *Madonna with Members of the Pesaro Family* (fig. **16.33**), commissioned in 1519 and installed in 1526 on the altar of the

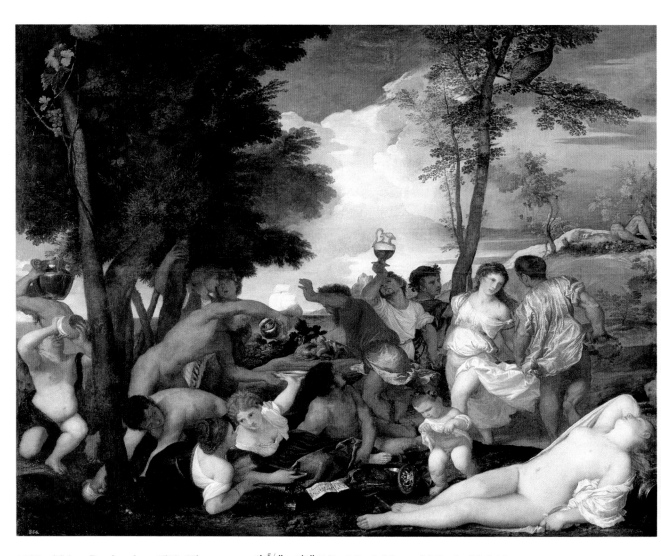

16.32. Titian. *Bacchanal*. ca. 1518. Oil on canvas, 5′8⅝″ × 6′4″ (1.7 × 1.9 m). Museo del Prado, Madrid

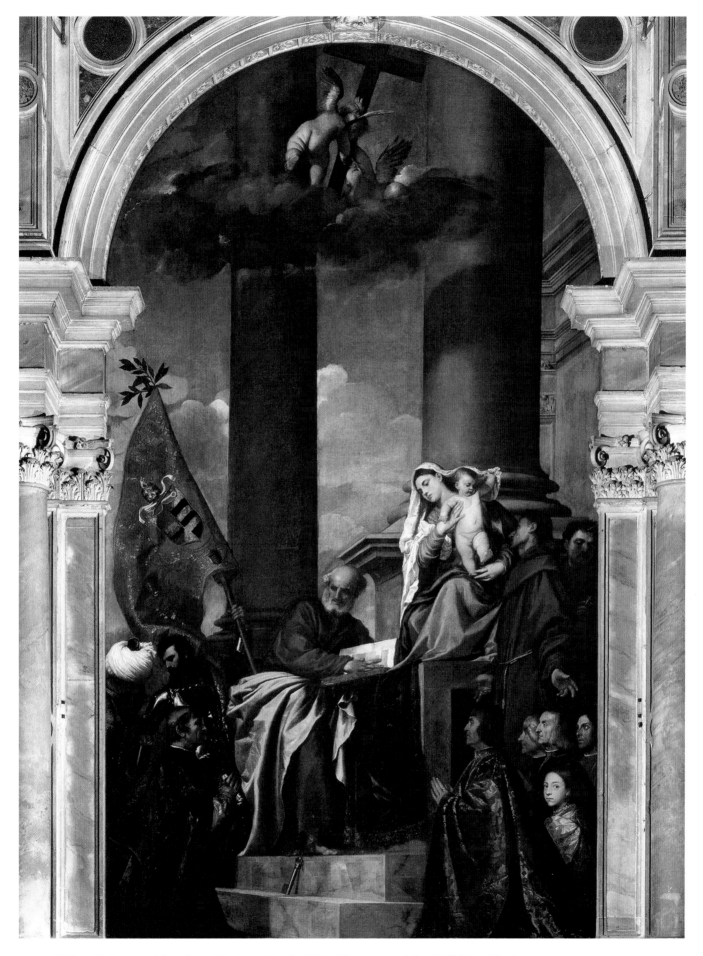

16.33. Titian. *Madonna with Members of the Pesaro Family.* 1526. Oil on canvas, 16′ × 8′10″ (4.9 × 2.7 m). Santa Maria Gloriosa dei Frari, Venice

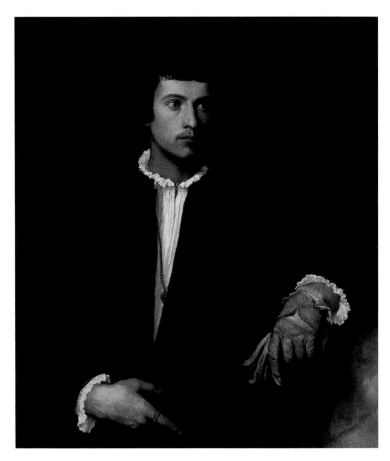

16.34. Titian. *Man with the Glove.* ca. 1520. Oil on canvas, 39½ × 35″ (100.3 × 89 cm). Musée du Louvre, Paris

Immaculate Conception of the Franciscan church of Santa Maria Gloriosa dei Frari. Here he takes a *sacra conversazione* in the tradition of Domenico Veneziano and Giovanni Bellini (figs. 15.30 and 15.57) and reimagines both the composition and the figures. He sets the Virgin and Child at the apex of a triangular arrangement of figures, but replaces the familiar frontal view with an oblique one that is far more active. The Infant Jesus is as natural as the child in the *Bacchanal,* pudgy and innocently playing with his mother's veil. More solemnly, the Virgin and St. Peter turn to the donor, Jacopo Pesaro, seen kneeling in devotion at the left. On the other side are the donor's brothers and sons with saints Francis and Anthony.

The Virgin is enthroned on the steps of a monumental church. The elevated columns, which are the key to the setting, represent the gateway to heaven, traditionally identified with Mary herself; the painting celebrates her as the Immaculate Conception, who was born without original sin. Because the view is diagonal, open sky and clouds fill most of the background. Except for the kneeling donors, every figure is in motion. The officer with the flag bearing the coats of arms of Pesaro and of Pope Alexander VI seems almost to lead a charge up the steps. He is probably St. Maurice, namesake of the battle at Santa Mauro. There, the papal fleet commanded by Pesaro, bishop of Paphos, and the Venetian navy, under his cousin

Benedetto Pesaro, defeated the Turks in 1502—note the turbaned figure beside him. St. Peter, identified by the key near his foot, represents the Catholic Church victorious over Islam and, as Pesaro's patron saint, acts as his intercessor with the Madonna. The design remains harmoniously self-contained, despite the strong drama. Brilliant sunlight makes every color and texture sparkle, in keeping with the joyous spirit of the altar. The only hint of tragedy is the Cross held by the two little angels. Hidden by clouds from the participants in the *sacra conversazione*, it adds a note of poignancy to the scene.

After Raphael's death, Titian became the most sought-after portraitist of the age. His immense gifts, evident in the donors' portraits in the *Pesaro Madonna*, are equally striking in the *Man with the Glove* (fig. **16.34**). The dreamy intimacy of this portrait, with its soft outline and deep shadows, reflects the soft chiaroscuro of Giorgione. This slight melancholy in his features has all the poetic appeal of *The Tempest*. In Titian's hands, the possibilities of the oil technique—rich, creamy highlights, deep dark tones that are transparent and delicately modulated—now are fully realized, and the separate brushstrokes, hardly visible before, become increasingly free. Titian's handling of oil became increasingly painterly in his later work, and established yet another tool for artists of future generations to explore.

SUMMARY

For a brief time in the early sixteenth century, highly skilled and insightful artists not only coexisted but competed with each other to excel in their chosen arts. This time, the High Renaissance, has since been seen seen as a high water mark for European art. Leonardo's inquisitive mind and insightful handling of light, Bramante's ambitious blending of antique forms with modern uses, Michelangelo's powerful renderings of the human body, Raphael's consummate compositions, Giorgione's sensitive evocation of moods, and Titian's brilliant handling of color and paint have been celebrated ever since.

Their activity occurred in a tumultuous period of intense creativity encouraged by a few key patrons. The loss of the patrons and the death or dispersal of the artists defused the competition. By 1520, Leonardo, Bramante, Giorgione, and Raphael were dead. The Catholic Church, which had been such a munificent patron, found itself challenged by the young Martin Luther in Wittenberg, as the Reformation gathered strength. The two artists who outlived the High Renaissance, Michelangelo and Titian, continued working in the changed conditions after 1520.

THE HIGH RENAISSANCE IN FLORENCE AND MILAN

The restored Republic of Florence was the home to two of the most influential artists of the Renaissance, Leonardo da Vinci and Michelangelo Buonarotti. Trained in the artistic innovations of the fifteenth century, these two men developed great technical virtuosity in their preferred media of painting and sculpture. Their achievements attracted other artists to Florence, including Raphael of Urbino. Leonardo da Vinci's mastery of chiaroscuro and his restless study of Nature led him to create emotionally rich and superbly naturalistic representations of religious and secular subjects. Michelangelo's dedication to the human figure led him into a deep study of ancient sculpture, giving his works not only tremendous naturalism, but also strong emotional impact.

ROME RESURGENT

Pope Julius II's commitment to renewing the city of Rome brought Michelangelo, Bramante, Raphael, and other artists to work there. Julius desired to rebuild the ancient city as a Christian capital that would outshine its pagan past. To further this goal, Bramante designed a huge new church of Saint Peter's intended to rival the ancient Pantheon. Julius found Michelangelo's powerful human forms appropriate for his tomb and for the monumental project of the Sistine Chapel ceiling. Raphael's accomplishment in Rome was to bring together the innovations of Leonardo in painting with the massive figural style of Michelangelo's sculpture. He did this by submerging both strains under his own personal gifts for harmonious composition and depth of meaning.

VENICE

Despite the uncertain political conditions of Venice in the early sixteenth century, patrons commissioned the painters Giorgione and Titian to produce lively and sumptuous paintings on both religious and secular themes. Working in a technique that stresses color and light, Giorgione created paintings that evoke a mood of poetic reverie. Titian exploited the traditions of Venetian art to create images that are astonishingly lifelike and sensual.

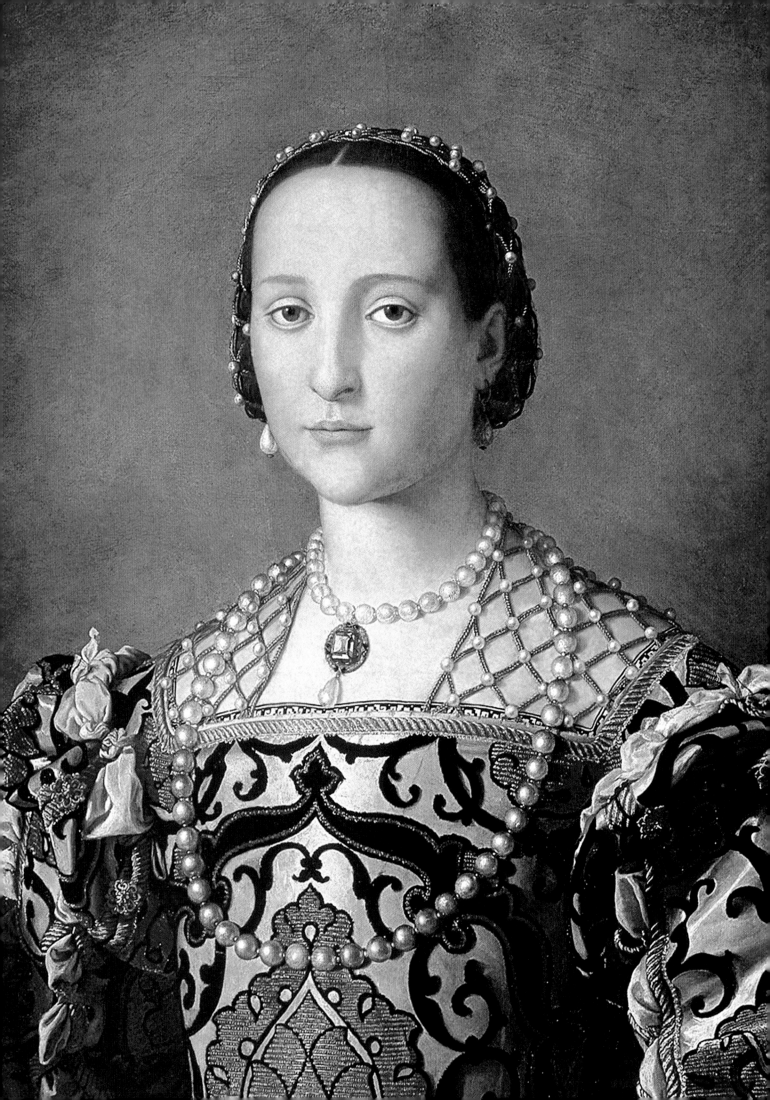

The Late Renaissance and Mannerism in Sixteenth-Century Italy

FROM THE MOMENT THAT MARTIN LUTHER POSTED HIS CHALLENGE TO THE Roman Catholic Church in Wittenburg in 1517, the political and cultural landscape of Europe began to change. Europe's ostensible religious unity was fractured as entire regions left the Catholic fold. The great powers of France, Spain, and Germany warred with each other on the Italian peninsula, even

as the Turkish expansion into Europe threatened all. The spiritual challenge of the Reformation and the rise of powerful courts affected Italian artists in this period by changing the climate in which they worked and the nature of their patronage. No one style dominated the sixteenth century in Italy, though all the artists working in what is conventionally called the Late Renaissance were profoundly affected by the achievements of the High Renaissance.

The authority of the generation of the High Renaissance would both challenge and nourish later generations of artists. In the works of Leonardo, Raphael, Bramante, and Giorgione, younger artists could observe their elders' skillful rendering of *chiaroscuro*, perspective, and *sfumato,* as well as the elder generation's veneration of antiquity. The new generations imitated their technical expertise, their compositions, and their themes. At the same time, the artists of the High Renaissance continued to seek new ways to solve visual problems. Indeed, two of the key figures of the older generation lived to transform their styles: Michelangelo was active until 1564 and Titian until 1576 (see map 17.1).

The notion of the artist as an especially creative figure was passed on to later generations, yet much had changed. International interventions in Italy came to a head in 1527 when Rome itself was invaded and sacked by imperial troops of the Habs-

Detail of figure 17.7, Agnolo Bronzino, *Portrait of Eleanora of Toledo and Her Son Giovanni de' Medici*

burgs; three years later, Charles V was crowned Holy Roman Emperor in Bologna. His presence in Italy had important repercussions: In 1530, he overthrew the reestablished Republic of Florence and restored the Medici to power. Cosimo I de' Medici became duke of Florence in 1537 and grand duke of Tuscany in 1569. Charles also promoted the rule of the Gonzaga of Mantua and awarded a knighthood to Titian. He and his successors became avid patrons of Titian, spreading the influence and prestige of Italian Renaissance style throughout Europe.

The Protestant movement spread quickly through Northern Europe, as Luther, Zwingli, Calvin, and other theologians rejected papal authority and redefined Christian doctrine. Some of the reformers urged their followers to destroy religious images as idolatrous, leading to widespread destruction of images, stained glass, and other religious art. Italy itself, home of the Roman Catholic Church, resisted the new faiths. Nonetheless, through the first half of the sixteenth century, pressures for reform in the Catholic Church grew. The Roman Church had traditionally affirmed the role of images as tools for teaching and for encouraging piety, and the Reformers affirmed this position as official Catholic Church policy (see end of Part III, *Additional Primary Sources*.) But with its authority threatened by the Protestant Reformation, the Catholic Church asserted control over the content and the style of images to assure doctrinal correctness. As the Catholic Church sought to define itself against the Protestant Reformation, religious imagery became increasingly standardized.

Map 17.1. Italy in the Sixteenth Century

Artists responded to all these phenomena. The Sack of Rome in 1527 scattered Roman-based artists throughout Italy and Europe. Commissions came mostly from the princely courts, so artists' works reflected the taste and concerns of this powerful elite. The connections among the courts helped to spread a new style, usually labeled *Mannerist*, which lasted through much of the century. The style was typically used for paintings and sculptures, though some works of architecture exhibit Mannerist tendencies.

The term derived from the word *maniera*, meaning manner or style, that was used approvingly by contemporaries. Building on the achievements of Raphael and Michelangelo, above all, artists of the 1520s and later developed a style that emphasized technical virtuosity, erudite subject matter, beautiful figures, and deliberately complex compositions that would appeal to sophisticated tastes. Mannerism became a style of utmost refinement, which emphasized grace, variety, and virtuoso display instead of clarity and unity. Mannerist artists self-consciously explored definitions of beauty: Rather than repeat ancient forms, they experimented with proportions, ideal figure types, and unusual compositions. Like the artists of the High Renaissance, they aimed for originality and personal expression, which they considered their due as privileged creators.

Just what mannerism represented continues to spark scholarly debate. Some have argued that it signified a decline, because it rejected the standards of the High Renaissance. (These critics, of course, prefer the "Classical" works of the High Renaissance.) But the reasons that artists rejected the stability, assurance, and ideal forms of the High Renaissance are not well understood. Perhaps the new generation was attempting to define itself as different from its elders. Or, mannerism may be seen as an expression of a cultural crisis. Some scholars relate it to the spiritual crises brought on by the Reformation and the Catholic Counter-Reformation, while others see mannerism as the product of an elite class's expression of its own identity and taste. Even as scholars debate its origins and meanings, it is clear that mannerism's earliest products appear in Florence in the 1520s, which was very different from the Florence of 1505.

LATE RENAISSANCE FLORENCE: THE CHURCH, THE COURT, AND MANNERISM

Under Medici rule, from 1512 to 1527, Florentine artists absorbed the innovations of the High Renaissance. Pope Leo X sent Michelangelo from Rome to Florence to work on projects for the Medici. The artistic descendants of Raphael came to the city as well. Having contributed so much to the development of the Early and High Renaissance, Florentine artists developed a new style of Renaissance art that seems to reject the serenity

and confidence of High Renaissance art. Using the techniques of naturalism, chiaroscuro, and figural composition learned from Leonardo, Michelangelo, and Raphael, this generation of artists made images that are less balanced and more expressive than those of the earlier generation. In works of the 1520s, a group of Florentine artists created images of deep spiritual power in this new style. This spiritual resurgence may be a reaction to the challenges of the Reformation, or it may be due to the legacy of the fiery preacher Savonarola, who had preached repentence in Florence in the 1490s.

Florentine Religious Painting in the 1520s

An early expression of the new style is *The Descent from the Cross* (fig. **17.1**) by Rosso Fiorentino (1495–1540), whose style is very idiosyncratic. A society of flagellants, Catholics whose penitential rituals included whipping themselves to express penitence, hired Rosso to paint this altarpiece in 1521. The Company of the Cross of the Day in the Tuscan city of Volterra chose the theme of the lowering of the body of Christ from the Cross, the subject of Rogier van der Weyden's painting of 1438 (fig. 14.17). To reference the name of the sponsoring group, Rosso has given a great deal of emphasis to the Cross itself.

17.2. Jacopo da Pontormo. *The Entombment*. ca. 1526–1528. Oil on panel, 10′3″ × 6′4″ (3.1 × 1.9 m). Santa Felicita, Florence

While the composition looks back in part to Early Renaissance art, such as Masaccio's *Trinity* fresco (fig. 15.14), the composition is much less stable than the triangle used by Masaccio. Instead of moving slowly and carefully back into space, the forms all appear on the same plane. The muscular bodies of the agitated figures recall Michelangelo, but the draperies have brittle, sharp-edged planes. The low horizon line sets the figures against a dark sky, creating a disquieting effect. The colors are not primaries but sharply contrasting, and the brilliant light seems to fall on the bodies irrationally. Unlike the orderly calm and deep space of Leonardo's *Last Supper* (fig. 16.6), Rosso creates an unstable composition within a compressed space staffed by figures that move frantically to lower the body of Christ. Only his figure appears serene in the midst of this emotionally charged image. The Mannerist rejection of High Renaissance ideals allows Rosso to create in *The Descent from the Cross* a work that was especially appropriate to the piety of the confraternity members who commissioned it. Rosso himself left central Italy after the Sack of Rome in 1527 by the troops of the Habsburg Charles V, ultimately being lured to France to work for Francis I at his palace of Fontainbleu (see Chapter 18).

Rosso's friend and contemporary, Jacopo da Pontormo (1494–1556), developed his own version of Mannerist style. He executed *The Entombment* (fig. **17.2**) for the Capponi family chapel in the venerable church of Santa Felicita in Florence

17.1. Rosso Fiorentino. *The Descent from the Cross*. 1521. Oil on panel, 11′ × 6′5½″ (3.4 × 2 m). Pinacoteca Comunale, Volterra

around 1526. The painting contrasts sharply with Rosso's *The Descent from the Cross*. This painting lacks a cross or any other indications of a specific narrative, so its subject is unclear. The Virgin swoons as two androgynous figures hold up the body of Christ for a viewer's contemplation. Unlike Rosso's elongated forms, Pontormo's figures display an ideal beauty and sculptural solidity inspired by Michelangelo, yet Pontormo has squeezed them into an implausibly confined space.

In Pontormo's painting, everything is subordinated to the play of graceful rhythms created by the tightly interlocking forms. The colors are off-primary: pale blues, pinks, oranges, and greens that may have been inspired by the colors of the Sistine Chapel ceiling (see fig. 16.17). Although they seem to act together, the mourners are lost in a grief too personal to share with one another. In this hushed atmosphere, anguish is transformed into a lyrical expression of exquisite sensitivity. The entire scene is as haunted as Pontormo's self-portrait just to the right of the swooning Madonna. As the body of Christ is held up for a viewer, much as the host is during the Mass, the image conveys to believers a sense of the tragic scale of Christ's sacrifice, which the Eucharist reenacts. Pontormo may have rejected the values of the High Renaissance, but he endows this image with deeply felt emotion.

The Medici in Florence: From Dynasty to Duchy

In the chaos after the Sack of Rome of 1527, the Medici were again ousted from Florence and the Republic of Florence was reinstated. But the restoration of relations between the pope and the emperor of the Holy Roman Empire allowed the Medici to return to power by 1530. The Medici Pope Clement VII (1523–1534) promoted his family interests, and worked to enhance the power of his family as the rulers of Florence. Although he was an ardent republican, Michelangelo was continually used by this court, executing works intended to glorify the Medici dynasty in Florence.

THE NEW SACRISTY Michelangelo's activities centered on the Medici church of San Lorenzo. A century after Brunelleschi's design for the sacristy of this church (see the plan of San Lorenzo, fig. 15.8), which held the tombs of an earlier generation of Medici, Pope Leo X decided to build a matching structure, the New Sacristy. It was to house the tombs of Leo X's father, Lorenzo the Magnificent, Lorenzo's brother Giuliano, and two younger members of the family, also named Lorenzo and Giuliano. Aided by numerous assistants, Michelangelo worked on the project from 1519 to 1534 and managed to complete the architecture and two of the tombs, those for the later Lorenzo and the later Giuliano (fig. **17.3**); these tombs are nearly mirror images of each other. Michelangelo conceived of the New Sacristy as an architectural-sculptural ensemble. The architecture begins with Brunelleschian pilasters and entablatures and uses *pietra serena* to articulate the walls, as Brunelleschi had done before. Then, however, Michelangelo took liberties with his model, treating the walls

themselves as sculptural forms in a way Brunelleschi never would. The New Sacristy is the only one of the artist's works in which the statues remain in the setting intended for them, although their exact placement remains problematic. Michelangelo's plans for the Medici tombs underwent many changes while the work was under way. Other figures and reliefs for the project were designed but never executed. The present state of the Medici tombs can hardly be what Michelangelo ultimately intended, as the process was halted when the artist permanently left Florence for Rome in 1534.

The tomb of Giuliano remains an imposing visual unit, composed of a sarcophagus structure supporting two sculpted nudes above which sits an armored figure, all framed by Michelangelo's inventive reimagining of Classical architecture.

17.3. Michelangelo. Tomb of Giuliano de' Medici. 1519–1534. Marble. Height of central figure 71" (180.5 cm). New Sacristy, San Lorenzo, Florence

The central niche, which barely accommodates the seated figure, is flanked by paired pilasters that support an entablature that breaks over them. On either side, blank windows are topped by curving pediments supported by volutes; these forms echo the shape of the sarcophagus below. The triangle of statues is held in place by a network of verticals and horizontals whose slender, sharp-edged forms contrast with the roundness and weight of the sculpture.

The design shows some kinship with such Early Renaissance tombs as Rossellino's tomb for Leonardo Bruni (see fig. 15.26), but the differences are marked. There is no outright Christian imagery, no inscription, and the effigy has been replaced by two allegorical figures—*Day* on the right and *Night* on the left. Some lines penned on one of Michelangelo's drawings suggest what these figures mean: "Day and Night speak, and say: We with our swift course have brought the Duke Giuliano to death . . . It is only just that the Duke takes revenge [for] he has taken the light from us; and with his closed eyes has locked ours shut, which no longer shine on earth." The reclining figures, themselves derived from ancient river gods, contrast in mood: *Day*, whose face was left deliberately unfinished, seems to brood, while *Night* appears restless. Giuliano, the ideal image of the prince, wears Classical military garb and bears no resemblance to the deceased. ("A thousand years from now, nobody will know what he looked like," Michelangelo is said to have remarked.) His beautifully proportioned figure seems ready for action, as he fidgets with his baton. His gaze was to be directed at the never completed tomb of Lorenzo the Magnificent. Instead of a commemorative monument that looks retrospectively at the accomplishments of the deceased, the Tomb of Giuliano and the New Sacristy as a whole was to express the triumph of the Medici family over time.

Michelangelo's reimagining of Brunelleschi at the New Sacristy inspired Vasari to write that "all artists are under a great and permanent obligation to Michelangelo, seeing that he broke the bonds and chains that had previously confined them to the creation of traditional forms." However, Michelangelo's full powers as a creator of architectural forms are displayed for the first time in the vestibule to the Laurentian Library, adjoining San Lorenzo.

THE LAURENTIAN LIBRARY Clement VII commissioned this library (fig. **17.4**) in 1523 to house, for the public, the huge collection of books and manuscripts belonging to the Medici family. Such projects display the Medici benificence to the city and their encouragement of learning. The Laurentian Library is a long narrow hall that is preceded by the imposing vestibule, begun in 1523 but not completed until much later.

According to the standards of Bramante or Vitruvius, everything in the vestibule is wrong. The pediment above the door is broken. The pilasters flanking the blank niches taper downward, and the columns belong to no recognizable order. The scroll brackets sustain nothing. Most paradoxical of all are the recessed columns. This feature flies in the face of convention. In the Classical post-and-lintel system, the columns (or pilasters) and entablature must project from the wall in order to stress

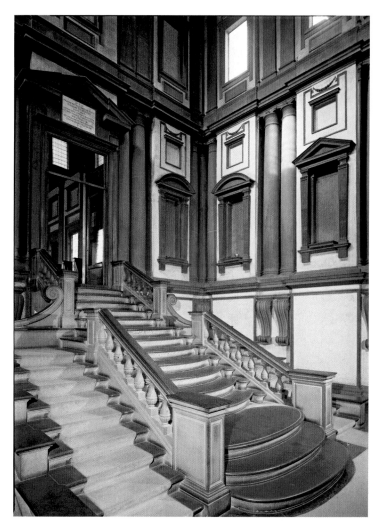

17.4. Michelangelo. Vestibule of the Laurentian Library, Florence. Begun 1523; stairway designed 1558–1559

their separate identities, as they do in the Roman Temple of Portunus (see fig. 7.2). The system could be reduced to a linear pattern (as in the Palazzo Rucellai, fig. 15.32), but no one before Michelangelo had dared to defy it by inserting columns into the wall. In the confined space of the entryway, Michelangelo gives the wall a monumental dignity without projecting the columns and letting them intrude into the vestibule. The grand staircase, designed later by Michelangelo and built by Bartolommeo Ammanati, activates the space through its cascading forms.

THE PALAZZO PITTI AND THE UFFIZI In concentrating their patronage at San Lorenzo, this generation of Medici followed the patterns of the fifteenth century. But the Medici dukes were not content to live in the Palazzo Medici built by Michelozzo. The family of Cosimo I de' Medici moved into the Palazzo della Signoria at the center of the city in 1540 (see fig. 13.16). Where earlier generations of Medici rulers separated their private residence from the seat of government, the Medici dukes did what they could to unite them. Consequently, the interior of the former town hall was remodeled to create a residential space, and new spaces for both court and government were created.

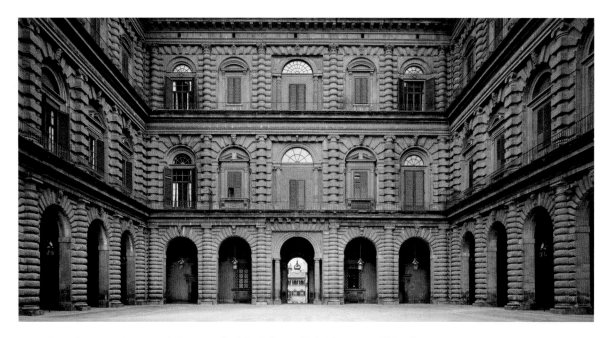

17.5. Bartolommeo Ammanati. Courtyard of the Palazzo Pitti, Florence. 1558–1570

In their search for appropriate settings for the court, the Medici acquired the Palazzo Pitti, across the Arno River, which had been built in the fifteenth century. The palazzo was enlarged by the sculptor Bartolommeo Ammanati (1511–1592), who built the courtyard between 1558 and 1570 (fig. **17.5**). Like Michelozzo's palace (fig. 15.33), the courtyard enframes a space that is both utilitarian and ceremonial, but where the fifteenth-century palace seems ornate and delicate, this courtyard has a fortresslike character. The three-story scheme of superimposed orders, derived from the Colosseum, has been overlaid with an extravagant pattern of rustication that "imprisons" the columns and reduces them to a passive role, despite the display of muscularity. The creative combination of a Classical vocabulary with the unorthodox treatment of the rustication creates a raw expression of power. The Palazzo Pitti functions today as a museum displaying many of the works collected by the Medici family.

Cosimo I de' Medici commissioned a new administrative structure to house the bureaucracies of his court in 1560. This project was assigned to Giorgio Vasari (1511–1574), a painter, historian, and architect. The building of the Uffizi, finished around 1580, consists of two long wings that face each other across a narrow court and are linked at one end by a loggia, or *testata* (fig. **17.6**). (It was originally conceived as a huge square, but this plan was deemed too grandiose by Cosimo.) Situated between the Palazzo della Signoria and the Arno, it served to restructure both the city space and the widely

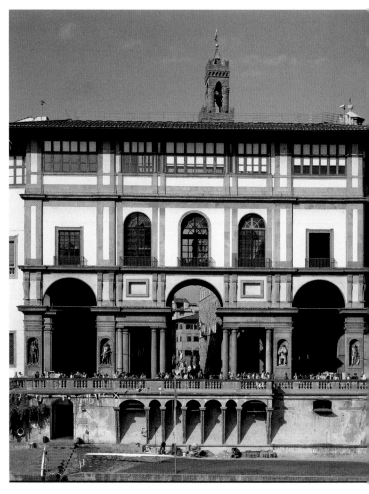

17.6. Giorgio Vasari. Facade of Uffizi, Florence. Begun 1560

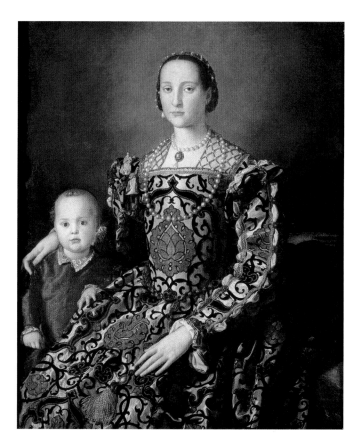

17.7. Agnolo Bronzino. *Portrait of Eleanora of Toledo and Her Son Giovanni de' Medici.* ca. 1550. Oil on panel, 45¼ × 37¾″ (115 × 96 cm). Galleria degli Uffizi, Florence

may account for the lightening of the blue background around Eleanora's face that suggests a halo. The image contains a complex set of allusions as flattering as the improvements in her looks. Bronzino's painting describes the sitter as a member of an exalted social class, not as an individual personality. This kind of formal, distant, and allusive court portrait quickly became the ideal of court portraiture throughout Europe. (See, for example, fig. 18.29, the *Portrait of Elizabeth I.*)

Bronzino was Eleanora's preferred painter and held a court appointment. His passion for drawing and his gift for poetry came together in many of his works. Nowhere is this better seen than in his *Allegory of Venus* (fig. **17.8**), which Duke Cosimo presented to Francis I of France. From these sources, Bronzino creates a complex allegory whose meanings art historians are still probing, through the approaches called iconography and iconology. (See *The Art Historian's Lens,* page 594.)

dispersed Florentine ministries. Although strongly marked by Michelangelo's architecture at San Lorenzo, the courtyard also makes reference to the Roman Forum and thus links Cosimo to Roman emperors.

PORTRAITURE AND ALLEGORY. The Medici court had refined tastes and a good sense of how to use the visual arts to express their new status. As in the fifteenth century, this generation of Medici patrons used portraiture as a means to this end. The *Portrait of Eleanora of Toledo and Her Son Giovanni de' Medici* (fig. **17.7**) by Agnolo Bronzino (1503–1572) exemplifies a new form of court portrait. This is a highly idealized portrayal of Eleanora, the wife of Cosimo I, who had blond hair (here darkened) and specific features that have been perfected in the portrait. She appears as an ideal of beauty, even as her husband was admired for his virile good looks and courage.

An important message of the portrait is the continuity of the Medici dynasty, as Eleanora's arm enframes the male heir, Giovanni (born in 1543), who, however, would not outlive her. (She bore 11 children, including eight sons, before her death from tuberculosis in 1562 at about the age of 43.) The dynastic message of the image requires the formality of the portrait with its frozen poses and aloof glances. Eleanora sits rigidly with her arm resting on her silent, staring child; she wears a complicated brocaded dress and jewelry that demonstrates her wealth and status. Bronzino depicts the pair almost like a Madonna and Child, subtly comparing Eleanora to the Virgin: This reference

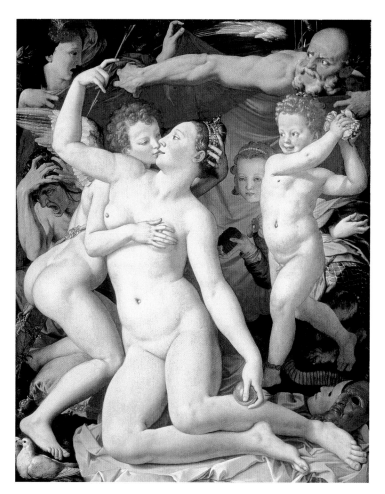

17.8. Agnolo Bronzino. *Allegory of Venus.* ca. 1546. Oil on panel, 57½ × 45⅝″ (146.1 × 116.2 cm). The National Gallery, London. Reproduced by courtesy of the trustees

Iconography and Iconology

Much of the practice of art history involves some form of the interpretation of works of art, attempting to decode what their meanings and messages were for their contemporary audiences. Among the methods that art historians rely on to further this process are iconography and iconology. *Iconography* deals with the study of the subject matter or content of works of art, identifying subjects, characters, or symbols used by artists to communicate their ideas.

Iconology is concerned with interpretation, too, but in a different way. It seeks to understand the relationship between works of art and their historical moment: how certain themes carry meaning at particular times, why certain subjects appear in art and then disappear. In this def-inition, iconology examines the relationship between form, content, and historical context. Where the practitioner of iconography may use dictionaries of saints' attributes, or symbols to put a label on a motif, the scholar interested in the iconology of a work will consider other products of the same cultural moment to identify the deeper cultural meanings associated with a theme, a motif, or a particular representation.

The term *iconology* was coined by the scholar Erwin Panofsky, whose many studies of Renaissance art continue to be very influential. One of the topics that most concerned him was the use of Classical themes during the Renaissance. His interpretations of works such as Titian's *Danaë* inquired why such themes were selected, the relationship between the painted image and literary texts on similar themes, the cultural evaluations of antiquity in the period, and other issues of context.

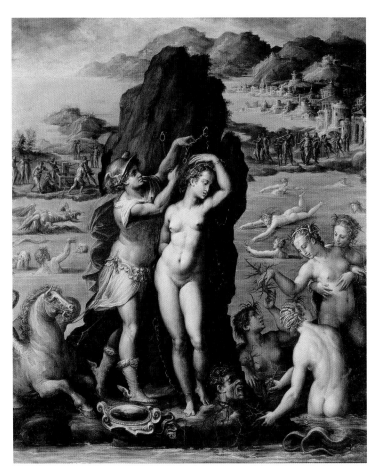

17.9. Giorgio Vasari. *Perseus and Andromeda*. 1570–1572. Oil on slate, 45¹⁄₂ × 34″ (115.6 × 86.4 cm). Studiolo, Palazzo Vecchio, Florence

Into a narrow plane close to the surface of the painting, Bronzino crowds a number of figures who have been identified only tentatively: The bald Father Time tears back the curtain from Fraud, the figure in the upper left-hand corner, to reveal Venus and Cupid in an incestuous embrace, much to the delight of the child Folly, who is armed with roses, and to the dismay of a figure tearing his hair, who has been identified as either Jealousy or Pain; on the right, Pleasure, half woman and half snake, offers a honeycomb. The moral of Bronzino's image may be that folly and pleasure blinds one to the jealousy and fraud of sensual love, which time reveals.

With its extreme stylization, Bronzino's painting proclaims a refined erotic ideal that reduces passion to a genteel exchange of gestures between figures as polished and rigid as marble. The literary quality of the allegory reflects Bronzino's skill as a poet. The complexity of the conceit matches the complexity of the composition; the high quality of the technique matches the cleverness of the content. In Bronzino, the Medici found an artist whose technical virtuosity, complex imagery, and inventive compositions perfectly matched their taste and exemplify the Mannerist style. Cosimo's gift of a painting of such erudite imagery and accomplished technique to the king of France demonstrated his realm's achievements in the literary and visual arts.

Such complex and learned treatments occur also in the *Perseus and Andromeda* (fig. **17.9**) by Giorgio Vasari, who was responsible for several major projects in the Palazzo della Signoria. This painting is part of Vasari's decorative scheme executed for the study of Cosimo's son, Francesco I de' Medici of Florence. (The program, devoted to what the ancients considered the four elements: water, wind, earth, and fire, was devised by the Humanist Vincenzo Borghini.) To represent water, the artist depicts the story of coral, which according to legend was formed by the blood of the monster slain by Perseus

when he rescued Andromeda. The subject provided an excuse to show voluptuous nudes, as the water nymphs or Nereids, lighthearted versions of Raphael's mythological creatures in the *Galatea* (fig. 16.28), frolic with bits of coral they have discovered in the sea. The central figure of Andromeda passively awaits her rescue by Perseus. Her figure with its long tapering proportions and elegant pose reflects the ideal of beauty preferred by the Medici court.

THE *ACCADEMIA DEL DISEGNO* One of the goals of the grand duke was to promote the arts in Tuscany, a goal shared by Giorgio Vasari, who had dedicated his collection of biographies, first published in 1550, to Cosimo I. Cosimo sponsored the *Accademia del Disegno* (Academy of Design) in 1563, intended to improve the training of artists and to enhance the status of the arts. Bronzino and Giorgio Vasari were founding members of the academy. Training in the academy stressed drawing and the study of the human figure, which was deepened not only by life drawing from the figure but also by dissections. Both nature and the ancients were esteemed, and the art of Michelangelo was held to be the highest achievement of the moderns. The academy emphasized the study of history and literature as well as the skills of the artist. The specifically Tuscan emphasis on drawing (*disegno*) reflected the patriotic aims of the founders, who stressed art as an intellectual activity, not mere craft.

To the academy came Jean de Bologne (1529–1608), a gifted sculptor from Douai in northern France, who had encountered Italian styles in the court of Francis I. He found employment at the granducal court and, under the Italianized name of Giovanni Bologna, became the most important sculptor in Florence during the last third of the sixteenth century. To demonstrate his skill, he chose to sculpt what seemed to him a most difficult feat: three contrasting figures united in a single action. When creating the group, Bologna had no specific theme in mind, but when it was finished the title *The Rape of the Sabine Woman* (fig. **17.10**) was proposed and accepted by the artist. The duke admired the work so much he had it installed near the Palazzo della Signoria.

The subject proposed was drawn from the legends of ancient Rome. According to the story, the city's founders, an adventurous band of men from across the sea, tried in vain to find wives among their neighbors, the Sabines. Finally, they resorted to a trick. Having invited the entire Sabine tribe into Rome for a festival, they attacked them, took the women away by force, and thus ensured the future of their race. This act of raw power and violence is sanitized in Bologna's treatment, as the figures spiral upward in carefully rehearsed movements. Bologna wished to display his virtuosity and saw his task only in formal terms: to carve in marble, on a massive scale, a sculptural composition that was to be seen from all sides. The contrast between form and content that the Mannerist tendency encouraged could not be clearer.

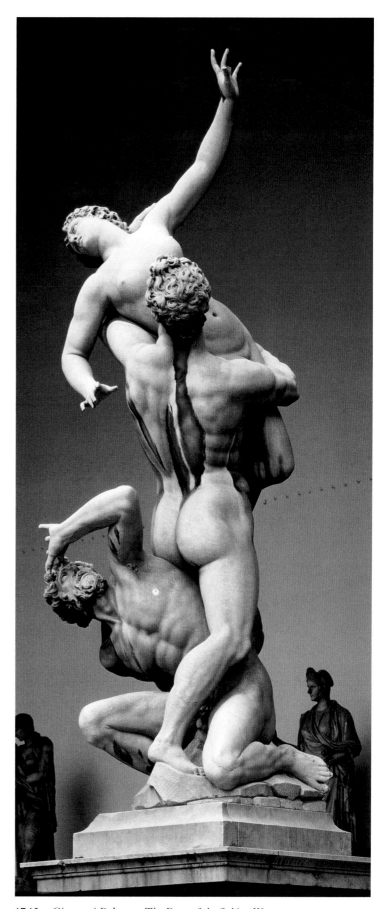

17.10. Giovanni Bologna. *The Rape of the Sabine Woman.* Completed 1583. Marble, height 13′6″ (4.1 m). Loggia dei Lanzi, Florence

ROME REFORMED

While the Medici were consolidating their power in Florence, in Rome, popes Julius II and Leo X sought to join their religious authority with secular power. Naturally, conflicts arose between the papacy and the princes of Europe. The contest between the papacy and the Holy Roman Empire resulted in the Sack of Rome in 1527 by Habsburg troops. Pope Leo X's cousin, Clement VII (1523–1534) fled, and much destruction ensued. Despite this shock to both the dignity of the city and to the papacy, Clement ultimately crowned Charles V as emperor, and returned, once again, to his project of promoting the Medici family. When Clement died in 1534, the cardinals turned to a reform-minded member of a distinguished Roman family to restore the papacy. They chose Alessandro Farnese, a childhood friend of Leo X who had been educated in the palace of Lorenzo the Magnificent. As Pope Paul III, he encouraged Charles V's efforts to bring German princes back to the Roman Church, while at the same time trying to reassure Charles's enemy, Francis I, that Germany would not overpower France.

Paul III was very concerned with the spiritual crisis presented by the Reformation. Martin Luther had challenged both the doctrine and the authority of the Church, and his reformed version of Christianity had taken wide hold in Northern Europe (see Chapter 18). To respond to the challenge of the Protestant Reformation, Paul III called the Council of Trent, which began its work in 1545 and issued its regulations in 1564.

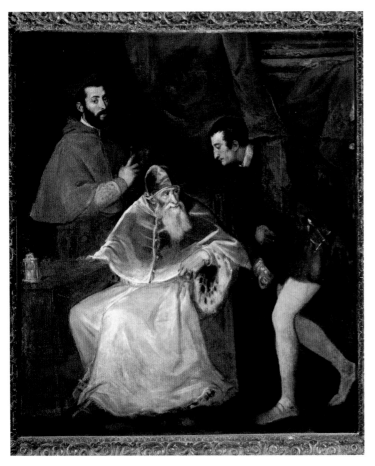

17.11. Titian. *Pope Paul III and His Grandsons.* 1546. Oil on canvas, 6′10″ × 5′8″ (2.1 × 1.7 m). Museo e Gallerie Nazionale di Capodimonte, Naples

The council reaffirmed traditional Catholic doctrine and recommended reforms of liturgy, Church practices, and works of art. (See end of Part III, *Additional Primary Sources*.)

The Catholic Church's most far-reaching and powerful weapon for combating what it considered heresy was the Inquisition, established in Italy in 1562 to investigate unapproved or suspect religious activities. Those found guilty of engaging in such heresy could be imprisoned or executed. To further control the spread of unorthodoxy, the Church compiled the Index of Prohibited Books in 1557. Texts by suspect authors or on subjects deemed unhealthful could be seized or denied publication.

Titian captured the character of Pope Paul III in his portrait *Pope Paul III and His Grandsons* (fig. **17.11**), painted in 1546 during a brief visit by the Venetian painter to Rome. The pope is depicted with the grandsons (sometimes called nephews) whose careers he sought to promote, and their dependence on him is reflected by the composition. The composition derives from Raphael's *Pope Leo X* (fig. 16.26). Yet rather than the sensual and smoothly blended brushstrokes of Raphael's portrait of the Medici pope, Titian's quick, slashing strokes give the entire canvas the spontaneity of a sketch. (In fact, some parts are unfinished.) The tiny figure of the pope, shriveled with age, manages to dominate his tall grandsons with awesome authority.

Michelangelo in Rome

Like his predecessors, Paul III saw the value in commissioning large-scale projects from the leading artists of his day. Thus he recalled Michelangelo to Rome to execute several key projects for him. Rome remained Michelangelo's home for the rest of his life. The new mood of Rome after the Sack of 1527 and during the Catholic Reformation may be reflected in the subject chosen for a major project in the Sistine Chapel. Beginning in 1534, Michelangelo painted for Paul III the powerful vision of *The Last Judgment* (fig. **17.12**). It took six years to complete this fresco, which was unveiled in 1541.

To represent the theme of the Last Judgment (Matthew 24:29–31) on the altar wall of the Sistine Chapel, Michelangelo had to remove not only the fifteenth-century frescoes commissioned by Sixtus IV but also parts of his own ceiling program in the upper lunettes. Traditional representations such as Giotto's at the Arena Chapel in Padua (see fig. 13.19) depict a conception of Hell as a place of torment. In envisioning his fresco, Michelangelo must have looked partly to Luca Signorelli's work for Orvieto Cathedral (fig. 15.60), with its muscular nudes set into vigorous action. Michelangelo replaces physical torments with spiritual agony expressed through violent physical contortions of the human body within a turbulent atmosphere. As angelic trumpeters signal the end of time, the figure of Christ sits at the fulcrum of a wheel of action: As he raises his arm, the dead rise from the Earth at the lower left to yearn toward heaven where the assembly of saints crowds about him. The damned sink away from heaven toward Charon, who ferries them to the underworld. Throughout the fresco, human figures bend, twist, climb, fall, or gaze at Christ, their forms almost superhuman in their muscular power. The nudity of the figures, which expresses

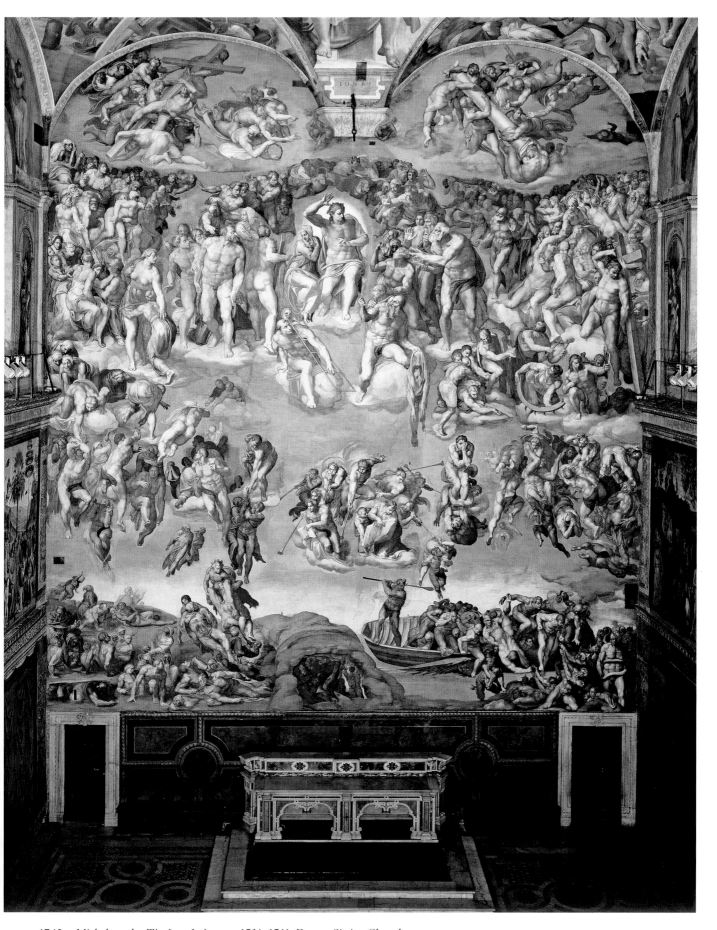

17.12. Michelangelo. *The Last Judgment.* 1534–1541. Fresco. Sistine Chapel

PRIMARY SOURCE

Michelangelo the Poet

Michelangelo's prodigious creativity was manifested in many different art forms: sculpture, painting, architecture, and poetry. Allusive and dense with imagery, his poems do not explain his works in visual media, but they sometimes treat parallel themes. This poem uses metaphors that appear visually in the Sistine Chapel's The Last Judgment. *It was a gift to his friend and reported lover, Tommaso Cavalieri, a Roman nobleman.*

The smith when forging iron uses fire
to match the beauty shaped within his mind;
and fire alone will help the artist find
a way so to transmute base metal higher

to turn it gold; the phoenix seeks its pyre
to be reborn; just so I leave mankind
but hope to rise resplendent, new refined,
with souls whom death and time will never tire.
And this transforming fire good fortune brings
by burning out my life to make me new
although among the dead I then be counted.
True to its element the fire wings
its way to heaven, and to me is true
by taking me aloft where love is mounted.

SOURCE: MICHELANGELO BUONAROTTI, *LIFE LETTERS AND POETRY*, ED. AND TR. G. BULL.
(OXFORD: OXFORD UNIVERSITY PRESS, 1987, P. 142.)

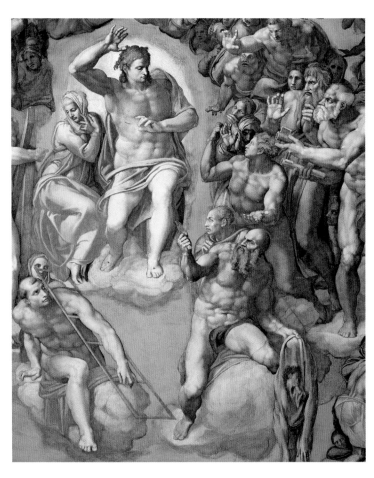

17.13. Michelangelo. *The Last Judgment* (detail, with self-portrait)

Michelangelo's belief in the sanctity of the human body, disturbed his contemporaries, and shortly after he died in 1564 one of his assistants was commissioned to add bits of cloth to the fresco to mask the nudity. The fresco was cleaned in 1994, bringing out the brilliant colors, the compressed space, and dramatic composition. These features link the work to the Mannerist style, though Michelangelo defies such labels.

That the fresco expresses Michelangelo's personal vision of the end of days is suggested by one detail: Straddling a cloud just below the Lord is the apostle Bartholomew, holding a human skin to represent his martyrdom by flaying (fig. **17.13**). The face on that skin, however, is not the saint's but Michelangelo's. In this grim self-portrait, so well hidden that it was recognized only in modern times, the artist represents himself as unworthy to be resurrected in the flesh, which is a key theme of the image. Already in his sixties, Michelangelo frequently meditated on death and salvation in his poetry of the period as well as in his art. Some parallel ideas and metaphors may be seen in a poem he composed around 1532 (see *Primary Source*, above).

These concerns also appear in his *Pietà*, begun around 1546 (fig. **17.14**). Here Michelangelo used his features again, this time for the hooded figure of Nicodemus, who holds the broken body of Christ. He intended this sculptural group for his own tomb. By casting himself as a disciple tending the body of Christ, Michelangelo gives form to a conception of personal, unmediated access to the divine. The Catholic Church may have found such an idea threatening during the Catholic Reformation, when the authority of the Roman Church was being reaffirmed as Protestantism spread throughout Europe. For whatever reason, Michelangelo smashed the statue in 1555, and left it unfinished. Compared with his 1499 *Pietà* (fig. 16.12), this work is more expressive than beautiful, as though the ideals of his youth had been replaced by a greater seriousness of spiritual purpose. Many of Michelangelo's latest sculptures remained unfinished, including the tomb of Julius II, as his efforts turned to architecture.

RESHAPING THE CAMPIDOGLIO While in Rome during the last 30 years of his life, Michelangelo's main pursuit was architecture. Among his activities were several public works projects. In 1537–1539, he received the most ambitious commission of his career: to reshape the Campidoglio, the top of Rome's Capitoline Hill, into a piazza and frame it with a

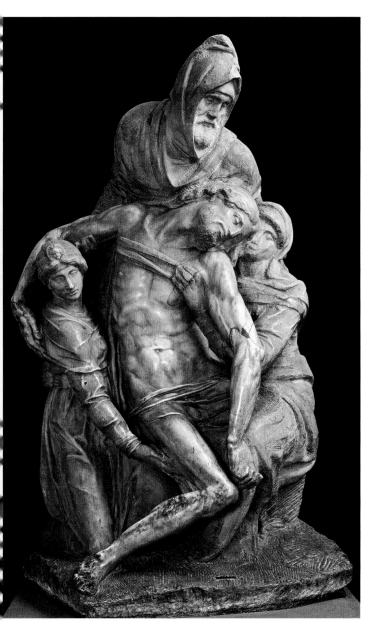

monumental architectural ensemble worthy of the site, which once had been the symbolic center of ancient Rome. This was an opportunity to plan on a grand scale. Pope Paul III worked with the civilian authorities of Rome (the Conservators) to renovate this site and made Michelangelo its designer. Although not completed until long after his death, the project was carried out essentially as Michelangelo designed it. The Campidoglio remains the most imposing civic center ever built, and it has served as a model for countless others. Pope Paul III transferred the equestrian monument of Marcus Aurelius (see fig. 7.21) from the Lateran Palace to the Campidoglio and had it installed on a base that Michelangelo designed. Placed at the top of a gently rising oval mound that defines the space, the statue became the focal point of the entire scheme. (The sculpture was recently removed to an interior space to protect it.) As the sculpted figure was thought to represent Constantine, the first Roman emperor to promote Christianity and the source of the papacy's claim to temporal power, by placing it at the center of the seat of secular government, the pope asserted papal authority in civic affairs.

Three sides of the piazza are defined by palace facades. An engraving based on Michelangelo's design (fig. **17.15**), imperfectly conveys the effect of the space created by the facades. The print shows the symmetry of the scheme and the sense of progression along the main axis toward the Senators' Palace, opposite the staircase that gives entry to the piazza. However, the shape of the piazza is not a rectangle but a trapezoid, a peculiarity dictated by the site. The Senators' Palace and the Conservators' Palace on the right were older buildings that had to be preserved behind new exteriors, but they were placed at an angle of 80 instead of 90 degrees. Michelangelo turned this problem into an asset. By adding the "New Palace" on the left, which complements the Conservators' Palace in style and placement, he makes the Senators' Palace look larger than it is, so that it dominates the piazza.

17.14. Michelangelo. *Pietà*. ca. 1546, Marble. Height 92″ (2.34 m). Museo del Opera del Duomo, Florence.

17.15. Michelangelo. The Campidoglio (engraving by Étienne Dupérac, 1569)

The whole conception has the effect of a stage set. All three buildings are long but relatively narrow, like a show front with little behind it. However, these are not shallow screens but three-dimensional structures (fig. **17.16**). The "New Palace" and its twin, the Conservators' Palace, combine voids and solids, horizontals and verticals with a plasticity not found in any piece of architecture since Roman antiquity. The open porticoes in each structure further link the piazza and facades, just as a courtyard is related to the arcades of a cloister.

The columns and beams of the porticoes are contained in a colossal order of pilasters that supports a heavy cornice topped by a balustrade. Alberti had experimented with the colossal order at Sant'Andrea in Mantua (see fig. 15.49), but Michelangelo fully exploited this device. For the Senators' Palace he used a colossal order and balustrade above a tall base, which emphasizes the massiveness of the building. The single entrance at the top of the double-ramped stairway (see fig. 17.15) seems to gather all the spatial forces set in motion by the oval mound and the flanking structures. It thus provides a dramatic climax to the piazza. Brunelleschi's design for the facade of the Innocenti in Florence (fig. 15.6), with its slim Tuscan columns and rythmic arcade, seems a delicate frame for a piazza compared with the mass and energy of the Campidoglio. Michelangelo's powerful example of molding urban spaces was important for subsequent city planners throughout Europe.

ST. PETER'S Michelangelo used the colossal order again on the exterior of St. Peter's (fig. **17.17**). The project had been inherited by several architects after Bramante's death. Michelangelo took over the design of the church in 1546 upon the death of the previous architect, Antonio da Sangallo the Younger, whose work he completely recast. Returning to a centrally focused plan, he adapted the system of the Conservators' Palace to the curving contours of the church, but with windows instead of open loggias and an attic instead of the balustrade.

Unlike Bramante's many-layered elevation (fig. 16.11), Michelangelo uses a colossal order of pilasters to emphasize the compact body of the structure, thus setting off the dome more dramatically. The same desire for compactness and organic unity led him to simplify the interior spaces (fig. **17.18**). He brought the complex spatial sequences of Bramante's plan (see fig. 16.10) into one cross and square, held in check by the huge piers that support the central dome. He further defined its main axis by modifying the eastern apse and adding a portico to it, although this part of his design was never carried out. The dome, however, reflects Michelangelo's ideas in every important respect, even though it was built after his death and has a steeper pitch.

Bramante had planned his dome as a stepped hemisphere above a narrow drum, which would have seemed to press down on the church. Michelangelo's, in contrast, has a powerful thrust that draws energy upward from the main body of the

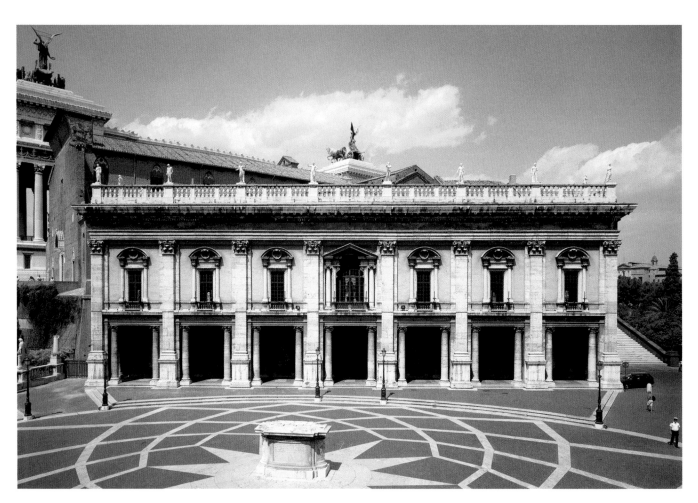

17.16. Michelangelo. Palazzo dei Conservatori, Campidoglio, Rome. Designed ca. 1545

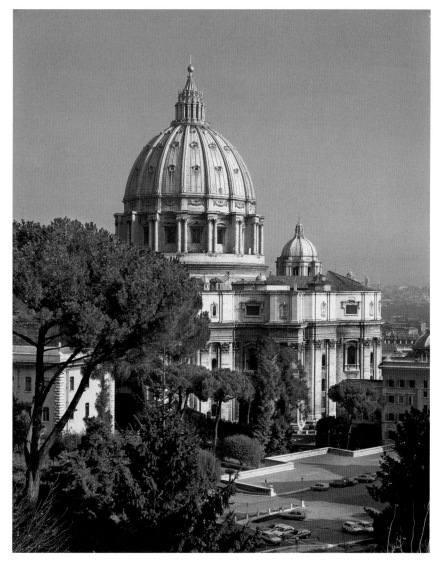

17.17. Michelangelo. St. Peter's, Rome, seen from the west. 1546–1564; dome completed by Giacomo della Porta, 1590

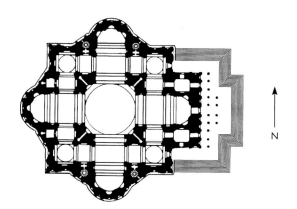

N

17.18. Michelangelo. Plan for St. Peter's

structure. Michelangelo borrowed not only the double-shell construction but also the Gothic profile from the Florence Cathedral dome (see fig. 15.2 and *Materials and Techniques*, page 508), yet the effect is very different. The smooth planes of Brunelleschi's dome give no hint of the internal stresses.

Michelangelo, however, gives sculptured shape to these forces and visually links them to the rest of the building. The vertical impetus of the colossal pilasters is taken up by the double columns of the high drum. It continues in the ribs and the raised curve of the cupola, then culminates in the tall lantern. The logic of this design is so persuasive that almost all domes built between 1600 and 1900 were influenced by it.

The Catholic Reformation and Il Gesù

Michelangelo's centralized plan for St. Peter's still presented problems for a reformed Catholic Church that was reasserting its traditions as the Council of Trent finished its deliberations in 1564. The liturgies propounded by the council worked best within a basilical structure. The council decreed that believers should see the elevation of the Host at the heart of the Mass, and this was best accomplished in a long basilical hall with an unencumbered view of the altar. Among the number of reforming religious orders established in the middle of the

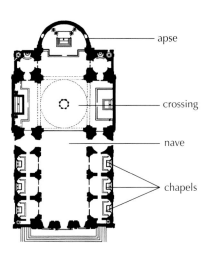

17.19. Giacomo Vignola. Plan of Il Gesù, Rome. 1568

sixteenth century, one of the most ambitious and energetic was the Society of Jesus, or Jesuits, founded by Ignatius of Loyola and promoted by Paul III. The order was approved in 1540 and by 1550 their church, Il Gesù in Rome, was being planned. Michelangelo once promised a design for this project, though apparently never furnished it; the plan that was adopted came from one of Michelangelo's assistants, Giacomo Vignola (1507–1573) in 1568. The facade was designed by Giacomo della Porta (ca. 1540–1602) but not completed until 1584. As the mother church of the Jesuits, its design must have been closely supervised so as to conform to the aims of the order. The Jesuits were at once intellectuals, mystics, and missionaries, whose charge was to fight heresy in Europe and spread Christianity to Asia and America. They required churches that adhered to the precepts of the Council of Trent—churches that would have impressive grandeur while avoiding excessive ornament. Their church of Il Gesù may be seen as the architectural embodiment of the spirit of the Catholic Reformation.

Il Gesù is a compact basilica dominated by its mighty nave (fig. **17.19**). The aisles have been replaced by chapels, thus assembling the congregation in one large, hall-like space directly in view of the altar. The attention of the audience is strongly directed toward altar and pulpit, as a representation of the interior shows (fig. **17.20**). (The painting depicts how the church would look from the street if the center part of the facade were removed. For the later decoration of the nave vault, see fig. 19.12.) The painting also depicts a feature that the ground plan cannot show: the dramatic contrast between the dim nave and the amply lighted eastern part of the church, thanks to the large windows in the drum of the dome. Light has been consciously

exploited for its expressive possibilities—a novel device, theatrical in the best sense of the term—to give Il Gesù a stronger emotional focus than we have as yet found in a church interior.

The facade by Giacomo della Porta (fig. **17.21**) is as bold as the plan. It is divided into two stories by a strongly projecting entablature that is supported by paired pilasters that clearly derive from Michelangelo, with whom Della Porta had worked. The same pattern recurs in the upper story on a somewhat smaller scale, with four instead of six pairs of supports. To bridge the difference in width and hide the roof line, Della Porta inserted two scroll-shaped buttresses. This device, taken from the facade of Santa Maria Novella in Florence by Alberti (fig. 15.31), forms a graceful transition to the large pediment crowning the facade, which retains the classic proportions of Renaissance architecture: The height equals the width.

Della Porta has masterfully integrated all the parts of the facade into a single whole: Both stories share the same vertical rhythm, which even the horizontal members obey. (Note the way the broken entablature responds to the pilasters.) In turn, the horizontal divisions determine the size of the vertical members, so there is no colossal order. Michelangelo inspired the sculptural treatment of the facade, which places greater emphasis on the main portal. Its double frame—two pediments resting on coupled pilasters and columns—projects beyond the rest of

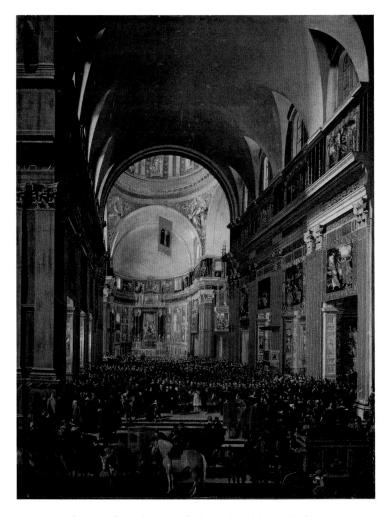

17.20. Andrea Sacchi and Jan Miel. *Urban VIII Visiting Il Gesù.* 1639–1641. Oil on canvas. Galleria Nazionale d'Arte Antica, Rome

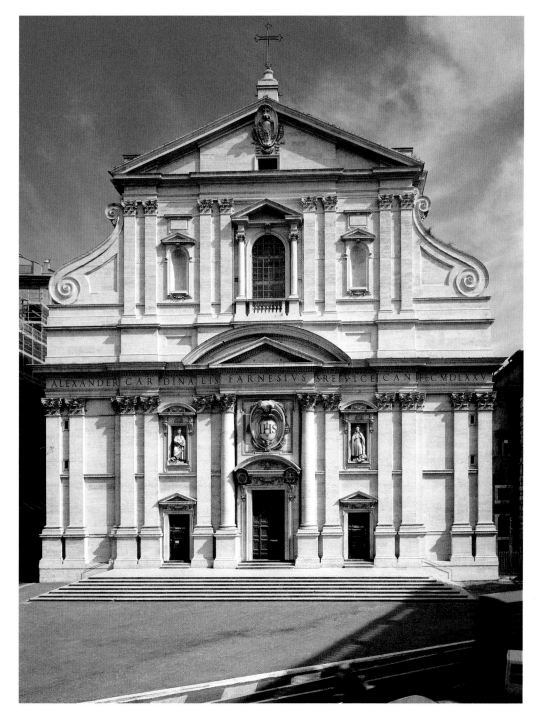

17.21. Giacomo della Porta. Facade of Il Gesù, Rome. ca. 1575–1584

the facade and gives strong focus to the entire design. Not since Gothic architecture has the entrance to a church received such a dramatic concentration of features. This facade and the freedom to add movement and plastic dimension to the facade were an important precedent for church architecture built by the Jesuits and by others during ensuing centuries.

MANTUA OF THE GONZAGA

Northern Italy was divided into a number of principalities that were smaller than the Grand Duchy of Tuscany or the Papal

States. One of the most stable of these principalities was Mantua, where the Gonzaga family retained the title of Marquis into the sixteenth century. Mantua was host to major artists in the fifteenth century, including Alberti and Mantegna. The family's traditions of patronage extended to women as well as men, as Isabella d'Este, the wife of Francesco II Gonzaga, was one of the most active patrons of the early sixteenth century. Her son, Federico, became Marquis in 1519, a title he held until Charles V named him Duke in 1530. Campaigns for such titles were often accompanied by displays of wealth and taste expressed through the arts.

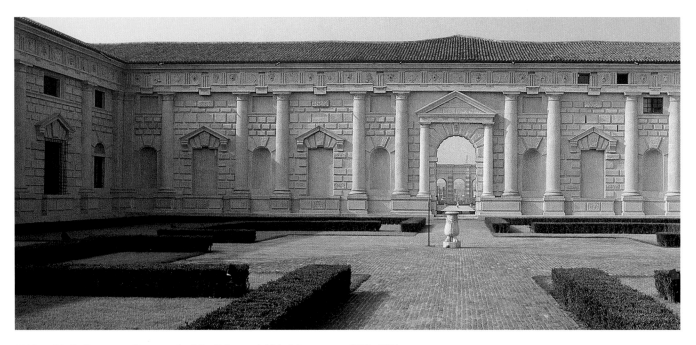

17.22. Giulio Romano. Courtyard of the Palazzo del Te, Mantua. ca. 1527–1534

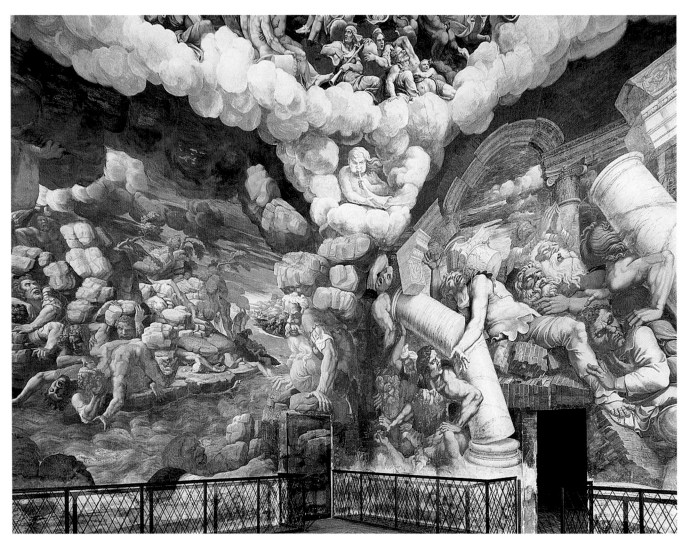

17.23. Giulio Romano. *Fall of the Giants from Mount Olympus*, from the Sala dei Giganti. ca. 1530–1532. Palazzo del Te, Mantua

The Palazzo del Te

As part of his campaign, Federico II Gonzaga commissioned Giulio Romano (ca. 1499–1546) to design a villa for him outside the city itself, called the Palazzo del Te, where he could house his mistress and receive the emperor. Giulio had been Raphael's chief assistant in Rome, but came to Mantua to follow in the footsteps of Mantegna and Alberti in 1524.

He designed the Palazzo del Te as a low structure appropriate to the flat landscape. For the courtyard facade (fig. **17.22**), Giulio used a vocabulary familiar to patrons of villas and palaces, such as the rusticated blocks and the smooth Tuscan order of engaged columns that support a projecting entablature. As Michelangelo did at the Laurentian Library, Giulio subverts the conventions of traditional Classical architecture. The massive keystones of the blank windows appear ready to burst the triangular lintels above them. The only true arch spans the central doorway, but it is surmounted by a pediment, a violation of the Classical canon. The triglyph midway between each pair of columns "slips" downward in defiance of all logic and accepted practice, thereby creating the sense that the frieze might collapse before our eyes. Giulio broke the rules of accepted practice as if to say that the rules do not apply to him, or to his patron.

What is merely a possibility on the exterior of the Palazzo del Te seems to come to pass on the interior, where Giulio painted a series of rooms with illusionistic frescoes on themes drawn from antiquity. Unlike the frescoes of Raphael in Rome, these are not images of a distant and beautiful Golden Age, but vivid and dramatic expressions of power. In the Room of the Giants in the Palazzo (fig. **17.23**), Giulio painted a fresco of the gods expelling the giants from Mount Olympus as a cataclysm of falling bodies and columns. A viewer seems to see an entire temple collapsing. The huge figures of the giants are about to be crushed by the falling architectural elements, which are being toppled by the winds, whose figures appear in the upper corners of the wall. As if witnessing the power of the new Olympian gods, a viewer feels transported into the terror of the event. Of course, the duke himself was imagined as Zeus (Jupiter) in this conceit, so the whole illusion speaks to the power of Duke Federico.

This conceit was also applied to paintings for the duke's palace in Mantua, which he commissioned from Antonio Allegri da Correggio (1489/94–1534), called Correggio, about the same time. This gifted northern Italian painter, who spent most of his brief career in Parma, absorbed the influences of Leonardo, the Venetians, Michelangelo, and Raphael into a distinctive and sensual style. Duke Federico commissioned a series of the Loves of Jupiter, among which is the *Jupiter and Io* (fig. **17.24**). As Ovid recounts, Jupiter changed his shape numerous times to seduce his lovers; here, the nymph Io, swoons in the embrace of a cloudlike Jupiter. The use of *sfumato*, combined with a Venetian sense of color and texture, produces a frank sensuality that exceeds even Titian's *Bacchanal* (see fig. 16.32). Correggio renders the vaporous form of the god with a remarkable degree of illusionism. The eroticism of the image reflects a taste shared by many of the courts of Europe, visible in Bronzino's *Allegory* (fig. 17.8) and Titian's *Danaë* (fig.17.31).

PARMA AND BOLOGNA

The larger political entities in Italy aimed to swallow up the smaller ones. The cities of Parma and Bologna in north central Italy were both part of the Papal States as the sixteenth century unfolded. Forms of art and patronage established by courts in Rome, Florence, and Milan were emulated by the citizens of these cities.

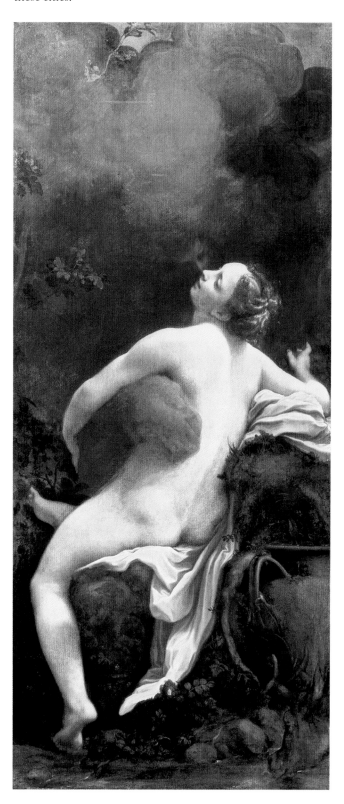

17.24. Correggio. *Jupiter and Io.* ca. 1532. Oil on canvas, 64½ × 27¾″ (163.8 × 70.5 cm). Kunsthistorisches Museum, Vienna

Correggio and Parmigianino in Parma

Correggio spent much of his career in the city of Parma, which had recently been absorbed into the Papal States. This new affiliation brought the city new wealth and inspired local patrons of art and architecture, and more than once Correggio was the artist chosen for their projects. He put his skills to work at the dome of Parma Cathedral where he painted the fresco of *The Assumption of the Virgin* between 1522 and 1530 (fig. **17.25**). The surfaces of the dome are painted away by Correggio's illusionistic perspective. A viewer standing below the dome is transported into the heavens, as the sky opens to receive the body of the Virgin rising into the light.

Correggio here initiates a new kind of visionary representation in which heaven and Earth are joined visually and spiritually through the magic of perspective and the artist's skill. Not since Mantegna's *Camera Picta* in Mantua (fig. 15.53) has a ceiling been so totally replaced by a painted illusion; the concept would reverberate in the works of other artists in the

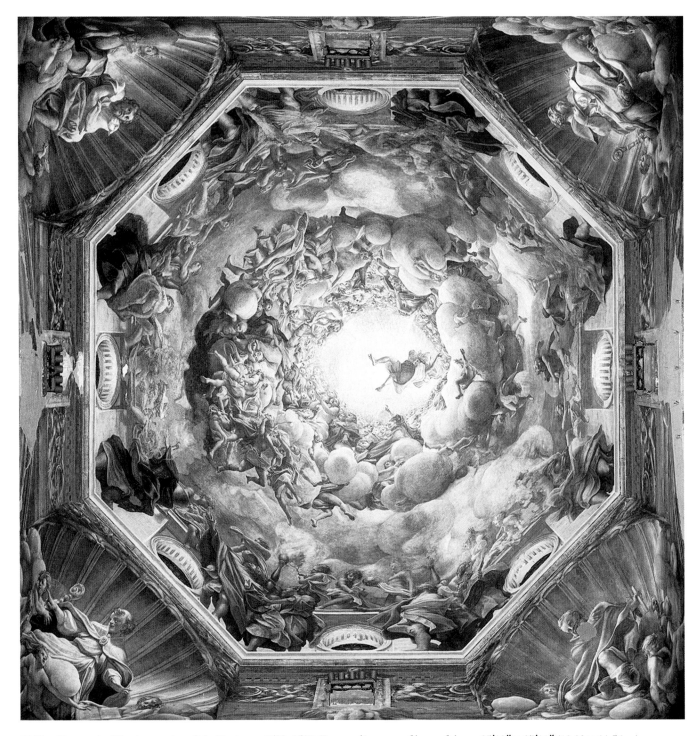

17.25. Correggio. *The Assumption of the Virgin.* ca. 1522–1530. Fresco, diameter of base of dome 35′10″ × 37′11″ (10.93 × 11.56 m). Dome of Parma Cathedral, Parma, Italy

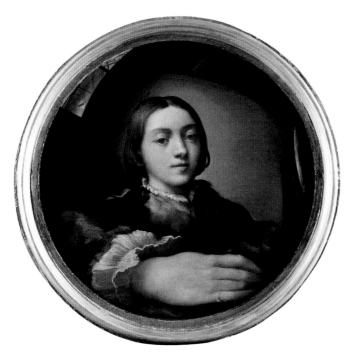

17.26. Parmigianino. *Self Portrait*. 1524. Oil on panel, diameter 9⅝″ (24.7 cm). Kunsthistorisches Museum, Vienna

ART IN TIME

1522—Plague returns to Italy

1530—Coronation of Charles V as Holy Roman Emperor in Bologna

1532—Correggio's *Jupiter and Io*

1535—Parmigianino's *The Madonna with the Long Neck*

1543—Vesalius publishes first text on human anatomy

1543—Copernicus publishes *On the Revolutions of the Celestial Orbs*

seventeenth century, when ceilings would disappear through illusionistic devices, as can be seen in the work of Pietro da Cortona (fig. 19.11) and Gaulli (fig. 19.12). Correggio also gave the figures themselves the ability to move with such exhilarating ease that the force of gravity seems not to exist for them, and they frankly delight in their weightless condition. Reflecting the influence of Titian, these are healthy, energetic beings of flesh and blood, which makes the Assumption that much more miraculous.

Parma was the birthplace of yet another gifted painter, Girolamo Francesco Maria Mazzola (1503–1540), known as Parmigianino. Precocious and intelligent, Parmigianino had made his reputation as a painter in Rome, Florence, and elsewhere before returning to Parma in 1530. His *Self Portrait* (fig. **17.26**), done as a demonstration piece, suggests his self-confidence. The artist's appearance is bland and well groomed. The features, painted with Raphael's smooth perfection, are veiled by a delicate Leonardoesque *sfumato*. The picture records what Parmigianino saw as he gazed at his reflection in a convex mirror, including the fishbowl distortions in his hand. Parmigianino substitutes his painting for the mirror itself, even using a specially prepared convex panel. The painting demonstrates his skill at recording what the eye sees, yet at the same time it shows off his learning by a subtle allusion to the myth of Narcissus, who according to Greek legend, looked in a pool of water and fell in love with his own reflection.

Parmigianino's skill is evident in his most famous work, *The Madonna with the Long Neck* (fig. **17.27**), commissioned in 1535 by a noblewoman of Parma for a family chapel in the church of Santa Maria dei Servi. Despite his deep study of

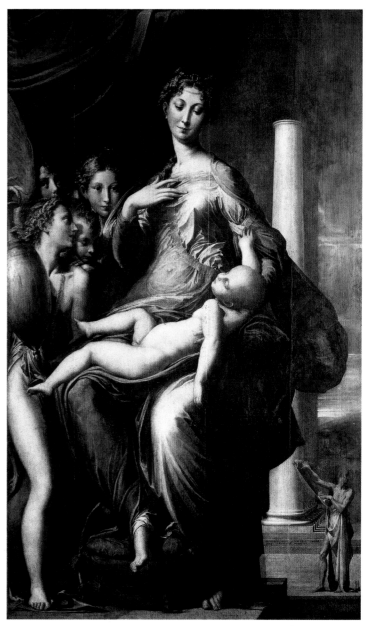

17.27. Parmigianino. *The Madonna with the Long Neck*. ca. 1535. Oil on panel, 7′1″ × 4′4″ (2.2 × 1.3 m). Galleria degli Uffizi, Florence

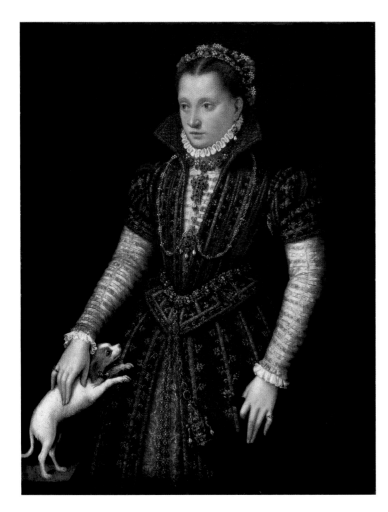

17.28. Lavinia Fontana. *Portrait of a Noblewoman*. ca. 1580. Oil on canvas, 45$\frac{1}{4}$″ × 35$\frac{1}{4}$″ (114 × 89.5 cm). National Museum of Women in the Arts, Washington, DC. Gift of Wallace and Wilhelmina Holladay

Raphael and Correggio, Parmagianino has a different ideal of beauty, which he establishes with the large amphora offered by the figure at the left. In his painting, the perfect oval of Mary's head rests on a swanlike neck, while her body swells only to taper to her feet, which mimics the shape of the amphora. By contrast, Raphael's *Belle Jardiniere* (fig. 16.22) seems all circles and cubes, and her features are sweet rather than haughty. Nor does Parmigianino attempt to replicate Raphael's stable compositions. Here, the sleeping Christ Child balances precariously on the Madonna's lap, as she lifts a boneless hand to her breast. The composition is as unbalanced as the postures: heavily weighted to the left, open and distant to the right. All the figures have elongated limbs and ivory-smooth features, and the space is compressed. In mannerist fashion, these elements draw attention to the artist's skill and his inversion of Raphael's ideals.

These choices may reflect the meaning of the image. The large Christ Child in his mother's lap recalls the theme of the *Pietà*, which shows that Jesus is already aware of his fate. Nor is the setting as arbitrary as it may seem. The gigantic column is a symbol often associated with the Madonna as the gateway to heaven and eternal life, as well as the Immaculate Conception. At the same time it may also refer to the column on which Jesus endured the flagellation during the Passion, which the tiny figure of a prophet foretells on his scroll. *The Madonna with the Long Neck* is a vision of unearthly perfection, with a cold and memorable elegance.

Lavinia Fontana in Bologna

Parmagianino had stopped for a period in Bologna, an important city north of Florence. Long a part of the Papal States, Bologna was not ruled by a prince, but controlled from Rome in conjunction with a senate composed of local aristocratic families. Its cultural character was also shaped by the presence of its ancient university. While painting in Bologna had not achieved the level of acclaim it had in Florence or Venice, the city was home to several women artists during the sixteenth century. One of the most important of these was Lavinia Fontana (1552–1614), whose reputation was great in her lifetime, though it became obscured later.

Fontana was the daughter of the painter Prospero Fontana, a distinguished painter and frequent head of the painter's guild. Her upbringing allowed her to learn an art form that increasingly was being restricted by the new training in the academies. Her style was formed by her studies with her father, and her experience of the works of Raphael, Correggio, and Parmigianino in Bologna. She developed a network of patrons, many of them among the noblewomen of the city, for whom she painted religious paintings and portraits.

A good example is the *Portrait of a Noblewoman,* dated to the 1580s (fig. **17.28**). Against a dark background, a young woman stands in the finery she wore on her wedding day. The light pouring in from the left distinguishes the forms. Fontana takes care in rendering the details of the dress, the jewelry, and the headdress. The young woman faces her married future as a decorous and decorative figure, her eyes averted from the spectator as if to demonstrate her modesty. With one hand she caresses a little dog, perhaps a pet, or perhaps a symbol of fidelity; with the other she holds a fur pelt attached by a jewel to her waist, another symbol, this time associated with fertility. Fontana's skill at composing such flattering and sumptuous images made her one of the most sought after artists of her city.

VENICE: THE SERENE REPUBLIC

Despite the attacks it endured at the beginning of the sixteenth century, Venice regained much of its territory and wealth by 1529. Its aristocracy reasserted their political and cultural power throughout the century, contributing to a distinctive situation

for artists and for patrons. Instead of a court, Venice remained a nominal republic, controlled by ancient families, such as the Loredan, the Vendramin, and the Barbaro. In addition to religious works of art, these families commissioned works for their homes in town and for their villas in the country, so artists had a wide variety of themes to depict. The city itself expressed its status through public works projects commissioned by the civic fathers and intended to beautify the Most Serene Republic (*Serenissima*). One example of this is the refashioning of the heart of the city—the piazzetta between San Marco and the Canal of San Marco—with a pair of buildings in the 1530s.

Sansovino in Venice

To design these structures, the Council of Ten who controlled the city held a competition in 1535 to design a new home for the state mint (fig. **17.29**, left). They selected Jacopo Sansovino

(1486–1570), a Florentine sculptor who left Rome for Venice after the Sack of Rome in 1527 and established himself as the chief architect of the city. Not surprisingly, his buildings are sculptural in character. In the spirit of earlier Venetian structures such as the Ca' d'Oro (fig. 15.54) and the Doge's Palace (fig. 13.34) nearby, Sansovino composed the facade to have numerous openings formed by arches and huge windows. The supporting arches and columns, however, are given greater stress through the rustication used throughout, which adds to the imposing effect of the building. (The top story was added around 1560.)

The Procurators of San Marco then hired Sansovino to build the Library of San Marco (fig. **17.29**, right) as a public library and a repository for a rich collection of Greek and Latin manuscripts. Situated next to the mint, the library uses a much more elegant architectural vocabulary. It is a long, two storied structure, composed as a series of arcades supporting heavy cornices.

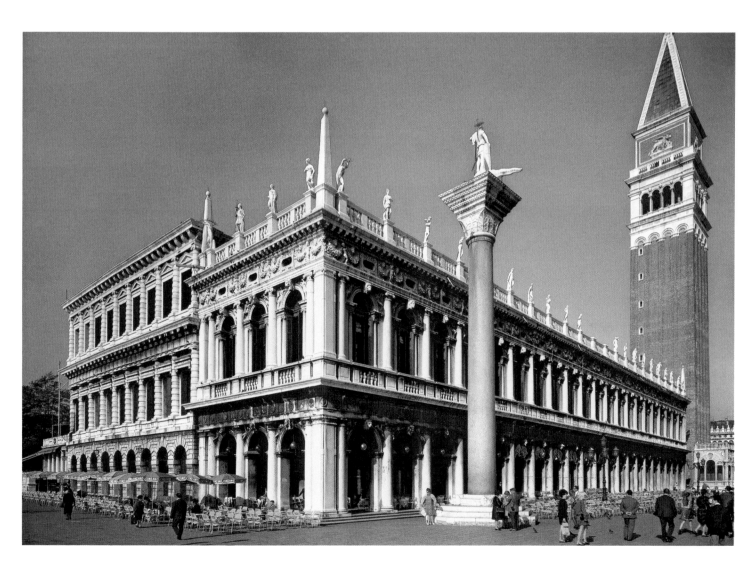

17.29. Jacopo Sansovino. Mint (left) and Library of St. Mark's, Venice. Begun ca. 1535/37

Oil on Canvas

For much of the Middle Ages and Renaissance, painters worked either directly on walls or on solid wood supports. Wood panels were formed of planks that had to be attached together, so seams are sometimes visible. While durable, wood is also heavy and susceptible to warping. In the fifteenth century, some artists both in Italy and in Northern Europe painted on cloth supports, usually canvas or linen, as a less expensive substitute for wood. Canvas is also lighter, and more easily portable. Painted canvases from Flanders, called *panni dipinti*, were imported in good numbers to Italy.

In the humid climate of Venice, where neither fresco nor wood panels would easily survive, artists preferred to work on canvas supports, especially on large-scale projects. By the middle of the sixteenth century, canvas began to replace wood as

Detail of Titian, *Danaë*

the support of choice. By 1600, oil on canvas was the preferred medium for most painters and for patrons who were not commissioning frescoes. Once the canvas itself had been stretched on a wooden framework, it would be covered with a gluelike material to seal the fibers. Then several priming coats would be applied and allowed to dry before the painting commenced.

Working on a large scale also inspired Venetian painters to experiment with the oil medium itself. Instead of building up layers of tinted glazes over large surfaces, artists loaded the brush with more opaque color and laid it on with broad strokes. Sometimes the thick paint looked pastelike, a technique called **impasto**. In such cases, the surface is not a mirrorlike smoothness, but it is rough, and unevenly catches the light. Titian is one of the innovators of this technique. His example was the inspiration for the painterly artists of the Baroque, including Rubens, Rembrandt, and Velasquez.

The street-level arcade is enframed by a Roman Doric order inspired by the Colosseum, while the upper story shows an elaborate treatment of the Ionic order (including triple engaged columns) surmounted by a garlanded entablature. The structure is capped off by a balustrade, with life-size statues over every column cluster and obelisks at each corner. The extravagant ornamentation of both structures creates an effect of opulence that proclaims the Venetian republic as a new Rome.

Titian

Titian dominated painting in Venice throughout the sixteenth century. Like Michelangelo, he lived a long life, and he had numerous pupils to spread his ideas and techniques. His fame was such that by the 1530s Titian's work was sought by the most elite patrons of Europe. For example, in 1538, Titian was commissioned by the duke of Urbino, Guidobaldo II della Rovere, to execute the so-called *Venus of Urbino* (fig. **17.30**). The painting, based on models by Giorgione, depicts a nude young woman lying on a bed in a well-furnished chamber. In the background, two women search in a *cassone* for something, perhaps for a garment. Details such as the presence of the *cassone* and the little dog lead some scholars to suggest that this may have been an image intended to celebrate a marriage. However, the owner referred to the picture only as "the naked woman." Titian's use of color records the sensuous textures of the woman's body, which has been placed on display for a viewer whose gaze she meets. It may have been intended as an erotic image, not a Classical theme.

Whether or not this is Venus, the sensuously depicted female nude became a staple product of Titian's workshop, which was supported by the patronage of other powerful men.

For Phillip II of Spain (the son of Charles V), Titian made series of images of the Loves of Jupiter based on Ovid's *Metamorphoses*. And the *Danaë* (fig. **17.31**), painted for Ottavio Farnese and delivered during a stay by the painter in Rome, shows Jupiter in the guise of a gold shower seducing a young woman, who had been locked in a tower by her father to keep away all suitors. By varying the consistency of his pigments, the artist was able to capture the texture of Danaë's flesh with great accuracy, while distinguishing it clearly from bed sheets and covers. To convey these tactile qualities, Titian built up his surface in thin, transparent glazes. The interaction between these layers produces unrivaled richness and complexity of color; yet the medium is so filmy that it becomes nearly as translucent as the cloud trailing off into the sky.

The figure shows the impact of Michelangelo's *Night* on the Tomb of Giuliano de' Medici, which Titian probably knew from an engraving. After seeing the canvas in the artist's studio, Michelangelo is said to have praised Titian's coloring and style but to have criticized his drawing. Michelangelo's practice was to make detailed drawings before carving his figures; such preliminary drawings for Titian's works have not survived. Although an excellent draughtsman, Titian apparently worked directly on the surface of his canvases and made adjustments as he went along, building forms out of layers of color. This emphasis on color rather than drawing was one of the distinctive aspects of Venetian painting, always criticized by the Florentine academy and its successors.

Titian experimented with many different forms, including prints, but his most enduring innovations were in the technique of painting on canvas (see *Materials and Techniques*, above). His late works demonstrate his most free brush work. Titian

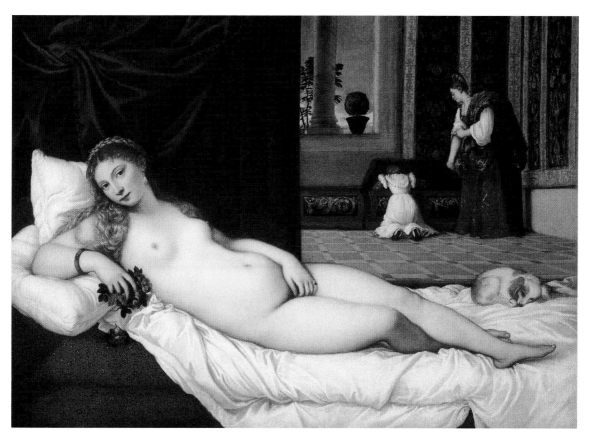

17.30. Titian. *Venus of Urbino.* ca. 1538. Gallerie degli Uffizi, Florence

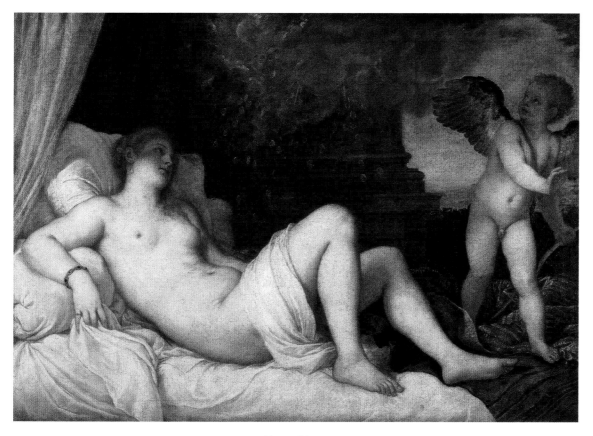

17.31. Titian. *Danaë.* ca. 1544–46. Oil on canvas, $47^{1}/_{4} \times 67^{3}/_{4}''$ (120×172 cm).
Museo e Gallerie Nazionale di Capodimonte, Naples

intended the *Pietà* (fig. **17.32**), for his own tomb in the Franciscan church of Santa Maria Gloriosa dei Frari; incomplete at his death in 1576, it was finished by one of his students. Like Michelangelo's late *Pietà* (fig. 17.14), Titian depicts the body of Christ in his mother's arms as friends and followers mourn. The figures of Moses and a sibyl flank a heavily rusticated niche reminiscent of the facade of Sansovino's mint (fig. 17.29). This large canvas owes it power not only to its large scale and dramatic composition, although these are contributing factors, but also to Titian's technique. The forms emerging from the semi-darkness consist wholly of light and color. The artist applies the color in thick masses of paint, yet despite this heavy impasto, the surfaces have lost every trace of material solidity. The gesture of

Mary Magdalen and the sorrow in the features of the Virgin add poignancy to the scene. A kneeling figure, possibly St. Jerome, stands in for Titian himself and reaches over to touch the body of Christ in reverence. The quiet, almost resigned mood is enhanced by the painting's ethereal forms.

Titian's Legacy

Titian's creative output and reputation drew many artists to work in his shop, but he had a tremendous influence even on those who did not. From the island of Crete (then owned by Venice), the young Domenikos Theotokopoulos, called El Greco, came to study in Titian's shop before heading to Spain

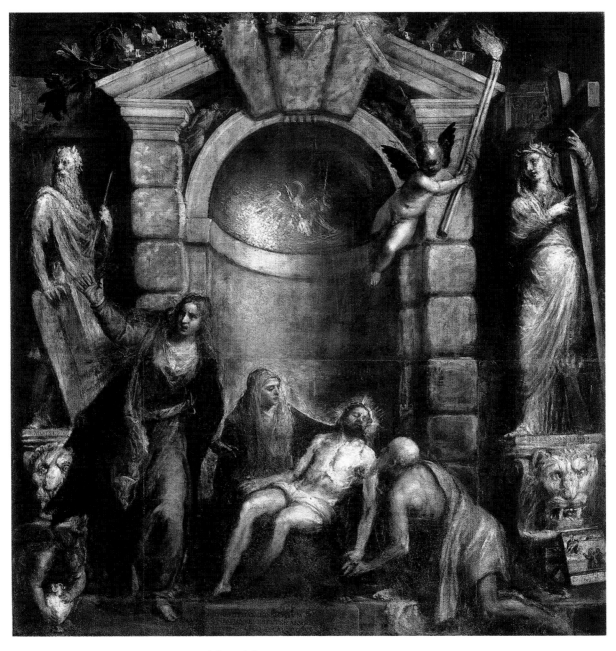

17.32. Titian. *Pietà*. ca. 1576. Canvas, 11′6″ × 12′9″ (3.51 × 3.89 m). Gallerie dell'Accademia, Venice

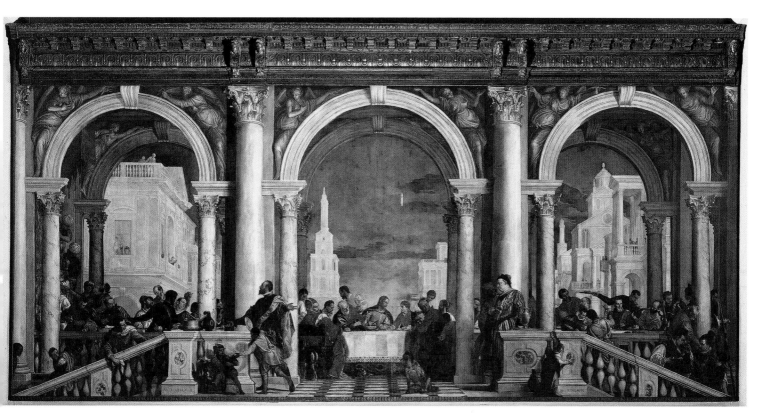

17.33. Paolo Veronese. *The Feast in the House of Levi.* 1573. Oil on canvas, 18′2″ × 42′ (5.5 × 12.8 m). Gallerie dell'Accademia, Venice

(see Chapter 18). The two leading painters in Venice after Titian, Veronese and Tintoretto, developed in different directions. Where Veronese made images that depend on early Titian works like the *Pesaro Madonna* (fig. 16.33) and aimed for naturalism, Tintoretto exploited the drama and fluid brushwork of Titian's later work, like the *Pietà*.

PAOLO VERONESE The paintings of Paolo Cagliari (1528–1588), called Paolo Veronese, who was born and trained in Verona, start from the naturalism inherent in Titian's style, but add an interest in details of everyday reality, as seen in animals, textiles, and foodstuffs—and in grand architectural frameworks. In his huge canvas called *Feast in the House of Levi* (fig. **17.33**), Veronese avoids all reference to the mystical. His symmetrical composition harks back to paintings by Leonardo and Raphael, while the festive mood of the scene reflects examples by Titian of the 1520s, so that at first glance the picture looks like a High Renaissance work born 50 years too late. Veronese, however, is less interested than Leonardo was in conveying spiritual or psychological depth. Originally commissioned for the refectory of a Dominican monastery, the painting depicts a sumptuous banquet, a true feast for the eyes. As with his contemporaries elsewhere in Italy, Veronese was deliberately vague about which event from the life of Jesus he originally meant to depict. He gave the painting its present title

only after he had been summoned by the religious tribunal of the Inquisition on the charge of filling his picture with "buffoons, drunkards, Germans, dwarfs, and similar vulgarities" unsuited to its theme. The account of the trial shows that the tribunal thought the representation of the *Last Supper* was irreverent (see *Primary Source*, page 614). In the face of their questions, Veronese settled on a different title, *The Feast in the House of Levi*, which permitted him to leave the offending incidents in place. He argued that they were no more objectionable than the nudity of Jesus and the Heavenly Host in Michelangelo's *Last Judgment*. Nevertheless, the tribunal failed to see the analogy, on the grounds that "in the Last Judgment it was not necessary to paint garments, and there is nothing in those figures that is not spiritual." Veronese claimed the privilege to "paint pictures as I see fit".

TINTORETTO Jacopo Robusti (1519–1594), called Tintoretto, took a less worldly attitude. Tintoretto reportedly wanted "to paint like Titian and to design like Michelangelo." He did not imitate the High Renaissance phases of those artists' careers, however, but absorbed their later styles, which are more expressive and less realistic in their effects. In a number of large-scale paintings for Venetian confraternities, groups of lay people organized for religious activities, he assimilated the visionary effects of Titian's late paintings and the energetic

From a Session of the Inquisition Tribunal in Venice of Paolo Veronese

Because of the liberal religious atmosphere of Venice, Veronese was never required to make the various changes to his painting of the Last Supper (see fig. 17.33) asked for by the tribunal of the Inquisition in this interrogation. All parties seem to have been satisfied with a mere change of title to Supper in the House of Levi *(now* Feast in the House of Levi*).*

Today, Saturday, the 18th of the month of July, 1573, having been asked by the Holy Office to appear before the Holy Tribunal, Paolo Caliari of Verona, questioned about his profession:

A: I paint and compose figures.

Q: Do you know the reason why you have been summoned?

A: No, sir.

Q: Can you imagine it?

A: I can well imagine.

Q: Say what you think the reason is.

A: According to what the Reverend Father, the Prior of the Convent of SS. Giovanni e Paolo, told me, he had been here and Your Lordships had ordered him to have painted [in the picture] a Magdalen in place of a dog. I answered him by saying I would gladly do everything necessary for my honor and for that of my painting, but that I did not understand how a figure of Magdalen would be suitable there.

Q: What picture is this of which you have spoken?

A: This is a picture of the Last Supper that Jesus Christ took with His Apostles in the house of Simon.

Q: At this Supper of Our Lord have you painted other figures?

A: Yes, milords.

Q: Tell us how many people and describe the gestures of each.

A: There is the owner of the inn, Simon; besides this figure I have made a steward, who, I imagined, had come there for his own pleasure to see how things were going at the table. There are many figures there which I cannot recall, as I painted the picture some time ago.

Q: In this Supper which you made for SS. Giovanni e Paolo what is the significance of the man whose nose is bleeding?

A: I intended to represent a servant whose nose was bleeding because of some accident.

Q: What is the significance of those armed men dressed as Germans, each with a halberd in his hand?

A: We painters take the same license the poets and the jesters take and I have represented these two halberdiers, one drinking and the other eating nearby on the stairs. They are placed there so that

they might be of service because it seemed to me fitting, according to what I have been told, that the master of the house, who was great and rich, should have such servants.

Q: And that man dressed as a buffoon with a parrot on his wrist, for what purpose did you paint him on that canvas?

A: For ornament, as is customary.

Q: Who are at the table of Our Lord?

A: The Twelve Apostles.

Q: What is St. Peter, the first one, doing?

A: Carving the lamb in order to pass it to the other end of the table.

Q: What is the Apostle next to him doing?

A: He is holding a dish in order to receive what St. Peter will give him.

Q: Tell us what the one next to this one is doing.

A: He has a toothpick and cleans his teeth.

Q: Did anyone commission you to paint Germans, buffoons, and similar things in that picture?

A: No, milords, but I received the commission to decorate the picture as I saw fit. It is large and, it seemed to me, it could hold many figures.

Q: Are not the decorations which you painters are accustomed to add to paintings or pictures supposed to be suitable and proper to the subject and the principal figures or are they for pleasure— simply what comes to your imagination without any discretion or judiciousness?

A: I paint pictures as I see fit and as well as my talent permits.

Q: Does it seem fitting at the Last Supper of the Lord to paint buffoons, drunkards, Germans, dwarfs, and similar vulgarities?

A: No, milords.

Q: Do you not know that in Germany and in other places infected with heresy it is customary with various pictures full of scurrilousness and similar inventions to mock, vituperate, and scorn the things of the Holy Catholic Church in order to teach bad doctrines to foolish and ignorant people?

A: Yes, that is wrong.

After these things had been said, the judges announced that the above named Paolo would be obliged to improve and change his painting within a period of three months from the day of this admonition and that according to the opinion and decision of the Holy Tribunal all the corrections should be made at the expense of the painter and that if he did not correct the picture he would be liable to the penalties imposed by the Holy Tribunal. Thus they decreed in the best manner possible.

SOURCE: *A DOCUMENTARY HISTORY OF ART*, VOL. 2, ED. ELIZABETH GILMORE HOLT. (PRINCETON, NJ: PRINCETON UNIVERISITY PRESS, 1982)

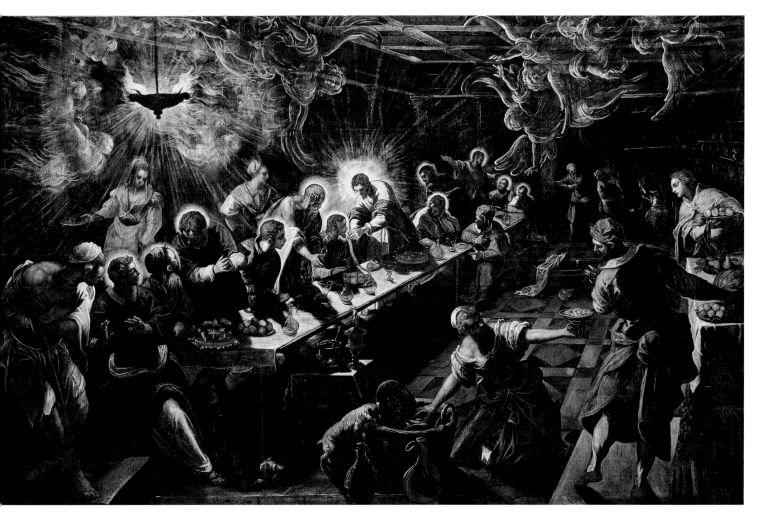

17.34. Jacopo Tintoretto. *The Last Supper.* 1594. Oil on canvas, 12′ × 18′8″ (3.7 × 5.7 m). San Giorgio Maggiore, Venice

compositions of the late Michelangelo. Tintoretto's final major work, *The Last Supper*, finished in 1594, is spectacular (fig. **17.34**). It seems to deny in every possible way the balance and clarity of Leonardo's version of the theme painted almost exactly a century before, which yet underlies Veronese's picture. Jesus, to be sure, is at the center of the composition, but his small figure in the middle distance is distinguished mainly by the brilliant halo. Tintoretto barely hints at the human drama of Judas' betrayal, so important to Leonardo. Judas can be seen isolated on the near side of the table across from Jesus (as Castagno had arranged him in his fresco in Sant'Apollonia, fig. 15.29), but his role is so insignificant that he could almost be mistaken for an attendant. The table is now placed at a sharp angle to the picture plane in exaggerated perspective. This arrangement had a purpose. It was designed to relate the scene to the space of the chancel of San Giorgio Maggiore in Venice, for which it was commissioned. It was seen on the wall near where the Benedictine friars knelt at the altar rail to receive Communion; from that angle the scene recedes less sharply than when viewed head on.

Tintoretto gives the event an everyday setting, cluttering the scene with attendants, containers of food and drink, and domestic animals. There are also celestial attendants who converge upon Jesus just as he offers his body and blood, in the form of bread and wine, to the disciples. The smoke from the blazing oil lamp miraculously turns into clouds of angels, blurring the distinction between the natural and the supernatural and turning the scene into a magnificently orchestrated vision. The artist's main concern has been to make visible the miracle of the Eucharist—the Transubstantiation of earthly into divine food—in both real and symbolic terms. (The central importance of this sacrament to Catholic doctrine was forcefully reasserted during the Catholic Reformation.) The painting was especially appropriate for its location in San Giorgio Maggiore, which played a prominent role in the reform movement.

Andrea Palladio (1508–1580)

From *The Four Books of Architecture*

Published in 1570, Palladio's The Four Books of Architecture *made an enormous impression on his European contemporaries. His book provided the basis for much French and English architecture of the seventeenth and eighteenth centuries.*

Guided by a natural inclination, I gave myself up in my most early years to the study of architecture: and as it was always my opinion, that the ancient Romans, as in many other things, so in building well, vastly excelled all those who have been since their time, I proposed to myself Vitruvius for my master and guide, who is the only ancient writer of this art, and set myself to search into the reliques of all the ancient edifices, that, in spight of time and the cruelty of the Barbarians, yet remain; and finding them much more worthy of observation, than at first I had imagined, I began very minutely with the utmost diligence to measure every one of their parts; of which I grew at last so sollicitous an examiner, (not finding any thing which was not done with reason and beautiful proportion) that I have very frequently not only travelled in different parts of Italy, but also out of it.

Whereupon perceiving how much this common use of building was different from the observations I had made upon the said edifices, and from what I had read in Vitruvius, Leon Battista Alberti, and in other excellent writers it seemed to me a thing worthy of a man, who ought not to be born for himself only, but also for the utility of others, to publish the designs of those edifices, (in collecting which, I have employed so much time, and exposed myself to so many dangers) and concisely to set down whatever in them appeared to me more worthy of consideration; and moreover, those rules which I have observed, and now observe, in building; that they who shall read these my books, may be able to make use of whatever will be good therein, and supply those things in which I shall have failed; that one may learn, by little and little, to lay aside the strange abuses, the barbarous inventions, the superfluous expence, and (what is of greater consequence) avoid the various and continual ruins that have been seen in many fabricks.

SOURCE: ANDREA PALLADIO, *THE FOUR BOOKS OF ARCHITECTURE*. REPRINT OF 1738 EDITION. (NY: DOVER PUBLICATIONS, 1965)

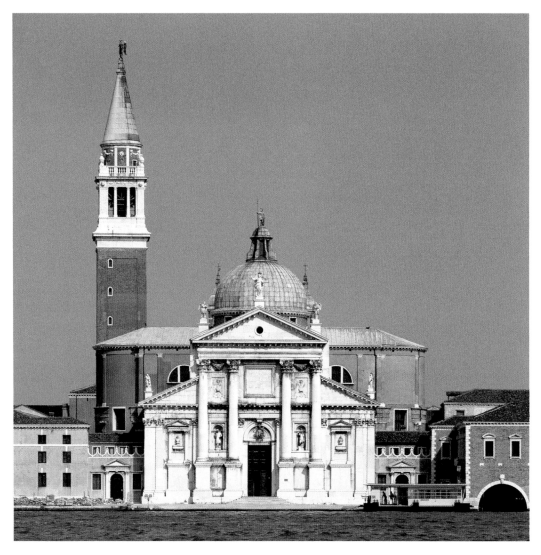

17.35. Andrea Palladio. San Giorgio Maggiore, Venice. Designed 1565

Andrea Palladio and Late Renaissance Architecture

The commission for San Giorgio Maggiore was awarded to one of the most influential architects of the Renaissance, Andrea Palladio (1508–1580) in 1565. Although Palladio's career centered on his native Vicenza, a town near Venice, his buildings and theoretical writings brought him international renown. Palladio believed that architecture must be governed by reason and by rules exemplified by the buildings of the ancients. He shared Leon Battista Alberti's faith in the significance of proportion (see *Primary Source*, page 511). The two architects differed in how they related theory and practice, however. With Alberti, this relationship had been flexible, whereas Palladio believed quite literally in practicing what he preached. This view stemmed in part from his earlier career as a stonemason and sculptor before entering the Humanist circles of Count Giangiorgio Trissino of Vicenza, where he studied Vitruvius and other ancient authors and was introduced to elite patrons of the Veneto.

His first great project in Venice itself was the Benedictine church of San Giorgio Maggiore (fig. **17.35**), begun in 1565. Like his predecessors, Palladio acknowledged that round temples are ideal because the circle is a symbol of uniformity and eternity; yet he and his patrons chose a basilican plan as the only one appropriate for Christian worship. The plan for San Giorgio Maggiore (fig. **17.36**) reflects the church's twofold purpose of serving a Benedictine monastery and a lay congregation. The main body of the church is strongly centralized—the transept is as long as the nave and a dome marks the crossing—

ART IN TIME

1538—Titian's *Venus of Urbino*
1570—Palladio's *Four Books on Architecture* **published**
1571—Venetian and Spanish navies defeat Turkish fleet at Lepanto
1596—Shakespeare's *Romeo and Juliet*

but the longitudinal axis reasserts itself in the separate compartments for the main altar and the large choir beyond, where the monks worshiped. On the facade, Palladio wished to express the dignity of the church using the architectural language of the ancients. He designed a flattened-out temple porch to the entrance on the grounds that "Temples ought to have ample porticos, and with larger columns than other buildings require; and it is proper that they should be great and magnificent . . . and built with large and beautiful proportions. They must be made of the most excellent and the most precious material, that the divinity may be honored as much as possible." To achieve this end, Palladio superimposed a tall, narrow temple front on another low, wide one to reflect the different heights of nave and aisles in the basilica itself. The interlocking design is held together by the four gigantic columns, which function as a variant of Alberti's colossal order.

Much of Palladio's architecture consists of town houses and country villas. The Villa Rotonda (fig. **17.37**), one of Palladio's finest buildings, exemplifies his interpretation of the ancients. This country residence, built near Vicenza, beginning in 1567, for the humanist cleric Paolo Almerico, consists of a square block surmounted by a dome, with identical porches in the shape of temple fronts on all four sides. Alberti had defined the ideal church as a symmetrical, centralized design of this sort, but Palladio adapted the same principles for the ideal country house. He was convinced, on the basis of Vitruvius and Pliny, that Roman private houses had porticoes like these. (Excavations have since proved him wrong.) Palladio's use of the temple front here is more than an expression of his regard for antiquity; he considered this feature both legitimate and essential for decorum—namely, appropriateness, beauty, harmony, and utility—befitting the houses of "great men." This concept was embedded in the social outlook of the later sixteenth century, which required the display of great wealth and taste to assert status. Palladio's design also takes advantage of the pleasing views offered in every direction by the site. Beautifully correlated with the walls behind and the surrounding vistas, the porches of the Villa Rotonda give the structure an air of serene dignity and festive grace that is enhanced by the sculptures on the facades.

His buildings alone would make Palladio an important figure in the history of art, but his influence extended beyond Italy, indeed beyond Europe, through his publications. Palladio's most important work in this field was his treatise of 1570, *The Four Books of Architecture* (excerpted in the *Primary Source*, facing page). While several architects, including Alberti,

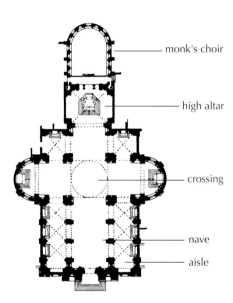

17.36. Plan of San Giorgio Maggiore

monk's choir

high altar

crossing

nave

aisle

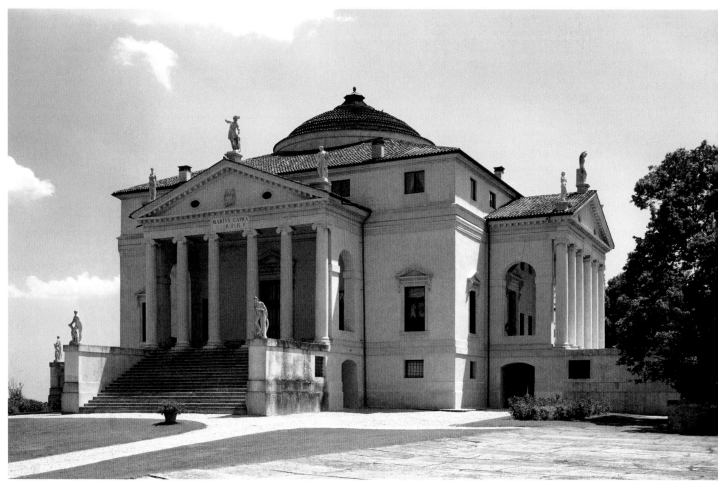

17.37. Andrea Palladio. Villa Rotonda, Vicenza. ca. 1567–1570

wrote treatises in the fifteenth century, sixteenth-century print-ed books on architecture by Sebastiano Serlio and Palladio became best sellers. Palladio's treatise was more practical than Alberti's, which may account for its great popularity among architects, and his many buildings are linked more directly with his theories. Some have claimed that Palladio designed only what was, in his view, sanctioned by ancient precedent. Indeed, the usual term for both Palladio's work and theoretical attitude is *classicizing*. This term denotes a conscious striving for qualities found in ancient art, although the results may not look like ancient works. Whenever later architects sought to express ideas through ancient forms, they consulted Palladio's *Four Books*. Thomas Jefferson, for instance, once referred to it as "the bible" and based several of his designs for buildings on its examples. Such treatises, with their rules for designing beautiful buildings, formulae for correct proportion, and extensive drawings, including ground plans and elevations in woodcut, were a treasure trove for architects elsewhere in Europe and later throughout the world.

SUMMARY

The later sixteenth century saw the growing power of princes and popes over the once independent cities of Italy. Courts were the major patrons of the arts, and princes and dukes shared a taste for erudite, complicated, and beautifully executed forms. This tendency has been labeled Mannerist, as it depended so much on the artifice or manner of the highly skilled artist. For these artists, often the subject matter or function of the object was less important than the quality of the execution.

LATE RENAISSANCE FLORENCE: THE CHURCH, THE COURT, AND MANNERISM

Ducal Florence was an important center for this development, as artists rejected the clarity and balance of the past in favor of more complex and sometimes puzzling images. The Medici rulers of the city built chapels and palaces, established an academy for training artists, and sent works of art as diplomatic presents. Their highly skilled and celebrated artists made portraits and religious works, as well as allegories based on Classical literature and art.

Florence's fame as a cradle of art was assisted by the international demand for works from Michelangelo, by the travels of artists to other courts, and by the publication of Vasari's *Lives of the Artists*.

ROME REFORMED

The complex, often erotic, and worldly representations made for princes clashed with calls for spiritual and moral renewal coming from the Catholic Church. The challenge of the Reformation and the shock of the Sack of Rome in 1527 encouraged the popes to expand both their spiritual and temporal authority. Papal projects included works in the Vatican and in the center of Rome itself. Michelangelo is the key figure for sixteenth-century Rome, in painting, sculpture, and architecture. His works were steeped in his reverence for antiquity, yet he freely manipulated a vocabulary borrowed from the ancients. The Catholic Reformation inspired new religious orders such as the Jesuits to commission large basilicas to serve their needs, instead of the centrally planned churches of the earlier Renaissance.

MANTUA OF THE GONZAGA

Courts throughout Italy and beyond Italy's borders hired artists who had trained in Florence or Rome to make visual statements of the local prince's power. The unexpected breaking of the rules of architecture in the Palazzo del Te by Giulio Romano is but one way he flatters his patron's wit and sophistication. Images of Greek and Roman gods stand in for the prince himself in paintings and sculptures of great technical virtuosity.

PARMA AND BOLOGNA

Smaller cities, like Parma and Bologna, had social structures that allowed patronage by elite families, who nonetheless were not princes. While some works made in these cities, such as Parmigianino's *The Madonna with the Long Neck*, reflect Mannerist innovations, patrons in these cities also commissioned works of great naturalism closer to the values of the High Renaissance.

VENICE: THE SERENE REPUBLIC

Venice remained a republic and clung to the traditions of the fifteenth century. Civic buildings blend the arcades of fourteenth- and fifteenth-century Venice with monumental pilasters and wall treatments inspired by Rome. Titian's long and productive life made his style dominant in the city, even as his technique and outlook changed over time. His followers expanded the Venetian preference for color and naturalism into large-scale canvases that overwhelm the spectator. The restrained architecture of Palladio placed the forms of antiquity at the service of wealthy patrons and the Church.

Renaissance and Reformation in Sixteenth-Century Northern Europe

EUROPEANS BEYOND THE ITALIAN PENINSULA CONFRONTED THE SAME breaks with tradition that Italians did in the sixteenth century. In addition to the religious challenge of the Reformation and the new cultural expressions of the Renaissance, Northern Europeans witnessed the growing power of large centralized states in France, England, Spain, and the Holy

Roman Empire, and the expansion of Europe's economic reach around the globe. As Northern Europe experienced the birth pangs of the modern era, artists reconciled local traditions with these new conditions.

The challenge of the Reformation to the Roman Catholic Church would fundamentally change the map of Europe. Proponents of religious reform including Luther, Ulrich Zwingli, John Calvin, and others attracted many adherents, and whole communities, cities, and even states were converted, fracturing the religious unity of Europe. Catholic Europe faced off against Protestant Europe, with great loss of life. While France and Spain remained loyal to the Roman Catholic Church, Germany, England, and the Netherlands were divided by religious sectarianism. The more radical reformed faiths deplored the Catholic tradition of religious images and relics and encouraged the destruction of images in the areas that converted to their beliefs.

Under such conditions, artists had to find new ways to pursue their craft and new markets for their products. Those markets would continue the trends established in the fifteenth century. A growing capitalist economy brought wealth and population to the cities, while landowning declined as a mea-

Detail of figure 18.17, Albrecht Dürer, *The Four Horsemen of the Apocalypse*

sure of wealth. Manufacturing and trade grew, especially with the new Atlantic trade routes and colonial settlements in the Americas and Asia. Even as the cities increased in economic and social importance, increasingly authoritarian rulers asserted control over their domains.

The arts in Northern Europe responded to these pressures. In part because of the Protestant Reformers' suspicion of sculptural expression, the medium of painting increased in importance. As religious patronage waned, artists turned to secular themes, which appealed to patrons in the cities and in the courts. To compete on the open market, artists began to specialize in particular subjects or themes. The achievements of the Italian Renaissance also challenged Northern artists, who absorbed Italian compositions, ideal figure types, and admiration of antiquity. Patrons in the courts found Italian style particularly useful for expressing their power, as they built monumental palaces. Catholic rulers often used Italianate forms to affirm their faith.

FRANCE: COURTLY TASTES FOR ITALIAN FORMS

France was fertile ground for the importation of Italian ideas. French kings had been intervening in Italy for centuries, which brought them into contact with developments in Italian

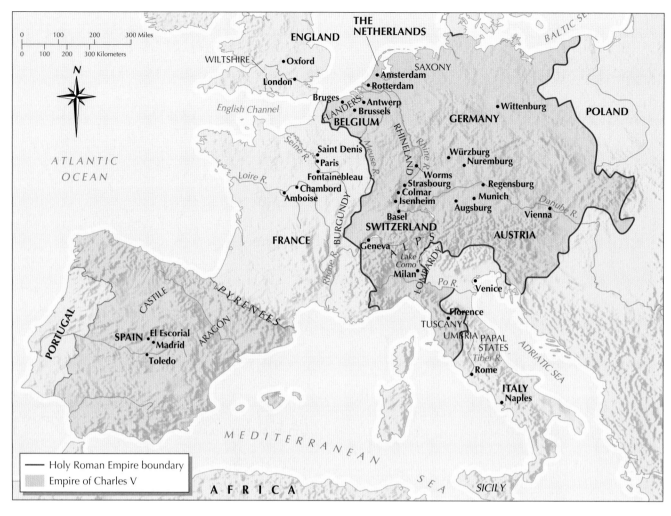

Map 18.1. Europe in the Sixteenth Century

Châteaux and Palaces: Translating Italian Architecture

art and architecture. Charles VII of France had invaded Milan in 1499, and his successors continued to meddle in the Italian peninsula. Francis I (r. 1515–1547) showed his admiration for Italian art by inviting Leonardo da Vinci to work for him in the Loire Valley. Leonardo had provided designs for a never constructed château for the king before dying in Amboise in 1519. Francis's appreciation for Italian art and his propensity for spending money made his court a magnet for many artists from Italy and from elsewhere in Europe. Rosso Fiorentino, Francesco Primaticcio, Benvenuto Cellini, and others found work there. French traditions were maintained, as well, as local architects interpreted Italian ideas for royal structures.

Châteaux and Palaces: Translating Italian Architecture

During the Renaissance, French castles lost their fortified aspect and became palaces for enjoying country life. The influence of Italian architectural design came into play in the design of many of these newer structures. An important early example is the Château of Chambord in the Loire Valley (fig. **18.1**),

begun in 1519 for Francis I as a hunting lodge. The design of the château combines traditional French castle architecture with Italianate organization. The plan of the center portion (fig. **18.2**) comprises a square block flanked by round towers, whose source is the *keep*, which is the central, most fortified section of medieval castles. Yet the space is arranged as a Greek cross that divides the interior into four sections, each subdivided into a suite of one large and two smaller rooms, and a closet. This functional grouping, imported from Italy, became a standard pattern in France. The focal point of the four corridors is a monumental double-spiral staircase; the arrangement centralizes the plan as contemporary Italian architectural theory promoted. Even though elements such as applied pilasters and balustrades emulate Italian models, however, the vertical massing of walls, turrets, high-pitched roofs, elongated windows, and tall chimneys reflect traditional castle design and Gothic proportions.

Italian influence is more apparent in the château that Francis I built south of Paris amid the forest of Fontainebleau. In 1528, he decided to expand the medieval hunting lodge that was once the haunt of King Louis IX. What began as a modest

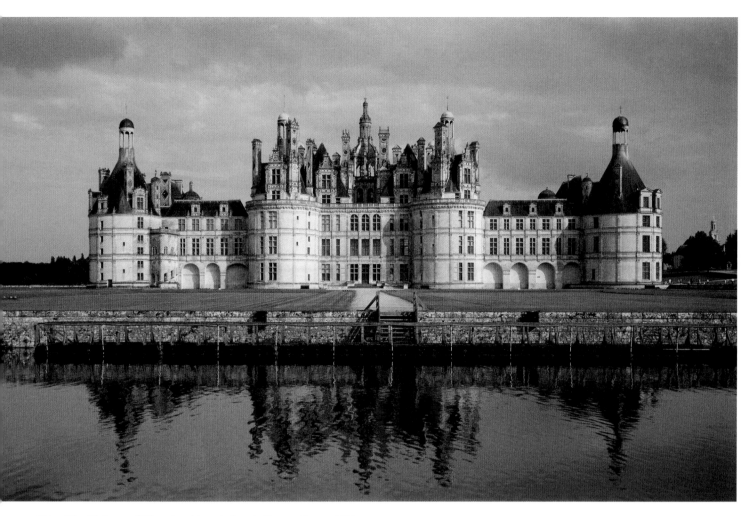

18.1. The Château of Chambord (north front), France. Begun 1519

enlargement soon developed into a sprawling palace. The original design, much altered over the years, was largely the work of the stonemason Gilles Le Breton (d. 1553), whose father, Jean (d. 1543/44) had helped design Chambord. Fontainebleau set a fashion for French translations of Italianate architecture followed for nearly all French châteaux for the next 250 years.

The Cour du Cheval Blanc (Court of the White Horse) is typical of the project as a whole (see fig. **18.3**). The design must have evolved in an organic fashion, with new generations of patrons and architects adding to it over time. (The Italianate staircase that now dominates the courtyard was built by Jean Androuet Du Cerceau in 1634.) The round towers at Chambord have been replaced by rectangular pavilions at regular intervals. The facade employs a vocabulary from Italian architecture: pilasters mark each story, entablatures tie the whole facade together horizontally, and the lowest level uses rusticated pilasters such as those used by Sansovino at the Mint in Venice (see fig. 17.29). But these elements are blended with vertical proportions, especially in the windows and along the roofline.

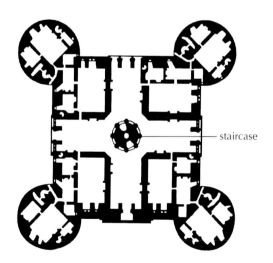

staircase

18.2. Plan of center portion, Château of Chambord (after Du Cerceau)

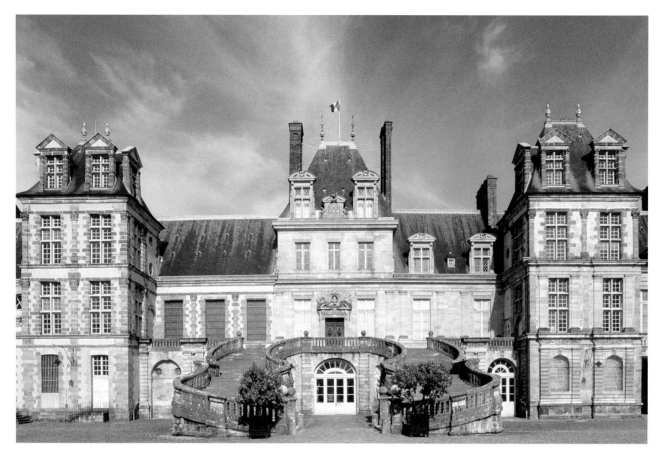

18.3. Gilles Le Breton. Cour du Cheval Blanc (Court of the White Horse), Fontainebleau. 1528–1540

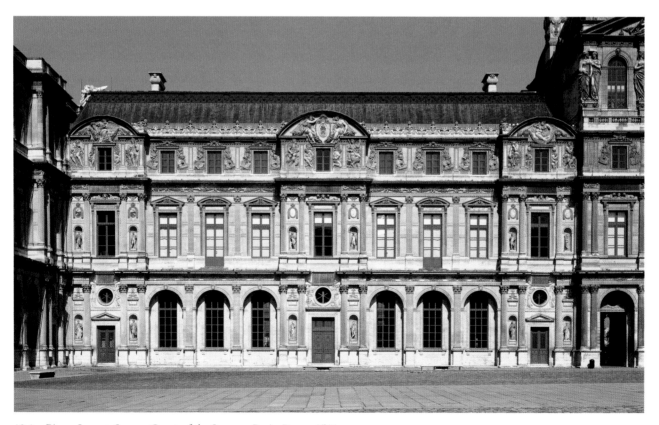

18.4. Pierre Lescot. Square Court of the Louvre, Paris. Begun 1546

THE LOUVRE Despite a variety of wars and other entanglements, Francis I had a great appetite for commissioning large-scale projects. In 1546 he decided to replace the Gothic royal castle in Paris, the Louvre, with a new palace on the old site. The project had barely begun at the time of his death, but his architect, Pierre Lescot (ca. 1515–1578), continued and enlarged it under his successor, Henry II. This scheme was not completed for more than a century. Lescot built the southern half of the court's west side (fig. **18.4**) in a more thoroughly Italianate style than seen either at Chambord or Fontainebleau.

The design represents a genuine synthesis of the traditional French château with the Italian palazzo. The superimposed Classical orders, the pedimented window frames, and the arcade on the ground floor are Italian. Three projecting pavilions, however, have replaced the château turrets to interrupt the continuity of the facade. The high-pitched roof is also French. The vertical accents, and the tall, narrow windows counteract the horizontal elements. The whole effect is symmetrical and well organized, yet sumptuous in the ornate carvings of the pilasters and their capitals and the relief sculpture that covers nearly all of the wall surface of the third story. These reliefs, beautifully adapted to the architecture, are by Jean Goujon (ca. 1510–1565), a French sculptor of the mid-sixteenth century with whom Lescot often collaborated.

Art for Castle Interiors

If the king showed a preference for Italian style, some members of the French court continued to commission works of art following the patterns established during the Middle Ages. Long after the invention of the printing press, French aristocrats continued to commission lavish books of hours and other illuminated books. French church architecture took the possibilities of the Gothic style to new heights. Stained glass windows remained an important medium, as did tapestry, for elite patrons. The walls of their dwellings were lined with sets of these woven hangings, often depicting secular or allegorical themes. Tapestry weaving was an important industry in the Netherlands and in France. (See *Materials and Techniques*, page 626.)

A famous survival of this art form is the set of tapestries depicting the *Hunt for the Unicorn*, woven around 1500 in the Southern Netherlands or northern France. *The Unicorn in Captivity* (fig. **18.5**) is the culmination of a series of images describing the hunt for and death of the unicorn, the mythical one-horned equine who could only be captured by a virgin. In this set of seven tapestries the unicorn is hunted, killed, and is then resurrected. The theme depicts the courtly pastime of hunting, but the unicorn itself has been read as symbolizing Christ (details in the imagery suggest this) and as a secular bridegroom. This panel, 12 by 8 feet, shows the unicorn fenced in below a pomegranate tree against a verdant background enlivened by numerous flowering plants. While specific elements like the plants and flowers are wonderfully detailed and naturalistic, the whole tapestry creates a sumptuous two-dimensional effect. The brilliant white body of the unicorn itself is the focal point at the center of the field of flowers.

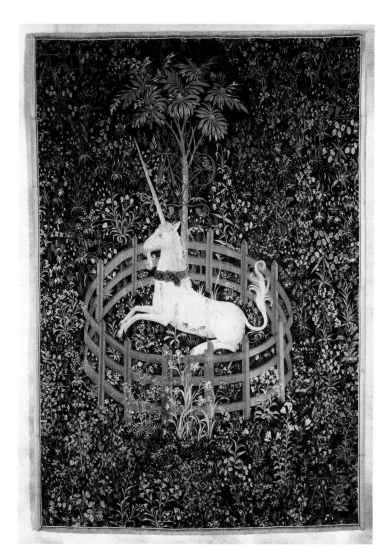

18.5. *The Unicorn in Captivity.* ca. 1500. Tapestry, from the Unicorn Tapestries. South Netherlandish or French. Wool warp, wool, silk, silver, and gilt weft, 12′1″ × 8′3″ (3.68 × 2.52 m). Metropolitan Museum of Art, New York. Gift of John D. Rockefeller, Jr. 1937.37. (37.80.6)

Details like the pomegranates—a symbol of fertility and of eternity—combine with the numerous plants and animals to suggest the theme of Christian salvation, but also marriage and procreation. Some scholars have suggested that these tapestries were created to celebrate a marriage, perhaps of the individuals whose initials (A and a backwards E) intertwine in the tree branches. Despite exhaustive research, their identification is still uncertain. Tapestries continued to be an important art form in France, given an important boost by the establishment of the royal factory of Gobelins in the seventeenth century.

THE SCHOOL OF FONTAINEBLEAU Francis I's preference for Italian art is apparent throughout the château at Fontainebleau. The king called upon Italian artists, most of them working in a Mannerist style, to work there, and these artists initiated the so-called School of Fontainebleau.

Making and Conserving Renaissance Tapestries

Tapestries—woven images hung on walls—were a major art form from the Middle Ages through the Baroque period. Elite patrons of Europe commissioned and purchased them to decorate the stone walls of their palaces and châteaux. In Flanders, the principal tapestry-making centers were in Arras, Tournai, and Brussels. In France, Louis XIV cemented the association of royalty with tapestry making by establishing the Royal Workshop of Gobelins in Paris, which dominated French tapestry production until the eighteenth century.

The textiles were woven on looms, such as the one pictured in the Penelope tapestry in figure 14.21. Before the weaving could begin, the patron and the master of the workshop would choose a design, which was worked up into a **cartoon**, a full-scale drawing for the weaver to follow.

To weave the textile, the weaver stretched supporting threads, called the *warp*, across the frame of a loom to the size desired. These warp threads are made of strong fibers, usually wool or linen. Colored threads of wool, silk, or spun metals are used to produce the design; these threads, called the *weft*, are then interwoven with the warp on the loom.

Renaissance tapestries are designated "high warp" and "low warp" according to the arrangement of the loom: The high-warp technique stretches the warp threads vertically on the loom, while the low-warp

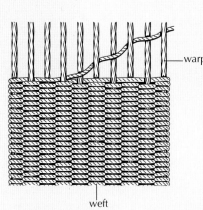

The weaver intertwines the horizontal threads (weft) with vertical threads (warp)

technique stretches the threads horizontally. The figure of Penelope uses a small low-warp loom, as was common in Flanders.

Once the warp threads are stretched on the loom, the cartoon is placed below the loom. The weaver pushes the weft threads through the warp threads, alternating colors to create the design, and then tamps the weft threads into place to form a tight weave. Because the weaver works on the back side of the tapestry as he follows the cartoon, so that different colors may be joined and threads knotted, the front (or visible side) of the tapestry reproduces the cartoon design in reverse.

Increasingly from the fifteenth century, the designs for tapestries came from painters, and as the pictorial ambitions of the painters grew, so did the techniques of the weavers to match them. The increasing illusionism in the cartoons inspired weavers to work with finer threads to make the tapestries more complex. Woven of wool, silk, and gilt threads, *The Unicorn in Captivity* (fig. 18.5) displays tremendously detailed images of flowers, foliage, and animals. One scholar estimates that it took one hour per square inch to weave these dense designs; at this rate, a team of weavers would have been able to complete only one tapestry per year.

Conservators worked on the Unicorn Tapestries recently, removing the linen backing of the tapestries in order to replace them. This made it possible to see the back of the tapestry, revealing the incredibly rich colors with which it was woven, but which have faded with the passage of time on the front. The tapestries were then immersed in purified water to be cleaned, before being allowed to dry. A new backing was then sewn into place.

To decorate the Gallery of Francis I, the king summoned Rosso Fiorentino from Italy. Between 1531 and 1540, Rosso executed frescoes framed by stucco *putti*. The combination of painting and sculpted imagery inspired another Italian emigré, Francesco Primaticcio (1504–1570), who replaced Rosso as the chief designer at the royal château. The influence of Parmigianino is clear in Primaticcio's most important surviving work, the decorations for the room of the king's mistress, the Duchesse d'Étampes (fig. **18.6**). Primaticcio follows Rosso's general scheme of embedding paintings in a luxuriously sculptured stucco framework, which nearly swallows them. However, the figures are subtly elongated in the style of Parmigianino. The four females in this detail have no specific allegorical significance, although their role recalls the nudes of the Sistine Chapel ceiling. These willowy figures (reminiscent of the caryatids in ancient Greek architecture) enframe paintings devoted to Alexander the Great that were executed by assistants from Primaticcio's designs.

The scene in figure 18.6 shows Apelles painting the abduction of Campaspe by Alexander, who gave his favorite concubine to the artist when he fell in love with her. Roman texts of this subject characterized this gift as a mark of Alexander's great respect for his court artist. Such mixtures of violence and eroticism appealed greatly to the courtly audience for which Primaticcio worked. The picture draws a parallel between Alexander and Francis I, and between Campaspe and the duchess, the king's mistress, who had taken Primaticcio under her protection. The artist may have seen himself in the role of Apelles.

Another Italian drawn to Fontainebleau between 1540 and 1546 was Benvenuto Cellini (1500–1571), a Florentine goldsmith and sculptor who owes much of his fame to his colorful autobiography. The gold saltcellar (fig. **18.7**) made for Francis I while Cellini worked at Fontainebleau is his only important work in precious metal to survive into the modern world. The famous object was stolen in 2003, and has yet to be recovered. The main function of this lavish object is clearly as a

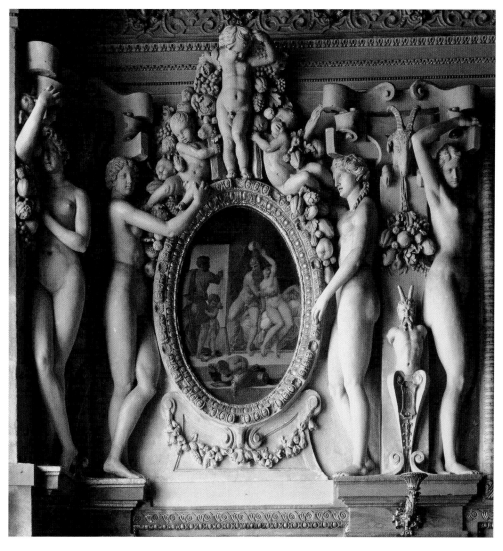

18.6. Francesco Primaticcio. *Stucco Figures*. ca. 1541–1545. Gallery of Francis I, designed for the Room of the Duchesse d'Étampes, Château of Fontainebleau, France

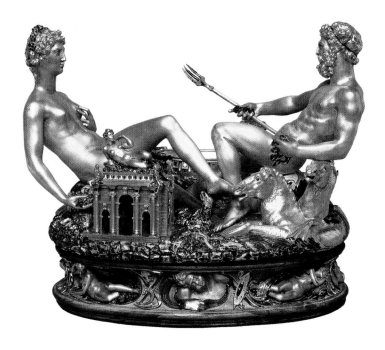

18.7. Benvenuto Cellini. *Saltcellar of Francis I*. 1540–1543. Gold with enamel, $10^{1}/_{4} \times 13^{1}/_{8}''$ (26 × 33.3 cm). Kunsthistorisches Museum, Vienna.

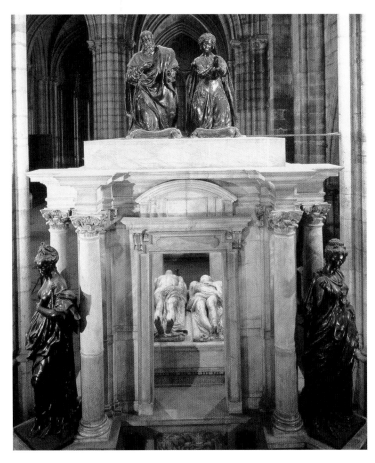

18.8. Francesco Primaticcio and Germain Pilon. *Tomb of Henry II and Catherine de' Medici*. 1563–1570. Abbey Church of Saint-Denis, Paris

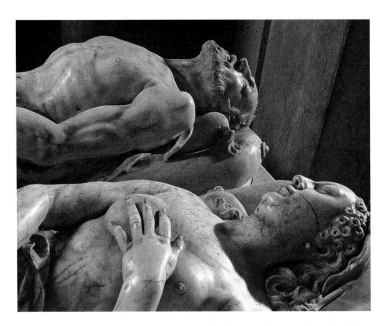

18.9. Germain Pilon. *Gisants* of the king and queen, detail of the *Tomb of Henry II and Catherine de' Medici*

conversation piece. Because salt comes from the sea and pepper from the earth, the boat-shaped salt container is protected by Neptune. The pepper, in a tiny triumphal arch, is watched over by a personification of Earth who, in another context, might be the god's consort Amphitrite. On the base are figures representing the four seasons and the four parts of the day. Such references remind the viewer of the Medici tombs, as does the figure personifying Earth. Cellini wants to impress with his ingenuity and skill. In his autobiography (see *Primary Source*, page 631), he explained how he came to design the model for the saltcellar and its iconography. He had designed the figure of the Earth as "a woman whose beautiful figure was as full of as much loveliness and grace as I was able and knew how to produce. . . ." In good Mannerist fashion, the allegorical significance of the design is simply a pretext for this display of virtuosity. Cellini then modestly reports the reaction of Francis I to his design: "This is a magnificent piece of work by this man! He should never stop working!"

ROYAL TOMBS AT SAINT-DENIS The presence of so many Italian artists at Fontainebleau made the château a laboratory of Italian style, which many French artists absorbed. For example, the sculptor Germain Pilon (ca. 1535–1590) created monumental sculpture that is informed not only by the elegance of the School of Fontainebleau, but also by elements taken from ancient sculpture, the Gothic tradition, and Michelangelo. His main works are tombs, such as the *Tomb of Henry II and Catherine de' Medici* (fig. **18.8**) executed for the French royal pantheon at Saint-Denis. Primaticcio designed the architectural framework, a free-standing chapel on a platform decorated with bronze and marble reliefs. He also designed the corner figures of virtues as elegant young women. Pilon executed the sculpture. On the top of the tomb are the bronze figures of the king and queen kneeling in prayer, while inside the chapel the couple reappear as recumbent marble **gisants**, or corpses (fig. **18.9**). The concept derives from the tomb of Francis I and his wife, Claude of France, in the same church, commissioned by Henry in 1547.

This contrast of effigies had been a characteristic feature of Gothic tombs since the fourteenth century and remained in vogue through the sixteenth. The *gisants* expressed the transient nature of the flesh, usually by showing the body in an advanced stage of decay, sometimes with vermin crawling through its open cavities. Pilon reverses the concept: instead of portraying decaying flesh, they are idealized nudes. While the likenesses of the royal couple kneeling atop the structure record their features in life, the *gisants* represent them as beautiful beings: The queen is in the pose of a Classical Venus and the king is represented similarly to the dead Christ. They evoke neither horror nor pity. Instead, they have the pathos of a beauty that continues even in death.

Henry II's death in 1559 left his minor son to inherit the throne, so his widow, Catherine de' Medici, acted as regent during a troubled period. Increasing conflicts between Catholic and Protestant groups, called Huguenots, erupted into massacres and warfare between 1562 and 1598, when a policy of official toleration was announced by Henry IV.

SPAIN: GLOBAL POWER AND RELIGIOUS ORTHODOXY

Several events came together in the early sixteenth century to make Spain a major power in European politics. In 1500, Charles V was born to the son of Maximilian of Habsburg and the daughter of Ferdinand and Isabella. He thus became heir to the thrones of Spain, Aragon, and the Burgundian territories; the title of Holy Roman Emperor was his birthright as well. Charles also asserted a Spanish claim to rule the kingdom of Naples in southern Italy. Spain was thus integrated more fully into European power struggles than it had been in previous centuries. At the same time, the colonization of the lands Columbus had claimed in the Americas brought massive wealth into Spanish hands. Charles V's efforts to promote and rule his vast holdings so exhausted him that in 1556 he divided his territory in half and abdicated to his son Philip and his brother Ferdinand. Ferdinand took control of the traditional Habsburg territories in Central Europe. Reigning as king of Spain, the Netherlands, and New Spain in the Americas from 1556 to 1598, Philip inherited the problems that had bedeviled his father. Having succeeded in preventing the Turkish advance into Europe in 1571, he turned his attention to the religious upheavals that the Reformation had brought to Christian Europe. Pious and

ART IN TIME

ca. 1527—Francis I commissions château in Fontainebleau

1536—John Calvin publishes the "Institutes of the Christian Religion"

ca. 1540—**Cellini's** *Saltcellar of Francis I*

1562—Wars of Religion begin

ardent in his orthodoxy, he tried to quash the rebellion of the Calvinist Northern Netherlands, and unsuccessfully attempted to invade England in 1588, when the Spanish Armada suffered a disastrous defeat in the English Channel.

The Escorial

Philip also inherited a taste for collecting works of art from his father; not only did he commission works from Titian and other Italian artists, he sought out fifteenth-century Flemish works, especially paintings by Bosch. Many of these objects were brought to his new palace and monastery complex outside Madrid, called the Escorial, built to commemorate Philip's victory over the French in 1557. This massive complex (see fig. **18.10**) was begun in 1563 by Juan Bautista de Toledo

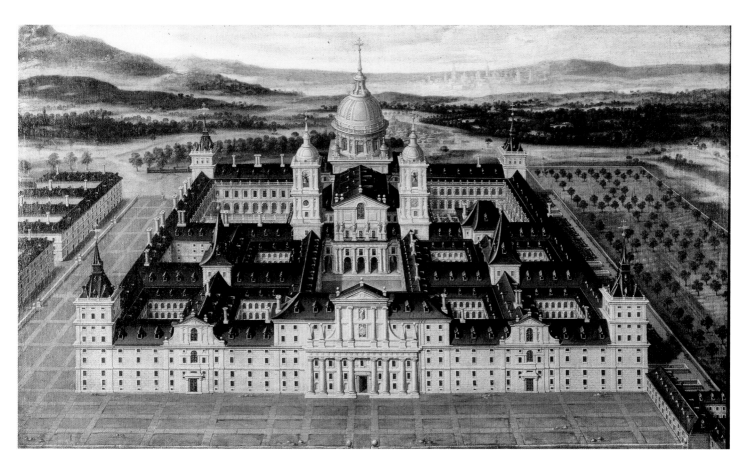

18.10. Juan Bautista de Toledo and Juan de Herrera. Escorial. Begun 1563.

(d. 1567), who had worked with Michelangelo in Rome. The symmetrical massing of the buildings and the focus on the Church of San Lorenzo at the center reflect Italian Renaissance models, but the scale and the simplicity of the facades were dictated by King Philip. In consultation with leading Italian architects, including Palladio and Vignola, Juan Bautista de Toledo's successor at the Escorial, Juan de Herrera, expanded the design and introduced classicizing details like the temple fronts on the facades of the main portal and the Church of San Lorenzo. These however, use a very plain Doric order and the whole facade exhibits a severity and seriousness that may express Philip's commitment to the ideals of the Catholic Reformation. The complex includes a monastery and church, a palace, a seminary, a library, and a burial chapel for the Spanish kings. Philip himself spent his last years here.

El Greco in Toledo

Philip did not much care for the work of the best known painter of sixteenth-century Spain, Domenikos Theotokopoulos (1541–1614), called El Greco. Born on Crete, which was then under Venetian rule, he probably trained there to become an icon painter. Some time before 1568 he arrived in Venice and quickly absorbed the lessons of Titian and Tintoretto, but he also knew the art of Raphael, Michelangelo, and the Italian Mannerists. He went to Spain in 1576/77 and settled in Toledo for the rest of his life. El Greco joined the leading intellectual circles of the city, then a major center of learning, as well as the seat of Catholic reform in Spain. El Greco's painting exhibits an exalted emotionalism informed by his varied artistic sources. His work seems to be a response to the mysticism that was especially intense in the Spain of Theresa of Ávila. The spiritual

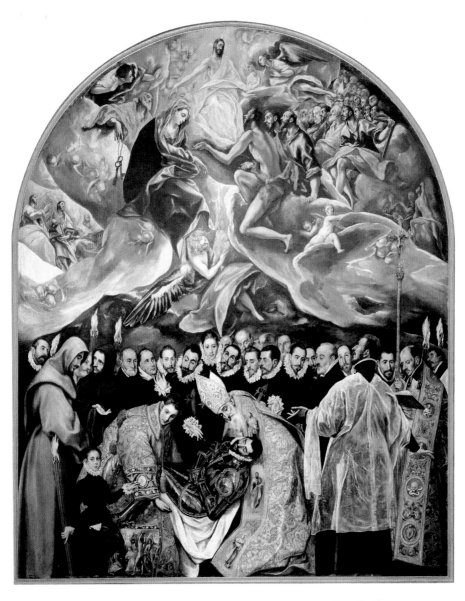

18.11. El Greco. *The Burial of Count Orgaz.* 1586. Oil on canvas, 16′ × 11′10″ (4.9 × 3.6 m). Santo Tomé, Toledo, Spain

Benvenuto Cellini (1500–1571)

From *The Autobiography*

The Florentine sculptor wrote his autobiography between 1558 and 1566. Cellini's book retells the story of his early life, training, and artistic triumphs. It was not published until the eighteenth century, when it inspired artists of that era and of the nineteenth century. This excerpt focuses on the design and reception of the Saltceller of Francis I. *Cellini took the advice of several courtiers in approaching the project, but ultimately made his own decision about what to render in the model.*

I made an oval shape the size of more than half an armslength—in fact, almost two thirds of an armslength—and on it, as if to show the Sea embracing the Land, I placed two nicely executed figures larger than a palm in size, seated with their legs intertwined in the same fashion as certain long-branched arms of the sea can be seen running into the land; and in the hand of the male figure of the Sea I placed a lavishly wrought ship, within which a great deal of salt could easily and well be accommodated; underneath this figure I placed four

seahorses, and in the hand of this figure of the Sea I placed his Trident. The Land I had represented as a woman whose beautiful figure was as full of as much loveliness and grace as I was able and knew how to produce, in whose hand I had placed a rich and lavishly decorated temple which rested upon the ground, and she was leaning on it with her hand; I had created the temple in order to hold the Pepper. I had placed a Horn of Plenty adorned with all the beautiful things I knew to exist in the world. Under this goddess and in the part that portrayed the earth, I had arranged all the most beautiful animals that the earth produces. Under the part devoted to the sea god I represented all the beautiful kinds of fishes and small snails that tiny space could contain; in the widest part of the oval space I created many extremely rich decorations. . . . I uncovered the model [before the King], and, amazed, the King said: "This is something a hundred times more divine than anything I might have imagined. This is a magnificent piece of work by this man. He should never stop working." Then he turned to me with an expression full of delight, and told me that this was a work that pleased him enormously and that he wanted me to execute it in gold.

SOURCE: *MY LIFE (VITA)* BY BENVENUTO CELLINI TR. JULIA CONAWAY BONDANELLA AND PETER BONDANELLA, (NY: OXFORD UNIVERSITY PRESS, 2002.)

18.12. Chapel with *The Burial of Count Orgaz*. 1586. Santo Tomé, Toledo, Spain

writings of this sixteenth-century nun and reformer, informed by her visions, urge prayer to achieve closer union with God (see fig. 19.30).

Among the most impressive of El Greco's commissions is *The Burial of Count Orgaz* (figs. **18.11** and **18.12**) executed in 1586 in the Church of Santo Tomé in Toledo. The program, which was dictated in the commission, emphasizes the Roman Catholic position that good works are required to achieve salvation and that saints serve as intercessors with heaven. This huge canvas honors a medieval benefactor so pious that St. Stephen and St. Augustine miraculously appeared at his funeral and lowered the body into its grave. Although the burial took place in 1323, El Greco presents it as a contemporary event and even portrays many of the local nobility and clergy of his time among the attendants. The display of color and texture in the armor and vestments reflects El Greco's Venetian training. Above, the count's soul (a small, cloudlike figure like the angels in Tintoretto's *Last Supper,* fig. 17.34) is carried to heaven by an angel. The celestial assembly in the upper half of the picture is painted very differently from the group in the lower half: Every form—clouds, limbs, draperies—takes part in the sweeping, flamelike movement toward the figure of Christ. El Greco's compressed space, unearthly light, and weightless bodies share stylistic features with Italian Mannerist works such as Rosso's *Descent from the Cross* (fig. 17.1).

Only when the work is seen in its original setting (fig. 18.12) does its full meaning become clear. Like a huge window, the painting fills one entire wall of its chapel. The bottom of the canvas is 6 feet above the floor, and as the chapel is only about 18 feet deep, a viewer must look sharply upward to see the upper half of the picture. The violent foreshortening is

calculated to achieve an illusion of boundless space above, while the figures in the lower foreground appear as on a stage. The large stone plaque set into the wall also belongs to the ensemble. It represents the front of the sarcophagus into which the two saints lower the body of the count, which explains the action in the picture. A viewer, then, perceives three levels of reality. The first is the grave itself, supposedly set into the wall at eye level and closed by an actual stone slab; the second is the reenactment of the miraculous burial; and the third is the vision of celestial glory witnessed by some of the participants. This kind of mysticism is very similar in character to parts of the *Spiritual Exercises* of Ignatius of Loyola, the founder of the Jesuits. Serving the aims of the Catholic Reformation, Ignatius taught believers to meditate in steps so that they might achieve visions so real that they would seem to appear before their very eyes. Such mysticism could be achieved only through strenuous devotion. That effort is mirrored in the intensity of El Greco's work, which expresses strenuous spiritual struggle.

CENTRAL EUROPE: THE REFORMATION AND ART

While France, Spain, and Italy adhered to the Catholic faith, the religious and artistic situation was more complex elsewhere in Europe. In addition to Spain, Charles V had inherited the many different political units that comprised what is now Germany, Austria, Hungary, and the Czech Republic. Governing so many disparate regions posed many challenges, which were passed along to Charles's brother Ferdinand when Charles stepped down as ruler in 1556. Though linked in many cases by language and cultural ties, as well as by trade, these were independent regions only nominally under control of the Holy Roman emperor. What unity they may have had suffered another blow after 1517, when religious unity was fractured by the Reformation.

In October 1517, Martin Luther, a former Augustinian friar who had become professor of theology at the University of Wittenberg, issued a public challenge to both the theology and the institutional practices of the Catholic Church. In his now famous *Ninety-five Theses*, which he nailed to the church door at Wittenberg Castle, Luther complained about the Catholic practice of selling indulgences—promises of redemption of sins; he argued too against the veneration of Mary and the saints. Most fundamental to his critique of Catholicism, Luther claimed that the Bible and natural reason were the sole bases of religious authority, and that the intervention of clerics

and saints was unnecessary for salvation, which was freely given by God. It followed then, that religious authority was transferred from the pope to the individual conscience of each believer. The Catholic Church responded by condemning him in 1521. But Luther's critique was accepted by many Christians in Europe, which eventually fueled political instability, rebellions, and wars. Many areas of northern Germany converted to the reform, while southern regions, like Bavaria, remained Catholic. In rethinking these basic issues of faith, Luther was joined by other religious reformers.

The Swiss pastor Ulrich Zwingli wanted to reduce religion to its essentials by stressing access to scriptures and preaching. As a result of his literal reading of the Bible, he denounced not only the sale of indulgences, but the visual arts as well. Zwingli interpreted the Eucharist as a symbolic, rather than actual, communion of bread and wine, which led to a split with Luther that was never healed. What concerned the reformers above all were the twin issues of grace and free will in attaining faith and salvation. By the time of Zwingli's death at the hands of the Catholic forces in 1531, the main elements of Protestant theology had nevertheless been defined. John Calvin of Geneva codified these tenets around midcentury; his vision of a moral life based on a literal reading of Scripture was to prove very influential. The spread of the reformed faiths led to decades of violence, including a Peasants' Revolt in 1525 and wars in regions that were converting to the Protestant confessions. From 1546 until 1555, German principalities fought with the emperor Charles V, until the Peace of Augsburg in 1555. By this compromise, the rulers of individual regions of Germany chose the faith for that region's inhabitants. This furthered the spread of the reformed faiths, but also fostered the political divisions of the area.

The repercussions for art were equally dramatic. Although Luther's own attitude toward the visual arts was ambivalent, he saw the value of art as a tool for teaching. (See end of Part III, *Additional Primary Sources*.) Some of the more radical reformers saw the many forms of Medieval and Renaissance religious art as nothing short of idolatry that needed to be cleansed. Inspired by reformers' zeal, civic leaders, artisans, and workers attacked religious images in the cities. Several waves of image destruction, called *iconoclasm*, resulted in great losses of works of art from earlier periods. And, as large areas of central Europe converted to the new confessions, art forms that had been the bread and butter for artists disappeared, as churches were whitewashed and religious commissions dried up. Artists in many media had to find new styles, new subjects, and new markets for their work.

Humanism and the new technology of printing played a vital role in the Reformation. The spirit of inquiry and respect for original texts inspired the writings of such famous intellectuals and teachers as Desiderius Erasmus of Rotterdam, Philip Melancthon in Germany, and Thomas More in England. Latin texts published in printed editions spread new ideas all over Europe. As a result, the printing press was an important factor in both the development and in the dispersion of Refor-

mation thought. Individual access to scripture was a fundamental tenet of the reformers, so they wanted good texts of the Bible and translations of it into vernacular languages. Luther himself translated the Bible into German. Printed images contributed to the spread of Reformation ideas; inexpensive woodcuts satirized the Catholic hierarchy while making heroes of the reformers. Prints also illustrated the tenets of the new faiths.

Grünewald's Isenheim Altarpiece

Yet not all regions of German-speaking Europe converted to the reformed faiths, and it was not until the 1520s that the Reformation took wide hold, so some traditional objects were created in the sixteenth century to serve Catholic patrons. One of the most memorable of these objects was an altarpiece executed by the painter Matthias Gothart Nithart, who was known for centuries only as Grünewald (ca. 1475–1528). This nickname was given to him by a seventeenth-century author; when German artists in the modern period began searching for roots, they discovered the artist through his nickname and it has stuck. Grünewald was born in Würzburg in central Germany and worked for the archbishop of Mainz. His most famous work is a transforming triptych called the *Isenheim Altarpiece*, similar in structure to the *St. Wolfgang Altarpiece* by Pacher (fig. 14.29). It was painted between 1509/10 and 1515 for the monastery church of the Order of St. Anthony at Isenheim, in Alsace, not far from the former abbey that now houses it in the city of Colmar.

This church served the monks of this order and the patients of the hospital attached to their monastery. The monks specialized in tending people who suffered from a disease called St. Anthony's Fire, which was a disorder caused by eating spoiled rye. This disease produced painful symptoms, including intestinal disorders, gangrenous limbs, and hallucinations. Treatment consisted mostly of soothing baths and in some cases the amputation of limbs. The altarpiece stood on the high altar of the monastery church, where it would have been seen by both monks and the sick in the hospital. This extraordinary altarpiece encases a huge shrine carved in wood by Nicolas Hagenau around 1505. Enclosing the carved central section are nine panels organized in two sets of movable wings. These open in three stages or "views." The first of these views, when all the wings are closed, shows *The Crucifixion* in the center panel (fig. **18.13**). This is the view that was visible during the week. The wings depict *St. Sebastian* (left), who was invoked against the plague (compare with fig. 15.52) and *St. Anthony Abbot* (right), who was revered as a healer. The central image of the *Crucifixion* draws on the late medieval tradition of the Andachtsbild (compare with fig. 12.56) to emphasize the suffering of Christ and the grief of his mother. The figure of Christ, with its twisted limbs, its many wounds, its streams of blood, matches the vision of the fourteenth-century mystic St. Bridget as described in her book of Revelations, which had been published in a German edition in 1501/02.

Grünewald renders the body on the cross on a heroic scale, so that it dominates the other figures and the landscape. The Crucifixion, lifted from its familiar setting, becomes a lonely event silhouetted against a ghostly landscape and a blue-black sky. Despite the darkness of the landscape, an eerie light bathes the foreground figures to heighten awareness of them. On the left, Mary's white garment enfolds her as she swoons at the sight of her tortured son; the red of St. John's robe accents her paleness. Below the cross, Mary Magdalen, identified by her ointment jar, kneels in grief to lament. On the right, John the Baptist points to the Crucified Christ with the words, "He must increase, and I must decrease," indicating the significance of Christ's sacrifice. Behind him a body of water recalls the healing power of baptism. The lamb at his feet bleeds into a chalice, as does the lamb in the central panel of the *Ghent Altarpiece* (fig. 14.12). The bleeding lamb is a reminder of the sacrament of the Eucharist, celebrated before the altarpiece. In the predella below, a tomb awaits the tormented body while his mother and friends bid farewell. The predella slides apart at Christ's knees, so victims of amputation may have seen their own suffering reflected in this image.

On Sundays and feastdays the outer wings were opened and the mood of the *Isenheim Altarpiece* changed dramatically (fig. **18.14**). All three scenes in this second view—*The Annunciation*, the *Madonna and Child with Angels*, and *The Resurrection* (fig. **18.15**)—celebrate events as jubilant as the Crucifixion is somber. Depicting the cycle of salvation, from the Incarnation to the Resurrection, this view of the altarpiece offered the afflicted a form of spiritual medicine while reminding them of the promise of heaven. Throughout these panels, Grünewald has rendered forms of therapy recommended for sufferers at the hospital: music, herbs, baths, and light. The contrast of the body of the dead Jesus in the predella with the Resurrected Christ in the right panel offers consolation to the dying.

Grünewald links the panels through color and composition. Reds and pinks in *The Annunciation* panel on the left are carried through the central panels to come to a crescendo with the brilliant colors surrounding the Risen figure of Christ on the right. The figure of the dead Jesus held by his mother and friends in the predella adds poignancy to the figure of the Child Jesus in his mother's arms in the central panel. The simple Gothic chapel in which the Annunciation takes place gives way in the next panel to a fanciful tabernacle housing choirs of angels who play stringed instruments and sing. Beneath that tabernacle appears a figure of the Virgin, crowned and glowing like a lit candle. The aureole surrounding this figure anticipates the brilliant figure of the Resurrected Christ in the right-hand panel, whose body seems to dissolve into light. The central image of the Madonna holding her child in a tender embrace gives way to a vision of heaven, also made of pure light.

These elements lead the eye to the right panel, where the body of Christ appears to float above the stone sarcophagus into which it had been placed in the predella. The guards set to watch the tomb are knocked senseless by the miracle. Their

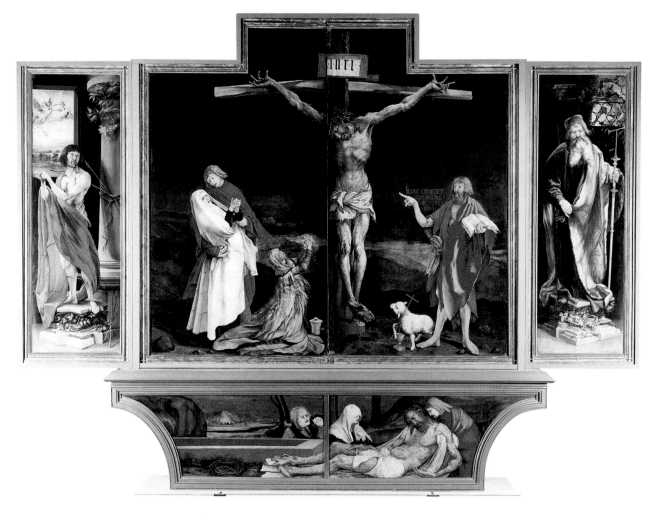

18.13. Matthias Grünewald. *St. Sebastian; The Crucifixion; St. Anthony Abbot;* predella: *Lamentation. Isenheim Altarpiece* (closed). ca. 1509/10–1515. Oil on panel, main body 9′9¹⁄₂″ × 10′9″ (2.97 × 3.28 m), predella 2′5¹⁄₂″ × 11′2″ (0.75 × 3.4 m). Musée d'Unterlinden, Colmar, France

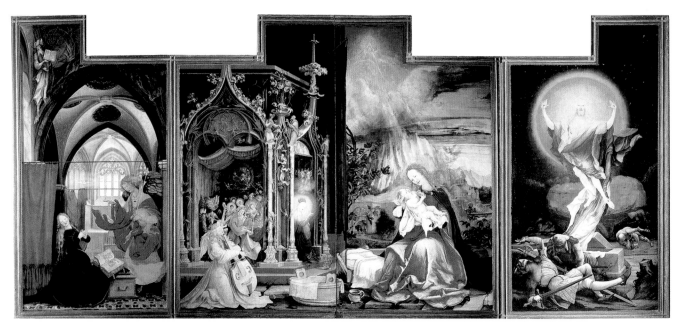

18.14. Matthias Grünewald. *The Annunciation; Madonna and Child with Angels; The Resurrection.* Second view of the *Isenheim Altarpiece.* ca. 1509/10–1515. Oil on panel, each wing 8′10″ × 4′8″ (2.69 × 1.42 m), center panel 8′10″ × 11′2¹⁄₂″ (2.69 × 3.41 m). Musée d'Unterlinden, Colmar, France

ures and the rendering of the tomb from which Christ rises is a study in perspective. Yet Grünewald does not try to convince the viewer of the weight and substance of his figures; his aim is to create an emotional response with the impact of a vision.

Albrecht Dürer and the Northern Renaissance

The key figure for the Renaissance in Germany is Grünewald's contemporary Albrecht Dürer (1471–1528). Dürer's style was formed in the tradition of Northern European realism (which we explored in Chapter 14), but he delved deeply into the innovations and possibilities of Italian art. After training as a painter and printmaker in his native Nuremberg, Dürer traveled in Northern Europe and Venice in 1494/95 before returning home to start his career. His travels not only expanded his visual repertoire, but changed his view of the world and the artist's place in it. (He returned to Italy in 1505.) Dürer adopted the ideal of the artist as a gentleman and humanistic scholar, and took the Italian view that the fine arts belong among the liberal arts, as artists like Mantegna and Alberti had argued (see Chapter 15). By cultivating his artistic and intellectual interests, Dürer incorporated into his work an unprecedented variety of subjects and techniques. His painting technique owes much to the Flemish masters, but making copies of Italian works taught him many of the lessons of the Italian Renaissance. He was able to synthesize these traditions in his paintings and prints. As the greatest printmaker of the time, he had a wide influence on sixteenth-century art through his woodcuts and engravings, which circulated all over Europe. His prints made him famous and wealthy—so much so that he complained about the relatively poor reward he earned for his paintings.

Dürer's debt to the legacy of Jan van Eyck and Rogier van der Weyden is clear in the many drawings and watercolors he made in preparation for his works. The watercolor of the *Hare* he made in 1502 (fig. **18.16**) demonstrates the clarity of his vision and the sureness of his rendering. This small representative of the natural world was treated with the dignity due to Nature herself, much as Van Eyck had painted the small dog in the foreground of The *"Arnolfini Portrait"* (fig. 14.16). Dürer uses the watercolor technique to render each hair of the fur, the curve of the ears, the sheen on the eyes. His monogram at the base of the page identifies Dürer as the creator of this image; this monogram was the signature he used on his mature prints.

Dürer's ability as a draftsman also informed his work as a printmaker. Having been trained in both woodcut and engraving, he pushed the limits of both media. As a mass medium, prints were not commissioned by individual patrons, but were made for the open market, so Dürer had to invest his own time and materials in these projects. This entrepreneurial spirit served him well, as his prints sold widely and quickly. Signs and portents, such as the threat of invasion by the Turks and the birth of malformed animals, worried Europeans as they awaited the approach of the year 1500. As this year approached, many people believed that the Second Coming of Christ was imminent, and prepared for the Millennium. Thus, with an eye

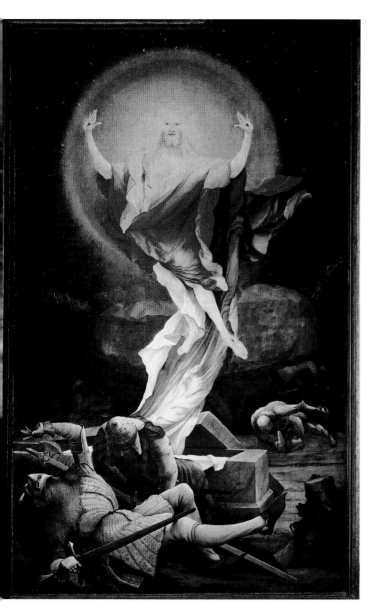

18.15. Matthias Grünewald. *The Resurrection*, from second view of the *Isenheim Altarpiece*. Musée d'Unterlinden, Colmar, France

figures, carefully arranged in a perspectival display, contrast to the weightless and transfigured body of Christ. He holds his hands up and allows the shroud to fall to reveal the wounds he suffered in death, now as brilliant as the halo that engulfs him. This figure differs dramatically from the figure on the Cross; his body bears no scars and the proportions are closer to the Italian ideal seen in Piero della Francesca's *Resurrection* (fig. 15.46).

Grünewald's strikingly individual approach to form is based on the traditions of the Northern European Renaissance established in the fifteenth century. His oil technique, his brilliant use of color, and the detailed rendering of objects draw from that tradition, but he must have learned from the Italian Renaissance too. The low horizon lines suggest a deep space for his fig-

to the market for things pertaining to popular fears about the end of time, Dürer produced a woodcut series illustrating the Apocalypse in 1498. This series was his most ambitious graphic work in the years following his return from Italy. The gruesome vision of *The Four Horsemen of the Apocalypse* (fig. **18.17**) offers the viewer a frightening visualization of the text of the book of Revelation. The image depicts War, Fire, Famine, and Death overrunning the population of the Earth. During his trip to Italy in 1494, Dürer had encountered prints by Mantegna, which he carefully copied. He especially admired the sculptural quality Mantegna achieved in paintings like the St. Sebastian (fig. 15.52). The physical energy and full-bodied volume of the figures in the Apocalypse woodcuts series is partly owed to Dürer's experience of Italian art, although he eliminates logical space in favor of an otherworldly flatness. Dürer has redefined his medium—the woodcut—by enriching it with the linear devices of engraving. Instead of the broad contours and occasional hatchings used to define form in earlier woodcuts, Dürer's wide range of hatching marks, varied width of lines, and strong contrasts of black and white give his woodcuts ambitious pictorial effects. (Compare, for example, the Buxheim St. Christopher of 1425 shown in fig. 14.30 with Dürer's woodcuts.) He set a standard that soon transformed the technique of woodcuts all over Europe.

Dürer's fusion of Northern European and Italian traditions is apparent in his engraving entitled *Adam and Eve* of 1504 (fig. **18.18**), for which the watercolor *Hare* was a preliminary study. Here the biblical subject allows him to depict the first parents as two ideal nudes: Apollo and Venus in a densely wooded forest. Unlike the picturesque setting and the animals in it, Adam and Eve are not observed from life; they are constructed according to what Dürer believed to be perfect proportions based on Vitruvius (see *Primary Source*, page 637). Once again, Dürer enlarged the vocabulary of descriptive marks an engraver could use: The lines taper and swell; they intersect at varying angles; marks start and stop and dissolve into dots, called *stipples*. The result is a monochrome image with a great tonal and textural range. The choice of animals that populate the Garden is very deliberate: The cat, rabbit, ox, and elk have been interpreted as symbols of the medieval theory that bodily fluids, called humors, controlled personality. The cat represents the choleric humor, quick to anger; the ox the phlegmatic humor, lethargic and slow; the elk stands for the melancholic humor, sad and serious; and the rabbit for the sanguine, energetic and sensual. In this moment before the fall, the humors coexist in balance and the humans retain an ideal beauty. The composition itself is balanced and unified by the tonal effects. Dürer's print, which he signed prominently on the plaque by Adam's head, was enormously influential. His ideal male and female figures became models in their own right to countless other artists.

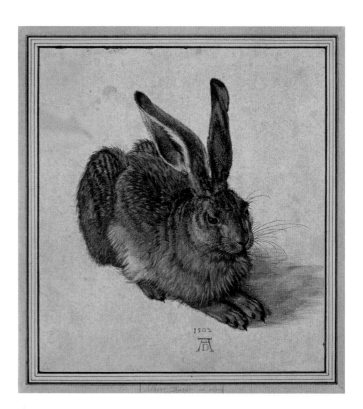

18.16. Albrecht Dürer. *Hare*. 1502. Watercolor. $9^7/_8 \times 8^7/_8$. Albertina, Vienna

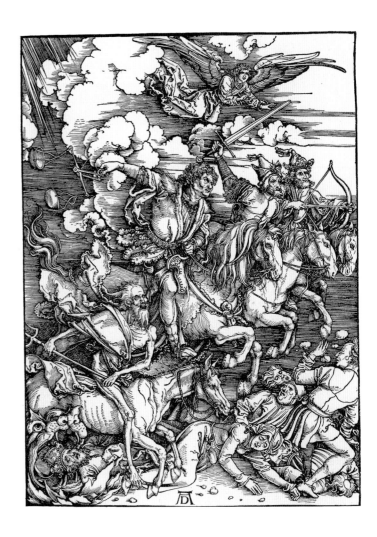

18.17. Albrecht Dürer. *The Four Horsemen of the Apocalypse*. 1498. Woodcut, $15^1/_2 \times 11^1/_8''$ (39.3 × 28.3 cm). The Metropolitan Museum of Art, New York. Gift of Junius S. Morgan, 1919

Albrecht Dürer (1471–1528)

From the draft manuscript for *The Book on Human Proportions*

Dürer made two trips to Italy and was exposed to the new art theories being discussed there, which impressed him greatly. He did not accept them uncritically, however. His rethinking of Italian ideas often appears only in preliminary form, in drafts such as this one, written in 1512–1513.

How beauty is to be judged is a matter of deliberation. . . . In some things we consider that as beautiful which elsewhere would lack beauty. "Good" and "better" in respect of beauty are not easy to discern, for it would be quite possible to make two different figures, neither of them conforming to the other, one stouter and the other thinner, and yet we scarce might be able to judge which of the two may excel in beauty. What beauty is I know not, though it adheres to many things. When we wish to bring it into our work we find it very hard. We must gather it together from far and wide, and especially in the case of the human figure. . . . One may often search through two or three hundred men without finding amongst them more than one or two points of beauty which can be made use of. You therefore, if you desire to compose a fine figure, must take the head from some and the chest, arm, leg, hand, and foot from others. . . .

Many follow their taste alone; these are in error. Therefore let each take care that his inclination blind not his judgment. For every mother is well pleased with her own child. . . .

Men deliberate and hold numberless differing opinions about these things and they seek after them in many different ways, although the ugly is more easily attained than the beautiful. Being then, as we are, in such a state of error, I know not how to set down firmly and with finality what measure approaches absolute beauty. . . .

It seems to me impossible for a man to say that he can point out the best proportions for the human figure; for the lie is in our perception, and darkness abides so heavily within us that even our gropings fail. . . .

However, because we cannot altogether attain perfection, shall we therefore wholly cease from our learning? This bestial thought we do not accept. For evil and good lie before men, wherefore it behooves a rational man to choose the better.

SOURCE: THE WRITINGS OF ALBRECHT DÜRER. TR. AND ED. BY WILLIAM MARTIN CONWAY. (NY: PHILOSOPHICAL LIBRARY, 1958)

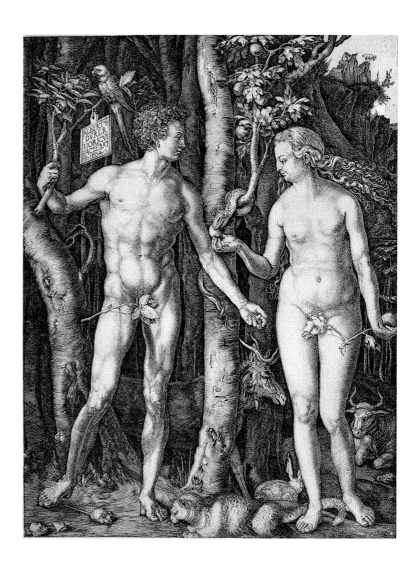

18.18. Albrecht Dürer. *Adam and Eve.* 1504. Engraving, $9^{7}/_{8}'' \times 7^{5}/_{8}''$ (25.2 × 19.4 cm). Museum of Fine Arts, Boston. Centennial gift of Landon T. Clay

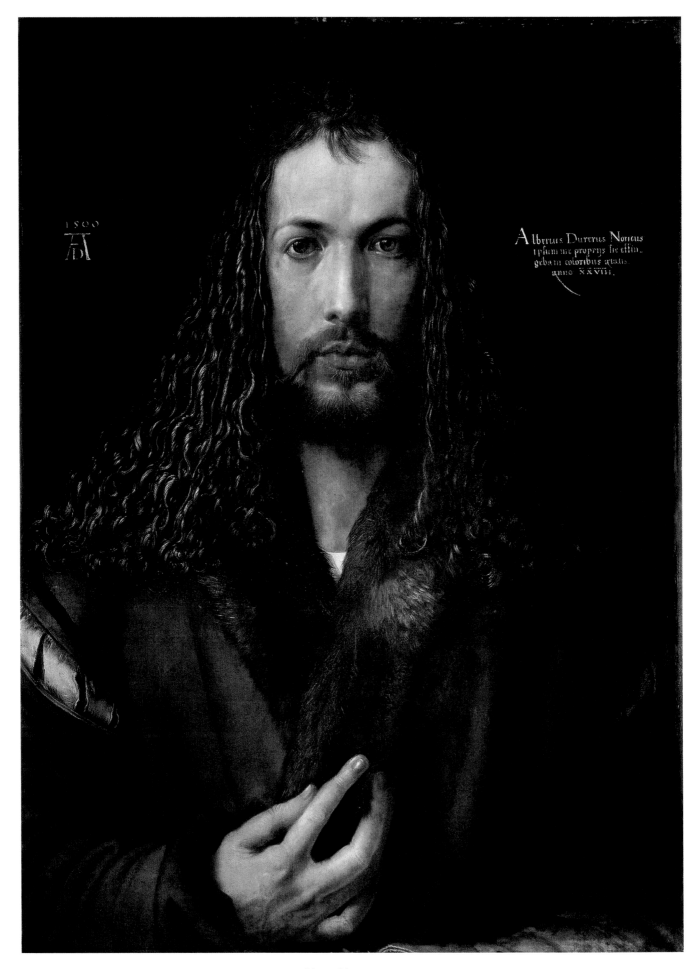

18.19. Albrecht Dürer. *Self-Portrait.* 1500. Oil on panel, 26$\frac{1}{4}$ × 19$\frac{1}{4}$″ (66.3 × 49 cm). Alte Pinakothek, Munich

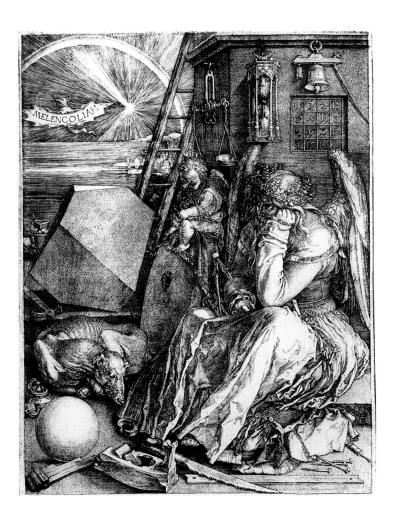

18.20. Albrecht Dürer. *Melencolia I.* 1514. Engraving, 9⅜ × 7½″ (23.8 × 18.9 cm). Victoria and Albert Museum, London

IMAGES ABOUT ARTISTRY Although best known for his prints, Dürer was also a gifted draftsman and skilled painter. One of his earliest works, a drawing made at 13, is a self-portrait that foreshadowed his fascination with his own image throughout his career. Most impressive, and very revealing, is the painted *Self-Portrait* of 1500 (fig. **18.19**). In pictorial terms, it belongs to the Flemish tradition of Jan van Eyck's *Man in a Red Turban* (see fig. 14.15), but the solemn pose and the idealization of the features have an authority not found in most portraits up to this time. Instead of a conventional three-quarters pose, Dürer places himself frontally in the composition, a pose usually reserved for images of the divine. The panel looks, in fact, like a secularized icon, for it is patterned after images of Christ. It reflects both Dürer's deep piety and the seriousness with which he viewed his mission as an artist and intellectual.

The status of the artist may also be the theme of one of Dürer's most famous and puzzling prints. This is an engraving labeled *Melencolia I* (fig. **18.20**), one of a trio of prints that Dürer sold or gave away together. Dated 1514, the image represents a winged female holding a compass, surrounded by the tools of the mathematician and the artist. She holds the tools of geometry, yet is surrounded by chaos. The figure is probably a personification, though her identity is controversial: Is she Melancholy? Is she Geometry? Is she Genius? Her face in shadow, she sits in a pose long associated with melancholy, which itself was associated with intellectual activity and creative genius. Compare her pose to Raphael's depiction of Michelangelo as Heraclitus in *The School of Athens* (fig. 16.25). Like Raphael, Dürer shrouds the face of Genius in shadow, as though the figure is lost in thought. Dürer's figure thinks but cannot act, while the infant scrawling on the slate, symbolizing practical knowledge, can act but not think. Dürer makes a statement here about the artistic temperament and its relationship to the melancholic humor.

The Italian Humanist Marsilio Ficino viewed melancholia (to which he was himself subject) as the source of divine inspiration. He tied it to Saturn, the Mind of the World, which, as the oldest and highest of the planets, he deemed superior even to Jupiter, the Soul of the World. His notion of the melancholic genius was widespread in Dürer's time, and the printmaker includes details that make reference to Saturn, to Jupiter, to divine inspiration, and to geometric theory. The print claims for the visual artist (and perhaps for Dürer himself?) the status of divinely inspired, if melancholic, genius.

A REFORMATION ARTIST Dürer became an early and enthusiastic follower of Martin Luther, although, like Grünewald, he continued to work for Catholic patrons. His new faith can be sensed in the growing austerity of style and subject in his religious works after 1520. The climax of this trend is represented by *The Four Apostles* (fig. **18.21**). These paired panels have rightly been termed Dürer's artistic testa-

ment. He presented them in 1526 to the city of Nuremberg, which had joined the Lutheran camp the year before. These four men are fundamental to Protestant doctrine. John and Paul, Luther's favorite authors of Scripture, face one another in the foreground, with Peter and Mark behind. Quotations from their writings, inscribed below in Luther's translation, warn the city not to mistake human error and pretense for the will of

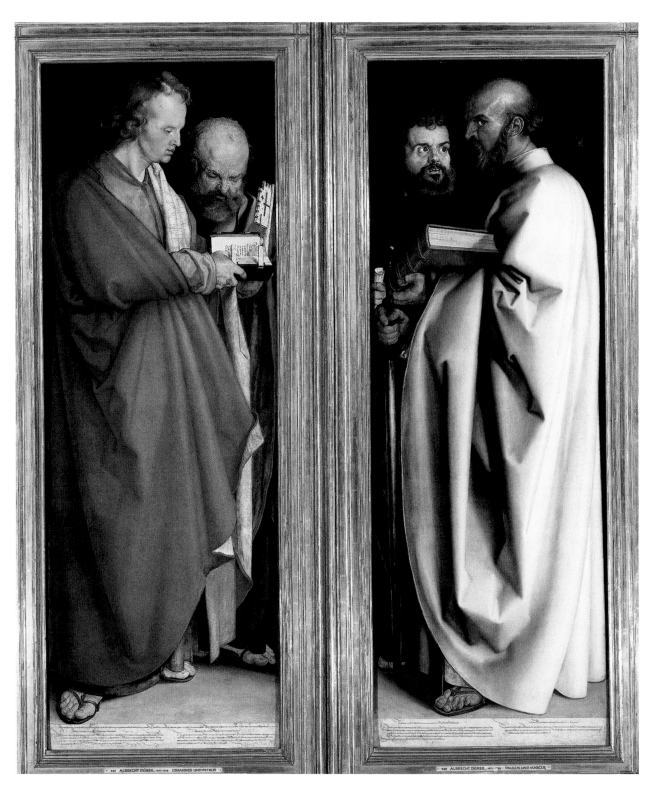

18.21. Albrecht Dürer. *The Four Apostles*. 1523–1526. Oil on panel, each 7'1" × 2'6" (2.16 × .76 m). Alte Pinakothek, Munich

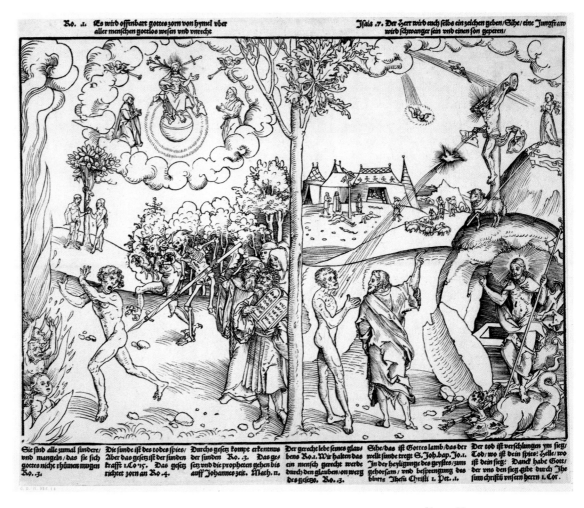

18.22. Lucas Cranach the Elder. *An Allegory of Law and Grace*. ca. 1530. Woodcut, $10\frac{5}{8} \times 1'3\frac{3}{4}''$ (27 × 32.4 cm). British Museum, London

God. They plead against Catholics and Protestant radicals alike. But in another, more universal sense, the figures represent the Four Temperaments and, by implication, the other cosmic quartets—the seasons, the elements, the times of day, and the ages of life. The apostles have a sculptural solidity that brings to mind Nanni di Banco's *Quattro Coronati* (fig. 15.5). The heavily draped figures have the weight and presence of Raphael's figures in the tapestry cartoon of *Saint Paul Preaching in Athens* (fig. 16.27), which Dürer probably saw on a trip to the Netherlands in 1521. Through the power of his paintings, the portable medium of prints and his workshop, Dürer was the most influential artist of sixteenth-century Germany.

Religious and Courtly Images in the Era of Reform

The realignment of German culture and society produced by the Reformation required artists to adapt their styles and subject matters for the reformed faiths. Prints were an important tool for spreading the tenets of the Protestant confessions. For courtly patrons, artists made images on classicizing themes, for which they used local visual traditions that emphasized detail, texture, and the natural world.

In Reformation Germany, painters had to contend with the Protestant leaders' ambivalence toward religious images. When a faith places the Word above the Image, the image becomes subordinate to the text; though Luther himself tolerated images (see end of Part III, *Additional Primary Sources*), the works that most deliberately address Lutheran themes are often literal illustrations of texts.

LUCAS CRANACH: REFORMER AND COURT ARTIST

Lucas Cranach the Elder (1472–1553), a close friend of Martin Luther, attempted to solve the problem of casting Luther's doctrines into visual form. Cranach made numerous prints and paintings to express the tenets of the reform. A woodcut of ca. 1530 entitled *An Allegory of Law and Grace* (fig. **18.22**) contrasts the difference between the fate of a Catholic and a Lutheran. The left side depicts the Catholic doctrine that the children of Adam and Eve, stained by original sin, must perform specific deeds according to the Law of Moses; when this is unsuccessful, the soul is consigned to hell at the Last Judgment. The right side

depicts the believer washed in the blood of Christ's Crucifixion; faith in Christ alone is needed to assure salvation, which is Luther's position. Compared to the complexity of Dürer's woodcuts, this image is rather simple and straightforward, without complex tonalities, illusions of space, or an emphasis on textures. Cranach makes the image almost as legible and accessible as the text.

In addition to images with Lutheran content, Cranach excelled in portraits and mythological scenes painted for aristocratic patrons, both Catholic and Protestant, in Saxony and elsewhere in Germany. In *The Judgment of Paris* (fig. **18.23**) of 1530, Cranach retells a story from Greek mythology in which the Trojan prince Paris selects the most beautiful goddess of Olympus. He depicts Paris as a German knight clad in the fashionable armor of the nobles at the court of Saxony. The sinewy figures of the goddesses are displayed for the judgment of the prince, who confides his choice to Mercury, also dressed in armor. Like many of his Italian contemporaries working for aristocratic patrons, Cranach gives his Classical subject an overtly erotic appeal, inviting a viewer to identify with Paris as the privileged observer of the female nudes. Yet the detailed, miniaturistic technique and the weightless bodies of the women are distinctive to Cranach. One of the striking features here is the landscape, whose lush vegetation recalls Dürer's *Adam and Eve* (fig. 18.18), though Cranach exaggerates its foliage into a sensual fantasy of natural beauty.

ALTDORFER'S *BATTLE OF ISSUS* Both Cranach and Dürer played a critical role in the development of the Danube School of landscape painting, which appeared in southern Germany and Austria in the first half of the sixteenth century. The key figure in this school, however, was Albrecht Altdorfer (ca. 1480–1538), a slightly younger artist who spent most of his career in Bavaria. Although he made prints and paintings on a variety of themes, Altdorfer's work is dominated by his fascination with landscape, which he used to great expressive effect. His most famous work is *The Battle of Issus* (fig. **18.24**). The painting, made in 1529, is one of a series of images depicting the exploits of historic heroes, commissioned for the Munich palace of William IV, Duke of Bavaria. In a sweeping landscape, Altdorfer depicts Alexander the Great's victory over Darius of Persia, which took place in 333 BCE at Issus. This victory was the subject of a composition attributed to the Greek painter Apelles, preserved in a mosaic at Pompeii (fig. 5.79). To make the subject clear, Altdorfer provided an explanatory text on the tablet suspended in the sky, inscriptions on the banners (probably written by the Regensburg court Humanist, Aventinus), and a label on Darius's fleeing chariot. The artist has tried to follow ancient descriptions of the actual number and kind of combatants in the battle and to record the geography of the Mediterranean.

Altdorfer adopts an omniscient point of view, as if looking down on the action from a great height to fit everything into the picture. From this planetary perspective, a viewer must search to find the two leaders lost in the antlike mass of their

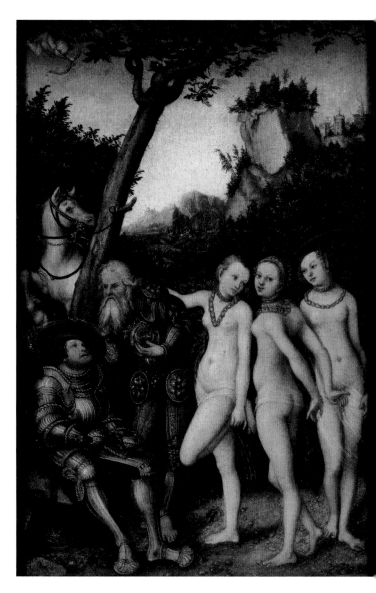

18.23. Lucas Cranach the Elder. *The Judgment of Paris.* 1530. Oil on panel, 13½ × 9½″ (34.3 × 24.2 cm). Staatliche Kunsthalle, Karlsruhe, Germany

own armies. The drama of Nature is more elaborated than the human actors: One can almost feel the rotation of the globe as the sun sets in the distance and the moon rises. The curve of the earth, the drama of the clouds, the craggy mountain peaks overwhelm the mass of humanity. Such details suggest that the events portrayed have an earth-shaking importance, which arguably, was the case for this historical event. However, the soldiers' armor and the fortified town in the distance are unmistakably of the sixteenth century, which encourages us to look for contemporary significance. The work was executed at the moment the Ottoman Turks were trying to invade Vienna after gaining control over much of Eastern Europe. (Though the imperial forces repelled the Turks this time, they were to threaten Europe repeatedly for another 250 years.) Altdorfer's image suggests that the contemporary battle between Europeans and Turks has the same global significance as Alexander's battle with Darius.

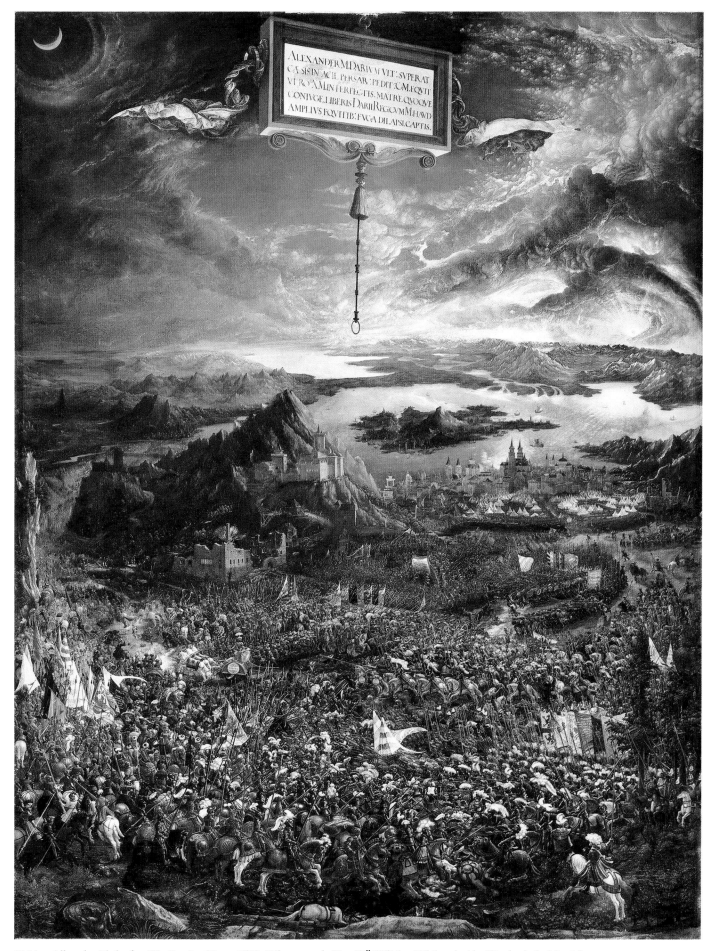

18.24. Albrecht Altdorfer. *The Battle of Issus*. 1529. Oil on panel, 62 × 47″ (157.5 × 119.5 cm). Alte Pinakothek, Munich

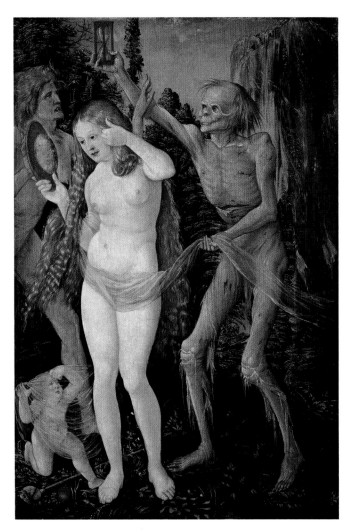

18.25. Hans Baldung Grien. *Death and the Maiden.* ca. 1510. Oil on panel, 15¾ × 12¾″ (40 × 32.4 cm). Kunsthistorisches Museum, Vienna

Painting in the Cities: Humanist Themes and Religious Turmoil

Cities along the Rhine River, especially Strasbourg and Basel, were centers of commerce, publishing, and humanism. The ancient city of Strasbourg's commercial success was due to its location and its industry. Further down the Rhine, Basel had a university as well as an early printing press. It was in Basel that Sebastian Brant's *Ship of Fools* was published in 1494 (see fig. 14.33). As elsewhere, the spread of the Reformation and Humanist ideas to these cities profoundly affected the arts, visible in the work of Hans Baldung Grien and Hans Holbein.

HUMANISM AND MORALITY: HANS BALDUNG GRIEN'S *DEATH AND THE MAIDEN* The impact of humanism on German artists may be seen in the work of the painter and printmaker Hans Baldung Grien (1484/85–1545). This former apprentice of Dürer spent much of his career in Strasbourg. Although he made some religious works, Baldung Grien made numerous secular images that explore themes of witchcraft, magic, and death. A characteristic example is his *Death and the Maiden* (fig. **18.25**) of about 1510. The painting depicts a self-absorbed, nude young woman who stares at her reflection in a mirror, while the skeletal figure of Death holds an hourglass triumphantly over her head. The young woman's companions are versions of herself at different ages: A child plays with the diaphanous veil that wraps around the woman, and an elderly woman moves abruptly to ward off death. The three ages of life—infancy, adulthood, old age—are visible in the mirror. Yet, although the three heads stare out forlornly at the young woman, she obliviously toys with her long hair. The young woman personifies the vice of Vanity, which must give way to death. Images of the fragility of beauty and the inevitability of death—called Vanitas emblems—were quite popular in a time when sudden death was frequent. Baldung's sources for this image include Dürer's Eve from the *Adam and Eve* engraving and Jan van Eyck's representations of mirrors (see fig. 14.16). The landscape has the lush fantastic quality that also appears in Cranach's work. Although the patron for this image is not known, its imagery allows a viewer to meditate on the proximity of death while enjoying the spectacle presented by the display of the young woman's body.

HANS HOLBEIN IN REFORMATION BASEL The son of a painter, Hans Holbein the Younger (1497–1543) was born and raised in Augsburg, but it was in Basel that Holbein sought to make his career. Basel, in what is now Switzerland, was another center of learning, publishing, and commerce. By 1520, Holbein was established there as a painter and a designer of woodcuts. He had also become a member of the Humanist circle that included the writer Desiderius Erasmus (1466–1536).

Holbein took Dürer as his point of departure, but he developed his own distinctive style informed by Netherlandish realism and Italian compositional techniques. He is best known for his portraits, such as the likeness of *Erasmus of Rotterdam* (fig. **18.26**). This was painted soon after the famous author had settled in Basel. Erasmus was one of the most prolific Humanists of the era, who corresponded with many of the leading thinkers of his day. Holbein's portrait reflects Erasmus's authority and status. Holbein depicts the scholar in profile busily engaged in the act of writing. This kind of profile view had been popular during the Early Renaissance in Italy (see fig. 15.47), although Holbein depicts the sitter in action. Even while using an older Italian format, Holbein renders the figure and his setting with an eye for realistic detail. The composition is simple to keep the focus on the concentration of the sitter. A representation of the very ideal of the scholar, this portrait of Erasmus exudes a calm rationality that lends him an intellectual authority formerly reserved for doctors of the Church. The similarity is probably intentional. Erasmus greatly admired St. Jerome, who translated the Bible into Latin (called the Vulgate) and who was the role model for Erasmus' own great work: the production of a printed edition of the Bible that included a Greek text and his own fresh Latin translation. This edition by Erasmus appeared in Basel in 1516 and was used by Luther to produce his German translation.

18.26. Hans Holbein the Younger. *Erasmus of Rotterdam.* ca. 1523. Oil on panel, $16\frac{1}{2} \times 12\frac{1}{2}''$ (42×31.4 cm). Musée du Louvre, Paris

The spread of the Reformation disrupted the Humanist circle in Basel. By 1525, followers of Zwingli preached the sole authority of Scripture, while more radical reformers preached that images were idols. To escape this climate, Holbein sought employment elsewhere. He had traveled to France in 1523–1524, perhaps intending to offer his services to Francis I. Hoping for commissions at the court of Henry VIII, Holbein went to England in 1527. He presented the portrait of Erasmus as a gift to the humanist Thomas More, who became his first patron in London. Erasmus, in a letter recommending Holbein to More, wrote: "Here [in Basel] the arts are out in the cold." By 1528, when Holbein returned to Basel, violence had replaced rhetoric. He witnessed Protestant mobs destroying religious images, a scene Erasmus described in a letter: "Not a statue has been left in the churches . . . or in the monasteries; all the frescoes have been whitewashed over. Everything which would burn has been set on fire, everything else hacked into little pieces. Neither value nor artistry prevailed to save anything." Holbein resolved to return to London.

ENGLAND: REFORMATION AND POWER

Holbein's patron in England was the ambitious Henry VIII, who reigned from 1509 to 1547. Henry wanted England to be a power broker in the conflicts between Francis I of France and the Emperor Charles V, although his personal situation complicated these efforts. Married to Catherine of Aragon in

ART IN TIME

- 1502—Peter Henlein of Nuremberg invents pocket watch
- **ca. 1509—Grünewald's *Isenheim Altarpiece***
- 1521—Diet of Worms condemns Luther
- 1525—Peasants' War ignited by Reformation
- **1526—Albrecht Dürer's *Four Apostles* presented to city of Nuremberg**
- 1555—Peace of Augsburg between Catholics and Lutherans

1509, twenty years later Henry was seeking to annul their union, for they had failed to produce a male heir to the throne. Thwarted by the Catholic Church, he broke away from Catholicism and established himself as the head of the Church of England. His desire for a male heir to the throne led Henry into a number of marriages, most of which ended either in divorce or in the execution of his wife. He had three children, who succeeded him as Edward VII, Mary I, and Elizabeth I.

Holbein's *Henry VIII* (fig. **18.27**) of 1540 captures the supreme self-confidence of the king. He uses the rigid frontality that Dürer had chosen for his self-portrait to convey the almost divine authority of the absolute ruler. The king's physical bulk creates an overpowering sense of his ruthless, commanding personality. The portrait shares with Bronzino's *Eleanora of Toledo* (fig. 17.7) an immobile pose, an air of unapproachability, and the

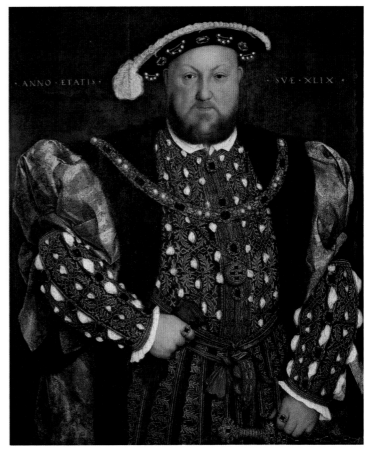

18.27. Hans Holbein the Younger. *Henry VIII.* 1540. Oil on panel. $32\frac{1}{2} \times 29''$ (82.6×74.5 cm). Galleria Nazionale d'Arte Antica, Rome

precisely rendered costume and jewels. Holbein fashioned for Henry VIII a memorable public image of strength and power. Holbein's portraits of the king and his courtiers molded British taste in aristocratic portraiture for decades.

Henry's daughter Elizabeth came to the throne in 1558 at the age of 20, and through her shrewdness and some good luck ruled until 1603. She managed to unite a country that had been bitterly divided by religious differences, and increased the wealth and status of England through her diplomacy, her perspicacious choice of advisers and admirals, and her daring. Her most important victory was the defeat of the Spanish Armada, sent to invade England in 1588, but the Elizabethan age is also rightly famous for its music and literary arts.

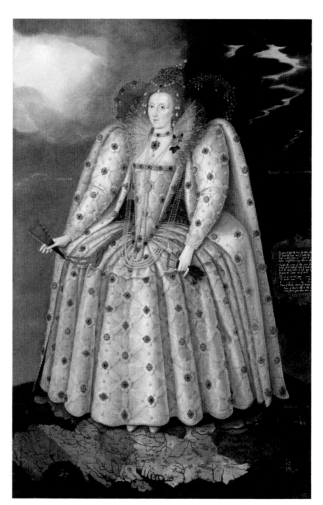

18.29. Marcus Gheeraerts the Younger. *Portrait of Elizabeth I (The Ditcheley Portrait).* ca. 1592. Oil on canvas, 95 × 60″ (241.3 × 152.4 cm). The National Portrait Gallery, London. Reproduced by Courtesy of the Trustees

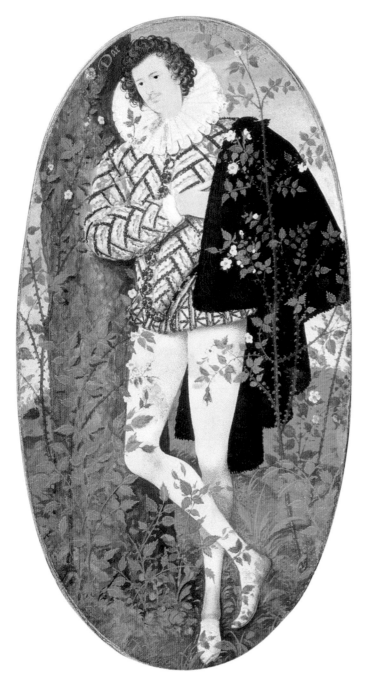

18.28. Nicholas Hilliard. *A Young Man Among Roses.* ca. 1588. Oil on parchment, 5⅜ × 2¾″ (13.7 × 7 cm). Victoria & Albert Museum, London

The influence of Elizabethan poetry may be seen in a miniature portrait by the English painter Nicholas Hilliard (1547–1619), usually called *A Young Man Among Roses* (fig. **18.28**). Inspired by ancient cameos, these portable portraits on parchment were tiny keepsakes often worn as jewelry. Hilliard's style reveals the influence of Holbein in the even lighting and careful detail. However, the tall, slender proportions, elegant costume, and languorous grace may reflect the impact of Italian mannerism, probably by way of Fontainebleau; compare the courtier's stance to that of Primaticcio's stucco figures from the French palace (fig. 18.6). In tremendous detail on a very small scale (the miniature is just over 5 inches high), Hilliard records the costume, features, tree, and flowers that surround the young man. An inscription suggests that he is suffering for his love. Other details—the black and white costume, the type of rose—imply that Elizabeth is his beloved, inspiring speculation about the man's identity. The image may represent Robert Devereaux, Earl of Essex, Elizabeth's one-time favorite. The floral imagery and the lovesick poet are frequent motifs in Elizabethan sonnets, such as those of Edmund Spenser or William Shakespeare. Many images from the Elizabethan era carry texts or symbols that have parallels in Elizabethan court rituals and literature. (See *Primary Source,* page 648.)

Like her father, Henry VIII, Elizabeth had a gift for managing her image. She had no Holbein in her employ to dominate the artistic life of the court, but she dictated to the many artists around her how she should be represented. She even imprisoned people for making unsanctioned images of her. A portrait by the Flemish artist Marcus Gheeraerts the Younger, called *The Ditcheley Portrait* (fig. **18.29**), exemplifies her carefully controlled iconography. The portrait represents Elizabeth standing on a map of her realm, which she dominates by her size and frontality. Sir Henry Lee, one of Elizabeth's courtiers, probably commissioned this portrait; Ditcheley was his estate near Oxford. Elizabeth wears one of the elaborate dresses that she favored, significantly in white, the color of virginity; Elizabeth steadfastly refused to marry, claiming that she was married to England. One side of the background is dark and gloomy: A storm has just passed and the sun shines again. A fragmentary sonnet expresses thanks for a grace given. The whole image is one of supreme and serene authority.

One hypothesis about this painting is that it commemorates a visit that Elizabeth paid to Sir Henry at his estate of Ditcheley. Such visits, called *progresses*, were ritual events in Elizabethan England expressing the relationship between the sovereign and the subject. In some cases, the host built an entire mansion solely for the purpose of receiving the Queen and her court. Robert Smythson (ca. 1535–1614) designed several such houses, including Longleat House (fig. **18.30**) in Wiltshire. The project went through several building campaigns and used the talents of Smythson and a French sculptor, Allen Maynard (active 1563–ca. 1584), who carved the chimney pieces and ornamentation. The plan (fig. **18.31**) shows that the house is perfectly symmetrical on all four sides, with spaces arranged around a

ART IN TIME

1509—Europe launches African slave trade with the New World

1515—Thomas More publishes *Utopia*

1534—Henry VIII breaks with Rome and forms Church of England

1572—Longleat House begun in Wiltshire

1588—England defeats the Spanish Armada

18.31. Plan of Longleat House, Wiltshire (after a plan from Sir Bannister Fletcher's *A History of Architecture*)

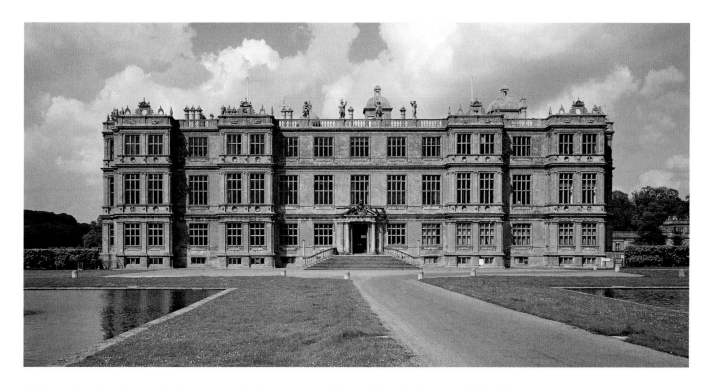

18.30. Robert Smythson, Allen Maynard, and others. Longleat House, Wiltshire, England. 1572–1580

Elizabethan Imagery

The poets and playwrights of Elizabethan England produced some of the most memorable literature in the English language. The sonnet, given authority as a poetic form by Petrarch, was the form chosen by both Edmund Spenser and William Shakespeare for their own love poetry. Spenser (ca. 1552–1599) is best known for his epic poem "The Faerie Queen," an allegory of Elizabeth I. Though best known for his plays, William Shakespeare (1564–1616) wrote many sonnets whose imagery is as vivid as the paintings of Nicholas Hilliard.

Edmund Spenser, Sonnet Sixty-four, from the Amoretti *(1595)*

Coming to kiss her lips, such grace I found
Me seemed I smelt a garden of sweet flowers
That dainty odours from them threw around
For damzels fit to deck their lovers' bowers:
Her lips did smell like unto gillyflowers;
Her ruddy cheeks like unto roses red;
Her snowy brows like budded bellamours;
Her lovely eyes like pinks but newly spread;
Her goodly bosom like a strawberry bed;

Her neck like to a bunch of columbines;
Her breast like lilies, ere their leaves be shed;
Her nipples like young blossomed jessamines:
Such fragrant flowers do give most odorous smell,
But her sweet odour did them all excel.

William Shakespeare, Sonnet Eighteen (*The Sonnets were published in 1609, though often dated to the 1590s*)

Shall I compare thee to a summer's day?
Thou art more lovely and more temperate:
Rough winds do shake the darling buds of May,
And summer's lease hath all too short a date:
Sometime too hot the eye of heaven shines,
And often is his gold complexion dimmed;
And every fair from fair sometime declines,
By chance, or nature's changing course, untrimmed:
But thy eternal summer shall not fade,
Nor lose possession of that fair thou ow'st;
Nor shall Death brag thou wand'rest in his shade,
When in eternal lines to time thou grow'st.
So long as men can breathe or eyes can see,
So long lives this, and this gives life to thee.

pair of interior courtyards. The facade is beautifully proportioned and uses a limited vocabulary of Italian forms, such as balustrades and entablatures. French rather than Italian in character, Longleat House reflects the taste of its owner, John Thynne. Nestled in its country park, Longleat is a perfect stage on which rituals of Elizabethan power could be performed.

THE NETHERLANDS: WORLD MARKETPLACE

Such displays of aristocratic power were controversial in the sixteenth-century Netherlands. This region, comprising present-day Holland and Belgium, had the most turbulent history of any country north of the Alps. Once united under the Burgundian rulers of the fifteenth century, the Netherlands passed to Habsburg control through the marriage of Mary of Burgundy to Maximilian I. When the Reformation began, it was part of the empire under Charles V, who was also king of Spain. Protestantism quickly gained adherents in the Northern Netherlands, and attempts to suppress the spread of reformed confessions led to a revolt there against Spanish rule that resulted in the provinces of the Northern Netherlands declaring their independence in 1579. After a bloody struggle, the Northern Provinces (present-day Holland) emerged at the end of the century as an independent state in all but name.

The Southern Provinces (roughly corresponding to present-day Belgium) remained in Spanish hands and committed to Roman Catholicism. Both Charles V and Philip II of Spain appointed regents to govern the Netherlands who established courts in the southern cities. The momentous changes in the political and religious situation were accompanied by economic changes. In the Southern Netherlands, the once thriving port of Bruges silted up and was replaced as a commercial center by Antwerp, with its deep harbor and strategic location. Antwerp became the commercial and artistic capital of the Southern Netherlands. In the Northern Netherlands the city of Amsterdam became a center of international trade.

One byproduct of the religious strife was the destruction of works of art in waves of iconoclasm, inspired by the reformers' suspicion of images. In both the Northern and Southern Netherlands vast numbers of medieval and earlier Renaissance works of art were lost, especially religious works and sculpture, as zealous reformers confiscated or burned images they considered idolatrous. The market for sculpture in the Netherlands was changed for the rest of the early modern period, as painting and other two-dimensional art forms dominated artistic production. Although some reformers allowed painted or printed images that taught the faithful about doctrine, the Catholic practice of commissioning large-scale sculpted works of saints or of the Virgin to install in churches was eliminated

in reformed regions. Artists' practices changed under these conditions; as religious commissions dried up, especially in the Northern Netherlands, artists no longer waited for patrons to hire them, but made works of art to sell in the open market. (See *The Art Historian's Lens*, page 650.) One result was the development of new genres of art that would supplement, and eventually replace, traditional religious subjects.

Netherlandish artists were also being challenged by the new Italianate style, which was gaining favor in the courts. Responses to Italian art varied. Some artists saw no reason to change the Northern European visual tradition they had inherited; some grafted Italianate decorative forms to their traditional compositions and techniques; and others dove deeply into Italian style. These artists had been inspired by the example of Dürer, by works of Michelangelo and Raphael they had seen in the Netherlands, and by their own experience of Italy.

The City and the Court: David and Gossaert

The city of Bruges in the Catholic Southern Netherlands remained an important center for commerce into the sixteenth century, though much of its trade and prosperity transferred to Antwerp early in the period. The distinguished tradition of Bruges painting that we saw in the work of Van Eyck and Memling was carried on by Gerard David (ca. 1460–1523). David's workshop dominated to the middle of the sixteenth century. In 1509, David made a gift of a large panel to the Carmelite nunnery in Bruges. This painting (fig. **18.32**) depicts the Virgin and Child surrounded by virgin saints; two angels serenade this assembly of women, while portraits of David and his wife, Cornelia Cnoop, appear in the corners. In traditional Flemish fashion, the forms exhibit detailed renderings of textures, layers of colors that create brilliant effects, and symbolic forms to enhance the meaning, such as the grapes held by the Christ Child and the attributes of the saints. Yet David's cool colors and soft modeling endows these figures with a calm and dignity that is enhanced by the balanced composition. These silent virgins gather around the mother and son as the nuns of the convent would gather for prayer.

David worked for individual patrons and for the open market, but some of his contemporaries found employment in the aristocratic courts of the Netherlands, including Jan Gossaert (ca. 1478–1532), nicknamed "Mabuse," for his hometown. His early career was spent in Antwerp, but in 1508 he accompanied Admiral Philip of Burgundy to Italy, where the Italian Renaissance and antiquity made a deep impression on him. He also worked for the regent of the Netherlands, Margaret of Austria. His work fuses the lessons of Italian monumentality with the detailed technique of the Netherlandish tradition. For courtly

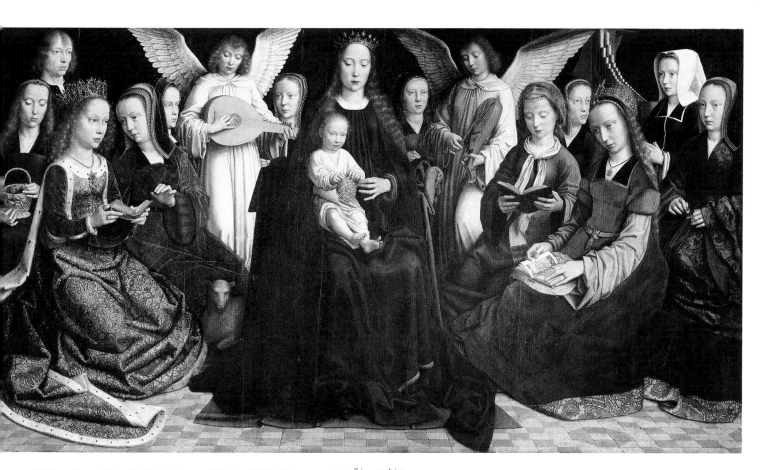

18.32. Gerard David. *Virgin Among Virgins*. 1509. Oil on panel. $46^{7}/_{8} \times 83^{1}/_{2}$″. Musée des Beaux Arts, Rouen

The Economics of Art

As trade, specialization, and a money economy came to dominate Northern Europe after the Middle Ages, the business of making and of selling art changed. The patron–artist relationship, where a contract specified the work to be produced and the money to be paid, gave way to the market system. Artists began to make their goods for sale on the open market. In recent years, art historians have been researching and writing about this change in the economics of art, focusing on centers such as Bruges, Antwerp, Delft, Haarlem, and Amsterdam.

Scholars have used documents, chronicles, and the study of the works themselves to explore the institutions that arose in response to these economic changes. The study of guilds and their regulation of the art trade illuminates one facet of the economics of art: Since the Middle Ages these organizations had regulated the training of artists and their commercial activity and controlled competition in their locales. The new technology of prints allowed artists to mass produce images that were not regulated by the guilds; prints were sold at trade fairs along with other commodities, sometimes by monks and nuns who sold them to support their monasteries. Dürer financed his trip from Nuremberg to Antwerp in 1521 by selling prints along the way.

By tracking the fluctuations in prices of works of art in the early modern period, scholars have been able to compare them to other commodities and to examine the impact of economic changes in the art trade on the artists themselves. Researchers have also explored the records and the physical arrangements of the market places and neighborhoods where the artists displayed their work for buyers to examine and purchase. Along with economic changes in the art trade a new player entered the art market—the dealer, who served as the middleman between the artist and the purchaser.

For art historians, an important issue is how these new economic changes and circumstances for making and selling art would affect the art works themselves. Evidence indicates that artists and workshops standardized their production techniques, subcontracted specific elements of projects, and specialized in particular forms or subjects. The choices made for subject matter in works of art responded to economic changes, too; images such as Aertsen's *The Meat Stall* (fig. 18.36) represent and comment on the market itself.

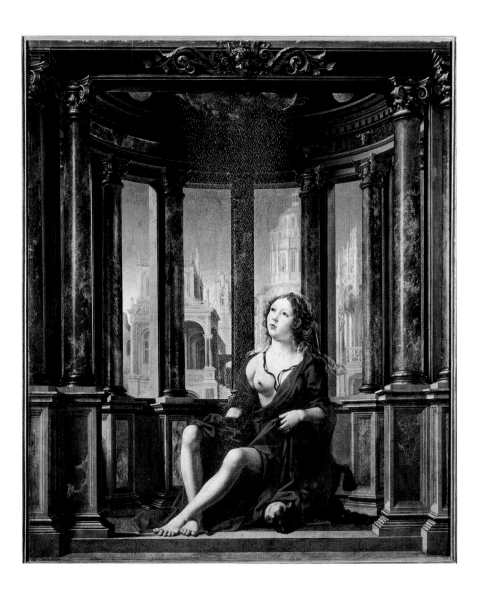

18.33. Jan Gossaert. *Danaë.* 1527. Oil on panel, 44$\frac{1}{2}$ × 37$\frac{3}{8}$″ (113 × 95 cm). Alte Pinakothek, Munich

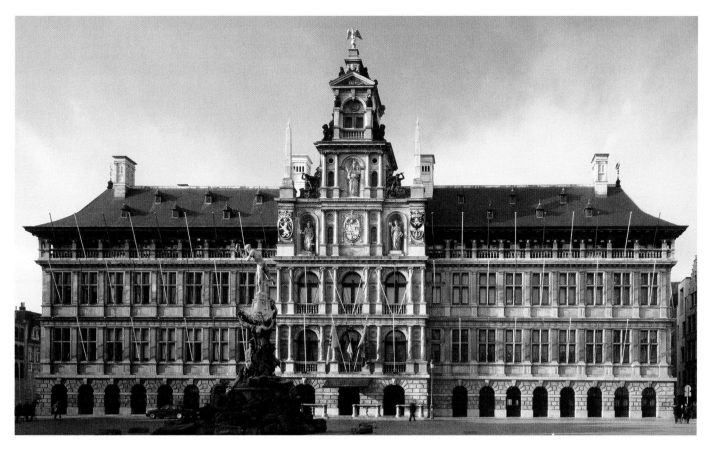

18.34. Cornelis Floris and Willem van den Broek, Town Hall, Antwerp. 1561–1566

patrons he made images of mythological subjects such as the *Danaë* (fig. **18.33**), signed and dated by Gossaert in 1527. Danaë has been locked away from male eyes, yet Jupiter finds a way to seduce her by disguising himself as a shower of gold. The picture may be seen as a counterpart to Correggio's *Jupiter and Io* (see fig. 17.24), painted only a few years later. Where Correggio's full-bodied Io seems to lose herself in the embrace of the Jovian cloud, Gossaert's Danaë gazes passively at the shower of gold falling toward her. Correggio focuses attention on Io, inferring the spatial context rather than defining it; Gossaert carefully constructs a round temple (perhaps an allusion to the Roman temple of the Vestal Virgins) and an architectural backdrop that competes for a viewer's attention. The figure of Danaë resembles Gossaert's images of the Madonna, complete with the blue robe traditional to the Virgin. Gossaert's *Danaë* displays the painter's fascination with antiquity and Italianate perspective, as well as his skill at rendering textures, details, and rich color.

Antwerp: Merchants, Markets, and Morality

Antwerp's rise as a center for commerce brought it new wealth and the desire for a new expression of that wealth. As with earlier Netherlandish cities, the town hall was the most important civic structure of the city, and in midcentury, the city held a competition for a new design. Cornelis Floris (1514–1575), a local sculptor and architect, won the commission and began work in 1561. Floris had traveled to Italy and had studied both antiquity and contemporary Italian architecture. In the design

for the Antwerp Town Hall, he combined the precepts of Italian Renaissance architecture with Northern European traditions to create the large and imposing structure that was completed by 1566 (fig. **18.34**). The building uses Italian devices: The base is a rusticated arcade, like Ammanati's Palazzo Pitti (fig. 17.5); the three stories above are articulated with Doric, Ionic, and Corinthian columns, like Alberti's Rucellai palace (fig. 15.32); a central pavilion mixes sculpture and architecture, like a Roman triumphal arch (see fig. 7.63). Yet the proportions are vertical, the roofline more in keeping with Netherlandish practice, and rich carvings on the central pavilion add a focal point at the tall mass of this section of the facade. The Antwerp Town Hall integrates Italian ideas differently from the way those ideas would be expressed in France, Spain, or England (compare with figs. 18.4, 18.10, and 18.30). Antwerp had become a world market by this point, trading a variety of goods, from textiles to foodstuffs, all over the world, including the Americas and Asia. The visual arts participated in this market in a variety of ways. Tapestries were exported through Antwerp; there was a thriving market in prints; and the Plantin-Moretus Press produced editions of books that were sent all over the world. Painters in particular developed new genres of art to tap into this expanding market. Still life, landscape, and genre paintings (images of daily life) had been explored by Flemish artists since the International Gothic Style and had become even more important during the fifteenth century as backdrops for religious themes. Some Antwerp artists of the sixteenth century specialized in these themes as subjects in themselves, perhaps in response to the loss

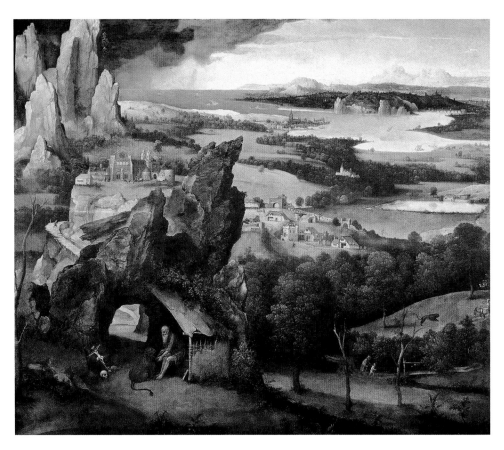

18.35. Joachim Patinir. *Landscape with St. Jerome Removing the Thorn from the Lion's Paw.* ca. 1520. Oil on panel, 29$\frac{1}{8}$ × 35$\frac{7}{8}$″ (74 × 91 cm). Museo del Prado, Madrid

of religious patronage, or perhaps as a way to gain market share. These images often carry multiple meanings, at once depicting the pleasures of the world, while warning about those same pleasures.

PATINIR: LANDSCAPE AS ALLEGORY Joachim Patinir (ca. 1480–1524) of Antwerp was an early specialist in landscape, whose work Dürer had seen and praised when he visited Antwerp in 1521. His *Landscape with St. Jerome Removing the Thorn from the Lion's Paw* (fig. **18.35**) of about 1520 shows that Patinir had studied the work of Hieronymous Bosch both for his treatment of nature and his choice of subject. The landscape dominates the scene in Patinir's painting, but the figures are central to both its composition and subject. St. Jerome's biography reports that he once removed a thorn from the paw of a lion that had entered his hermitage; as a result, the lion became his companion. In the lower left of the foreground, St. Jerome appears as a hermit with the lion's paw in his hand. Jerome's hermitage abuts a strange rock formation that isolates him from the rest of the landscape. But this narrative is completely subordinate to the deep vista of the Earth, whose fields, forests, mountains, seas, and sky fill most of the panel. The human presence is very small in this landscape. Some tiny figures wander through this world, and villages, cities, even ships can be distinguished in the distance. Significantly, the structures nearest Jerome's hermitage are ecclesiastical, though he seems unaware of them.

This kind of landscape, which became very popular among European collectors in the sixteenth century, has been called a "world landscape," because of the focus on deep vistas into the distance. Like Altdorfer, Patinir uses a high viewpoint to allow the distant view, yet he also provides a shelf of space in the foreground for the narrative. Creating a smooth relationship between the foreground and the distance is of less interest to Patinir than describing the blue mountains and the verdant forests. How such landscapes were interpreted in Patinir's time is not entirely clear. On the one hand, the vista itself invites careful perusal, and viewers could study the picture and imagine the distant lands then being explored instead of traveling there themselves. At the same time, the painting has a religious subject that may have a moralizing message. Perhaps Patinir was commenting on the dangers of life in the world compared with the hermit's saintly rejection of worldly things.

AERTSEN'S *THE MEAT STALL* A moralizing meaning has also been ascribed to the still lifes painted by the North Netherlandish painter Pieter Aertsen (1507/08–1575). He spent his early career in Antwerp, then returned to Amsterdam in 1557, where he saw firsthand the destruction of religious images by iconoclasts in 1566. *The Meat Stall* (fig. **18.36**), done in 1551 while the artist was still in Antwerp, seems at first glance to be a purely secular picture. In the foreground, we see the products for sale in a butcher's shop in overwhelming detail, with tiny figures in the background almost blotted out by the food.

A sign to the upper right also advertises a farm for sale, so the power of the market economy is reflected in the imagery.

The still life so dominates the picture that it seems independent of the religious subject in the background. But in the distance to the left we see the Virgin and Child on the Flight into Egypt giving bread to the poor, who are ignored by the worshipers lined up for church. To the right is a tavern scene where the excesses of the senses are for sale. (The many oyster shells refer to its rumored qualities as an aphrodisiac.) The eye meanders over the objects on display: some of them items of gluttony; some, like the pretzels, eaten during Lent. Some of the products may be read as Christian symbols, such as the two pairs of crossed fish signifying the Crucifixion. The two background scenes suggest different choices a viewer could make: a life of dissipation or a life of almsgiving. The foreground with its emphasis on items for sale may implicate Antwerp's principal economic activity in these choices.

PIETER BRUEGEL THE ELDER Aertsen's younger contemporary and fellow Antwerp resident, Pieter Bruegel the Elder (1525/30–1569) used this same device of "inverted"

ART IN TIME

1509—Erasmus publishes *In Praise of Folly*
1568–1648—Dutch Wars of Independence from Spain
1565—Pieter Bruegel the Elder's *The Return of the Hunters*
1579—Establishment of Dutch Republic

perspective—putting the apparent subject of the picture in the background of many of his images. He explored landscape, peasant life, and moral allegory in his paintings. Although his career was spent in Antwerp and Brussels, he may have been born near 's Hertogenbosch, the home of Hieronymus Bosch. Certainly Bosch's paintings impressed him deeply, and his work is similarly ambiguous. Bruegel's contemporaries admired his wit and his ability to mimic nature, though solid personal information about Bruegel is scarce.

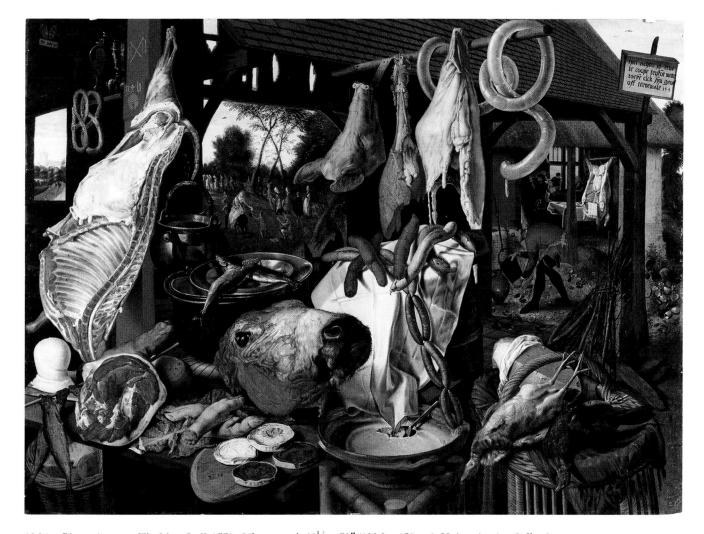

18.36. Pieter Aertsen. *The Meat Stall.* 1551. Oil on panel, 48$\frac{1}{2}$ × 59″ (123.3 × 150 cm). University Art Collections, Uppsala University, Sweden

Karel van Mander Writes About Pieter Bruegel the Elder

From *The Painter's Treatise (Het Schilder Boeck) 1604*

Van Mander's biography of Pieter Bruegel the Elder remains an important source of information about the artist, whose talent he appreciated fully.

On his journeys Bruegel did many views from nature so that it was said of him, when he traveled through the Alps, that he had swallowed all the mountains and rocks and spat them out again, after his return, on to his canvases and panels, so closely was he able to follow nature here and in her other works. . . .

He did a great deal of work [in Antwerp] for a merchant, Hans Franckert, a noble and upright man, who found pleasure in Breugel's company and met him every day. With this Franckert, Breugel often went out into the country to see peasants at their fairs and weddings. Disguised as peasants they brought gifts like the other guests, claiming relationship or kinship with the bride or groom. Here Breugel delighted in observing the droll behavior of the peasants, how they ate, drank, danced, capered, or made love, all of which he was well able to reproduce cleverly and pleasantly. . . . He represented the peasants—men and women of the Campine and elsewhere—naturally, as they really were, betraying their boorishness in the way they walked, danced, stood still, or moved.

. . .An art lover in Amsterdam, Sieur Herman Pilgrims, owns a *Peasant Wedding* painted in oils, which is most beautiful. The peasants' faces and the limbs, where they are bare are yellow and brown, sunburnt; their skins are ugly, different from those of town dwellers . . .

. . . Many of his compositions of comical subjects, strange and full of meaning, can be seen engraved; but he made many more works of this kind in careful and beautifully finished drawings to which he had added inscriptions. But as some of them were too biting and sharp, he had them burnt by his wife when he was on his deathbed, from remorse or fear that she might get into trouble and have to answer for them. . . .

SOURCE: *DUTCH AND FLEMISH PAINTERS* BY KAREL VAN MANDER. TR. CONSTANT VANDE WALL. (MANCHESTER, NH: AYER COMPANY PUBLISHERS, 1978)

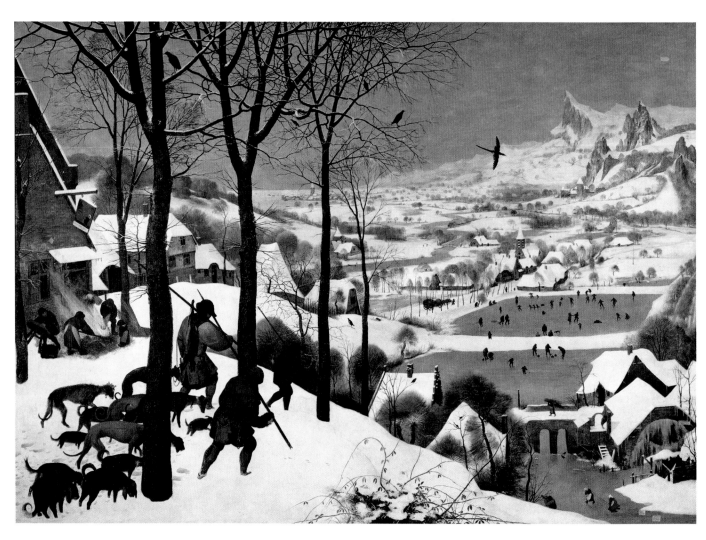

18.37. Pieter Bruegel the Elder. *The Return of the Hunters.* 1568. Oil on panel, $46\frac{1}{2} \times 63\frac{3}{4}''$ (117 × 162 cm). Kunsthistorisches Museum, Vienna

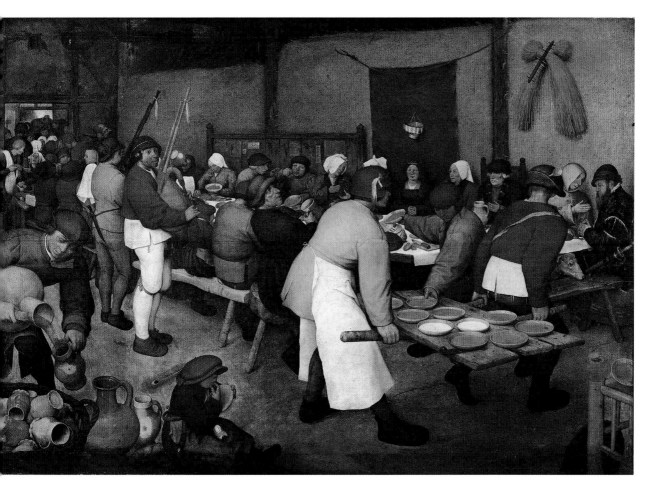

18.38. Pieter Bruegel the Elder. *Peasant Wedding*. ca. 1568. Oil on panel, 44⁷⁄₈ × 64″ (114 × 162.5 cm). Kunsthistorisches Museum, Vienna

Working as a painter and a designer of prints, he made pictures that demonstrate his interest in folk customs and the daily life of humble people. Bruegel himself was highly educated and the friend of humanists, who, with wealthy merchants, were his main clients. Urban elites collected images of the country and the people who worked the land. He also made images that many scholars have seen as political commentary about the Habsburg rule over the Southern Netherlands. Members of the Habsburg court also collected his work, but during the turbulent climate of the 1560s when Philip II of Spain attempted to quash the Protestant rebellion in the Netherlands, Bruegel became fearful that his politically barbed imagery might cause trouble for his family. (See *Primary Source*, page 654.)

Like his contemporaries who followed Dürer's example, Bruegel traveled to Italy in 1552–1553, visiting Rome, Naples, and the Strait of Messina. The famous monuments admired and sketched by other Northern European artists, however, seem not to have interested him. He returned instead with a sheaf of magnificent landscape drawings, especially Alpine views. Out of this experience came the sweeping landscapes of Bruegel's mature style. *The Return of the Hunters* (fig. **18.37**) is

one of a set of paintings depicting the months. (He often composed in series; those in this group were owned in 1566, a year after they were painted, by Niclaes Jonghelink, an Antwerp merchant.) Such scenes had their origin in medieval calendar illustrations, such as those in the *Tres Riches Heures* of Jean de Berry (see fig. 14.5). In Bruegel's work, however, Nature is more than a setting for human activities. It is the main subject of the picture.

Like Patinir, Bruegel provides in *The Return of the Hunters* a shelf of space in the foreground that moves precipitously into the distance toward a far horizon. In the snow covered landscape, human and canine members of a hunting party return to their village with their skimpy catch in the grey of a northern winter. They move down a hill toward a village, where the water has frozen and become a place of recreation and where people rush to get back indoors. Human activity is fully integrated into the natural landscape in Bruegel's image.

The *Peasant Wedding* (fig. **18.38**), dated around 1568, is one of Bruegel's memorable scenes of peasant life. His biographer, Karel van Mander, reported that Bruegel and his patron Hans Franckert often disguised themselves as peasants and joined in their revelries so Bruegel could observe and sketch them

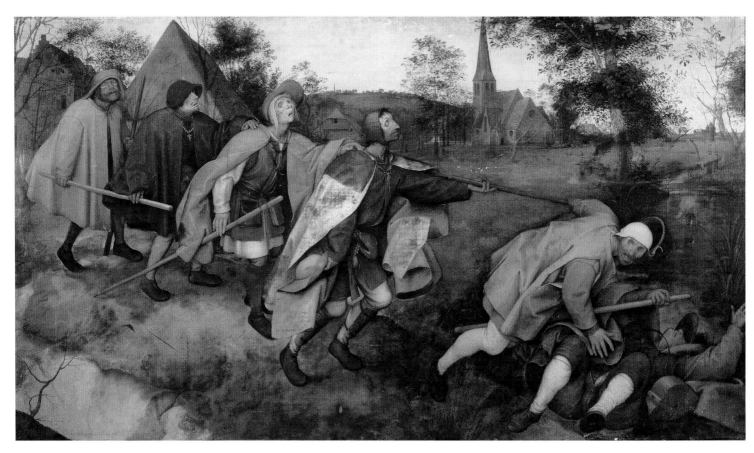

18.39. Pieter Bruegel the Elder. *The Blind Leading the Blind.* ca. 1568. Oil on panel, 34½ × 60⅝″ (85 × 154 cm). Museo e Gallerie di Capodimonte, Naples

(see *Primary Source*, page 654). In this painting Bruegel depicts a gathering of rustic folks in a barn that has been decorated for a wedding. He has totally mastered Italian perspective, so the viewer enters a capacious room dominated by the table at which the wedding guests are gathered. The bride sits before a green curtain to distinguish her, though it is more difficult to identify the groom. Food is being distributed in the foreground, while the many empty jugs in the lower left suggest that much liquid has already been consumed. Far from the varieties of meats and fish depicted in Aertsen's *The Meat Stall*, the food here is simple porridge. Bagpipers stand ready to play, but the noise level already seems high with so many figures talking amid the clattering of pottery. Bruegel's technique is as precise and detailed as many of his Flemish predecessors, and his figures have a weight and solidity that adds to the impression of reality.

Interpreting Bruegel's images of peasants has challenged art historians. Some scholars have seen Bruegel's peasant pictures as brutal caricatures of rural folk for the consumption of town dwellers; by this reading, urbane townsfolk could chuckle at the foibles of their country cousins. Still, Bruegel treats this country wedding as a serious event, and if Bruegel records the peasants' rough manners, he also records their fellowship. He treats the least of the least, like the child licking a bowl in the foreground, as worthy of observation and remembrance. For

Bruegel, the common man occupies an important place in the scheme of things.

Many of Bruegel's pictures offer ambivalent lessons, some of them based on the proverbial wisdom that permeates Netherlandish literature. One of his last pictures, *The Blind Leading the Blind* (fig. **18.39**), presents such a visual interpretation of verbal wisdom. Its source is the Gospels (Matthew 15:12–19). Jesus, speaking of the Pharisees, says, "And if the blind lead the blind, both shall fall into the ditch." This parable recurs in humanistic as well as popular literature, and it appears in at least one earlier work. However, the tragic depth of Bruegel's image gives urgency to the theme. Bruegel uses the detailed rendering of the Netherlandish tradition to record the infirmities and the poverty of the blind beggars who march across this village landscape. The pose of each figure along the downward diagonal is more unstable than the last, leaving little doubt that everyone will end up in the ditch with the leader. Above the gap between the two groups, Bruegel places a village church, suggesting to some critics that the blindness comes from the ecclesiastical establishment. But other readings are possible. Could the presence of the church refer to the men's spiritual blindness? Perhaps he found the meaning of the parable especially appropriate to his time, which was marked by religious and political fanaticism. The ambiguity of Bruegel's pictures has inspired critics and artists for centuries.

SUMMARY

Northern Europe in the sixteenth century had to absorb the breakdown of traditional certainties and the emergence of innovations from many quarters. The knowledge of the world was expanding through explorations and colonization of Asia and the Americas. The Catholic religious order was challenged and fractured. Political boundaries were being redrawn and nations being formed. Scientists and Humanists were developing new ideas about the universe and man's place in it. Older forms of wealth were giving way to capitalist economies. And visual artists felt the need to respond to the new visual language that was developing in Italy.

FRANCE: COURTLY TASTES FOR ITALIAN FORMS

French patrons and architects were particularly receptive to Italian influence. French courtly architecture, principally palaces, follow Italian ideas about composition and the use of ancient orders on the exterior of buildings, though the proportions of French structures tend to be more vertical than those in Italy. The presence of Italian Mannerists at the royal court of Fontainebleau established a courtly taste for slim, elegant nudes and antique subject matter.

SPAIN: GLOBAL POWER AND RELIGIOUS ORTHODOXY

Enriched by gold from the New World and the vast European holdings of its Habsburg rulers, Spain became a global power in the sixteenth century and maintained a fierce allegiance to Catholicism. Spanish patrons commissioned religious art that was strongly affected by Italian models or made by artists trained in Italy. Philip II's grand monastic complex at the Escorial shows the impact of sixteenth-century Italian ideas. The art of El Greco blends Mannerist compositional techniques with Venetian color to create visionary religious images.

CENTRAL EUROPE: THE REFORMATION AND ART

The Reformation profoundly affected the art of the German-speaking regions of Europe. The antipathy of some of the Protestant faiths to images resulted in iconoclasm and reductions in commissions to produce religious art. Where Catholicism still prevailed, artists made religious images that drew on the Northern European traditions of realism with the added influence of Italian art. Dürer is the preeminent German artist of the Renaissance, because of his powerful fusion of Northern European and Italian traditions, his commitment to the ideal of the artist as an intellectual, and his mastery in the popular medium of printmaking, which spread his influence all over Europe. Prints also assisted in the spread of Reformation ideas. In the absence of Church commissions, artists specialized in more secular subjects, such as landscapes, classical mythology, and portraits.

ENGLAND: REFORMATION AND POWER

Portraiture was the dominant art form in the England of Henry VIII and Elizabeth I, as the English Reformation also diminished the market for religious art. Artists from the Continent brought with them the styles of Germany, the Netherlands, France, and Italy. Holbein's portraits are informed by Northern European traditions and Italian art. Art in the Elizabethan era drew from Holbein's achievements, but added complex iconographies that flattered the queen. In architecture, the Elizabethan country house was conceived as a stage for royal visits.

THE NETHERLANDS: WORLD MARKETPLACE

The naturalism that distinguishes the art of the fifteenth-century Netherlands is the starting point for the styles of the sixteenth century. Again, the impact of the Reformation was important, resulting in iconoclasm and political division between the Northern and Southern Netherlands. While some artists in the Catholic Southern Netherlands continued to make religious art on commission, many artists chose to sell their work on the open market. New subjects, such as landscapes, still lifes, and genre scenes, became more prominent, as artists sought to appeal to a wide clientele. Humanist inspired themes could be expressed in styles informed by the Italian Renaissance, or, in the case of Bruegel, in a style deeply rooted in the local traditions of the Netherlands.

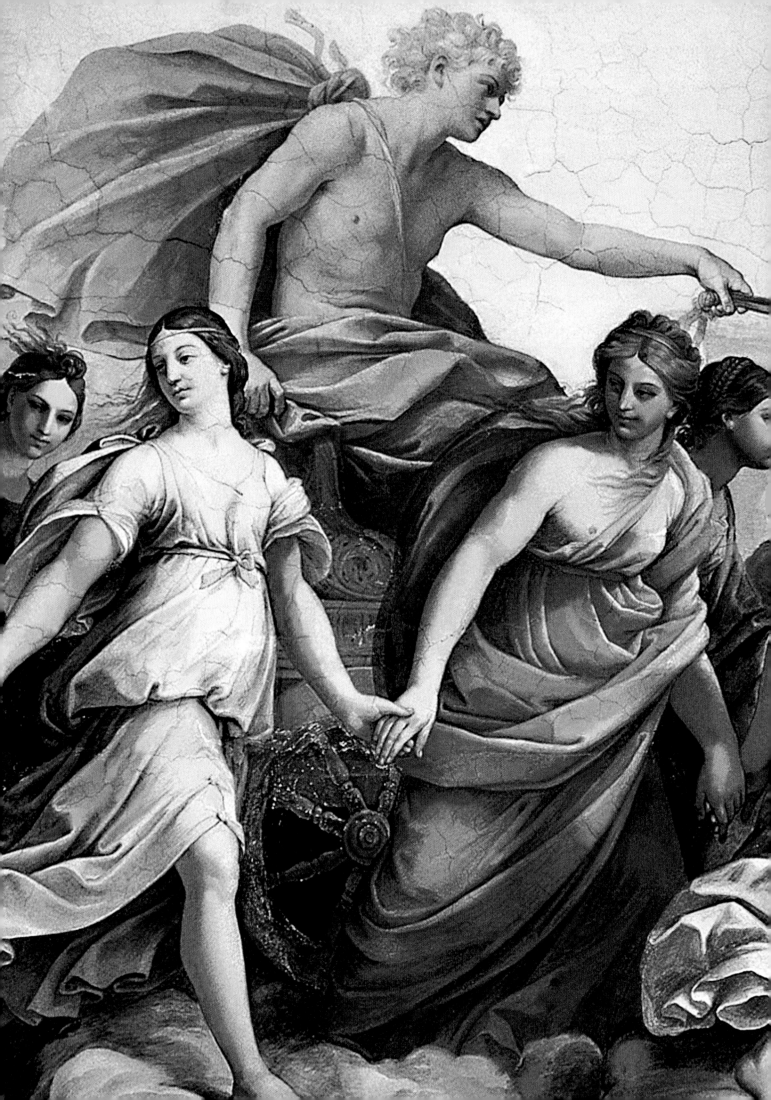

The Baroque in Italy and Spain

T HE TERM BAROQUE MAY COME FROM THE PORTUGUESE WORD *BARROCCO*, referring to an irregular pearl; it means contorted, even grotesque, and was intended as a disparaging description of the grand, turbulent, dynamic, overwhelming style of seventeenth-century art. Art historians remain divided over its definition. Should the term Baroque only be used for the

dominant style of the seventeenth century, or should it include other tendencies, such as classicism, to which it bears a complex relationship? Should the time frame also include the period 1700 to 1750, known as the *Rococo*? More important, is the Baroque distinct from both the Renaissance and the Modern eras? Although a good case can be made for viewing the Baroque as the final phase of the Renaissance, we shall treat it as a distinct era. It is the beginning of the Early Modern Period, as so many of the same concerns—issues of gender, class, and sexuality—are explored. The desire to evoke emotional states by appealing to the senses and to persuade, often in dramatic ways, underlies Baroque art. Some of the qualities that characterize the Baroque are grandeur, sensual richness, emotional exuberance, tension, movement, and the successful unification of the various arts.

The expansive, expressive quality of the Baroque paralleled the true expansion of European influence—geographical, political and religious—throughout the seventeenth century. The exploration of the New World that began in the sixteenth century, mobilized primarily by Spain, Portugal, and England (See map 19.1), developed in the seventeenth century into colonization, first of the eastern coasts of North and South America,

and then to Polynesia and Asia. The Dutch East India Company developed trade with the East and was headquartered in Indonesia. Jesuit missionaries traveled to Japan, China, and India, and settled in areas of North and South America. In style and spirit, the reach of the Baroque was global.

The Baroque has been called a style of persuasion, as the Catholic Church attempted to use art to speak to the faithful and to express the spirit of the Counter-Reformation. In the sixteenth century, the Church tried to halt the spread of Protestantism in Europe, but by the seventeenth century, the Church declared this effort a success and celebrated its triumph. Private influential families, some who would later claim a pope as a member, other private patrons, and ecclesiastical orders (Jesuits, Theatines, Carmelites, and Oratorians) each built new and often large churches in Rome in the seventeenth century. And the largest building program of the Renaissance—the rebuilding of St. Peter's—would finally come to an end, and with its elaborate decoration, profoundly reflect the new glory of the Church.

This remastering of the Church began a wave of canonizations that lasted through the mid-eighteenth century. The religious heroes of the Counter-Reformation—Ignatius of Loyola, Francis Xavier (both Jesuits), Theresa of Ávila, and Filippo Neri—were named saints. (Carlo Borromeo had already been made one in 1610.) In contrast to the piety and good deeds of these reformers, the new princes of the Church were vigorous

Detail of figure 19.9, Guido Reni, *Aurora*

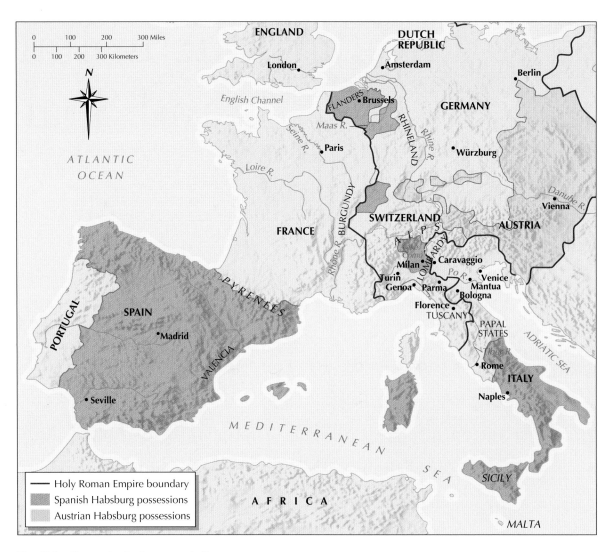

Map 19.1. Europe in the Seventeenth Century

patrons of the arts, both for the glory of the Church and for the posthumous fame of their own families.

During the first half of the the seventeenth century, Europe was torn by almost continual warfare, which involved almost every European nation in a complex web of shifting alliances. The Thirty Years' War (1618–1648) was fueled by the ambitions of the kings of France, who sought to dominate Europe, and the Habsburgs, who ruled not only Austria and Spain but also the Southern Netherlands, Bohemia, and Hungary. Although fought largely in Germany, the war eventually engulfed nearly all of Europe. After the Treaty of Westphalia in 1648 ended the war and formally granted their freedom, the United Provinces—or The Dutch Republic as the independent Netherlands was known—entered into a series of battles with England and France that lasted until 1679. Yet, other than in Germany, which was fragmented into over 300 little states, many in financial ruin, there is little correlation between these rivalries and the art of the period. In fact, the seventeenth century has been called the Golden Age of painting in France, Holland, Flanders, and Spain.

The Baroque has also been identified as "the style of absolutism," reflecting the centralized state ruled by an autocrat of unlimited powers. In the latter half of the seventeenth century, Baroque palaces were built on an increasingly monumental scale to display the power and grandeur of their owners. Architecture emphasized massiveness, dramatic spaces and lighting, rich interior decoration from floor to ceiling, and luxurious material; and it was meant as a reflection of political and economic power. Absolutism reached its climax during the reign of Louis XIV in the late seventeenth century, and is seen in his palace at Versailles, with its grandiose combination of architecture, painting, decoration, and extensive gardens. But we can also associate absolutism with the Vatican and the power of the pope and his claim of authority won and reestablished through the Counter-Reformation. The power of absolutism suggests a style that will overwhelm and inspire awe in the spectator. And that is the art—the painting, sculpture, and architecture—of the Baroque.

The new style was not specifically Italian, even though it was born in Rome during the final years of the sixteenth century.

Nor was it confined to religious art. Baroque elements of dramatic lighting and sweeping gestures entered the vocabulary of Northern European art. But the introduction of new subject matter—the still life, the genre scene, and the landscape—quickly entered the art world of the Protestant North through etchings and paintings. Still-life paintings and landscapes were informed by the scientific observation of Nature.

A recognition of the subtle relationship between Baroque art and science is essential to an understanding of the age. The complex metaphysics of the Humanists, which gave everything religious meaning, was replaced by a new physics. The change began with Nicholas Copernicus, Johannes Kepler, and Galileo Galilei, and culminated in René Descartes and Isaac Newton. Their cosmology brought scientific understanding to sensory perception. By placing the sun, not the Earth (and humanity), at the center of the universe, it contradicted what our eyes (and common sense) tell us: that the sun revolves around the Earth. Scientists now defined underlying relationships in mathematical and geometrical terms as part of a simple, orderly system of mechanics. Not only was the seventeenth century's worldview fundamentally different from the Renaissance's, but its understanding of visual reality was forever changed by the new science, thanks to advances in optical physics and physiology. Thus we may say that the scientists and artists of the Baroque literally saw with new eyes.

These scientists knew, or corresponded with, each other and with the artists of their time, and their views and discoveries were known to the larger intellectual and artistic community. Newton's mathematics were known to Sir Christopher Wren and were possibly used in his rebuilding both of London and St. Paul's Cathedral (see Chapter 21). Vermeer, who experimented with optical effects (see pages 728–729), would have known the developer of the microscope, Anthony van Leewenhoek, and the philosopher and scientist Descartes had his portrait painted by Frans Hals. Descartes postponed the publication of his own controversial work *The World* until after his death, as he had learned of Galileo's imprisonment and was also concerned for his own eternal soul, for he, too, was a Catholic. Galileo's scientific and religious adversaries were the Jesuits, who considered Galileo's views to be the antithesis of the Church's teachings. Opposing Galileo as well was Pope Urban VIII (Barberini), the same pope who envisioned a new Rome, and who was the most significant patron of Bernini. The ceiling paintings, filled with astronomical and astrological figures so prominent in the Baroque, were executed to convey the all-encompassing power of the patron, who by implication controlled even the very heavens above.

The rise of science also had the effect of displacing natural magic, a precursor of modern science that included both astrology and alchemy. Unlike the new science, natural magic tried to control the world through prediction and manipulation; it did so by uncovering nature's "secrets" instead of natural laws. Yet, because it was linked to religion and morality, natural magic lived on in popular literature and folklore well beyond the seventeenth century.

Folklore, literature, and plays became subject matter in the Baroque, usually depicted as a **genre scene**—a scene from everyday life—which became a popular theme in the seventeenth century. These genre paintings include scenes of people eating, playing board games, drinking, smoking, and playing musical instruments. But sometimes they illustrate proverbs, plays, and the senses. They are often moralizing; that is, they often warn against the very things they are depicting! Such paintings were already executed in the sixteenth century (see Bruegel, page 653), but they develop into a major force, along with landscape and still-life painting, in the seventeenth century in nearly every European country—in Italy, Spain, Flanders, The Dutch Republic, and France. Paintings of foods—plain and exotic—and landscapes of rural, urban, or far-off places were popular. There were also paintings of ordinary people often in domestic situations. All of this subject matter provides us with a gateway into the Baroque world. Turkish carpets, African elephants and lions, Brazilian parrots, Ming vases, and peoples from Africa, India, and South America can be found in seventeenth-century art. In part, this list represents "exotica"—but the exotic was a major part of the seventeenth century as people, many of them artists, traveled to faraway places.

In the end, Baroque art was not simply the result of religious, political, intellectual, or social developments: The strengthened Catholic faith, the absolutist state, the new science, and the beginnings of the modern world combined in a volatile mixture that gave the Baroque era its fascinating variety. What ultimately unites this complex era is a reevaluation of humanity and its relation to the universe. Philosophers gave greater prominence to human passion, which encompassed a wider range of emotions and social levels than ever before. The scientific revolution leading up to Newton's unified mechanics in physics responded to this same new view of humanity, which presumes a more active role for people through their ability to understand and affect the world around them. Remarkably, the Early Modern World remained an age of great religious faith, however divided people may have been in their loyalties. The interplay of passion, intellect, and spirituality may be seen as forming a dialogue that has never been truly resolved.

PAINTING IN ITALY

Around 1600, Rome became the fountainhead of the Baroque, as it had of the High Renaissance a century before, by attracting artists from other regions. The papacy and many of the new Church orders (Jesuits, Theatines, and Oratorians), as well as numerous private patrons from wealthy and influential families (Farnese, Barberini, and Pamphili) commissioned art on a large scale, with the aim of promoting themselves and making Rome the most beautiful city of the Christian world "for the greater glory of God and the Church." This campaign had begun as early as 1585 (indeed, we may even date this revitalization to the reign of Julius II), and by the opening of the seventeenth century, Rome attracted ambitious young artists, especially from northern Italy. It was they who created the new style.

Caravaggio and the New Style

Foremost among the young artists was a painter of genius, Michelangelo Merisi (1571—1610), called Caravaggio after his birthplace near Milan. After finishing his training under a minor Milanese painter, he came to Rome sometime before 1590 and worked as an assistant to various artists before setting out on his own. His style of painting, his new subjects, his use of lighting, and his concept of naturalism changed the world of painting. Caravaggio's style was the initial stamp of Baroque and caused a stir in the art world (see end of Part III *Additional Primary Sources*.) He had numerous followers and imitators, and critics, both Italian and Northern European, wrote of his work, so Caravaggio and his paintings became internationally known almost immediately.

Caravaggio's first important public commission was a series of three monumental canvases devoted to St. Matthew that he painted for the Contarelli Chapel in San Luigi dei Francesi from 1599 to 1602 (fig. **19.1**). The Church for the French Community (dei Francesi) in Rome, founded in 1518 by Cardinal Giulio de' Medici (later Pope Clement VII) and designed by Giacomo della Porta, was finished in 1589. The Chapel of St. Louis (Luigi) was endowed by the French Cardinal Mathieu Contrel (Contarelli) in 1565, but the decoration was not immediately completed. Caravaggio finally received the commission to complete the work years later through the intervention of his patron, Cardinal del Monte.

As decorations, the Contarelli paintings perform the same function that fresco cycles had in the Renaissance. Our view of the chapel includes two of the three paintings. In the chapel view we see *St. Matthew and the Angel*, in which the tax collector Matthew turns dramatically for inspiration to the angel who dictates the gospel. The main image on the left in the chapel illustrates *The Calling of St. Matthew* (fig. **19.2**). The third canvas is devoted to the saint's martyrdom. Caravaggio's style is remote from both mannerism and the High Renaissance. His naturalism is a new and radical kind. According to contemporary accounts, Caravaggio painted directly on the canvas, as had Titian, but he worked from a live model. He depicted the world he knew, so that his canvases are filled with ordinary people. They are not idealized as High Renaissance figures, nor given Classical bodies, clean clothes, and perfect features. But neither are they distorted, elogated, or overtly elegant as in Mannerism. This was an entirely new conception that was raw, immediate, and palpable.

For Caravaggio, naturalism was not an end in itself but a means of conveying profoundly spiritual content. *The Calling of St. Matthew* (fig. 19.2), shows these qualities. Never before have we seen a sacred subject depicted so entirely in terms of contemporary lowlife. Matthew, the well-dressed tax collector, sits with some armed men, who must be his agents, in a common, sparse room. The setting and costumes must have been very familiar to Caravaggio. Two figures approach from the right. The arrival's bare feet and simple biblical garb contrast strongly with the colorful costumes of Matthew and his companions.

Caravaggio's paintings have a quality of "lay Christianity" that spoke powerfully to both Catholics and Protestants. Stripped of its religious context, the men seated at the table would seem like figures in a genre scene. Indeed, Caravaggio's painting would become a source for similar secular scenes. Likewise, fanciful costumes, with slashed sleeves and feathered berets, will appear in the works of Caravaggio's followers. Figures seen in half-length (showing only the upper half of their bodies), will also be a common element in other works by Caravaggio and his followers (see fig. 20.15).

Why do we sense a religious quality in this scene and not mistake it for an everyday event? What identifies one of the figures on the right as Christ, who has come to Matthew and says "Follow me"? It is surely not his halo, the only supernatural feature in the picture, which is a thin gold band that we might easily overlook. Our eyes fasten instead on his commanding gesture, borrowed from Michelangelo's Adam in *The Creation of Adam* (see fig. 16.21), which bridges the gap between the two groups of people and is echoed by Matthew, who points questioningly at himself.

The men at the right at the table seem not to be engaged in the drama enfolding, while the ones at the left concentrate on

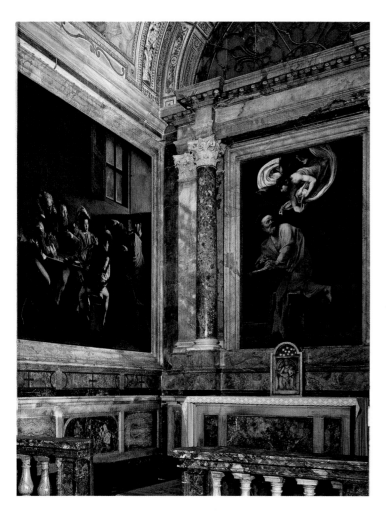

19.1. Contarelli Chapel, San Luigi dei Francesi, Rome

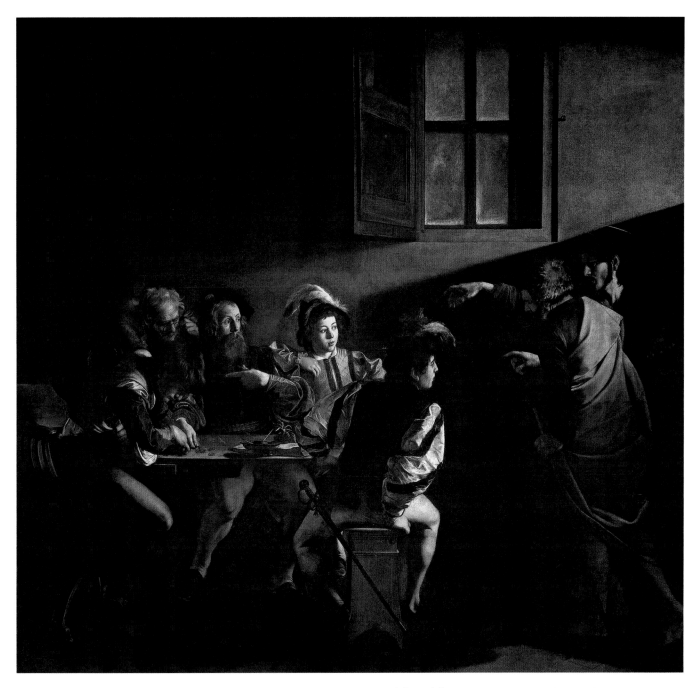

19.2. Caravaggio. *The Calling of St. Matthew.* ca. 1599–1600. Oil on canvas, 11′1″ × 11′5″ (3.4 × 3.5 m). Contarelli Chapel, San Luigi dei Francesi, Rome

the money being counted. In shadows, they are blind to the entrance of Christ—one even wears eyeglasses. Caravaggio uses the piercing light in this scene to announce Christ's presence, as Christ himself brought light: "I am the light of the world; he that followeth me shall not walk in darkness, but shall have the light of life." (John: 8:12.)

The beam of sunlight in the darkness above Jesus is most decisive in meaning and style. The dark painting is referred to as *tenebristic* (dark). This strong beam of light in the dark background is known as a tenebristic effect, or **tenebrism**. Caravaggio illuminates Christ's face and hand in the gloomy interior so

that we see the *moment* of his calling to Matthew and witness a critical piece of religious history and personal conversion. Without this light, so natural yet so charged with meaning, the picture would lose its power to make us aware of the divine presence. Caravaggio gives direct expression to an attitude shared by certain saints of the Counter-Reformation: that the mysteries of faith are revealed not by speculation but through an inner experience that is open to all people. What separates the Baroque from the early Counter-Reformation is the externalization of the mystic vision, which appears to us complete and without any signs of spiritual struggle.

This intense, extreme, and vivid tenebrism, the corner-stone of Caravaggio's style, can be seen to dramatic effect in his *The Conversion of St. Paul* (fig. **19.3**). He employed it to heighten the drama and to suggest divine light at the same time. The painting is one of a pair (the other is *The Crucifixion of St. Peter*) to the left and right of the rich, colorful altarpiece of *The Assumption of the Virgin* by Annibale Carracci, which Caravaggio would have seen before he executed this work.

In contrast to that altarpiece, Caravaggio uses muted tones and a nearly black background. He uses neither color nor line (indeed, there are no known drawings by him) to indicate his narrative. Rather, he uses light to spotlight, even shock a view-er. A fallen Saul (to become St. Paul at this conversion) lies foreshortened on his back, helpless, being struck by the light of God, which also reveals the flank and mane of his huge horse, which takes up most of the space. The intense raking

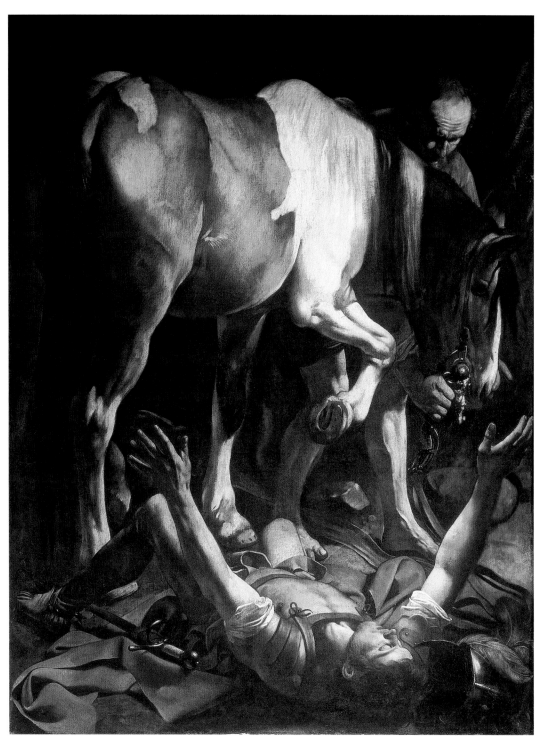

19.3. Caravaggio. *The Conversion of St. Paul.* ca. 1601. Oil on canvas, 7′6″ × 5′7″ (2.3 × 1.75 m). Cerasi Chapel, Santa Maria del Popolo, Rome

19.4. Caravaggio. *The Musicians.* ca. 1595.
Oil on canvas, 36¼ × 46⅝″ (92.1 × 118.4 cm).
The Metropolitan Museum of Art, New York.
Rogers Fund, 1952

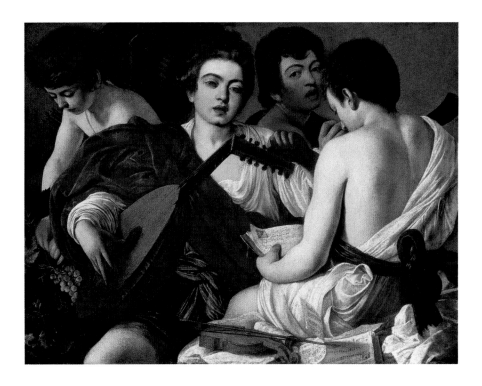

light from an unseen source at the left is used to model forms and create textures. The figures are nearly too big for the space. They overwhelm us as we imagine them larger and only partly revealed by the light. The selective highlighting endows the life-size figures with a startling presence and theatricality typical of the Baroque.

Another aspect of Caravaggio's work is his focus on the sensual and erotic nature of both music and young men, who are depicted as seducing and soliciting. We see these elements in *The Musicians* (fig. **19.4**), with the four androgynous, seminude youths. Actually, it may be two youths seen from two points of view. The musicians are half-length, but life-size; their blushed cheeks and full lips suggest erotic, sensual pleasures, enjoyed with each other and offered to a particular viewer. That viewer (the patron) was Cardinal del Monte, the influential patron who arranged the St. Matthew commission for Caravaggio and who commissioned other homoerotic paintings from Caravaggio. The lute, the violin, and the music sheets surrounding these half-draped men, and even the grapes being plucked on the side, suggest a contemporary bacchanal. The subject may be disturbing or unsettling, but this is part of the sensuality and passion—both physical and erotic—that will be explored in the Baroque and frequently imitated in later works of art.

An interest in pleasure, in the sensual and erotic, can be seen in Caravaggio's personality. Highly argumentative, Caravaggio carried a sword and was often in trouble with the law for fighting. When he killed a friend in a duel over a game, Caravaggio fled Rome and spent the rest of his short life on the run. He first went to Naples, then Malta, then returned briefly to Naples. He died on a journey back to Rome, where he had hoped to gain a pardon. In Italy, Caravaggio's work was praised by

artists and connoisseurs—and also criticized. Conservative critics regarded Caravaggio as lacking decorum: the propriety and reverence that religious subjects demanded. And many who did not like Caravaggio the man were influenced by his work and had to concede that his style was pervasive. The power of Caravaggio's style and imagery lasted into the 1630s, when it was absorbed into other Baroque tendencies.

Artemisia Gentileschi

Most men who were artists had fathers who were also artists, and this was true for most of the few women artists of the seventeenth century as well. Born in Rome, Artemisia Gentileschi (1593–ca. 1653) was the daughter of Caravaggio's friend and follower Orazio Gentileschi, and she became one of the major painters of her day. She took great pride in her work but found the way difficult for a woman artist. In a letter of 1649 (see *Primary Source*, page 667), she wrote that "people have cheated me" and that she had submitted a drawing to a patron only to have him commission "another painter to do the painting using my work. If I were a man, I can't imagine it would have turned out so . . ." Her characteristic subjects are heroines: Bathsheba, the tragic object of King David's passion, and Judith, who saved her people by beheading Holofernes. Both themes were popular during the Baroque era, which delighted in erotic and violent scenes. Artemisia's frequent depictions of these biblical heroines (she often showed herself in the lead role) suggest an ambivalence toward men that was rooted in her turbulent life. (Artemisia was raped by her teacher, Agostino Tassi (see fig. 19.10), who was acquitted in a jury trial but expelled from Rome.)

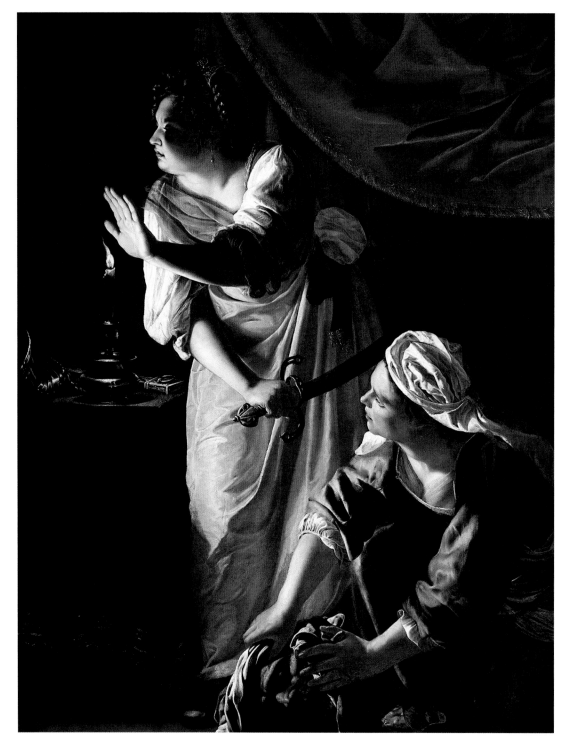

19.5. Artemisia Gentileschi. *Judith and Her Maidservant with the Head of Holofernes*. ca. 1625. Oil on Canvas, 6′1⁄2″ × 4′7″ (1.84 × 1.41 m). The Detroit Institute of Arts. Gift of Leslie H. Green

Artemisia's *Judith and Her Maidservant with the Head of Holofernes* (fig. **19.5**) is a fully mature, independent, dramatic, and large work, no less powerful for its restraint. The theme is the apocryphal story of the Jewish widow Judith, who saved her people by traveling with her maid to the tent of the Assyrian General Holofernes, got him drunk, and then cut off his head with his own sword; it yields parallels to the story of David and Goliath—might conquered by virtue and innocence.

However, with the theme of Judith slaying Holofernes, the victor was not always seen positively, but with some suspicion since her triumph was one of deceit: The unspoken promise of sexual activity was never realized. Rather than the beheading itself, the artist shows the instant after. Momentarily distracted, Judith gestures theatrically as her servant stuffs Holofernes's head into a sack. The object of their attention remains hidden from view, heightening the air of suspense and intrigue.

Artemisia Gentileschi (1593–ca. 1653)

From a letter to Don Antonio Ruffo

Artemisia Gentileschi's letter of November 13, 1649, to her patron reveals the relationship of the painter to her patron and issues of originality, of price, of working with models—and, throughout, the letter discloses her acute awareness and even contempt for those who treated her less fairly because she is a woman.

I have received a letter of October 26th, which I deeply appreciated, particularly noting how my master always concerns himself with favoring me, contrary to my merit. In it, you tell me about that gentleman who wishes to have some paintings by me, that he would like a Galatea and a Judgment of Paris, and that the Galatea should be different from the one that Your Most Illustrious Lordship owns. There was no need for you to urge me to do this, since by the grace of God and the Most Holy Virgin, they [clients] come to a woman with this kind of talent, that is, to vary the subjects in my painting; never has anyone found in my pictures any repetition of invention, not even of one hand.

As for the fact that this gentleman wishes to know the price before the work is done, . . . I do it most unwillingly. . . I never quote a price for my works until they are done. However, since Your Most Illustrious Lordship wants me to do this, I will do what you command. Tell this gentleman that I want five hundred ducats for both; he can show them to the whole world and, should he find anyone who does not think the paintings are worth two hundred scudi more, I won't ask him to pay me the agreed price. I assure Your Most Illustrious Lordship that these are paintings with nude figures requiring very expensive female models, which is a big headache. When I find good ones they fleece me, and at other times, one must suffer [their] pettiness with the patience of Job.

As for my doing a drawing and sending it, I have made a solemn vow never to send my drawings because people have cheated me. In particular, just today I found. . . that, having done a drawing of souls in Purgatory for the Bishop of St. Gata, he, in order to spend less, commissioned another painter to do the painting using my work. If I were a man, I can't imagine it would have turned out this way. . . .

I must caution Your Most Illustrious Lordship that when I ask a price, I don't follow the custom in Naples, where they ask thirty and then give it for four. I am Roman, and therefore I shall act always in the Roman manner.

SOURCE: GENTILESCHI'S LETTERS IN *THE VOICES OF WOMEN ARTISTS*, ED. THE WENDY SLATKIN (ENGLEWOOD CLIFFS, NJ: PRENTICE HALL, 1993)

The hushed, candlelit atmosphere—tenebrism made intimate—creates a mood of mystery that conveys Judith's complex emotions with unsurpassed understanding. Gentileschi's rich palette was to have a strong influence on painting in Naples, where she settled in 1630.

We know that for possibly a few years (ca. 1638–1640), Artemisia also worked in London where her father was court painter to Charles I of England from 1626 to 1639. Indeed several of her paintings were recorded in the king's inventory after his execution. Among them was her most daring and creative *Self-Portrait as the Allegory of Painting* (fig. **19.6**), one of the most innovative self-portraits of the Baroque period.

Artemisia was able to execute here what no male artist could: She depicted herself as the female allegorical figure of Painting, *La Pittura*. The dress and activity of the subject conforms to Cesare Ripa's description of *La Pittura* in his popular *Iconologia* (1593), a book of allegories and symbolic emblems for artists. There, the allegorical figure of Painting is described, in part, as a beautiful woman, with disheveled black hair, wearing a gold chain which hangs from her neck, and holding a brush in one hand and a palette in the other. Thus, the painting asserts Artemisia's unique role as a woman painter—representing not just herself, but all of Painting and reflecting the new, elevated status of artists.

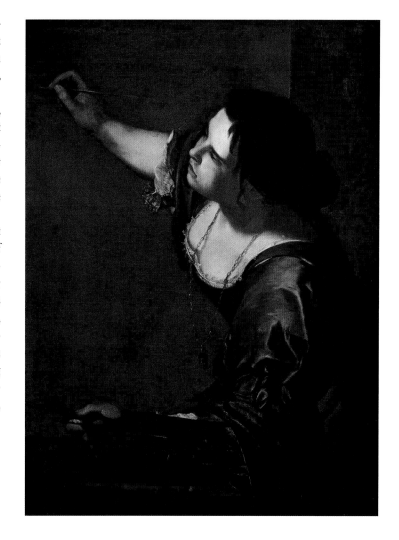

19.6. Artemisia Gentileschi. *Self-Portrait as the Allegory of Painting (La Pittura)*. ca. 1638–1639. Oil on canvas, 38⅞ × 29⅝″ (98.6 × 75.2 cm). The Royal Collection, © 2005 Her Majesty Queen Elizabeth II

19.7. Annibale Carracci. *Loves of the Gods*. 1597–1601. Ceiling fresco. Gallery, Palazzo Farnese, Rome

Ceiling Painting and Annibale Carracci

The conservative tastes of many Italian patrons were met by artists who were less radical than Caravaggio, and who continued a more Classical tradition steeped in High Renaissance ideals. They took their lead instead from Annibale Carracci (1560–1609), who arrived in Rome in 1595. Annibale came from Bologna where, in the 1580s, he and two other members of his family formed an "Academy" (also see Vasari, page 595,

and Goltzius, page 711) and evolved an anti-Mannerist style based on northern Italian realism and Venetian art. He was a reformer rather than a revolutionary. Athough we do not know completely what this "Academy" entailed, it seems to have incorporated life-drawing from models and drawing after ancient sculpture. As with Caravaggio, who admired Annibale, his experience of Roman classicism transformed his art. He, too, felt that painting must return to Nature, not unlike the

theory underlying Caravaggio's work, but his approach emphasized a revival of the classics, which to him meant the art of antiquity. Annibale also sought to emulate Raphael, Michelangelo, Titian, and Correggio. In his best work, he was able to fuse these diverse elements.

Between 1597 and 1601 Annibale produced a ceiling fresco, *Loves of the Gods*, in the gallery of the Farnese Palace (fig. **19.7**), his most ambitious work, which soon became so famous that it ranked behind only the murals of Michelangelo and Raphael. Although we have seen ceiling painting in the Renaissance—from the fifteenth through the sixteenth centuries, with works by Mantegna, Correggio, and of course Michelangelo, whose painting of the ceiling of the Sistine Chapel would become the work against which all others would be judged—it is the Baroque period which is most associated with this form of painting.

Executed in chapels, churches, and private residences—in entranceways, hallways, and dining rooms—ceiling painting was meant to convey the power, domination, or even extravagance of the patron. One could not enter such a painted room without an element of awe. The styles from the beginning of the seventeenth century to the end become increasingly extravagant and contest even the majesty of Michelangelo. The Farnese Palace ceiling, commissioned to celebrate a family wedding, wears its humanist subject, the Loves of the Classical Gods, lightly. As on the Sistine Chapel ceiling, the narrative scenes are surrounded by painted architecture, simulated sculpture, and nude youths, which are carefully foreshortened and lit from below so that they appear real. But the fresco does not rely

solely on Michelangelo's masterpiece. The main panels are presented as easel pictures, a solution adopted from Raphael. The "framed" painting, "medallions," and "sculpture" on the ceiling in *trompe l'oeil*, is known as *quadri riportati*, pictures transported to the ceiling (singular is *quadro riportato*) without account for our point of view. (When the viewpoint of the spectator is considered, then the artist is using "*di sotto in su*"—literally, "from below to above," as in the works of Mantegna fig. 15.53 and Correggio, fig. 17.25.) This ceiling reflects the collection of the Farnese that was actually in that room. The figure of Polyphemus, seen on the short wall, hurling the stone in the "easel painting" is based on the "Farnese Hercules," a Hellenistic sculpture owned by the family and displayed in the courtyard. The ceiling is held together by an illusionistic scheme that reflects Annibale's knowledge of Correggio (see fig. 17.25) and Veronese (see fig. 17.33). Each of these levels of reality is handled with consummate skill, and the entire ceiling has an exuberance that sets it apart from both Mannerism and High Renaissance art.

The sculptured precision of the Farnese Gallery shows us only one side of Annibale Carracci's style. Another important aspect is seen in his landscapes, such as the *Landscape with the Flight into Egypt* (fig. **19.8**). Its pastoral mood and the soft light and atmosphere hark back to Giorgione and Titian (see figs. 16.30 and 16.31). The figures, however, play a minor role here. They are as small and incidental as those in any Northern European landscape (compare with fig. 18.35). The landscape only hints at the suggestion of a Flight into Egypt (there are some camels on the hillside). The landscape would be

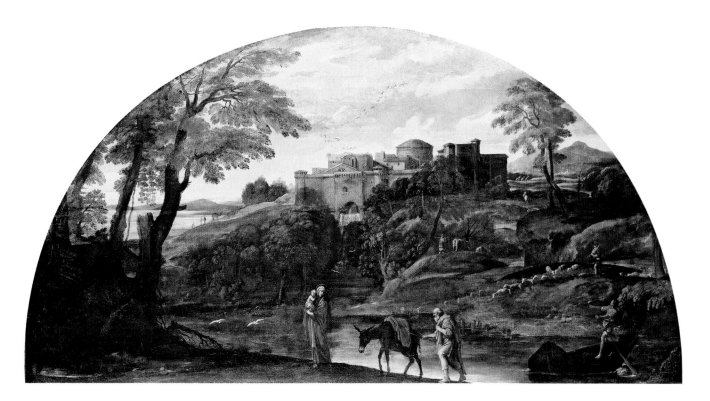

19.8. Annibale Carracci. *Landscape with the Flight into Egypt.* ca. 1603. Oil on canvas, 4′1¼″ × 8′2½″ (1.22 × 2.50 m). Galleria Doria Pamphili, Rome

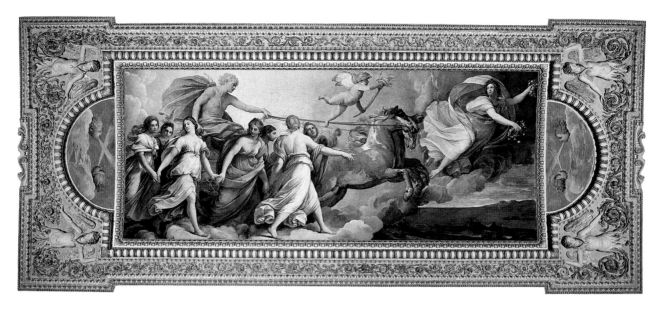

19.9. Guido Reni. *Aurora*. 1613. Ceiling fresco. Casino dell'Aurora, Palazzo Rospigliosi-Pallavinci, Rome

equally suitable for almost any story. The old castle, the roads and fields, the flock of sheep, the ferryman with his boat, all show that this "civilized," hospitable countryside has been inhabited for a long time. Hence the figures, however tiny, do not appear lost or dwarfed. Their presence is implied by the orderly, domesticated quality of the setting. This firmly constructed "ideal landscape" evokes a vision of Nature that is gentle yet austere, grand but not awesome.

GUIDO RENI AND GUERCINO Baroque ceilings, which began with the Annibale Carracci's illusionistic ceiling of the Farnese Palace, continued in Rome with Annibale's Bolognese followers Guido Reni (1575–1642) and Giovanni Francesco Barbieri (1591–1666), called Guercino, who were inspired by him. Guercino exercised leadership of the Bolognese School of painting, but both he and Reni worked in Rome and executed ceilings in the second and third decades of the seventeenth century.

The Farnese Gallery seemed to offer two alternatives to them and others inspired by it. Using the Raphaelesque style of the mythological panels, they could arrive at a deliberate "official" classicism; or they could take their cue from the illusionism of the framework. The approach varied according to personal style and the specific site. Among the earliest examples of the first alternative is Reni's *quadro riportato* ceiling fresco *Aurora* (fig. **19.9**), which shows Apollo in his chariot (the Sun) led by Aurora (Dawn). Here grace becomes the pursuit of perfect beauty. The relieflike design with glowing colors and dramatic light gives the painting an emotional force that the figures alone could never achieve. This style is called Baroque Classicism to distinguish it from all earlier forms of Classicism, no matter how much it may be indebted to them.

The *Aurora* ceiling (fig. **19.10**), painted less than ten years later by Guercino, is the very opposite of Reni's. Here architec-

tural illusionistic framework (painted by Agostino Tassi), known as *quadratura*, combined with the pictorial illusionism of Correggio (see fig. 17.25), and the intense light and color of Titian, converts the entire surface into one limitless space, in which the figures sweep past as if driven by the winds. Rather than viewing Aurora in profile as in Reni's, we are clearly below, looking up, seeing even the underbelly of the horses as they gallop over our heads. With this work, Guercino continued and expanded the tradition descended from Correggio and started what became a flood of similar visions characteristic of the dynamic fulfillment of this style, the High Baroque, after 1630.

PIETRO DA CORTONA AND THE BARBERINI CEILING The most overpowering of these illusionistic ceilings is the fresco by Pietro da Cortona (1596–1669) in the great hall of the Barberini Palace in Rome (fig. **19.11**). This enormous painting combines all three illusionistic systems—*quadratura* in its painted architectural framework, *quadri riportati* in the scenes on the sides and *di sotto in su* in setting our point of view to fully understand the ceiling. This work, a complex allegory, glorifies the reign of the Barberini pope, Urban VIII. The allegorical female figure of *Divine Providence*, its central theme, dominates the ceiling, proclaiming that the pope was chosen by her and not by political favor. Indeed, a swarm of bees (part of the Barberini coat of arms featured prominently in the ceiling) was said to have descended on the Vatican just prior to his election. Urban VIII was the first pope elected by the new secret ballot system in the College of Cardinals. Allegorical figures emphasize the pope's divine position: The Barberini bees are surrounded by the Theological Virtues: Faith, Hope, and Charity, while the papal tiara is carried by Rome and the Keys of St. Peter by Religion. As in the Farnese Gallery, the ceiling area is subdivided by a painted framework that simulates architecture and

sculpture, but beyond it we now see the limitless sky, as in Guercino's *Aurora*. Clusters of figures, perched on clouds or soaring freely, swirl above as well as below this framework. They create a dual illusion: Some figures appear to hover inside the hall, close to us, while others recede into the distance.

Cortona's frescoes were the focal point for the rift between the High Baroque, the exaggerated, triumphal style of the age, and the Baroque Classicism that grew out of the Farnese Gallery ceiling. The Classicists insisted that art serves a moral purpose and must observe the principles of clarity, unity, and decorum. And, supported by a tradition based on Horace's adage *ut pictura poesis*, they maintained that painting should follow the example of tragic poetry in conveying meaning through a minimum of figures whose movements, gestures, and expressions can be easily read. Cortona, while not anti-Classical, presented the case for art as epic poetry, with many actors and episodes that expand on the central theme and create a magnificent effect. He was also the first to argue that art has a

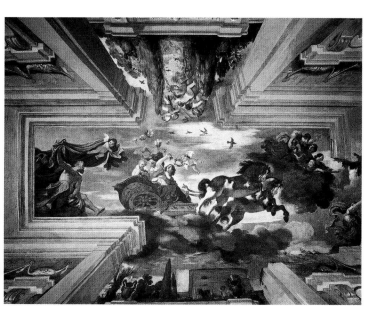

19.10. Guercino and Agostino Tassi. *Aurora*. 1621–1623. Ceiling fresco. Villa Ludovisi, Rome

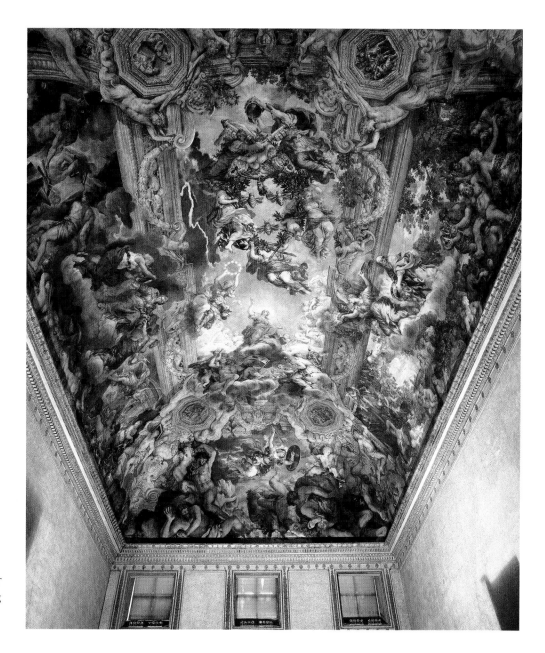

19.11. Pietro da Cortona. *Allegory of Divine Providence*. 1633–1639. Ceiling fresco from intended viewpoint. Palazzo Barberini, Rome

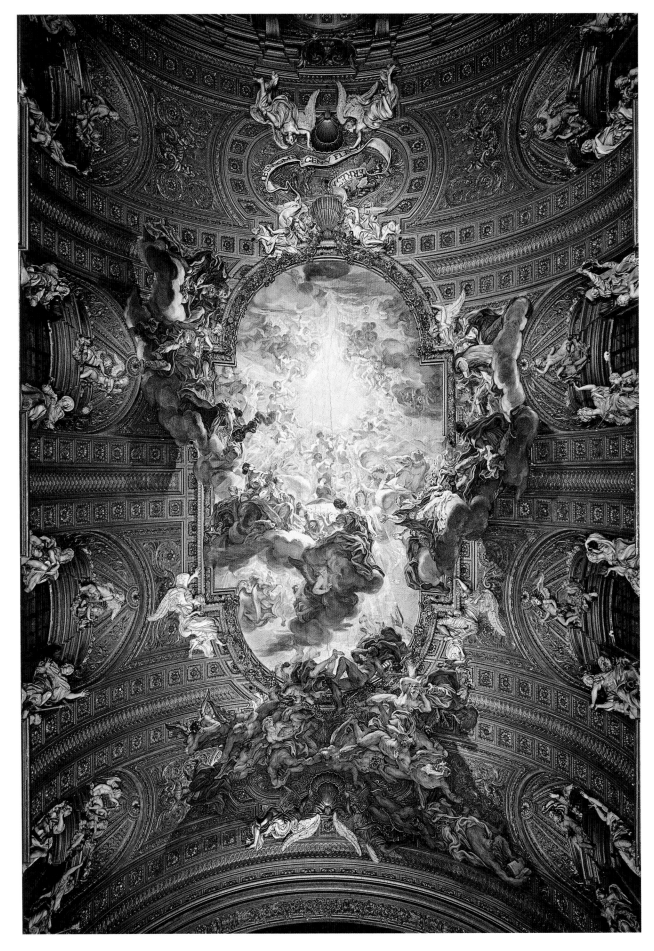

19.12. Giovanni Battista Gaulli. *Triumph of the Name of Jesus*. 1672–1679. Ceiling fresco. Il Gesù, Rome

sensuous appeal which exists as an end in itself. Although it took place largely on a theoretical level, the debate over illusionistic ceiling painting involved more than opposing approaches to telling a story and expressing ideas in art. The issue lies at the very heart of the Baroque. Illusionism allowed artists to overcome the apparent contradictions of the era by fusing separate levels of reality into a pictorial unity of such overwhelming grandeur as to sweep aside any differences between them. Despite the intensity of the debate, in practice the two sides rarely came into conflict over easel paintings, where the differences between Cortona's and Carracci's followers were not always so clear-cut. Surprisingly, Cortona found inspiration in Classical art and Raphael throughout his career. The leader of the reaction against the "excesses" of the High Baroque was neither a fresco painter nor an Italian, but a French artist living in Rome: Nicolas Poussin (see page 737), who moved early on in the same antiquarian circle as Cortona but drew very different lessons from it.

GIOVANNI BATTISTA GAULLI AND IL GESÙ It is a strange fact that few ceiling frescoes were painted after Cortona finished his *Divine Providence*. Ironically, the new style of architecture fostered by Francesco Borromini and Guarino Guarini (see pages 676–682) provided few opportunities for decoration. But after 1670 such frescoes enjoyed a revival in older buildings, and this revival reached its peak in the interior of Il Gesù (fig. **19.12**), the Mother Church for the Jesuit Order. Although his role in this case was only advisory, it is clear that Gianlorenzo Bernini, the greatest sculptor-architect of the century (see page 674) must have planned this work. At his suggestion, the commission for the ceiling frescoes went to his young protégé Giovanni Battista Gaulli (1639–1709), known as Il Baciccio. A talented assistant, Antonio Raggi (1624–1686), made the stucco sculpture. The program, which proved extraordinarily influential, shows Bernini's imaginative daring. As in the Cornaro Chapel (see fig. 19.31), the ceiling is treated as a single unit that evokes a mystical vision. The nave fresco, with its contrasts of light and dark, spills dramatically over its frame, then turns into sculptured figures, combining painting, sculpture, and architecture. Here Baroque illusionism achieves its ultimate expression. The subject of the ceiling painting is the illuminated name of Jesus—the IHS—in the center of the golden light. It is a stirring reference both to the Jesuit Order, dedicated to the Name of Jesus and to the concept that Christ is the Light of the World. The impact of his light and holiness then creates the overflowing turbulence that tumbles out of the sky at the end of days and spreads the word of the Jesuit missionaries: "That at the name of Jesus, every knee should bow . . ." (Epistle of St. Paul to the Philippians, 2:10).

ARCHITECTURE IN ITALY

The Baroque style in architecture, like that of painting, began in Rome, which was a vast construction site from the end of the sixteenth through the middle of the seventheenth century.

ART IN TIME

1597—Carracci's *Loves of the Gods*
1599–1600—Caravaggio's *The Calling of St. Matthew*
1609—Galileo Galilei refines astronomical telescope

The goals of the Counter-Reformation caused the Church to embark on a major building campaign. New churches were constructed and the new St. Peter's was finally completed. Although many of the building projects began during Renaissance, they developed distinctly different characteristics as they were completed during the Baroque. Some architects continued to use a Classical vocabulary but expanded or stretched it, so that the idea of perfection was not considered a circle, but an oval or ellipse (a modern concept that was frequently the object of astonomical discussions). They incorporated domes based on Michelangelo's (fig. 17.17) but which had a steeper profile to suggest greater drama in punctuating the sky; others designed buildings based on amorphic shapes that used Classical ornamentations but not its principles.

The Completion of St. Peter's and Carlo Maderno

Carlo Maderno (ca. 1556–1629) was the most talented young architect to emerge in the vast ecclesiastical building program that commenced in Rome toward the end of the sixteenth century. In 1603, he was given the task of completing, at long last, the church of St. Peter's (fig. **19.13**). Pope Clement VIII had decided to add a nave and narthex to the west end of Michelangelo's building, thereby converting it into a basilica plan. The change of plan, which had already been proposed by Raphael in 1514, made it possible to link St. Peter's with the Vatican Palace to the right of the church (fig. **19.14**).

Maderno's design for the facade follows the pattern established by Michelangelo for the exterior of the church. It consists of a colossal order supporting an attic, but with a dramatic emphasis on the portals. The effect can only be described as a crescendo that builds from the corners toward the center. The spacing of the supports becomes closer, the pilasters turn into columns, and the facade wall projects step by step. This quickened rhythm had been hinted at a generation earlier in Giacomo della Porta's facade of Il Gesù (see fig. 17.21). Maderno made it the dominant principle of his facade designs, not only for St. Peter's but for smaller churches as well. In the process, he replaced the traditional concept of the church facade as one continuous wall surface, which was not yet challenged by the facade of Il Gesù, with the "facade-in-depth," dynamically related to the open space before it. The possibilities of this new treatment, which derives from Michelangelo's Palazzo dei Conservatori (fig. 17.16), were not to be exhausted until 150 years later. Recent cleaning of the facade of St. Peter's revealed it to be of a warm cream color, which emphasized its sculptural qualities.

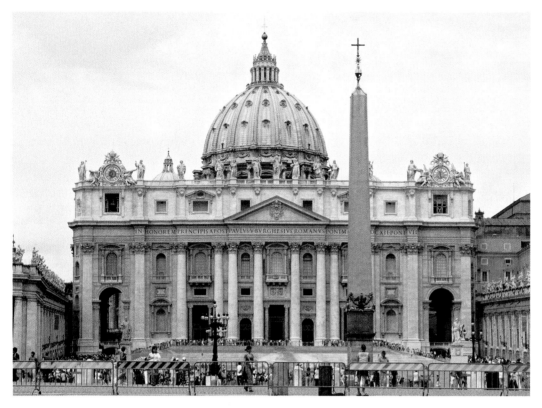

19.13. Carlo Maderno. Facade of St. Peter's. Rome. 1607–1612

Bernini and St. Peter's

After Maderno's death in 1629, his assistant Gianlorenzo Bernini (1598–1680) assumed the title "architect of St. Peter's." Considering himself Michelangelo's successor as both architect and sculptor, Bernini's directed the building campaign and coordinated the decoration and sculpture within the church as well. Given these tasks, the enormous size of St. Peter's posed equal challenges for anyone seeking to integrate architecture and sculpture. How could its vastness be related to the human scale and given a measure of emotional warmth? Once the nave was extended following Maderno's design, Bernini realized that the interior needed an internal focal point in this vast space. His response was to create the monumental sculptural/architectural composite form, known as the *Baldacchino* (fig. **19.15**), the

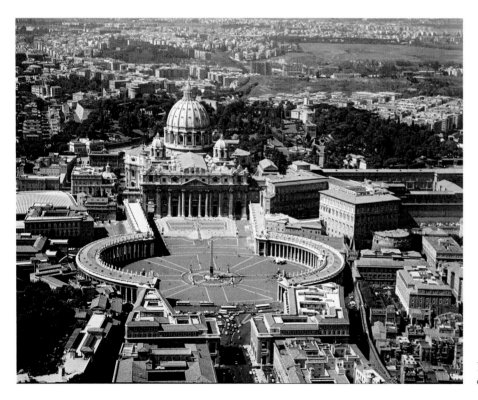

19.14. Aerial view of St. Peter's. Rome.
Nave and facade by Carlo Maderno, 1607–1612;
colonnade by Gianlorenzo Bernini, designed 1657

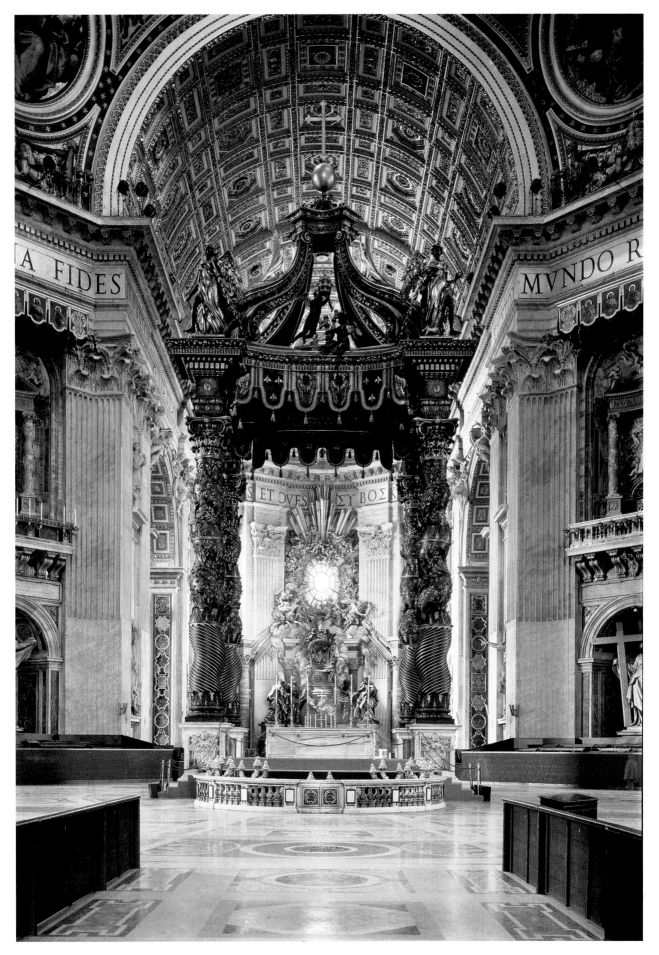

19.15. Bernini, *Baldacchino*. 1624–1633. At crossing. St. Peter's, Rome

"canopy" for the main altar of St. Peter's, at the very crossing of the transept and the nave, directly under Michelangelo's dome (see fig. 17.17) and just above the actual crypt of St. Peter where the Pope would celebrate the mass. This nearly 100-foot sculptural/architectural piece created mostly in bronze stripped from the ancient Pantheon (see fig. 7.39, stands on four twisted) columns, reminiscent of those from the original St. Peter's (and thought, too, to replicate those of Solomon's Temple). Rather than an architectural entablature mounted between the columns, Bernini inventively suggests fabric hanging between them. The *Baldacchino* is a splendid fusion of sculpture and architecture. At its corners are statues of angels and vigorously curved scrolls, which raise a cross above a golden orb, the symbol of the triumph of Christianity throughout the world. The entire structure is so alive with expressive energy that it may be considered as the epitome of Baroque style. In a related tribute, we see through the columns of the *Baldacchino* to the sculptural reliquary of the throne of St. Peter, the *Cathedra Petri* in the apse of the church, also designed by Bernini.

The papal insignia—the triple crown and crossed keys of St. Peter—and the coat of arms of the pope under whose patronage this structure was created—the Barberini bees of Urban VIII—are significant elements of decoration in the *Baldacchino*. These same identifiers can also be seen in Cortona's Barberini ceiling (see fig. 19.11). Bernini's *Baldacchino* honors not just the power and majesty of God, but that of his emissary on Earth, the pope. Bernini's relationship with the pope was one of the most successful and powerful ones in the history of patronage. Indeed, upon elevation to the papacy, Urban VIII was said to have told the artist: "It is your great good luck, Cavaliere, to see Maffeo Barberini pope; but We are even luckier in that Cavaliere Bernini lives at the time of our pontificate." (However, the artistic aims of this pope drained the papal treasury and both the pope and, by association, Bernini were blamed for the excesses after Urban's death.) As Bernini directed our attention within the church, he also (later, under the patronage of Pope Alexander VII (1655–1667) orchestrated our entrance into St. Peter's. Thus he molded the open space in front of the facade into a magnificent oval piazza that is amazingly sculptural (see fig. 19.14). This "forecourt," which imposed a degree of unity on the sprawling Vatican complex, acts as an immense atrium framed by colonnades, while screening off the surrounding slums. This device, which Bernini himself likened to the motherly, all-embracing arms of the Church, is not new. It had been used at private villas designed by Jacopo Vignola for the Farnese in the 1550s; but these were, in effect, *belvederes* opening onto formal gardens to the rear. What is novel is the idea of placing it at the main entrance to a building. Also new is the huge scale. For sheer impressiveness, this integration of architecture and grandiose setting can be compared only with the ancient Roman sanctuary at Palestrina (see fig. 7.6). Bernini's one major failure in the visual effect of St. Peter's was his inability to execute the bell towers that were initially planned by Bramante (see fig. 16.10). He began construction, but they were found to be structurally unsound and physically damaging to the facade; they had to be dismantled. This failure would haunt him, but would provide a competitive resource for his rival Borromini in Italy and later Wren in England.

Architectural Components in Decoration

The huge scale, the dynamic sculptural vitality, and the ornamentation of Baroque architecture were expressed in the decorative arts as well. The five foot high clock seen in figure **19.16** is made of colorful marble, lapis lazuli, black ebony, and gilt bronze with an oil on copper painting.

Clocks in the seventeenth century were not yet accurate, certainly not silent, and not readible at night. This clock was known as an *orologio della notte* (nocturnal clock)—a clock that would work even at night, an innovation that was designed by Pier Tommaso Campani (active ca. 1650–1700). A nocturnal clock had been seen by Bernini in France in 1665 and was considered a true marvel. This clock was made for Pope Alexander VII, a known insomniac, who requested a clock that could display time even in darkness and run without sound. The time here is expressed in Roman numerals, pierced so that light from a hidden oil lamp could pass through them; a drum was used to quash the ticktocking sound of a pendulum.

The clock was encased in an elaborate architectural structure with paired columns, scrolled feet, and resembles a tabernacle. It shows the influence of both Bernini and Borromini. The painting at its center, by Francesco Trevisani (1656–1746), is the *Flight into Egypt*. This theme is a pun on time—as time also flees (flies). Trevisani was a well-known Roman painter, and this was no small commission. Indeed, we know that Gaulli, the painter of the ceiling of Il Gesù (fig. 19.12), also executed paintings for such clocks.

A Baroque Alternative: Francesco Borromini

As a personality, Bernini represents a type we first met among the artists of the Early Renaissance, a self-assured person of the world. His greatest rival in architecture, Francesco Borromini (1599–1667), was just the opposite: a secretive and emotionally unstable genius who died by suicide. The Baroque heightened the tension between the two types. The contrast between these two would be evident from their works alone, even without the accounts by their contemporaries. Both represent the climax of Baroque architecture in Rome. Yet Bernini's church designs are dramatically simple and unified, while Borromini's structures are extravagantly complex. And whereas the surfaces of Bernini's interiors are extremely rich, Borromini's are surprisingly plain. They rely on Borromini's phenomenal grasp of spatial

19.16. Pier Tommaso Campani and Francesco Trevisani. *Nocturnal Clock*. ca. 1680–1690. Ebony and other types of hardwood, oil on copper, gilt bronze, colored stones, $63 \times 45^{1}/_{4} \times 18^{1}/_{2}''$ ($160 \times 115 \times 47$ cm). Pinacoteca Capitolini, Rome

geometry to achieve their spiritual effects. Bernini himself agreed with those who denounced Borromini for flagrantly disregarding the Classical tradition, enshrined in Renaissance theory and practice, that architecture must reflect the proportions of the human body. Surely, of the two, Bernini, even at the height of the Baroque, was the one more tied to a Classical vocabulary. But perhaps Bernini's criticism of Borromini only represented all-too-human rivalries.

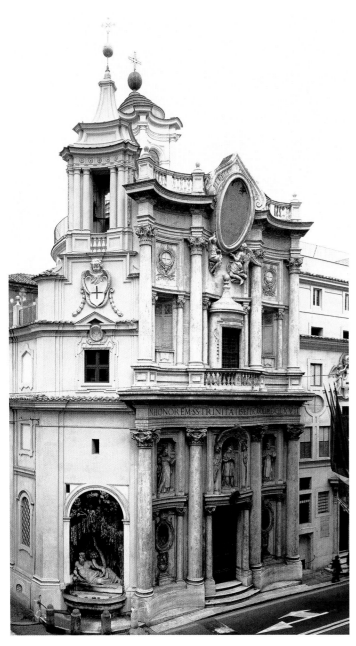

SAN CARLO ALLE QUATTRO FONTANE Borromini's first major project was the church of San Carlo alle Quattro Fontane (figs. **19.17**, **19.18**, and **19.19**), a small structure on a difficult-to-fit corner, yet it is the syntax, not the vocabulary, that is new and disquieting. The ceaseless play of concave and convex surfaces makes the entire structure seem elastic, as if pulled out of shape by pressures that no previous building could have withstood. The plan (fig. 19.18) is a pinched oval that suggests a distended and half-melted Greek cross. The inside of the coffered dome (fig. 19.19), like the plan, looks "stretched": If the tension were relaxed, it would snap back to normal. Light coming from the windows, partially hidden at the base of the dome, and a honeycomb of fanciful coffers make the dome appear weightless. The symbol of the Trinity appears in the vault of the lantern in this church, built for the Trinitarians, an order dedicated to the mysteries of the Holy Trinity.

On the facade (fig. 19.17), designed almost 30 years later, the pressures and counterpressures reach their maximum intensity. Borromini merges architecture and sculpture in a way that must have shocked Bernini. No such union had been attempted since Gothic art. The statues above the entrance appear to emerge like actors entering a stage from behind a thin screen. The sculptures, interestingly enough, are by Bernini's assistant Antonio Raggi, who also worked on the ceiling of Il Gesù (fig. 19.12). San Carlo alle Quattro Fontane established the architect's fame. "Nothing similar," wrote the head of the religious order for which the church was built, "can be found anywhere in the world. This is attested by the foreigners who . . . try to procure copies of the plan. We have been asked for them by Germans, Flemings, Frenchmen, Italians, Spaniards, and even Indians."

SANT' IVO Borromini's church of Sant'Ivo alla Sapienza (figs. **19.20** and **19.21**) was built at the end of an existing cloister for a university, which soon became the University of Rome. It is more compact than San Carlo, but equally daring. Sant'Ivo is a small, central-plan church based on a star-hexagon. The six-pointed star plan represents Sapienza (wisdom), although as the church was first built under Pope Urban VIII (Barberini) it was suggested by contemporaries that the plan represented the Barberini bee, also seen in Bernini's *Baldacchino* and Cortona's ceiling (figs. 19.15 and 19.11). In designing this unique church, Borromini may have been thinking of octagonal structures, such as San Vitale in Ravenna (fig. 8.21), but the result is completely novel. Inside, it is a single, unified, organic experience, as the walls extend the ground plan into the vault, culminating in Borromini's unique, spiral lantern. It continues the star-hexagon pattern up to the circular base of the lantern. The stars on the wall refer to the Chigi family of Pope Alexander VII, who was reigning when the building was completed.

19.17. Francesco Borromini. Facade of San Carlo alle Quattro Fontane, Rome. ca.1665–1667

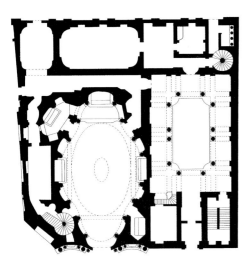

19.18. Plan of San Carlo alle Quattro Fontane. 1638–1641

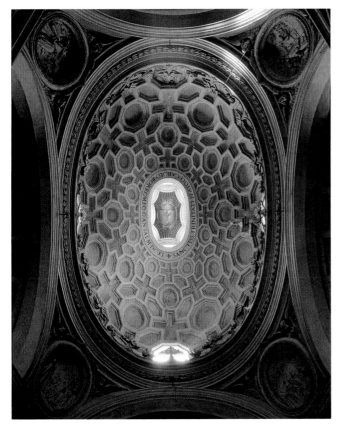

19.19. Dome of San Carlo alle Quattro Fontane. 1638–1641

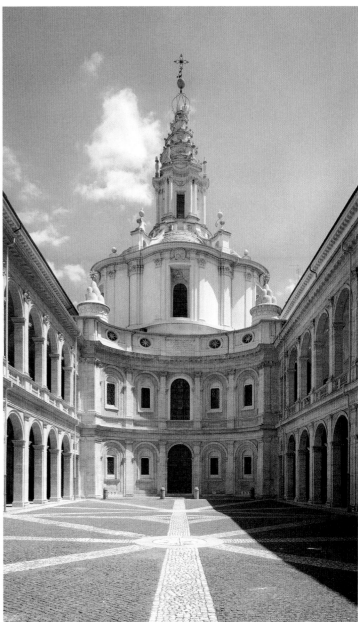

19.20. Francesco Borromini. Exterior of Sant'Ivo. Rome. Begun 1642

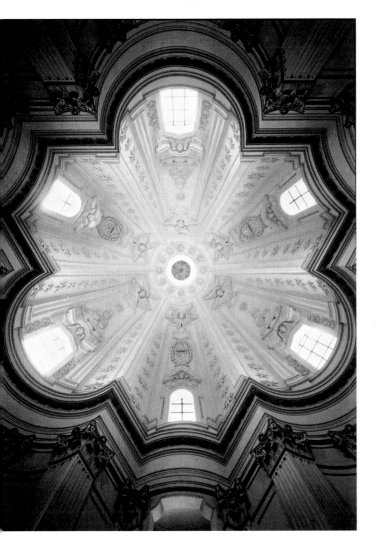

19.21. Dome of Sant'Ivo

SANT'AGNESE A third project by Borromini, Sant'Agnese in Piazza Navona (figs. **19.22** and **19.23**), is of special interest as a critique of St. Peter's. There were two problems that Maderno had been unable to solve at St. Peter's. Although his facade forms an impressive unit with Michelangelo's dome when seen from a distance, the dome is gradually hidden by the new facade as we approach the church. It appears to "sink." Furthermore, the towers he planned for each end posed formidable structural difficulties. After his first attempt to overcome these

problems failed, Bernini proposed making the towers freestanding, but he was forced to abandon the plan when it was severly criticized. The facade of Sant'Agnese is a brilliant solution to both of these issues. Borromini took over the project, which had been begun by another architect, Carlo Rainaldi (1611–1691), the year before, and he completely recast it without completely abandoning the Greek-cross plan. The design is essentially a central-plan (fig. 19.23), and the dome is not set back at all. The facade's lower part is adapted from the facade of St. Peter's, but it curves inward, so that the dome (a tall, slender version of Michelangelo's) functions as the upper part of the facade. As the dome is nearly at the entranceway, the problem of a "sinking" dome is solved—but of course without the inherent difficulty found in St. Peter's and its Latin-cross plan. The dramatic juxtaposition of concave and convex, so characteristic of Borromini, is emphasized by the two towers, which form a monumental group with the dome. Once again Borromini joins Gothic and Renaissance features—the two-tower facade and the dome—into a remarkably elastic compound.

The Baroque in Turin: Guarino Guarini

The new ideas introduced by Borromini were developed further not in Rome but in Turin, the capital of Piedmont, which became the creative center of Baroque architecture in Italy toward the end of the seventeenth century. In 1666, Guarino Guarini (1624–1683), Borromini's most brilliant successor, was called to Turin as an engineer and mathematician by Duke Carlo Emanuele II. Guarini was a Theatine priest whose genius was grounded in philosophy and mathematics. His design for the facade of the Palazzo Carignano (figs. **19.24** and **19.25**) for the cadet branch of the House of Savoy repeats on a larger scale the undulating movement of San Carlo alle Quattro Fontane (see fig. 19.17), using a highly individualized vocabulary. Incredibly, the exterior of the building, in the local tradition, is almost entirely of brick, but was probably meant to be stuccoed in imitation marble.

Even more extraordinary is Guarini's dome of the Chapel of the Holy Shroud, a round structure attached to Turin Cathedral (fig. **19.26**). The dome and the tall drum, with its alternating windows and niches, consists of familiar Borrominian motifs. Yet it ushers us into a realm of pure illusion completely unlike anything by the earlier architect. Here, the surface has disappeared in a maze of ribs that is both unusual and exotic, created though the manipulation of repeated geometric forms. As a result, we find ourselves staring into a huge kaleidoscope. Above this seemingly infinite funnel of space hovers the dove of the Holy Spirit within a 12-point star inside the chapel, which holds one of the most precious relics of Christendom, the Shroud of Christ.

Guarini's dome retains the symbolic meaning of the dome of heaven. It repeats architecturally what Correggio achieved in painting in his *Assumption of the Virgin* (fig. 17.25). A concentric structure of alternating rings of light and shadow enhances the illusion of great depth and features brilliant light at its center, and it also recalls the passion of Christ. The objective harmony of the Renaissance has become subjective, a compelling

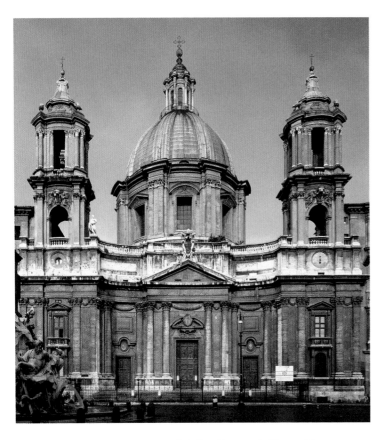

19.22. Francesco Borromini. Sant'Agnese in Piazza Navona, Rome. 1653–1663

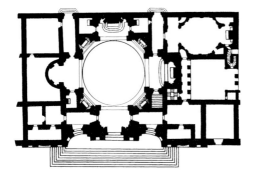

19.23. Francesco Borromini. Plan of Sant'Agnese

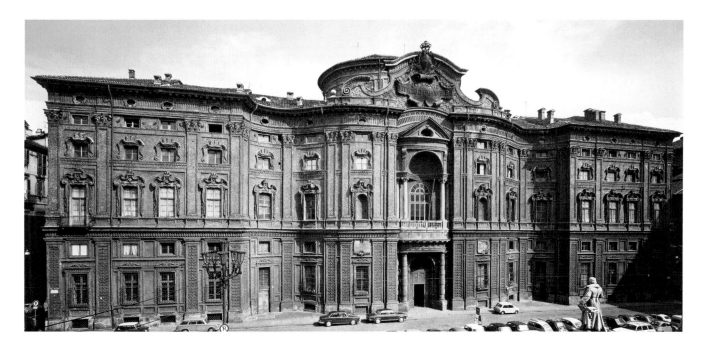

19.24. Guarino Guarini. Facade of Palazzo Carignano. Turin. Begun 1679

19.25. Plan of Palazzo Carignano

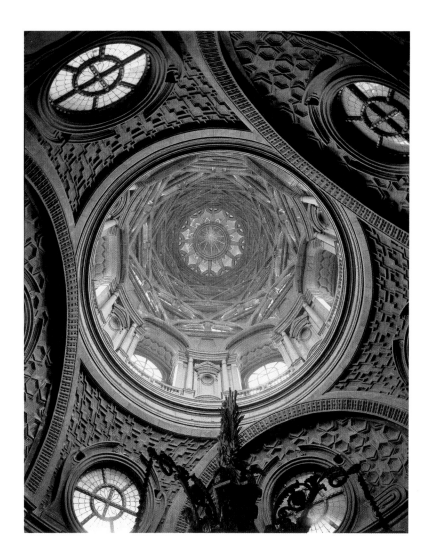

19.26. Guarino Guarini. Dome of the Chapel of the Holy Shroud. Turin Cathedral. 1668–1694

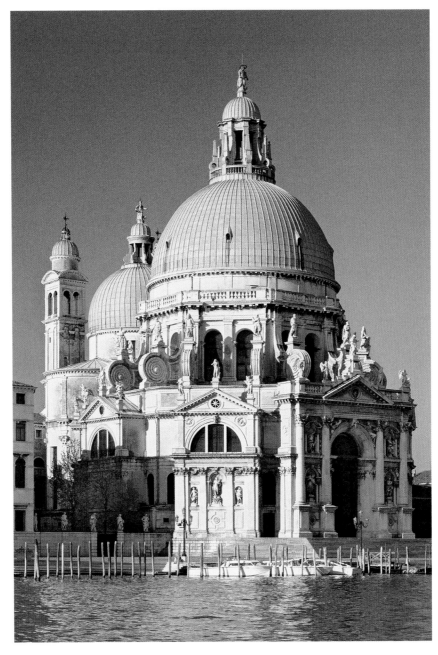

19.27. Baldassare Longhena. Santa Maria della Salute. Venice. 1631–1687

experience of the infinite, close to the Gothic mysticism of Abbot Suger's infinite (see pages 388–389). If Borromini's style at times suggests a fusion of Gothic and Renaissance, Guarini takes the next step. In his writings, Guarini contrasts the "muscular" architecture of the ancients with the effect of Gothic churches, which appear to stand only by means of some kind of miracle, and he expresses equal admiration for both. This attitude corresponds exactly to his own practice. Guarini and Borromini were obsessed with originality and were willing to break architectural rules to achieve it. By using the most advanced mathematical techniques of his day, he achieved wonders even greater than the seeming weightlessness of Gothic structures. The dome itself, for example, is on three pendentives instead of the usual four—a completely fresh approach to a traditional form.

The Baroque in Venice: Baldassare Longhena

At the head of the Grand Canal in Venice, the church of Santa Maria della Salute (fig. **19.27**) was commissioned by the Republic to commemorate the end of the plague of 1630. It was built by Baldassare Longhena (1598–1682). Begun in 1631 and consecrated in 1687, after Longhena's death, it took the heart of the century to complete and rivals the masterpieces of Rome. "*Salute*" ("Health") dominates the Grand Canal and has since become a focal point on the Venice skyline—unique, graceful, Classical, yet ornate.

The most important aspect of the building is that its plan is that of a regular octagon whose distinctive shape can be seen on its multiple facades, with a dome rising from its center. Each face

is a double-columned triumphal arch whose columns stand on high pedestals. The entablature is joined to the drum in a series of large sculptural volutes that are both elegant and distinctive. The details—drum, double columns, and octagonal shape—all have their sources in the early Church, and in works by Bramante and Palladio, but they became the hallmark of the Baroque in Venice.

SCULPTURE IN ITALY

Baroque sculpture, like Baroque painting, was vital, energized, and dynamic, suggesting action and deep emotion. The subject matter was intended to evoke an emotional response in the viewer. The sculpture was usually life-size, but with a sense of grandeur that suggested larger than life-size figures; and many figures were indeed monumental. Deeply cut, the facial expressions and clothing caught the light and cast shadows to create not just depth but drama.

Early Baroque Sculpture: Stefano Maderno

Baroque sculpture began with the delicate naturalism of *Santa Cecilia* (fig. **19.28**) by Stefano Maderno (ca. 1576–1636). Rather than standing as a living saint, as with almost all depictions of saints, Maderno created *Santa Cecilia* as a recumbent dead body. This fifth-century saint's body had been found, uncorrupted, just a year before in the church of Santa Cecilia in Trastevere. The recovery of her body prompted numerous depictions in the Baroque of Santa Cecilia, the patron saint of music, but always showing her young, alive, engaged, and often playing a musical instrument. Here she lies on her right

ART IN TIME

1607—Maderno begins completion of St. Peter's Basilica
1623—Urban VIII assumes papal throne
1629—Bernini commissioned to complete St. Peter's Basilica
1633—The Inquisition forces Galileo Galilei to recant
1642—Borromini's Sant'Ivo

side, on a slab of marble, her dress pulled between her knees and down to her toes as if lying on a bed rather than a morgue slab. The cut in her neck and her head twisted away indicate she is dead. She lies somehow vulnerable even in her death, evoking pathos. The poignancy of this depiction is one of the characteristics of the Baroque.

The Evolution of the Baroque: Gianlorenzo Bernini

Bernini was a sculptor as well as an architect, and sculpture and architecture are never far apart in his work as we have seen in the *Baldacchino* (fig. 19.15). He was trained by his father, Pietro Bernini (1562–1629), a sculptor who worked in Florence, Naples, and Rome, but was also influenced by Giovanni Bologna (see fig. 17.10). Bernini's style was thus a direct outgrowth of Mannerist sculpture in many ways, but this debt alone does not explain his revolutionary qualities, which emerged early in his career.

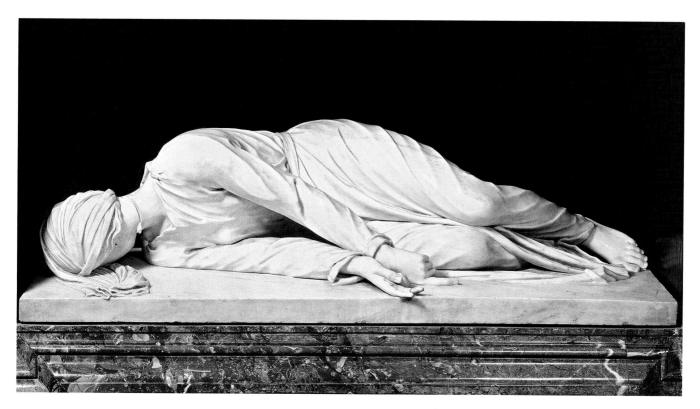

19.28. Stefano Maderno. *Santa Cecilia*. 1600. Marble, life-size. Santa Cecilia in Trastevere, Rome

DAVID As in the colonnade for St. Peter's (see fig. 19.14), we can often see a strong relationship between Bernini's sculpture and antiquity. If we compare Bernini's *David* (fig. **19.29**) with Michelangelo's (see fig. 16.13) and ask which is closer to the Pergamon frieze or *The Laocoön* (see fig. 5.74 and page 179), our vote must go to Bernini, whose sculpture shares with Hellenistic works that union of body and spirit, of motion and emotion, which Michelangelo so consciously tempers. This does not mean that Michelangelo (who had witnessed the unearthing of *The Laocoön*) is more Classical than Bernini. It shows, rather, that both the Baroque and the High Renaissance drew different lessons from ancient art.

Bernini's *David* suggests the fierceness of expression, movement, and dynamism of *The Laocoön* (see *Materials and Techniques* page 687). In part, what makes it Baroque is the implied

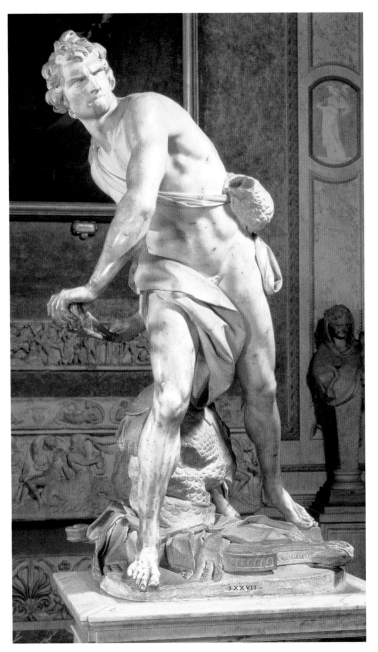

19.29. Gianlorenzo Bernini. *David.* 1623. Marble, life-size. Galleria Borghese, Rome

presence of Goliath. Unlike earlier statues of David, including Donatello's (see fig. 15.35), Bernini's is conceived not as a self-contained figure but as half of a pair, his entire action focused on his adversary. His *David* tells us clearly enough where he sees the enemy. Consequently, the space between David and his invisible opponent is charged with energy—it "belongs" to the statue.

Bernini's *David* shows us the distinctive feature of Baroque sculpture: its new, active relationship with the surrounding space. But it is meant to be seen, as is most other Baroque sculpture, from one primary point of view. Bernini presents us with "the moment" of action, not just the contemplation of the killing—as in Michelangelo's work—or the aftermath of it, as in Donatello's. Baroque sculpture often suggests a heightened vitality and energy. It rejects self-sufficiency in favor of the illusion of a presence or force implied by the action of the statue. Because it so often presents an "invisible complement" (like the Goliath of Bernini's *David*), Baroque statues attempt pictorial effects that were traditionally outside the realm of monumental sculpture. Such a charging of space with energy is, in fact, a key feature of Baroque art. Caravaggio had achieved it in his *St. Matthew* with the aid of a sharply focused beam of light. And as we have seen in Gaulli's ceiling of Il Gesù (fig. 19.12), both painting and sculpture may even be combined with architecture to form a compound illusion, such as that seen on a stage.

THE CORNARO CHAPEL: *THE ECSTASY OF ST. THERESA* Bernini had a passionate interest in the theater and was an innovative scene designer. A contemporary wrote that Bernini "gave a public opera wherein he painted the scenes, cut the statues, invented the engines, composed the music, writ the comedy, and built the theatre." Thus he was at his best when he could merge architecture, sculpture, and painting (see end of Part III *Additional Primary Sources*.) His masterpiece in this vein is the Cornaro Chapel in the church of Santa Maria della Vittoria, containing the famous group *The Ecstasy of St. Theresa* (figs. **19.30** and **19.31**). Theresa of Ávila, one of the great saints of the Counter-Reformation and newly canonized only in 1622, had described how an angel pierced her heart with a flaming golden arrow: "The pain was so great that I screamed aloud; but at the same time I felt such infinite sweetness that I wished the pain to last forever. It was not physical but psychic pain, although it affected the body as well to some degree. It was the sweetest caressing of the soul by God."

Bernini has made Theresa's visionary experience as sensuously real as Correggio's *Jupiter and Io* (see fig. 17.24), and the saint's rapture is obvious. (In a different context the angel could be Cupid.) The two figures on their floating cloud are lit from a hidden window above, so that they seem almost dematerialized. A viewer thus experiences them as visionary. The "invisible complement" here, less specific than *David*'s but equally important, is the force that carries the figures toward heaven and causes the turbulence of their drapery. Its divine nature is suggested by the golden rays, which come from a source high above the altar. In an illusionistic fresco by Guidobaldo Abbatini on the vault of the chapel, the glory of the heavens is revealed as a dazzling burst of

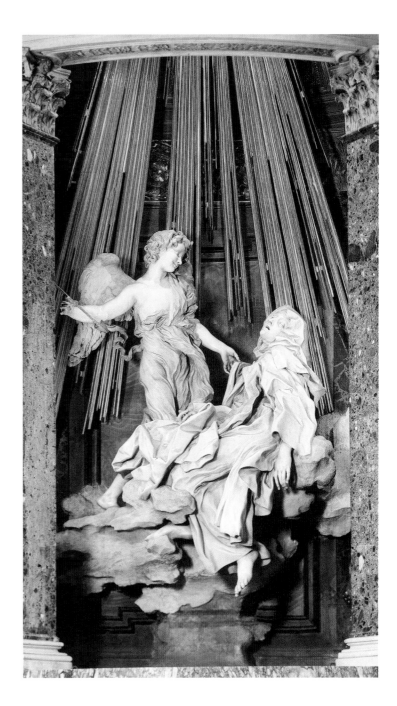

19.30. Gianlorenzo Bernini. *The Ecstasy of St. Theresa* (detail of sculptural group). 1645–1652. Marble, life-size. Cornaro Chapel, Santa Maria della Vittoria, Rome

19.31. Gianlorenzo Bernini. *The Ecstasy of St. Theresa* (full chapel view). 1645–1652. Marble, life-size. Cornaro Chapel, Santa Maria della Vittoria, Rome

light from which tumble clouds of jubilant angels. This celestial explosion gives force to the thrusts of the angel's arrow and makes the ecstasy of the saint fully believable.

To complete the illusion, Bernini even provides a built-in audience for his "stage." On the sides of the chapel are balconies resembling theater boxes that contain marble figures depicting members of the Cornaro family, who also witness the vision. Their space and ours are the same, and thus are part of everyday reality, while the saint's ecstasy, which is framed in a niche, occupies a space that is real but beyond our reach, for it is intended as a divine realm.

Finally, the ceiling fresco represents the infinite space of heaven. We may recall that *The Burial of Count Orgaz* and its setting also form a whole that includes three levels of reality (see fig. 18.12). Yet there is a fundamental difference between the two chapels. El Greco's mannerism evokes an ethereal vision in which only the stone slab of the sarcophagus is "real,"

ART IN TIME

1607—First opera, *L'Orfeo* by Claudio Montverdi, performed

1622—Ignatius Loyola, founder of the Jesuit Order and Francis Xavier, Theresa of Ávila, Philip Neri, all canonized

1645—Bernini's *The Ecstasy of St. Theresa*

in contrast to Bernini's Baroque staging, where the distinction nearly breaks down. It would be easy to dismiss *The Ecstasy of St. Theresa* as a theatrical display, but Bernini also was a devout Catholic who believed (as did Michelangelo) that he was inspired directly by God. Like the *Spiritual Exercises* of Ignatius of Loyola, which Bernini practiced, his religious sculpture is intended to help a viewer identify with miraculous events through a vivid appeal to the senses. Theatricality in the service of faith was basic to the Counter-Reformation, which often referred to the Church as the theater of human life: It took the Baroque to bring this ideal to life.

19.32. Alessandro Algardi. *The Meeting of Pope Leo I and Attila*. 1646–1653. Marble, 28′1³⁄₄″ × 16′2¹⁄₂″ (8.5 × 4.9 m). St. Peter's, The Vatican, Rome

Bernini was steeped in Renaissance humanism. Central to his sculpture is the role of gesture and expression in arousing emotion. While these devices were also important to the Renaissance (as we have seen with Leonardo), Bernini uses them with a freedom that seems anti-Classical. However, he essentially followed the concept of decorum (which also explains why his *David* is not completely nude), and he planned his effects carefully by varying them in accordance with his subject. Unlike the Frenchman Nicolas Poussin (whom he respected, as he did Annibale Carracci), Bernini did this for the sake of expressive impact rather than conceptual clarity. The approaches of the two artists were diametrically opposed as well. For Bernini, antiquity served as no more than a point of departure for his own inventiveness, whereas for Poussin it was a standard of comparison. It is nevertheless characteristic of the Baroque that Bernini's theories were far more orthodox than his art. Thus he often sided with the Classicists against his fellow High Baroque artists, especially Pietro da Cortona, who, like Raphael before him, also made an important contribution to architecture and was a rival in that sphere.

A Classical Alternative: Alessandro Algardi

It is no less ironic that Cortona was the closest friend of the sculptor Alessandro Algardi (1598–1654), who is regarded as the leading Classical sculptor of the Italian Baroque. His main contribution is *The Meeting of Pope Leo I and Attila* (fig. **19.32**), done when he took over Bernini's role at St. Peter's during the papacy of Innocent X. It introduces a new kind of high relief that soon became widely popular. Bernini avoided doing reliefs (his studio executed this area of projects when he had to do them), but Algardi liked working in this more pictorial sculptural form.

The scene depicts the Huns under Attila being driven away after threatening an attack on Rome in 452, a fateful event in the early history of Christianity, when its very survival was at stake. (The actual event was very different: Leo persuaded the Huns not to attack, just as he did with the Vandals three years later. Both protagonists were on horseback, not on foot as seen here.) The subject revives one that is familiar to us from antiquity: the victory over barbarian forces. Now, however, it is the Church, not civilization, that triumphs, and the victory is spiritual rather than military.

The commission was given for a sculpture because water condensation caused by the location in an old doorway of St. Peter's (and through most of the church) made a painting impossible. But the viewing problems for a painting were also difficult for relief sculpture. Never before had an Italian sculptor attempted such a large relief—it stands nearly 28 feet high (nearly twice the height of Ghiberti's bronze doors, *The Gates of Paradise*, fig. 15.22). The problems posed by translating a pictorial conception (it had been treated by Raphael in one of the Vatican Stanze) into a relief on this gigantic scale were formidable. If Algardi has not succeeded in resolving every detail, his

Bernini's Sculptural Sketches

Small sketches in sculpture—for large-scale sculpture or architecture—serve as models, practice-pieces, or as presentation pieces for the artist to show a patron. These sculptural models are called *bozzetti* or *modelli*. A *bozzetto* (singular) means a sketch, and *bozzetti* are generally smaller and less finished than *modelli*, which may be closer to the final product, or in some other way "finished" as a work for a patron to see before the completion of the final project.

Artists may do several drawings as well as several *bozzetti* for a completed piece. And, indeed, Bernini did both drawings in pen and ink, in red or black chalk, or even in combinations of chalk and pen in preparation for a project, as well as making *bozzetti*. Bernini's *bozzetti* and *modelli* are made in clay (terra cotta), although the completed sculptures were executed in marble. This is not just a difference in medium, but in technique. Marble sculpture is created through a subtractive process—marble is chiseled away. But clay can be worked with both additive and subtractive methods, and we know that Bernini's work in clay was primarily additive.

We can see multiple methods and evidence of a variety of tools used by Bernini in his clay *bozzetto* of the life-size *Head of St. Jerome*, created for a life-size, full-length marble sculpture of the saint. Analysis of the clay sculpture has shown that this piece, as many others, was made from wedged clay—that is, fresh clay that is rolled, smashed, and rolled repeatedly to expel air from the clay, and then subsequently "worked." The clay is worked on by hand, with fingers (most probably the thumbs, index fingers, and middle fingers), with fingernails creating tracks, and with tools that often have teeth.

The idea that the clay is worked on by the artist with his own hands—his own fingers—is a tantalizing one. Large-scale sculpture and complex sculptural and architectural projects may employ several assistants chiseling marble. But here in a *bozzetto* we may be seeing the handwork—the very fingerprints—of the artist. Several of Bernini's *bozzetti* have been examined for fingerprints in the clay, and indeed many have been found. Of the fifteen Bernini *bozzetti* at the Fogg Art Museum (the largest single collection of his *bozzetti*), thirteen have fingerprints and multiple examples of them. Thirty-four fingerprints have been found and some of the same prints have been found in works executed years apart. Therefore, it is most likely that these prints are Bernini's own. He smoothed surfaces, added clay, created lines and edges with his nails, wiped and depressed the clay with his own fingers.

Gianlorenzo Bernini, *Head of St. Jerome*, ca. 1661. Terra cotta, height $14\frac{1}{4}$" (36.2 cm). Courtesy of the Fogg Art Museum, Harvard University Art Museum, Cambridge, MA. Alpheus Hyatt Purchasing and Friends of the Fogg Art Museum Funds, 1937.77

The *Head of St. Jerome* reveals Bernini's fingerprints, evidence of nail edging, texturing from tined tools as he added more clay to represent the hair and nose. We know that the clay was hollowed out from the back, after being scooped out with fingers. As clay would be added to the face and hair, chances of cracking and breaking off increased. And we see much evidence of cracking in this *bozzetto*. It is apparent that areas were specifically smoothed over to prevent this. There is further evidence that a cloth was placed over the *Head* to keep the clay moist for continued work and to prevent further cracking.

The *Head of St. Jerome* is enormously expressive, looking tortured, pained, with his deep-set eyes, hollow cheeks, gaunt face, but it is the textures in clay that make this visage most memorable.

achievement is stupendous nonetheless. By varying the depth of the carving, he nearly convinces us that the scene takes place in the same space as ours. The foreground figures are in such high relief that they seem detached from the background. To emphasize the effect, the stage on which they are standing projects several feet beyond its surrounding niche. Thus Attila seems to rush out toward us in fear and astonishment as he flees the vision of the two apostles defending the faith. The result is surprisingly persuasive in both visual and expressive terms.

Such illusionism is quintessentially Baroque. So is the intense drama, which is heightened by the twisting poses and theatrical gestures of the figures. Algardi was obviously touched by Bernini's genius. Strangely enough, the relief is partly a throwback to an *Assumption of the Virgin* of 1606–1610 in Santa. Maria Maggiore by Bernini's father, Pietro. Only in his observance of the three traditional levels of relief carving (low, middle, and high, instead of continuously variable depth), his preference for frontal poses, and his restraint in dealing with the violent action can Algardi be called a Classicist, and then purely in a relative sense. Clearly we must not draw the distinction between the High Baroque and Baroque Classicism too sharply in sculpture any more than in painting.

Politics, art, and a common bond of loyalty to the Catholic Church connected Italy and Spain in the seventeenth century. Spain, still in the throes of the Inquisition (a medieval institution that was established separately in Spain in 1478 to enforce religious orthodoxy and revived in Italy in 1542), was staunchly conservative and unflinching; their king was titled "The Most Catholic Majesty." Spain restricted the Church to only those who professed their unaltering loyalty, and imprisoned, executed, or expelled those who did not, while the Vatican used its resources to bring reformers and the disaffected back to the Church. The Counter-Reformation, or Catholic Reform, began in Rome with a style—Baroque—intended to convince viewers of the dynamism and power of the Catholic Church, its patrons, and defenders. And, at the beginning of the seventeenth century, the largest city on the Italian mainland, Naples, was under the rulership of Spain. So the impact of Baroque Roman art on Neopolitan and Spanish art was profound.

At the height of its political and economic power during the sixteenth century, Spain had produced great saints and writers, but no artists of the first rank. Nor did El Greco's presence stimulate native talent. The Spanish court and most of the aristocracy held native artists in low esteem, so that they preferred to employ foreign painters whenever possible—above all Titian. Thus the main influences came from Italy and the Netherlands, which was then ruled by Spain. Jan van Eyck (see pages 479–485) visited Spain and inspired followers there, Titian worked for Charles V of Spain, and in the seventeenth century Rubens visited at least twice and his work was very much admired. Spanish Baroque art was heavily influenced by the style and subject matter of Caravaggio—directly and via Naples—but with a greater starkness. Spanish naturalism may throw a harsher, stronger light on its subjects, but it is ultimately at least as sympathetic.

Spanish Still Life: Juan Sánchez Cotán

Inspired by the example of Aertsen and other Netherlandish painters, Spanish artists began to develop their own versions of still life in the 1590s, and connoisseurs acquired vast collections of them. We see the distinctive character of this new subject in the example (fig. **19.33**) by Juan Sánchez Cotán (1561–1627). This minor religious artist, who became a Carthusian monk, is remembered today as one of the first and most remarkable members of the Toledo school of still-life painters. Cotán's painting has a clear order and stark simplicity completely controlled by the artist, who hung the vegetables with a fine string at different levels to coordinate the design while other vegetables sit on a ledge or window sill. A window frames the still life: This orchestration of still life in direct sunlight against impenetrable darkness is the hallmark of early Spanish still-life painting. The painstaking realism and abstract form creates a memorable image of the humble fruits and vegetables.

19.33. Juan Sánchez Cotán. *Quince, Cabbage, Melon, and Cucumber.* ca. 1602. Oil on canvas, $27\frac{1}{8} \times 33\frac{1}{4}$" (68.8 × 84.4 cm). San Diego Museum of Art. Gift of Misses Anne R. and Amy Putnam

Although he probably used northern Italian paintings as his point of departure, Sánchez Cotán's still lifes make one think of Caravaggio, whose effect on Spanish art, however, is not found until considerably later. We do not know exactly how Caravaggism was transmitted. The likeliest source was through Naples, where Caravaggio had fled to safety, which was under Spanish rule. His principal follower there was Jusepe Ribera.

Naples and the Impact of Caravaggio: Jusepe de Ribera

Caravaggio's main disciple in Naples, then under Spanish rule, was the Spaniard Jusepe de Ribera (1591–1652). Ribera settled there after having seen Caravaggio's paintings in Rome. Especially popular were Ribera's paintings of saints, prophets, and ancient beggar-philosophers. Their asceticism appealed strongly to the otherworldliness of Spanish Catholicism. Such pictures also reflected the learned humanism of the Spanish nobility, who were the artist's main patrons. Most of Ribera's figures possess the unique blend of inner strength and intensity.

His *The Club-Footed Boy* (fig. **19.34**) smiles openly and endearingly out at us, with a dimpled cheek, although we may be somewhat discomforted by his peasant dress, his begging, and his handicap. The words on the paper he holds state (in translation): "Give me alms for the love of God." In Counter-Reformation theory, this plea for charity indicates that only through good works may the rich hope to attain salvation. The painting, indeed, was made for the Viceroy of Naples, a wealthy collector who would have seen this as a testament to the importance of Christian charity and mercy to the poor.

The boy seems almost monumental here as he stands against the broad sky with a low horizon line, like a musketeer; but instead of a weapon held across his shoulder, it is his crutch. His deformed foot appears in shadow and one doesn't quite see it at first, but as the leg is lit, clearly Ribera directs our attention to it. The deformity may in fact not be a clubfoot but an indication of cerebral palsy. In either case, in the seventeenth century, such a deformity would have committed one to a life of begging.

Ribera executed other large paintings of beggars, of the poor, and of the blind. These were also the subjects of Pieter Bruegel the Elder (*The Blind Leading the Blind*, fig. 18.39), who made prints and drawings of beggars using various crutches. As with Bruegel's works, *The Club-Footed Boy* is made with a moral

19.35. Diego Velázquez. *The Water Carrier of Seville*. ca. 1619. Oil on canvas, $41\frac{1}{2} \times 31\frac{1}{2}$ " (105.3 × 80 cm). Wellington Museum, London Crown Copyright Reserved

19.34. Jusepe de Ribera. *The Club-Footed Boy*. 1642. Oil on canvas, $64\frac{1}{8} \times 36\frac{5}{8}$ " (164 × 93 cm). Musée du Louvre, Paris

purpose. The boy himself seems an embodiment of joy as he smiles, even laughs. This was considered as a way for the subject to withstand misfortune, for he has the ability to dispense grace: the opportunity for others to do good. Ribera's use of naturalism is a hallmark of Spanish and Neapolitan painting and etching, and it extends Caravaggio's impact. The impact of Caravaggism was felt especially in Seville, the home of the most important Spanish Baroque painters before 1640: Diego Velázquez.

Diego Velázquez: From Seville to Court Painter

Diego Velázquez (1599–1660) painted in a Caravaggesque vein during his early years in Seville. His interests at that time centered on scenes of people eating and drinking rather than religious themes. Known as *bodegónes* they evolved from the paintings of table-top displays brought to Spain by Flemish artists in the early seventeenth century. *The Water Carrier of Seville* (fig. **19.35**), which Velázquez painted at age 20 under the

apparent influence of Ribera, already shows his genius. His powerful grasp of individual character and dignity gives this everyday scene the solemn spirit of a ritual. The scene is related to Giving Drink to the Thirsty, one of the Seven Acts of Mercy, a popular theme among Caravaggesque painters of the day. Velázquez's use of focused light and the revelation of shapes, textures, surfaces—from the glass of water to the sweat of water on the pottery jug—is almost miraculous. He must have thought so, too, as he gave this painting to his sponsor, a royal chaplain from Seville, no doubt in hopes of attaining royal attention.

In the late 1620s, Velázquez was appointed court painter to Philip IV, whose reign from 1621 to 1665 was the great age of painting in Spain. Much of the credit must go to the duke of Olivares, who largely restored Spain's fortunes and supported an ambitious program of artistic patronage to proclaim the monarchy's greatness. Upon moving to Madrid, Velázquez quickly displaced the Florentines who had enjoyed the favor of Philip III and his minister, the duke of Lerma. A skilled courtier, the artist soon became a favorite of the king, whom he served as chamberlain. Velázquez spent most of the rest of his life in Madrid painting mainly portraits of the royal family.

The earlier of these still have the strong division of light and dark and the clear outlines of his Seville period, but his work soon acquired a new fluency and richness.

SURRENDER AT BREDA During his visit to the Spanish court on a diplomatic mission in 1628, the Flemish painter Peter Paul Rubens (see pages 699–704) helped Velázquez discover the beauty of the many Titians in the king's collection. We see this most immediately in Velázquez's *Surrender at Breda* (fig. **19.36**), a dramatic and lush painting with color as rich as Titian's. It, too, would have been in the royal collection, intended as part of a series for the Buen Retiro Palace. The subject is an interpretation of an event in the war between the United Provinces (the Netherlands) and Spain which took place in 1625, just a few years before the painting's execution. Although the surrender indeed occurred, it did not transpire in this elegant fashion. Here the two generals, Justin of Nassau on the left, bows to give the keys of the city to General Ambrogio de Spinola, who has just gotten off his horse to meet the Dutch general, even to comfort him, as he places his hand on the shoulder of the vanquished officer. Smoke comes from the left

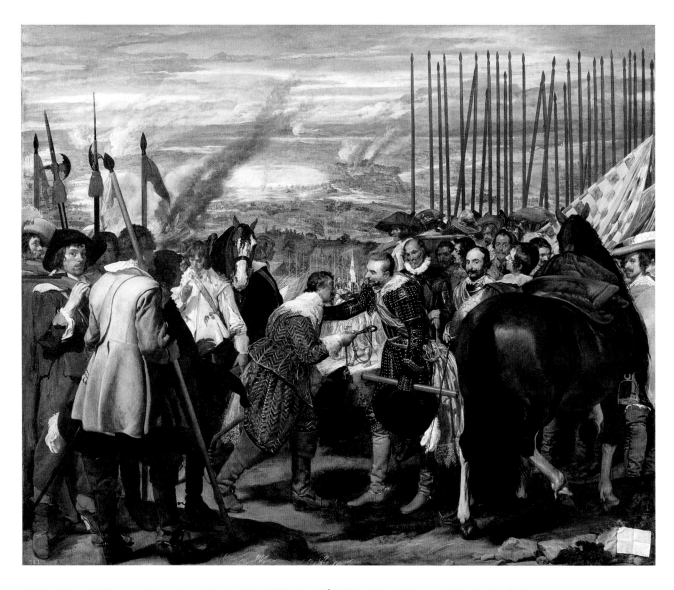

19.36. Diego Velázquez. *Surrender at Breda*. 1634–1635. 10 × 12′ (3.07 × 3.7 m). Museo del Prado, Madrid

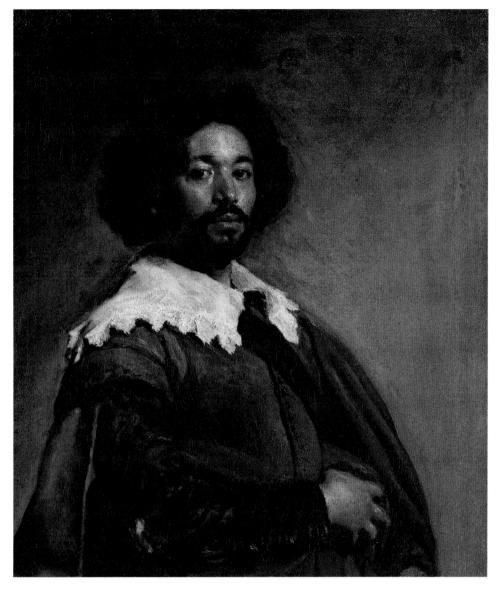

19.37. Diego Velázquez, *Juan de Pareja*. 1650. Oil on canvas, 32 × 27½″ (81.3 × 69.9 cm). The Metropolitan Museum of Art, New York. Purchase, Fletcher and Rogers Funds, and Bequest of Miss Adelaide Milton de Groot (1876–1967), by exchange, supplemented by gifts from Friends of the Museum, 1971. (1971.86)

over the heads of the Dutch soldiers who seem a bit dazed and forlorn, signaling the defeat of Breda. On the right are the Spanish troops who, by standing before the lances, seem to be standing more erect. More lances can be seen in the middle distance and one expects that they outnumbered the Dutch.

In truth, the Netherlands' revolt against Spain had ended by about 1585, with a truce in 1609, but battles continued to flare up. There were no keys to the city, and the general probably did not get off his horse. But by having the two generals confront each other not with hate but with acquiesence, Velázquez transforms a military drama into a human one. The scene Velázquez set may have been one from a contemporary play in which Spinola states "Justin, I accept them [the keys] in full awareness of your valor; for the valor of the defeated confers fame upon the victor."

THE PORTRAIT OF JUAN DE PAREJA At court, Velázquez was famed as a portrait painter. And so when Philip IV dispatched Velázquez to Rome in 1648 to purchase paintings and antique sculpture, he also gave permission for the artist to paint Pope Innocent X. But Velázquez's reputation seemed not to have preceeded him when he arrived in 1649, and he was left waiting. It was during this interlude that he painted the portrait of his Sevillian assistant and servant of Moorish descent, Juan de Pareja (ca. 1610–1670), who accompanied him to Rome and was an artist himself (fig. **19.37**). The portrait, stunningly lifelike, was acclaimed when exhibited at an annual art show in the Pantheon in Rome in March 1650. It was said that of all the paintings, this one was "truth." Juan de Pareja is shown half-length, turned at a three-quarter view, but facing us—a triangular format developed by Raphael and

Antonio Palomino (1655–1726)

From El museo pictórica y escala óptica: On Velázquez

In 1724, Palomino wrote a biography of Spanish artists with a focus on Velázquez, who he revered above others. The following is a description of Velázquez's The Maids of Honor, *with the identification of the figures and comments on its reception.*

Among the marvelous pictures done by Velázquez was a large canvas with the portrait of the Empress (then the Infanta of Spain), Margarita María of Austria, as a young child. . . . Kneeling at her feet is María Agustina, maid of honor of the Queen, giving her water in a small vessel. On the other side is Isabel de Velasco, also a maid of honor, who seems to be speaking. In the foreground is a dog lying down and next to it Nicolas Pertusato, a dwarf, who is stepping on it to show that it is a gentle animal in spite of its ferocious appearance. These two figures are in shadow and impart great harmony to the composition. Behind is Mari-Bárbola, a formidable-looking dwarf, and slightly farther back and in darker colors are Marcela de Ulloa, attendant to the ladies-in-waiting, and a bodyguard. On the other side is Diego Velázquez painting; he holds the palette in his left hand and a brush in his right. Around his waist he wears the key to the King's Chamber and on his breast, the Cross of the Order of Santiago that was added at His Majesty's orders after Velázquez died,

because Velázquez was not a member of this Order when the picture was painted. . . .

The canvas on which he is painting is large, and nothing of what he paints can be seen because only the back part is visible.

Velázquez proved his great genius because of the clever way in which he reveals the subject of what he is painting. He makes use of the mirror at the rear of the gallery to show us the reflection of our Catholic kings, Philip and Mariana. In this gallery, which is called the Room of the Prince, where he used to paint, several pictures can be seen indistinctly on the walls. These are known to be by Rubens and represent stories from Ovid's *Metamorphoses*. This gallery has several windows that are shown in perspective to make the room seem large. The light comes from the [picture's] left but enters only through the front and rear windows. . . . To the left of the mirror is an open door where stands Joseph Nieto, the Queen's Marshal. He can be clearly seen in spite of the distance and poor light. Between the figures there is atmosphere. The figure painting is superior, the conception new, and in short it is impossible to overrate this painting because it is truth, not painting. Velázquez finished it in 1656. . . .

The painting was highly esteemed by His Majesty and he frequently went to look at it. It was placed in the King's lower suite, in the office, along with other excellent works. In our own day, Luca Giordano was asked by Charles the Second what he thought of it and he answered, "Sir, this is the theology of Painting."

SOURCE: *ITALIAN & SPANISH ART, 1600–1750: SOURCES AND DOCUMENTS.* ED. BY ROBERT ENGGASS AND JONATHAN BROWN. (EVANSTON, IL: NORTHWESTERN UNIVERSITY PRESS, 1999)

Titian in the High Renaissance, simplifying, but using the *Mona Lisa* (fig. 16.7) as their point of departure. The same format used here is a powerful one, riveting our attention to his face. The feathery lace collar, brilliantly painted, picks up the white highlights of his face creating the formidable sculptural visage. A white patch, a tear in his clothing at the elbow, reminds a viewer of his class, a device Velázquez had used earlier in *The Water Carrier of Seville* (fig. 19.35). The success of this portrait and Velázquez's new fame in Rome may have prompted the pope to sit for him, which he did, soon after.

THE MAIDS OF HONOR Velázquez's mature style is seen at its fullest in *The Maids of Honor* (fig. **19.38**). Both a group portrait and a genre scene, it might be subtitled "the artist in his studio," for Velázquez depicts himself at work on a huge canvas. In the center is the Princess Margarita, who has just posed for him, among her playmates and maids of honor. The faces of her parents, King Philip IV and Queen Maria Anna, appear in the mirror on the back wall. Their position also suggests a slightly different vantage point than ours, and indeed there are several viewpoints throughout the picture. In this way, the artist perhaps intended to include a viewer in the scene by implication, even though it was clearly painted for the king and hung in the office of his summer quarters at the Alcázar Palace. Antonio Palomino, the first to discuss *The Maids of Honor*, wrote ". . . the name of Velázquez will live from

century to century, as long as that of the most excellent and beautiful Margarita, in whose shadow his image is immortalized." Thanks to Palomino (see *Primary Source*, above), we know the identity of every person in the painting. Through the presence of the princess and the king and queen, the canvas commemorates Velázquez's position as royal painter and his aspiration to the knighthood in the Order of Santiago—a papal military order to which he gained admission only with great difficulty three years after the painting was executed. In the painting, he wears the red cross of the order, which was added later after his death.

Velázquez had struggled for status at court since his arrival. Even though the usual family investigations (almost 150 friends and relatives were interviewed) assisted his claim to nobility, the very nature of his profession worked against him. "Working with his hands," conveyed on Velázquez the very antithesis of noble status. Only by papal dispensation was he accepted. *The Maids of Honor*, then, is a response to personal ambition; it is a claim for both the nobility of the act of painting and that of the artist himself. The presence of the king and queen affirm his status. The Spanish court had already honored Titian and Rubens (although not to the same order), and as these artists were both held in high regard, they served as models for Velázquez. They continued to have a significant impact on Velázquez, as men and because of their painterly style.

The painting reveals Velázquez's fascination with light as fundamental to vision. The artist challenges us to match the mirror image against the paintings on the same wall, and against the "picture" of the man in the open doorway. Although the side lighting and strong contrasts of light and dark still suggest the influence of Caravaggio, Velázquez's technique is far more subtle. The glowing colors have a Venetian richness, but the brushwork is even freer and sketchier than Titian's. Velázquez explored the optical qualities of light more fully than any other painter of his time. His aim is to represent the movement of light itself and the infinite range of its effects on form and color. For Velázquez, as for Jan Vermeer in Holland (see pages 728–730), light *creates* the visible world.

ART IN TIME

1605—Miguel de Cervantes Saavedra writes *Don Quixote*
1642—Ribera's *The Club-Footed Boy*
1656—Velázquez's *The Maids of Honor*

Monastic Orders and Zurbarán

Francisco de Zurbarán (1598–1664) began, as did Velázquez, as a painter from Seville, and he stands out among his contemporaries for his quiet intensity. His most important works, done for monastic orders, are filled with an ascetic piety that is

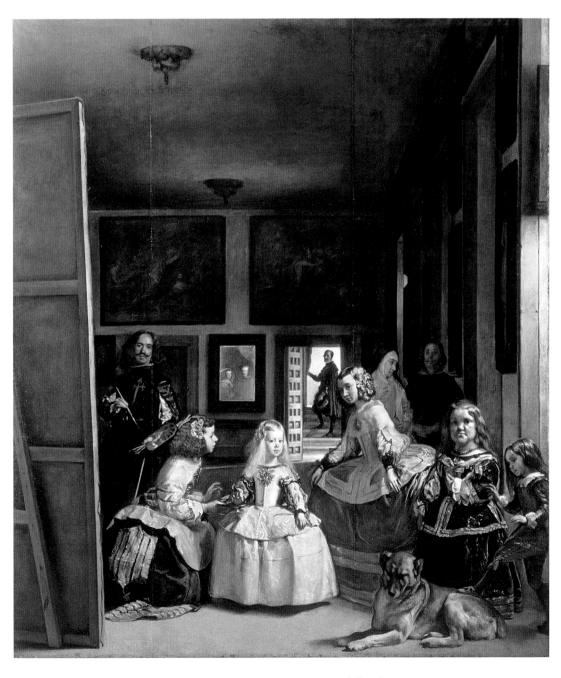

19.38. Diego Velázquez. *The Maids of Honor.* 1656. Oil on canvas, 10'5" × 9' (3.2 × 2.7 m). Museo del Prado, Madrid

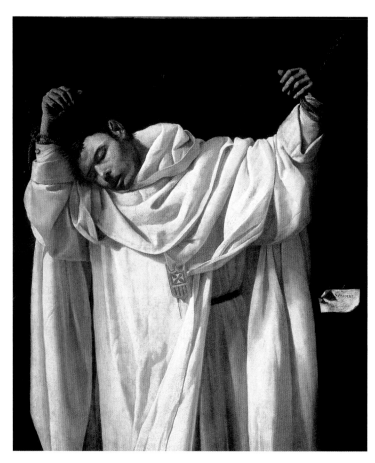

uniquely Spanish. *St. Serapion* (fig. **19.39**) shows an early member of the Mercedarians (Order of Mercy) who was brutally murdered by pirates in 1240 but canonized only a hundred years after this picture was painted. The canvas was placed as a devotional image in the funerary chapel of the order, which was originally dedicated to self-sacrifice.

Zurbarán's painting reminds us of Caravaggio. Shown as a life-size, three-quarter–length figure, St. Serapion fills the picture plane: He is both a hero and a martyr. The contrast between the white habit and the dark background gives the figure a heightened visual and expressive presence, so that a viewer contemplates the slain monk with a mixture of compassion and awe. Here pictorial and spiritual purity become one, and the stillness creates a reverential mood that complements the stark realism. As a result, we identify with the strength of St. Serapion's faith rather than with his physical suffering. The absence of rhetorical pathos is what makes this image deeply moving.

Culmination in Devotion: Bartolomé Esteban Murillo

The work of Bartolomé Esteban Murillo (1617–1682), Zurbarán's successor as the leading painter in Seville, is the most cosmopolitan, as well as the most accessible, of any of the Spanish

Baroque artists. For that reason, he had countless followers, whose pale imitations obscure his real achievement. He learned as much from Northern European artists, including Rubens and Van Dyck, as he did from Italians such as Reni and Guercino. *The Virgin and Child* (fig. **19.40**) unites the influences of Northern European and Italian artists in an image that nevertheless remains unmistakably Spanish in character. His many religious images, especially *The Virgin and Child* and *The Virgin of the Immaculate Conception* were hallmarks of the insistence of Spanish art to promote the Virgin into the visual vocabulary of the seventeenth century, and they were much copied. The insistence on Virgin imagery defied the Protestant influence in much of Europe. The haunting expressiveness of the faces has a gentle pathos that is more emotionally appealing than Zurbarán's austere pietism. This human warmth reflects a basic change in religious outlook. It is also an attempt to inject new life into standard devotional images that had been reduced to formulas in the hands of lesser artists. The extraordinary sophistication of Murillo's brushwork and the subtlety of his color show the influence of Velázquez. He succeeded so well that the vast majority of religious paintings in Spain and its South American colonies were derived from his work for the next 150 years.

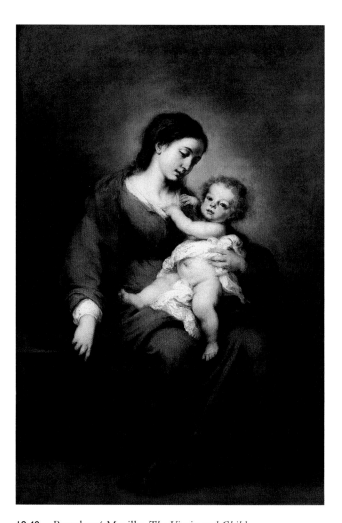

SUMMARY

The Baroque—the pervasive, dramatic style of the seventeenth century—began in Italy and spread throughout Europe, through the travel of artists and patrons. It conveyed dynamism and strong emotion and was used as the style of the Counter-Reformation, to proclaim the triumph of the Church over Protestantism. Its effects were seen in paintings, sculpture, architecture, the minor arts, and the ornate complex decorations of the age.

This period also marks the colonization of the Americas and the East by governments and religious orders who had explored these lands in the sixteenth century and now began settling them in the seventeenth. Issues of class, gender, science, medicine, and exotica, became central to life and art in this period, now known as the Early Modern World.

PAINTING IN ITALY

Caravaggio was the most significant Baroque painter because of his innovations at the beginning of the seventeenth century and his long influence. He had many followers in Italy, among them Artemisia Gentileschi, and throughout Europe, especially in Holland and Flanders. His innovations were found in his subject matter: the introduction of genre painting, usually half-length, life-size figures set behind a table against neutral background. Innovations were also seen in his style: dramatic, lighting and the suggestion of momentary action. His altarpieces were truly revolutionary.

Ceiling painting, too, became an important Baroque choice for a variety of wealthy private patrons and for Church orders—to suggest their dynamic rule over the heavens. Many artists produced illusionistic ceiling paintings that defied space, as figures seemed to fall from the heavens, or that suggested sculpture or architecture that was really painted in fresco. Among the many artists to execute and continually create innovations in this area were Annibale Carracci, Guercino, and Pietro da Cortona.

ARCHITECTURE IN ITALY

The new St. Peter's (begun at the turn of the sixteenth century) was completed during the Baroque period and became the greatest symbol of the revival and vitality of the Church. The central sculptural/architectural focus of the interior decoration was the *Baldacchino* (central altar) executed by Bernini. The exterior, a monumental, elliptical arc and piazza also designed by Bernini, was a remarkable development, suggesting the all-encompassing arms of the Church. Smaller churches, organic and irregularly shaped, with complex domes by Borromini, also became typical of the time.

SCULPTURE IN ITALY

Baroque sculpture suggested action, vitality, and emotion—with a single figure or with more complex sculptural and theatrical productions, such as Bernini's *Ecstasy of St. Theresa*. Bernini was the most significant sculptor, both for his own works and, as coordinator of the decoration plan for St. Peter's, for creating assignments for other artists.

PAINTING IN SPAIN

Spanish Baroque art was largely influenced by Italian art and Caravaggio, through Naples. Ribera, who worked there, executed genre scenes (*The Club-Footed Boy*) and religious paintings that suggest his admiration for naturalism.

Paintings suggesting strong religious piety were frequently commissioned by monastic orders, as in the case of Zurbarán. Velázquez, the most important artist of this Golden Age of Spain, was court painter to Philip IV of Spain in Madrid, but he began his career in Seville, in a style which owed a debt to Caravaggio. Titian, whose paintings were in the Spanish royal collection, and Rubens, a major Flemish artist who traveled to Spain and advised Velázquez to study the works of Titian, also influenced Spanish art and the work of Velázquez. Although genre painting and still life were also popular, the promotion of the Virgin in Spanish art as a significant subject as in the work of Murillo, defined Spain's Catholic and conservative art and its role in defying the Reformation of Northern Europe.

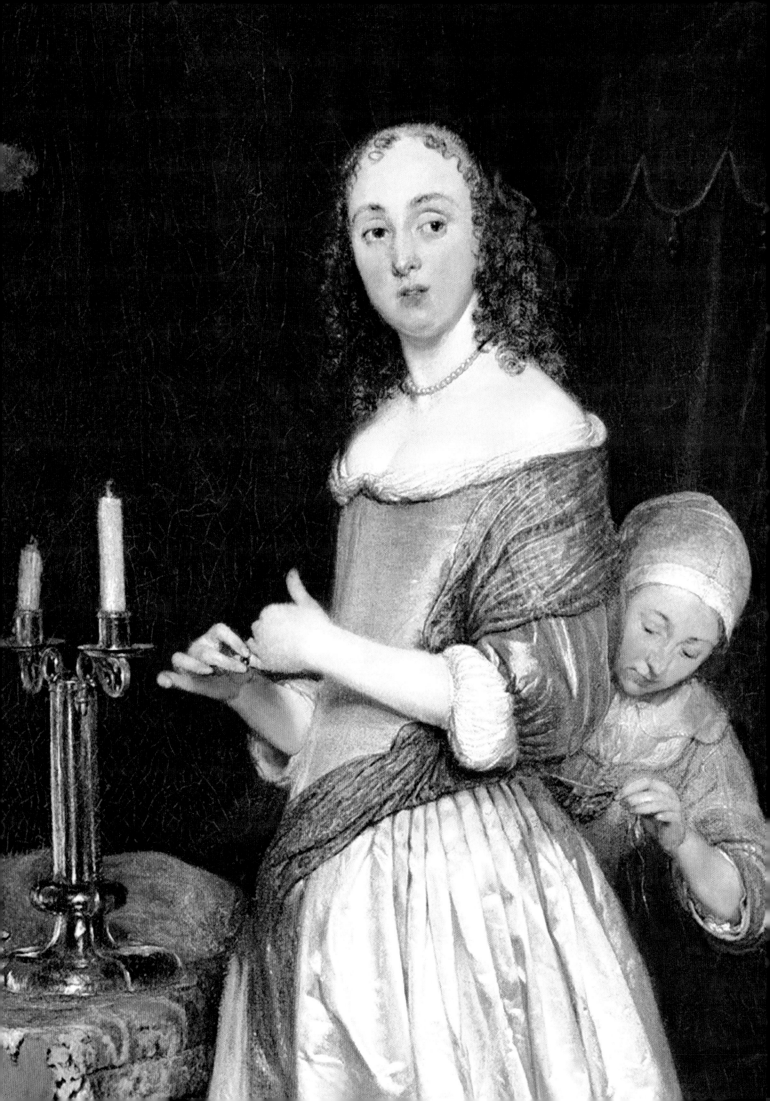

The Baroque in The Netherlands

THE SEVENTEENTH CENTURY BROUGHT A DIVISION OF THE NETHERLANDS into two parts: the Northern Netherlands (present-day The Netherlands) and the Southern Netherlands (present day Belgium and part of France). (See map 20.1.) Each is often known by the name of its most important province: Holland (North) and Flanders (South). The Catholic Spanish Habsburgs had

ruled the Netherlands in the sixteenth century but Philip II's repressive measures against the Protestants and his attempts to curtail their local government led to a rebellion that lasted 15 years. In 1581, the northern provinces of the Netherlands, led by William the Silent of Nassau of the House of Orange, declared their independence from Spain. Spain soon recovered the Southern Netherlands, and Catholicism remained the official religion. After a long struggle, the seven major provinces of the North, whose inhabitants were predominantly of the Reformed Church, became the United Provinces and gained their autonomy, which was recognized by the truce declared in 1609. Although hostilities broke out once more in 1621, the freedom of the Dutch was never again seriously in doubt. Their independence was finally ratified by the Treaty of Münster, which ended the Thirty Years' War in 1648. The Dutch Republic was formally recognized by the rest of Europe as an independent state.

The division of the Netherlands had very different consequences for the economy, social structure, culture, and religion of the North and the South. At the same time throughout the seventeenth century, people crossed back and forth between the two regions providing some social and cultural fluidity. After being sacked by Spanish troops in 1576, Antwerp, the leading

port of the Southern Netherlands, lost half its population. Many migrated to the Northern Netherlands. The city gradually regained its position as Flanders's commercial and artistic capital, although Brussels was the seat of government. As part of the Treaty of Münster, however, the Scheldt River leading to Antwerp's harbor was closed to shipping, thus crippling trade for the next two centuries. Because Flanders continued to be ruled by Spanish regents, the Habsburgs, who viewed themselves as the defenders of the "true" (i.e., Catholic) faith, its artists relied primarily on commissions from Church and state, but the aristocracy and wealthy merchants were also important patrons.

Holland, in contrast, was proud of its hard-won freedom. Although the predominant religion was the Reformed Church, the Dutch were notable for their religious tolerance. Even Catholicism continued to flourish, and included many artists among its ranks, while Jews found a haven from persecution. While the cultural links with Flanders remained strong, several factors encouraged the quick development of Dutch artistic traditions. Unlike Flanders, where all artistic activity radiated from Antwerp, Holland had a number of local schools of painting. Besides Amsterdam, the commercial capital, there were important artists in Haarlem, Utrecht, Leiden, Delft, and other towns that established local styles centered on the teachers of the community. Thus Holland produced an almost bewildering variety of masters and styles.

Detail of figure 20.36, Gerard ter Borch, *Lady at Her Toilet*

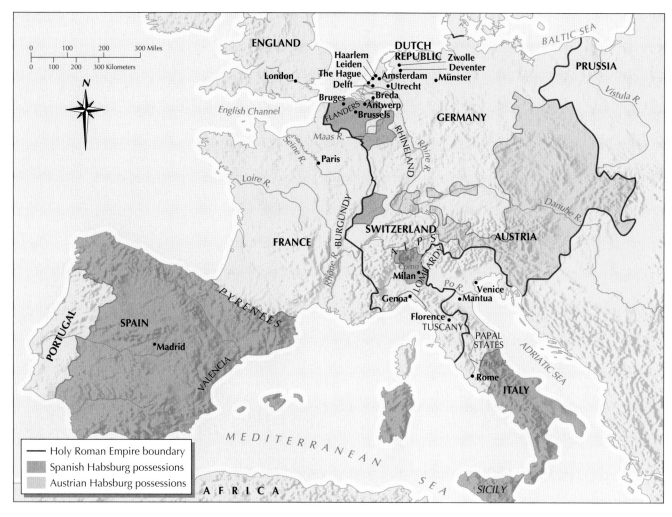

Map 20.1. Europe in 1648

The new nation was one of merchants, farmers, and sea-farers, who may have earned their living from local commerce such as the fishing trade, but who had the opportunity to have more distant adventures with the development of the famous Dutch East India Company (known as the VOC from its Dutch initials) established in 1602 and its counterpart, established in 1621, the Dutch West India Company. These companies developed trade in East Asia (China, Japan, and Indonesia), and in the Americas, bringing home exotic wares, strange creatures, and fabulous flora and fauna, as well as engaging in exploration, map making, and the creation of colonial settlements. These adventures rippled though the economy: The sailors experienced them, but they also had a direct impact on the directors and governors of the companies, who made their fortunes from these ventures. Even the townspeople, who stayed home, were able to purchase or at least see some of the wonders brought back from faraway places. From this time forward the Dutch could never again be considered provincial; even the those who did not travel could be considered, and would consider themselves, worldly.

As the Reformed Church was iconoclastic, Dutch artists rarely had the large-scale church altarpiece commissions that were available throughout the Catholic world. While the House of Orange in The Hague and city governments and civic bodies such as militias provided a certain amount of art patronage, their demands were limited. As a result, private collectors became the painters' chief source of support. This was true before 1600, but the full effect of such patronage can be seen only after that date. There was no shrinkage of output. On the contrary, the public developed such an appetite for pictures that the whole country became gripped by a kind of collector's mania. During a visit to Holland in 1641, the English traveler John Evelyn noted in his diary that ". . . tis an ordinary thing to find, a common Farmor lay out two, or 3000 pounds in this Commodity, their houses are full of them, and they vend them at their kermas'es [fairs] to very great gaines." Although it was unlikely farmers' houses were filled with paintings, or Evelyn even visited them, there is no doubt paintings were not only made for the church and the court class. In the Northern Netherlands (as well as the Southern Netherlands) a new class of patron arose—the wealthy merchant.

FLANDERS

Art in seventeenth-century Flanders was defined by the art of Peter Paul Rubens. Rubens brought Flanders, really Antwerp, to international notice and the art of the western world to Flanders. He did this through his own travels (bringing ideas back to Antwerp), his commissions, and his own extensive workshop.

Baroque art in Flanders was based on commissions. Its many churches could now, with the peace, be rebuilt and redecorated. The Habsburg archduke and archduchess, their family, and private patrons provided these commissions. Rubens's own interests were largely within the realm of painting, but his role in sculpture and sculptural decoration, architecture, costumes, and illustrated books (published by the famous Plantin Press in Antwerp) was significant. All these art forms were directly affected by Rubens and the art of Rubens.

The subjects of Flemish art, and the subjects of Rubens's paintings, were primarily religious—they were frequently large altarpieces with life-size figures, but portraits also accounted for many works. Although Rubens also executed landscapes, other artists, including Frans Snyders, Clara Peeters, Jan de Heems, and Jan Brueghel the Elder, frequently painted still lifes, or game pieces. Rubens's one-time assistant Anthony van Dyck excelled in portraits, religious and mythological painting, as did Jacob Jordaens, who also painted genre scenes. But all artistic efforts were influenced by Rubens.

Peter Paul Rubens and Defining the Baroque

Although the Baroque style was born in Rome, it soon became international. The great Flemish painter Peter Paul Rubens (1577–1640) played a role of unique importance in this process. He epitomized the Baroque ideal of the virtuoso artist, acting diplomat and advisor, with entrée to the courts of Europe. He was widely read and widely traveled, with a knowledge of Classical literature and several languages. He was acclaimed for his intellect, and for a vitality that enabled him to unite the natural and supernatural and to attain a Baroque theatricality and drama that we have also seen in Bernini (see Chapter 19). He finished what Dürer had started a hundred years earlier and was continued with Jan Gossaert and Cornelis Floris (see Chapter 18): the breakdown of the artistic barriers between Northern and Southern Europe. Rubens's father was a prominent Antwerp Protestant who had fled to Germany to escape Spanish persecution during the war of independence. The family had returned to Antwerp after his death, when Peter Paul was 10 years old, and the boy had grown up a devout Catholic. Trained by local painters, Rubens became a master in 1598, but he developed a personal style only when he went to Italy two years later.

During his eight years in Italy, in the art and patronage centers of Mantua, Genoa, Florence, and Rome, he absorbed the Italian tradition far more completely than had any Northern European before him. He eagerly studied ancient sculpture, the masterpieces of the High Renaissance, and the work of Caravaggio and Annibale Carracci. In fact, Rubens competed

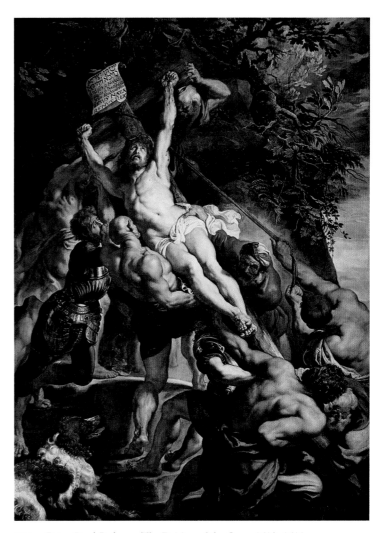

20.1. Peter Paul Rubens. *The Raising of the Cross.* 1610–1611. Center panel of a triptych, 15′1″ × 11′9⅝″ (4.6 × 3.4 m). Antwerp Cathedral, Belgium

on even terms with the best Italians of his day and could well have made his career in Italy. Indeed, he had major commissions there for both portraits and altarpieces.

RUBENS AND THE ALTARPIECE *The Raising of the Cross* (central panel, fig. **20.1**), whose very subject speaks to the dynamism of the Baroque, was the first major altarpiece Rubens painted after his return to Antwerp in 1609, and it shows how much he was indebted to his Italian experience. The muscular figures, modeled to show their physical power and passionate feeling, recall the antique, Hellenistic sculpture that Rubens saw, drew, and collected (see *Primary Source*, page 701), and the figures from the Sistine Chapel ceiling that he also copied (fig. **20.2**). These works of art served as models for his heroic figures throughout his life. He also gathered inspiration from the Farnese Gallery, while the lighting suggests Caravaggio's work (see figs. 19.1–19.4). The composition of the altarpiece recalls that of Rosso's *Descent from the Cross* (fig. 17.1), yet, the painting is more heroic in scale and conception than any previous Northern European work. Its rich color and luminosity is ultimately due to the influence of Titian (compare with fig. 16.32). Thus, the panel owes much of its success to Rubens's

20.3. Peter Paul Rubens. *Drawing after Michelangelo's Ignudi from the Sistine Chapel Ceiling*. ca. 1601–1602. Red chalk with touches of red wash. 15⅓″ × 11″ (38.9 × 27.8 cm.). British Museum, London

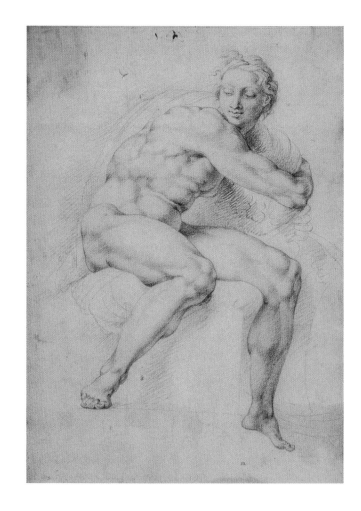

20.3. Peter Paul Rubens. *Sketch for the Raising of the Cross*. ca. 1610. Oil on panel, three panels, 26⅓″ × 10″; 26¾ × 20″; 26⅓ × 10″ (67 × 25 cm.; 68 × 51 cm.; 67 × 25 cm.). MNR 411. Musée du Louvre, Paris

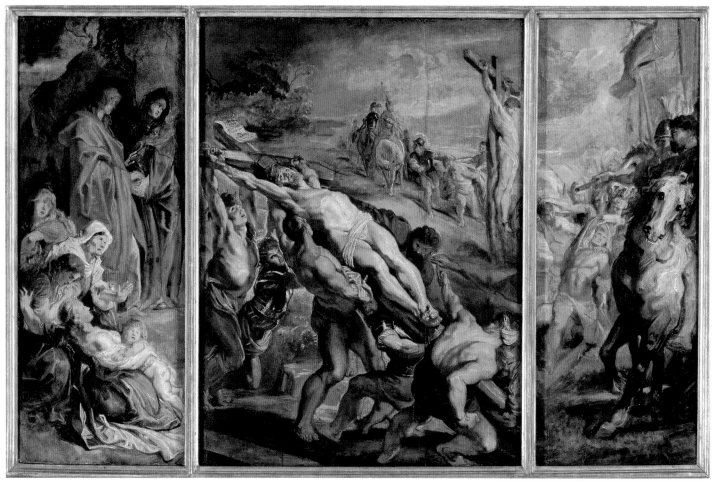

PRIMARY SOURCE

Peter Paul Rubens (1577–1640)

From a Letter to Sir Dudley Carleton

In 1618, Rubens began correspondence with Sir Dudley Carleton (1573–1632), the English Ambassador to The Hague, in order to arrange an exchange of the Englishman's antique sculptures for paintings by Rubens. Well-traveled and with diplomatic appointments to Paris and Venice (he was later made Secretary of State), Carleton had acquired a notable collection of antique sculpture during his time in Italy (1610–1615). Rubens, too, had a collection that he began to amass during his own stay in Italy (1600–1608). In his first letter, Rubens proposed the exchange for "pictures by my hand," and in this letter explains that the paintings he proposes to offer are the "flower of his stock," implying that many paintings by Rubens were not in fact executed for specific commissions but kept by him (he lists 12 paintings in his house). The deal went through, and Rubens then had the greatest collection of antique sculpture in Northern Europe, until he in turn sold part of it a few years later. In the end, 123 marbles from Carleton were exchanged for nine paintings by Rubens, and three paintings by Tintoretto, as well as a set of tapestries from Rubens's collection.

Most Excellent Sir:

By the advice of my agent, I have learned that Your Excellency is very much inclined to make some bargain with me concerning your antiquities; and it has made me hope well of this business, to see that you go about it seriously, having told him the exact price that they cost you. In regard to this, I wish to place my complete trust in your knightly word. . . . Your Excellency may be assured that I shall put prices on my pictures, just as if I were negotiating to sell them for cash; and in this I beg you to rely upon the word of an honest man. I find that at present I have in the house the flower of my stock, particularly some pictures which I have kept for my own enjoyment; some I have even repurchased for more than I had sold them to others. But the whole shall be at the service of Your Excellency, because I like brief negotiations, where each party gives and receives his share at once. To tell the truth, I am so burdened with commissions, both public and private, that for some years to come I cannot commit myself. Nevertheless, in case we agree as I hope, I will not fail to finish as soon as possible all those pictures that are not yet entirely completed, even though named in the list here attached. [*In the margin*: The greater part are finished.] Those that are finished I would send immediately to Your Excellency. In short, if Your Excellency will resolve to place as much trust in me as I do in you, the matter is settled. I am content to offer Your Excellency of the pictures by my hand, enumerated below, to the value of 6,000 florins, at current cash prices, for all those antiquities in Your Excellency's house, of which I have not yet seen the list, nor do I even know the number, but in everything I trust your word. Those pictures which are finished I will consign immediately to Your Excellency, and for the others that remain in my hands to finish, I will furnish good security to Your Excellency, and finish them as soon as possible. . . .

From Your Excellency's most affectionate servant,
Peter Paul Rubens

Antwerp, April 28, 1618

SOURCE: *THE LETTERS OF PETER PAUL RUBENS*, ED. AND TR. RUTH SAUNDERS MAGURN, (CAMBRIDGE, MA: HARVARD UNIVERSITY PRESS, 1971)

ability to combine Italian influences with Netherlandish ideas, thereby creating something entirely new. Rubens is also a Flemish realist in such details as the foliage, the armor of the soldier, and the curly haired dog in the foreground. These varied elements are integrated into a composition of tremendous force. The unstable pyramid of bodies, swaying precariously under the strain of the dramatic action, bursts the limits of the frame in a typically Baroque way, making a viewer feel like a participant in the action.

OIL SKETCHES *The Raising of the Cross* was created for the high altar of the Church of St. Walburga (now destroyed), but we can see from his early oil sketch for this painting (fig. **20.3**) that the dynamic elements characteristic of Baroque style were not yet there. The sketch is more crowded, less focused, and the body of Christ lies nearly perpendicular to the picture plane. In the painting, however, Christ is parallel to the plane, so that we fully see him being raised to the crucifixion. The very concept of "the raising" is a Baroque one; it implies movement and action that is happening at that moment. The entire scene is also dramatic, powerful, and monumental. The oil sketch, which is one of hundreds he produced as preparation in light and color for his finished works, only suggests what is to come—an altarpiece that would be 35 feet high in its final form—a triptych (the wings are not shown here) with a now lost painting of God the Father above, which explains Christ's heavenward imploring glance. The painting was placed on the high altar at the top of 19 steps, so the entire altarpiece ensemble would have towered above all else.

Rubens's epic canvases defined the scope and the style of High Baroque painting. They possess a seemingly boundless energy and inventiveness, which, like his heroic nudes, express life at its fullest. And his portraits were equally inventive and dramatic.

RUBENS AS PORTRAITIST Rubens was one of the greatest and most influential portraitists of the seventeenth century, recording the vast wealth and stature of his often noble patrons. He painted several portraits while in Italy and maintained contacts with his Genoese patrons for years after he left. His resplendent portrait of *Marchesa Brigida Spinola Doria* (fig. **20.4**), a member of the ruling class of Genoese banking families, who invested in trade with Africa and the East, was painted in 1606, probably in celebration of her wedding at age 22.

Although a large painting, it was even more monumental in the seventeenth century—perhaps 9 feet high—before it was

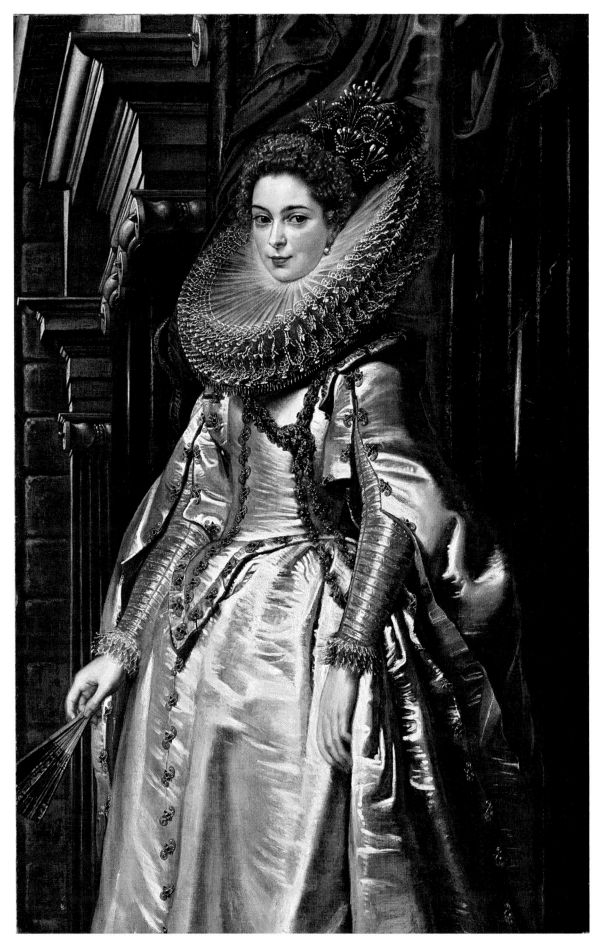

20.4. Peter Paul Rubens. *Marchesa Brigida Spinola Doria*. 1606. Oil on canvas, 5′ × 3′2⅞″ (152.2 × 98.7 cm). The National Gallery of Art, Washington, DC. Samuel H. Kress Collection. 1961.9.60.

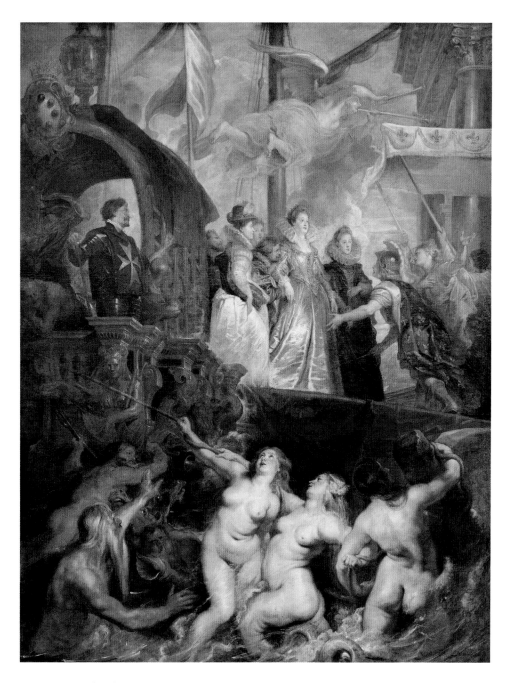

20.5. Peter Paul Rubens. *Marie de' Medici, Queen of France, Landing in Marseilles (3 November 1600).* 1622–1625. Oil on canvas, 12'11½" × 9'7" (3.94 × 2.95 m.). Musée du Louvre, Paris

later cut down on all four sides. A nineteenth-century lithograph of the painting shows that the Marchesa was originally full length, and was shown striding from the terrace of her palazzo. She is sumptuously dressed in white satin, with a matching cape, bejeweled with a rope of gold set with gems of onyx and rubies. Her huge, multilayered ruff, typical of her time and class, frames her face, and her red hair is arranged with decorative combs of pearls and feathers. The vast flowing red cloth, which unfurls behind her, sets the color contrast with her dress and heightens the color of her face. The diagonal movement of this drapery also suggests her forward stride. The size, full-length view, elements of movement, and color against her face are just a few of the aspects that will influence Rubens's student and assistant Anthony van Dyck (see fig. 20.7 and

fig. 20.8) in his portraits. Later stately portraits of the eighteenth and nineteenth centuries will also reflect these influences.

MARIE DE' MEDICI CYCLE Rubens exhibited his virtuoso talent in portraits and monumental historical works in the 1620s with his famous cycle of paintings glorifying the career of Marie de' Medici, widow of Henry IV and mother of Louis XIII, in the Luxembourg Palace in Paris. The cycle consists of 21 paintings at least 13 feet high, with some as much as 28 feet wide. Our illustration shows one episode: the young queen landing in Marseilles (fig. **20.5**). This is hardly an exciting subject, yet Rubens has turned it into a spectacle of unparalleled splendor, combining both reality and allegory. As Marie de' Medici walks down the gangplank (she actually walked up, not

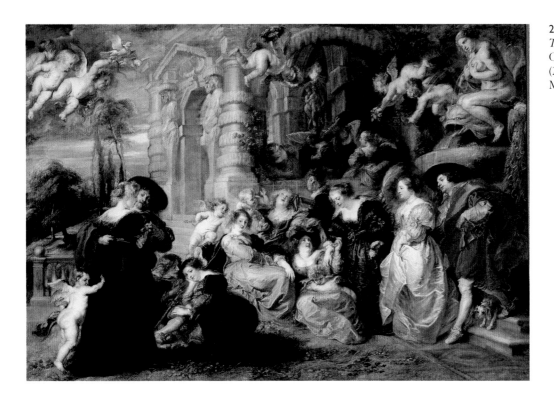

20.6. Peter Paul Rubens. *The Garden of Love*. ca. 1638. Oil on canvas, 6′6″ × 9′3½″ (2 × 2.8 m). Museo del Prado, Madrid

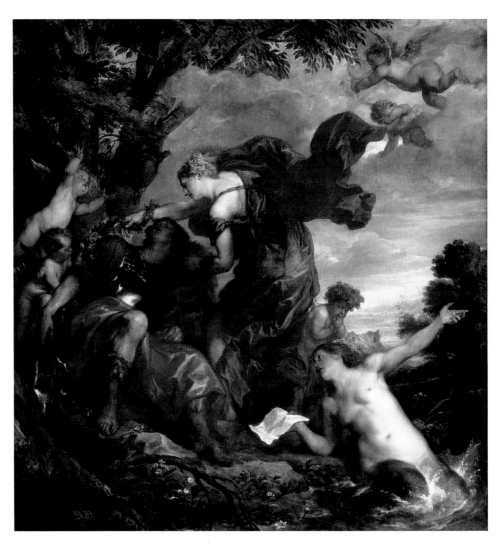

20.7. Anthony van Dyck. *Rinaldo and Armida*. 1629. Oil on canvas, 7′9″ × 7′6″ (2.36 × 2.24 m). The Baltimore Museum of Art, Baltimore, MD. The Jacob Epstein Collection

down—Rubens altered reality to create a diagonal) to enter France, having already married Henry IV by proxy in Florence, she had not yet met her husband. Accompanied by her sister and aunt as Fame flies overhead sounding a triumphant blast on two trumpets, she is welcomed by France, represented allegorically by a figure draped in a *fleur-de-lis* cape. Neptune and his fish-tailed crew, the Nereids, rise from the sea; having guarded the queen's journey, they rejoice at her arrival. Everything flows together here in swirling movement: heaven and Earth, history and allegory.

RUBENS'S WORKSHOP To produce these large paintings, painting cycles, ceilings, and altarpieces, Rubens had a large workshop and most of the Flemish artists that we will discuss in this chapter studied with Rubens. They often traveled as he did, worked on paintings he began or sketched, or began paintings he completed.

Rubens worked as painter and as royal emissary. Diplomatic errands gave him entry to the royal households of the major powers, where he received numerous commissions. He visited the courts of Europe, which took him to Paris, London, and Madrid—having already been to Italy—and he went to the Northern Netherlands to find an engraver for his work. He was truly an international artist.

LATE RUBENS In the 1630s, after Rubens remarried at the age of 53, his art turned inward with the many paintings of his beautiful young wife, his home, and children. He even wrote of being "at home, very contented." Rubens's *The Garden of Love* (fig. **20.6**) is a glowing tribute to life's pleasures. There are couples, cupids, and a lifelike statue of Venus (at the upper left) in a garden in front of a building, much like Rubens's own Italianate house in Antwerp. Suggestions have been made that the male figure on the left is Rubens, and several of the women (mostly, the center-seated one) look like his new wife, Hélène Fourment. Certainly, the sensuality of the *Garden of Love* parallels his life. This painting (and several copies and drawings for it) and the Paris Marie de' Medici cycle would influence eighteenth-century rococo painting (see page 759).

Anthony van Dyck: History and Portraiture at the English Court

Besides Rubens, only one other Flemish Baroque artist won international stature: Anthony van Dyck (1599–1641). He was that rarity among painters: a child prodigy. Before he was 20 he had become Rubens's most valued assistant. And, like Rubens, he developed his mature style only after a stay in Italy.

As a history painter, Van Dyck was at his best in lyrical scenes of mythological love. *Rinaldo and Armida* (fig. **20.7**) is taken from Torquato Tasso's immensely popular poem about the Crusades, *Jerusalem Freed* (1581), which gave rise to a new courtly ideal throughout Europe and inspired numerous operas, as well as paintings (a popular subject of Tiepolo). Men and women at court masques played the roles of Christian Knight and Bewitching Sorceress in acting out this love and adventure story. Van Dyck similarly shows the sorceress falling in love

with the Christian Knight she had intended to slay. The canvas reflects the conception of Charles I, the English monarch for whom it was painted, and who also found parallels in his own life with Tasso's epic. The English monarch, a Protestant, had married the Catholic Henrietta Maria, sister of his main rival, the king of France. Charles saw himself as the virtuous ruler of a peaceful realm much like the Fortunate Isle where Armida had brought Rinaldo. (Ironically, Charles's reign ended in civil war.) The artist tells his story of ideal love in the pictorial language of Titian and Veronese, with an expressiveness and opulence that would have been the envy of any Venetian painter. The picture was so successful that it helped Van Dyck gain appointment to the English court two years later.

Van Dyck's fame rests mainly on the portraits he painted in London between 1632 and 1641. The *Portrait of Charles I Hunting* (fig. **20.8**) shows the king standing near a horse and two grooms in a landscape. Representing the sovereign at ease, the painting might be called a "dismounted equestrian portrait," and it is vastly different in effect from Holbein's *Portrait of*

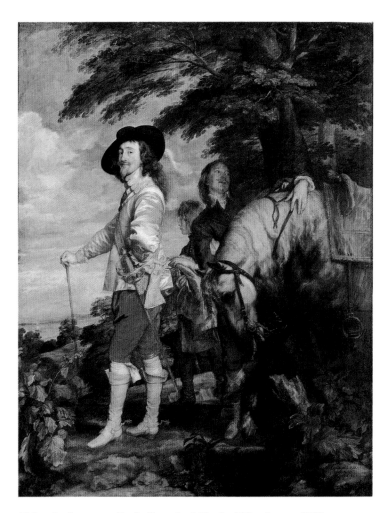

20.8. Anthony van Dyck. *Portrait of Charles I Hunting.* ca. 1635. Oil on canvas, 8'11" × 6'11½" (2.7 × 2.1 m). Musée du Louvre, Paris. Inv.1236

Henry VIII (fig. 18.27). It is less rigid than a formal state portrait, but hardly less grand, for the king remains in full command of the state, symbolized by the horse, which bows its head toward its master. The fluid movement of the setting complements the self-conscious elegance of the king's pose, which continues the stylized grace of Hilliard's portraits (compare with fig. 18.28). Charles's position, however, was less secure than his confidence suggests. Charles I's reign ended in civil war, and he was beheaded in 1649. Charles was succeeded by the Puritan leader Oliver Cromwell and his followers, known as the "Roundheads" in reference to their short cropped hair. In contrast, note that in the painting Charles I's tresses drop below his shoulder in the French (Catholic) manner. However, Charles's son, Charles II, assumed the throne later in the period known as the Restoration.

Van Dyck has brought the court portrait up to date by using Rubens and Titian as his points of departure. He died eight years before the beheading of Charles I and so never worked for the subsequent courts. But he created a new aristocratic portrait tradition that continued in England until the late eighteenth century and which had considerable influence on the Continent as well.

Local Flemish Art and Jacob Jordaens

Jacob Jordaens (1593–1678) was the successor to Rubens and Van Dyck as the leading artist in Flanders, and he outlived both of them. Unlike his predecessors, he did not travel to Italy, and his patrons were mostly of the middle class. Although Jordaens was never a student of Rubens, he was a member of his workshop, and he collaborated with Rubens, turning to

him for inspiration throughout his career. Jordaens's most characteristic subjects are mythological themes depicting the revels of nymphs and satyrs. Like his eating and drinking scenes, which illustrate popular sayings, his mythological paintings reveal him to be a close observer of people. The dwellers of the woods in *Homage to Pomona (Allegory of Fruitfulness)* (fig. **20.9**) inhabit an idyllic realm, untouched by human cares. The painterly execution shows a strong debt to Rubens, but the monumental figures lack Rubens's heroic vigor; there is softness, roundness, and plainness to his figures, which distinguishes his work.

The Bruegel Tradition

The leader of the preceding generation, Jan Brueghel the Elder (1568–1625) was the principal heir to the tradition of his illustrious father, Pieter Bruegel the Elder (see Chapter 18), whom he hardly knew but whom he copied. Jan Brueghel was one of the developers of the "art collection" paintings unique to Flanders that provide us with a view into the depth and variety of European "art collections," which developed in the princely quarters of Antwerp in the seventeenth century. These eclectic collections were known as *kunstkammern* (literally "rooms of art") or *wunderkammern* ("rooms of wonder"), and they provide us with a glimpse of the vast collections of exotica, from sea shells, insects, and rare flowers to scientific instruments and paintings, that were accumulated by the aristocracy and the wealthy at that time.

His *Allegory of Sight* (fig. **20.10**) from a set of *The Five Senses*, executed with Rubens, shows such a *wunder-* or *kunstkammer*. The *Allegory of Sight*, viewed in an art gallery

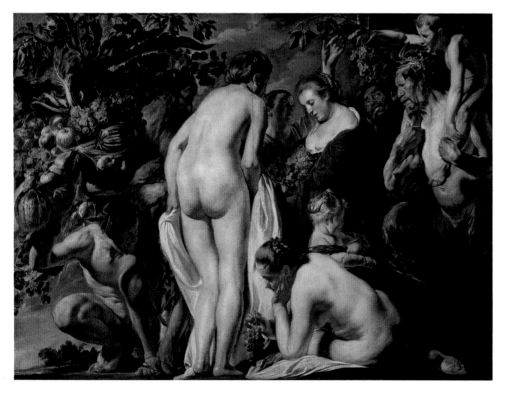

20.9. Jacob Jordaens. *Homage to Pomona (Allegory of Fruitfulness)*. ca. 1623. Oil on canvas, 5'10⅞" × 7'10⅞" (1.8 × 2.4 m). Musées Royaux d'Art et d'Histoire, Brussels. Inv. 119

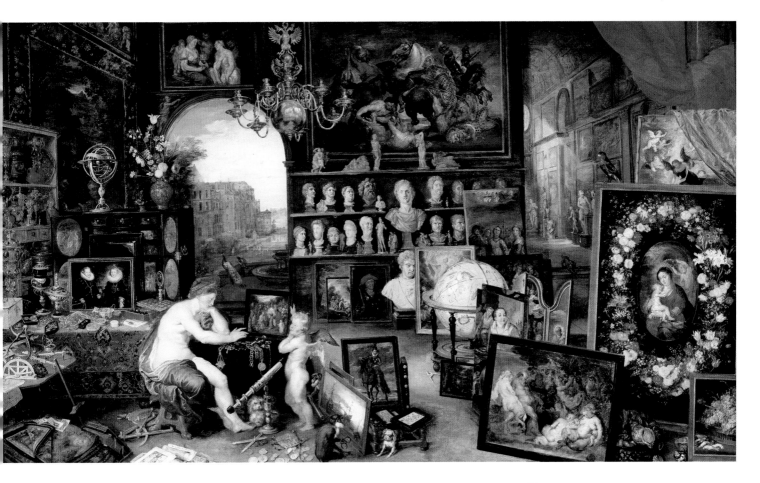

20.10. Jan Brueghel the Elder and Peter Paul Rubens. *Allegory of Sight*. ca. 1617–1618. Oil on panel. 25⅝ × 43″ (65 × 109 cm). Museo del Prado, Madrid

and appreciated only by seeing, is, of course, meant as a visual pun. Jan Brueghel also painted other allegories—*The Seasons* and *The Four Elements*—and was so successful at this and similar paintings that he was appointed by the Antwerp city fathers to direct the efforts of talented painters, including Rubens and Frans Snyders, to create two paintings entitled *The Five Senses* as a gift to the archduke. The collection seen here is that of the Habsburg archduke and archduchess (Albert and Isabella), depicted in a double portrait on the left (by Rubens). They were Catholic rulers who would have associated this homage to the visible world as one connected to spiritual insight (explaining the painting of the Virgin and Child in the foreground). We only glimpse part of the collection in the foreground as the background at right indicates other rooms with more items, but the collection of paintings is prime here. We see scientific instruments (telescopes, globes), a Persian carpet (suggesting the bounty of the world), Roman portrait busts, and large and small paintings: portraits, mythological scenes, and still lifes. Some of the paintings are recognizably by Rubens and indicate his wide range—from a mythological scene of Silenus at the lower right to a lion and

tiger hunt at top left. The large painting seen at right of the *Virgin and Child*, encircled by a wreath of flowers, like this one, is a collaborative effort between Jan Brueghel and Rubens, where Rubens did the figures. Jan Brueghel also collaborated with other artists and was a noted flower painter.

Still-Life Painting

Still-life painting in seventeenth-century Flanders took many forms—in paintings of flowers, game, food, and precious objects. Even Jan Brueghel's *Allegory of Sight* (fig. 20.10) enters into this realm. We usually do not know who commissioned these works and presume they were for private patrons for their homes.

The century opens with predominantly simple paintings, but by mid-century this genre explores the elaborate and dramatic explosion of objects collected at that time.

EARLY STILL LIFE: CLARA PEETERS Probably born in Antwerp, and most closely associated with that city, Clara Peeters (active 1607–ca. 1621) may have also worked in Haarlem, in The Netherlands. Her name, however, is not listed in

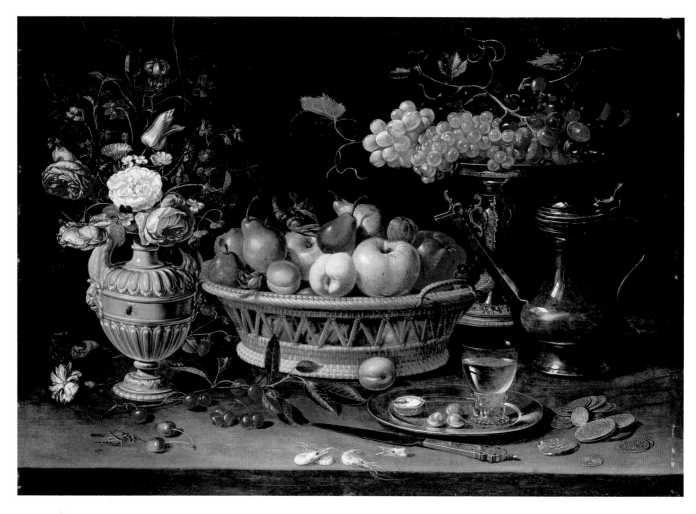

20.11. Clara Peeters. *Still Life with Fruit and Flowers*. ca. 1612. Oil on copper, 25$\frac{1}{5}$ × 35″ (64 × 89 cm) Ashmolean Museum, Oxford

any archival record of these cities, even though the guild in these cities began to admit women and the number of signed works by her indicate that she was a professional artist. Little is known of her life, patrons, or teachers. Nevertheless, she created some of the earliest still-life paintings. *Still Life with Fruit and Flowers* (fig. **20.11**) is an early work that combines studies of both flowers and fruit and displays several different containers, exploring a variety of textures. In the center is a basket of fruit (apples, pears, plums, apricots, and filberts), flanked on the left by a bouquet of colorful flowers (roses, a tulip, columbine, marigold, a cornflower, borage, wild pansies, forget-me-nots, and lilies) in a white pottery vase. On the right is a pewter wine tankard (with a reflection of Peeters) and a silver *tazza* (an Italian-made plate) holding a bunch of grapes. Also on the right is a pewter plate with a glass of white wine and some nuts. Strewn across the wooden table top are prawns, a carnation, a plum, cherries, a grasshopper, a strawberry, some gold and silver coins, and a knife.

Although the natural life here is plentiful, it is the coins and knife that are particularly important for both dating and determining the possible use or meaning of the painting. The coins

have been dated to the reign of the Archduke Albert and Archduchess Isabella (1598–1621), and, based on the painting's style, a date of 1612 has been suggested. The knife (with its matching fork not seen here) is quite special and is a type given as a wedding or betrothal gift. The same knife appears several times in her paintings and was probably copied from an actual one. It is inscribed in Latin with words meaning "fidelity" and "temperance," and is illustrated by small allegorical figures with hearts and clasped hands. Such a knife would often be inscribed with the bride's name, and here it is inscribed "Clara Peeters." Thus, it has been suggested that she painted the work in celebration of her own wedding—and all the fruits and flowers represent the bounty and hopefulness of this event. Such paintings were frequently hung in the dining room of houses and complemented the meals and festivities. Many of Clara Peeters's paintings still remain in private collections today.

GAME STILL LIFE: FRANS SNYDERS A frequent collaborator of Rubens, Frans Snyders (1579–1657) studied with Pieter Brueghel the Younger (1564–1638), brother of Jan Brueghel the Elder and another son of Pieter Bruegel the

Elder. Snyders concentrated on elaborate tabletop still lifes, piled high with foods. His splendid *Market Stall* (fig. **20.12**), an early picture and a masterpiece of its kind, is a frank appeal to the senses. The artist revels in the virtuoso application of paint to create the varied textures of the game. The youth picking the old man's pocket and the hens fighting in the foreground, as a cat looks on from its safe retreat beneath the low bench, further enliven the scene.

Even here Rubens's influence can be found: The composition descends from one Snyders painted with Rubens, based on the latter's design, shortly after they had returned from Italy around 1609. *Market Stall* can be considered an updated version of *The Meat Stall* of Pieter Aertsen (see fig. 18.36). Unlike Aertsen, Snyders subordinates everything to the ensemble, which is characteristically Baroque in its lavishness and immediacy. The painting celebrates a time of peace and prosperity after the truce of 1609, when hunting was resumed in the replenished game preserves.

THE FLAMBOYANT STILL LIFE: JAN DE HEEM By mid-century, still-life paintings were often a lavish display, known as the *pronk* still life for its visual splendor, as *pronk* means "showy" or "ostentatious." This type reached its peak in

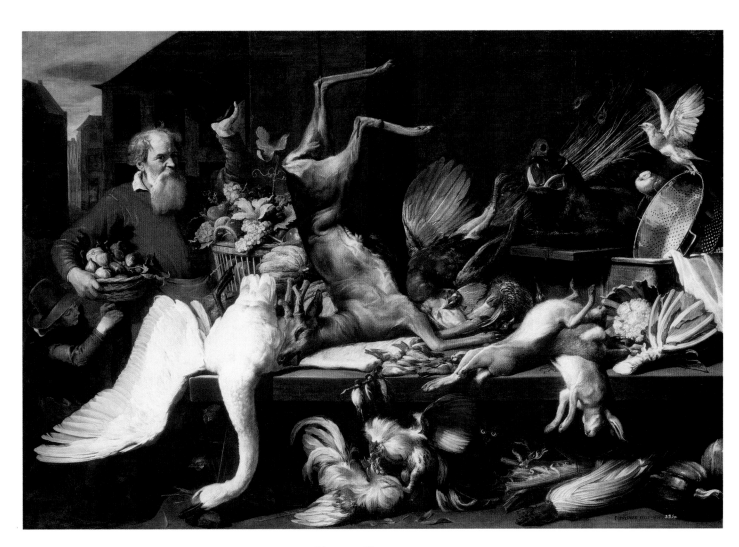

20.12. Frans Snyders. *Market Stall.* 1614. Oil on canvas, 6′11⅞″ × 10′3⅝″ (2.1 × 3 m).
© 1991 The Art Institute of Chicago. Charles H. and Mary F. S. Worcester Fund, 1981.182

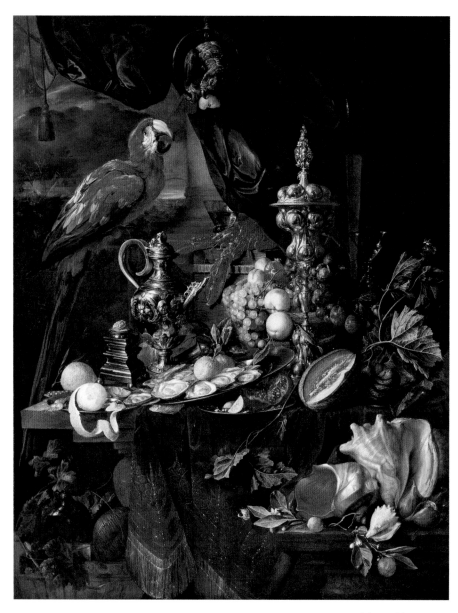

20.13. Jan de Heem. *Still Life with Parrots*. Late 1640s. Oil on canvas, $59\frac{1}{4} \times 45\frac{1}{2}''$ (150.5 × 115.5 cm). Bequest of John Ringling. Collection of the John and Mable Ringling Museum of Art, the State Art Museum of Florida, Sarasota, Florida

the work of Jan de Heem (1606–1684). De Heem began his career in Holland but he soon moved to Flanders where he transformed the still life into his unique, flamboyant style. In *Still Life with Parrots* (fig. **20.13**), he depicts delicious food, exotic birds, and luxurious goods from around the world: The conch and nautilus shells, the parrots, and the lobsters are probably from the New World, and the Seville oranges, plums, grapes, lemons, melons, pomegranates, and oysters are all imported, commanding high prices in the marketplace.

The food is piled up on pewter platters that are unstable and suggest extravagance. Unlike the even, horizontal composition of Peeters, early in the century, the silver, pewter, glass, and gilt ware is set in varying heights, building up to a crescendo topped by the parrots. De Heem intends this to be theatrical, drawing back a curtain for us to see. Even the column in the background is meant to suggest a heroic work. The result is a stunning display of virtuosity and defines the elements of a *pronk* still life.

THE DUTCH REPUBLIC

Art in the Dutch Republic, unlike the art of Flanders, was not based largely on church or state commissions, but was one exercised primarily though private patronage and the open art market. Pictures became a commodity, and their trade followed the law of supply and demand. Many artists produced for the market rather than for individual patrons. They were lured into becoming painters by hopes of success that often failed to materialize, and even the greatest masters were sometimes hard-pressed and could not fully support themselves with the money earned from their art. It was not unusual for an artist to keep an inn or run a small business on the side. Yet they survived—less secure, but freer as a community of artists.

And there were many artistic communities—in Haarlem, Utrecht, Amsterdam, and Delft—to name but a few. Artists frequently traveled between these cities and may have known

each other's work, but most artists are usually associated with only one place—Goltzius and Frans Hals in Haarlem; Terbrugghen in Utrecht; Rembrandt in Amsterdam, and Vermeer in Delft. Some of the paintings were religious in nature, but most were not. There were portraits, group portraits commissioned by civic groups, landscapes, cityscapes, architectural paintings, still lifes, and genre paintings.

There were many types of paintings, and they ranged from large to small—small enough to hold in your hand or for ordinary people to hang on the walls of their homes.

The Haarlem Academy:
Hendrick Goltzius

Like Rubens, Van Dyck, and even Jan Brueghel the Elder, many Dutch artists learned of the greatness of contemporary art in Rome and of its roots in antiquity by going there. And some, like Hendrick Goltzius (1558–1617), made numerous prints and drawings on their sojourn and brought them back for their own and others' use. Goltzius (with two other artists, Karel van Mander and Cornelis Cornelisz van Haarlem) created an "academy" in Haarlem in 1585. We know little about it, but copying from prints, from antiquity, and from each other, was part of their program. The academy also established teachers for the next generation and made the city of Haarlem a focal point for early Dutch painting, printmaking, and drawing.

The collaborative efforts in the academy seem to be limited to Goltzius's engravings of the works of his colleagues, based on their designs or paintings. He was a masterful engraver, whose injured hand (burned in a childhood accident) may have created the force behind his deep curvilinear cuts in the metal (see *Materials and Techniques*, page 498). He also executed woodcuts and only began painting after 1600.

The engraving of the *Farnese Hercules* (fig. **20.14**) illustrates the back of the Hellenistic sculpture owned by the Farnese family, housed in their palace, and also immortalized in a painting in the ceiling (fig. 19.7). It is seen here in its monumental, heroic scale, being viewed by two Dutch men—probably Goltzius's two companions in Italy during his trip of 1590–1591. In many ways, it is an allegory for the wide-eyed Dutch experience in Rome—filled with ruins, architecture, and sculpture of an ancient past. (Indeed, the Dutch would later decide to keep as ruins those buildings nearly destroyed by the Spanish—to have their own ruins of a heroic past.) This *Hercules*, as are others in his series, is also a very large print—a Herculean effort. Goltzius's trip to Italy was taken before Caravaggio and the Baroque, and thus the impact upon him grew from the art of the past, rather than from contemporary Italian works.

The Caravaggisti in Holland:
Hendrick Terbrugghen

The Baroque style came to Holland from Antwerp through the work of Rubens, and from Rome through contact with Caravaggio's followers. Although most Dutch painters did not go to Italy, the majority of those who went in the early years of the century were from Utrecht, a town with strong Catholic traditions. One of the artists from Utrecht, Hendrick Terbrugghen (1588–1629), worked in Italy for several years and was one of the first of the "Caravaggisti" to return to the North. He adapted Caravaggio's style for religious painting, but also for the single figure, genre painting. Terbrugghen's *Singing Lute Player* (fig. **20.15**) is inspired by Caravaggio's painting of the same subject, by his *Musicians* (fig. 19.4), and by others like it, such as the young men in Caravaggio's *The Calling of St. Matthew* (fig. 19.2), who wear slashed doublets and feathered berets. Terbrugghen's portrayal of a life-size, half-length figure, filling the entire canvas, became a common one in Utrecht painting and became popular elsewhere in Holland. The Utrecht School transmitted the style of Caravaggio to other Dutch masters, such as Frans Hals.

20.14. Hendrick Goltzius. *Farnese Hercules*. ca. 1592. Engraving. $16^{1}/_{2} \times 11^{3}/_{4}$" (418 × 301 cm). The Metropolitan Museum of Art, New York. Gift of Henry Walters, 1917. (17.37.59)

20.15. Hendrick Terbrugghen. *Singing Lute Player*. 1624.
Oil on canvas. 39⅝ × 31″ (100.5 × 78.7 cm).
The National Gallery, London. Trustees of the National Gallery

The Haarlem Community and Frans Hals

One of the first to profit from these new ideas permeating the Dutch Republic was Haarlem artist Frans Hals (ca. 1585–1666), who was born in Antwerp. Hals captured his contemporaries in both portraiture and genre painting, and he excelled at combining both—animating his portraits and setting their poses in somewhat relaxed or even casual stances. His genre painting, usually of single figures, portrayed characters that seem to be drawn from real life.

HALS AND THE CIVIC GUARD Hals's six group portraits of the Civic Guards allowed him to provide multiple enlivened portraits into single dynamic paintings. The Civic Guards, founded in the fourteenth century, were local voluntary militia groups that were instrumental in defending their cities through military service. They also had civic and religious duties, and they began having their portraits painted in the early sixteenth century. Although they had successfully defended their cities from the Spanish in the 1580s and, indeed, were proud of this accomplishment, with the truce of 1609, the Civic Guards became more like civic fraternities, with annual banquets, as seen in the *Banquet of the Officers of*

the *St. George Civic Guard* (fig. **20.16**). The military aspects are indeed subordinated to the sense of general prosperity orchestrated in ritual. The captain in the center back wields a knife, but not as a military weapon; he is about to cut the roast. As is the custom, the colonel at the left raises his wine glass at the entrance of the standard bearer walking in with an unfurled banner. The highest ranking officers are seated, while the men of lower rank and the servants stand at the back. The men turn and face each other and the viewer, surrounding a table laden with food on a white damask tablecloth. But 12 men around a table beg comparison with Leonardo's *Last Supper* (fig. 16.6). This is an undeniably secular painting, yet the event depicted is steeped in ceremony.

Although the painting vividly suggests a moment in time at an actual gathering, art historians do not believe that Hals painted an actual event. The officers did not pose for this seating. The realism comes from the life-size scale, their gestures, the three-dimensional modeling created by paint applied "wet-in-wet" with strokes of varied width and length. This modeling creates its own vibrancy, making the men as "speaking likenesses." The Civic Guard painting would become a staple in Haarlem and also in Amsterdam. Rembrandt's *Night Watch* (fig. 20.23) represents another form of this standard.

In Hals's painting, the black-and-white fashions and the setting vibrates with the red-and-white sashes, creating a brilliant tableau. These men, the officers of the company, were wealthy citizens (in the case of Haarlem, they were brewers and merchants) who may have used this civic service to further their careers in government. Some even engaged Hals to execute individual portraits of themselves and family members, and Hals himself became a member of this company in 1612.

A WEDDING PORTRAIT Hals's only double portrait, *Married Couple in a Garden, Portrait of Isaac Massa and Beatrix van der Laen* (fig. **20.17**) probably commemorates the wedding in 1622 of Isaac Massa (1586–1643) and his wife Beatrix van der Laen. It combines the relaxed informal atmosphere of genre painting with the likeness and formal attire of portraiture. This life-size couple seem to enjoy each other and they modestly display their affection by sitting close to each other. Her arm is loped over his elbow displaying her ring (customary on the index finger); they smile broadly, their eyes twinkling, as they sit in a garden—an imaginary Garden of Love—surrounded by ivy, a symbol of steadfast love, faithfulness, and fidelity. Indeed, they seem in love with each other. His right hand touches his chest (his heart) as a show of his intended affection. This painting can be seen in sharp contrast to Jan van Eyck's *The Arnolfini Portrait* (fig. 14.16), and whether we interpret that earlier couple's presence as a betrothal, wedding, or contract, we can see that the emotional tie between the Arnolfini couple was not Van Eyck's concern. This is more than a difference in personal artistic style; it is the difference between the Renaissance and the Baroque, occurring over the course of 200 years. Between Van Eyck and Hals also stood Rubens, who had also executed a wedding portrait of himself and his first wife that may have served as an example to Hals.

20.16. Frans Hals. *Banquet of the Officers of the St. George Civic Guard*. 1616. Oil on canvas, 5'9 × 10'7½" (175 × 324 cm). Frans Hals Museum, Haarlem

20.17. Frans Hals. *Married Couple in a Garden, Portrait of Isaac Massa and Beatrix van der Laen*. ca. 1622. Oil on canvas. 55 × 65½" (140 × 166.5 cm). Rijksmuseum, Amsterdam

Ingeniously, Hals set the couple off center, which adds to the sense of spontaneity, punctuated by the sense that Massa is open-mouthed and speaking to us. They wear expensive lace cuffs; his is a lace collar customary for men and she wears a millstone collar, with an embroidered and ribboned cap, usually worn indoors or under another hat. Her skirt is of silk and her *vlieger* (bodice) of velvet.

Hals painted Isaac Massa, an important and wealthy diplomat, at least two more times as a single figure. Massa had an adventurous life: He was a geographer and a cartographer of Siberia. He traveled to Russia in 1600 and lived there for 8 years where he became fluent in the language. He was active in the fur trade and influential in establishing trade routes between The Netherlands and Russia. But his worldliness is only suggested in this wedding portrait set in his own garden.

HALS AND GENRE PAINTING Hals's mature style is seen in *The Jolly Toper* (fig. **20.18**), which perhaps represents an allegory of Taste, one of the Five Senses, among the most popular themes in the seventeenth century. The painting combines Rubens's robustness with a focus on the "dramatic moment" that must be derived from Caravaggesque painters in Utrecht. Everything here conveys complete spontaneity: the twinkling eyes and half-open mouth, the raised hand, the teetering wine-

glass, and—most important of all—the quick way of setting down the forms. Hals worked in dashing brushstrokes, each so clearly visible that we can almost count the total number of "touches." With this open, split-second technique, the completed picture has the immediacy of a sketch. The impression of a race against time is, of course, deceptive. Hals spent hours on this life-size canvas, but he maintains the illusion of having done it all in the wink of an eye.

Hals, like Rembrandt van Rijn and Jan Vermeer who we will meet in this chapter, is most closely identified with a period referred to as the Golden Age of Dutch Art. Individually these three artists develop and create from their Northern heritage, the unique style of seventeeth-century Dutch art in Haarlem, Amsterdam, and Delft respectively. Neither Hals, Rembrandt, nor Vermeer traveled to Italy.

The Next Generation in Haarlem: Judith Leyster

The most important follower of Hals was Judith Leyster (1609–1660), who was responsible for a number of works that once passed as Hals's own, although she also painted works most unlike his: candle-light scenes and paintings that explored the relationship between men and women. She painted portraits and still lifes, but mostly genre paintings. Her *Self-Portrait*

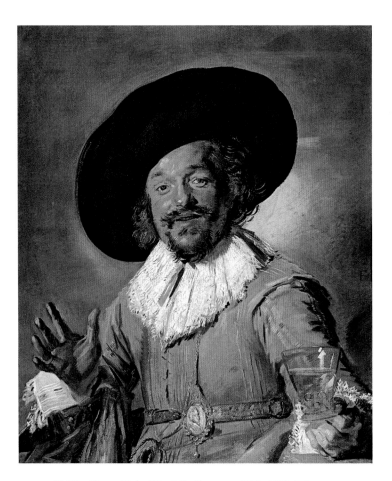

20.18. Frans Hals. *The Jolly Toper.* ca. 1628–1630. Oil on canvas. 31⁷⁄₈ × 26¹⁄₄″ (81 × 66.6 cm). Rijksmuseum, Amsterdam

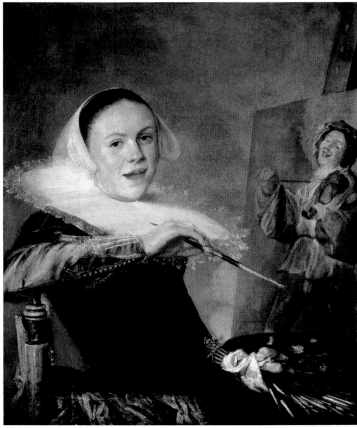

20.19. Judith Leyster. *Self-Portrait.* ca. 1633. Oil on canvas. 29³⁄₈ × 25⁵⁄₈″ (72.3 × 65.3 cm). National Gallery of Art, Washington, DC. Gift of Mr. and Mrs. Robert Woods Bliss

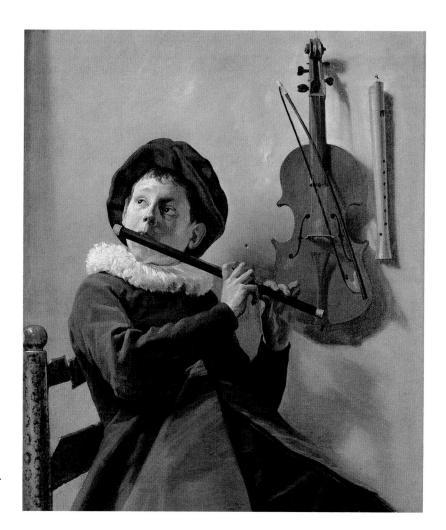

20.20. Judith Leyster. *Young Flute Player.* ca. 1635. Oil on canvas, 28⅝ × 24⅜" (72.1 × 61.9 cm). National Museum, Stockholm

(fig. **20.19**) shows Leyster as both a portrait and genre painter and was executed no doubt to show her mastery of both. It was probably her presentation piece to the Guild of St. Luke in Haarlem in 1633, as her master's piece, when she became a master and had her own students. The painting on the easel is a detail of a popular work of hers, and so she is advertising her diverse talents. It reveals her technical skill as she wields numerous brushes and a palette, as she sits in her studio, open-mouthed and casually conversing with us. Many women artists, as Leyster does here, showed themselves painting—indicating their new professional status and their unique position. Indeed, Artemisia Gentileschi's *Self-Portrait as the Allegory of Painting (La Pittura)* (fig. 19.6), executed about the same time, also explores this same theme.

Leyster did not come from a family of artists, but married into one, when she married a fellow student of Hals's, Jan Miense Molenaer (ca. 1610–1668), who also excelled in genre and portrait painting. Together, the couple moved from Haarlem to Amsterdam. Leyster's *Young Flute Player* (fig. **20.20**) is signed on the recorder on the wall with her monogram, a conjoined J, L, and star, punning on her name, which means "leading star." Indeed, she was referred to during her lifetime as a "leading star" in art. Her rapt musician, possibly representing the Sense of Hearing, is a memorable expression of lyrical mood and is not surprisingly related to Terbrugghen's *Singing Lute Player* (fig. 20.15), as she had spent some time in Utrecht. Leyster explored the poetic quality of light pouring in from the left with an intensity that suggests her work bridges the generation between the Caravaggisti and Jan Vermeer (see figs. 20.34 and 20.35).

Rembrandt and the Art of Amsterdam

Like Hals and Leyster, Rembrandt van Rijn (1606–1669) was influenced indirectly by Caravaggio through the Utrecht School. Rivaling Rubens as the most famous artist of his age, Rembrandt is an artist perhaps better known to us today. A painter, draughtsman, and printmaker, he is equally significant in each medium and established himself in the growing and prosperous center city of Amsterdam. Rembrandt is known both for the intimacy and poignancy of images that convey personal relationships and emotions (see end of Part III, *Additional Primary Sources*)—an aspect seldom explored before—as well as for producing large group portraits and history pieces. He had an active workshop (see *Art Historian's Lens*, page 716) for four decades and many of his followers became significant artists in his native Leiden or in Amsterdam.

Authenticity and Workshops for Rubens and Rembrandt

Rubens and Rembrandt are among the many artists who ran workshops employing other artists. Anthony van Dyck, Frans Snyders, and Jan Breughel the Elder worked with Rubens as well as independently. Frequently, paintings by Rubens will be attributed to "Rubens and Workshop." On the other hand, the idea of collaboration with Rembrandt in a workshop has been slow to develop. The notion of Rembrandt as a solitary genius remained through the twentieth century and has only recently been examined. Paintings found to be not wholly by Rembrandt have been "demoted" and attributed to an artist of his workshop. Art historians have thus begun to rethink workshop practices.

According to some art historians, Rembrandt's *oeuvre* (the number of paintings produced) grew to almost a thousand; other historians thought he had produced a few hundred. In the 1960s, as exhibitions celebrating the three hundredth year after his death were being organized (for 1969), it was clear that art historians had different views of who Rembrandt was and what he did. As such, in 1968, the Rembrandt Research Project was developed, in which a team of art historians who would use scientific methods as well as connoisseurship to establish the authenticity of works attributed to Rembrandt. They would study the wood and canvas supports, date the wood (a process called dendrochronology), take x-rays, use infrared photography, examine paints and ground samples, and view the paintings in teams and see works in raking (strong) light. The researchers made their reports and jointly issued three volumes, *The Corpus of Rembrandt Paintings*, reporting on works painted in 1625–1631, 1631–1634, and 1635–1642. At present, because of deaths and retirements, the committee's personnel has changed, but the project continues.

Although their deliberate and scientific examination has been incredibly useful and a model for others, their analysis of the attributions of Rembrandt works into three categories, A, B, and C, has been most controversial: "A" for authentic works by Rembrandt; "B" for paintings that cannot be either accepted or rejected as authentic (recently, the "B" category has been sarcastically labeled as "Bothersome"); and "C" for works rejected as authentic and to be attributed to others, usually to named followers of Rembrandt. What is missing from this list is the notion of collaboration—the usual workshop method we have seen in the work and workshop of Rubens. Although Rembrandt and Rubens both had active workshops over the course of their careers, art historians have viewed the art from these workshops differently.

20.21. Rembrandt van Rijn. *Portrait of Saskia van Uylenburgh.* 1633. Silverpoint on white prepared parchment, arched at the top. 7¼ × 4″ (185 × 107 mm.). Staatliche Museen Preussischer Kulturbesitz, Kupferstichkabinett, Berlin. Inv. Kdz 1152

REMBRANDT'S DRAWINGS The poignancy of his drawings can be seen in many of his studies "from life"—that is, with the model before him. He drew in pen and ink, wash, red or black chalk, silverpoint, and combinations of these. Rembrandt's drawing of his wife in the *Portrait of Saskia van Uylenburgh* (fig. **20.21**), upon their engagement, is executed in silverpoint, an unforgiving drawing tool (before the invention of the pencil) that requires precision and a sure hand, on parchment. It is clearly meant as a very special drawing to commemorate their betrothal. The inscription states (in Dutch) "this is drawn after my wife, when she was 21 years old, the third day of our betrothal, the 8th of June 1633." They were married a year later; the drawing shows a dreamy-eyed Saskia looking very much in love with the viewer (artist). She wears a straw hat, usually associated with shepherdesses and pastoral, amorous scenes. The flowers in her hat and hands further embellish this idea. Saskia came from a well-to-do family and was the niece of Rembrandt's art dealer. Her features appear in many of his paintings and studies for etchings, until her death at the age of 30 in 1642.

REMBRANDT'S PAINTINGS Rembrandt's earliest paintings are small, sharply lit, and intensely realistic. Many deal with Old Testament subjects, a lifelong preference. (See end of Part III, *Additional Primary Sources*; see also fig. 20.26.) They show both his greater realism and his new emotional attitude. Rembrandt and, indeed, many seventeenth-century Protestants, viewed the stories of the Old Testament in much the same lay Christian spirit that governed Caravaggio's approach to the New Testament—as direct accounts of God's ways with his human creations. Some of these paintings were produced for the

national court in The Hague (despite the Reformation, the use of such images died hard), as well as for private patrons.

How strongly these stories affected him is clear in *The Blinding of Samson* (fig. **20.22**). Painted in the Baroque style he developed in the 1630s after moving to Amsterdam, it shows Rembrandt as a master storyteller. The artist depicts the Old Testament world as full of Oriental splendor and violence, and he is directly influenced by Caravaggio through the Utrecht Caravaggisti. The theatrical light pouring into the dark tent heightens the drama to the pitch of *The Raising of the Cross* (see fig. 20.1) by Rubens, whose work Rembrandt sought to rival. But Rembrandt's decision not to travel to Italy to see the art of antiquity or the Renaissance may have limited his opportunities (see end of Part III, *Additional Primary Sources*). Instead, he brought the outside world to himself. Rembrandt was an avid collector of Near Eastern objects, which often served as props in his pictures.

REMBRANDT AND THE CIVIC GUARD By the 1640s, Rembrandt had become Amsterdam's most sought-after portrait painter, and a man of considerable wealth. His famous group portrait known as *The Night Watch* (fig. **20.23**), because

of its old darkened varnish (now cleaned off), was painted in 1642. It shows a military company in the tradition of Frans Hals's Civic Guard groups (fig. 20.16), possibly assembling for the visit of Marie de' Medici of France to Amsterdam. Although the members of the company had each contributed toward the cost of the huge canvas (originally it was much larger), Rembrandt did not give them equal weight pictorially. He wanted to avoid the mechanically regular designs of earlier group portraits—a problem only Frans Hals had solved successfully. Instead, he made the picture a virtuoso performance filled with movement and lighting, which captures the excitement of the moment and gives the scene unique drama. The focus is on Captain Frans Banning Cocq, whose hand extends toward us and even creates a shadow across the yellow jacket of his lieutenant, while some figures are plunged into shadow and others are hidden by overlapping. Legend has it that the people whose portraits he had obscured were not satisfied with the painting, but there is no evidence for this claim. On the contrary, we know that the painting was much admired in its time, and Rembrandt continued to receive some major public commissions in the 1650s and 1660s.

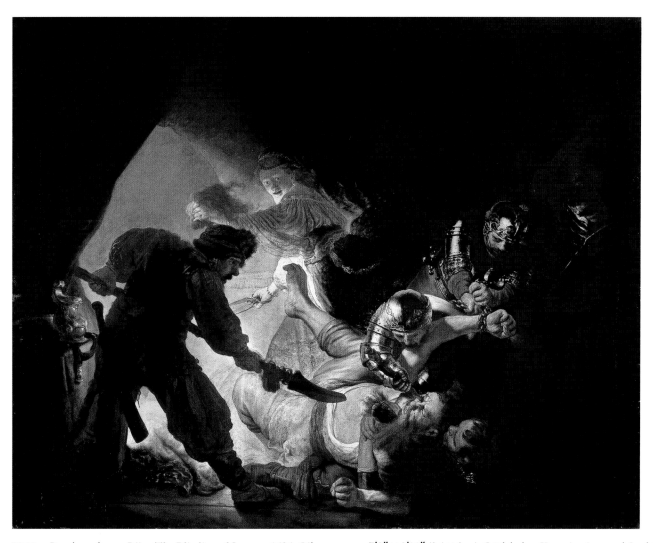

20.22. Rembrandt van Rijn. *The Blinding of Samson*. 1636. Oil on canvas, 7′9″ × 9′11″ (2.4 × 3 m). Städelsches Kunstinstitut und Stadtische Galerie, Frankfurt

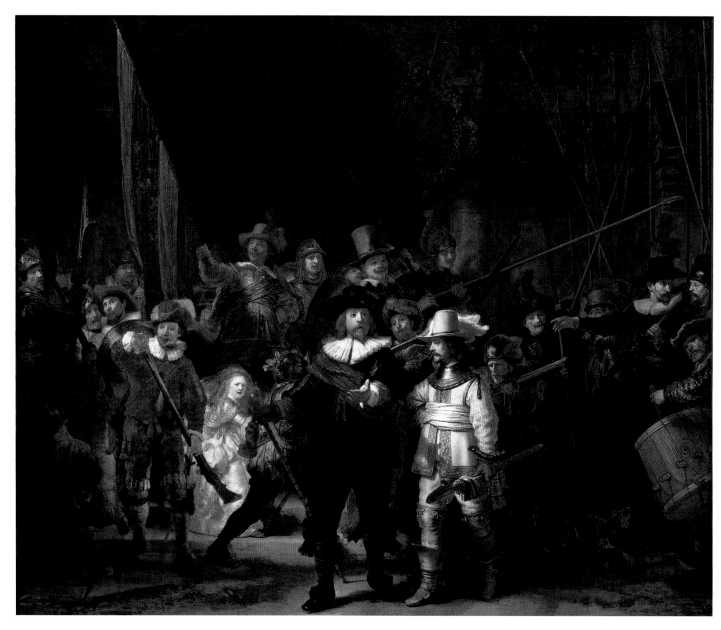

20.23. Rembrandt van Rijn. *The Night Watch (The Company of Captain Frans Banning Cocq).* 1642. Oil on canvas, 12′2″ × 14′7″ (3.8 × 4.4 m). Rijksmuseum, Amsterdam

REMBRANDT AS PRINTMAKER Rembrandt's etchings, such as his famed *The Hundred Guilder Print* (fig. **20.24**), executed in stages over many years, show a new depth of feeling not seen yet in the paintings we have examined. The etching, which has been interpreted as a depiction of the entire nineteenth chapter of the Gospel of St. Matthew, combines various aspects of Christ's preachings, including the healing of the multitudes, and the gathering of children and those who had forsaken all to come to him. This is crystallized in the phrase from a contemporary poem: "The Son of God in a world of sorrow. . . ." The print is poignant and filled with pathos, revealing a humble world of bare feet and ragged clothes. The scene is full of the artist's deep compassion for the poor and outcast, who make up the audience in the print. Rembrandt had a special sympathy for the Jews, both as heirs of the biblical past and as victims of persecution, and they were often his models and also his patrons. The setting of this print suggests some corner in Amsterdam where the Jews had found a haven; they are used here to provide an "authentic" setting for Christ's teachings. Rembrandt incorporates observations of life from the drawings he made throughout his career; several of these drawings have been identified as studies for this work. Here, as in Caravaggio's *The Calling of St. Matthew* (see fig. 19.2), it is the magic of light and dark that gives the *The Hundred Guilder Print* its spiritual significance.

The print derives its name from a story that 100 guilders was the great price paid for it at a contemporary auction. It is a virtuoso combination of etching and drypoint (see *Materials and Techniques*, page 721), which creates a velvety tone that can only be suggested in the reproduction here. Rembrandt's importance as a graphic artist is second only to Dürer's, although we get no more than a hint of his virtuosity from this single example.

SELF-PORTRAITURE Rembrandt painted many self-portraits over his long career. They are experimental in the early Leiden years, theatrically disguised in the 1630s, and frank toward the end of his life. (There have been many suggestions for the reasons behind their execution—as models for other paintings, as explorations of different expressions, and as possible advertisements for his craft.) While our late example (fig. **20.25**) is partially indebted to Titian's portraits (compare with fig. 16.34), Rembrandt examines himself with a typically Northern European candor. The bold pose and penetrating look bespeak a resigned but firm resolve that suggests princely nobility. A comparison with Holbein's *Henry VIII* (fig. 18.27) suggests the similar concept of power, but Holbein's interest in

ART IN TIME

1602—Dutch East India Company founded

1616—Hals's *Banquet of the Officers of the St. George Civic Guard*

1626—New Amsterdam (New York City) founded by the Dutch West India Company

1642—Rembrandt's, *The Night Watch*

1648—Treaty of Münster legally recognizes the Dutch Republic

the detail of fabric and jewels dominates while Rembrandt's display of *chiaroscuro* suggests its mood. There is also a marked difference in technique, as Rembrandt uses impasto, which is the layering of paints and glazes to achieve textured and atmospheric effects. Rembrandt painted several large self-portraits, including this one, toward the end of his life, and the acquisition of a "large mirror" (its breaking is documented) may have allowed him to do this.

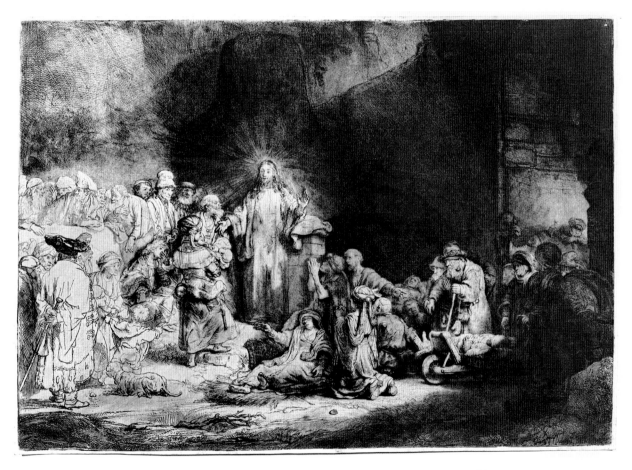

20.24. Rembrandt van Rijn. *The Hundred Guilder Print*. ca. 1647. Etching and dry point. 11 × 12³⁄₄ ″ (27.8 × 32.4 cm). The Metropolitan Museum of Art, New York. H.O. Havemeyer Collection, Bequest of Mrs H.O. Havemeyer, 1929 (29.107.35)

Etching, Drypoint, and Selective Wiping

Etching is a form of intaglio printing. The modern technique calls for a metal plate to be cut by the artist using acid. The process begins with the metal plate initially being coated with a waxy substance. Instead of gouging grooves directly in the metal, the artist can lightly "draw" on the plate with a stylus, thereby removing the waxy coating and revealing the metal beneath. The plate is then placed in an acid bath, and the revealed metal will react with the acid, which will burn away the metal creating grooves. The plate is then removed, wiped off, and covered in ink. The excess ink is then wiped off, leaving ink only in the grooves. As with engraving, dampened paper is used to cover the plate. This is then rolled through a press. But, because the acid continues to burn the metal, the etched lines may be uneven, and depending on the length of time in the acid bath, the grooves may be deeper. With etching, therefore, the actual creation is much like drawing (artists may even carry prepared plates with them), but the finished process also includes a component of chance.

The possibilities for creating greater tonal qualities increased with the introduction of different varieties of paper. In the seventeenth century, several printmakers, including Rembrandt, used papers ranging in quality and origin, from fine laid to a creamy, nubby oatmeal paper, to tan Chinese and Japanese papers, which seemed to make the blacks even blacker. Rembrandt also printed on vellum and even on pigskin.

The range of blacks were further explored by the use of **drypoint**. Drypoint is the process of picking out the metal on a plate with a fine, hard needle and leaving the burr, the metal filings, which will then gather up the ink. This process has the possibility of creating areas of higher black density, as in Rembrandt's *The Hundred Guilder Print* (see fig. 20.24). Drypoint is often used in combination with etching and engraving.

Another option for creating greater tonal range is not to wipe the plate completely clean. This is called **selective wiping**. It can achieve an overall dark tone, creating *chiaroscuro* effects. In some cases, Rembrandt seems to have hardly wiped the plate at all, keeping it mostly inked. This very selective wiping was used to create nocturnal *tenebristic* effects. Rembrandt's dark printed images created an enthusiasm for these dark etchings, and a new form of etching was developed in the late seventeenth century, called mezzotint. This is a process of creating many indentations in the metal so that the entire plate (called a "rocked" plate) will print dark and only some areas, smoothed out by the artist, will print light. This process has recently been revived with the availability of prepared "rocked" plates.

In each of these processes, changes are possible. The initial print is called a *state*. In each case, after printing one example, the artist can make a change. The second printing, using the same plate or block, is called a *second state*. There can be many states for a single print. The block or plate is therefore quite valuable and can be used many years later—even after the artist's death, thereby providing family members or others with income. The block or plate can be purchased, and those who make new prints can even produce new states. Sometimes the artist will deface a plate (called "striking" it) to prevent unauthorized people from using it.

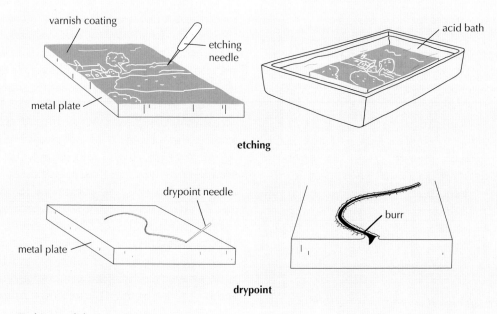

Etching and drypoint

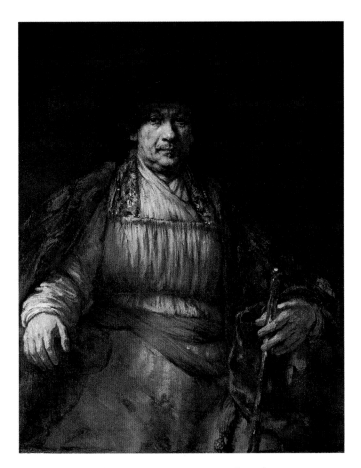

20.25. Rembrandt van Rijn. *Self-Portrait*. 1658. Oil on canvas, 52⅝ × 40⅞″ (133.6 × 103.8 cm). The Frick Collection, New York. Copyright the Frick Collection

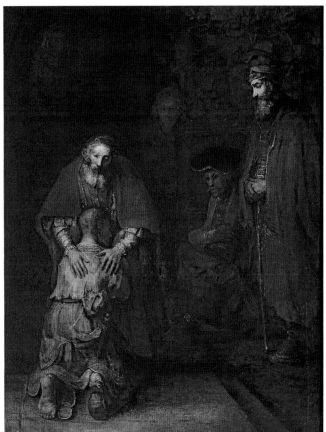

20.26. Rembrandt van Rijn. *The Return of the Prodigal Son*. ca. 1669. Oil on canvas, 8′8″ × 6′7¾″ (2.6 × 2.1 m). Hermitage Museum, St. Petersburg. Inv. GE-742

REMBRANDT'S LATE WORK Rembrandt's work toward the end of his life is punctuated by many religious paintings. *The Return of the Prodigal Son* (fig. **20.26**), created just before his death, may be his most moving painting. It is also his quietest—a moment stretching into eternity. So pervasive is the mood of tender silence that a viewer feels a kinship with this group. That bond is perhaps stronger and more intimate in this picture than in any earlier work of art. In the seventeenth century, artists often explored a different aspect of the adventures of the prodigal son, who is frequently seen spending his inheritance on drink and women. Here, the money has run out; the son has been impoverished and humiliated, and then returns home—to a welcome embrace. In Rembrandt, understanding accumulated over a lifetime achieves a universal expression of sorrow and forgiveness.

THE MARKET: LANDSCAPE, STILL-LIFE, AND GENRE PAINTING

While Italian art was dominated by private patronage or that of the Church, art in Northern Europe was largely made for an open market. Of course, portraits and group portraits, like those for the Civic Guards, were commissioned works, but a great number of paintings were made "on spec"—that is, with the hope that they would be purchased on the open market

from dealers, fairs, stores, and lotteries. We know (see *Primary Source*, page 701) that Rubens kept paintings in stock for his own use, and that these were not commissioned works. Perhaps with princely patrons in mind, Rubens painted many large works, but in Holland, paintings were often small, cabinet size, and with subjects suitable for a middle-class home. Most art buyers in Holland preferred subjects within their own experience: landscapes, architectural views, still lifes, and genre (everyday) scenes. These subjects, we recall, emerged in the latter half of the sixteenth century (see Ch. 18, page 652). As the subjects became fully defined, artists began to specialize. Although this trend was not confined to Holland, Dutch painting was its fountainhead in both volume and variety.

The richest of the newly developed "specialties" was landscape, both as a portrayal of familiar views and as an imaginative vision of nature. Landscapes—frequently with only small human figures or none at all—became a staple of seventeenth-century Dutch painting. We can see the beginnings of this in the work of Pieter Bruegel the Elder (see fig. 18.37) and in Italy as well, in such paintings as Carracci's *Landscape with Flight into Egypt* (see fig. 19.8). But in The Netherlands, the sense of reality, almost a "portrait of the land," was a common theme. A contemporary said of these landscapes: ". . . nothing is lacking except the warmth of the sun and the movement caused by the gentle breeze."

20.27. Jan van Goyen. *Pelkus Gate Near Utrecht.* 1646. Oil on panel, $14\frac{1}{2} \times 22\frac{1}{2}''$ (36.8 × 57.2 cm). The Metropolitan Museum of Art, New York. Gift of Francis Neilson, 1945. (45.146.3)

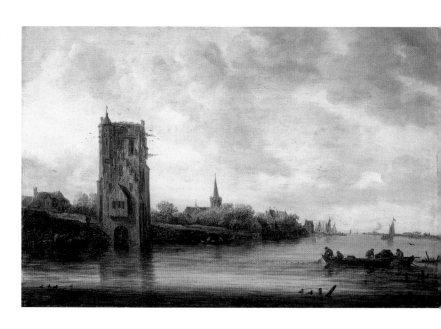

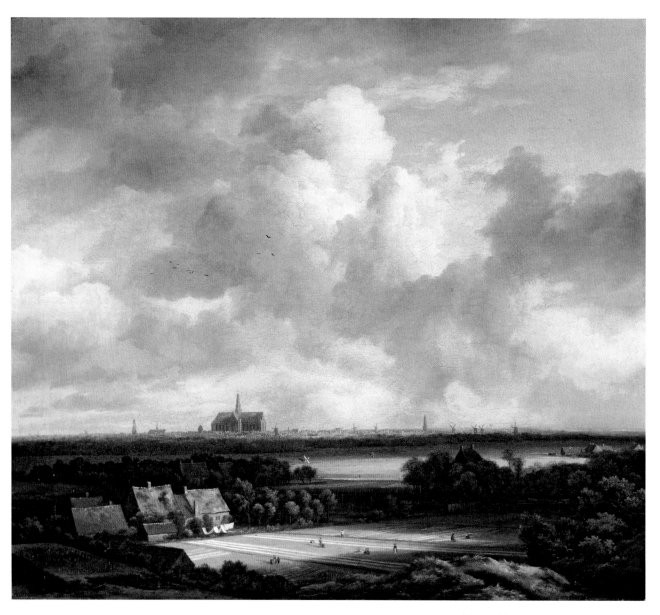

20.28. Jacob van Ruisdael. *Bleaching Grounds Near Haarlem.* ca. 1670. Oil on canvas. $21\frac{2}{3} \times 24\frac{1}{2}''$ (55.5 × 62 m). Royal Cabinet of Paintings, Mauritshuis, The Hague. Inv. 1.55

Landscape Painting: Jan van Goyen

Jan van Goyen's (1596–1656) *Pelkus Gate Near Utrecht* (fig. **20.27**), a seascape or marine painting, is the kind of landscape that enjoyed great popularity because its elements were so familiar: the distant town, seen with a low horizon line, under an overcast sky, through a moist atmosphere across an expanse of water. The painting is characteristic of Van Goyen's ability to combine the familiar with the picturesque, creating a melancholic mood of these "nether lands," ever threatened by the sea, but also in need of it.

Like other early Dutch Baroque landscapists, Van Goyen frequently used only grays and browns, highlighted by green accents, but within this narrow range he achieved an almost infinite variety of effects. The tonal landscape style in Holland was accompanied by radically simplified compositions, and we see this effect in the monochromatic still-life painting (fig. 20.31) of the same time. As he worked in several cities (Haarlem, Leiden, and The Hague), Van Goyen was especially influential and extremely prolific; he is credited with over 1,200 paintings and 800 drawings. His family is also evidence of the interrelationship of artists—his daughter married the genre painter, Jan Steen (see pages 726–728).

City Views Painting: Jacob van Ruisdael

Identifiable city views—panoramic landscapes with their outlying countryside and picturesque sand dunes, showing Amsterdam, Haarlem, Deventer—became popular throughout the century. In the art of Jacob van Ruisdael (ca. 1628–1682) these views become testaments to the city skyline—and to the sky. The sky might occupy three-quarters of the painting, as it does in this painting of Haarlem (fig. 20.28). Ruisdael did many paintings of Haarlem, known as *Haarlempjes* (little views of Haarlem). The church spires, windmills, and ruins are all identifiable, as is the major church, the *Grote-Kerk* (Big Church), known before the Reformation as St. Bavo (see fig. 20.30). In the foreground are the bleaching fields, where both domestic and foreign linen was washed and set out to be bleached by the sun. Haarlem water was well known for its purity and so the city was famous for its linen bleaching and beer production.

A heightened sense of drama is the core of Ruisdael's *The Jewish Cemetery* (fig. **20.29**), for which several drawings of the site exist. Natural forces dominate this wild scene, which is imaginary except for the tombs from the Jewish cemetery near Amsterdam. As we have seen in Rembrandt's work (fig. 20.24), Jews had been living in Amsterdam through the

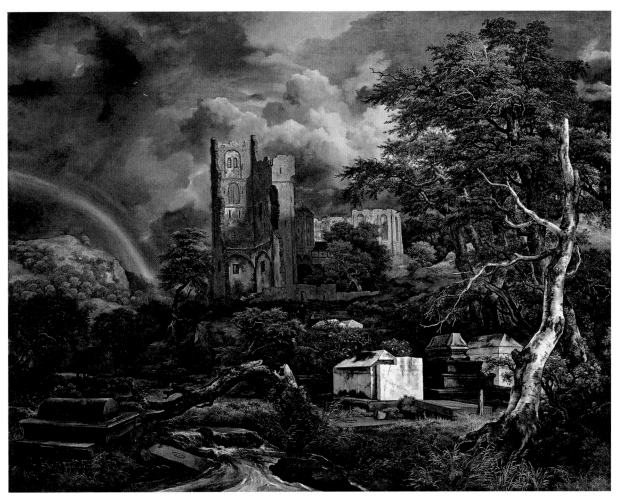

20.29. Jacob van Ruisdael. *The Jewish Cemetery*. 1655–1670. Oil on canvas, 4′6″ × 6′2¹⁄₂″ (1.42 × 1.89 m). The Detroit Institute of Arts, Detroit, MI. Gift of Julius H. Haass in memory of his brother, Dr. Ernest W. Haass

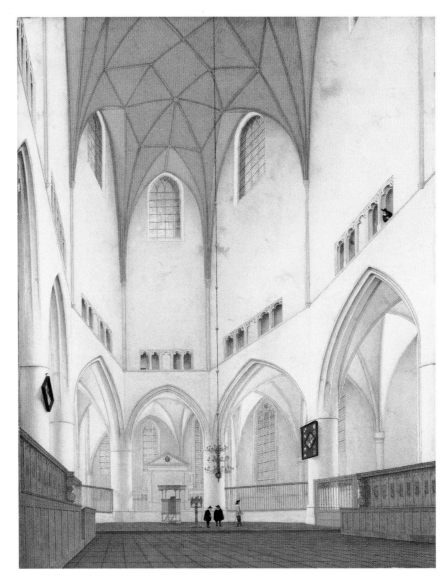

20.30. Pieter Saenredam. *Interior of the Choir of St. Bavo's Church at Haarlem.* 1660. Oil on panel, $27^7/_8 \times 21^5/_8''$ (70.4 × 54.8 cm). Worcester Art Museum, Worcester, Massachusetts. Charlotte E. W. Buffington Fund.1951.29

seventeenth century—some often poor, from Germany and Eastern Europe, others often more prosperous, newly arrived from Brazil, where they sought refuge from the Inquisition in Spain. The cemetery, called *Bet Haim* (House of Life), belonged to the latter group, the Sephardic or Portuguese and Spanish Jews. Each of the tombs has been identified, and, though appearing ancient, they were all erected in the seventeenth century. Several drawings of this site by Ruisdael exist, as do prints by other artists. Jews in Amsterdam were exotic—the "other"— and this may account for the theme's popularity. Foreigners who came to Amsterdam visited and wrote about this community with curiosity and even awe.

In addition to this imaginary wild scene, Ruisdael adds other nonrealistic elements: The ruined building in the background has been identified as Egmond Abbey (Catholic), and it suggests a contrast (or perhaps a complementary relationship) between Jews and Catholics, as both are superseded in the Dutch Republic by the Reformed Church. Thus, the theme of death—the

cemetery, the tombs, the crumbling ruins of the abbey, and the dead trees—suggests the painting as a *vanitas*, a memorial to the brevity of life. The term, *vanitas*, comes from the Biblical book of Ecclesiastes and its phrase "vanity of vanities." It is a text on the passage of time and on mortality, just as this painting is also a visual reminder of the shortness of life. Yet the cemetery is all arced by a rainbow, a sign of God's promise and redemption. *The Jewish Cemetery* inspires that awe on which the Romantics, 150 years later, based their concept of the sublime.

Architectural Painting and Pieter Saenredam

In contrast to the dramatic mood and theatrical setting of *The Jewish Cemetery,* there are many examples, in paintings, prints, and drawings, of descriptive images of the interior of the Sephardic Synagogue and of many of the austere Reformed churches. The *Interior of the Choir of St. Bavo's Church at*

Haarlem (fig. **20.30**), painted by Pieter Saenredam (1597–1665), one of eleven that he painted, is meant to serve as more than a mere record. It is, in fact, an impossible view, suggesting a greater sense of vastness in the medieval structure than actually exists. Saenredam went to great lengths to construct his paintings. First, he made both freehand sketches and measured drawings in the church. His next step was to combine the two in additional drawings. Finally, he would paint a representation of the church that utilized the accurate details of his drawings but also included exaggerated elements for effect. This is the same church that is the focus of Ruisdael's *Bleaching Grounds Near Haarlem* (fig. 20.28). It is shown here stripped of all furnishings and whitewashed under the Protestants, and it has acquired a crystalline purity that invites spiritual contemplation through the painting's quiet intensity. (Both Saenredam and Frans Hals would be buried here.) The tiny figures in the interior provide scale and often narrative. Note the fellow at right looking out the triforium.

Still-life Painting: Willem Claesz. Heda

Dutch still lifes may show the remains of a meal—suggesting pleasure—of food and drink and luxury objects, such as crystal goblets, glasses of different sizes, and silver dishes, chosen for their contrasting shapes, colors, and textures. Flowers, fruits,

and sea shells may be shown. All are part of the world of still life. And these are not too different from ingredients in a Flemish still life; many artists, such as Clara Peeters and Jan de Heem, traveled between both regions.

As seen here in his *Still Life* (fig. **20.31**), the Haarlem artist, Willem Claesz. Heda (1594–1680) was fascinated by various surfaces and reflections—the rough edge of the lemon, the liquid, slimy quality of the oysters, the sparkling light on the glass, the multiple reflections of the window in the glass, the *prunts* (glass drops) on the *roemer* (wine glass), and the engraving on the silver. Heda is famous for these light effects, which are heightened by the tonal quality of the painting, which is largely monochromatic, much as in Jan van Goyen's landscape (fig. 20.27), also of mid-century. These are in marked contrast to the colorful Flemish works of Clara Peeters and Jan de Heem (fig. 20.11 and fig. 20.13). The table is set with white wine, lemon, oysters, and pepper in a cone—a bit of a fancy appetizer in this work—especially as oysters were known as aphrodisiacs. Yet the broken glass and overturned silver *tazza* suggest some upheaval on a narrative level. Whoever sat at this table was suddenly forced to leave the meal. The curtain that time has lowered on the scene, as it were, gives the objects a strange pathos. The unstable composition, with its signs of a hasty departure, suggests transience—a *vanitas*.

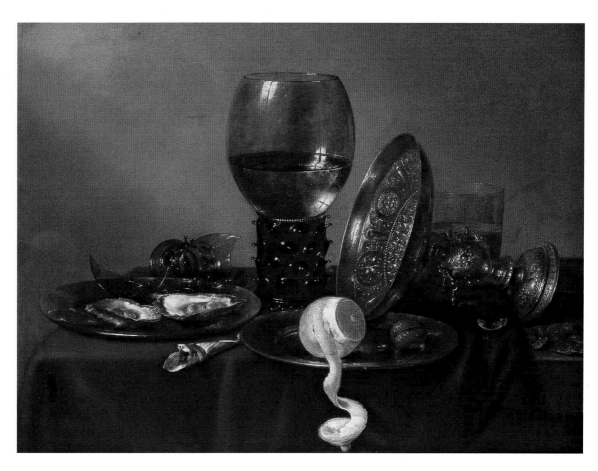

20.31. Willem Claesz. Heda. *Still Life*. 1634. Oil on panel, $16^7/_8 \times 22^7/_8''$ (43×57 cm). Museum Boijmans-van Beuningen, Rotterdam, The Netherlands

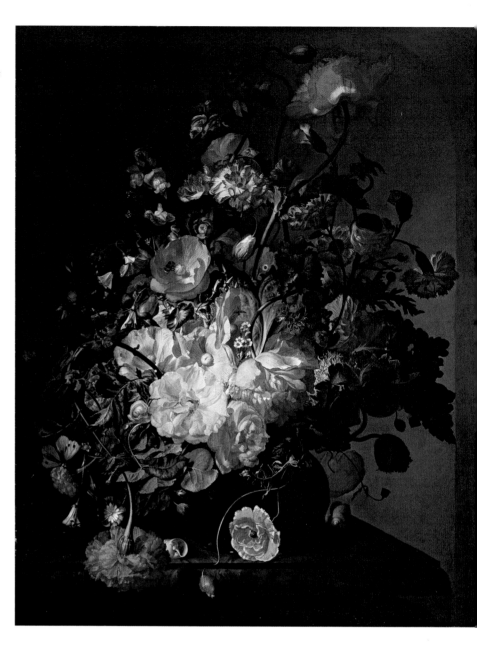

20.32. Rachel Ruysch. *Flower Still Life.* After 1700. Oil on canvas, $29\frac{3}{4} \times 23\frac{7}{8}''$ (75.5 × 60.7 cm). The Toledo Museum of Art, Toledo, Ohio. Purchased with Funds from the Libbey Endowment, Gift of Edward Drummond Libbey. 1956.57

Flower Painting and Rachel Ruysch

The independent floral still life seems to have begun in Flanders, but it developed in both Northern and Southern Netherlands. Rachel Ruysch (1664–1750) was one of the leading Dutch flower painters of the day, and was lauded as such in her lifetime. She had a long and prolific career and worked in Amsterdam, The Hague, and Düsseldorf, where she, with her husband Juriaen Pool II (1665–1745), a portraitist, became, as a team, court painters to the Elector Palatine until his death. One could even say she was born to be a flower painter, as her father was a professor of anatomy and botany. Ruysch knew every blossom, every butterfly, moth, and snail she put into a piece. We know from the inclusion of flowers in earlier paintings, such as the lilies in a vase in the *Mérode Altarpiece* (fig. 14.9), that flowers can have meaning beyond their beauty. The flowers in figure **20.32**, some with stems, wild and impossibly long, are arranged to create an extravaganza of color. Like the Heda *Still Life* (fig. 20.31) with broken glass, this still life has fallen, drooping flowers and suggests the *vanitas* theme.

Genre Painting: Jan Steen

GENRE PAINTING At the end of the seventeenth century, the same themes of genre painting are continued but then contain more narrative. Often there are interior scenes of homes and taverns. The human figures are often no longer half-length; they are shown full length, even when the paintings are small, creating a further sense of intimacy. The paintings of Jan Steen, Jan Vermeer and Gerard ter Borch, provide a range of subject matter from the comical to the deeply introspective, while suggesting a glimpse into the home, family, relationships, and even fashion of the seventeenth century. A scene of both comical circumstance and family intimacy can be seen in *The Feast of St. Nicholas* (fig. **20.33**) by Jan Steen, (1626–1679), St. Nicholas has just paid his pre-Christmas visit to the household, leaving toys, candy, and cake for the children. The little girl and boy are delighted with their presents. She holds a doll of St. John the Baptist and a bucket filled with sweets, while he plays with a golf club and ball. Everybody is jolly except their

brother, on the left, who has received only a birch rod (held by the maidservant) for caning naughty children. Soon his tears will turn to joy, however: His grandmother, in the background, beckons to the bed, where a toy is hidden.

Steen tells the story with relish, embroidering it with many delightful details. Of all the Dutch painters of daily life, he was the sharpest and the most good-humored observer. To supplement his earnings he kept an inn, which may explain his keen insight into human behavior. His sense of timing and his characterizations often remind us of Frans Hals (see figs. 20.16, 20.17, and 20.18), while his storytelling stems from the tradition of Pieter Bruegel the Elder (see fig. 18.38). Steen was also a gifted

ART IN TIME

1639—Japan enforces policy of isolation from Europeans; permits a Dutch trading post

1655/60—Ruisdael's, *The Jewish Cemetery*

1656—Christiaan Huygens invents pendulum clock

1666—Vermeer's, *The Love Letter*

1676—Anthony van Leeuwenhoek first to record bacteria under a microscope

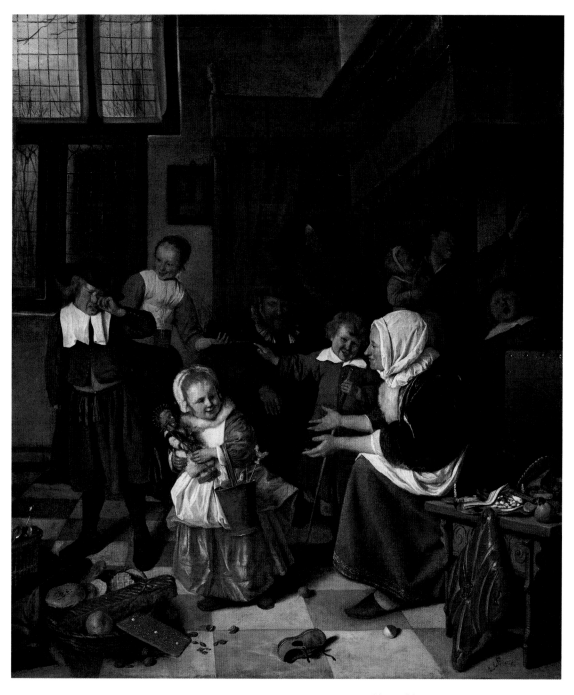

20.33. Jan Steen. *The Feast of St. Nicholas.* ca. 1665–1668. Oil on canvas, $32\frac{1}{4} \times 27\frac{3}{4}''$ (82 × 70.5 cm). Rijksmuseum, Amsterdam

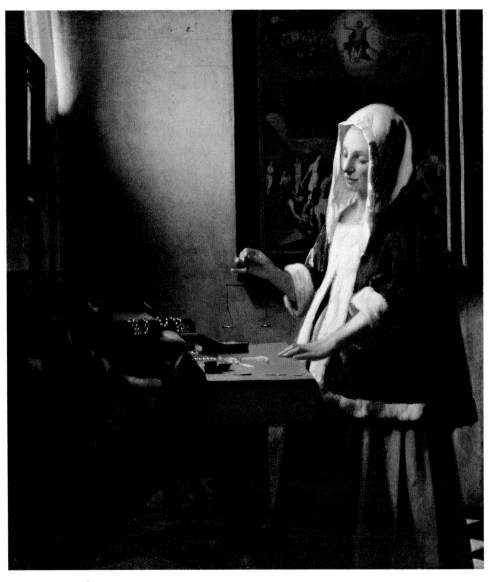

20.34. Jan Vermeer. *Woman Holding a Balance.* ca. 1664. Oil on canvas, $16^{3}/_{4} \times 15''$ (42.5 × 38.1 cm). National Gallery of Art, Washington, DC. Widener Collection. (1942.9.97)

history painter, and although portions of his work are indeed humorous, they usually convey a serious message as well. *The Feast of Saint Nicholas* has such a content: The doll of St. John the Baptist is meant as a reminder of the importance of spiritual matters over worldly possessions, no matter how pleasurable.

Intimate Genre Painting and Jan Vermeer

In the genre scenes of the Delft artist Jan Vermeer (1632–1675), by contrast, there is no clear narrative. Single figures, usually women, are seemingly engaged in everyday tasks at private moments. They exist in a timeless "still life" world, as if becalmed by a spell. In *Woman Holding a Balance* (fig. **20.34**), a young woman, richly dressed in the at-home wear of the day, is contemplating a balance in her hand, with strings of pearls and gold coins spread out on the table before her. The painting gives a view into such a still-life world—with pearls and gold, paintings and fur all magically created to provide an eternal,

yet momentary, glance into a private world where, in fact, our view is not acknowledged. The painting in the background depicts Christ at the Last Judgment, when every soul is weighed. This may refer to the soul of her unborn child, and it parallels the woman's own activity, now contemplating the future of her unborn child. The pans of the balance were once thought to contain gold or pearls but scientific analysis of the painting indicates that they actually contain nothing, only beads of light. The painting is intensely private, quiet, yet also highly sensual, created with optical effects that make the surface shimmer.

Vermeer's use of light, frequently from a window at the left, with flecks of light on fabric, and reflections, mark his work. To achieve these effects that create a perfectly balanced painting, he seems to have used mechanics that are both old and new. Vermeer may have used a *camera obscura*, an experimental optical device (a forerunner of the photographic camera) that created

an image by means of a hole for light on the inside of a dark box. The hole acts as a primitive lens and a scene from outside the box can be seen, inverted, inside it. It is not suggested here that Vermeer copied such scenes, but he may have been inspired by them. Such scenes have a sparkling quality, often seen in parts of Vermeer's work (as seen here in the pearls and in the light on the balance). These sparkling areas are known as "discs of confusion." The *camera obscura* was well-known, and there is considerable evidence that it was used by Dutch artists. Further, Anthony van Leeuwenhoek, the inventor of the modern microscope, was a contemporary who lived in Delft and this suggests a local interest in practical optics.

This new way of looking is paired with an old way—one-point perspective view with a vanishing point. It has been shown that a hole (for a pin and string) was set in a number of Vermeer's paintings to create a one-point perspective system. The vanishing point in figure 20.34 is just to the left of the pinky finger that holds the balance. It sets the balance of all elements of the painting.

Vermeer's mastery of light's expressive qualities raises his concern for the reality of appearance to the level of poetry. He is concerned with all of light's visual and symbolic possibilities. *Woman Holding a Balance* is also testimony to the artist's faith: He was a Catholic (as was Jan Steen) living in Protestant Holland, where his religion was officially banned, although worship in private houses was tolerated.

A contemporary of Vermeer's remarked that he had seen "some examples of his [Vermeer's] art, the most extraordinary and most curious aspect of which consists in the perspective." Surely he was writing about *The Love Letter* (fig. **20.35**) or paintings like it, where the perspective system, through the use of the patterned tiled floor and doorway, is most striking. And indeed a vanishing point with pinhole is also observable in an x-ray. The subject of the painting itself is one of triple intimacy—between the woman and her lover (the sender of the letter), between the woman and her maid (who hands her employer this piece of private correspondence), and between us and this scene (as we peer, perhaps spy, into it).

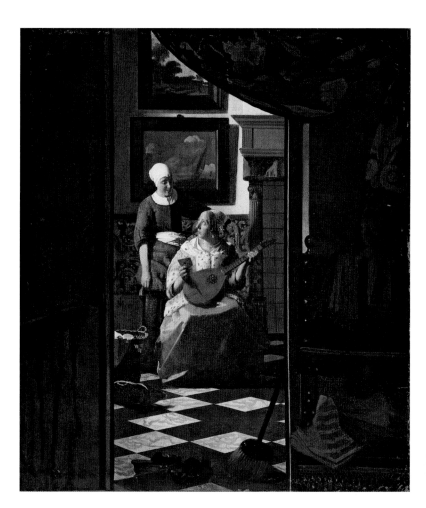

20.35. Jan Vermeer. *The Love Letter.* 1665–1668. Oil on canvas, 17¼ × 15¼″ (43.8 × 38.7 cm). Rijksmuseum, Amsterdam

The Exquisite Genre Painting of Gerard ter Borch

Perhaps the most elegant—even exquisite—Dutch genre paintings were executed by Gerard ter Borch (1617–1681), who worked in the small city of Zwolle, but traveled widely both within Holland (he worked in both Haarlem and Amsterdam) and Europe. He came from a family of artists but little is known of his patrons or commissions. He painted both portraits and genre scenes; both types were often small (about the size of a notebook), but the figures were full-length and attired in the height of fashion. Such is the case in the *Lady at Her Toilet* (fig. **20.36**). She is, as are most of his women, dressed in satin, and Ter Borch was noted as an expert in recording this luxurious fabric. He did this by creating highly contrasting areas of light and dark, and by allowing the long satin skirts to reach the floor and buckle, creating even more shadows. This exact dress is also worn by another woman in a different painting, and these repeated patterns suggest that Ter Borch made drawings that he could use over again. The figures stand in a seemingly contemporary, but possibly imaginary, late seventeenth-century room, with a marble, four-column fireplace, and with canopied bed in the background. There is a Turkish-carpeted table and a page, magnificently dressed. (Pages or messengers similarly dressed also appear in paintings by other contemporary artists.) The simplicity of the room accentuates the high fashion of the woman, who appears more elegant than the equally wealthy subject of Vermeer's *The Love Letter* (fig. 20.35). Her maid adjusts her dress. The mirror set in a contemporary gilt frame reflects the profile of the woman; in reality, she could not be seen from that angle. The theme of "Venus at her Toilet" can be seen in the work of Titian, Vouet, and Boucher (figs. 17.30, 21.3, 22.5), but this is a nonmythological Venus, whose breathtaking beauty is reflected in all the trappings around her. The painting looks forward to the magnificence and opulence of the eighteenth century.

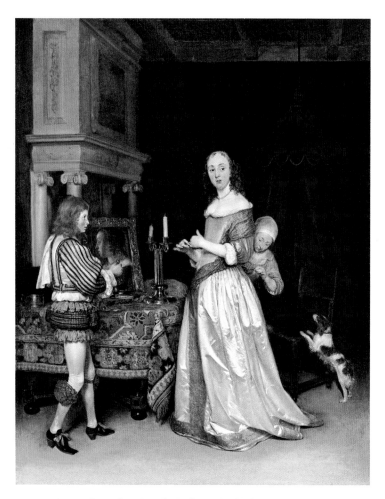

20.36. Gerard ter Borch. *Lady at Her Toilet*. ca. 1660. Oil on canvas. 30 × 23½″ (76.2 × 59.7 cm.). The Detroit Institute of Art, Detroit, MI. Founders Society Purchase, Eleanor Clay Ford Fund, General Membership Fund, Endowment Income Fund, and Special Activities Fund. 65.10

The theme of love letters was common in the seventeenth century. Here, the woman (in fig. **20.35**), dressed sumptuously in ermine and satin and bedecked in pearls, receives a letter (envelope) while sitting beneath a painting of the sea. Emblematic literature suggests that this refers to a lover far away and a letter sent by sea. The lute, an instrument filled with erotic meaning, traditionally signifies the harmony between lovers. The woman's yellow satin cape trimmed with ermine, as well as the pearl earrings and necklace, can also be seen in at least three other paintings by Vermeer. In the estate inventory after his death, a yellow satin jacket hemmed with white fur is listed and may have been a studio prop.

But all of these facts somehow do not get to the magical, hypnotic, truly original nature of his paintings. We do not know Vermeer's teachers or how he developed his unique style. No painter since Jan van Eyck *saw* as intensely as Vermeer. No other painter recorded his seeing in this exact yet somehow personal way.

SUMMARY

In the seventeenth century, the Southern Netherlands (often know as Flanders) and the Northern Netherlands (eventually the Dutch Republic, often called Holland) were separated, even divided, by religion and government, and thus patronage in the two regions differed as well. Flanders, under Spanish rule was Catholic, and the Dutch Republic was predominately of the Reformed Church. Thus Catholic Church altarpieces, funded by major commissions, were executed in Flanders, whereas paintings of genre, still life, and landscape, while also painted in Flanders, were the dominant themes in Dutch art. Both Flanders and Holland saw the production of many portraits—with Civic Guard portraiture becoming a staple in Holland. Artists frequently traveled between the two regions.

FLANDERS

Peter Paul Rubens and his workshop dominated the art of Flanders. Rubens was the dominant force in Antwerp, and he created the Baroque style there. His style was disseminated by his workshop, both by individual artists

and through collaborative projects. His paintings were grand, dynamic, and expressive. Upon his return from a time in Italy, he brought much of the force and dynamism of the Italian Baroque style to Northern Europe. The influence of Michelangelo, Caravaggio, and Titian can be seen in his works. The majority of his major commissions were altarpieces and portraits for the wealthy and ruling families of Italy and France, including the Marie de' Medici cycle. His workshop included artists who completed and collaborated on his works or who later worked independently, executing their own major commissions.

Anthony van Dyck, Rubens's assistant, was primarily a portrait and history painter. He also went to Italy, but later became the court painter to Charles I of England. His paintings are known for their elegance and for the impact of their color, which owed a debt to Titian.

Still-life painting in Flanders was executed in many forms; as a background for figure painting or as independent works. An example of collaborative work is the painting by Jan Brueghel and Rubens of the Five Senses. Independently executed still lifes, including both flower and food subjects, may be seen in the works of Clara Peeters. Game pieces were made by Frans Snyders, and elaborate (known as *pronk*) still lifes were produced by Jan de Heem.

HOLLAND

Painting in the Dutch Republic was centered in several different cities: Utrecht, Haarlem, Amsterdam, and Delft. Ultrecht artists such as Hendrick Terbrugghen were frequently followers of Caravaggio. The Haarlem community of artists focused on portraits and genre painting—with the innovations in brushwork and in the representation of the individual. This can be seen in the individual, couple, and group portraits of Frans Hals. His work on Civic Guard portraiture was revolutionary. He, too, had many followers, although they were more independent than Rubens's followers. They included Judith Leyster, a genre, portrait, and still-life painter.

Rembrandt and his school dominated Amsterdam. Rembrandt produced many history paintings, portraits, and etchings. He is known for his depiction of the inner person and for revealing the pathos in a scene or moment. His works are famous for their poignancy.

THE MARKET: LANDSCAPE, STILL-LIFE, AND GENRE PAINTING

Landscape, still-life, and genre painting were the staple of the Dutch art market. Many of the landscapes were inspired by actual locales, and we can recognize these places in the works of Jan van Goyen and Jacob van Ruisdael, as well as in the architectural painting of Pieter Saenredam. Dutch still-life paintings paralleled those of Flanders in that they were simpler early in the seventeenth century and became more elaborate later—as in the flower still lifes of Rachel Ruysch. Vermeer's contribution to genre painting lies in the isolation of the single figure, suggesting a powerful intimacy. Other genre painters from the latter half of the century are Jan Steen and Gerard ter Borch.

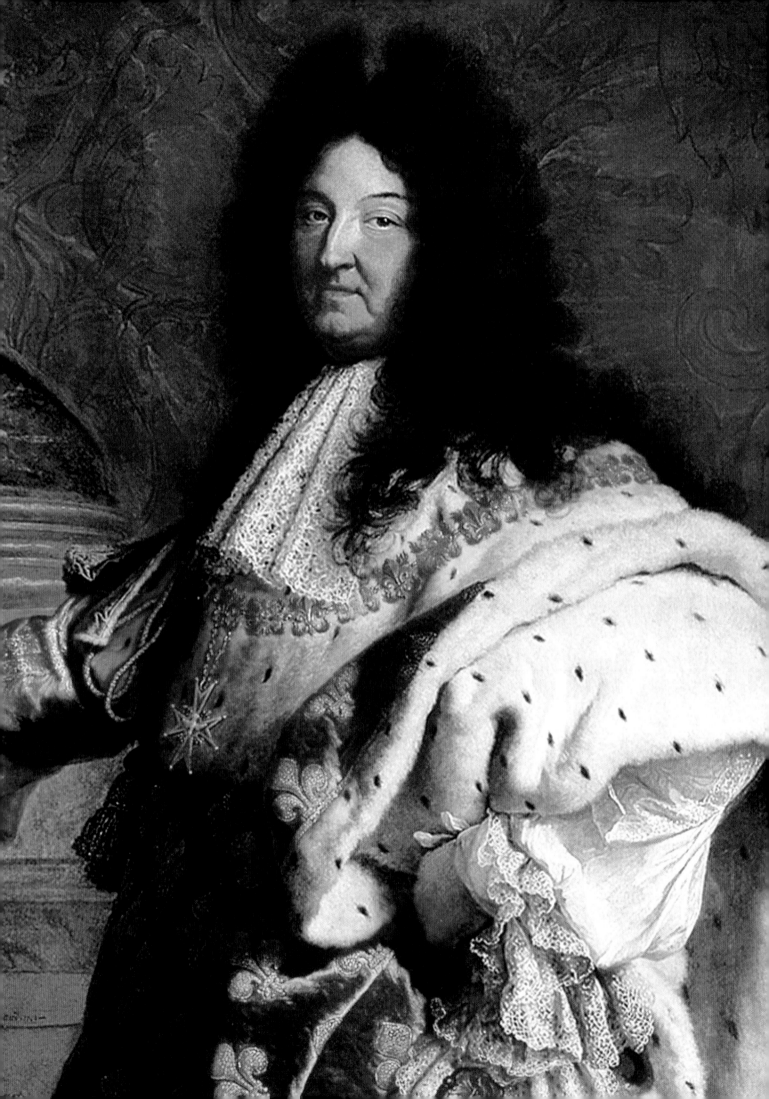

The Baroque in France and England

DURING THE COURSE OF THE TUMULTUOUS SEVENTEENTH CENTURY, the great monarchies of France and England—the former led by an absolute ruler, the latter governed by a king who shared power with the Parliament—underwent dramatic change. Devastated by the previous era's religious wars and dynastic struggles, both nations saw their

treasuries sorely drained, their populations severely reduced, and their societies bitterly divided. The theological controversies that had characterized the earlier Reformation and Counter-Reformation continued in this period, with Catholicism becoming the dominant religion in France and Protestantism in England. Each successive French and English monarch sought to strike a delicate balance between these competing forces while attempting to favor the religion of his choice. Such was true throughout Europe, where isolated skirmishes eventually coalesced into a conflict that encompassed nearly all nations—the Thirty Years' War (1618–1648).

England faced still more upheaval as its kings engaged in bitter battles with Parliament. The situation degenerated in 1642 into a civil war that led to the trial of King Charles I, who was convicted of treason and beheaded in 1649. With the abolishment of the monarchy, the Puritan Oliver Cromwell was named head of state and Lord Protector. Gradually his rule became a dictatorship with its own monarchial abuses, and upon his death in 1658 his government floundered. Two years later, in 1660, Parliament offered the throne to the son of the beheaded king, Charles II (1649–1685), thus ushering in the period known as the Restoration. Unfortunately, old religious rivalries and economic crises persisted, and the reign of Charles II's

successor, James II (r. 1685–1688), was soon in jeopardy. In the so-called Glorious Revolution of 1688, a relatively peaceful and bloodless event, members of the governing classes of Whigs and Tories proclaimed the Prince of Orange, Stadholder, ruler of the Dutch Republic, as king of England, who reigned as William III from 1689 to 1702. The Bill of Rights (1689) established Parliament's supremacy, thus creating a unique form of government that would gradually influence nations worldwide, notably the British colonies in North America.

Waging war was an expansive undertaking requiring an efficient government system to be successful, and sovereigns throughout Europe quickly realized the pressing need to consolidate the state's power and exert economic control. In France, which by midcentury had emerged as Europe's most powerful nation both militarily and culturally, this centralization was most successfully implemented by Louis XIV (1638–1715). Louis evoked the age-old divine right of kings—the idea that the monarch received his authority directly from God—in order to increase the state's power by gaining control over the nobility, amassing revenue through taxation, and curbing the power of local authorities. He relied on a form of royal government known as absolutism, which gave full power to the monarch. The absolute monarchy in France differed from England's constitutional monarchy, which divided power between the ruler and other institutions, Parliament being the most significant, although all European monarchies shared to some degree the

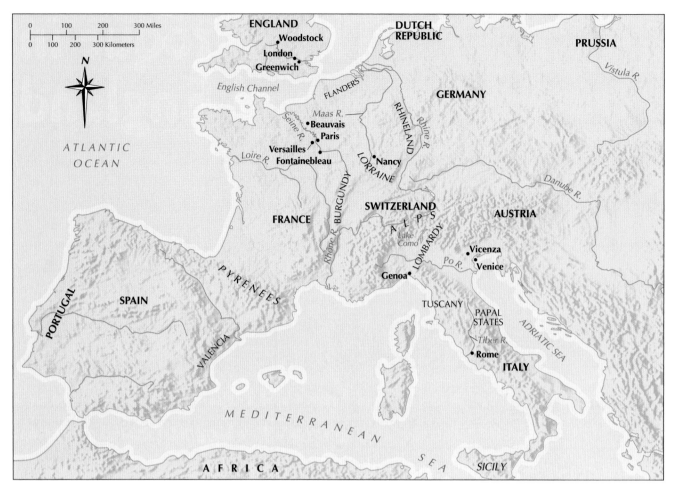

Map 21.1. Europe in the Seventeenth Century

notion of divine right. In his quest to assert the preeminence of France, Louis XIV embarked on a series of military campaigns from 1688 to 1713 against his rivals, Spain, The Dutch Republic, Germany, and England. Despite eventual defeat, France remained a world power upon Louis's death in 1715.

The wars and social turmoil took perhaps their harshest toll on peasants and commoners, who reeled from continually increasing taxes as well as from devastating natural disasters and the ensuing food shortages, famine, and rising prices. Rural and urban revolts broke out frequently, but such resistance was doomed, harshly suppressed by the state. Yet despite the abject poverty endured by some members of society, others enjoyed new wealth and prosperity. Both England and France reaped enormous profits from investments in their colonial empires, and established trading routes delivering a wider range of goods that enhanced the lifestyles of all Europeans. The development of mercantilism and a worldwide marketplace brought about the rise of a class of increasingly wealthy urban merchants seeking art to furnish and decorate their homes.

In the emerging capital cities of Paris and London (see map 21.1), the grandiose style of expanding civic projects, notably architecture, symbolized the wealth of each nation. By the late seventeenth century Paris was vying with Rome as Europe's art center. The French kings Henry IV (r. 1589–1610), Louis XIII (r. 1610–1643), and Louis XIV (r. 1643–1715)—aided by ambi-

tious and able ministers and advisers such as the Duc de Sully, cardinals Richelieu and Mazarin, and Jean-Baptiste Colbert—created the climate for this exciting turn of events. The kings and their officials recognized the power of art to convey the majesty and strength of the monarchy, and they set out on a massive program of patronage of all the arts and sciences—painting, sculpture, architecture, landscape design, decorative arts, theoretical and applied science, philosophy, and literature. Louis XIV especially manipulated art to serve as propaganda for his absolutist policies. He adopted the symbolic imagery of the sun as well as the Greek god Apollo and came to be called the Sun King. This symbolism provided an ancient lineage for Louis that would serve his principle as absolute ruler. The ideal of *gloire* (glory), seen in the portraits and architecture he commissioned, reflected his desire to give concrete form to the majesty of his rule, and thus of France.

During this period, the royal courts in England and France served as the greatest patron of the arts. Art historians most associate the style of classicism with the art of these two nations. Through its use of Classical vocabulary—from columns, capitals, and pediments in architecture to styles of dress in painting—classicism represents a response to the ancient world and suggests authority, order, and enduring tradition in its evocation of the imperial grandeur of Rome. Although the Mannerist style of the later school of Fontainebleau persisted in France

until about 1625 (see pages 625–628), classicism soon became the hallmark of seventeenth-century French art. It became the official court style of painting between 1660 and 1685, a period corresponding to the climactic phase of Louis XIV's reign. Classical principles also dominated architecture, with the new Louvre and Versailles representing the most visible accomplishments of Baroque classicism in France.

In England, too, classicism dominated art and architecture, notably the hospitals, churches, and country houses designed by Inigo Jones and Sir Christopher Wren. In the wake of the Great Fire of London in 1666, architecture thrived as massive reconstruction projects were undertaken to rebuild the city. Yet England's lasting artistic successes in the seventeenth century were in literature, with notable works by William Shakespeare, John Donne, and John Milton as well as the royal committee's translation of what would become known as the King James Bible.

FRANCE: THE STYLE OF LOUIS XIV

Because the Palace of Versailles and other vast building projects glorified the French king, we are tempted to think of French art in the age of Louis XIV as the expression of absolute rule. This perception holds true for the period 1660–1685, but by that time seventeenth-century French painting and sculpture had already attained its distinctive, Classical character. French historians are reluctant to call this style Baroque but refer to it instead as the *Style of Louis XIV*. They also use this term to describe art created prior to Louis XIV, particularly art produced in the court of his father, Louis XIII. In addition, scholars often describe the period's art and literature as "classic." In this context, the word has three meanings. It is a synonym for "highest achievement," which suggests that the Style of Louis XIV is the equivalent of the High Renaissance in Italy or the age of Perikles in ancient Greece. It also refers to the imitation of the forms and subject matter of Classical antiquity. Finally, it suggests qualities of balance and restraint shared by ancient art and the Renaissance. The last two meanings describe what could more accurately be called **classicism**. Because the Style of Louis XIV reflects Italian Baroque art, although in modified form, we may call it Baroque classicism.

Painting and Printmaking in France

The many foreign artists working in France drew inspiration from that country's styles and traditions, whereas French artists often traveled to Italy and The Netherlands to work. In the hopes of creating a nucleus of artists who would determine the Baroque in France, Louis XIII began officially recalling these artists to Paris. Among the summoned artists were painters Nicolas Poussin and Simon Vouet, who had been working in Rome, and the printmaker Jacques Callot, who returned from Florence to his home in northern France.

JACQUES CALLOT: A TRANSITIONAL FIGURE One of the most important early seventeenth-century artists was Jacques Callot (1592/93–1635), an etcher and engraver whose small-scale prints recording actual experiences inspired his compatriot Georges de La Tour (discussed below) and the young Rembrandt. Callot's exploitation of the medium's ability to produce stark tonal contrasts and intricate details reflects the tradition, dating from the fifteenth century, of using mass-produced prints to disseminate information. Yet his poignant representations of contemporary figures and events places him firmly in the art of his own time. Callot spent much of his early career at the court of Cosimo II de' Medici in Florence, where he produced prints inspired primarily by the theater and especially the *commedia dell'arte*. After returning to his native town of Nancy in 1621, he began to concentrate almost exclusively on the technique of etching and the subject of his work changed. He visited Breda in 1626, soon after the surrender of Dutch troops there (see fig. 19.36), and executed six plates showing a large panorama of the site.

Callot's insight into the personal and political geography of battle can best be seen in the series *The Great Miseries of War*, which represents a distillation of his experience of the Thirty Years' War. (Scholars once thought Callot executed the series in 1633 but now consider it to be from 1629–1632.) In the 18 etchings in the series, Callot reveals the misery, destruction, and poverty brought by the invading army. Several prints are devoted to the soldiers' crimes, whereas others, including *Hangman's Tree* (fig. **21.1**), focus on the punishments dealt to

21.1. Jacques Callot. *Hangman's Tree,* from *The Great Miseries of War*. 1633. Etching, 3½ × 9″ (9 × 23 cm). The British Museum, London

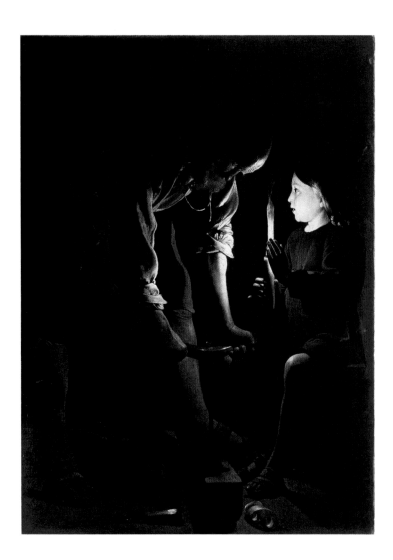

21.2. Georges de La Tour. *Joseph the Carpenter*. ca. 1642. Oil on canvas, $51\frac{1}{8} \times 39\frac{3}{4}''$ (130 × 100 cm). Musée du Louvre, Paris

the French army for their excesses. The inscription at the bottom reads: "Finally these thieves, sordid and forlorn, hanging like unfortunate pieces of fruit from this tree, experience the justice of Heaven sooner or later." Despite the work's small size (it measures only a few inches), nearly 50 figures inhabit the scene. The awkward perspective emphasizes the tiny, elongated, Mannerist-style figures; in the figures on the right, however, Callot has shown a naturalism in costume and attitude that is characteristic of the new Baroque style. The bleak scene is as disturbing as Hieronymus Bosch's vision of hell in *The Garden of Earthly Delights* (fig. 14.24), and it may be even more so, for it is based on the artist's own experience of the horrors of war.

GEORGES DE LA TOUR AND THE INFLUENCE OF CARAVAGGIO Many French painters in the early seventeenth century were influenced by Caravaggio, although how they may have been exposed to the Italian artist's style remains unclear. Most were minor artists toiling in the provinces, but a few developed highly original styles. The finest of these was Georges de La Tour (1593–1652), whose importance was recog-

nized only in the nineteenth century. Although La Tour spent his career in Lorraine in northeast France (and, as such, suffered directly as a result of the Thirty Years' War), he was by no means a simple provincial artist. Besides being named a painter to King Louis XIII, he received important commissions from the governor of Lorraine. He began his career painting picturesque genre figures before turning to religious scenes that appealed to adherents of the Catholic faith, then the predominant religion in France. His use of light and his reliance on detailed naturalism derived largely from Caravaggio's Northern European followers (see page 711), whom he may have visited in the Dutch Republic.

La Tour's mature religious pictures effectively convey the complex mysteries of the Christian faith. With its carefully observed details and seemingly humble subject *Joseph the Carpenter* (fig. **21.2**) might initially be mistaken for a genre scene, but its devotional spirit soon overwhelms us. The two figures are set in profile, thus yielding little in their expressions. La Tour lends maximum significance to each gesture, each expression. The boy Jesus holds a candle, a favorite device of the artist, whose flame reinforces the devotional mood and imbues the scene with intimacy and tenderness. The painting has the power of Caravaggio's *Calling of St. Matthew* (see fig. 19.2), but the simplified forms, warm palette, and arrested movement are characteristic of La Tour's restrained and focused vision.

SIMON VOUET AND THE DECORATIVE STYLE
Although Simon Vouet (1590–1649) became the leader of the French Caravaggesque painters in Rome, he painted in many styles throughout his career. At an early age he accompanied his artist father to England and Constantinople, but his most significant foreign travels were to Rome, where he lived from 1613 to 1627. In Rome he became an adherent of Caravaggio's style but was also later influenced by the Bolognese artist Annibale Carracci. Vouet was so well respected that he was elected President of the Academy of St. Luke in Rome. Officially recalled to France in 1627 by Louis XIII, he settled in Paris and became the leading painter of his day. Vouet quickly shed all traces of Caravaggio's manner and developed a colorful style, which won such acclaim that he was named First Painter to the king. It is from Vouet's studio that the official style in France emanated in the 1630s and 1640s. His paintings, influenced by Venetian artists, were known for their rich colors and use of light and thus provided the interiors of royal residences and a growing number of French aristocratic houses with a new vibrant decorative style.

21.3. Simon Vouet. *The Toilet of Venus*. ca. 1640. Oil on canvas, 65¼ × 45″ (165.7 × 114.3 cm). The Carnegie Museum of Art, Pittsburgh. Gift of Mrs. Horace Binney Hare

The Toilet of Venus (fig. 21.3), possibly painted for one of the king's mistresses, is one of several on this theme that Vouet executed. It depicts a subject popular in Venice, notably executed by Titian and Veronese, and also treated by Rubens. The figure recalls Correggio's *Jupiter and Io* (fig. 17.24) but lacks that work's frank eroticism. Instead, Vouet has imbued his Venus with an elegant sensuousness that is uniquely French. The use of continuous swirling circles, near nudity, interest in fabric, and luminous colors only suggest the erotic, whose appeal would continue well into the eighteenth century and provide the basis for the Rococo style in painting. Vouet taught the next generation of artists, including those who worked on Louis XIV's palace at Versailles, the landscape designer and royal gardener André Le Nôtre, and Charles Le Brun, the royal painter who would later establish the French Royal Academy (from which he would exclude his teacher).

NICOLAS POUSSIN AND BAROQUE CLASSICISM

Despite Vouet's earlier influence on painting, after the 1640s classicism reigned supreme in France. The artist who contributed most to its rise was Nicolas Poussin (1594–1665), one of the most influential French painters of the century. Aside from an ill-fated two-year sojourn in Paris, however, Poussin spent his career in Rome. There he hosted and taught visiting French artists, absorbing the lessons of Raphael's and Carracci's classically ordered paintings and developing his own style of rational classicism. Patrons brought Poussin's paintings back to Paris, where they influenced the royal court. Indeed, when establishing the curriculum of the French Royal Academy in the 1660s, Jean-Baptiste Colbert, the king's chief adviser, and artist Charles Le Brun chose Poussin's Classical style to serve as a model for French artists. Yet the rivalry between Poussin and Vouet continued long afterward as the artists' differing traditions vied with each other through the next century, alternating in succession without either one gaining the upper hand for long.

POUSSIN AND HISTORY PAINTING: ANCIENT THEMES IN THE GRAND MANNER Arriving in Rome via Venice in early 1624, Poussin studied perspective and anatomy and examined ancient sculpture, such as *The Laocoön, The Belvedere Torso,* and *The Apollo Belvedere,* the reliefs on ancient sarcophagi and vases, and the paintings of Raphael. His *The Death of Germanicus* (fig. 21.4) reflects much of his studies. The work served as a model for artistic depictions of heroic deathbed scenes for the next two centuries and may in

fact be the first example of this subject in the history of art. A typical history painting, the work relates the powerful themes of death, loyalty, and revenge. The story comes from Tacitus and is set in 19 CE. Germanicus was a Roman general who had led campaigns against the Germanic tribes. At the urging of Tiberius, Germanicus' adoptive father, the ruler in Syria, poisoned the powerful general. Poussin depicts him on his deathbed, flanked on the left by his loyal soldiers swearing revenge and on the right by his mournful family. The promise to avenge is set at the center, commanding attention, as figures gesture their grief, loyalty, and suffering. Framed by the two groups, Germanicus becomes the focus of the composition, which is based on antique scenes of the death of Meleager (see fig. 7.62). The architecture sets the stage for the figures, which are arranged horizontally in a rectangular space, as in a Classical frieze. The curtain in the rear restricts the action to a shallow space, heightening the drama and creating a more intimate environment.

Nicolas Poussin (1594–1665)

From an undated manuscript

Poussin's ideas on art were central to the formation of the French Academy in 1648 and, because of the preeminence of that academy, therefore to the entire European academic movement of the seventeenth through the nineteenth centuries.

The magnificent manner consists of four things: subject, or topic, concept, structure and style. The first requirement, which is the basis for all the others, is that the subject or topic should be great, such as battles, heroic actions and divine matters. However, given the subject upon which the painter is engaged is great, he must first of all make every effort to avoid getting lost in minute detail, so as not to detract from the dignity of the story. He should describe the magnificent and great details with a bold brush and disregard anything that is vulgar and of little substance. Thus the painter should not only be skilled in formulating his subject matter, but wise enough to know it well and to choose something that lends itself naturally to embellishment and perfection. Those who choose vile topics take refuge in them on account of their own lack of ingenuity. Faintheartedness is therefore to be despised, as is baseness of subject matter for which any amount of artifice is useless. As for the concept, it is simply part of the spirit, which concentrates on things, like the concept realized by Homer and Phidias of Olympian Zeus who could make the Universe tremble with a nod of his head. The drawing of things should be such that it expresses the concept of the things themselves. The structure, or composition of the parts, should not be studiously researched, and not sought after or contrived with effort but should be as natural as possible. Style is a particular method of painting and drawing, carried out in an individual way, born of the singular talent at work in its application and in the use of ideas. This style, and the manner and taste emanate from nature and from the mind.

SOURCE: ALAIN MEROT, *NICOLAS POUSSIN*. TR. BY FABIA CLARIS (LONDON: THAMES AND HUDSON LTD., 1990)

This early work by Poussin, painted just a few years after he arrived in Rome, was probably created for Cardinal Francesco Barberini's secretary, Cassiano dal Pozzo (1588–1657), a major patron of the arts. Its composition, setting, and heroic historical subject (see *Primary Source*, above), are typical of Poussin's classicism.

THE ABDUCTION OF THE SABINE WOMEN Showing Poussin's allegiance to classicism, *The Abduction of the Sabine Women* (fig. **21.5**) displays the severe discipline of his intellectual style, which developed in response to what he regarded as the excesses of the High Baroque (see page 671). The strongly modeled figures are "frozen in action," like statues. Many are,

21.4. Nicolas Poussin. *The Death of Germanicus.* 1627–1628. Oil on canvas, 58¼ × 78″ (147.96 × 198.12 cm) Minneapolis Institute of Art, Minneapolis, MN. The William Hood Dunwoody Fund. 58.28

21.5. Nicolas Poussin. *The Abduction of the Sabine Women*. ca. 1633–1634. Oil on canvas, 5'7⅞" × 6'10⅝" (1.54 × 2.09 m). The Metropolitan Museum of Art, New York. Harris Brisbane Dick Fund, 1946

in fact, derived from Hellenistic sculpture, but the main group is directly inspired by Giovanni Bologna's *Rape of the Sabine Woman* (fig. 17.10). Poussin has placed them before reconstructions of Roman architecture that he believed to be archeologically correct. Emotion is abundantly displayed in the dramatic poses and expressions, but the lack of spontaneity causes it to fail to touch us. The scene has a theatrical air, and for good reason. Before beginning the painting, Poussin arranged wax figurines on a miniature stagelike setting until he was satisfied with the composition.

Poussin strikes us today as an artist who knew his own mind, an impression confirmed by the numerous letters in which he stated his views to friends and patrons. The highest aim of painting, he believed, is to represent noble and serious human actions. This is true even in *The Abduction of the Sabine Women,* whose subject many people admired as an act of patriotism ensuring the future of Rome. According to the accounts of Livy and Plutarch, the Sabines were young women abducted by the Romans to become their wives; the women later acted as peacemakers between the two opposing sides. Clearly the women do not go willingly as swords are drawn, babies are abandoned, and the elderly suffer. But Poussin's apparent detachment and lack of sympathy has caused the work to be labeled heroic. He appealed to the mind, that is, to the larger view of history, rather than to the senses. Poussin suppressed color and instead stressed form and composition. He believed that the viewer must be able to "read" the emotions of each figure as they related to the story. Such beliefs later proved influential to his student Charles Le Brun when establishing an approved court style for French painting.

These ideas were not new. We recall Horace's motto *Ut pictura poesis* ("As is painting, so is poetry"), and Leonardo's statement that the highest aim of painting is to depict "the intention of man's soul" (see page 560). Before Poussin, however, no artist had made the analogy between painting and literature so closely or put it into practice so single mindedly. His method accounts for the visual rhetoric in *The Abduction of the Sabine Women* that makes the picture seem so remote. The preliminary drawing (fig. **21.6**) for the theme (this drawing is in fact for a different version of the painting) suggests the artist's deliberate process. Using pen and ink and wash, Poussin worked out many of his compositions beforehand, as did Rubens. In this example, he placed figures in the foreground

21.6. Nicolas Poussin. *The Abduction of the Sabine Women*. ca. 1630. Brush drawing, 6¼ × 8⅛" (16.1 × 20.7 cm). Arhivio del Gabinetto Disegni e Stampe, Galleria degli Uffizi, Florence

and ancient architecture as a stage set in the background. Such studies contrast sharply with the methods of Caravaggio and the Caravaggisti, who supported painting "from nature," that is, from living models and without the aid of preparatory drawings. Poussin regarded history painting as more intellectual and as derived from the imagination. Poussin, who would have seen these differences as dramatic and, perhaps, incomprehensible, reportedly told a contemporary that "Caravaggio had come into the world to destroy painting."

POUSSIN AND THE IDEAL LANDSCAPE The "ideal" landscape, serene and balanced, does not represent a particular locale but rather a generalized and often beautiful place. Because figures play only a minor role in such a setting, it is surprising that Poussin chose to explore this subject. The austere beauty and somber calm of the ideal landscape can be seen in his *Landscape with St. John on Patmos* (fig. **21.7**), which continues the Classical landscape tradition of Annibale Carracci. The ancient landscape strewn with architectural ruins suggests both the actual site and the concept of antiquity. Trees on either side balance the composition, and many of the ruins are set parallel to the picture plane. A reclining St. John, who at the end of his life lived on the island of Patmos, reportedly in somewhat abject circumstances, is shown in profile facing left. Poussin's pendant (paired) painting, *Landscape with St. Matthew*, shows that saint facing right, yet each work was created independently. Poussin executed both paintings in Rome for the secretary to Pope Urban VIII. The composition suggests the physical, rational arrangement of a spiritual world—a dichotomy truly suited and best explored by

Baroque classicism. Poussin's mythological landscapes show a similar construct of the physical, rational, and mythic.

CLAUDE LORRAIN AND THE IDYLLIC LANDSCAPE
While Poussin developed the heroic qualities of the ideal landscape, the great French landscapist Claude Lorrain (Claude Gellée, also called Claude; 1604/05?–1682) brought out its idyllic aspects. He, too, spent nearly his entire career in Rome, beginning as a pastry chef. From 1625 to 1627, however, he returned briefly to Nancy, where he was familiar with fellow resident Jacques Callot. He later copied Callot's etchings from *The Great Miseries of War* series (fig. 21.1). Claude's family in Nancy had been victims of the Thirty Years' War and so the series may have had particularly personal meaning for him. While in Rome Claude worked with several artists and was a pupil and assistant to Agostino Tassi (see fig. 19.10). Like many Northern Europeans, Claude thoroughly explored the surrounding countryside, the *campagna*, of Italy and his countless drawings made on site reveal his powers of observation. He is also the first artist known to have painted oil studies outdoors. Sketches, however, were only the raw material for his landscapes. To guard against forgeries, about 1635 Claude began making drawings of his paintings, which he kept as a record in a book known as *Liber Veritatis (The Book of Truth)*. (See *The Art Historian's Lens*, page 743.) It is from annotations on the verso of these drawings that we have learned the subjects of his paintings known as "pastorals," a literary genre that flourished in Venice in the sixteenth century in works by painters such as Giorgione and Titian (see figs. 16.30 and 16.31).

21.7. Nicolas Poussin. *Landscape with St. John on Patmos.* 1640. Oil on canvas, 39$^{1}/_{2}$ × 53$^{3}/_{4}$″ (100.3 × 136.4 cm.). Art Institute of Chicago. A. A. Munger Collection. (1930.500)

21.8. Claude Lorrain. *A Pastoral Landscape.* ca. 1648. Oil on copper, $15\frac{1}{2} \times 21''$ (39.3 × 53.3 cm). Yale University Art Gallery, New Haven, CT. Leonard C. Hanna, Jr., B. A. 1913, Fund. 1959.47

Claude's themes are often historical or pastoral, as in *A Pastoral Landscape* (fig. **21.8**). He does not aim for topographic accuracy in his paintings but evokes the poetic essence of a countryside filled with echoes of antiquity. Many of Claude's paintings are visual narratives of ancient texts, such as the epic tales and poetry of Virgil. Often, as in this painting, the compositions have the hazy, luminous atmosphere of early morning or late afternoon. One can refer to Claude's views as painting "into the light," that is, his sunlight (often sunsets) is at the center and at the horizon line of the painting so that the architecture and other elements appear almost as silhouettes. This example is painted on copper, a support seventeenth-century artists frequently employed for small paintings. The surfaces of these copper paintings are luminous. Here the space expands serenely rather than receding step-by-step as in works by Poussin. An air of nostalgia, of past experience enhanced by memory, imbues the scene. It is this nostalgic mood founded in ancient literature that forms its subject.

Claude succeeded in elevating the landscape genre, which traditionally had been accorded very low status. Prevailing artistic theory had ranked the rendering of common nature at the bottom of the hierarchy of painting genres (with landscape only just above still life). Claude, encouraged by sophisticated patrons, progressively moved away from showing the daily activity of life at the sea ports, and embellished his seascapes and landscapes with historical, biblical, and mythological subjects, thereby raising the status of the genre.

CHARLES LE BRUN AND THE ESTABLISHMENT OF THE ROYAL ACADEMY In art as in life, the French monarchy sought to maintain strict control, and thus the Royal Academy of Painting and Sculpture was founded in Paris in 1648. One of the 12 original founders was artist Charles Le Brun (1619–1690), who helped reorganize the academy in the 1660s into a formal institution. Although the academy came to be associated with the absolutism of Louis XIV's reign, at its

21.9. Henri Testelin after Charles Le Brun, *The Expressions*, 6th plate in *Henri Testelin's Sentiments de Plus Habiles Peintres*. Paris, 1696. Etching, 13$\frac{1}{16}$ × 17$\frac{3}{4}$″ (33.1 × 45.1 cm). The Metropolitan Museum of Art, Rogers Fund, 1968. (68.513.6(6))

Much of this doctrine was derived from Poussin, with whom Le Brun had studied for several years in Rome. The academy also devised a method for assigning numerical grades to artists past and present in such categories as drawing, expression, and proportion. The ancients received the highest marks, followed by Raphael and his school, and then Poussin. Venetian artists, who "overemphasized" color, ranked low, while the Flemish and Dutch were placed lower still. Subjects were also classified: At the top was history (that is, narrative subjects, whether Classical, biblical, or mythological) and at the bottom was still life, with portraiture falling in between.

HYACINTHE RIGAUD AND THE SPLENDOR OF LOUIS XIV The monumental *Portrait of Louis XIV* (fig. **21.10**) by Hyacinthe Rigaud (1659–1743) conveys the power, drama, and splendor of the absolutist reign. The king is shown life-size and full-length, much like Van Dyck's portrait of Charles I (see fig. 20.8). The comparison is intentional, and the work follows the then formulaic nature of royal portraiture to espouse power and authority through the use of the insignias of rulership and the symbols of the opulence of the monarch's reign. Louis is

inception the king was only 10 years old, his mother Anne was regent, and Cardinal Mazarin effectively controlled the affairs of state. Yet the ideology of the academy and the throne would coincide with and strengthen each other in the ensuing years.

When Louis XIV assumed control of the government in 1661, Jean-Baptiste Colbert, his chief adviser, built the administrative apparatus to support the power of the absolute monarch. In this system, aimed at controlling the thoughts and actions of the nation, the task of the visual arts was to glorify the king. As in music and theater, which shared the same purpose, the official "royal style" was classicism. Centralized control over the visual arts was exerted by Colbert and Le Brun, who became supervisor of all the king's artistic projects. As chief dispenser of royal art patronage, Le Brun's power was so great that for all practical purposes he acted as dictator of the arts in France.

Upon becoming the academy's director in 1663, Le Brun established a rigid curriculum of instruction in practice and in theory, which he based on a system of rules. He lectured extensively at the academy; several lectures were devoted to examining the art of Poussin, venerating the works of Raphael, and studying physiognomy (facial expressions). Probably about 1668 he codified facial expressions in a series of annotated drawings published posthumously as engravings (fig. **21.9**). His lectures documented the movements of eyes, eyebrows, and mouths to show passions and emotions such as fear, anger, and surprise, corresponding to the *Passions of the Soul,* published in 1649 by Descartes. Le Brun's schemata were intended to be used as formulas by artists to establish narratives in their paintings that could be easily "read" by viewers.

21.10. Hyacinthe Rigaud. *Portrait of Louis XIV.* 1701. Oil on canvas, 9′2 × 6′3″ (2.8 × 1.9 m). Musée du Louvre, Paris. Inv. 7492

Forgeries and *The Book of Truth*

Art forgery—the deliberate copying or creation of a work of art without permission and with the intention to deceive—has long posed a serious threat to both artists and collectors. Art forgers have targeted jewelry, sculpture, painting, and prints, usually in the hopes of selling their fakes for personal gain.

Forgers may copy the works or style of artists from either the past or present. In ancient times, reports surfaced of forgeries made after the works of Myron and Praxiteles (see Chapter 5). We know, too, that Michelangelo made "antique" forgeries (see page 179) by burying sculpture to produce a patina imitating the effects of time and wear. To create the look of an older product, forgers may use authentic materials such as old paper, homemade paints, previously used canvases, and wood that has been peppered with buckshot to resemble aged wood infested with wormholes.

Not only are artists deprived of monetary compensation by a forgery, but their reputation can also be jeopardized by art of lesser quality passed off as theirs. Such was the case for Albrecht Dürer (see Chapter 18), who discovered upon his visit to Venice in 1506 that the well-known printmaker Marcantonio Raimondi (ca. 1480–ca. 1527) was selling engravings that he created in the manner of Dürer's woodcuts and bearing Dürer's monogram. Dürer sued, and although Raimondi could continue to produce the engravings, he could no longer include Dürer's signature on them.

Claude Lorrain experienced a similar problem, for which he developed a unique solution. We know from the writer Filippo Baldinucci (1625–1697) that Claude discovered that another artist, Sébastien Bourdon (1616–1671), was adept at imitating the light and tonal effects in Claude's paintings. In fact, Bourdon's skill in producing them was so proficient that after visiting Claude's studio, he painted a landscape and sold it as a work purportedly by Claude. Other artists also found it easy to imitate Claude's techniques and compositions.

To safeguard against any such dishonest practices, around 1635 Claude decided to compile the *Liber Veritatis (The Book of Truth)*, an album of drawings that reproduce his paintings from that time on. On the verso, he annotated each drawing with the name of the patron, buyer, or place the work was sent; he sometimes included the date and a reference to the work's subject as well. Collectors could consult the book and verify whether a painting was included—and thus foil any potential forger.

By the time of his death, Claude had made drawings of 195 of his paintings. He did not record paintings made before 1635, and therefore an estimated 50 works are missing from the album. Claude was a prolific draughtsman—over 1,200 drawings by him are known, although the album records only drawings of his finished paintings (see Claude's draw-

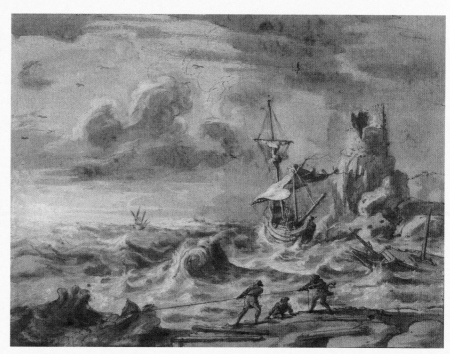

Claude Lorrain. *The Tempest*. ca. 1635. Pen and brown wash, heightened with white highlights on blue paper. $7^{11}/_{16} \times 10^{1}/_{4}''$ (195 × 260 cm). Courtesy of the Trustees of The British Museum, London

ing of *The Tempest*, above). *The Liber Veritatis*, now in the collection of The British Museum, consists of sheets measuring $7^{11}/_{16}$ by $10^{1}/_{4}$ inches (195 × 260 mm) that are organized in groups of four white sheets alternating with four blue ones. Scholars have speculated that Claude chose these paper colors to reflect the light effects in his paintings. This method also suggests that he probably did not execute the drawings in chronological order. To create them, he used pen and ink with brown and sometimes gray washes. He added highlights with white chalk and touches of gold. Such time-consuming details, especially evident in the book's later drawings, show that Claude began to use the album not just to reproduce paintings but to create elaborate, finished drawings that stand on their own as accomplished works of art.

Dealers and collectors today often rely on a comparable type of book called a *catalogue raisonné*. Compiled by an expert after years of meticulous research, this publication describes and illustrates all the known, verified, and some attributed (but nonauthenticated) works by a particular artist as well as pertinent information about each object's dimensions, condition, and provenance (history of ownership). But perhaps most important in the fight against forgeries is the wide range of available technologies—from carbon dating to infrared spectroscopy—to analyze and date a work's materials and stages of creation. Still, even with these advanced detection methods, not all experts agree about the authenticity of a work in question since these technologies can often only verify the time or place a work was produced and not the artist's hand. For that we still rely on connoisseurship and the experience and expertise of the art historian.

shown draped with his velvet coronation robes lined with ermine and trimmed with gold *fleurs-de-lis*. He appears self-assured, powerful, majestic—and also tall, an illusion created by the artist, for his subject measured only 5 feet 4 inches. The portrait proudly displays the king's shapely legs (emphasized by the high heels Louis himself designed to increase his height), for they were his pride as a dancer. Indeed, the king actively participated in the ballets of Jean Baptiste Lully (1632–1687) from the 1650s until his coronation. All the arts, from the visual arts to the performing arts, fell under royal control—a fact exemplified in Rigaud's painting, which expresses Louis's dominance and unequaled stature as the center of the French state.

French Classical Architecture

Because they were large, ostentatious, and public, building projects, even more than painting, transmitted the values of the royal court to a wide audience. In French architecture, the Classical style expressed the grandeur and authority of imperial Rome and confirmed the ideals of tradition, omnipotence, absolutism, strength, and permanence espoused by the monarchy. Mammoth scale and repetition of forms evoke these broad concepts, which were embodied in royal structures erected in the heart of Paris as well as outside the city, in the palace and gardens of Versailles.

In 1655, Louis XIV declared *"L'état, c'est moi"* ("I am the state"). This statement was not just political but represented an artistic and aesthetic intention as well. Louis's projects for his palace and court took on colossal proportions and represented not a single individual, or even a single monarch, but the entirety of France. He began by renovating the Louvre, a project begun by his father, but that had proven insufficient. Louis wanted to move his entire royal court to a more isolated location where he could control them more efficiently, and so he

began construction on the palace and gardens of Versailles, located a few miles outside Paris. These complex building projects all share a single style—that of Baroque Classicism.

FRANÇOIS MANSART The foundations of Baroque Classicism in architecture were laid by a group of designers of whom the best known was François Mansart (1598–1666). The classicism introduced by Lescot at the Louvre (see fig. 18.7) reached its height in the mid-1500s under Henry II and was continued by Salomon de Brosse (ca. 1571–1626) at Marie de' Medici's Luxembourg Palace. Mansart, who probably began his career under de Brosse in 1618, showed a precocious talent. Within five years he had established his reputation.

Although apparently Mansart never visited Italy, he was familiar with the new Italian style through other French architects who had imported and adapted Baroque aspects into their designs. His most important buildings are châteaux, and in this area the French Renaissance tradition outweighed any Italian influences. For that reason Mansart's earlier designs are also the most Classical. The Château de Maisons near Paris, built in the 1640s for the financier René du Longueil, shows Mansart's mature style. The exterior departs little from the precedents set by de Brosse, although it possesses a Classical logic and clarity that surpass any previous French design. The interior, however, breaks new ground. The vestibule leading to the grand staircase (fig. **21.11**) recalls Palladio, whose treatise Mansart knew and admired. Sculpture is used as an integral part of the architectural design, a characteristically French idea pioneered by De Brosse. The spread-winged eagles (from the owner's heraldry) soften the intersecting cornice line and bridge the space between the springing points of the vault ribs. These complex curves and the near disappearance of the planar wall below indicate that this structure, for all its classicism, fits squarely in the Baroque style.

21.11. François Mansart. Vestibule of the Château de Maisons. 1642–1650

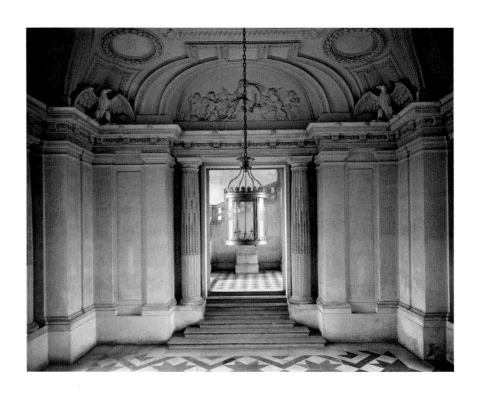

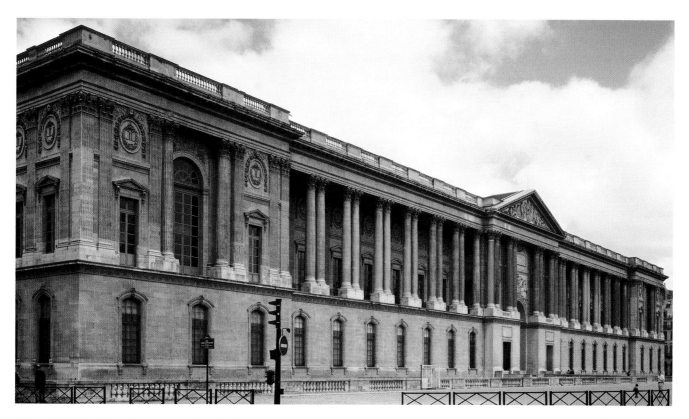

21.12. Louis Le Vau, Claude Perrault, and Charles Le Brun. East front of the Louvre, Paris. 1667–1670

THE LOUVRE Work on the palace had proceeded intermittently for more than a century, following Lescot's original design under Francis I; what remained was to close the square court on the east side with an impressive facade. Colbert was dissatisfied with the proposals of French architects including Mansart, who submitted designs not long before his death. Colbert then invited Bernini to Paris in the hope that the most famous artist of the Roman Baroque would do for the French king what he had done for the popes in Italy. Bernini spent several months in Paris in 1665 and submitted three designs, all on a scale that would have dwarfed the existing palace. After much argument and intrigue, Louis XIV rejected the plans and turned over the problem to a committee: Charles Le Brun, his court painter; Louis Le Vau (1612–1670), his court architect who had already done much work on the Louvre (including the Gallery of Apollo, the Queen's court, and the south facade); and Claude Perrault (1613–1688), an anatomist and student of ancient architecture but not a professional architect. All three men were responsible for the structure (fig. **21.12**), but Perrault is rightly credited with the major share. Certainly his supporters and detractors at the time thought so, and he was often called upon to defend his design.

Perrault based the center pavilion on a Roman temple front, and the wings look like the sides of the temple folded outward. The temple theme required a single order of free-standing columns, but the Louvre had three stories. Perrault solved this problem by treating the ground story as the podium of the temple and recessing the upper two stories behind the screen of a colonnade. Although the colonnade itself was controversial because of its use of paired columns, this treatment thereafter became a characteristic of French classicism in architecture.

The east front of the Louvre signaled the victory of French classicism over the Italian Baroque as the royal style. It further proclaimed France as the new Rome, both politically and culturally, by linking Louis XIV with the glory of the Caesars. The grand and elegant design in some ways suggests the mind of an archeologist, but one who also knew how to choose those features of Classical architecture that would be compatible with the older parts of the palace. This revitalization of the antique, both in its conception and its details, was Perrault's main contribution.

Perrault owed his position to his brother Charles Perrault (1628–1703), who, as Colbert's Master of Buildings under Louis XIV, had helped undermine Bernini during his stay at the French court. It is likely that Claude Perrault shared the views set forth some 20 years later in his brother's *Parallels Between the Ancients and Moderns* in which Charles claimed that "Homer and Virgil made countless mistakes which the moderns no longer make [because] the ancients did not have all our rules." The Louvre's east front presents not simply a Classical revival but a vigorous distillation of what Claude Perrault considered to be the eternal ideals of beauty, intended to surpass anything built by the Romans themselves. Indeed, Perrault had annotated Vitruvius and wrote his own treatise on the orders of columns.

THE PALACE OF VERSAILLES Louis XIV's largest enterprise was the Palace of Versailles (fig. **21.13**), located eleven miles from the center of Paris. By forcing the aristocracy to live under royal scrutiny outside Paris, the king hoped to prevent a repeat of the civil rebellion known as the Fronde, which had occurred during his minority in 1648–1653.

The project was begun in 1669 by Le Vau, who designed the elevation of the Garden Front (fig. **21.14**), but within a year he died. Under the leadership of Jules Hardouin-Mansart (1646–1708), a great-nephew and pupil of Mansart, the structure was greatly expanded to accommodate the ever-growing royal household. The Garden Front, intended by Le Vau to be the main view of the palace, was stretched to an enormous length but with no change in the architectural elements. As a result Le Vau's original facade design, a less severe variant of the Louvre's east front, looks repetitious and out of scale. The center block contains a single room measuring 240 feet long, the spectacular Galerie des Glaces, or Hall of Mirrors (fig. **21.15**). At either end are the Salon de la Guerre (Salon of War) and its counterpart, the Salon de la Paix (Salon of Peace). The sumptuous effect of the Galerie des Glaces recalls the Gallery of Francis I at Fontainebleau, but the use of full-length mirrors (composed of smaller mirrors) was unique, for such mirrors were rare and represented a great investment on the part of the monarchy. This art of large mirror-making was invented in Venice and brought to France by agents of Colbert. Such extravagant details were meant to reinforce the majesty of both Louis's reign and of France. The mirrors were placed to reflect the gardens outside, making the room appear larger by day. At night, the myriad reflections of candlelight illuminated the grand space. Whether day or night, the effect was impressive.

Baroque features, although not officially acknowledged by the architects, appeared inside the palace. This shift reflected the king's own taste. Louis XIV was interested less in architectural theory and monumental Classical exteriors than in the lavish interiors that would provide suitable settings for himself and his court. Thus the man to whom he listened most reliably

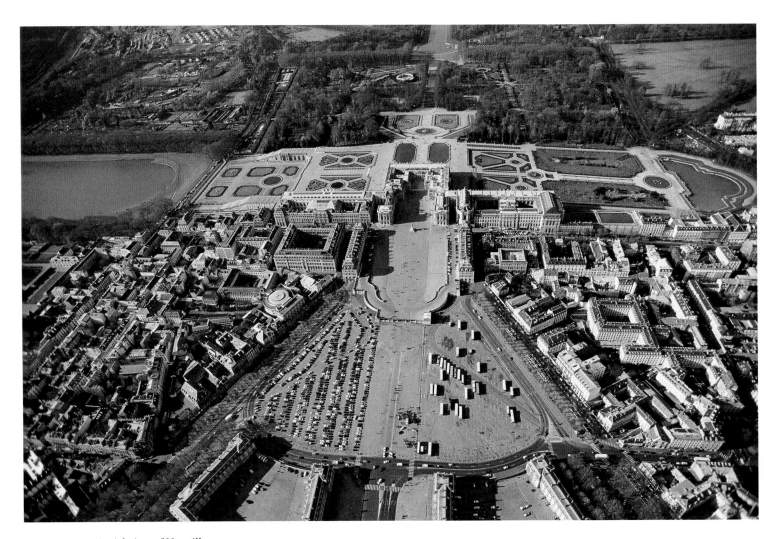

21.13. Aerial view of Versailles

21.14. Louis Le Vau and Jules Hardouin-Mansart. Garden front of the center block of the Palace of Versailles. 1669–1685

21.15. Hardouin-Mansart, Louis Le Vau, and Le Brun. Galerie des Glaces (Hall of Mirrors), Palace of Versailles. Begun 1678

was not an architect but the painter Le Brun, whose goal was to subordinate all the arts to the expression of the king's power. To achieve this aim, he drew freely on his memories of Rome, and the great decorative schemes of the Italian Baroque surely must have impressed him. Although a disciple of Poussin, Le Brun had studied first with Vouet and became a superb decorator. At Versailles, he employed architects, sculptors, painters, and decorators to produce ensembles of unprecedented splendor. The *Salon de la Guerre* (Salon of War, fig. **21.16**) is closer in many ways to the theatricality and the use of a variety of media of Bernini's Cornaro Chapel (fig. 19.31) than to the vestibule at Maisons. Although Le Brun's ensemble is less adventurous than Bernini's, he has given greater emphasis to surface decoration. As in many Italian Baroque interiors, the separate components are less impressive than the effect of the whole.

THE GARDENS OF VERSAILLES Apart from the magnificent interior, the most impressive aspect of Versailles is the park extending west of the Garden Front for several miles (see fig. 21.13). The vast park was designed by André Le Nôtre (1613–1700), who had become director of the gardens of Louis XIII in 1643 and whose family had served as royal gardeners for generations. The type of formal garden at Versailles had its beginnings in Renaissance Florence but had never been used on the scale achieved by Le Nôtre, who transformed an entire natural forest into a controlled park, a massive and expensive enterprise that reflected the grandeur of the king. In concept, the landscape is as significant as the palace—perhaps more so, for it suggests the king's dominion over Nature. The landscape design is so strictly correlated with the plan of the palace that it in effect continues the architectural space. Like the interiors, the formal gardens were meant to provide a suitable setting for the king's public appearances. They form a series of "outdoor rooms" for the splendid fêtes and spectacles that formed an integral part of Louis's court.

The spirit of absolutism is even more striking in the geometric regularity imposed upon an entire countryside than it is in the palace itself. Le Nôtre's plan called for the taming of Nature: Forests were thinned to create stately avenues, plants were shaped into manicured hedges, water was pumped into exuberant fountains and serene lakes. The formal gardens consist of a multitude of paths, terraces, basins, mazes, and parterres that create a unified geometric whole. Further from the palace, the plan becomes less formal and incorporates the site's densely wooded areas and open meadows. Throughout, carefully planned vistas result in unending visual surprises. An especially important aspect of the landscape design was the program of sculpture, much of which incorporated images of Apollo, the sun god, a favorite symbol of Louis XIV.

The elaborate and expansive gardens had its detractors as well. From these critics we are able to ascertain what life was like at Versailles. Duc de Saint-Simon, a member of the court but no admirer of Louis, recorded in his diary:

Versailles ... the dullest of all places, without prospect, without wood, without water without soil; for the ground is all shifting sand or swamp, the air accordingly bad. ... You are introduced [in the gardens] to the freshness of the shade only by a vast torrid zone. ... The violence everywhere done to nature repels and wearies us despite ourselves. The abundance of water forced up and gathered together in all parts is rendered green thick and muddy; it disseminates humidity, unhealthy and evident; and an odor still more so. I might never finish upon the monstrous defects of a palace so immense.

Memoirs of Louis XIV and His Court and of the Regency by the Duke of Saint-Simon. Vol. II. (New York: P. F. Collier and Son, 1910, p. 889)

THE STYLE OF JULES HARDOUIN-MANSART Constrained at Versailles by the design of Le Vau, Jules Hardouin-Mansart's own style can be better appreciated in the Church of the Invalides (fig. **21.17**), best known today for housing the tomb of Napoleon. Originally the structure formed part of a hospital that served as a hostel for the many disabled soldiers caused by Louis's continuous wars, gathering them off the streets of Paris where they might incite disorder. The complex consists of a series of dormitories, dining halls, infirmaries, and two chapels—a simple, unadorned one for the soldiers and an elaborate, domed space for the king, where he could be seen high above them during his visits. Hardouin-Mansart's design

21.16. Hardouin-Mansart, Le Brun, and Coysevox. Salon de la Guerre (Salon of War), Palace of Versailles. Begun 1678

21.17. Jules Hardouin-Mansart. Church of the Invalides, Paris. 1677–1691

ART IN TIME

1608—Samuel de Champlain, explorer of Canada, settles Quebec

1633–1634—Poussin's, *The Abduction of the Sabine Women*

ca. 1642—La Tour's, *Joseph the Carpenter*

1643—Louis XIV crowned king of France

1648—French Royal Academy of Painting and Sculpture founded

1666—Moliere, *The Misanthrope*

1669–1685—Palace of Versailles built

reflects the influence of Michelangelo, but it consists of three shells instead of the usual two. The facade breaks forward repeatedly in the crescendo effect introduced by Maderno (see fig. 19.13), and the facade and dome are as closely linked as at Borromini's Sant'Agnese in Piazza Navona (see fig. 19.22). The dome itself is the most original, as well as the most Baroque, feature of Hardouin-Mansart's design. Tall and slender, it rises in one continuous curve from the base of the drum to the spire atop the lantern. On the first drum rests a second, short drum. Its windows provide light for the paintings on the dome's interior. The windows are hidden behind a "pseudo-shell" with a large opening at the top so that the painted visions of heavenly glory seem to be mysteriously illuminated and suspended in space. The bold theatrical lighting of the Invalides places it firmly within the Baroque style.

Sculpture: The Impact of Bernini

Sculpture evolved into an official royal style in much the same way as did architecture—through the influence of Rome and the impact of Bernini's visit to the royal court in 1665. While in Paris, Bernini carved a marble bust of Louis XIV. He was also commissioned to create an equestrian statue of the king, which he later executed in Rome and sent back to Paris, where it was reworked. It is now at Versailles.

ANTOINE COYSEVOX Bernini's influence can be seen in the work of Antoine Coysevox (1640–1720), the first of a long line of distinguished French portrait sculptors and one of the artists employed by Le Brun at Versailles. The large stucco relief of the victorious Louis XIV that Coysevox made for the Salon de la Guerre (see fig. 21.16) retains the pose of Bernini's equestrian statue, although with more restraint. In a vivacious terra-cotta portrait of Le Brun (fig. **21.19**), Coysevox shows the artist with slightly parted lips and head turned to the side. The drapery folded over itself below the shoulder line recalls the general outline of Bernini's bust of Louis XIV. Le Brun's face, however, shows a naturalism and subtle characterization that are Coysevox's own.

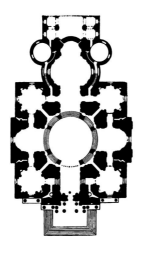

21.18. Plan of the Church of the Invalides

visually connected the sacrifice of the soldiers to their allegiance to the king and the absolute authority of monarchy.

In plan the Invalides consists of a Greek cross with four corner chapels (fig. **21.18**); it is based on Michelangelo's and Bramante's centralized plans for St. Peter's. The dome, too,

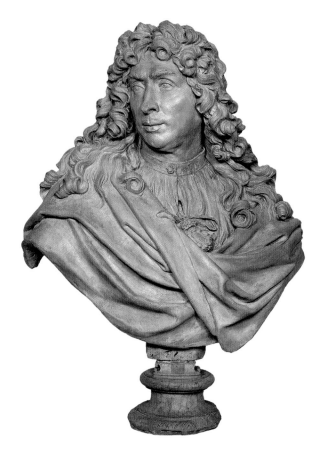

21.19. Antoine Coysevox. *Charles Le Brun.* 1676. Terra cotta, height 26″ (66 cm). The Wallace Collection, London. Reproduced by Permission of the Trustees

PIERRE-PAUL PUGET Of the seventeenth-century French sculptors, Pierre-Paul Puget (1620–1694) best represents the High Baroque style. Puget had no success at court until after Colbert's death, when Le Brun's power began to decline. His finest statue, *Milo of Crotona* (fig. **21.20**), benefits from a comparison with Bernini's *David* (see fig. 19.29). Although Puget's composition is more contained, he nevertheless successfully conveys the dramatic force of the hero attacked by a lion while his hand is trapped in a tree stump. The creature attacks from behind and digs its claws deeply into the thigh of Milo, who twists painfully and cries out in agony. The violent action imbues the statue with an intensity that also recalls the *Laocoön*. This reference to antiquity, one suspects, is what made the work acceptable to Louis XIV.

BAROQUE ARCHITECTURE IN ENGLAND

The English gained much but contributed little to the development of Baroque painting and sculpture. Foreign painters mainly from Italy, Flanders, and the Dutch Republic dominated the English royal court. During the reign of Charles I, the court painter Van Dyck executed both portraits and allegorical paintings. After his death many court artists continued his style of portraiture, initiating little in the visual arts until the Restoration of Charles II in 1660. After the Great Fire of

London in 1666, the rebuilding of the city gave priority to architecture, which thereafter represented the most important English artistic achievement.

Inigo Jones and the Impact of Palladio

The first significant English architect was Inigo Jones (1573–1652), architect to James I and Charles I as well as the era's leading English theatrical designer. Jones's style developed from the country house tradition of large private mansions in parklike settings, such as Longleat (see 18-30). Jones took two lengthy trips to Italy (and visited Venice) from 1597 to 1603 and during 1613–1614, with an interlude in Paris in 1609. Upon returning from his second trip to Italy, he was appointed Surveyor of the King's Works, a post he held until 1643. Jones was now an affirmed disciple of Andrea Palladio, whose Classical design principles he admired and whose treatises (along with those of Alberti) he owned and annotated. Before Jones, English architecture was a pastiche of medieval and Renaissance

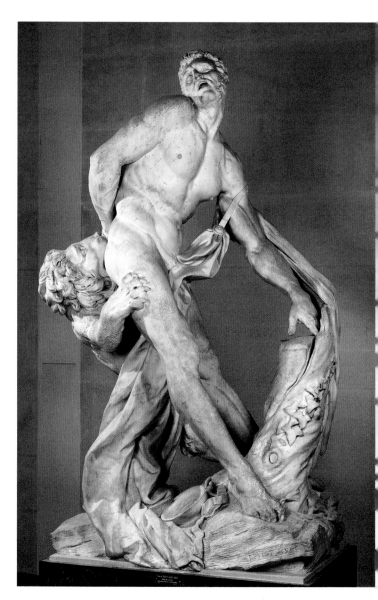

21.20. Pierre-Paul Puget. *Milo of Crotona.* 1671–1682. Marble. Height 8′10½″ (2.7 m). Musée du Louvre, Paris

forms. He is responsible for introducing Palladio's Renaissance Classicism to England, although the style took root only in the early decades of the eighteenth century, when a building boom resulted in the trend called the Palladian Revival.

The Banqueting House Jones built at Whitehall Palace in London (fig. **21.21**) conforms to the principles in Palladio's treatise, although it does not copy any specific Palladian project. Originally intended to be used for court ceremonies and performances called masques (a spectacle combining dance, theater, and music), evening entertainments were halted after 1635 because smoke from torchlights was damaging Rubens's *Apotheosis of James I*, painted in the recessed compartment of the ceiling. The Banqueting House is essentially a Vitruvian "basilica," a double-cube with an apse for the king's throne, which Jones has treated as a Palladian villa. It is more like a Renaissance palazzo than any building north of the Alps designed at that time. Jones uses an ordered, Classical vocabulary and the rules of proportion to compose a building in three parts. The Ionic and Composite orders of the pilasters add an understated elegance, and alternating segmental and triangular pediments over the first floor windows create a rhythmic effect. The sculpted garland below the roofline and the balustrade above decoratively enhance the overall structure. The building is perhaps starker than originally conceived; it once bore colored stones for each of the stories, but the facade was later resurfaced. Jones's spare style stood as a beacon of Classicist orthodoxy in England for 200 years.

Sir Christopher Wren

If not for the destruction caused by the Great Fire of London of 1666, Sir Christopher Wren (1632–1723), the most important English architect of the late seventeenth century, might have

remained an amateur. Wren may be considered the Baroque counterpart of the Renaissance artist-scientist. An intellectual prodigy, he first studied anatomy and then physics, mathematics, and astronomy, and he was highly esteemed by Sir Isaac Newton for his understanding of geometry. Early in his career, Wren held the position of chair in the astronomy department at Gresham College, London, and then at Oxford University. His interest in architecture did not surface until he was about 30 years old. His technological knowledge may have affected the shape of his buildings; certainly, no previous architect went to such lengths to conceal a building's structural supports. Only an architect thoroughly grounded in geometry and mathematics could have achieved such results, and the technical proficiency of Wren's structures has continually confounded his critics.

After the catastrophic fire of 1666, Wren was named to the short-lived royal commission to reconstruct the city (see end of Part III, *Additional Primary Sources*). A few years later he

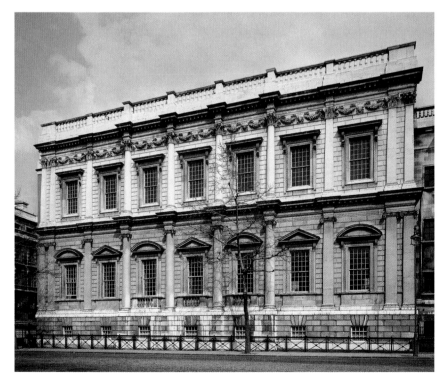

21.21. Inigo Jones. West Front of the Banqueting House, Whitehall Palace, London. 1619–1622

21.22. Sir Christopher Wren. Facade of St. Paul's Cathedral, London. 1675–1710

began his designs for the rebuilding of St. Paul's Cathedral (fig. **21.22**), one of many churches destroyed in the conflagration. Wren favored central-plan churches and originally conceived of St. Paul's in the shape of a Greek cross with a huge domed crossing, based on Michelangelo's plan of St. Peter's. This idea was evidently inspired by a previous design by Inigo Jones, who had been involved with the restoration of the original Gothic structure of St. Paul's earlier in the century. Wren's proposal was rejected by church authorities, however, who favored a conventional basilica as more suitable for a Protestant structure. In the end, the plan is that of a Latin cross (fig. **21.23**), the same followed for most Catholic churches including St. Peter's, an ironic outcome given that the building program could have provided an opportunity to create a new vocabulary for the Protestant Church of England.

On his only journey abroad in 1665–1666, Wren visited France and met with Bernini who was in Paris at the invitation of Louis XIV to design and complete the Louvre. The influence of this trip can be seen on the facade of St. Paul's, which bears a striking resemblance to Hardouin-Mansart's Church of the Invalides. The Invalides also inspired the three-part construction of the dome, which like St. Peter's has a diameter as wide as the nave and aisles combined. But St. Paul's dome rises high above the building and dominates the facade. The buttresses that support it are ingeniously hidden behind a screen wall, which further helps brace them. The classicism of Jones can also be seen in the dome, which looks like a much-enlarged version of Bramante's Tempietto (fig. 16.8). St. Paul's is an up-to-date Baroque design that reflects Wren's thorough knowledge of the Italian and French architecture of the day. Indeed, Wren believed that Paris provided "the best school of architecture in Europe," and he was equally affected by the Roman Baroque. The lantern and upper part of the bell towers

21.24. Sir Christopher Wren. Steeple of the Church of St. Mary-Le-Bow, 1680. London

suggest that he knew Borromini's Sant'Agnese in Piazza Navona, probably from drawings or engravings. The resulting structure reflects not only the complex evolution of the design but also later changes made by the commission overseeing construction, which dismissed Wren in 1718.

For Wren as for Newton (who was appointed a Commissioner of St. Paul's in 1697), mathematics and geometry were central to the new understanding of the universe and humanity's place in it. In Wren's *Five Tracts*, written toward the end of his life and presented by his son to the Royal Society in 1740, he stated that architecture must conform to "natural reason," which is the basis of eternal Beauty. In other words, architecture must use rational (that is, abstract) geometrical forms, such as the square and the circle, as well as proportion, perspective, and harmony—but it must not sacrifice variety. Such rationality and diversity are clearly evident in Wren's design for St. Paul's.

The Great Fire of London in 1666 provided Wren with the opportunity to rebuild and reframe the city and its skyline. Besides St. Paul's, he worked on 52 of the 87 damaged or destroyed churches, designing distinctive steeples for many of them. The steeple of the Church of St. Mary-Le-Bow (fig. **21.24**) provides us with his most famous example. (It should be noted that many of these churches, including this one, were damaged

21.23. Plan of St. Paul's Cathedral

during the bombing of London in World War II and have been reconstructed.) The steeple is exceptionally tall (225 feet high) and even today soars over surrounding buildings. The height is achieved through an unusual stacking of components: a two-story base (with arched entrance), plain attic, bell housing with paired pilasters, and a colonnaded temple surmounted by buttresses that support a lantern and obelisklike pinnacle as seen in the Church of the Invalides. To indicate the church's dedication, Wren designed twelve "bows"—actually inverted brackets— at the base of the round temple. The result is an elaborate, multi-storied steeple, Gothic in its verticality yet based on Classical motifs. Nothing like it had yet been seen. Wren's innovation in this church, and in his variations for the churches built after the Great Fire, distinguished English Baroque church architecture.

John Vanbrugh and Nicholas Hawksmoor

The marriage of English, French, and Italian Baroque elements is still more evident in Blenheim Palace (fig. 21.25), a grandiose structure designed by Sir John Vanbrugh (1664–1726), a gifted amateur, with the aid of Nicholas Hawksmoor (1661–1736), Wren's most talented pupil. Although Blenheim is considered to be Vanbrugh's greatest work, the building was in fact completed by Hawksmoor; yet the architecture is seamless. Blenheim skillfully combines the massing of an English castle with the breadth of a country house such as Longleat (see fig. 18.30), the rambling character of a French château such as Fontainebleau (see fig. 18.3), and a facade inspired by Sir Christopher Wren, Vanbrugh's rival. However, when Blenheim and its framing colonnade are compared with the piazza of St. Peter's (see fig. 19.14), Vanbrugh's design reveals itself to be even closer to Bernini. The main block uses a colossal Corinthian order to wed a temple portico with a Renaissance palace, while the wings rely on a low-slung Doric order. Such an eclectic approach, extreme even by the relaxed standards of the period, is maintained in the details. Vanbrugh, like Inigo Jones, had a strong interest in the theater and was a popular playwright. Blenheim's theatricality and massiveness make it a symbol of English power, a fitting, but more modest, counterpart to Versailles in both structure and grounds. Designed mainly for show and entertainment, it was presented by a grateful nation to the duke of Marlborough for his victories over French and German forces at the Battle of Blenheim in 1704, during the War of Spanish Succession.

21.25. Sir John Vanbrugh and Nicholas Hawksmoor. Blenheim Palace, Woodstock, England. Begun 1705

SUMMARY

At the beginning of the seventeenth century, the great monarchies of France and England faced seemingly endless crises. With continued political, social, and religious turmoil plaguing both nations, each successive sovereign sought to consolidate power and centralize administration. From England's constitutional monarchy to France's absolutism, the royal state reigned supreme. Yet the societies they governed were in dramatic flux. Despite increased wealth among the bourgeoisie—coupled with an emerging mercantile system, growing trade routes, and profitable colonial empires—most people suffered overwhelming poverty. Weakened under the burden of ever-increasing taxes and disenfranchised from the political system, Europe's peasantry was realizing their inability to change the government except through violent uprising. At the same time, nobles were formulating their own complaints against the centralized authority, which was robbing them of power and privileges.

Set against this compelling backdrop, monarchs throughout Europe evoked the age-old divine right of kings. They used art to convey the power and prestige of the monarchy, and the royal courts of both France and England became the most important patrons of the arts. Grandiose Baroque art and architecture stood as symbols not only of their authority but also of the pride and glory of the nation as well. Classicism, with its references to the tradition and supremacy of ancient Greece and Rome, became the favored style of the court, arbiter of taste during this tumultuous period.

FRANCE: THE STYLE OF LOUIS XIV

Art produced during the reign of Louis XIII varied greatly, from the scathing documentary prints of Jacques Callot to the meditative religious themes of Georges de La Tour, to the colorful and decorative paintings of Simon Vouet.

By 1640 the calm classicism of Nicolas Poussin dominated French Baroque art. Working in Rome, Poussin advocated that artists explore the "great" themes of art as established by the French Academy: narratives, heroic battles, religious themes, and subjects from antiquity. In the 1660s his Classical style became the model for French artists trained at the French Academy, which had been founded in 1648. Like Poussin, Claude Lorrain also favored a rational classicism, which permeates his sophisticated, carefully rendered idyllic landscapes. Sculpture, meanwhile, shows the influence of Bernini, as seen in the sculpted portraits of Antoine Coysevox and the intense statues of Pierre-Paul Puget.

Native artists remaining on French soil likewise set the tone for French art. Employed by the royal courts, these artists worked specifically in the service of glorifying the king. From the symbolic portraits of Hyacinthe Rigaud to the ostentatious facade of the Louvre, much French art was spectacle meant to transmit the values of the monarchy to a wide audience. Perhaps the most grandiose architectural project of the 1600s was Versailles, both its palace and its gardens. The Classical style, repeated forms, and colossal size convey the power of Louis XIV and reflect his philosophy of absolute monarchy.

BAROQUE ARCHITECTURE IN ENGLAND

As in France, English Baroque art and architecture were dominated by classicism. Although English painting was primarily the realm of foreign painters from Italy, Flanders, and the Dutch Republic, architecture developed a distinctive national style. Inigo Jones, the first significant English architect, introduced Andrea Palladio's Renaissance Classicism to England, as seen in the Banqueting House at Whitehall Palace in London. In the latter half of the century, Christopher Wren became the country's preeminent architect. Distinguished by a technical proficiency lauded by his contemporaries, Wren created some of the era's most masterful structures, including the renovated St. Paul's Cathedral. The Great Fire of 1666 provided Wren with the opportunity to rebuild and reframe London and its skyline, and many of the city's redesigned churches bear the mark of his architectural genius.

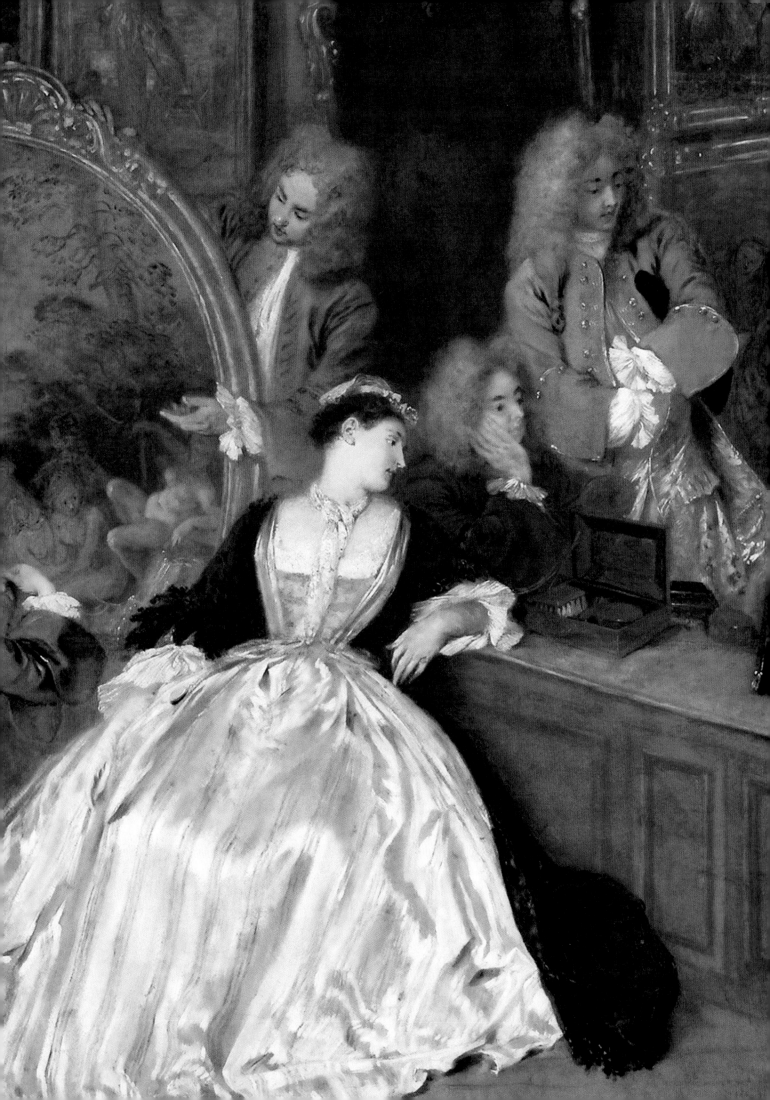

The Rococo

N FRANCE THE ROCOCO STYLE IS LINKED WITH LOUIS XV (1710–1774) BECAUSE it corresponds roughly to his lifetime. But the first signs of the Rococo style had appeared as much as 50 years earlier than Louis's birth, during the popularity of the late seventeenth-century Baroque style, and it extended through the excesses of the reign of Louis XVI (r. 1774–1792) and his wife, Marie Antoinette,

to the French Revolution of 1789. As noted by the philosopher François-Marie Arouet, better known by his pen name Voltaire (1694–1778), the eighteenth century lived indebted to the past. In art, Poussin and Rubens cast their long shadows over the period. The controversy between their followers, in turn, goes back much further to the debate between the supporters of Michelangelo and those of Titian over the merits of drawing versus color (see page 759). In this sense, the Rococo, like the Baroque, still belongs to the Renaissance world.

Despite similarities between the Baroque and Rococo, a fundamental difference exists between the two styles. In a word, it is fantasy. If the Baroque presents theater on a grand scale, the Rococo stage is smaller and more intimate. Its artifice evokes an enchanted realm that presents a diversion from real life. In some ways the Rococo in France manifests a shift in taste among aristocrats, who reasserted their power as patrons and began to favor stylized motifs from nature and a more domestic art—private rather than public—to decorate their new homes in Paris, called hôtels. The word Rococo fits well, for it implies both a natural quality and a sense of ornamentation well suited to the frivolity of court life. It was coined in the nineteenth century as a disparaging term, taken from the French word *rocaille*

(meaning "pebble") and *barocco* ("baroque"), to refer to what was then perceived as the excessive and ornate taste of the early eighteenth century. The word *Rococo*, then, refers to the playful, irregular pebbles, stones, and shells that decorated grottoes of Italian gardens and became the principal motifs of French interior designs.

Although sometimes viewed as the final phase of the Baroque, the Rococo asserted its own independent stylistic traits and represents a period of intense creative and intellectual activity. French artists continued to be trained in the tradition of the Royal Academy of Painting and Sculpture, which stressed working from live models, studying anatomy, and practicing perspective and proportion—lessons supplemented by lectures on the art of Raphael and Poussin. Yet artists also began exploring new subjects or treating old themes in new ways. The interest in the poetic genre of the pastoral, as practiced by Baroque artists including Claude, took on growing importance in the eighteenth century. Artists turned to pastorals and subjects of love and loss, romantic trysts, and poetic musings in response to demand from the art market and from patrons who were increasingly taken with the notion of "simple man" existing in an idealized nature. The appeal of these themes proved so strong that the French Academy established a new category called the *fête galante*, a type of painting introduced by Jean-Antoine Watteau. Some scholars today criticize the Rococo for its unabashed escapism and eroticism. Yet, to its

Detail of figure 22.4, Jean-Antoine Watteau, *Gersaint's Signboard*

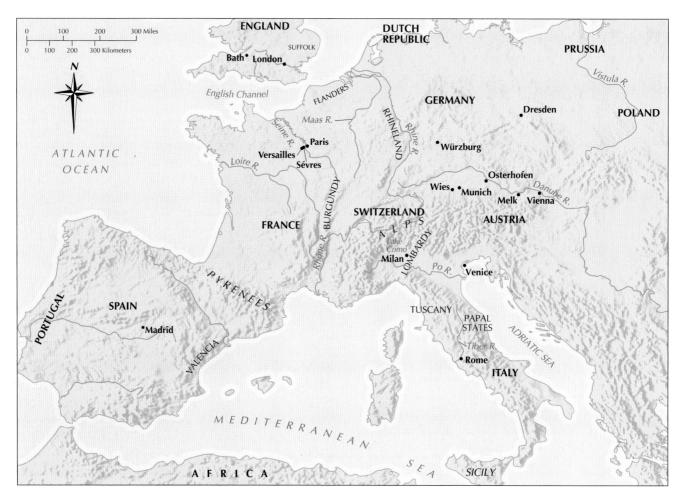

Map 22.1. Europe in the Rococo Period

credit, the style celebrated the tradition of love and broadened the range of human emotion depicted in art to include the family as a major theme.

Although most directly associated with France, the Rococo cast a wide geographical influence that affected the arts in England as well as most of western and central Europe (see map 22.1). English art, long dominated by foreign artists, saw the development of a distinct school of painting and the establishment of the Royal Academy of Arts in 1768, whose annual exhibitions attracted a fashionable London clientele and the best-known native artists. In western and central Europe, notably in Germany and Austria, the devastation of the Thirty Years' War (1618–1648) was followed in the eighteenth century by a period of rebuilding and the growth of pilgrimage churches, whose architecture and decoration reflected the Rococo style. Italian artists such as Tiepolo, with his assistants, painted ceiling frescos in central European churches and palaces in this new elaborate and elegant style and produced similar works for their native city of Venice as well. There, Canaletto painted *vedute,* or scenes of the city, which provided foreign visitors with souvenirs of their Venetian stay.

Also in the 1700s, European colonization of the New World continued. Armies battled to secure these distant lands, depleting their nations' treasuries yet succeeding in sending back to their homelands exotic objects, including feathers, jewels, and metals that collectors coveted and artists used in the creation of new art. In addition, European art often showed these foreign lands, albeit in imaginary or allegorical images, and gave concrete form to the wealth of the patrons. The period also saw the rise of aesthetics, a category of philosophy put forth by Immanuel Kant (1724–1804), stating that, among other things, humans have the capacity to judge beauty. In the performing arts, the Venetian composer Antonio Vivaldi (1678–1741) and the German composer Johann Sebastian Bach (1685–1750) produced extraordinary operas and choral music, and London became home to the establishment of legitimate theater, notably in Haymarket, Drury Lane, and Covent Garden.

FRANCE: THE RISE OF THE ROCOCO

After the death of Louis XIV in 1715, the nobility, formerly attached to the court at Versailles, were now freer from royal control. Louis XV, only 5 years old at his father's death, would not be crowned until 1723. This early period of the Rococo—between 1715 and 1723—is known as the Regency, so-called because France was governed by Louis's cousin Philip, duke of Orléans, acting as regent. With a nobleman in power, the aristocracy regained much power and authority, and they abandoned

the strict, demanding court life of Versailles. Rather than returning to their châteaux in the provinces, many chose to live in Paris, where they built elegant town houses called *hôtels*. Hôtels had been used as city residences by the landed aristocracy since about 1350, but during the seventeenth century they developed into social centers, a trend that continued in the eighteenth. The small, intimate rooms in the hôtels often served as the settings for informal intellectual and entertaining gatherings known as *salons*, which were hosted by powerful women (namely mesdames de Staël and de la Fayette, among others) and became enormously popular among the Parisian aristocracy. The rooms were decorated with paintings, porcelain, and small sculpture that created a lavish, light-hearted mood. Paintings, therefore, were just one part of the creation of the ambiance of refinement that permeated pre-Revolutionary France. These paintings, as well as interior designs, would influence the decor of western and central Europe throughout the century.

Painting: Poussinistes versus Rubénistes

Toward the end of the seventeenth century, a dispute arose among the members of the French Academy, who then formed two factions: the **Poussinistes** against the **Rubénistes**. Neither Poussin nor Rubens was still alive during this debate, which focused on the issue of drawing versus color. French artists were familiar with Poussin's paintings, which had been sent from Rome to Paris throughout his career, and they knew Rubens's work from the Marie de' Medici cycle in the Luxembourg Palace. The conservatives defended Poussin's view that drawing, which appealed to the mind, was superior to color, which appealed to the senses. The Rubénistes (many of whom were of Flemish descent) favored color, rather than drawing, as being truer to nature. They also pointed out that drawing, admittedly based on reason, appeals only to the expert few, whereas color appeals to everyone. This argument had important implications. It suggested that the layperson should be the judge of artistic values and this challenged the Renaissance notion that painting, as a liberal art, could be appreciated only by the educated mind. The colorists eventually won the day, due in part to the popularity of painter Jean-Antoine Watteau.

JEAN-ANTOINE WATTEAU The greatest of the Rubénistes was Jean-Antoine Watteau (1684–1721). Born in Valenciennes, which until a few years before his birth had still been part of the South Netherlands, Watteau showed an affinity for Rubens, the region's greatest artist. After moving to Paris in 1702 Watteau made many drawings styled after Rubens's French works, including the Marie de' Medici cycle (see fig. 20.5). Watteau was a significant contributor to the new Rococo style as well as to the new subjects associated with it. His painted visions of fantasy show idyllic images of aristocratic life, with elegant figures luxuriously dressed in shimmering pastel colors and set in dreamlike outdoor settings. He often seamlessly interweaves theater and real life in his works, incorporating well-known characters from the *commedia dell'arte* (a type of improvisational Italian theater) and creating stagelike

settings that serve as backdrops for the actors. The carefully posed figures evoke forlorn love, regret, or nostalgia and imbue the scenes with an air of melancholy. Such works became increasingly sought after by collectors in France, and the popularity of this theme soon spread throughout Europe.

Because Watteau's fantasies had little historical or mythological basis, his paintings broke many academic rules and did not conform to any established category. To admit Watteau as a member and accept his romantic paintings, the French Academy created the new classification of painting called *fêtes galantes* (meaning "elegant fêtes" or "outdoor entertainments"). This category joined the hierarchy of genres that had been established in the seventeenth century by academy member André Félibien (1619–1695). The premier category was history painting, considered to be the highest form of art because it was thought to require the most imagination and was therefore the most difficult to execute. Next were portraits, landscapes, and then still life. Watteau's reception piece for the Academy, required when he became a member in 1712, was not delivered until 5 years later. The work, *A Pilgrimage to Cythera* (fig. **22.1**), is an evocation of love and includes elements of Classical mythology. Cythera, which came to be viewed as an island of love, was one of the settings for the Greek myth of the birth of Aphrodite (Venus), who rose from the foam of the sea. The title suggests this traditional subject, but the painting was described in the French Academy records as a *fête galante*, perhaps the first use of this term.

It is unclear whether the couples are arriving at or leaving the island. What is certain is that Watteau has created a delightful yet slightly melancholic setting of love, where the couples may enjoy a melding of human passions and Nature in privacy and freedom. The action unfolds in the foreground from right to left like a continuous narrative, which suggests that the figures may be about to board the boat. Two lovers remain engaged in their amorous tryst; behind them, another couple rises to follow a third pair down the hill as the reluctant young woman casts a longing look back at the goddess's sacred grove. Young couples, accompanied by swarms of cupids, pay homage to Venus, whose garlanded sculpture appears on the far right. The delicate colors—pale greens, blues, pinks, and roses—suggest the gentle nature of the lovers' relationship. The subtle gradations of tone showed Watteau's debt to Rubens and helped establish the supremacy of the Rubénistes.

As a fashionable conversation piece, the scene recalls the elegant figures in the courtly scenes of the Limbourg brothers' illuminations and those in Rubens's *Garden of Love* (see fig. 20.6), but Watteau has altered the scale and added a touch of poignancy reminiscent of Giorgione and Titian. Watteau's figures are slim, graceful, and small in scale; they appear even more so when compared with most Baroque imagery. Yet the landscape does not overwhelm the scene but echos its idyllic and somewhat elegiac mood. Watteau produces a sense of nostalgia, with its implications of longing and unrealized passion, through not only the figures and their gentle touching and hesitancy but also the sympathetic parallel found in his landscape and the sculptures in it.

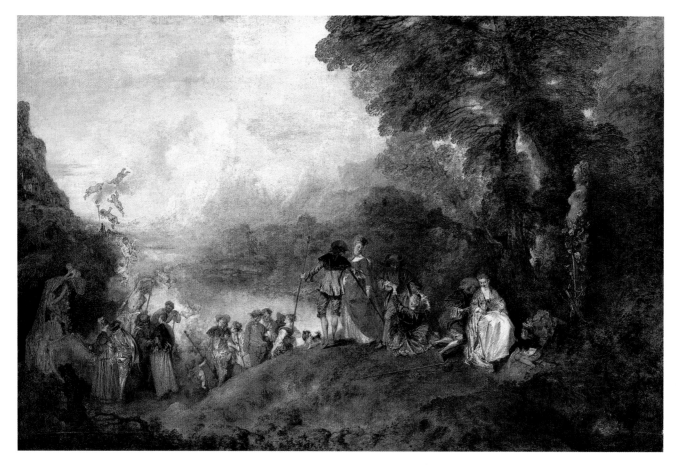

22.1. Jean-Antoine Watteau. *A Pilgrimage to Cythera*. 1717. Oil on canvas, 4′3″ × 6′4½″ (1.3 × 1.9 m). Musée du Louvre, Paris

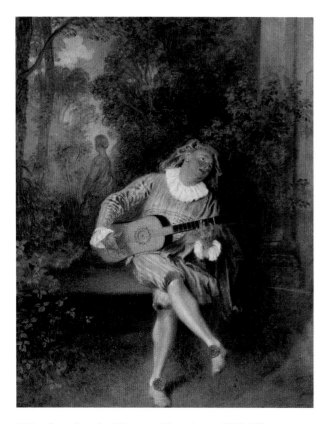

22.2. Jean-Antoine Watteau. *Mezzetin*. ca. 1718. Oil on canvas, 21¾ × 17″ (55.3 × 43.2 cm). The Metropolitan Museum of Art, New York. Munsey Fund, 1934 (34.138)

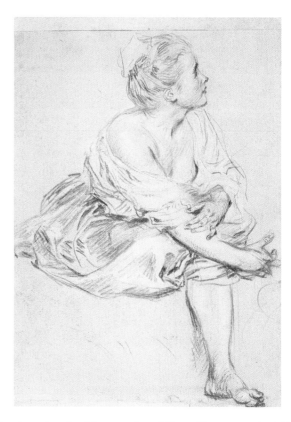

22.3. Jean-Antoine Watteau. *Seated Young Woman*. ca. 1716. *Trois crayon* drawing; red, black, and white chalks on cream paper, 10 × 6¾″ (25.5 × 17.1 cm). The Pierpont Morgan Library, New York

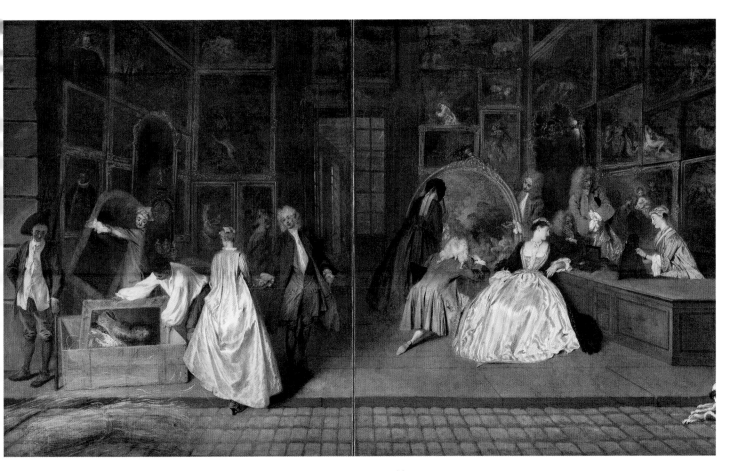

22.4. Jean-Antoine Watteau. *Gersaint's Signboard.* 1721. Oil on canvas, 5'5 1/4″ × 10' (163 × 308 cm). (Later cut in two pieces and then rejoined.) Schloss Charlottenburg, Staatliche Schlösser und Gärten, Berlin

This nostalgic atmosphere is also evoked in Watteau's musician, *Mezzetin* (fig. **22.2**), a stock figure of the *commedia dell'arte*, whose name means "half-measure" and who played the role of an amorous suitor. He sings a pleading love song while playing his guitar in a parklike setting decorated with a statue of a woman in the background. Scholars presume that he is playing his music to her. It has been suggested that the painting, which was owned by Watteau's friend Jean de Jullienne (the author of a biography of the artist; see *Primary Source*, page 762), may have related to Jean's courtship of his wife. The wistful musician strains to look up to the right, out of the picture. Yet the fantastic, delicately striped costume of rose, pale blue, and white, paired with yellow shoes and rose beret and cape, transforms the scene from melancholic to magical. The small, single figure in pastel colors, set amid this pale verdant setting, is typical of the Rococo in spirit, figure type, and color of costume and setting.

Watteau's use of color planted him firmly in the Rubéniste camp. However, his innovations and creativity as a draftsman (which would have implied a Poussiniste status) combined both color and line (see *Materials and Techniques*, page 763). Although previous artists, including Rubens, may have drawn with red or black chalk heightened with white, Watteau excelled in the *trois crayons* technique. In *Seated Young Woman*

(fig. **22.3**), he uses the three chalks to best effect, so that the red color that defines her body—legs, hands, parts of her face (lips, tip of nose), nape, breast—suggests a vivacious quality when contrasted against the black and white of her clothing, eyebrows, and upswept hair. The colors enliven and add a spontaneity to this life drawing. In numerous sketches Watteau often worked out poses, movements, gestures, and expressions, many of which (although not this drawing) served as studies for figures in his paintings.

The same informality can be seen in one of Watteau's best-known works, *The Shopsign* or *Gersaint's Signboard* (fig. **22.4**). Created to advertise the wares of his friend and art dealer Edmé Gersaint, the sign does not in fact show Gersaint's gallery. Gersaint wrote about this commission and indicated that it was made at Watteau's suggestion to "stretch his fingers" after Watteau returned from a trip to London. Watteau had been physically ill (he would die soon after of tuberculosis), and the implication was that the artist used this work as part of a brief recovery. This account has since been disputed, but the work remains Watteau's last. The painting (originally arched at top) reportedly took only eight mornings to complete. It was meant to be exhibited outside but was shown for only 15 days (perhaps due to the weather or because it sold quickly). Gersaint reported that the painting attracted many

Jean de Jullienne (1686–1767)

A Summary of the Life of Antoine Watteau, 1684–1721

Jullienne, a dyer and later the Director of the Gobelin Tapestry, was a life-long friend of Watteau's and a collector of his works. At Watteau's death, he had all of the artist's drawings engraved and later did the same with the paintings, after buying many of them. His biography of the artist was published in 1726–1728, along with 350 engravings after Watteau's paintings and drawings, in two volumes as Figures de différents caractères. *Another two volumes followed.*

Watteau, inclined more and more to study, and excited by the beauties of the gallery of this palace [the Luxembourg Palace] painted by Rubens, often went to study the color and the composition of this great master. This in a short time gave him a taste much more natural and very different from that which he had acquired with Gillot. …

Watteau was of medium height and weak constitution. He had a quick and penetrating mind and elevated sensibilities. He spoke little but well, and wrote likewise. He almost always meditated. A great admirer of nature and of all the masters who have copied her, assiduous work had made him a little melancholy. Cold and awkward in demeanor, which sometimes made him difficult to his friends and often to himself, he had no other fault than that of indifference and of a liking for change. It can be said that no painter ever had more fame than he during his life as well as after his death. His paintings which have risen to a very high price are today still eagerly sought after. They may be seen in Spain, in England, in Germany, in Prussia, in Italy, and in many places in France, especially in Paris. Also one must concede that there are no more agreeable pictures for small collections than his. They incorporate the correctness of drawing, truth of color and an inimitable delicacy of brushwork. He not only excelled in *gallant* and rustic compositions, but also in subjects of the army, of marches, and bivouacs of soldiers, whose simple and natural character makes this sort of pictures very precious. He even left a few historical pieces whose excellent taste shows well enough that he would have been equally successful in this genre if he had made it his principal objective.

Although Watteau's life was very short, the great number of his works could make one think that it was very long, whereas it only shows that he was very industrious. Indeed, even his hours of recreation and walking were never spent without his studying nature and drawing her in the situations in which she seemed to him most admirable.

The quantity of drawings produced by his study and which have been chose to be engraved and to form a separate work is a proof of this truth.

SOURCE: *A DOCUMENTARY HISTORY OF ART*, VOL II. ELIZABETH GILMORE HOLT ED. (PRINCETON, NJ: PRINCETON UNVERSITY PRESS, 1982)

artists as well as passersby who admired the natural, elegant poses of the figures—traits still admired today. The voluminous rose satin dress of the woman on the left, seen from the back, draws the eye; this figure is balanced by the languidly leaning woman on the right. Sophisticated and comfortable in the setting, the women are attended to by a solicitous staff as they admire paintings in the shop, arranged three to four high on the walls. Scholars do not believe these are copies of actual paintings but rather variants on Flemish and Venetian works, a theory that seems plausible when this work is compared with Jan Brueghel the Elder's *Allegory of Sight* and its real painting gallery (see fig. 20.10). The shop's stock also includes a variety of clocks and mirrors, which create an atmosphere of opulence and would remind the viewer of the world of the *ancien régime*. This association is supported by a portrait of Louis XIV based on Rigaud's (see fig. 21.10), seen on the left, which is being placed in a crate. Although on one level the presence of the king's image suggests the departure of the old (he had died only a few years before in 1715), it is actually a pun on the name of the shop, Au Grand Monarque. Watteau's extraordinary abilities as a painter are apparent as he transforms this commercial venture into a sensitive work of sophistication and tender beauty.

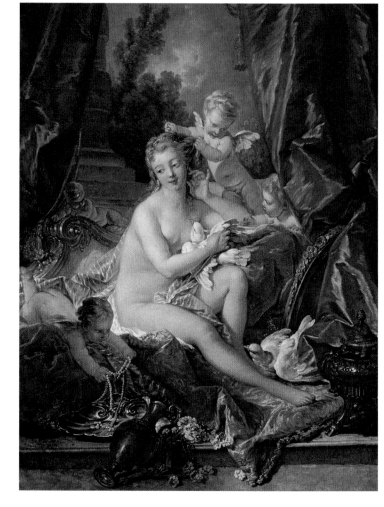

22.5. François Boucher. *The Toilet of Venus*. 1751. Oil on canvas, 43 × 33½″ (109.2 × 85.1 cm). The Metropolitan Museum of Art, New York. Bequest of William K. Vanderbilt. 1920. (20.155.9)

Pastel painting

Pastels are a form of colored chalks or powders that are mixed (or filtered) with glue, juice, gum arabic, or whey and then rolled into a cylindrical tube. They are made and sold today in much the same way as they were in the Rococo era. The fillers and water enable the pastels to be applied smoothly. Pastels can be soft or hard, but they must be dried out to be packaged as pastel crayons.

Leonardo had worked with pastels in the late fifteenth century (for his portrait of Isabella d'Este, 1499), but they gained popularity among artists in the sixteenth century. Yet artists used them only to execute preparatory drawings, not to create finished works. In the eighteenth century, however, artists realized the possibilities of the medium and began making pastel paintings as finished works. Pastels, as well as the popular **trois crayons** technique (see Watteau, fig. 22.3), had the advantage of suggesting both line and color at the same time. Since much debate arose in the late seventeenth and early eighteenth centuries about drawing (i.e., line) versus color, and since critics lauded artists such as Raphael who could combine both, the use of pastels may be considered a response to this issue. The lines could be smudged, built on each other, or hatched so that a single line could become an area of color and several together could create and an even more vibrant patch.

Artists chose pastels primarily to make portraits, applying flicks of color to suggest animation, emotion, or expression and thus make the sitter appear more vivid and lifelike. One of the greatest pastel portraitists is Rosalba Carriera (1675–1757), a Venetian artist known for revealing the psychological intensity of her sitters. Carriera was famous in her own time and had an international clientele of British, French, German, and Polish patrons. She was a member of the Academy of St. Luke of Rome in 1705, the Academy Clementina of Bologna in 1720, and the French Academy in 1721. Upon traveling to Paris in 1720–1721, she was hailed by both the French court and French artists including Hyacinthe

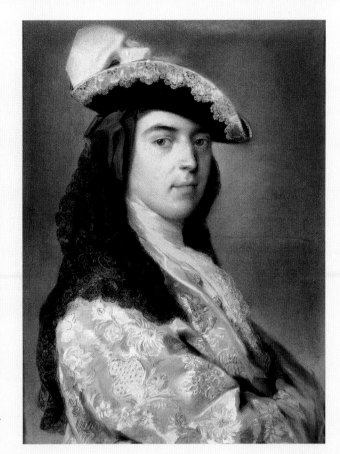

Rosalba Carriera. *Charles Sackville, Second Duke of Dorset.* ca. 1730. Pastel on paper, 25 × 19″ (63.5 × 48.3 cm). Private Collection

Rigaud (see Chapter 21) and Watteau (see pages 759–762), who made several drawings of her. The intimacy and immediacy of her technique, combined with the indistinct, even hazy, quality of the image, suggest a tantalizingly allusive sensuality, as seen in this portrait of the second Duke of Dorset.

FRANÇOIS BOUCHER Following the untimely death of Watteau in 1721, François Boucher (1703–1770) rose to prominence in French painting. Boucher built his reputation on his imaginative compositions, pastoral landscapes, and scenes of bourgeois daily life. He served as court painter to Madame de Pompadour, Louis XV's mistress and frequent political advisor and a major patron of the arts. Boucher painted her portrait and other works for her, including *The Toilet of Venus* (fig. **22.5**) for her private retreat outside Paris. Although not a portrait of Madame de Pompadour, it is probably an allusion to her title role in the play *A Toilet of Venus*, performed at Versailles in 1750. Compared with Vouet's sensuous goddess (see fig. 21.3), Boucher's Venus has been transformed into an eternally youthful being. The pink tones of her skin are echoed in the pink chaise and the deep rose of fabric at her feet. Venus is engulfed by pale aquamarine drapery. The lush and erotic painting is typical of the Rococo in its figure type and sensual use of textures and colors—pastel pinks, roses, and blues. If Watteau elevated human love to the level of mythology, Boucher raised playful eroticism to the realm of the divine. He uncovered the

fantasies that enrich people's lives. Indeed, Boucher's joyful visions of human dreams and desires were a mirror of the luxurious and exuberant lifestyles of his patrons in the French royalty and aristocracy, for whom his works held great appeal.

JEAN-HONORÉ FRAGONARD Transforming fantasy into reality in paint was the forte of Jean-Honoré Fragonard (1732–1806)—or at least that was the reputation of this star pupil of Boucher. Also a brilliant colorist, Fragonard won the distinguished Rome Prize in 1752 and spent five years in Rome, beginning in 1756. Upon his return to Paris, he worked mostly for private collectors. Fantasy, flirtation, and licentiousness—in short, the spirit of the Rococo—coalesce in his painting *The Swing* (fig. **22.6**). An anecdote provides an interpretation of the painting. According to the story, another artist, Gabriel-François Doyen, was approached by the Baron de Saint-Julien to paint his mistress "on a swing which a bishop is setting in motion. You will place me in a position in which I can see the legs of the lovely child and even more if you wish to enliven the picture." Doyen declined the commission but directed it to Fragonard.

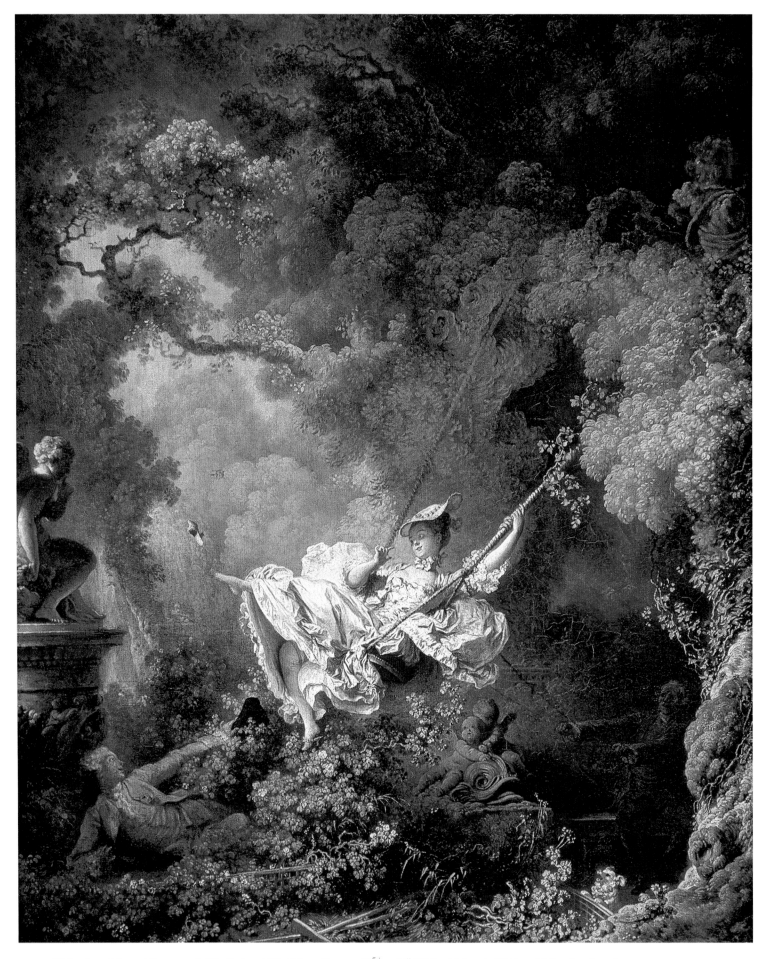

22.6. Jean-Honoré Fragonard, *The Swing*. 1767. Oil on Canvas, $32\frac{5}{8} \times 26''$ (82.9 × 66.0 cm). Wallace Collection, London

The painting, an example of an "intrigue," suggests a collusion in erotic fantasy between the artist and patron, with the clergy as their unwitting dupe. Like Boucher's *The Toilet of Venus*, this "boudoir painting" offers the thrill of sexual opportunity and voyeurism but here in a stagelike outdoor setting. The innocence of the public arena heightens the teasing quality of the motion of the swing toward the patron-viewer. The painted sculpture of a cupid to the left, holding a finger to his lips, suggests the conspiracy to the erotic escapade at which we as viewers are now participants. Fragonard used painted sculpture in many of his works to echo or reinforce their themes. Set in a lush arbor, this scene encapsulates the "place of love" secluded by trees that provides secrecy for this erotic encounter. The dense and overgrown landscape, lit by radiant sunlight, suggests the warmth of spring or summer and their overtones of sexuality and fertility. The glowing pastel colors create an otherworldly haze that enhances the sensuality of this fantasy spun by Fragonard.

Fragonard represented the epitome of the sensuality of the Rococo, and his works are marked by an extraordinary virtuosity in his use of color. His paintings range from erotic fantasies to intimate studies and pastoral landscapes, subjects that provided distraction for his wealthy patrons.

JEAN-SIMÉON CHARDIN Raised in a bourgeois household, Jean-Siméon Chardin (1699–1779) rose to become Treasurer of the French Academy as well as its Tapissier, responsible for installing the paintings at the Academy exhibitions. This role was especially notable because although Chardin was actively engaged in Academy life, his expertise was in still life, the area of painting considered the lowest in the Academy's hierarchy of subjects. Yet in his masterful hands, he raised this genre to an exalted and esteemed level. The interest in still-life paintings as well as in genre (which also became one of Chardin's specialties after colleagues encouraged him to paint figures as a way of raising his status) was inspired by the many Dutch and Flemish seventeenth-century paintings then in France. These artists settled in France in growing numbers after about 1550, maintaining close ties to their native region through the sale of Dutch paintings in French auction houses. They spurred a fascination with foreign painting, and indeed some of Chardin's own patrons were important collectors of seventeenth-century Dutch and Flemish art.

A keen observer of daily life, Chardin's genre paintings act as moral lessons not by conveying symbolic messages but by affirming the rightness of the existing social order and its values. To his patrons, members of the rising bourgeoisie in France, such genre scenes and domestic still lifes proclaimed the virtues of hard work, frugality, honesty, and devotion to family. Chardin's quiet household scenes struck a chord with his sophisticated patrons, and demand for them was so high that he often painted copies of his most popular subjects. His paintings were also reproduced as prints, making them affordable to those who lacked the means to buy an original work.

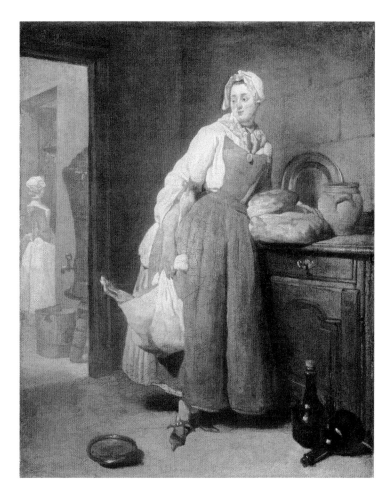

22.7. Jean-Siméon Chardin. *Back from the Market.* 1739. Oil on canvas, $18^{1}/_{2} \times 14^{3}/_{4}''$ (47×37.5 cm). Musée du Louvre, Paris

Back from the Market (fig. **22.7**) shows life in a Parisian bourgeois household. The beauty hidden in everyday life and a clear sense of spatial order beg comparison with the Dutch artist Jan Vermeer (see figs. 20.34 and 20.35). However, Chardin's technique differs significantly from that of any Dutch artist. As opposed to the exactitude seen in earlier Dutch still lifes, Chardin's brushwork is soft at the edges and suggests objects rather than defines them. Rather than painting every detail, Chardin seeks to reveal the inner nature of objects, summarizing forms and subtly altering their appearance and texture. Given his increasing fascination with the mere suggestion, the appeal of pastel painting is understandable, and Chardin often turned to this medium late in life, when his eyes were failing him. In this and other genre scenes, he reveals the complex beauty of even the most humble objects and endows them with timeless dignity.

Chardin's still lifes usually depict the same modest environment and, unlike Dutch still lifes, often focus on a few objects painstakingly rendered. *Kitchen Still Life* (fig. **22.8**) shows only the everyday items common to any kitchen: earthenware jugs, a casserole, a copper pot, a piece of raw meat, smoked herring, two eggs. But how important they seem, each so firmly placed in relation to the rest, each so worthy of the artist's—and a viewer's—attention. Despite his concern with formal problems,

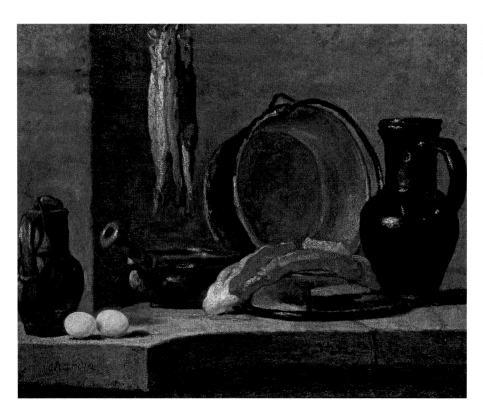

22.8. Jean-Siméon Chardin. *Kitchen Still Life.* ca. 1733. Oil on canvas, $12\frac{1}{2} \times 15\frac{3}{8}''$ (32 × 39 cm). Ashmolean Museum, Oxford. Bequeathed by Mrs. W. F. R. Weldon

evident in the beautifully balanced composition, Chardin treats these objects with a respect close to reverence. Beyond their shapes, colors, and textures, they are to him symbols of the life and values of common people.

Blowing Bubbles (fig. **22.9**) is very much an outgrowth of Dutch genre painting and the vanitas symbols frequently seen in the still-life tradition. The bubble, intact only for a moment, symbolizes the brevity of life, which serves as one of the painting's underlying themes. However, Chardin has chosen a charming, endearing way to send his message to a viewer. He presents two children, an older boy, possibly instructing a younger one eagerly looking on, since play was a common theme in Chardin's work. He frequently depicted children or young adolescents at play or engaged in a card game. Unlike most Rococo painting, the figures in this work are lifesize rather than diminutive, and their size affects our understanding of the reality. The scale reinforces the possibility that we could encounter a similar scene in our own world.

ÉLISABETH-LOUISE VIGÉE-LEBRUN Portraits allow us to gain the clearest understanding of the French Rococo, for the transformation of the human image lies at the heart of the age. In portraits of the aristocracy, men were endowed with the illusion of substance as an attribute of their noble birth. But the finest Rococo portraits were those of elaborately garbed women, hardly a surprising fact in a society that idolized love and feminine beauty. Indeed, one of the finest, most accomplished, and most successful portrait painters of the Rococo was Élisabeth-Louise Vigée-Lebrun (1755–1842). As court painter to Marie Antoinette, and therefore responsible for glorifying

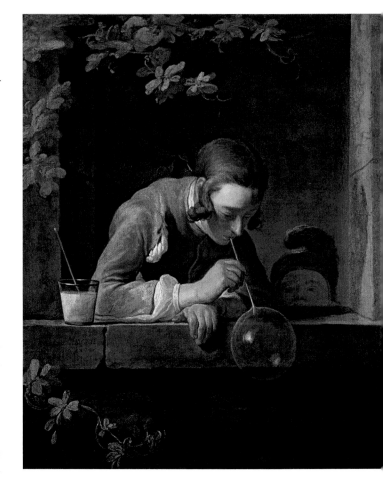

22.9. Jean-Simeon Chardin. *Blowing Bubbles.* ca. 1733. Oil on canvas, $36\frac{5}{8} \times 29\frac{3}{8}$ (93 × 74.6 cm). The National Gallery of Art, Washington, DC. Gift of Mrs. John W. Simpson

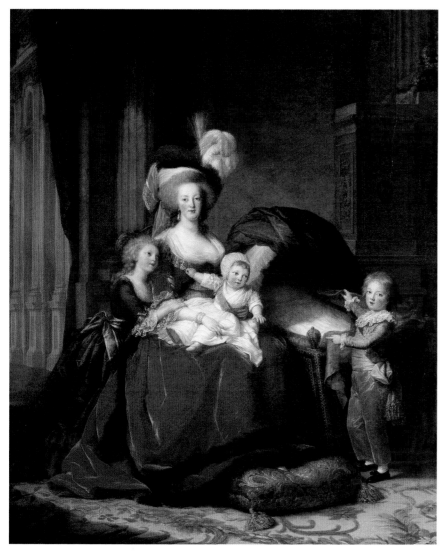

22.10. Élisabeth-Louise Vigée-LeBrun. *Marie Antoinette and Her Children*. 1787. Oil on canvas, $9'1\frac{1}{2}'' \times 7'5\frac{5}{8}''$ (2.75 × 2.15 m). Musée National du Château de Versailles, Versailles

the image of the monarch, Vigée-Lebrun held a dangerous position in the 1780s as the French Revolution approached. Yet she survived the war and serves as a bridge between the *ancien régime* of Louis XVI and the post-Revolutionary period.

Marie Antoinette and Her Children (fig. **22.10**) embodies the vision Vigée-Lebrun chose for the royal mother and the one the queen most attempted to incorporate into her life at Versailles. Surrounded by her children, Marie Antoinette is shown as a "normal," humble woman. At a time when a high infant mortality was the norm, the image of the empty cradle suggests the death of an infant, reinforcing the ordinariness of the royal family. The queen's eldest son, Louis Joseph (known as *le dauphin*; he would die of natural causes just two years later), is pointing to the empty cradle of Sophie. The second son, Louis Charles, sits on his mother's lap while her daughter, Marie Thérèse, stands at her side. This type of imagery, not just of a family scene but specifically of a mother with her children, was in vogue in both painting and in literature. Indeed, the concept

of motherhood as the epitome of a woman's life became fully developed at this time. A glimpse into the intimate life of the royal family, Vigée-Lebrun's portrait is intended to convey the ordinariness of what was likely the most extraordinary family in eighteenth-century France.

The French Rococo Interior

It is in the intimate spaces of early eighteenth-century interiors that the full elegance and charm of the Rococo are shown to full extent. This fact is manifest—yet disguised—in Vigée-Lebrun's portrait of Marie Antoinette, which is set in the midst of the magnificence of Versailles. But Versailles is not the only measure of the social world. The Parisian hôtels of the dispersed nobility soon developed into social centers. As state-sponsored building activity was declining, the field of "design for private living" took on new importance. Because these city sites were usually cramped and irregular, they offered few opportunities for impressive exteriors. Hence the layout and

décor of the rooms became the architects' main concern. The hôtels demanded an intimate style of interior decoration that gave full scope to individual fancy, uninhibited by the classicism seen at Versailles.

Crucial to the development of French décor was the importance assigned to interior designers. Their engravings established new standards of design that were expected to be followed by artisans, who thereby lost much of their independence. Designers also collaborated with architects, who became more involved in interior decoration. Along with sculptors, who often created the architectural ornamentation, and painters, whose works were inserted over doors, architects helped to raise the decorative arts to the level of the fine arts, thus establishing a tradition that continues today. The decorative and fine arts were most clearly joined in furniture. French cabinetmakers known as *ébénistes* (after ebony, their preferred wood veneer) helped to bring about the revolution in interior décor by introducing new materials and techniques. Gilt, metals, and enamels were often applied to these to create the feathery ornamentation associated with the Rococo. Many of these artisans came originally from Holland, Flanders, Germany, and Italy.

The decorative arts played a unique role during the Rococo. Hôtel interiors were more than collections of objects. They were total environments assembled with extraordinary care by discerning collectors and the talented architects, sculptors, decorators, and dealers who catered to their exacting taste. A room, like an item of furniture, could involve the services of a wide variety of artisans: cabinetmakers, wood carvers, gold-

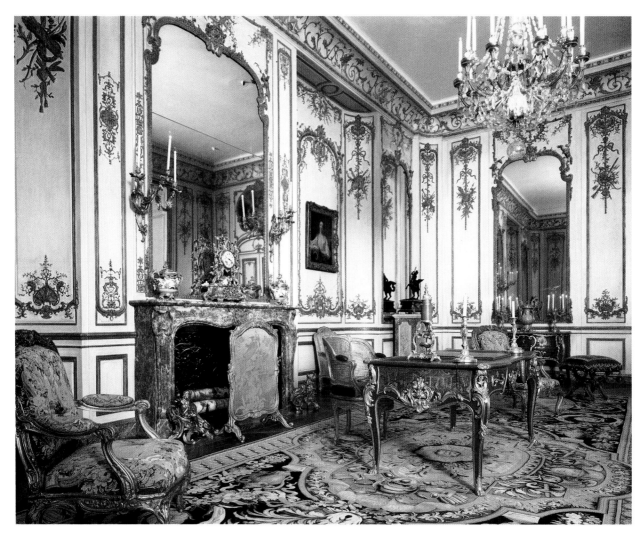

22.11. Nicolas Pineau. Varengeville Room in the Hôtel de Varengeville, 217 Boulevard St.-Germain, Paris. ca. 1735. (The chimney piece on the wall at left is not original to room.) Original paneling probably commissioned by Pineau. Carved, painted, and gilded oak, 18'3¾" × 40'6½" × 23'2½" (5.58 × 12.35 × 7.07 m). The Metropolitan Museum of Art, New York. Purchase, Mr. and Mrs. Charles Wrightsman Gift, 1963. (63.228.1)

and silversmiths, upholsterers, and porcelain makers. The varied artistic products of these artisans were set in rooms that were usually painted white and decorated with gilt molding and pastel-colored Rococo paintings set in walls and over doors, all enhanced by mirrors and light. The artists were dedicated to producing the ensemble, even though each craft was, by tradition, a separate specialty subject to strict regulations. Together they fueled the insatiable hunger for novelty that swept the aristocracy and haute bourgeoisie of Europe.

NICOLAS PINEAU Few of these Rococo rooms survive intact; the vast majority have been destroyed or greatly changed, or the objects and decorations have been dispersed. Even so, we can get a good idea of their appearance through the reconstruction of one such room (perhaps from the ground floor behind the garden elevation) from the Hôtel de Varengeville, Paris (fig. **22.11**), designed about 1735 by Nicolas Pineau (1684–1754) for the Duchesse de Villars. Pineau had spent 14 years in Russia as a collaborator with other French craftsmen on Peter the Great's new city of St. Petersburg. His room for the duchess incorporates many contemporary Rococo features. To create a sumptuous effect, the white walls are encrusted with gilded stucco ornamentation in arabesques, C-scallops, S-scrolls, fantastic birds, bat's wings, and acanthus foliage sprays. The elaborately carved furniture is embellished with gilt bronze. Everything swims in a sea of swirling patterns united by the most sophisticated sense of design and materials the world has ever known. No clear distinction exists between decoration and function in the richly designed fireplace and the opulent chandelier. The paintings, too, have been completely integrated into the decorative scheme, with paintings by Boucher set over two of the doors (these paintings even established a type of work, called overdoors).

Porcelain, and especially porcelain by Sèvres, the manufactory established by Louis XV and closely associated with the tastes of his mistress Madame de Pompadour, would have once been one of the prominent decorations within the interior, from the dinner and tea services to containers for playful bowls of potpourri (fig. **22.12**). In this example, the portholes of the shiplike vessel allow the sweet fragrance of the potpourri to escape. We see a similar example (although not of Sèvres) in the lower right corner of Boucher's *The Toilet of Venus* (fig. 22.5). These porcelain objects, even more popular later in Germany due to the popularity of wares produced by the Meissen pottery, transformed the colors of Rococo paintings and pastels—rose pinks, pale greens, turquoise blues—into three-dimensional art trimmed with gold.

CLODION AND FRENCH ROCOCO SCULPTURE Used to adorn interiors, French Rococo sculpture took many forms and was designed to be viewed at close range. A typical example is the miniature *Nymph and Satyr Carousing* (fig. **22.13**) by Claude Michel (1738–1814), known as Clodion, a successful sculptor of the Rococo period who later effectively adapted his style to the more austere Neoclassical manner. Clodion began his studies

22.12. Potpourri container. ca. 1758. Sèvres Royal Porcelain Factory, France. Soft paste porcelain with polychrome and gold decoration, vase without base $14^{3}/_{4} \times 13^{3}/_{4} \times 6^{7}/_{8}$″ (37.5 × 34.6 × 17.5 cm). The Frick Collection, New York

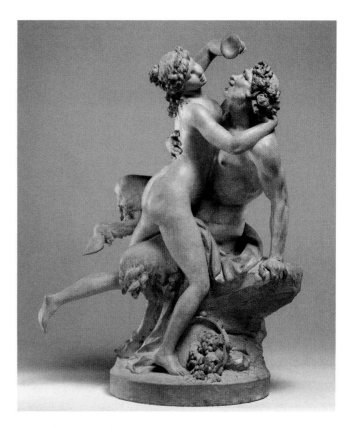

22.13. Claude Michel, known as Clodion. *Nymph and Satyr Carousing*. ca. 1780. Terra cotta, height $23^{1}/_{4}$″ (59 cm). The Metropolitan Museum of Art, New York. Bequest of Benjamin Altman, 1913. (14.40.687)

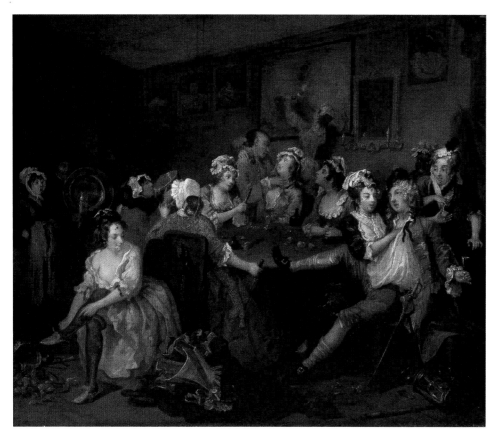

22.14. William Hogarth. *The Orgy*. Scene III of *The Rake's Progress*. ca. 1734. Oil on canvas, 24½ × 29½″ (62.2 × 74.9 cm). Sir John Soane's Museum, London. By Courtesy of the Trustees

at Versailles and won the prestigious Rome Prize. His greatest contribution to the Rococo was transforming the fantasies of Boucher and Fragonard into three-dimensional works of coquettish eroticism. The open and airy composition of this sculpture is related to a work by Bernini, but its reduced scale produces a more intimate and sensual effect. Although Clodion undertook several large sculptural cycles in marble, he reigned supreme in the intimate medium of terra cotta.

ENGLAND: PAINTING AND PRINTMAKING

The French Rococo exerted a major influence across the English Channel, where foreign artists—Holbein, Gentileschi, Rubens, Van Dyck—had flourished for generations in England, and the works of Dutch and Italian artists were widely collected. The Rococo helped to bring about the first school of English painting since the Middle Ages that had more than local importance. As we have seen with the works of Chardin and Rubens, among others, printmaking was used not just to create new compositions but to disseminate painted works, giving them a larger audience and broader appeal. This task proved most useful for landscapes and genre paintings, areas of great interest to, and increasingly collected by, the British public.

William Hogarth and the Narrative

William Hogarth (1697–1764) was the first major native English artist since Nicholas Hilliard (see fig. 18.28). Hogarth

began his career as an engraver and soon took up painting. Although he must have learned lessons about color and brushwork from Venetian and French examples, as well as from Van Dyck, his work is so original that it has no real precedent. He made his mark in the 1730s with a new kind of picture, which he described as "modern moral subjects ... similar to representations on the stage." This new type of picture follows the vogue for sentimental comedies, such as the plays of Richard Steele, which attempted to teach moral lessons through satire. Hogarth's work is in the same vein as John Gay's *The Beggar's Opera* of 1728, a biting social and political parody that Hogarth illustrated in one of his paintings. He created these pictures, and the prints made from them for sale to the public, in series and repeated certain details in each scene to unify the sequence. Hogarth's morality paintings teach, by bad example, solid middle-class virtues and reflect the desire for a return to simpler times and values. They proved enormously popular among the newly prosperous middle class in England.

In *The Orgy* (figs. **22.14** and **22.15**), from *The Rake's Progress*, the artist shows a young wastrel who is overindulging in wine and women. (Later in the series, the rogue is arrested for debt, enters into a marriage of convenience, turns to gambling, goes to debtor's prison, and dies in an insane asylum.) The scene is set in a famous London brothel, The Rose Tavern. The girl adjusting her shoe in the foreground is preparing for a vulgar dance involving the silver plate and candle behind her; to the left a chamber pot spills its foul contents over a chicken dish; and in

the background a singer holds sheet music for a bawdy song of the day. The scene is full of witty visual clues, which the viewer would discover little by little, adding a comic element to the satire of social evils. Hogarth combines Watteau's sparkling color with Jan Steen's emphasis on the narrative (compare with figs. 22.1 and 20.33). His moral narratives are so entertaining that viewers enjoy his sermon without being overwhelmed by the stern message.

Thomas Gainsborough and the English Portrait

Portraiture remained the only constant source of income for English painters. Thomas Gainsborough (1727–1788), the country's greatest master of portraiture, began by painting landscapes

but prospered greatly as the favorite portraitist of British high society. His early works, such as *Robert Andrews and His Wife* (fig. **22.16**), have a lyrical charm and light and airy sentimentality, qualities appreciated by his patrons and collectors but not always found in his later pictures. The outdoor setting, although clearly indebted to the French Rococo artists Boucher and Fragonard, was largely an invention of the English artist Francis Hayman (1708–1766), whom Gainsborough came to know as an art student in London. Gainsborough even painted the backgrounds in some of Hayman's works during the 1750s but soon surpassed him. Compared with Van Dyck's artifice in *Charles I Hunting* (see fig. 20.8) or Hals's larger and more exuberant figures in *Married Couple in a Garden, Portrait of Isaac Massa and Beatrix van der Laen* (fig. 20.17), Gainsborough's nonchalant country squire and his wife appear comfortably at home in their

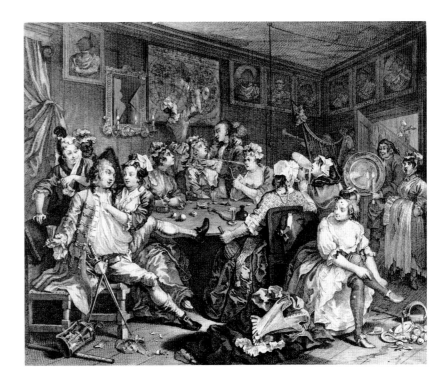

22.15. William Hogarth. *He Revels (The Orgy)*, Scene III of *The Rake's Progress*. 1735. Engraving. The Metropolitan Museum of Art, New York. Harris Brisbane Dick Fund, 1932. (32.35(30))

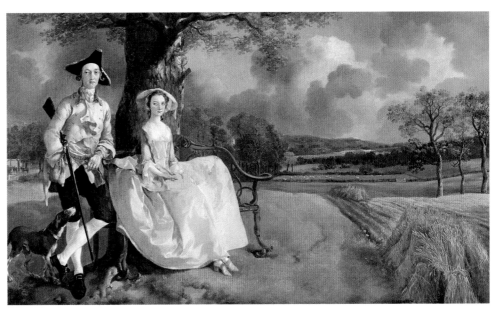

22.16. Thomas Gainsborough. *Robert Andrews and His Wife*. ca. 1748–1750. Oil on canvas, 27$\frac{1}{2}$ × 47″ (69.7 × 119.3 cm). The National Gallery, London. Reproduced by Courtesy of the Trustees

unpretentious setting. The landscape is derived from Ruisdael (see fig. 20.28) and his school, but it has a more open, sunlit, and hospitable air. The casual grace of these two figures recalls Watteau's style. The newlywed couple do not till the soil themselves. She is dressed in the fashionable attire of the day, while he is armed with a rifle to denote his status as a country squire. (Hunting was the privilege of wealthy landowners.) The painting nevertheless conveys the gentry's closeness to the land, from which the English derived much of their sense of identity. Out of this attachment to place, a feeling for nature developed that became the basis for English landscape painting, to which Gainsborough himself made an important early contribution.

Gainsborough spent most of his career working in the provinces, first in his native Suffolk, then in the resort town of Bath. Toward the end of his career he moved to London, where his work underwent a major change. The splendid portrait (fig. **22.17**) of the famous tragic actress Sarah Siddons (1755–1831) displays the virtues of the artist's late style: a cool elegance that translates Van Dyck's aristocratic poses into late eighteenth-century terms and a fluid, translucent technique reminiscent of Rubens's that renders the glamorous sitter, with her fashionable attire and coiffure, to ravishing effect. The portrait's unique qualities were summarized most ably by the French nineteenth-century critic Théophile Thoré-Burger (1807–1869) in 1857, more than 70 years after the portrait was painted:

> The great tragic actress, who interpreted the passions with such energy and such feeling, and who felt them so strongly herself, is better portrayed in this simple half length, in her day dress, than in allegorical portraits as the Tragic Muse or in character parts. This portrait is so original, so individual, as a poetic expression of character, as a deliberate selection of pose, as bold color and free handling, that it is a work of no other painter. It is useless to search for parallels, for there are none. Veronese a little—but no, it is a quite personal creation. This is genius.

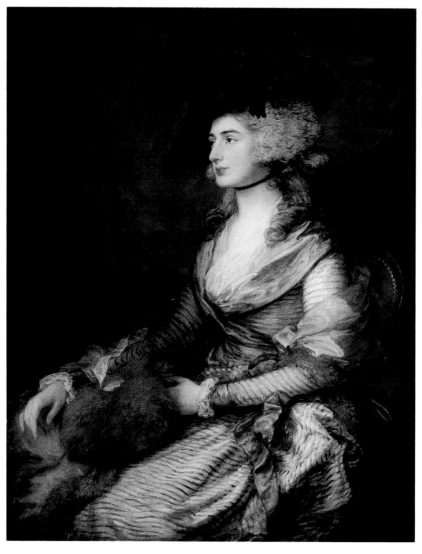

22.17. Thomas Gainsborough. *Mrs. Siddons.* 1785. Oil on canvas, 49$\frac{1}{2}$ × 39″ (125.7 × 99.1 cm). The National Gallery, London. Reproduced by Courtesy of the Trustees

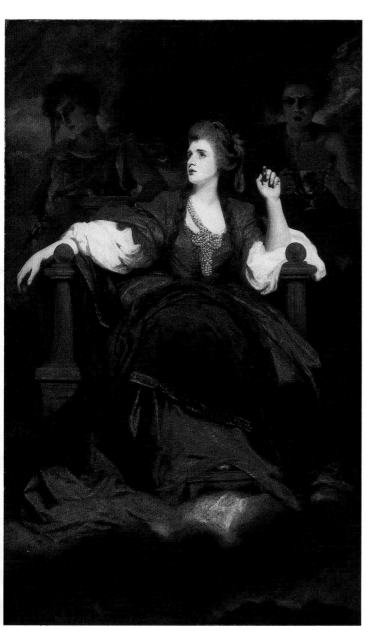

ART IN TIME

1707—Act of Union unites England and Scotland

1719—Daniel Defoe publishes *Robinson Crusoe*

1768—British Royal Academy of Arts founded in London

1785—Gainsborough's *Mrs. Siddons*

which he was well versed after having spent two years in Rome (see *Primary Source*, page 774). In his *Discourses* (annual lectures he presented to academy members), he set forth what he considered to be necessary rules and theories. His views were essentially those of Charles Le Brun, and like the French artist, Reynolds found it difficult to live up to his theories in practice. Although he preferred history painting in the grand style (as in the works of Poussin), most of his paintings are portraits that use allegory to ennoble them. We see this use here, for Reynolds has shown Siddons as the muse personified seated in her throne, and she is flanked by the allegorical figures of Pity and Terror.

Although his style owed a debt to the color and lighting of the Venetians, the Flemish Baroque artists, and even Rembrandt, Reynolds developed his own approach to the landscape that reflected a quintessential English attitude toward the land and its associations with personal liberty and prosperity. He was generous enough to praise Gainsborough, whom he eulogized as one who saw with the eye of a painter rather than a poet. For all their differences the two artists had more in common, artistically and philosophically, than they cared to admit. Reynolds and Gainsborough looked back to Van Dyck while drawing different lessons from his example. Both emphasized in varying degrees the visual appeal and technical skill of their paintings.

22.18. Sir Joshua Reynolds. *Mrs. Siddons as the Tragic Muse.* 1784. Oil on canvas, 7′9″ × 4′9½″ (2.36 × 1.46 m). Henry E. Huntington Library and Art Gallery, San Marino, California

Joshua Reynolds

As the French critic's pointed remarks suggest, Gainsborough painted Siddons to outdo his great rival on the London scene, Sir Joshua Reynolds (1723–1792), who had portrayed her as the embodiment of the Tragic Muse (fig. **22.18**). Siddons was one of the era's several well-known English actresses, and she made her fame playing tragic roles, of which the critic William Hazlitt wrote: "Power was seated on her brow, passion emanated from her breast as from a shrine. She was tragedy personified."

For his portrait Reynolds relied on expression and pose, derived from Michelangelo's Prophet Isaiah from the Sistine Chapel ceiling (fig. 16.17), to suggest the aura of the strength of Siddons's moral character. Reynolds, president of the British Royal Academy of Arts since its inception in 1768, championed the academic approach to art (copying the Old Masters), in

GERMANY AND AUSTRIA AND THE ROCOCO IN CENTRAL EUROPE

Rococo architecture was a refinement in miniature of the curvilinear, "elastic" Baroque of Borromini and Guarini. It was readily united with the architecture of Central Europe, where the Italian Baroque had firmly taken root. It is not surprising that the Italian style received such a warm response there. In Austria and southern Germany, ravaged by the Thirty Years' War, patronage for the arts was limited and the number of new buildings remained small until near the end of the seventeenth century. By the eighteenth century these countries, especially the Catholic parts, were beginning to rebuild. The Baroque was an imported style, practiced mainly by visiting Italian artists. Not until the 1690s did native architects come to the fore. There followed a period of intense activity that lasted more than 50 years and gave rise to some of the most imaginative creations in the history of architecture. These monuments were built to glorify princes and prelates who are generally remembered only as lavish patrons of the arts. Rococo architecture in Central

Sir Joshua Reynolds (1723–1792)

From "A Discourse, Delivered at the Opening of the Royal Academy, January 2, 1769"

The Royal Academy of London was founded in November 1768, based on the principles of the Academy of St. Luke in Rome and the French Academy, each founded more than a century earlier. The annual exhibition in London became the Royal Academy's prominent aspect, although teaching was, in theory, fundamental to all academies. Sir Joshua Reynolds, the academy's first president, explained its teaching principles in his first address.

The principal advantage of an Academy is, that … it will be a repository for the great examples of the Art. These are the materials on which Genius is to work, and without which the strongest intellect may be fruitlessly or deviously employed. By studying these authentick models, that idea of excellence which is the result of the accumulated experience of past ages may be at once acquired, and the tardy and obstructed progress of our predecessors, may teach us a shorter and easier way. The Student receives, at one glance, the principles which many Artists have spent their whole lives in ascertaining. … How many men of great natural abilities have been lost to this nation, for want of these advantages? …

Raffaelle, it is true, had not the advantage of studying in an Academy; but all *Rome*, and the works of Michael Angelo in particular, were to him an Academy.

One advantage, I will venture to affirm, we shall have in our Academy, which no other nation can boast. We shall have nothing to unlearn. …

But as these Institutions have so often failed in other nations … I must take leave to offer a few hints, by which those errors may be rectified. …

I would chiefly recommend, that an implicit obedience to the *Rules of Art*, as established by the practice of the great Masters, should be exacted from the *young* Students. That those models, which have passed through the approbation of ages, should be considered by them as perfect and infallible Guides; as subjects for their imitation, not their criticism.

I am confident, that this is the only efficacious method of making a progress in the Arts; and that he who sets out with doubting, will find life finished before he becomes master of the rudiments. For it may be laid down as a maxim, that he who begins by presuming on his own sense, has ended his studies as soon as he has commenced them. Every opportunity, therefore, should be taken to discountenance that false and vulgar opinion, that rules are the fetters of Genius.

SOURCE: *SEVEN DISCOURSES DELIVERED IN THE ROYAL ACADEMY,* BY THE PRESIDENT. (CHAMPSHIRE: SCHOLAR PRESS, 1971)

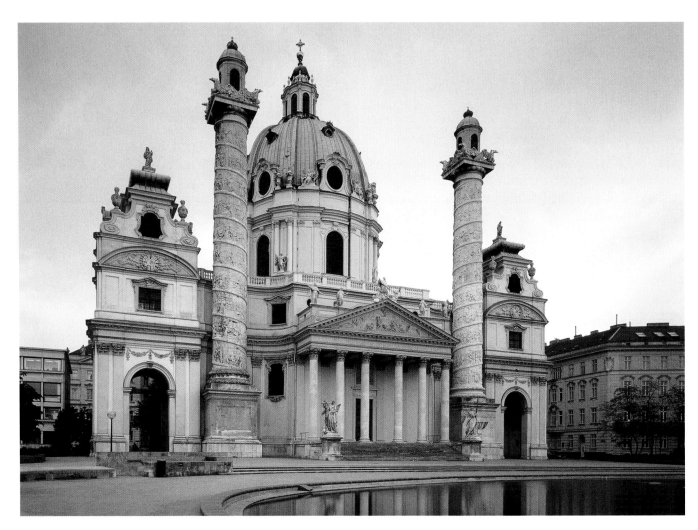

22.19. Johann Fischer von Erlach. Facade of St. Charles Borromaeus (Karlskirche), Vienna. 1716–1737

Europe is larger in scale and more exuberant than that in France. Moreover, painting and sculpture are more closely linked with their settings. Palaces and churches are decorated with ceiling frescoes and sculpture unsuited to domestic interiors, however lavish, although they reflect the same taste that produced the Rococo French hôtels.

Johann Fischer von Erlach

The Austrian Johann Fischer von Erlach (1656–1723), the first great architect of the Rococo in Central Europe, had studied in Rome and was closely linked to the Italian tradition. His work represents the decisive shift of the center of architecture from Italy to north of the Alps. His masterpiece, the church of St. Charles Borromaeus (Karlskirche) in Vienna (figs. **22.19** and **22.20**), was built in thanks for the ending of the plague of 1713, much like the church of Santa Maria della Salute in Venice of the previous century (see fig. 19.27). It was dedicated to the Counter-Reformation saint bearing the given name of the emperor, Charles VI, whose symbolism is apparent throughout. Fischer von Erlach uses several Italian and French architectural standards to new effect, combining the facade of Borromini's Sant'Agnese and the Pantheon portico (see figs. 19.22 and 7.39). He added a pair of huge columns, derived from the Column of Trajan (see fig. 7.28), and decorated with scenes from the life of the saint. The two columns symbolize the columns of Hercules—the straits of Gibraltar—a reference to Charles VI's claim to the throne of Spain. They also take the place of towers, which have become corner pavilions reminiscent of Lescot's Louvre court facade (see fig. 18.7). The church celebrates the emperor Charles VI as a Christian ruler and reminds us that the Turks, who repeatedly menaced Austria and Hungary, had been defeated at the siege of Vienna only in 1683, thanks mainly to the intervention of John III of Poland and that they remained a serious threat as late as 1718. Fischer von Erlach uses aspects of major works of the canon of Western architecture to create an entirely new work that brings with it all the grandeur and esteem of the old traditions.

ART IN TIME

1703—Saint Petersburg founded by Peter the Great. It serves as the Russian capital until 1918

1716–1737—Fischer von Erlach's Karlskirche built in Vienna

1740–1748—War of Austrian Succession

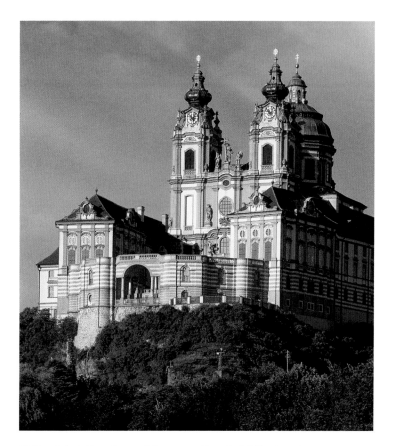

22.21. Jakob Prandtauer. Monastery Church, Melk, Austria. Begun 1702

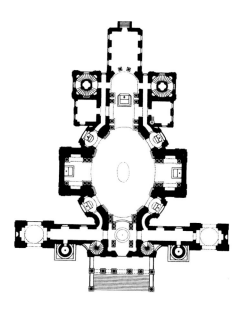

22.20. Plan of St. Charles Borromaeus

The extraordinary breadth of this ensemble is due to the site itself (fig. 22.19). It obscures the equally long main body of the church, which is a large oval with side chapels and a deep choir. With the inflexible elements of Roman imperial art embedded into the elastic curves of his church, Fischer von Erlach expresses, more boldly than any Italian architect of the time, the power of the Christian faith to transform the art of antiquity. Indeed, it was now Italy's turn to respond to the North.

Jakob Prandtauer

The Austrian architect Jakob Prandtauer (1660–1726) was a contemporary of Fischer von Erlach. Prandtauer, a mason, sculptor, and architect, began work in southern Germany and excelled in developing local traditions, which in Austria meant simple, refined exteriors integrated into the expansive landscape. Prandtauer's lifetime work, the Monastery of Melk (fig. **22.21**), owes

much of its monumental effect to its site on the crest of a cliff above the Danube, from which it rises like a vision of heavenly glory. The polychromed buildings form a tightly knit unit that centers on the church. The wings, housing the library and imperial hall, are joined at the west by curving arms, which meet at a high balcony that provides a dramatic view onto the world beyond the monastery. Although Prandtauer never went to Italy to study from original works, he read Italian architectural treatises, which formed a basis for his work.

Balthasar Neumann

The work of Balthasar Neumann (1687–1753), who designed buildings exuding lightness and elegance, is the culmination of the Rococo in Central Europe. Trained as a military engineer, he was named a surveyor for the Residenz (Episcopal Palace) in Würzburg after his return from a visit to Milan in 1720. The basic plan was already established and although Neumann greatly modified it, he was required to consult the leading architects of Paris and Vienna in 1723. The final result is a skillful blend of the latest German, French, and Italian ideas. The breathtaking Kaisersaal (fig. 22.22) is a great oval hall decorated in the favorite color scheme of the mid-eighteenth century: white, gold, and pastel shades. The structural importance of the columns, pilasters, and architraves has been minimized in favor of their decorative role. Windows and vault segments are framed by continuous, ribbonlike moldings, and the white surfaces are covered with irregular ornamental designs. These lacy, curling motifs, the hallmark of the French style (see fig. 22.11), are happily combined with German Rococo architecture. (The basic design recalls an early interior by Fischer von Erlach.)

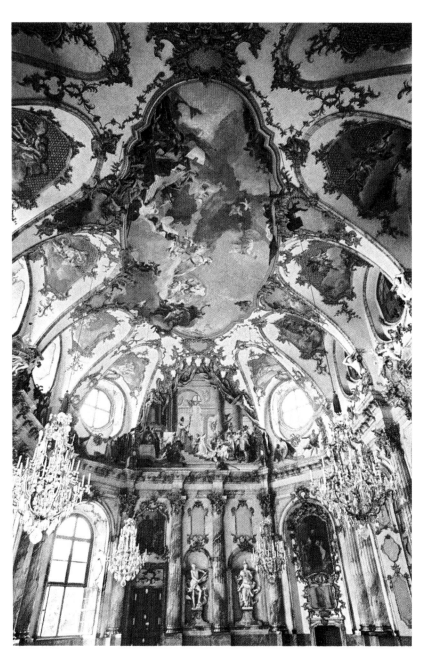

22.22. Balthasar Neumann. Kaisersaal Residenz, Würzburg, Germany. 1719–44. Frescoes by Giovanni Battista Tiepolo, 1751–1752

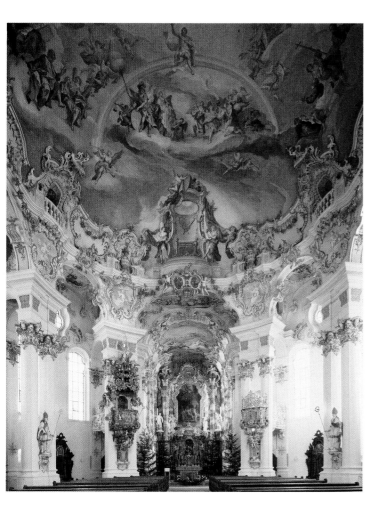

Dominikus Zimmermann

Dominikus Zimmermann (1685–1766), a contemporary of Balthasar Neumann, created what may be the finest design of the mid-eighteenth century: the rural Bavarian pilgrimage church nicknamed *Die Wies* ("The Meadow"). The exterior is so plain that by comparison the interior seems overwhelming (figs. **22.23** and **22.24**). This interior richness reflects the fact that the architect and his brother, Johann Baptist Zimmermann (1680–1758), who was responsible for the frescoes, were initially trained as stucco workers. The interior design includes a combination of sculptural painted stucco decoration and painting. Like Fischer von Erlach's St. Charles Borromaeus, this church's basic shape is oval. Yet because the ceiling rests on paired, free-standing supports, the space is more fluid and complex, recalling a German Gothic Hallenkirche (hall church). Even the way the Rococo decor tends to break up the ceiling recalls the webbed vaults of the Gothic Heiligenkreuz in Schwäbisch-Gmünd (see fig. 12.52). Here Guarini's prophetic reevaluation of Gothic architecture has become reality.

ITALY

Just as the style of architecture invented in Italy achieved its climax north of the Alps, much Italian Rococo painting took place in other countries. The timidity of the Late Baroque style in Italy was transformed during the first decade of the eighteenth century by the rise of the Rococo in Venice, which had stagnated as an artistic backwater for one hundred years. The Italian Rococo is distinguished from the Baroque by a revived appreciation of Veronese's colorism and pageantry, but with an airy sensibility that is new. The Venetians, colorists skilled in Baroque illusionism, were active in every major center throughout Europe, especially in London, Dresden, and Madrid. They were not alone: Many artists from Rome and other parts of Italy also worked abroad.

Giovanni Battista Tiepolo and Illusionistic Ceiling Decoration

The last and most refined stage of Italian illusionistic ceiling decoration can be seen in the works of Giovanni Battista Tiepolo (1696–1770), who spent most of his life in Venice, where his works defined the Rococo style. Tiepolo spent two years in Germany, and in the last years of his life he worked for Charles III in Spain. His mastery of light and color, his grace and masterful touch, and his power of invention made him famous far beyond his home territory. When Tiepolo painted the Würzburg frescoes (figs. 22.22, **22.25**, and **22.26**), his powers were at their height. The tissuelike ceiling gives way so often to illusionistic openings, both painted and sculpted, that we no longer feel it to be a spatial boundary. Unlike Baroque ceilings (compare with figs. 19.11 and 19.12), these openings do not reveal avalanches of figures propelled by dramatic bursts of light. Rather, blue sky and sunlit clouds are dotted with an occasional winged creature soaring in the limitless expanse. Only along the edges of the ceiling do solid clusters of figures appear.

22.23. Dominikus Zimmermann. Interior of "Die Wies," Upper Bavaria, Germany. 1757

22.24. Plan of "Die Wies"

The abundant daylight, the play of curves and countercurves, and the weightless grace of the stucco sculpture give the Kaisersaal an airy lightness far removed from the Roman Baroque. The vaults and walls seem thin and pliable, like membranes easily punctured by the expansive power of space.

At one end, replacing a window, is *The Marriage of Frederick Barbarossa* (see figs. 22.22 and 22.26). As a public spectacle, it is as festive as *Feast in the House of Levi* by Veronese (see fig. 17.33). The artist has followed Veronese's example by putting the event, which took place in the twelfth century, in a contemporary setting. Its allegorical fantasy is "revealed" by the carved putti opening a gilt-stucco curtain onto the wedding ceremony in a display of theatrical illusionism worthy of Bernini. Unexpected in this festive procession is the element of classicism, which gives an air of noble restraint to the main figures, in keeping with the solemnity of the occasion.

Tiepolo later became the last in the long line of Italian artists who were invited to work at the Royal Palace in Madrid. There he encountered the German painter Anton Raphael Mengs, a champion of the Classical revival, whose presence signaled the end of the Rococo.

Canaletto

During the eighteenth century, landscape painting in Italy evolved into a new form in keeping with the character of the Rococo: These paintings were called **vedute** (meaning "view" paintings). The new form can be traced back to the seventeenth century, when many foreign artists, such as Claude Lorrain (see fig. 21.8), specialized in depicting the Roman countryside. After 1720, however, *vedute* took on a specifically urban identity, focusing more narrowly on buildings or cityscapes. The most famous of the vedutists was Canaletto (Giovanni Antonio Canal, 1697–1768) of Venice. His pictures found great favor with the British, particularly young men on the Grand Tour after their schooling, who brought them home as souvenirs. Canaletto later became one of several Venetian artists to spend long sojourns in London, where he created views of the city's new skyline dotted with the church towers of Wren

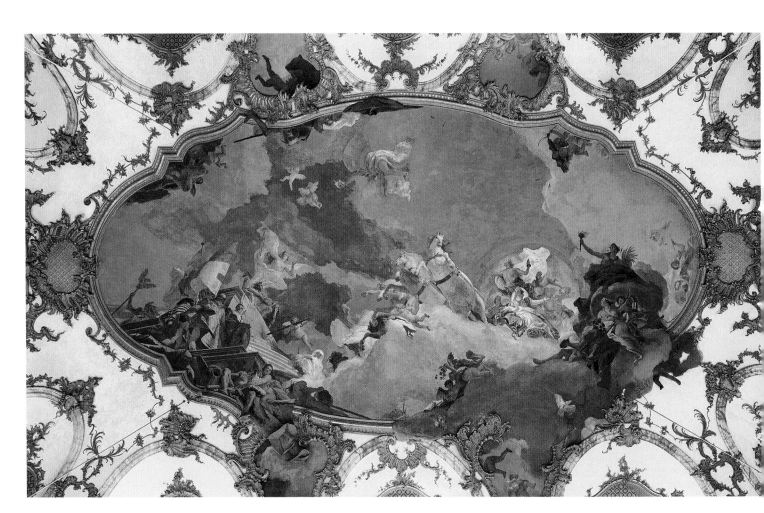

22.25. Giovanni Battista Tiepolo. Ceiling fresco (detail). 1751. Kaisersaal, Residenz, Würzburg

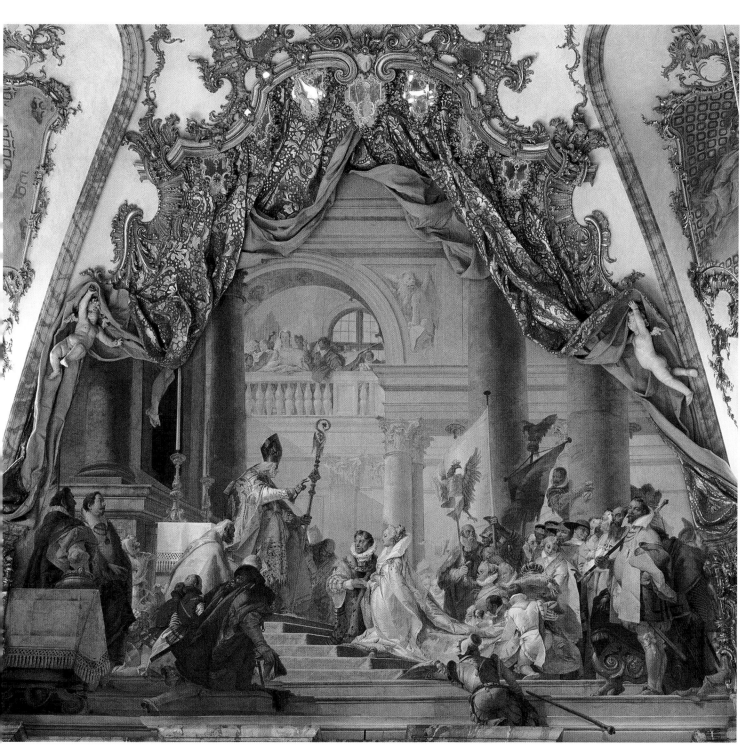

22.26. Giovanni Battista Tiepolo. *The Marriage of Frederick Barbarossa* (partial view). 1752. Fresco. Kaisersaal, Residenz, Würzburg

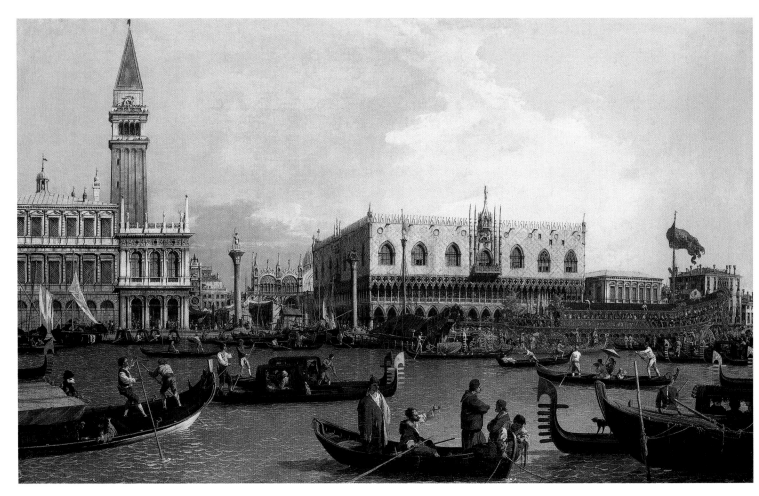

22.27. Canaletto. *The Bucintoro at the Molo.* ca. 1732. Oil on canvas, $30^{1}/_{4} \times 49^{1}/_{2}''$ (77×126 cm). The Royal Collection. © 2004 Her Majesty Queen Elizabeth II

(see pages 752–753). *The Bucintoro at the Molo* (fig. **22.27**) is one of a series of paintings of Venice commissioned by Joseph Smith, an English entrepreneur (later named British Consul to Venice) living there. Smith later issued the paintings as a suite of etchings to meet the demand for mementos of Venice from those who could not afford an original canvas by the artist. It shows a favorite subject: the Doge returning on his magnificent barge to the Piazza San Marco from the Lido (the city's island beach) on Ascension Day after celebrating the Marriage of the Sea. Canaletto has captured the pageantry of this great public celebration, which is presented as a brilliant theatrical display.

Canaletto's landscapes are, for the most part, topographically accurate. However, he was not above tampering with the truth. While he usually made only slight adjustments for the sake of the composition, he would sometimes treat scenes with considerable freedom or create composite views. He may have used a mechanical or optical device, perhaps a *camera obscura*, a forerunner of the photographic camera (see Vermeer, pages 728–729), to render some of his views. The liveliness and

sparkle of his pictures, as well as his sure sense of composition, sprang in large part from his training as a scenographer. As in our example, Canaletto often included vignettes of daily life in Venice that lend a human interest to his scenes and make them fascinating cultural documents as well.

SUMMARY

France in the eighteenth century was defined by longstanding tradition. The monarchy continued its dominance, and the policies and practices of the *ancien régime* persisted through the reign of Louis XV and his influential mistress, Madame de Pompadour. French aristocracy regained its freedom and set about consolidating power during the long rule of Louis XV. Yet wealth was bestowed upon the privileged few, and the era was characterized by gaping disparities between rich and poor, aristocracy and peasantry.

The Rococo style emerged in the eighteenth century partially as a reaction to the large, dynamic, and dark or intensely colored works of the 1600s. Characterized by pastel colors, small scale, and delicately rendered figures and settings, Rococo art reflected the frivolity and extravagance enjoyed by the aristocracy. These wealthy classes indulged in the construction of elaborate hôtels (townhouses) in Paris and extensively patronized the arts to decorate their new homes. As the sites of salons and other gatherings of the intellectual and financial elites, hôtels boasted lavish interiors decorated in pastel color schemes and embellished with charming, intimate paintings and sculptures evoking the gaiety and lighthearted mood sought by aristocratic patrons. The charm and appeal of the Rococo style proved popular throughout Europe, and its lasting influence was felt in England and in central and western Europe as well.

FRANCE: THE RISE OF THE ROCOCO

To some extent, the rise of the Rococo in France parallels the ascending power of the aristocracy, its main patrons. Painter Jean-Antoine Watteau effectively captured the optimistic spirit of his clientele and elevated the Rococo to its esteemed status. He developed the painting type known as the *fête galante,* and his subtly gradated tones helped solidify the supremacy of the Rubénistes over the Poussinistes in the debate of color versus drawing. François Boucher and Jean-Honoré Fragonard continued this tradition in sensual, allegorical portraits and landscapes, while Élisabeth-Louise Vigée-Lebrun focused on portraying Marie Antoinette in the guise of an ordinary Frenchwoman, just as the queen wished. By contrast, the humble painting categories of still life and genre scenes were given renewed significance by Jean-Siméon Chardin, whose carefully observed scenes abound with quiet dignity as well as moral lessons, recalling Dutch and Flemish seventeenth-century traditions. Sculpture, too, embodied the Rococo propensity for intimacy and sensuality, seen especially in the work of Clodion. Yet it was in hôtel interiors that the Rococo style was displayed most elaborately, exerting an influence that swept Europe's aristocracy and *haute bourgeoisie.*

ENGLAND: PAINTING AND PRINTMAKING

English painters borrowed elements from the Rococo and formed a style uniquely their own. The British public was especially interested in collecting genre paintings and landscapes, and painters such as William Hogarth and Thomas Gainsborough responded to this ever-growing demand. Hogarth's satirical scenes of daily life—in fact thinly disguised moralizing narratives—often contained humorous details that added a sense of levity to the harsh social commentary embedded within them. Gainsborough concentrated on portraiture, often placing his figures in typically English landscapes with which his patrons and viewers identified. Joshua Reynolds also concerned himself with portraits, working in a refined, elegant style that soon became the height of fashion and was much sought after by his aristocratic English clientele.

GERMANY AND AUSTRIA AND THE ROCOCO IN CENTRAL EUROPE

The Rococo in Germany and Austria exhibited itself primarily in architecture. Architects developed a refined, scaled-down version of the curvilinear, "elastic" qualities of the Italian Baroque style already popular in Central Europe. The new Rococo style was preferred for the many churches, palaces, and other monuments erected after the Thirty Years' War. These structures are decorated with paintings and sculpture that are closely linked with their settings. In the church of St. Charles Borromaeus, architect Johann Fischer von Erlach incorporates aspects from the canon of Western architecture to produce an entirely new building type that projects the power of the Christian faith to transform the art of antiquity. The elaborate, elegant interiors of buildings such as Balthasar Neumann's Kaisersaal or Dominikus Zimmermann's *"Die Wies"* church embody the culmination of the Rococo in Central Europe.

ITALY

Many Italian artists worked abroad, and therefore much Italian Rococo painting was produced in other countries. Giovanni Battista Tiepolo, in particular, executed the illusionistic ceiling decorations of several German and Austrian churches and palaces. Venetian painter Canaletto painted *vedute,* or view paintings, of Venice which became particularly popular with young Englishmen who brought these works back to England as souvenirs of their Grand Tour.

Giovanni Boccaccio (1313–1375)

Decameron, from "The First Day"

The young people who tell the 100 stories of Boccaccio's Decameron *have fled Florence to escape the bubonic plague. At the beginning of the book, Boccaccio describes the horror of the disease and the immensity of the epidemic, as well as the social dissolution it produced.*

The years of the fruitful Incarnation of the Son of God had attained to the number of one thousand three hundred and forty-eight, when into the notable city of Florence, fair over every other of Italy, there came the death-dealing pestilence, through the operation of the heavenly bodies or of our own iniquitous doings, being sent down upon mankind for our correction by the just wrath of God. In men and women alike there appeared, at the beginning of the malady, certain swellings, either on the groin or under the armpits, whereof some waxed to the bigness of a common apple, others to the size of an egg, and these the vulgar named plague-boils. From these two parts the aforesaid death-bearing plague-boils proceeded, in brief space, to appear and come indifferently in every part of the body; wherefrom, after awhile, the fashion of the contagion began to change into black or livid blotches.

Well-nigh all died within the third day from the appearance of the aforesaid signs, this one sooner and that one later, and for the most part without fever or other complication. The mere touching of the clothes or of whatsoever other thing had been touched or used by the sick appeared of itself to communicate the malady to the toucher.

Well-nigh all tended to a very barbarous conclusion, namely, to shun and flee from the sick and all that pertained to them. Some there were who conceived that to live moderately and keep oneself from all excess was the best defense; they lived removed from every other, taking refuge and shutting themselves up in those houses where none were sick and where living was best. Others, inclining to the contrary opinion, maintained that to carouse and make merry and go about singing and frolicking and satisfy the appetite in everything possible and laugh and scoff at whatsoever befell was a very certain remedy for such an ill.

The common people (and also, in great part, the middle class) fell sick by the thousand daily and being altogether untended and unsuccored, died well-nigh all without recourse. Many breathed their last in the open street, by day and by night, while many others, though they died in their homes, made it known to the neighbors that they were dead rather by the stench of their rotting bodies than otherwise; and of these and others who died all about, the whole city was full. The consecrated ground not sufficing for the burial of the vast multitude of corpses there were made throughout the churchyards, vast trenches, in which those who came were laid by the hundred, being heaped up therein by layers, as goods are stowed aboard ship.

So great was the cruelty of heaven that, between March and the following July, it is believed for certain that upward of a hundred thousand human beings perished within the walls of the city of Florence. Alas, how many great palaces, how many goodly houses, how many noble mansions, once full of families, of lords and of ladies, remained empty even to the meanest servant! How many memorable families, how many ample heritages, how many famous fortunes were seen to remain without lawful heir! How many valiant men, how many fair ladies, how many sprightly youths, breakfasted in the morning with their kinsfolk, comrades and friends and that same night supped with their ancestors in the other world!

SOURCE: *GIOVANNI BOCCACCIO, DECAMERON. TR. JOHN PAYNE, REV. CHARLES S. SINGLETON.* (BERKLEY, CA: UNIVERSITY OF CALIFORNIA PRESS, 1984)

Petrarch (1304–1374)

Sonnet from the Rime Sparse, n. 77 (Translation by A. S. Kline)

The humanist Petrarch encountered the unattainable Laura in Avignon, and immortalized his love for her in many sonnets. This poem, number 77 from his Rime Sparse *(Scattered Rhymes), describes his reaction to a portrait of Laura painted by his friend, the Sienese painter Simone Martini. The portrait itself does not survive, but Petrarch's words make a comparison between the fourteenth-century painter and the famous Greek Sculptor, Polyclitus. Such learned references to the ancients in service of human emotion parallels the innovations of visual artists who explored the emotional content of religious narratives.*

Polyclitus gazing fixedly a thousand years
with the others who were famous in his art,
would not have seen the least part
of the beauty that has vanquished my heart.

But Simone must have been in Paradise
(from where this gentle lady came)
saw her there, and portrayed her in paint,
to give us proof here of such loveliness.

This work is truly one of those that might
be conceived in heaven, not among us here,
where we have bodies that conceal the soul.

Grace made it: he could work on it no further
when he'd descended to our heat and cold,
where his eyes had only mortal seeing.

SOURCE: *PETRARCH: THE CANZONIERE, SONNET 77. TR. A.S. KLINE. HTTP://WWW.TONYKLINE.CO.UK)*

Dante Alighieri (1265–1321)

The Divine Comedy: Purgatory, from Canto X

In the first circle of Purgatory are those guilty of the sin of pride. Dante meets a famous manuscript illuminator who has learned the vanity of pride and the fleeting nature of fame, illustrated by the rapidity with which Giotto eclipsed Cimabue.

"Oh!" I said, "*you* must be that Oderisi,
honor of Gubbio, honor of the art
which men in Paris call 'Illuminating.'"

"The pages Franco Bolognese paints,"
he said, "my brother, smile more radiantly;
his is the honor now—mine is far less.

Less courteous would I have been to him,
I must admit, while I was still alive
and my desire was only to excel.

For pride like that the price is paid up here;
I would not even be here, were it not
that, while I still could sin, I turned to God.

Oh, empty glory of all human power!
How soon the green fades from the topmost bough,
unless the following season shows no growth!

Once Cimabue thought to hold the field
as painter; Giotto now is all the rage,
dimming the lustre of the other's fame."

SOURCE: *DANTE ALIGHIERI'S, DIVINE COMEDY.* TR. MARK MUSA. (BLOOMINGTON, IN: INDIANA UNIVERSITY PRESS, 1986)

Karel Van Mander (1548–1606)

From *The Painter's Treatise*

Van Mander's biographies of distinguished Dutch and Flemish painters, published in 1604, are a counterpart to the lives of Italian artists by Giorgio Vasari, which first appeared in 1550. Van Mander, a painter himself, begins his biographies with Jan van Eyck because he was considered the inventor of oil painting and consequently the originator, with his brother Hubert, of the Netherlandish tradition of painting.

It is supposed that the art of painting with a glue and egg medium [tempera painting] was imported into the Netherlands from Italy, because, as we have noted in the biography of Giovanni of Cimabue, this method was first used in Florence, in 1250. . . .

According to the people of Bruges, Joannes [Jan] was a learned man, clever and inventive, who studied many subjects related to painting: He examined many kinds of pigment; he studied alchemy and distillation. At length, he worked out a method of varnishing his egg and glue paintings with oil, so that these shining and lustrous pictures exceedingly delighted all who saw them. . . .

Joannes had painted a panel on which he had spent much time. . . . He varnished the finished panel according to his new invention and placed it in the sunlight to dry. . . . The panel burst at the joints and fell apart. Joannes . . . took a resolve that the sun should not damage his work ever again.

Accordingly, . . . he set himself to discover or invent some kind of varnish which would dry within the house, away from the sunlight. He had already examined many oils and other similar materials supplied by nature, and had found that linseed oil and nut oil had the best drying ability of them all. . . .

Joannes found, after many experiments, that colors mixed with these oils could be handled easily, that they dried well, became hard,

and, once dry, could resist water. The oil made the color appear more alive, owing to a lustre of its own, without varnish. And what surprised and pleased him most was that paint made with oil could be applied more easily and mixed more thoroughly than paint made with egg and glue. . . .

Joannes . . . had created a new type of painting, to the amazement of the world. . . . This noble discovery, of painting with oil, was the only thing the art of painting still needed to achieve naturalistic rendition.

If the ancient Greeks, Apelles and Zeus [Zeuxis] had come to life again in this country and had seen this new method of painting, they would not have been any less surprised than if war-like Achilles [had] witnessed the thunder of cannon fire. . . .

The most striking work which the Van Eyck brothers did together is the altar-piece in the church of St John, in Ghent. . . .

The central panel of the altar-piece represents a scene from the Revelation of St John, in which the elders worship the Lamb. . . . In the upper part, Mary is represented; she is being crowned by the Father and the Son. . . .

Next to the figure of Mary are little angels singing from sheets of music. They are painted so exquisitely and so well that one can detect readily, from their facial expressions, who is singing the higher part, the high counter part, the tenor part, and the bass. . . .

Adam and Eve are represented. One may observe that Adam has a certain fear of breaking the command of the Lord, for he has a worried expression. . . .

The altar painting of the Van Eyck brothers was shown only to a few personages of high standing or to someone who would reward the keeper very well. Sometimes it was shown on important holidays, but then there was usually such a crowd that it was difficult to come near it. Then the chapel containing the altar-piece would be filled with all kinds of people—painters young and old, every kind of art lover, swarming like bees and flies around a basket of figs or raisins. . . .

Some Florentine merchants sent a splendid painting, made in Flanders, by Joannes to King Alphonso I of Naples. . . . A huge throng of artists came to see this marvelous painting, when it reached Italy. But although the Italians examined the picture very carefully, touching it, smelling at it, scenting the strong odor produced by the mixture of the colors with oil, and drawing all kinds of conclusions, the secret held until Antonello of Messina, in Sicily, went to Bruges to learn the process of oil-painting. Having mastered the technique, he introduced the art into Italy, as I have described in his biography. . . .

Joannes had once painted in oil two portraits in a single scene, a man and a woman, who give the right hand to each other, as if they had been united in wedlock by *Fides*. This little picture came through inheritance into the hands of a barber in Bruges. Mary, aunt of King Philip of Spain and widow of King Louis of Hungary, . . . happened to see this painting. The art loving princess was so pleased with this picture that she gave a certain office to the barber which brought him a yearly income of a hundred guilders.

SOURCE: KARE VAN MANDER, *DUTCH AND FLEMISH PAINTERS*. TR. CONSTANT VAN DE WALL. (MANCHESTER, NH: AYER CO. PUBLISHERS, 1978)

Giorgio Vasari (1511–1574)

From *The Lives of the Most Excellent Italian Architects, Painters, and Sculptors from Cimabue to Our Times*

Vasari was inspired to write The Lives *by his patron, Cardinal Alessandro Farnese. The book, first published in 1550 and expanded in 1568, was based on interviews conducted throughout Italy. Vasari personally knew many of the artists about whom he wrote, including Michelangelo, whom he idolized at the expense of others, most notably Raphael. Although art historians have spent entire careers disproving details of Vasari's narrative, they remain the starting point for the study of Italian Renaissance art.*

This marvellous and divinely inspired Leonardo . . . would have been proficient at his early lessons if he had not been so volatile and unstable; for he was always setting himself to learn many things only to abandon them almost immediately. . . . Clearly, it was because of his profound knowledge of painting that Leonardo started so many things without finishing them; for he was convinced that his hands, for all their skill, could never perfectly express the subtle and wonderful ideas of his imagination. . . .

For Francesco del Giocondo, Leonardo undertook to execute the portrait of his wife, Mona Lisa. He worked on this painting for four years, and then left it still unfinished. . . . If one wanted to see how faithfully art can imitate nature, one could readily perceive it from this head; for here Leonardo subtly reproduced every living detail. . . . Leonardo also made use of this device: while he was painting Mona Lisa, who was a very beautiful woman, he employed singers and musicians or jesters to keep her full of merriment and so chase away the melancholy that painters usually give to portraits. As a result, in this painting of Leonardo's there was a smile so pleasing that it seemed divine rather than human; and those who saw it were amazed to find that it was as alive as the original.

. . . Raphael Sanzio of Urbino, an artist as talented as he was gracious, . . . was endowed by nature with the goodness and modesty to be found in all those exceptional men whose gentle humanity is enhanced by an affable and pleasing manner, expressing itself in courteous behaviour at all times and towards all persons. . . . Raphael [had] the finest qualities of mind accompanied by such grace, industry, looks, modesty, and excellence of character as would offset every defect, no matter how serious, and any vice, no matter how ugly. . . .

At the time when Raphael determined to change and improve his style he had never studied the nude as intensely as it requires, for he had only copied it from life, employing the methods he had seen used by Perugino, although he gave his figures a grace that he understood instinctively. . . . Nonetheless, Raphael realized that in this manner he could never rival the accomplishments of Michelangelo, and . . . being unable to compete with Michelangelo in the branch of painting to which he had set his hand, resolved to emulate and perhaps surpass him in other respects. So he decided not to waste his time by imitating Michelangelo's style but to attain a catholic excellence in the other fields of painting. . . .

When Michelangelo had finished the statue [of Pope Julius II, later destroyed], Bramante, the friend and relation of Raphael and therefore ill-disposed to Michelangelo, seeing the Pope's preference for sculpture, schemed to divert his attention, and told the Pope that it would be a bad omen to get Michelangelo to go on with his tomb, as it would seem to be an invitation to death. He persuaded the Pope to get Michelangelo, on his return, to paint the vaulting of the Sistine Chapel. In this way Bramante and his other rivals hoped to confound him, for by taking him from sculpture, in which he was perfect, and putting him to colouring in fresco, in which he had had no experience, they thought he would produce less admirable work than Raphael. . . . Thus, when Michelangelo returned to Rome, the Pope was disposed not to have the tomb finished for the time being, and asked him to paint the vaulting of the chapel. Michelangelo tried every means to avoid it, and recommended Raphael. . . . At length, seeing that the Pope was resolute, [he] decided to do it. . . . Michelangelo then made arrangements to do the whole work singlehanded. . . . When he had finished half, the Pope . . . daily became more convinced of Michelangelo's genius, and wished him to complete the work, judging that he would do the other half even better. Thus, singlehanded, he completed the work in twenty months, aided only by his mixer of colours. He sometimes complained that owing to the impatience of the Pope he had not been able to finish it as he would have desired, as the Pope was always asking him when he would be done. On one occasion Michelangelo replied that he would be finished when he had satisfied his own artistic sense. "And we require you to satisfy us in getting it done quickly," replied the Pope, adding that if it was not done soon he would have the scaffolding down. . . . Michelangelo wanted to retouch some parts of the painting *a secco,* as the old masters had done on the scenes below . . . in order to heighten the visual impact. The Pope, learning that this ornamentation was lacking . . . wanted him to go ahead. However, he lacked the patience to rebuild the scaffolding, and so the ceiling stayed as it was. . . .

Giovanni Bellini and other painters of [Venice], through not having studied antiquities, employed a hard, dry and laboured style, which Titian acquired. But in 1507 arose Giorgione, who began to give his works more tone and relief, with better style, though he imitated natural things as best he could, colouring them like life, without making drawings previously, believing this to be the true method of procedure. He did not perceive that for good composition it is necessary to try several various methods on sheets, for invention is quickened by showing these things to the eye, while it is also necessary to a thorough knowledge of the nude. . . .

On seeing Giorgione's style Titian abandoned that of Bellini, although he had long practised it, and imitated Giorgione so well that in a short time his works were taken for Giorgione's. . . . Titian's methods in these paintings differ widely from those he adopted in his youth. His first works are executed with a certain fineness and diligence, so that they may be examined closely, but these are done roughly in an impressionist manner, with bold strokes and blobs, to obtain the effect at a distance. This is why many in trying to imitate him have made clumsy pictures, for if people think that such work can be done without labour they are deceived, as it is necessary to retouch and recolour them incessantly, so that the labour is evident. The method is admirable and beautiful if done judiciously, making paintings appear alive and achieved without labour.

SOURCE: GIORGIO VASARI, *THE LIVES OF PAINTERS, SCULPTORS, AND ARCHITECTS.* EVERYMAN'S LIBRARY EDITION, ED. WILLIAM GAUNT (1963 EDITION, FIRST PUBLISHED 1927)

From the Canon and Decrees of the Council of Trent, 1563

The Catholic Church responded to the growth in Northern Europe of independent "Reformed" churches (inaugurated by Martin Luther's 1517 critique of the Church) by attempting to stop the Reformation and win back the territories and peoples lost to the Roman Church. These various measures of the sixteenth and early seventeenth centuries are collectively called the Catholic Reformation. One agency of this development was the Council of Trent, a series of three meetings of church leaders in 1545–1547, 1551–1552, and 1562–1563. The following is from one of the council's last edicts, dated December 3–4, 1563, a response to ongoing Protestant attacks against religious images.

The holy council commands all bishops and others who hold the office of teaching and have charge of the *cura animarum,* [care of souls] that in accordance with the usage of the Catholic and Apostolic Church, received from the primitive times of the Christian religion, and with the unanimous teaching of the holy Fathers and the decrees of sacred councils, they above all instruct the faithful diligently in matters relating to intercession and invocation of the saints, the veneration of relics, and the legitimate use of images. Moreover, that the images of Christ, of the Virgin Mother of God, and of the other saints are to be placed and retained especially in the churches, and that due honor and veneration is to be given them; not, however, that any divinity or virtue is believed to be in them by reason of which they are to be venerated, or that something is to be asked of them, or that trust is to be placed in images, as was done of old by the Gentiles who placed their hope in idols; but because the honor which is shown them is referred to the prototypes which they represent, so that by means of the images which we kiss and before which we uncover the head and prostrate ourselves, we adore Christ and venerate the saints whose likeness they bear. That is what was defined by the decrees of the councils, especially of the Second Council of Nicaea, against the opponents of images.

Moreover, let the bishops diligently teach that by means of the stories of the mysteries of our redemption portrayed in paintings and other representations the people are instructed and confirmed in the articles of faith, which ought to be borne in mind and constantly reflected upon; also that great profit is derived from all holy images, not only because the people are thereby reminded of the benefits and gifts bestowed on them by Christ, but also because through the saints the miracles of God and salutary examples are set before the eyes of the faithful, so that they may give God thanks for those things, may fashion their own life and conduct in imitation of the saints and be moved to adore and love God and cultivate piety. But if anyone should teach or maintain anything contrary to these decrees, let him be anathema.

If any abuses shall have found their way into these holy and salutary observances, the holy council desires earnestly that they be completely removed, so that no representation of false doctrines and such as might be the occasion of grave error to the uneducated be exhibited. Finally, such zeal and care should be exhibited by the bishops with regard to these things that nothing may appear that is disorderly or unbecoming and confusedly arranged, nothing that is profane, nothing disrespectful, since holiness becometh the house of God.

SOURCE: *CANONS AND DECREES OF THE COUNCIL OF TRENT.* TR. H.I. SHROEDER. (ROCKFORD, IL TAN BOOKS AND PUBLISHERS, 1978)

Martin Luther (1483–1546)

From *Against the Heavenly Prophets in the Matter of Images and Sacraments, 1525*

Luther inaugurated the Protestant Reformation movement in 1517 with a public critique of certain Church practices, including the sale of indulgences. His actions soon inspired a number of similar reformers in Northern Europe, some of whom were more extreme in their denunciations of the conventional artistic and musical trappings of the Church. The ideas of one of these, Andreas Bodenstein von Karlstadt, inspired this writing of 1525.

I approached the task of destroying images by first tearing them out of the heart through God's Word and making them worthless and despised. . . . For when they are no longer in the heart, they can do no harm when seen with the eyes. But Dr. Karlstadt, who pays no attention to matters of the heart, has reversed the order by removing them from sight and leaving them in the heart. . . .

I have allowed and not forbidden the outward removal of images, so long as this takes place without rioting and uproar and is done by the proper authorities. . . . And I say at the outset that according to the law of Moses no other images are forbidden than an image of God which one worships. A crucifix, on the other hand, or any other holy image is not forbidden. Heigh now! you breakers of images, I defy you to prove the opposite! . . .

Thus we read that Moses' Brazen Serpent remained (Num. 21:8) until Hezekiah destroyed it solely because it had been worshiped (II Kings 18:4). . . .

However, to speak evangelically of images, I say and declare that no one is obligated to break violently images even of God, but everything is free, and one does not sin if he does not break them with violence. . . .

Nor would I condemn those who have destroyed them, especially those who destroy divine and idolatrous images. But images for memorial and witness, such as crucifixes and images of saints, are to be tolerated. This is shown above to be the case even in the Mosaic law. And they are not only to be tolerated, but for the sake of the memorial and the witness they are praiseworthy and honorable, as the witness stones of Joshua (Josh. 24:26) and of Samuel (I Sam. 7:12).

SOURCE: *LUTHER'S WORKS,.* VOL. 40. TR. BERNHARD ERLING, ED. CONRAD BERGENDORFF. (MINNEAPOLIS, MN: AUGSBURG FORTRESS PUBLISHERS, 1958)

Giovanni Pietro Bellori (1613–1696)

From *Lives of the Modern Painters, Sculptors, and Architects: On Caravaggio*

Bellori's account was published in Rome in 1672, and it provides biographical information and criticism of seventeenth-century (mostly Italian) artists. His writing on Caravaggio's painting "from nature" is significant for understanding seventeenth-century views and for recognizing the sharp criticism of his work and his methods.

He [Caravaggio] recognized no other master than the model and did not select the best forms of nature but emulated art—astonishingly enough—without art . . .

Now he began to paint according to his own genius. He not only ignored the most excellent marbles of the ancients and the famous paintings of Raphael, but he despised them, and nature alone became the object of his brush. . . . Caravaggio . . . was making himself more and more notable for the color scheme which he was introducing, not soft and sparingly tinted as before, but reinforced throughout with bold shadows and a great deal of black to give relief to the forms. He went so far in this manner of working that he never brought his figures out into the daylight, but placed them in the dark brown atmosphere of a closed room, using a high light that descended vertically over the principal parts of the bodies while leaving the remainder in shadow in order to give force through a strong contrast of light and dark. The painters then in Rome were greatly impressed by his novelty and the younger ones especially gathered around him and praised him as the only true imitator of nature. Looking upon his works as miracles, they outdid each other in following his method . . . , undressing their models and placing their lights high; without paying attention to study and teachings, each found easily in the piazza or in the street his teacher or his model for copying nature. This facile manner attracted many, and only the old painters who were accustomed to the old ways were shocked at the new concern for nature, and they did not cease to decry Caravaggio and his manner. They spread it about that he did not know how to come out of the cellar and that, poor in invention and design, lacking in decorum and art, he painted all his figures in one light and on one plane without gradations. These accusations, however, did not retard the growth of his fame. . . .

He never introduced clear blue atmosphere into his pictures; on the contrary he always used black for the ground and depths and also for the flesh tones, limiting the force of the light to a few places. Moreover, he followed his model so slavishly that he did not take credit for even one brush stroke, but said it was the work of nature. He repudiated every other precept and considered it the highest achievement in art not to be bound to the rules of art. Because of these innovations he received so much acclaim that some artists of great talent and instructed in the best schools were impelled to follow him. With all this, many of the best elements of art were not in him; he possessed neither invention, nor decorum, nor design, nor any knowledge of the science of painting.

SOURCE: *ITALIAN & SPANISH ART, 1600–1750: SOURCES AND DOCUMENTS.* ED. R. ENGGASS AND J. BROWN, (EVANSTON, IL: NORTHERN UNIVERSITY PRESS, 1999)

Filippo Baldinucci (1625–1697)

From the *Life of Cavalier Gianlorenzo Bernini*

An artist, scholar, and consultant to the Medicis, Baldinucci published his laudatory biography of Bernini in 1682, shortly after the artist's death. Commissioned by Queen Christina of Sweden, it is still the main source of information on the artist.

The opinion is widespread that Bernini was the first to attempt to unite architecture with sculpture and painting in such a manner that together they make a beautiful whole. This he accomplished by removing all repugnant uniformity of poses, breaking up the poses sometimes without violating good rules, although he did not bind himself to the rules. His usual words on this subject were that those who do not sometimes go outside the rules never go beyond them. He thought, however, that those who were not skilled in both painting and sculpture should not put themselves to that test but should remain rooted in the good precepts of art. He knew from the beginning that his strong point was sculpture. . . .

Before Bernini's and our own day there was perhaps never anyone who manipulated marble with more facility and boldness. He gave his works a marvelous softness from which many great men who worked in Rome during his time learned. Although some censured the drapery of his figures as too complex and sharp, he felt this, on the contrary, to be a special indication of his skill. Through it he demonstrated that he had overcome the great difficulty of making the marble, so to say, flexible and of finding a way to combine painting and sculpture, something that had not been done by other artists.

It is not easy to describe the love Bernini brought to his work. He said that, when he began work, it was for him like entering a pleasure garden.

SOURCE: *ITALIAN & SPANISH ART, 1600–1750: SOURCES AND DOCUMENTS.* ED. R. ENGGASS AND J. BROWN. (EVANSTON, IL: NORTHERN UNIVERSITY PRESS, 1999)

Constantijn Huygens (1596–1687)

From his *Autobiography*

Contantijn Huygens (1596–1687), diplomat from The Netherlands to Venice and London, was secretary and advisor to the Stadhoulder Frederick Henry of Orange (r. 1625–1647), and then to William II of Orange (r. 1647–1650). He acted as intermediary for Rembrandt for his Passion Series, and was a promoter of Rembrandt's work. This selection from his Autobiography praises both Rembrandt the man and the emotional content of Rembrandt's work and compares him to a contemporary, Jan Lievens (1607–1674); he exhorts them both to keep a record of their works and to travel to Italy.

The first, who I described as an embroiderer's son, is called Jan Lievens; the other, whose cradle stood in a mill, Rembrandt. Both are still beardless and, going by their faces, more boys than men. I am neither able nor willing to judge each according to his works and application. As in the case of the aforementioned Rubens, I wish these two would draw up an inventory of their works and describe their paintings. Each could supply a modest explanation of his method, going on to indicate how and why (for the admiration and education of all future generations) they had designed, composed and worked out each painting.

I venture to suggest offhand that Rembrandt is superior to Lievens in his sure touch and liveliness of emotions. . . . Rembrandt . . .

devotes all his loving concentration to a small painting, achieving on that modest scale a result which one would seek in vain in the largest pieces of others. I cite as an example his painting of the repentant Judas returning to the high priest the silver coins which were the price for our innocent Lord. Compare this with all Italy, indeed, with all the wondrous beauties that have survived from the most ancient of days. The gesture of that one despairing Judas (not to mention all the other impressive figures in the painting), that one maddened Judas, screaming, begging for forgiveness, but devoid of hope, all traces of hope erased from his face; his gaze wild, his hair torn out by the roots, his hands clenched until they bleed; a blind impulse has brought him to his knees, his whole body writing in pitiful hideousness. All this I compare with all the beauty that has been produced throughout the ages . . . [to see] that a youth, a Dutchman, a beardless miller, could put so much into one human figure and depict it all. Even as I write these words I am struck with amazement. All honour to thee, Rembrandt! To transport Troy, indeed all Asia, to Italy is a lesser achievement than to heap the laurels of Greece and Italy on the Dutch, the achievement of a Dutchman who has never ventured outside the walls of his native city. . . . I do however censure one fault of these celebrated young men, from whom I can scarcely tear myself away in this account. I have already criticized Lievens for his self-confidence, which Rembrandt shares; hitherto, neither has found it necessary to spend a few months travelling through Italy. This is naturally a touch of folly in figures otherwise so brilliant. If only someone could drive it out of their young heads, he would truly contribute the sole element still needed to perfect their artistic powers. How I would welcome their acquaintance with Raphael and Michelangelo, the feasting of their eyes on the creations of such gigantic spirits! How quickly they would surpass them all, giving the Italians due cause to come to Holland. If only these men, born to raise art to the highest pinnacle, know themselves better!

SOURCE: ERNST VAN DE WETERING AND BERNHARD SCHNACKENBURG AND OTHERS. *THE MISTERY OF YOUNG REMBRANDT.* (WOLFRATSHAUSEN: EDITION MINERVA, 2001)

Sir Christopher Wren (1632–1723)

Report on Old St. Paul's after the Fire (between September 5, 1666 and February 26, 1667)

Christopher Wren had already delivered a report on Old St. Paul's and its condition before the Great Fire of London, but his report now will justify the authorization by the king to rebuild this church. The Fire, which left a "pile of Pauls," also decimated the heart of London.

Advise to the Reverend the Deane & Chapter of St. Pauls concerning the ruines of that Cathedrall.

What time & weather had left intire in the old, & art in the new repaired parts of this great pile of Pauls, the late Calamity of fire hath soe weakened & defaced, that it now appears like some antique ruine of 2,000 years standing, & to repaire it sufficiently will be like the mending of the Argo navis [the ship of the Argonauts], scarce any thing will at last be left of the old.

The first decayes of it were great, from severall causes first from the originall building it selfe, for it was not well shaped & designed for the firme bearing of its one vault how massie soever the walls seemed to be (as I formerly shewed in another paper) nor were the materialls good, for it seemed to have been built out of the stone of some other auncient ruines . . . A second reason of the decayes, which appeared before the last fire, was in probability the former fire which consumed the whole roofe in the raine of Queen Elizabeth. The fall of timber then upon the vault was certainly one maine cause of the cracks which appeared in the vault & of the spreading out of the walls above 10 inches in some places from their new perpendicular as it now appeares more manifestly. . .

. . .Having shewn in part the deplorable condition of our patient wee are to consult of the Cure if possibly art may effect it, & herein wee must imitate the Physician who when he finds a totall decay of Nature bends his skill to a palliation, to give respite for a better settlement of the estate of the patient. The Question is then where bes[t] to begin the kind of practice, that is to make a Quire for present use.

SOURCE: LYDIA M. SOO, *WREN'S "TRACTS" ON ARCHITECTURE AND OTHER WRITINGS.* (NEW YORK: CAMBRIDGE UNIVERSITY PRESS, 1997)

ABACUS. A slab of stone at the top of a Classical capital just beneath the architrave.

ABBEY. (1) A religious community headed by an abbot or abbess. (2) The buildings that house the community. An abbey church often has an especially large choir to provide space for the monks or nuns.

ACADEMY. A place of study, the word coming from the Greek name of a garden near Athens where Plato and, later, Platonic philosophers held philosophical discussions from the 5th century BCE to the 6th century CE. The first academy of fine arts was the Academy of Drawing, founded 1563 in Florence by Giorgio Vasari. Later academies were the Royal Academy of Painting and Sculpture in Paris, founded 1648, and the Royal Academy of Arts in London, founded 1768. Their purpose was to foster the arts by teaching, by exhibitions, by discussion, and occasionally by financial aid.

ACANTHUS. (1) A Mediterranean plant having spiny or toothed leaves. (2) An architectural ornament resembling the leaves of this plant, used on moldings, friezes, and Corinthian capitals.

ACROTERION (pl. **ACROTERIA**). Decorative ornaments placed at the apex and the corners of a pediment.

ACRYLIC. A plastic binder medium for pigments that is soluble in water. Developed about 1960.

ACTION PAINTING. In Abstract art, the spontaneous and uninhibited application of paint, as practiced by the avant-garde from the 1930s through the 1950s.

AERIAL PERSPECTIVE. See *perspective*.

AISLE. The passageway or corridor of a church that runs parallel to the length of the building. It often flanks the nave of the church but is sometimes set off from it by rows of piers or columns.

ALBUMEN PRINT. A process in photography that uses the proteins found in eggs to produce a photographic plate.

ALLA PRIMA. A painting technique in which pigments are laid on in one application with little or no underpainting.

ALTAR. A mound or structure on which sacrifices or offerings are made in the worship of a deity. In a Catholic church, a tablelike structure used in celebrating the Mass.

ALTARPIECE. A painted or carved work of art placed behind and above the altar of a Christian church. It may be a single panel or a *triptych* or a *polytych*, both having hinged wings painted on both sides. Also called a reredos or retablo.

ALTERNATE SYSTEM. A system developed in Romanesque church architecture to provide adequate support for a *groin-vaulted nave* having *bays* twice as long as the side-aisle bays. The *piers* of the nave *arcade* alternate in size; the heavier *compound piers* support the main nave vaults where the *thrust* is concentrated, and smaller, usually cylindrical, piers support the side-aisle vaults.

AMAZON. One of a tribe of female warriors said in Greek legend to dwell near the Black Sea.

AMBULATORY. A covered walkway. (1) In a basilican church, the semicircular passage around the apse. (2) In a central-plan church, the ring-shaped aisle around the central space. (3) In a cloister, the covered colonnaded or arcaded walk around the open courtyard.

AMPHITHEATER. A double theater. A building, usually oval in plan, consisting of tiers of seats and access corridors around the central theater area.

AMPHORA (pl. **AMPHORAE**). A large Greek storage vase with an oval body usually tapering toward the base. Two handles extend from just below the lip to the shoulder.

ANDACHTSBILD. German for "devotional image." A picture or sculpture with imagery intended for private devotion. It was first developed in Northern Europe.

ANIMAL STYLE. A style that appears to have originated in ancient Iran and is characterized by stylized or abstracted images of animals.

ANNULAR. From the Latin word for "ring." Signifies a ring-shaped form, especially an annular barrel vault.

ANTA (pl. **ANTAE**). The front end of a wall of a Greek temple, thickened to produce a pilasterlike member. Temples having columns between the antae are said to be "*in antis*."

APOCALYPSE. The Book of Revelation, the last book of the New Testament. In it, St. John the Evangelist describes his visions, experienced on the island of Patmos, of Heaven, the future of humankind, and the Last Judgment.

APOSTLE. One of the twelve disciples chosen by Jesus to accompany him in his lifetime and to spread the gospel after his death. The traditional list includes Andrew, Bartholomew, James the Greater (son of Zebedee), James the Lesser (son of Alphaeus), John, Judas Iscariot, Matthew, Peter, Philip, Simon the Canaanite, Thaddaeus (or Jude), and Thomas. In art, however, the same twelve are not always represented, since "apostle" was sometimes applied to other early Christians, such as St. Paul.

APSE. A semicircular or polygonal niche terminating one or both ends of the nave in a Roman basilica. In a Christian church, it is usually placed at the east end of the nave beyond the transept or choir. It is also sometimes used at the end of transept arms.

APSIDIOLE. A small apse or chapel connected to the main apse of a church.

AQUATINT. A print processed like an etching, except that the ground or certain areas are covered with a solution of asphalt, resin, or salts that, when heated, produces a granular surface on the plate and rich gray tones in the final print. Etched lines are usually added to the plate after the aquatint ground is laid.

AQUEDUCT. Latin for "duct of water." (1) An artificial channel or conduit for transporting water from a distant source. (2) The overground structure that carries the conduit across valleys, rivers, etc.

ARCADE. A series of arches supported by piers or columns. When attached to a wall, these form a blind arcade.

ARCH. A curved structure used to span an opening. Masonry arches are generally built of wedge-shaped blocks, called *voussoirs*, set with their narrow sides toward the opening so that they lock together. The topmost *voussoir* is called the *keystone*. Arches may take different shapes, such as the pointed Gothic arch or the rounded Classical arch.

ARCHBISHOP. The chief bishop of an ecclesiastic district.

ARCHITECTURAL ORDER. An architectural system based on the column and its entablature, in which the form of the elements themselves (capital, shaft, base, etc.) and their relationship to each other are specifically defined. The five Classical orders are the Doric, Ionic, Corinthian, Tuscan, and Composite.

ARCHITRAVE. The lowermost member of a classical entablature, such as a series of stone blocks that rest directly on the columns.

ARCHIVOLT. A molded band framing an arch, or a series of such bands framing a tympanum, often decorated with sculpture.

ARCUATION. The use of arches or a series of arches in building.

ARIANISM. Early Christian belief, initiated by Arius, a 4th-century CE priest in Alexandria. It was later condemned as heresy and suppressed, and it is now largely obscure.

ARRICCIO. A coating of rough plaster over a stone or cement wall that is used as a smooth base or ground (support) in fresco painting.

ART BRUT. Meaning "raw art" in French, *art brut* is the direct and highly emotional art of children and the mentally ill that served as an inspiration for some artistic movements in Modern art.

ASHLAR MASONRY. Carefully finished stone that is set in fine joints to create an even surface.

ATRIUM. (1) The central court or open entrance court of a Roman house. (2) An open court, sometimes colonnaded or arcaded, in front of a church.

ATTIC. A low upper story placed above the main cornice or entablature of a building and often decorated with windows and pilasters.

AUTOCHROME. A color photograph invented by Louis Lumière in 1903 using a glass plate covered with grains of starch dyed in three colors to act as filters and then a silver bromide emulsion.

AUTOMATIC DRAWING. A technique of drawing in Modern art whereby the artist tries to minimize his or her conscious and intellectual control over the lines or patterns drawn, relying instead on subconscious impulses to direct the drawing.

AVANT-GARDE. Meaning "advance force" in French, the artists of the avant-garde in 19th- and 20th-century Europe led the way in innovation in both subject matter and technique, rebelling against the established conventions of the art world.

BACCHANT (fem. **BACCHANTE**). A priest or priestess of the wine god, Bacchus (in Greek mythology, Dionysus), or one of his ecstatic female followers, who were sometimes called maenads.

BALDACCHINO. A canopy usually built over an altar. The most important one is Bernini's construction for St. Peter's in Rome.

BALUSTRADE. (1) A railing supported by short pillars called balusters. (2) Occasionally applied to any low parapet.

BANQUET PIECE. A variant of the still life, the banquet piece depicts an after-meal scene. It focuses more on tableware than food and typically incorporates a vanitas theme.

BAPTISTRY. A building or a part of a church in which the sacrament of baptism is administered. It is

often octagonal in design, and it contains a baptismal *font*, or a receptacle of stone or metal that holds the Holy Water for the rite.

BARREL VAULT. A vault formed by a continuous semicircular arch so that it is shaped like a half-cylinder.

BAR TRACERY. A style of tracery in which glass is held in place by relatively thin membranes.

BAS-DE-PAGE. Literally "bottom of the page." An illustration or decoration that is placed below a block of text in an illuminated manuscript.

BASE. (1) The lowermost portion of a column or pier, beneath the shaft. (2) The lowest element of a wall, dome, or building or occasionally of a statue or painting.

BASILICA. (1) In ancient Roman architecture, a large, oblong building used as a public meeting place and hall of justice. It generally includes a nave, side aisles, and one or more apses. (2) In Christian architecture, a longitudinal church derived from the Roman basilica and having a nave, an apse, two or four side aisles or side chapels, and sometimes a narthex. (3) Any one of the seven original churches of Rome or other churches accorded the same religious privileges.

BATTLEMENT. A parapet consisting of alternating solid parts and open spaces designed originally for defense and later used for decoration. See *crenelated*.

BAY. A subdivision of the interior space of a building. Usually a series of bays is formed by consecutive architectural supports.

BELVEDERE. A structure made for the purpose of viewing the surroundings, either above the roof of a building or freestanding in a garden or other natural setting.

BENEDICTINE ORDER. Founded at Monte Cassino in 529 CE by St. Benedict of Nursia (ca. 480–ca. 553). Less austere than other early orders, it spread throughout much of western Europe and England in the next two centuries.

BIBLE MORALISÉE. A type of illustrated Bible in which each page typically contains four pairs of illustrations representing biblical events and their related lessons.

BISHOP. The spiritual overseer of a number of churches or a diocese. His throne, or cathedra, placed in the principal church of the diocese, designates it as a cathedral.

BLACK-FIGURED. A style of ancient Greek pottery decoration characterized by black figures against a red background. The black-figured style preceded the red-figured style.

BLIND ARCADE. An arcade with no openings. The arches and supports are attached decoratively to the surface of a wall.

BLOCK BOOKS. Books, often religious, of the 15th century containing woodcut prints in which picture and text were usually cut into the same block.

BODEGÓNES. Although in modern Spanish *bodegón* means "still life," in 17th-century Spain, *bodegónes* referred to genre paintings that included food and drink, as in the work of Velázques.

BOOK COVER. The stiff outer covers protecting the bound pages of a book. In the medieval period, they were frequently covered with precious metal and elaborately embellished with jewels, embossed decoration, etc.

BOOK OF HOURS. A private prayer book containing the devotions for the seven canonical hours of the Roman Catholic church (matins, vespers, etc.), liturgies for local saints, and sometimes a calendar. They were often elaborately illuminated for persons of high rank, whose names are attached to certain extant examples.

BRACKET. A stone, wooden, or metal support projecting from a wall and having a flat top to bear the weight of a statue, cornice, beam, etc. The lower part may take the form of a scroll; it is then called a scroll bracket.

BROKEN PEDIMENT. See *pediment*.

BRONZE AGE. The earliest period in which bronze was used for tools and weapons. In the Middle East, the Bronze Age succeeded the Neolithic period in ca. 3500 BCE and preceded the Iron Age, which commenced ca. 1900 BCE.

BRUSH DRAWING. See *drawing*.

BUON FRESCO. See *fresco*.

BURIN. A pointed metal tool with a wedged-shaped tip used for engraving.

BUTTRESS. A projecting support built against an external wall, usually to counteract the lateral thrust of a vault or arch within. In Gothic church architecture, a *flying buttress* is an arched bridge above the aisle roof that extends from the upper nave wall, where the lateral thrust of the main vault is greatest, down to a solid pier.

BYZANTIUM. City on the Sea of Marmara, founded by the ancient Greeks and renamed Constantinople in 330 CE. Today called Istanbul.

CAESAR. The surname of the Roman dictator, Caius Julius Caesar, subsequently used as the title of an emperor; hence, the German Kaiser and the Russian czar (tsar).

CALLIGRAPHY. From the Greek word for "beautiful writing." (1) Decorative or formal handwriting executed with a quill or reed pen or with a brush. (2) A design derived from or resembling letters and used to form a pattern.

CALOTYPE. Invented in the 1830s, calotype was the first photographic process to use negatives and positive prints on paper.

CALVARY. The hill outside Jerusalem where Jesus was crucified, also known as *Golgotha*. The name *Calvary* is taken from the Latin word *calvaris*, meaning skull; the word *Golgotha* is the Greek transliteration of the word for "skull" in Aramaic. The hill was thought to be the spot where Adam was buried and was thus traditionally known as "the place of the skull." See *Golgotha*.

CAMEO. A low relief carving made on agate, seashell, or other multilayered material in which the subject, often in profile view, is rendered in one color while the background appears in another, darker color.

CAMERA OBSCURA. Latin for "dark room." A darkened enclosure or box with a small opening or lens on one wall through which light enters to form an inverted image on the opposite wall. The principle had long been known but was not used as an aid in picture making until the 16th century.

CAMES. Strips of lead in stained-glass windows that hold the pieces of glass together.

CAMPAGNA. Italian word for "countryside." When capitalized, it usually refers to the countryside near Rome.

CAMPANILE. From the Italian word *campana*, meaning "bell." A bell tower that is either round or square and is sometimes free-standing.

CAMPOSANTO. Italian word for "holy field." A cemetery near a church, often enclosed.

CANON. A law, rule, or standard.

CANOPY. In architecture, an ornamental, rooflike projection or cover above a statue or sacred object.

CAPITAL. The uppermost member of a column or pillar supporting the architrave.

CARDINAL. In the Roman Catholic church, a member of the Sacred college, the ecclesiastical body that elects the pope and constitutes his advisory council.

CARMELITE ORDER. Originally a 12th-century hermitage claimed to descend from a community of hermits established by the prophet Elijah on Mt. Carmel, Palestine. In the early 13th century it spread to Europe and England, where it was reformed by St. Simon Stock and became one of the three great mendicant orders.

CARTHUSIAN ORDER. An order founded at Chartreuse, France, by Saint Bruno in 1084; known for its very stringent rules. See *Chartreuse*.

CARTOON. From the Italian word *cartone*, meaning "large paper." (1) A full-scale drawing for a picture or design intended to be transferred to a wall, panel, tapestry, etc. (2) A drawing or print, usually humorous or satirical, calling attention to some action or person of popular interest.

CARVING. (1) The cutting of a figure or design out of a solid material such as stone or wood, as contrasted to the additive technique of modeling. (2) A work executed in this technique.

CARYATID. A sculptured female figure used in place of a column as an architectural support. A similar male figure is an *atlas* (pl. *atlantes*).

CASEMATE. A chamber or compartment within a fortified wall, usually used for the storage of artillery and munitions.

CASSONE (pl. *CASSONI*). An Italian dowry chest often highly decorated with carvings, paintings, inlaid designs, and gilt embellishments.

CASTING. A method of duplicating a work of sculpture by pouring a hardening substance such as plaster or molten metal into a mold.

CAST IRON. A hard, brittle iron produced commercially in blast furnaces by pouring it into molds where it cools and hardens. Extensively used as a building material in the early 19th century, it was superseded by steel and ferroconcrete.

CATACOMBS. The underground burial places of the early Christians, consisting of passages with niches for tombs and small chapels for commemorative services.

CATALOGUE RAISONNÉ. A complete list of an artist's works of art, with a comprehensive chronology and a discussion of the artist's style.

CATHEDRA. The throne of a bishop, the principal priest of a diocese. See *cathedral*.

CATHEDRAL. The church of a bishop; his administrative headquarters. The location of his *cathedra* or throne.

CELLA. (1) The principal enclosed room of a temple used to house an image. Also called the *naos*. (2) The entire body of a temple as distinct from its external parts.

CENTERING. A wooden framework built to support an arch, vault, or dome during its construction.

CENTRAL-PLAN CHURCH. (1) A church having four arms of equal length. The crossing is often covered with a dome. Also called a Greek-cross church. (2) A church having a circular or polygonal plan.

CHAMPLEVÉ. An enameling method in which hollows are etched into a metal surface and filled with enamel.

CHANCEL. The area of a church around the altar, sometimes set off by a screen. It is used by the clergy and the choir.

CHAPEL. (1) A private or subordinate place of worship. (2) A place of worship that is part of a church but separately dedicated.

CHARTREUSE. French word for a Carthusian monastery (in Italian, Certosa). The Carthusian Order was founded by St. Bruno (ca. 1030–1101) at Chartreuse near Grenoble in 1084. It is an eremitic order, the life of the monks being one of silence, prayer, and austerity.

CHASING. (1) A technique of ornamenting a metal surface by the use of various tools. (2) The procedure used to finish a raw bronze cast.

CHÂTEAU (pl. **CHÂTEAUS** or **CHÂTEAUX**). French word for "castle," now used to designate a large country house as well.

CHEVET. In Gothic architecture, the term for the developed and unified cast end of a church, including choir, apse, ambulatory, and radiating chapels.

CHEVRON. A V-shaped decorative element that, when used repeatedly, gives a horizontal, zigzag appearance.

CHIAROSCURO. Italian word for "light and dark." In painting, a method of modeling form primarily by the use of light and shade.

CHOIR. In church architecture, a square or rectangular area between the apse and the nave or transept. It is reserved for the clergy and the singing choir and is usually marked off by steps, a railing, or a choir screen. Also called the *chancel*.

CHOIR SCREEN. A screen, frequently ornamented with sculpture and sometimes called a *rood screen*, separating the choir of a church from the nave or transept. In Orthodox Christian churches it is decorated with icons and thus called an *iconostasis*.

CHRISTOLOGICAL CYCLE. A series of illustrations depicting the life of Jesus Christ.

CIRE-PERDU PROCESS. The lost-wax process of casting. A method in which an original is modeled in wax or coated with wax, then covered with clay. When the wax is melted out, the resulting mold is filled with molten metal (often bronze) or liquid plaster.

CISTERCIAN ORDER. Founded at Cîteaux in France in 1098 by Robert of Molesme with the objective of reforming the Benedictine Order and reasserting its original ideals of a life of severe simplicity.

CITY-STATE. An autonomous political unit comprising a city and the surrounding countryside.

CLASSICISM. Art or architecture that harkens back to and relies upon the style and canons of the art and architecture of ancient Greece or Rome, which emphasize certain standards of balance, order, and beauty.

CLERESTORY. A row of windows in the upper part of a wall that rises above an adjoining roof. Its purpose is to provide direct lighting, as in a basilica or church.

CLOISONNÉ. An enameling method in which the hollows created by wires joined to a metal plate are filled with enamel to create a design.

CLOISTER. (1) A place of religious seclusion such as a monastery or nunnery. (2) An open court attached to a church or monastery and surrounded by an ambulatory. Used for study, meditation, and exercise.

CLUNIAC ORDER. Founded at Cluny, France, by Berno of Baume in 909. It had a leading role in the religious reform movement in the Middle Ages and had close connections to Ottonian rulers and to the papacy.

CODEX (pl. **CODICES**). A manuscript in book form made possible by the use of parchment instead of papyrus. During the 1st to 4th centuries CE, it gradually replaced the *rotulus*, or "scroll," previously used for written documents.

COFFER. (1) A small chest or casket. (2) A recessed, geometrically shaped panel in a ceiling. A ceiling decorated with these panels is said to be coffered.

COLLAGE. A composition made of cut and pasted scraps of materials, sometimes with lines or forms added by the artist.

COLONNADE. A series of regularly spaced columns supporting a lintel or entablature.

COLONNETTE. A small, often decorative, column that is connected to a wall or pier.

COLOPHON. (1) The production information given at the end of a book. (2) The printed emblem of a book's publisher.

COLOR-FIELD PAINTING. A technique of Abstract painting in which thinned paints are spread onto an unprimed canvas and allowed to soak in with minimal control by the artist.

COLOSSAL ORDER. Columns, piers, or pilasters in the shape of the Greek or Roman orders but that extend through two or more stories rather than following the Classical proportions.

COLUMN. An approximately cylindrical, upright architectural support, usually consisting of a long, relatively slender shaft, a base, and a capital. When imbedded in a wall, it is called an engaged column. Columns decorated with wraparound reliefs were used occasionally as freestanding commemorative monuments.

COMPOSITE IMAGE. An image formed by combining different images or different views of the subject.

COMPOUND PIER. A pier with attached pilasters or shafts.

CONCRETE. A mixture of sand or gravel with mortar and rubble invented in the ancient Near East and further developed by the Romans. Largely ignored during the Middle Ages, it was revived by Bramante in the early 16th century for St. Peter's.

CONTÉ CRAYON. A crayon made of graphite and clay used for drawing. Produces rich, velvety tones.

CONTINUOUS NARRATION. Portrayal of the same figure or character at different stages in a story that is depicted in a single artistic space.

CONTRAPPOSTO. Italian word for "set against." A composition developed by the Greeks to represent movement in a figure. The parts of the body are placed asymmetrically in opposition to each other around a central axis, and careful attention is paid to the distribution of weight.

CORBEL. (1) A bracket that projects from a wall to aid in supporting weight. (2) The projection of one course, or horizontal row, of a building material beyond the course below it.

CORBEL VAULT. A vault formed by progressively projecting courses of stone or brick, which eventually meet to form the highest point of the vault.

CORINTHIAN STYLE. An ornate Classical style of architecture, characterized in part by columns combining a fluted shaft with a capital made up of carved acanthus leaves and scrolls (*volutes*).

CORNICE. (1) The projecting, framing members of a classical pediment, including the horizontal one beneath and the two sloping or "raking" ones above. (2) Any projecting, horizontal element surmounting a wall or other structure or dividing it horizontally for decorative purposes.

COUNTER-REFORMATION. The movement of self-renewal and reform within the Roman Catholic church following the Protestant Reformation of the early 16th century and attempting to combat its influence. Also known as the Catholic Reform. Its principles were formulated and adopted at the Council of Trent, 1545–1563.

COURT STYLE. See *Rayonnant*.

CRENELATED. Especially in medieval Europe, the up-and-down notched walls (*battlements*) of fortified buildings and castles; the *crenels* served as openings for the use of weapons and the higher *merlons* as defensive shields.

CROMLECH. From the Welsh for "concave stone." A circle of large upright stones probably used as the setting for ritual ceremonies in prehistoric Britain.

CROSSHATCHING. In drawing and etching, parallel lines drawn across other parallel lines at various angles to represent differences in values and degrees of shading. See also *hatching*.

CROSSING. The area in a church where the transept crosses the nave, frequently emphasized by a dome or crossing tower.

CROSS SECTION. (1) In architecture, a drawing that shows a theoretical slice through a building along an imagined plane in order to reveal the design of the structure. (2) An imagined slice through any object along an imagined plane in order to reveal its structure.

CRYPT. A space, usually vaulted, in a church that sometimes causes the floor of the choir to be raised above that of the nave; often used as a place for tombs and small chapels.

CUNEIFORM. The wedge-shaped characters made in clay by the ancient Mesopotamians as a writing system.

CURTAIN WALL. A wall of a modern building that does not support the building; the building is supported by an underlying steel structure rather than by the wall itself, which serves the purpose of a facade.

CYCLOPEAN. An adjective describing masonry with large, unhewn stones, thought by the Greeks to have been built by the Cyclopes, a legendary race of one-eyed giants.

DAGUERREOTYPE. Originally, a photograph on a silver-plated sheet of copper, which had been treated with fumes of iodine to form silver iodide on its surface and then after exposure developed by fumes of mercury. The process, invented by L. J. M. Daguerre and made public in 1839, was modified and accelerated as daguerreotypes gained popularity.

DECALCOMANIA. A technique developed by the artist Max Ernst that uses pressure to transfer paint to a canvas from some other surface.

DEËSIS. From the Greek word for "entreaty." The representation of Christ enthroned between the Virgin Mary and St. John the Baptist, frequent in Byzantine mosaics and depictions of the Last Judgment. It refers to the roles of the Virgin Mary and St. John the Baptist as intercessors for humankind.

DENTIL. A small, rectangular, tooth-like block in a series, used to decorate a classical entablature.

DIKKA. An elevated, flat-topped platform in a mosque used by the muezzin or cantor.

DIORITE. An igneous rock, extremely hard and usually black or dark gray in color.

DIPTYCH. (1) Originally a hinged, two-leaved tablet used for writing. (2) A pair of ivory carvings or panel paintings, usually hinged together.

DIPYLON VASE. A Greek funerary vase with holes in the bottom through which libations were poured to the dead. Named for the cemetery near Athens where the vases were found.

DISGUISED SYMBOLISM. "Hidden" meaning in the details of a painting that carry a symbolic message.

DOLMEN. A structure formed by two or more large, upright stones capped by a horizontal slab. Thought to be a prehistoric tomb.

DOME. A true dome is a vaulted roof of circular, polygonal, or elliptical plan, formed with hemispherical or ovoidal curvature. May be supported by a circular wall or drum and by pendentives or related constructions. Domical coverings of many other sorts have been devised.

DOME VAULT. The arched sections of a dome that, joined together, form the rounded shape of a dome. See *dome, vault,* and *arch*.

DOMINICAN ORDER. Founded as a mendicant order by St. Dominic in Toulouse in 1220.

DOMUS. Latin word for "house." A detached, one-family Roman house with rooms frequently grouped around two open courts. The first court, called the *atrium*, was used for entertaining and conducting business. The second court, usually with a garden and surrounded by a *peristyle* or colonnade, was for the private use of the family.

DONOR. The patron or client at whose order a work of art was executed; the donor may be depicted in the work.

DORIC STYLE. A simple style of Classical architecture, characterized in part by smooth or fluted column shafts and plain, cushionlike capitals, and a frieze of *metopes* and *triglyphs*.

DRAWING. (1) A work in pencil, pen and ink, charcoal, etc., often on paper. (2) A similar work in ink or wash, etc., made with a brush and often called a brush drawing. (3) A work combining these or other techniques. A drawing may be large or small, a quick sketch or an elaborate work. Among its various forms are a record of something seen, a study for another work, an illustration associated with a text, and a technical aid.

DRESSED STONE. A masonry technique in which exposed stones are finished, or dressed, to produce a surface that is smooth and formal.

DRÔLERIES. French word for "jests." Used to describe the lively animals and small figures in the margins of late medieval manuscripts and in wood carvings on furniture.

DRUM. (1) A section of the shaft of a column. (2) A circular-shaped wall supporting a dome.

DRYPOINT. A type of *intaglio* printmaking in which a sharp metal needle is use to carve lines and a design into a (usually) copper plate. The act of drawing pushes up a burr of metal filings, and so, when the plate is inked, ink will be retained by the burr to create a soft and deep tone that will be unique to each print. The burr can only last for a few printings. Both the print and the process are called drypoint.

EARTHWORKS. Usually very large scale, outdoor artwork that is produced by altering the natural environment.

ECHINUS. In the Doric or Tuscan Order, the round, cushionlike element between the top of the shaft and the abacus.

ELEVATION. (1) An architectural drawing presenting a building as if projected on a vertical plane parallel to one of its sides. (2) Term used in describing the vertical plane of a building.

EMBLEM BOOK. A reference book for painters of Christian subjects that provides examples of objects and events associated with saints and other religious figures.

EMBOSSING. A metalworking technique in which a relief design is raised by hammering into the back side of a metal sheet.

EMPIRICISM. The philosophical and scientific idea that knowledge should be attained through observation and the accumulation of evidence through repeatable experiments.

ENAMEL. (1) Colored glassy substances, either opaque or translucent, applied in powder form to a metal surface and fused to it by firing. Two main techniques developed: champlevé (from the French for "raised field"), in which the areas to be treated are dug out of the metal surface; and cloisonné (from the French for "partitioned"), in which compartments or cloisons to be filled are made on the surface with thin metal strips. (2) A work executed in either technique.

ENCAUSTIC. A technique of painting with pigments dissolved in hot wax.

ENGAGED COLUMN. A column that is joined to a wall, usually appearing as a half-rounded vertical shape.

ENGRAVING. (1) A means of embellishing metal surfaces or gemstones by incising a design on the surface. (2) A print made by cutting a design into a metal plate (usually copper) with a pointed steel tool known as a burin. The burr raised on either side of the incised line is removed. Ink is then rubbed into the V-shaped grooves and wiped off the surface. The plate, covered with a damp sheet of paper, is run through a heavy press. The image on the paper is the reverse of that on the plate. When a fine steel needle is used instead of a burin and the burr is retained, a drypoint engraving results, characterized by a softer line. These techniques are called, respectively, engraving and drypoint.

ENTABLATURE. (1) In a classical order, the entire structure above the columns; this usually includes architrave, frieze, and cornice. (2) The same structure in any building of a classical style.

ENTASIS. A swelling of the shaft of a column.

ENVIRONMENT. In art, environment refers to the Earth itself as a stage for Environmental art, works that can be enormously large yet very minimal and abstract. These works can be permanent or transitory. The term Earth art is also used to describe these artworks.

ETCHING. (1) A print made by coating a copperplate with an acid-resistant resin and drawing through this ground, exposing the metal with a sharp instrument called a *stylus*. The plate is bathed in acid, which eats into the lines; it is then heated to remove the resin and finally inked and printed on paper. (2) The technique itself is also called etching.

EUCHARIST. (1) The sacrament of Holy Communion, the celebration in commemoration of the Last Supper. (2) The consecrated bread and wine used in the ceremony.

EVANGELISTS. Matthew, Mark, Luke, and John, traditionally thought to be the authors of the Gospels, the first four books of the New Testament, which recount the life and death of Christ. They are usually shown with their symbols, which are probably derived from the four beasts surrounding the throne of the Lamb in the Book of Revelation or from those in the vision of Ezekial: a winged man or angel for Matthew, a winged lion for Mark, a winged ox for Luke, and an eagle for John. These symbols may also represent the evangelists.

FACADE. The principle face or the front of a building.

FAIENCE. (1) A glass paste fired to a shiny opaque finish, used in Egypt and the Aegean. (2) A type of earthenware that is covered with a colorful opaque glaze and is often decorated with elaborate designs.

FATHERS OF THE CHURCH. Early teachers and defenders of the Christian faith. Those most frequently represented are the four Latin fathers: St. Jerome, St. Ambrose, and St. Augustine, all of the 4th century, and St. Gregory of the 6th.

FERROCONCRETE. See *reinforced concrete*.

FERROVITREOUS. In 19th-century architecture, the combining of iron (and later steel) with glass in the construction of large buildings (e.g., railway stations, exhibition halls, etc.).

FIBULA. A clasp, buckle, or brooch, often ornamented.

FILIGREE. Delicate decorative work made of intertwining wires.

FINIAL. A relatively small, decorative element terminating in a gable, pinnacle, or the like.

FLAMBOYANT GOTHIC. A style of Late Gothic architecture in which the bar tracery supporting the strained glass windows is formed into elaborate pointed, often flamelike, shapes.

FLUTING. In architecture, the ornamental grooves channeled vertically into the shaft of a column or *pilaster*. They may meet in a sharp edge, as in the Doric style, or be separated by a narrow strip or fillet, as in the Ionic, Corinthian, and composite styles.

FLYING BUTTRESS. An arch or series of arches on the exterior of a building, connecting the building to detached pier buttresses so that the thrust from the roof vaults is offset.

FOLIO. A leaf of a manuscript or a book, identified so that the front and the back have the same number, the front being labeled *recto* and the back *verso*.

FONT. (1) In printing, a complete set of type in which the letters and numbers follow a consistent design and style. (2) The stone or metal container that holds the Holy Water in a baptistry.

FORESHORTENING. A method of reducing or distorting the parts of a represented object that are not parallel to the picture plane in order to convey the impression of three dimensions as perceived by the human eye.

FORMALISM. The emphasis in art on form; i.e, on line, shape, color, composition, etc. rather than on subject matter. Hence, art from any era may be judged on the basis of its formal elements alone.

FORUM (pl. **FORA**). In an ancient Roman city, the main public square, which was a public gathering place and the center of judicial and business activity.

FOUR-IWAN MOSQUE. A mosque with a rectangular interior courtyard designed with a large vaulted chamber or recess open to the courtyard on each side.

FRANCISCAN ORDER. Founded as a mendicant order by St. Francis of Assisi (Giovanni de Bernardone, ca. 1181–1226). The order's monks aimed to imitate the life of Christ in its poverty and humility, to preach, and to minister to the spiritual needs of the poor.

FRESCO. Italian word for "fresh." Fresco is the technique of painting on plaster with pigments ground in water so that the paint is absorbed by the plaster and becomes part of the wall itself. *Buon fresco* is the technique of painting on wet plaster; *fresco secco* is the technique of painting on dry plaster.

FRIEZE. (1) A continuous band of painted or sculptured decoration. (2) In a Classical building, the part of the entablature between the architrave and the cornice. A Doric frieze consists of alternating triglyphs and metopes, the latter often sculptured. An Ionic frieze is usually decorated with continuous relief sculpture.

FRONTALITY. Representation of a subject in a full frontal view.

FROTTAGE. The technique of rubbing a drawing medium, such as a crayon, over paper that is placed over a textured surface in order to transfer the underlying pattern to the paper.

GABLE. (1) The triangular area framed by the cornice or eaves of a building and the sloping sides of a pitched roof. In Classical architecture, it is called a *pediment*. (2) A decorative element of similar shape, such as the triangular structures above the portals of a Gothic church and sometimes at the top of a Gothic picture frame.

GALLERY. A second story placed over the side aisles of a church and below the clerestory. In a church with a four-part elevation, it is placed below the triforium and above the nave arcade.

GENIUS. A winged semi-nude figure, often purely decorative but frequently personifying an abstract concept or representing the guardian spirit of a person or place.

GENRE. The French word for "kind" or "sort." In art, a genre scene is a work of art, usually a painting, depicting a scene from everyday, ordinary life.

GEOMETRIC ARABESQUE. Complex patterns and designs usually composed of polygonal geometric forms, rather than organic flowing shapes; often used as ornamentation in Islamic art.

GESSO. A smooth mixture of ground chalk or plaster and glue used as the basis for tempera painting and for oil painting on panel.

GESTURE PAINTING. A technique in painting and drawing where the actual physical movement of the artist is reflected in the brush stroke or line as it is seen in the artwork. The artist Jackson Pollock is particularly associated with this technique.

GIGANTOMACHY. From Greek mythology, the battle of the gods and the giants.

GILDING. (1) A coat of gold or of a gold-colored substance that is applied mechanically or chemically to surfaces of a painting, sculpture, or architectural decoration. (2) The process of applying this material.

GIORNATA. Because fresco painting dries quickly, artists apply only as much wet plaster on the wall as can be painted in one day. That amount of work is called the *giornata*, from the Italian word *giorno*, meaning "day." So, *giornata* means "one day's work."

GISANT. In a tomb sculpture, a recumbent effigy or representation of the deceased. At times, the gisant may be represented in a state of decay.

GLAZE. (1) A thin layer of translucent oil color applied to a painted surface or to parts of it in order to modify the tone. (2) A glassy coating applied to a piece of ceramic work before firing in the kiln as a protective seal and often as decoration.

GLAZED BRICK. Brick that is baked in a kiln after being painted.

GLORIOLE (or **GLORY**). The circle of radiant light around the heads or figures of God, Christ, the Virgin Mary, or a saint. When it surrounds the head only, it is called a *halo* or *nimbus*; when it surrounds the entire figure with a large oval, it is called a *mandorla* (the Italian word for "almond"). It indicates divinity or holiness, though originally it was placed around the heads of kings and gods as a mark of distinction.

GOLD LEAF. (1) Gold beaten into very thin sheets or "leaves" and applied to illuminated manuscripts and panel paintings, to sculpture, or to the back of the glass tesserae used in mosaics. (2) *Silver leaf* is also used, though ultimately it tarnishes. Sometimes called gold foil, silver foil.

GOLGOTHA. From the word in Aramaic meaning "skull," Golgotha is the hill outside Jerusalem where the Crucifixtion of Jesus Christ took place; it is also known as Calvary. See *Calvary*.

GORGON. In Greek mythology, one of three hideous female monsters with large heads and snakes for hair. Their glance turned men to stone. Medusa, the most famous of the Gorgons, was killed by Perseus only with help from the gods.

GOSPEL. (1) The first four books of the New Testament. They tell the story of Christ's life and death and are ascribed to the evangelists Matthew, Mark, Luke, and John. (2) A copy of these, usually called a Gospel Book, often richly illuminated.

GRANULATION. A technique of decoration in which metal granules, or tiny metal balls, are fused to a metal surface.

GRATTAGE. A technique in painting whereby an image is produced by scraping off paint from a canvas that has been placed over a textured surface.

GREEK CROSS. A cross with four arms of equal length arranged at right angles.

GREEK-CROSS CHURCH. A church designed using the shape of an equal-armed Greek cross; it has a central room with four equally sized rooms extending outward from the main room.

GRISAILLE. A monochrome drawing or painting in which only values of black, gray, and white are used.

GRISAILLE GLASS. White glass painted with gray designs.

GROIN VAULT. A vault formed by the intersection of two barrel vaults at right angles to each other. A groin is the ridge resulting from the intersection of two vaults.

GROUND-LINE. The line, actual or implied, on which figures stand.

GROUND PLAN. An architectural drawing presenting a building as if cut horizontally at the floor level. Also called a *plan*.

GUTTAE. In a Doric entablature, small peglike projections above the frieze; possibly derived from pegs originally used in wooden construction.

HALL CHURCH. See *hallenkirche*.

HALLENKIRCHE. German word for "hall church." A church in which the nave and the side aisles are of the same height. The type was developed in Romanesque architecture and occurs especially frequently in German Gothic churches.

HALO. In painting, the circle or partial circle of light depicted surrounding the head of a saint, angel, or diety to indicate a holy or sacred nature; most common in medieval paintings but also seen in more modern artwork. Also called a *nimbus*.

HAPPENING. A type of art that involves visual images, audience participation, and improvised performance, usually in a public setting and under the loose direction of an artist.

HATAIJI STYLE. Meaning literally "of Cathay" or "Chinese"; used in Ottoman Turkish art to describe an artistic pattern consisting of stylized lotus blossoms, other flowers, and sinuous leaves on curving stems.

HATCHING. A series of parallel lines used as shading in prints and drawings. When two sets of crossing parallel lines are used, it is called *crosshatching*.

HERALDIC COMPOSITION. A design that is symmetrical around a central axis.

HIERATIC SCALE. An artistic technique in which the importance of figures is indicated by size, so that the most important figure is depicted as the largest.

HIEROGLYPH. A symbol, often based on a figure, animal, or object, standing for a word, syllable, or sound. These symbols form the early Egyptian writing system, and are found on ancient Egyptian monuments as well as in Egyptian written records.

HIGH RELIEF. See *relief*.

HÔTEL. French word for "hotel" but used also to designate an elegant town house.

HOUSE CHURCH. A place for private worship within a house; the first Christian churches were located in private homes that were modified for religious ceremonies.

HUMANISM. A philosophy emphasizing the worth of the individual, the rational abilities of humankind, and the human potential for good. During the Italian Renaissance, humanism was part of a movement that encouraged study of the classical cultures of Greece and Rome; often it came into conflict with the doctrines of the Catholic church.

HYPOSTYLE. A hall whose roof is supported by columns.

ICON. From the Greek word for "image." A panel painting of one or more sacred personages, such as Christ, the Virgin, or a saint, particularly venerated in the Orthodox Christian church.

ICONOCLASM. The doctrine of the Christian church in the 8th and 9th centuries that forbade the worship or production of religious images. This doctrine led to the destruction of many works of art. The iconoclastic controversy over the validity of this doctrine led to a division of the church. Protestant churches of the 16th and 17th centuries also practiced iconoclasm.

ICONOGRAPHY. (1) The depicting of images in art in order to convey certain meanings. (2) The study of the meaning of images depicted in art, whether they be inanimate objects, events, or personages. (3) The content or subject matter of a work of art.

ILLUSIONISM. In artistic terms, the technique of manipulating pictorial or other means in order to cause the eye to perceive a particular reality. May be used in architecture and sculpture, as well as in painting.

IMPASTO. From the Italian word meaning "to make into a paste"; it describes paint, usually oil paint, applied very thickly.

IN ANTIS. An architectural term that indicates the position of the columns on a Greek or Roman building when those columns are set between the junction of two walls.

INCISION. A cut made into a hard material with a sharp instrument.

INLAID NIELLO. See *niello*.

INSULA (pl. **INSULA**). Latin word for "island." (1) An ancient Roman city block. (2) A Roman "apartment house": a concrete and brick building or chain of buildings around a central court, up to five stories high. The ground floor had shops, and above were living quarters.

INTAGLIO. A printing technique in which the design is formed from ink-filled lines cut into a surface. Engraving, etching, and drypoint are examples of intaglio.

INTONACO. The layer of smooth plaster on which paint is applied in fresco painting.

IONIC STYLE. A style of Classical Greek architecture that is characterized in part by columns that have fluted shafts, capitals with volutes (scrolls), and a base; a continuous frieze is also characteristic.

IWAN. A vaulted chamber in a mosque or other Islamic structure, open on one side and usually opening onto an interior courtyard.

JAMBS. The vertical sides of an opening. In Romanesque and Gothic churches, the jambs of doors and windows are often cut on a slant outward, or "splayed," thus providing a broader surface for sculptural decoration.

JAPONISME. In 19th-century French and American art, a style of painting and drawing that reflected the influence of the Japanese artworks, particularly prints, that were then reaching the West.

JESUIT ORDER. The "Society of Jesus" was founded in 1534 by Ignatius of Loyola (1491–1556) and was especially devoted to the service of the pope. The order was a powerful influence in the struggle of the Catholic Counter-Reformation with the Protestant Reformation and was also very important for its missionary work, disseminating Christianity in the Far East and the New World. The mother church in Rome, Il Gesù, conforms in design to the preaching aims of the new order.

KEEP. (1) The innermost and strongest structure or central tower of a medieval castle, sometimes used as living quarters, as well as for defense. Also called a donjon. (2) A fortified medieval castle.

KEYSTONE. The highest central stone or voussoir in an arch; it is the final stone to be put in place, and its weight holds the arch together.

KITSCH. A German word for "trash," in English *kitsch* has come to describe a sensibility that is vulgar and sentimental, in contrast to the refinement of "high" art or fine art.

KORE (pl. **KORAI**). Greek word for "maiden." An Archaic Greek statue of a standing, draped female.

KOUROS (pl. **KOUROI**). Greek word for "male youth." An Archaic Greek statue of a standing, nude youth.

KRATER. A Greek vessel, of assorted shapes, in which wine and water are mixed. A *calyx krater* is a bell-shaped vessel with handles near the base; a *volute krater* is a vessel with handles shaped like scrolls.

KUFIC. One of the first general forms of Arabic script to be developed, distinguished by its angularity; distinctive variants occur in various parts of the Islamic worlds.

KUNSTKAMMEN (German, pl. **KUNSTKAMMERN**; in Dutch, **KUNSTKAMER**). Literally this is a room of art. Developed in the 16th century, it is a forerunner of the museum—a display of paintings and objects of natural history (shells, bones, etc.) that formed an encyclopedic collection.

KYLIX. In Greek and Roman antiquity, a shallow drinking cup with two horizontal handles, often set on a stem terminating in a foot.

LABORS OF THE MONTHS. The various occupations suitable to the months of the year. Scenes or figures illustrating these were frequently represented in illuminated manuscripts. Sometimes scenes of the labors of the months were combined with signs of the zodiac.

LAMASSU. An ancient Near Eastern guardian of a palace; often shown in sculpture as a human-headed bull or lion with wings.

LANCET. A tall, pointed window common in Gothic architecture.

LANDSCAPE. A drawing or painting in which an outdoor scene of nature is the primary subject.

LANTERN. A relatively small structure crowning a dome, roof, or tower, frequently open to admit light to an enclosed area below.

LAPITH. A member of a mythical Greek tribe that defeated the Centaurs in a battle, scenes from which are frequently represented in vase painting and sculpture.

LATIN CROSS. A cross in which three arms are of equal length and one arm is longer.

LAY BROTHER. One who has joined a monastic order but has not taken monastic vows and therefore belongs still to the people or laity, as distinguished from the clergy or religious.

LEKYTHOS (pl. **LEKYTHOI**). A Greek oil jug with an ellipsoidal body, a narrow neck, a flanged mouth, a curved handle extending from below the lip to the shoulder, and a narrow base terminating in a foot. It was used chiefly for ointments and funerary offerings.

LIBERAL ARTS. Traditionally thought to go back to Plato, they comprised the intellectual disciplines considered or necessary to a complete education and included grammar, rhetoric, logic, arithmetic, music, geometry, and astronomy. During the Middle Ages and the Renaissance, they were often represented allegorically in paintings, engravings, and sculpture.

LINTEL. In architecture, a horizontal beam of any material that is held up by two vertical supports.

LITHOGRAPH. A print made by drawing a design with an oily crayon or other greasy substance on a porous stone or, later, a metal plate; the design is then fixed, the entire surface is moistened, and the printing ink that is applied adheres only to the oily lines of the drawing. The design can then be transferred easily in a press to a piece of paper. The technique was invented ca. 1796 by Aloys Senefelder and quickly became popular. It is also widely used commercially, since many impressions can be taken from a single plate.

LOGGIA. A covered gallery or arcade open to the air on at least one side. It may stand alone or be part of a building.

LONGITUDINAL SECTION. A cross section of a building or other object that shows the lengthwise structure. See *cross section*.

LOUVERS. A series of overlapping boards or slats that can be opened to admit air but are slanted so as to exclude sun and rain.

LOW RELIEF. See *relief*.

LUNETTE. (1) A semicircular or pointed wall area, as under a vault, or above a door or window. When it is above the portal of a medieval church, it is called a *tympanum*. (2) A painting, relief sculpture, or window of the same shape.

MADRASA. An Islamic religious college.

MAESTÀ. Italian word for "majesty," applied in the 14th and 15th centuries to representations of the Madonna and Child enthroned and surrounded by her celestial court of saints and angels.

MAGICO-RELIGIOUS. In art, subject matter that deals with the supernatural and often has the purpose of invoking those powers to achieve human ends, e.g., prehistoric cave paintings used to ensure a successful hunt.

MAGUS (pl. **MAGI**). (1) A member of the priestly caste of ancient Media and Persia. (2) In Christian literature, one of the three Wise Men or Kings who came from the East bearing gifts to the newborn Jesus.

MANDORLA. A representation of light surrounding the body of a holy figure.

MANIERA. In painting, the "Greek style" of the 13th century that demonstrated both Italian and Byzantine influences.

MANUSCRIPT ILLUMINATION. Decoration of handwritten documents, scrolls, or books with drawings or paintings. Illuminated manuscripts were often produced during the Middle Ages.

MAQSURA. A screened enclosure, reserved for the ruler, often located before the *mihrab* in certain important royal Islamic mosques.

MARTYRIUM (pl. **MARTYRIA**). A church, chapel, or shrine built over the grave of a Christian martyr or at the site of an important miracle.

MASTABA. An ancient Egyptian tomb, rectangular in shape, with sloping sides and a flat roof. It covered a chapel for offerings and a shaft to the burial chamber.

MATRIX. (1) A mold or die used for shaping a ceramic object before casting. (2) In printmaking, any surface on which an image is incised, carved, or applied and from which a print may be pulled.

MAUSOLEUM. (1) The huge tomb erected at Halikarnassos in Asia Minor in the 4th century BCE by King Mausolos and his wife Artemisia. (2) A generic term for any large funerary monument.

MEANDER. A decorative motif of intricate, rectilinear character applied to architecture and sculpture.

MEDIUM (pl. **MEDIUMS**). (1) The material or technique in which an artist works. (2) The vehicle in which pigments are carried in paint, pastel, etc.

MEGALITH. From the Greek *mega*, meaning "big," and *lithos*, meaning "stone." A huge stone such as those used in cromlechs and dolmens.

MEGARON (pl. **MEGARONS** or **MEGARA**). From the Greek word for "large." The central audience hall in a Minoan or Mycenaean palace or home.

MENHIR. A megalithic upright slab of stone, sometimes placed in rows by prehistoric peoples.

MESOLITHIC. Transitional period of the Stone Age between the Paleolithic and the Neolithic.

METOPE. The element of a Doric frieze between two consecutive triglyphs, sometimes left plain but often decorated with paint or relief sculpture.

MIHRAB. A niche, often highly decorated, usually found in the center of the *qibla* wall of a mosque, indicating the direction of prayer toward Mecca.

MINARET. A tower on or near a mosque, varying extensively in form throughout the Islamic world, from which the faithful are called to prayer five times a day.

MINBAR. A type of staircase pulpit, found in more important mosques to the right of the mihrab, from which the Sabbath sermon is given on Fridays after the noonday prayer.

MINIATURE. (1) A single illustration in an illuminated manuscript. (2) A very small painting, especially a portrait on ivory, glass, or metal.

MINOTAUR. In Greek mythology, a monster having the head of a bull and the body of a man who lived in the Labyrinth of the palace of Knossos on Crete.

MODEL. (1) The preliminary form of a sculpture, often finished in itself but preceding the final casting or carving. (2) Preliminary or reconstructed form of a building made to scale. (3) A person who poses for an artist.

MODELING. (1) In sculpture, the building up of a figure or design in a soft substance such as clay or wax. (2) In painting and drawing, producing a three-dimensional effect by changes in color, the use of light and shade, etc.

MODULE. (1) A segment of a pattern. (2) A basic unit, such as the measure of an architectural member. Multiples of the basic unit are used to determine proportionate construction of other parts of a building.

MOLDING. In architecture, any of various long, narrow, ornamental bands having a distinctive profile that project from the surface of the structure and give variety to the surface by means of their patterned contrasts of light and shade.

MONASTIC ORDER. A religious society whose members live together under an established set of rules.

MONOTYPE. A unique print made from a copper plate or other type of plate from which no other copies of the artwork are made.

MOSAIC. Decorative work for walls, vaults, ceilings, or floors composed of small pieces of colored materials, called *tesserae*, set in plaster or concrete. Romans, whose work was mostly for floors, used shaped pieces of colored stone. Early Christians used pieces of glass with brilliant hues, including gold, and slightly irregular surfaces, producing an entirely different glittering effect.

MOSQUE. A building used as a center for community prayers in Islamic worship; it often serves other functions including religious education and public assembly.

MOTIF. A visual theme, a motif may appear numerous times in a single work of art.

MOZARAB. Term used for the Spanish Christian culture of the Middle Ages that developed while Muslims were the dominant culture and political power on the Iberian peninsula.

MUQARNAS. A distinctive type of Islamic decoration consisting of multiple nichelike forms usually arranged in superimposed rows, often used in zones of architectural transition.

MURAL. From the Latin word for wall, *murus*. A large painting or decoration either executed directly on a wall (fresco) or done separately and affixed to it.

MUSES. In Greek mythology, the nine goddesses who presided over various arts and sciences. They are led by Apollo as god of music and poetry and usually include Calliope, muse of epic poetry; Clio, muse of history; Erato, muse of love poetry; Euterpe, muse of music; Melpomene, muse of tragedy; Polyhymnia, muse of sacred music; Terpsichore, muse of dancing; Thalia, muse of comedy; and Urania, muse of astronomy.

MUTULES. A feature of Doric architecture, mutules are flat rectangular blocks found just under the cornice.

NAOS. See *cella*.

NARTHEX. The transverse entrance hall of a church, sometimes enclosed but often open on one side to a preceding atrium.

NATURALISM. A style of art that aims to depict the natural world as it appears.

NAVE. (1) The central aisle of a Roman basilica, as distinguished from the side aisles. (2) The same section of a Christian basilican church extending from the entrance to the apse or transept.

NECROPOLIS. Greek for "city of the dead." A burial ground or cemetery.

NEOLITHIC. The New Stone Age, thought to have begun ca. 9000–8000 BCE. The first society to live in settled communities, to domesticate animals, and to cultivate crops, it saw the beginning of many new skills, such as spinning, weaving, and building.

NEW STONE AGE. See *neolithic*.

NIELLO. Dark metal alloys applied to the engraved lines in a precious metal plate (usually made of gold or silver) to create a design.

NIKE. The ancient Greek goddess of victory, often identified with Athena and by the Romans with Victoria. She is usually represented as a winged woman with windblown draperies.

NIMBUS. See *halo*.

NOCTURNE. A painting that depicts a nighttime scene, often emphasizing the effects of artificial light.

NONOBJECTIVE PAINTING. In Abstract art, the style of painting that does not strive to represent objects, including people, as they would appear in everyday life or in the natural world.

OBELISK. A tall, tapering, four-sided stone shaft with a pyramidal top. First constructed as *megaliths* in ancient Egypt, certain examples have since been exported to other countries.

OCULUS. The Latin word for "eye." (1) A circular opening at the top of a dome used to admit light. (2) A round window.

ODALISQUE. Turkish word for "harem slave girl" or "concubine."

OIL PAINTING. (1) A painting executed with pigments mixed with oil, first applied to a panel prepared with a coat of gesso (as also in tempera painting), and later to a stretched canvas primed with a coat of white paint and glue. The latter method has predominated since the late 15th century. Oil painting also may be executed on paper, parchment, copper, etc. (2) The technique of executing such a painting.

OIL SKETCH. A work in oil painting of an informal character, sometimes preparatory to a finished work.

OLD STONE AGE. See *paleolithic*.

OPTICAL IMAGES. An image created from what the eye sees, rather than from memory.

ORANT. A standing figure with arms upraised in a gesture of prayer.

ORCHESTRA. (1) In an ancient Greek theater, the round space in front of the stage and below the tiers of seats, reserved for the chorus. (2) In a Roman theater, a similar space reserved for important guests.

ORTHODOX. From the Greek word for "right in opinion." The Eastern Orthodox church, which broke with the Western Catholic church during the 5th century CE and transferred its allegiance from the pope in Rome to the Byzantine emperor in Constantinople and his appointed patriarch. Sometimes called the Byzantine church.

ORTHOGONAL. In a perspective construction, an imagined line in a painting that runs perpendicular to the picture plane and recedes to a vanishing point.

ORTHOSTATS. Upright slabs of stone constituting or lining the lowest courses of a wall, often in order to protect a vulnerable material such as mud-brick.

PALAZZO (pl. **PALAZZI**). Italian word for "palace" (in French, palais). Refers either to large official buildings or to important private town houses.

PALEOLITHIC. The Old Stone Age, usually divided into Lower, Middle, and Upper (which began about 35,000 BCE). A society of nomadic hunters who used stone implements, later developing ones of bone and flint. Some lived in caves, which they decorated during the latter stages of the age, at which time they also produced small carvings in bone, horn, and stone.

PALETTE. (1) A thin, usually oval or oblong board with a thumbhole at one end, used by painters to hold and mix their colors. (2) The range of colors used by a particular painter. (3) In Egyptian art, a slate slab, usually decorated with sculpture in low relief. The small ones with a recessed circular area on one side are thought to have been used for eye makeup. The larger ones were commemorative objects.

PANEL. (1) A wooden surface used for painting, usually in tempera, and prepared beforehand with a layer of gesso. Large altarpieces require the joining together of two or more boards. (2) Recently, panels of Masonite or other composite materials have come into use.

PANTHEON. From *pan*, Greek for "all," and *theos*, Greek for "god." A Hellenistic Greek or Roman temple dedicated to all of the gods; in later years, often housing tombs or memorials for the illustrious dead of a nation.

PANTOCRATOR. A representation of Christ as ruler of the universe that appears frequently in the dome or apse mosaics of Byzantine churches.

PAPYRUS. (1) A tall aquatic plant that grows abundantly in the Near East, Egypt, and Abyssinia. (2) A paperlike material made by laying together thin strips of the pith of this plant and then soaking, pressing, and drying the whole. The resultant sheets were used as writing material by the ancient Egyptians, Greeks, and Romans. (3) An ancient document or scroll written on this material.

PARCHMENT. From Pergamon, the name of a Greek city in Asia Minor where parchment was invented in the 2nd century BCE. (1) A paperlike material made from bleached animal hides used extensively in the Middle Ages for manuscripts. Vellum is a superior type of parchment made from calfskin. (2) A document or miniature on this material.

PASSION. (1) In ecclesiastic terms, the events of Jesus' last week on earth. (2) The representation of these events in pictorial, literary, theatrical, or musical form.

PASTEL. (1) A soft, subdued shade of color. (2) A drawing stick made from pigments ground with chalk and mixed with gum water. (3) A drawing executed with these sticks.

PEDESTAL. An architectural support for a statue, vase, column, etc.

PEDIMENT. (1) In Classical architecture, a low gable, typically triangular, framed by a horizontal cornice below and two raking cornices above; frequently filled with sculpture. (2) A similar architectural member used over a door, window, or niche. When pieces of the cornice are either turned at an angle or interrupted, it is called a *broken pediment*.

PELIKE. A Greek storage jar with two handles, a wide mouth, little or no neck, and resting on a foot.

PENDENTIVE. One of the concave triangles that achieves the transition from a square or polygonal opening to the round base of a dome or the supporting drum.

PERFORMANCE ART. A type of art in which performance by actors or artists, often interacting with the audience in an improvisational manner, is the primary aim over a certain time period. These artworks are transitory, perhaps with only a photographic record of some of the events.

PERIPTERAL. An adjective describing a building surrounded by a single row of columns or colonnade.

PERISTYLE. (1) In a Roman house or *domus*, an open garden court surrounded by a colonnade. (2) A colonnade around a building or court.

PERPENDICULAR STYLE. The third style of English Gothic architecture, in which the bar tracery uses predominantly vertical lines. The fan vault is also used extensively in this style.

PERSPECTIVE. A system for representing spatial relationships and three-dimensional objects on a flat two-dimensional surface so as to produce an effect similar to that perceived by the human eye. In *atmospheric* or *aerial* perspective, this is accomplished by a gradual decrease in the intensity of color and value and in the contrast of light and dark as objects are depicted as farther and farther away in the picture. In color artwork, as objects recede into the distance, all colors tend toward a light bluish-gray tone. In *scientific* or *linear* perspective, developed in Italy in the 15th century, a mathematical system is used based on orthogonals receding to vanishing points on the horizon. Transversals intersect the orthogonals at right angles at distances derived mathematically. Since this presupposes an absolutely stationary viewer and imposes rigid restrictions on the artist, it is seldom applied with complete consistency. Although traditionally ascribed to Brunelleschi, the first theoretical text on perspective was Leon Battista Alberti's *On Painting* (1435).

PHILOSOPHES. Philosophers and intellectuals of the Enlightenment, whose writings had an important influence upon the art of that time.

PHOTOGRAM. A shadowlike photograph made without a camera by placing objects on light-sensitive paper and exposing them to a light source.

PHOTOGRAPH. The relatively permanent or "fixed" form of an image made by light that passes through the lens of a camera and acts upon light-sensitive substances. Often called a print.

PHOTOMONTAGE. A photograph in which prints in whole or in part are combined to form a new image. A technique much practiced by the Dada group in the 1920s.

PIAZZA (pl. **PIAZZE**). Italian word for "public square" (in French, place; in German, platz).

PICTURE PLANE. The flat surface on which a picture is painted.

PICTURESQUE. Visually interesting or pleasing, as if resembling a picture.

PIER. An upright architectural support, usually rectangular and sometimes with capital and base. When columns, pilasters, or shafts are attached to it, as in many Romanesque and Gothic churches, it is called a compound pier.

PIETÀ. Italian word for both "pity" and "piety." A representation of the Virgin grieving over the dead Christ. When used in a scene recording a specific moment after the Crucifixion, it is usually called a Lamentation.

PIETRA SERENA. A limestone, gray in color, used in the Tuscany region of Italy.

PILASTER. A flat, vertical element projecting from a wall surface and normally having a base, shaft, and capital. It has generally a decorative rather than a structural purpose.

PILGRIMAGE CHOIR. The unit in a Romanesque church composed of the apse, ambulatory, and radiating chapels.

PILGRIMAGE PLAN. The general design used in Christian churches that were stops on the pilgrimage routes throughout medieval Europe, characterized by having side aisles that allowed pilgrims to ambulate around the church. See *pilgrimage choir*.

PILLAR. A general term for a vertical architectural support that includes columns, piers, and pilasters.

PILOTIS. Pillars that are constructed from *reinforced concrete* (*ferroconcrete*).

PINNACLE. A small, decorative structure capping a tower, pier, buttress, or other architectural member. It is used especially in Gothic buildings.

PLAN. See *ground plan*.

PLATE TRACERY. A style of tracery in which pierced openings in an otherwise solid wall of stonework are filled with glass.

PLEIN-AIR. Sketching outdoors, often using paints, in order to capture the immediate effects of light on landscape and other subjects. Much encouraged by the Impressionists, their *plein-air* sketches were often taken back to the studio to produce finished paintings, but many *plein-air* sketches are considered masterworks.

PODIUM. (1) The tall base upon which rests an Etruscan or Roman temple. (2) The ground floor of a building made to resemble such a base.

POLYTYCH. An altarpiece or devotional work of art made of several panels joined together, often hinged.

PORCH. General term for an exterior appendage to a building that forms a covered approach to a doorway.

PORTA. Latin word for "door" or "gate."

PORTAL. A door or gate, usually a monumental one with elaborate sculptural decoration.

PORTICO. A columned porch supporting a roof or an entablature and pediment, often approached by a

number of steps. It provides a covered entrance to a building and a connection with the space surrounding it.

POST AND LINTEL. A basic system of construction in which two or more uprights, the posts, support a horizontal member, the lintel. The lintel may be the topmost element or support a wall or roof.

POUNCING. A technique for transferring a drawing from a cartoon to a wall or other surface by pricking holes along the principal lines of the drawing and forcing fine charcoal powder through them onto the surface of the wall, thus reproducing the design on the wall.

POUSSINISTES. Those artists of the French Academy at the end of the17th century and the beginning of the 18th century who favored "drawing," which they believed appealed to the mind rather than the senses. The term derived from admiration for the French artist Nicolas Poussin. See *Rubénistes*.

PREDELLA. The base of an altarpiece, often decorated with small scenes that are related in subject to that of the main panel or panels.

PREFIGURATION. The representation of Old Testament figures and stories as forerunners and foreshadowers of those in the New Testament.

PRIMITIVISM. The appropriation of non-Western (e.g., African, tribal, Polynesian) art styles, forms, and techniques by Modern era artists as part of innovative and avant-garde artistic movements; other sources were also used, including the work of children and the mentally ill.

PRINT. A picture or design reproduced, usually on paper and often in numerous copies, from a prepared wood block, metal plate, stone slab, or photograph.

PRONAOS. In a Greek or Roman temple, an open vestibule in front of the *cella*.

PRONK. A word meaning ostentatious or sumptuous; it is used to refer to a still life of luxurious objects.

PROPYLAEUM (pl. **PROPYLAEA**). (1) The often elaborate entrance to a temple or other enclosure. (2) The monumental entry gate at the western end of the Acropolis in Athens.

PROVENANCE. The place of origin of a work of art and related information.

PSALTER. (1) The book of Psalms in the Old Testament, thought to have been written in part by David, king of ancient Israel. (2) A copy of the Psalms, sometimes arranged for liturgical or devotional use and often richly illuminated.

PULPIT. A raised platform in a church from which the clergy delivers a sermon or conducts the service. Its railing or enclosing wall may be elaborately decorated.

PUTTO (pl. **PUTTI**). A nude, male child, usually winged, often represented in classical and Renaissance art. Also called a cupid or amoretto when he carries a bow and arrow and personifies Love.

PYLON. Greek word for "gateway." (1) The monumental entrance building to an Egyptian temple or forecourt consisting either of a massive wall with sloping sides pierced by a doorway or of two such walls flanking a central gateway. (2) A tall structure at either side of a gate, bridge, or avenue marking an approach or entrance.

QIBLA. The direction toward Mecca, which Muslims face during prayer. The qibla wall in a mosque identifies this direction.

QUADRANT VAULT. A half-barrel vault designed so that instead of being semicircular in cross-section, the arch is one-quarter of a circle.

QUADRA RIPORTATE. Painted scenes depicted in panels on the curved ceiling of a vault.

QUATREFOIL. An ornamental element composed of four lobes radiating from a common center.

RADIATING CHAPELS. Term for chapels arranged around the ambulatory (and sometimes the transept) of a medieval church.

RAYONNANT. The style of Gothic architecture, described as "radiant," developed at the Parisian court of Louis IX in the mid-13th century. Also referred to as *court style*.

READYMADE. An ordinary object that, when an artist gives it a new context and title, is transformed into an art object. Readymades were important features of the Dada and Surrealism movements of the early 20th century.

RED-FIGURED. A style of ancient Greek ceramic decoration characterized by red figures against a black background. This style of decoration developed toward the end of the 6th century BCE and replaced the earlier *black-figured* style.

REFECTORY. (1) A room for refreshment. (2) The dining hall of a masonry, college, or other large institution.

REFORMATION. The religious movement in the early 16th century that had for its object the reform of the Catholic church and led to the establishment of Protestant churches.

REGISTER. A horizontal band containing decoration, such as a relief sculpture or a fresco painting. When multiple horizontal layers are used, registers are useful in distinguishing between different visual planes and different time periods in visual narration.

REINFORCED CONCRETE. Concrete that has been made stronger, particularly in terms of tensile strength, by the imbedding of steel rods or steel mesh. Introduced in France ca. 1900. Many large modern buildings are only feasible through the use of reinforced concrete.

RELIEF. (1) The projection of a figure or part of a design from the background or plane on which it is carved or modeled. Sculpture done in this manner is described as "high relief" or "low relief" depending on the height of the projection. When it is very shallow, it is called *schiacciato*, the Italian word for "flattened out." (2) The apparent projection of forms represented in a painting or drawing. (3) A category of printmaking in which lines raised from the surface are inked and printed.

RELIQUARY. A container used for storing or displaying relics.

RESPOND. (1) A half-pier, pilaster, or similar element projecting from a wall to support a lintel or an arch whose other side is supported by a free-standing column or pier, as at the end of an arcade. (2) One of several pilasters on a wall behind a colonnade that echoes or "responds to" the columns but is largely decorative. (3) One of the slender shafts of a compound pier in a medieval church that seems to carry the weight of the vault.

RHYTON. An ancient drinking or pouring vessel made from pottery, metal, or stone, and sometimes designed in a human or animal form.

RIB. A slender, projecting, archlike member that supports a vault either transversely or at the groins, thus dividing the surface into sections. In Late Gothic architecture, its purpose is often primarily ornamental.

RIBBED VAULT. A style of vault in which projecting surface arches, known as ribs, are raised along the intersections of segments of the vault. Ribs may provide architectural support as well as decoration to the vault's surface.

ROMANESQUE. (1) The style of medieval architecture from the 11th to the 13th centuries that was based upon the Roman model and that used the Roman rounded arch, thick walls for structural support, and relatively small windows. (2) Any culture or its artifacts that are "Roman-like."

ROOD SCREEN. A partition in a church on which a crucifix (rood) is mounted and that separates the public nave area from the choir. See also *choir screen*.

ROSE WINDOW. A large, circular window with stained glass and stone tracery, frequently used on facades and at the ends of transepts in Gothic churches.

ROSTRUM (pl. **ROSTRA**). (1) A beaklike projection from the prow of an ancient warship used for ramming the enemy. (2) In the Roman forum, the raised platform decorated with the beaks of captured ships from which speeches were delivered. (3) A platform, stage, or the like used for public speaking.

ROTULUS (pl. **ROTULI**). The Latin word for scroll, a rolled written text.

RUBBING. A reproduction of a relief surface made by covering it with paper and rubbing with pencil, chalk, etc. Also called frottage.

RUBÉNISTES. Those artists of the French Academy at the end of the 17th century and the beginning of the 18th century who favored "color" in painting because it appealed to the senses and was thought to be true to nature. The term derived from admiration for the work of the Flemish artist Peter Paul Rubens. See *Poussinistes*.

RUSTICATION. A masonry technique of laying rough-faced stones with sharply indented joints.

SACRA CONVERSAZIONE. Italian for "holy conversation." A composition of the Madonna and Child with saints in which the figures all occupy the same spatial setting and appear to be conversing or communing with one another.

SACRISTY. A room near the main altar of a church, or a small building attached to a church, where the vessels and vestments required for the service are kept. Also called a *vestry*.

SALON. (1) A large, elegant drawing or reception room in a palace or a private house. (2) Official government-sponsored exhibition of paintings and sculpture by living artists held at the Louvre in Paris, first biennially, then annually. (3) Any large public exhibition patterned after the Paris Salon.

SANCTUARY. (1) A sacred or holy place or building. (2) An especially holy place within a building, such as the cella of a temple or the part of a church around the altar.

SARCOPHAGUS (pl. **SARCOPHAGI**). A large coffin, generally of stone, and often decorated with sculpture or inscriptions. The term is derived from two Greek words meaning "flesh" and "eating."

SATYR. One of a class of woodland gods thought to be the lascivious companions of Dionysos, the Greek god of wine (or of Bacchus, his Roman counterpart). They are represented as having the legs and tail of a goat, the body of a man, and a head with horns and pointed ears. A youthful satyr is also called a faun.

SAZ. Meaning literally "enchanted forest," this term describes the sinuous leaves and twining stems that are a major component of the *hatayi* style under the Ottoman Turks.

SCHIACCIATO. Italian for "flattened out." Describes low relief sculpture used by Donatello and some of his contemporaries.

SCIENTIFIC PERSPECTIVE. See *perspective*.

SCRIPTORIUM (pl. **SCRIPTORIA**). A workroom in a monastery reserved for copying and illustrating manuscripts.

SCROLL. (1) An architectural ornament with the form of a partially unrolled spiral, as on the capitals of the Ionic and Corinthian orders. (2) A form of written text.

SCUOLA. Italian word for school. In Renaissance Venice it designated a fraternal organization or confraternity dedicated to good works, usually under ecclesiastic auspices.

SECCO (or *A SECCO*). See *fresco secco* under *fresco*.

SECTION. An architectural drawing presenting a building as if cut across the vertical plane at right angles to the horizontal plane. A *cross section* is a cut along the

transverse axis. A *longitudinal section* is a cut along the longitudinal axis.

SELECTIVE WIPING. The planned removal of certain areas of ink during the etching process to produce changes in value on the finished print.

SEXPARTITE VAULT. See *vault.*

SFUMATO. Italian word meaning "smoky." Used to describe very delicate gradations of light and shade in the modeling of figures. It is applied especially to the work of Leonardo da Vinci.

SGRAFFITO **ORNAMENT.** A decorative technique in which a design is made by scratching away the surface layer of a material to produce a form in contrasting colors.

SHAFT. In architecture, the part of a column between the base and the capital.

SIBYLS. In Greek and Roman mythology, any of numerous women who were thought to possess powers of divination and prophecy. They appear on Christian representations, notably in Michelangelo's Sistine ceiling, because they were believed to have foretold the coming of Christ.

SIDE AISLE. A passageway running parallel to the nave of a Roman basilica or Christian church, separated from it by an arcade or colonnade. There may be one on either side of the nave or two, an inner and outer.

SILENI. A class of minor woodland gods in the entourage of the wine god, Dionysos (or Bacchus). Like Silenus, the wine god's tutor and drinking companion, they are thick-lipped and snub-nosed and fond of wine. Similar to satyrs, they are basically human in form except for having horses' tails and ears.

SILKSCREEN PRINTING. A technique of printing in which paint or ink is pressed through a stencil and specially prepared cloth to produce a previously designed image. Also called serigraphy.

SILVER LEAF. See *gold leaf.*

SILVERPOINT. A drawing instrument (stylus) of the 14th and 15th centuries made from silver; it produced a fine line and maintained a sharp point.

SILVER SALTS. Compounds of silver—bromide, chloride, and iodide—that are sensitive to light and are used in the preparation of photographic materials. This sensitivity was first observed by Johann Heinrich Schulze in 1725.

SINOPIA (pl. *SINOPIE*). Italian word taken from "Sinope," the ancient city in Asia Minor that was famous for its brick-red pigment. In fresco paintings, a full-sized, preliminary sketch done in this color on the first rough coat of plaster or *arriccio.*

SITE-SPECIFIC ART. Art that is produced in only one location, a location that is an integral part of the work and essential to its production and meaning.

SKETCH. A drawing, painting, or other artwork usually done quickly, as an aid to understanding and developing artistic skills; sometimes a sketch may lead to a more finished work of art.

SOCLE. A portion of the foundation of a building that projects outward as a base for a column or some other device.

SPANDREL. The area between the exterior curves of two adjoining arches or, in the case of a single arch, the area around its outside curve from its springing to its keystone.

SPHINX. (1) In ancient Egypt, a creature having the head of a man, animal, or bird and the body of a lion; frequently sculpted in monumental form. (2) In Greek mythology, a creature usually represented as having the head and breasts of a woman, the body of a lion, and the wings of an eagle. It appears in classical, Renaissance, and Neoclassical art.

SPIRE. A tall tower that rises high above a roof. Spires are commonly associated with church architecture and are frequently found on Gothic structures.

SPOLIA. Latin for "hide stripped from an animal." Term used for (1) spoils of war and (2) fragments of architecture or sculpture reused in a secondary context.

SPRINGING. The part of an arch in contact with its base.

SQUINCHES. Arches set diagonally at the corners of a square or rectangle to establish a transition to the round shape of the dome above.

STANZA (pl. **STANZE**). Italian word for "room."

STEEL. Iron modified chemically to have qualities of great hardness, elasticity, and strength.

STELE. From the Greek word for "standing block." An upright stone slab or pillar, sometimes with a carved design or inscription.

STEREOBATE. The substructure of a Classical building, especially a Greek temple.

STEREOSCOPE. An optical instrument that enables the user to combine two photographs taken from points of view corresponding to those of the two eyes. The combined single image has the depth and solidity of ordinary binocular vision. First demonstrated by Sir Charles Wheatstone in 1838.

STILL LIFE. A term used to describe paintings (and sometimes sculpture) that depict familiar objects such as household items and food.

STILTS. Term for pillars or posts supporting a superstructure; in 20th-century architecture, these are usually of ferroconcrete. Stilted, as in stilted arches, refers to tall supports beneath an architectural member.

STOA. In Greek architecture, a covered colonnade, sometimes detached and of considerable length, used as a meeting place or promenade.

STOIC. A member of a school of philosophy founded by Zeno about 300 BCE and named after the stoa in Athens where he taught. Its main thesis is that man should be free of all passions.

STRUCTURAL STEEL. Steel used as an architectural building material either invisibly or exposed.

STUCCO. (1) A concrete or cement used to coat the walls of a building. (2) A kind of plaster used for architectural decorations, such as cornices and moldings, or for sculptured reliefs.

STUDY. A preparatory sketch, drawing, painting, or other artwork that is used by an artist to explore artistic possibilities and solve problems before a more finished work is attempted. Often studies come to be regarded as finished works of art.

STYLOBATE. A platform or masonry floor above the stereobate forming the foundation for the columns of a Greek temple.

STYLUS. From the Latin word "stilus", the writing instrument of the Romans. (1) A pointed instrument used in ancient times for writing on tablets of a soft material such as clay. (2) The needlelike instrument used in drypoint or etching.

SUBLIME. In 19th-century art, the ideal and goal that art should inspire awe in a viewer and engender feelings of high religious, moral, ethical, and intellectual purpose.

SUNKEN RELIEF. Relief sculpture in which the figures or designs are modeled beneath the surface of the stone, within a sharp outline.

SUPERIMPOSED ORDERS. Two or more rows of columns, piers, or pilasters placed above each other on the wall of a building.

SYMPOSIUM. In ancient Greece, a gathering, sometimes of intellectuals and philosophers to discuss ideas, often in an informal social setting, such as at a dinner party.

TABERNACLE. (1) A place or house of worship. (2) A canopied niche or recess built for an image. (3) The portable shrine used by the ancient Jews to house the Ark of the Covenant.

TABLEAU VIVANT. A scene, usually derived from myth, the Bible, or literary sources, that is depicted by people standing motionless in costumes on a stage set.

TABLINUM. The Latin word meaning "writing tablet" or "written record." In a Roman house, a room at the far end of the atrium, or between the atrium and the second courtyard, used for keeping family records.

TEMPERA PAINTING. (1) A painting made with pigments mixed with egg yolk and water. In the 14th and 15th centuries, it was applied to panels that had been prepared with a coating of gesso; the application of gold leaf and of *underpainting* in green or brown preceded the actual tempera painting. (2) The technique of executing such a painting.

TENEBRISM. The intense contrast of light and dark in painting.

TERRA COTTA. Italian word for "baked earth." (1) Earthenware, naturally reddish-brown but often glazed in various colors and fired. Used for pottery, sculpture, or as a building material or decoration. (2) An object made of this material. (3) Color of the natural material.

TESSERA (pl. **TESSERAE**). A small piece of colored stone, marble, glass, or gold-backed glass used in a mosaic.

THEATER. In ancient Greece, an outdoor place for dramatic performances, usually semicircular in plan and provided with tiers of seats, the orchestra, and a support for scenery.

THEATINE ORDER. Founded in Rome in the 16th century by members of the recently dissolved Oratory of Divine Love. Its aim was to reform the Catholic church, and its members pledged to cultivate their spiritual lives and to perform charitable works.

THERMAE. A public bathing establishment of the ancient Romans that consisted of various types of baths and social gymnastic facilities.

THOLOS. A building with a circular plan, often with a sacred nature.

THRUST. The lateral pressure exerted by an arch, vault, or dome that must be counteracted at its point of greatest concentration either by the thickness of the wall or by some form of buttress.

TONDO. A circular painting or relief sculpture.

TRACERY. (1) Ornamental stonework in Gothic windows. In the earlier or plate tracery, the windows appear to have been cut through the solid stone. In bar tracery, the glass predominates, the slender pieces of stone having been added within the windows. (2) Similar ornamentation using various materials and applied to walls, shrines, façades, etc.

TRANSEPT. A cross arm in a basilican church placed at right angles to the nave and usually separating it from the choir or apse.

TRANSVERSALS. In a perspective construction, transversals are the lines parallel to the picture plane (horizontally) that denote distances. They intersect orthogonals to make a grid that guides the arrangement of elements to suggest space.

TREE OF KNOWLEDGE. The tree in the Garden of Eden from which Adam and Eve ate the forbidden fruit that destroyed their innocence.

TREE OF LIFE. A tree in the Garden of Eden whose fruit was reputed to give everlasting life; in medieval art it was frequently used as a symbol of Christ.

TRIBUNE. A platform or walkway in a church constructed overlooking the *aisle* and above the *nave.*

TRIFORIUM. The section of a nave wall above the arcade and below the clerestory. It frequently consists of a blind arcade with three openings in each bay. When the gallery is also present, a four-story elevation results, the triforium being between the gallery and clerestory. It may also occur in the transept and the choir walls.

TRIGLYPH. The element of a Doric frieze separating two consecutive metopes and divided by grooves into three sections.

TRIPTYCH. An altarpiece or devotional picture, either carved or painted, with one central panel and two hinged wings.

TRIUMPHAL ARCH. (1) A monumental arch, sometimes a combination of three arches, erected by a Roman emperor in commemoration of his military exploits and usually decorated with scenes of these deeds in relief sculpture. (2) The great transverse arch at the eastern end of a church that frames altar and apse and separates them from the main body of the church. It is frequently decorated with mosaics or mural paintings.

TROIS CRAYONS. The use of three colors, usually red, black, and white, in a drawing; a technique popular in the 17th and 18th centuries.

TROMPE L'OEIL. Meaning "trick of the eye" in French, it is a work of art designed to deceive a viewer into believing that the work of art is reality, an actual three-dimensional object or scene in space.

TROPHY. (1) In ancient Rome, arms or other spoils taken from a defeated enemy and publicly displayed on a tree, pillar, etc. (2) A representation of these objects, and others symbolic of victory, as a commemoration or decoration.

TRUMEAU. A central post supporting the lintel of a large doorway, as in a Romanesque or Gothic portal, where it is frequently decorated with sculpture.

TRUSS. A triangular wooden or metal support for a roof that may be left exposed in the interior or be covered by a ceiling.

TURRET. (1) A small tower that is part of a larger structure. (2) A small tower at a corner of a building, often beginning some distance from the ground.

TUSCHE. An inklike liquid containing crayon that is used to produce solid black (or solid color) areas in prints.

TYMPANUM. (1) In Classical architecture, a recessed, usually triangular area often decorated with sculpture. Also called a *pediment*. (2) In medieval architecture, an arched area between an arch and the lintel of a door or window, frequently carved with relief sculpture.

TYPOLOGY. The matching or pairing of pre-Christian figures, persons, and symbols with their Christian counterparts.

UNDERPAINTING. See *tempera painting*.

VANISHING POINT. The point at which the orthogonals meet and disappear in a composition done with scientific perspective.

VANITAS. The term derives from the book of Ecclesiastes I:2 ("Vanities of vanities, …") that refers to the passing of time and the notion of life's brevity and the inevitability of death. The vanitas theme found expression especially in the Northern European art of the 17th century.

VAULT. An arched roof or ceiling usually made of stone, brick, or concrete. Several distinct varieties have been developed; all need buttressing at the point where the lateral thrust is concentrated. (1) A barrel vault is a semicircular structure made up of successive arches. It may be straight or annular in plan. (2) A groin vault is the result of the intersection of two barrel vaults of equal size that produces a bay of four compartments with sharp edges, or groins, where the two meet. (3) A ribbed groin vault is one in which ribs are added to the groins for structural strength and for decoration. When the diagonal ribs are constructed as half-circles, the resulting form is a domical ribbed vault. (4) A sexpartite vault is a ribbed groin vault in which each bay is divided into six compartments by the addition of a transverse rib across the center. (5) The normal Gothic vault is quadripartite with all the arches pointed to some degree. (6) A fan vault is an elaboration of a ribbed groin vault, with elements of tracery using cone-like forms. It was developed by the English in the 15th century and was employed for decorative purposes.

VEDUTA (pl. **VEDUTE**). A view painting, generally a city landscape.

VELLUM. See *Parchment*.

VERISTIC. From the Latin *verus*, meaning "true." Describes a hyperrealistic style of portraiture that emphasizes individual characteristics.

VESTRY. A chamber in a church where the vestments (clerical garbs) and sacramental vessels are maintained. Also called a *sacristy*.

VICES. Often represented allegorically in conjunction with the seven virtues, they include Pride, Envy, Avarice, Wrath, Gluttony, Lust, and Sloth, though others such as Injustice and Folly are sometimes substituted.

VILLA. Originally a large country house but in modern usage a lso a detached house or suburban residence.

VIRTUES. The three theological virtues, Faith, Hope, and Charity, and the four cardinal ones, Prudence, Justice, Fortitude, and Temperance, were frequently represented allegorically, particularly in medieval manuscripts and sculpture.

VOLUTE. A spiraling architectural element found notably on Ionic and Composite capitals but also used decoratively on building façades and interiors.

VOTIVE. A devotional image used in the veneration or worship of a deity or saint.

VOUSSOIR. A wedge-shaped piece of stone used in arch construction.

WASH. A thin layer of translucent color or ink used in watercolor painting and brush drawing, and occasionally in oil painting.

WATERCOLOR PAINTING. Painting, usually on paper, in pigments suspended in water.

WEBS. Masonry construction of brick, concrete, stone, etc. that is used to fill in the spaces between groin vault ribs.

WESTWORK. From the German word *Westwerk*. In Carolingian, Ottonian, and German Romanesque architecture, a monumental western front of a church, treated as a tower or combination of towers and containing an entrance and vestibule below and a chapel and galleries above. Later examples often added a transept and a crossing tower.

WING. The side panel of an altarpiece that is frequently decorated on both sides and is also hinged, so that it may be shown either open or closed.

WOODCUT. A print made by carving out a design on a wooden block cut along the grain, applying ink to the raised surfaces that remain, and printing from those.

WROUGHT IRON. A comparatively pure form of iron that is easily forged and does not harden quickly, so that it can be shaped or hammered by hand, in contrast to molded cast iron.

WUNDERKAMMER (pl. **WUNDERKAMMERN**). Literally a "room of wonders." This forerunner of the museum developed in the 16th century. Such rooms displayed wonders of the world, often from exotic, far off places. The objects displayed included fossils, shells, coral, animals (bones, skins, etc.), and gems in an effort to form an encyclopedic collection. See *kunstkammen*.

ZIGGURAT. From the Assyrian word *ziqquratu*, meaning "mountaintop" or "height." In ancient Assyria and Babylonia, a pyramidal mound or tower built of mud-brick forming the base for a temple. It was often either stepped or had a broad ascent winding around it, which gave it the appearance of being stepped.

ZODIAC. An imaginary belt circling the heavens, including the paths of the sun, moon, and major planets and containing twelve constellations and thus twelve divisions called signs, which have been associated with the months. The signs are Aries, the ram; Taurus, the bull; Gemini, the twins; Cancer, the crab; Leo, the lion; Virgo, the virgin; Libra, the balance; Scorpio, the scorpion; Sagittarius, the archer; Capricorn, the goat; Aquarius, the waterbearer; and Pisces, the fish. They are frequently represented around the portals of Romanesque and Gothic churches in conjunction with the Labors of the Months.

Books for Further Reading

This list is intended to be as practical as possible. It is therefore limited to books of general interest that were printed over the past 20 years or have been generally available recently. However, certain indispensable volumes that have yet to be superseded are retained. This restriction means omitting numerous classics long out of print, as well as much specialized material of interest to the serious student. The reader is thus referred to the many specialized bibliographies noted below.

REFERENCE RESOURCES IN ART HISTORY

1. BIBLIOGRAPHIES AND RESEARCH GUIDES

Arntzen, E., and R. Rainwater. *Guide to the Literature of Art History*. Chicago: American Library, 1980.

Barnet, S. *A Short Guide to Writing About Art*. 8th ed. New York: Longman, 2005.

Ehresmann, D. *Architecture: A Bibliographical Guide to Basic Reference Works, Histories, and Handbooks*. Littleton, CO: Libraries Unlimited, 1984.

———. *Fine Arts: A Bibliographical Guide to Basic Reference Works, Histories, and Handbooks*. 3d ed. Littleton, CO: Libraries Unlimited, 1990.

Freitag, W. *Art Books: A Basic Bibliography of Monographs on Artists*. 2d ed. New York: Garland, 1997.

Goldman, B. *Reading and Writing in the Arts: A Handbook*. Detroit, MI: Wayne State Press, 1972.

Kleinbauer, W., and T. Slavens. *Research Guide to the History of Western Art*. Chicago: American Library, 1982.

Marmor, M., and A. Ross, eds. *Guide to the Literature of Art History 2*. Chicago: American Library, 2005.

Sayre, H. M. *Writing About Art*. New ed. Upper Saddle River, NJ: Pearson Prentice Hall, 2000.

2. DICTIONARIES AND ENCYCLOPEDIAS

Aghion, I. *Gods and Heroes of Classical Antiquity*. Flammarion Iconographic Guides. New York: Flammarion, 1996.

Boström, A., ed. *Encyclopedia of Sculpture*. 3 vols. New York: Fitzroy Dearborn, 2004.

Brigstocke, H., ed. *The Oxford Companion to Western Art*. New York: Oxford University Press, 2001.

Burden, E. *Illustrated Dictionary of Architecture*. New York: McGraw-Hill, 2002.

Carr-Gomm, S. *The Hutchinson Dictionary of Symbols in Art*. Oxford: Helicon, 1995.

Chilvers, I., et al., eds. *The Oxford Dictionary of Art*. 3d ed. New York: Oxford University Press, 2004.

Congdon, K. G. *Artists from Latin American Cultures: A Biographical Dictionary*. Westport, CT: Greenwood Press, 2002.

Cumming, R. *Art: A Field Guide*. New York: Alfred A. Knopf, 2001.

Curl, J. *A Dictionary of Architecture*. New York: Oxford University Press, 1999.

The Dictionary of Art. 34 vols. New York: Grove's Dictionaries, 1996.

Duchet-Suchaux, G., and M. Pastoureau. *The Bible and the Saints*. Flammarion Iconographic Guides. New York: Flammarion, 1994.

Encyclopedia of World Art. 14 vols., with index and supplements. New York: McGraw-Hill, 1959–1968.

Fleming, J., and H. Honour. *The Penguin Dictionary of Architecture and Landscape Architecture*. 5th ed. New York: Penguin, 1998.

———. *The Penguin Dictionary of Decorative Arts*. New ed. London: Viking, 1989.

Gascoigne, B. *How to Identify Prints: A Complete Guide to Manual and Mechanical Processes from Woodcut to Inkjet*. New York: Thames & Hudson, 2004.

Hall, J. *Dictionary of Subjects and Symbols in Art*. Rev. ed. London: J. Murray, 1996.

———. *Illustrated Dictionary of Symbols in Eastern and Western Art*. New York: HarperCollins, 1995.

International Dictionary of Architects and Architecture. 2 vols. Detroit, MI: St. James Press, 1993.

Langmuir, E. *Yale Dictionary of Art and Artists*. New Haven: Yale University Press, 2000.

Lever, J., and J. Harris. *Illustrated Dictionary of Architecture, 800–1914*. 2d ed. Boston: Faber & Faber, 1993.

Lucie-Smith, E. *The Thames & Hudson Dictionary of Art Terms*. New York: Thames & Hudson, 2004.

Mayer, R. *The Artist's Handbook of Materials and Techniques*. 5th ed. New York: Viking, 1991.

———. *The HarperCollins Dictionary of Art Terms & Techniques*. 2d ed. New York: HarperCollins, 1991.

Murray, P., and L. Murray. *A Dictionary of Art and Artists*. 7th ed. New York: Penguin, 1998.

———. *A Dictionary of Christian Art*. New York: Oxford University Press, 2004, © 1996.

Nelson, R. S., and R. Shiff, eds. *Critical Terms for Art History*. Chicago: University of Chicago Press, 2003.

Pierce, J. S. *From Abacus to Zeus: A Handbook of Art History*. 7th ed. Englewood Cliffs, NJ: Pearson Prentice Hall, 2004.

Reid, J. D., ed. *The Oxford Guide to Classical Mythology in the Arts 1300–1990*. 2 vols. New York: Oxford University Press, 1993.

Shoemaker, C., ed. *Encyclopedia of Gardens: History and Design*. Chicago: Fitzroy Dearborn, 2001.

Steer, J. *Atlas of Western Art History: Artists, Sites, and Movements from Ancient Greece to the Modern Age*. New York: Facts on File, 1994.

West, S., ed. *The Bulfinch Guide to Art History*. Boston: Little, Brown, 1996.

———. *Portraiture*. Oxford History of Art. New York: Oxford University Press, 2004.

3. INDEXES, PRINTED AND ELECTRONIC

ARTbibliographies Modern. 1969 to present. A semiannual publication indexing and annotating more than 300 art periodicals, as well as books, exhibition catalogues, and dissertations. Data since 1974 also available electronically.

Art Index. 1929 to present. A standard quarterly index to more than 200 art periodicals. Also available electronically.

Avery Index to Architectural Periodicals. 1934 to present. 15 vols., with supplementary vols. Boston: G. K. Hall, 1973. Also available electronically.

BHA: Bibliography of the History of Art. 1991 to present. The merger of two standard indexes: *RILA* (*Répertoire International de la Littérature de l'Art/International Repertory of the Literature of Art*, vol. 1. 1975) and *Répertoire d'Art et d'Archéologie* (vol. 1. 1910). Data since 1973 also available electronically.

Index Islamicus. 1665 to present. Multiple publishers. Data since 1994 also available electronically.

The Perseus Project: An Evolving Digital Library on Ancient Greece and Rome. Medford, MA: Tufts University, Classics Department, 1994.

4. WORLDWIDE WEBSITES

Visit the following websites for reproductions and information regarding artists, periods, movements, and many more subjects. The art history departments and libraries of many universities and colleges also maintain websites where you can get reading lists and links to other websites, such as those of museums, libraries, and periodicals.

http://www.aah.org.uk/welcome.html Association of Art Historians

http://www.amico.org Art Museum Image Consortium

http://www.archaeological.org Archaeological Institute of America

http://archnet.asu.edu/archnet Virtual Library for Archaeology

http://www.artchive.com

http://www.art-design.umich.edu/mother/ Mother of all Art History links pages, maintained by the Department of the History of Art at the University of Michigan

http://www.arthistory.net Art History Network

http://artlibrary.vassar.edu/ifla-idal International Directory of Art Libraries

http://www.bbk.ac.uk/lib/hasubject.html Collection of resources maintained by the History of Art Department of Birkbeck College, University of London

http://classics.mit.edu The Internet Classics Archive

http://www.collegeart.org College Art Association

http://www.constable.net

http://www.cr.nps.gov/habshaer Historic American Buildings Survey

http://www.getty.edu Including museum, five institutes, and library

http://www.harmsen.net/ahrc/ Art History Research Centre

http://icom.museum/ International Council of Museums

http://www.icomos.org International Council on Monuments and Sites

http://www.ilpi.com/artsource

http://www.siris.si.edu Smithsonian Institution Research Information System

http://whc.unesco.org/ World Heritage Center

5. GENERAL SOURCES ON ART HISTORY, METHOD, AND THEORY

Andrews, M. *Landscape and Western Art*. Oxford History of Art. New York: Oxford University Press, 1999.

Barasch, M. *Modern Theories of Art: Vol. 1, From Winckelmann to Baudelaire. Vol. 2, From Impressionism to Kandinsky*. New York: 1990–1998.

———. *Theories of Art: From Plato to Winckelmann*. New York: Routledge, 2000.

Battistini, M. *Symbols and Allegories in Art*. Los Angeles: J. Paul Getty Museum, 2005.

Baxandall, M. *Patterns of Intention: On the Historical Explanation of Pictures*. New Haven: Yale University Press, 1985.

Bois, Y.-A. *Painting as Model*. Cambridge, MA: MIT Press, 1993.

Broude, N., and M. Garrard. *The Expanding Discourse: Feminism and Art History*. New York: Harper & Row, 1992.

———., eds. *Feminism and Art History: Questioning the Litany*. New York: Harper & Row, 1982.

Bryson, N., ed. *Vision and Painting: The Logic of the Gaze*. New Haven: Yale University Press, 1983.

———., et al., eds. *Visual Theory: Painting and Interpretation*. New York: Cambridge University Press, 1991.

Chadwick, W. *Women, Art, and Society*. 3d ed. New York: Thames & Hudson, 2002.

D'Alleva, A. *Methods & Theories of Art History*. London: Laurence King, 2005.

Freedberg, D. *The Power of Images: Studies in the History and Theory of Response*. Chicago: University of Chicago Press, 1989.

Gage, J. *Color and Culture: Practice and Meaning from Antiquity to Abstraction.* Berkeley: University of California Press, 1999.

Garland Library of the History of Art. New York: Garland, 1976. Collections of essays on specific periods.

Goldwater, R., and M. Treves, eds. *Artists on Art, from the Fourteenth to the Twentieth Century.* 3d ed. New York: Pantheon, 1974.

Gombrich, E. H. *Art and Illusion.* 6th ed. New York: Phaidon, 2002.

Harris, A. S., and L. Nochlin. *Women Artists, 1550–1950.* New York: Random House, 1999.

Holly, M. A. *Panofsky and the Foundations of Art History.* Ithaca, NY: Cornell University Press, 1984.

Holt, E. G., ed. *A Documentary History of Art: Vol. 1, The Middle Ages and the Renaissance. Vol. 2, Michelangelo and the Mannerists. The Baroque and the Eighteenth Century. Vol. 3, From the Classicists to the Impressionists.* 2d ed. Princeton, NJ: Princeton University Press, 1981. Anthologies of primary sources on specific periods.

Johnson, P. *Art: A New History.* New York: HarperCollins, 2003.

Kemal, S., and I. Gaskell. *The Language of Art History.* Cambridge Studies in Philosophy and the Arts. New York: Cambridge University Press, 1991.

Kemp, M., ed. *The Oxford History of Western Art.* New York: Oxford University Press, 2000.

Kleinbauer, W. E. *Modern Perspectives in Western Art History: An Anthology of Twentieth-Century Writings on the Visual Arts.* Reprint of 1971 ed. Toronto: University of Toronto Press, 1989.

Kostof, S. A. *History of Architecture: Settings and Rituals.* 2d ed. New York: Oxford University Press, 1995.

Kruft, H. W. *A History of Architectural Theory from Vitruvius to the Present.* Princeton, NJ: Princeton Architectural Press, 1994.

Kultermann, U. *The History of Art History.* New York: Abaris Books, 1993.

Langer, C. *Feminist Art Criticism: An Annotated Bibliography.* Boston: G. K. Hall, 1993.

Laver, J. *Costume and Fashion: A Concise History.* 4th ed. The World of Art. London: Thames & Hudson, 2002.

Lavin, I., ed. *Meaning in the Visual Arts: Views from the Outside: A Centennial Commemoration of Erwin Panofsky (1892–1968).* Princeton, NJ: Institute for Advanced Study, 1995.

Minor, V. H. *Art History's History.* Upper Saddle River, NJ: Pearson Prentice Hall, 2001.

Nochlin, L. *Women, Art, and Power, and Other Essays.* New York: HarperCollins, 1989.

Pächt, O. *The Practice of Art History: Reflections on Method.* London: Harvey Miller, 1999.

Panofsky, E. *Meaning in the Visual Arts.* Reprint of 1955 ed. Chicago: University of Chicago Press, 1982.

Penny, N. *The Materials of Sculpture.* New Haven: Yale University Press, 1993.

Pevsner, N. *A History of Building Types.* Princeton, NJ: Princeton University Press, 1976.

Podro, M. *The Critical Historians of Art.* New Haven: Yale University Press, 1982.

Pollock, G. *Differencing the Canon: Feminist Desire and the Writing of Art's Histories.* New York: Routledge, 1999.

———. *Vision and Difference: Femininity, Feminism, and the Histories of Art.* New York: Routledge, 1988.

Prettejohn, E. *Beauty and Art 1750–2000.* New York: Oxford University Press, 2005.

Preziosi, D., ed. *The Art of Art History: A Critical Anthology.* New York: Oxford University Press, 1998.

Rees, A. L., and F. Borzello. *The New Art History.* Atlantic Highlands, NJ: Humanities Press International, 1986.

Roth, L. *Understanding Architecture: Its Elements, History, and Meaning.* New York: Harper & Row, 1993.

Sedlmayr, H. *Framing Formalism: Riegl's Work.* Amsterdam: G+B Arts International, © 2001.

Smith, P., and C. Wilde, eds. *A Companion to Art Theory.* Oxford: Blackwell, 2002.

Sources and Documents in the History of Art Series. General ed. H. W. Janson. Englewood Cliffs, NJ: Prentice Hall. Anthologies of primary sources on specific periods.

Sutton, I. *Western Architecture.* New York: Thames & Hudson, 1999.

Tagg, J. *Grounds of Dispute: Art History, Cultural Politics, and the Discursive Field.* Minneapolis: University of Minnesota Press, 1992.

Trachtenberg, M., and I. Hyman. *Architecture: From Prehistory to Post-Modernism.* 2d ed. New York: Harry N. Abrams, 2002.

Watkin, D. *The Rise of Architectural History.* Chicago: University of Chicago Press, 1980.

Wolff, J. *The Social Production of Art.* 2d ed. New York: New York University Press, 1993.

Wölfflin, H. *Principles of Art History: The Problem of the Development of Style in Later Art.* Various eds. New York: Dover.

Wollheim, R. *Art and Its Objects.* 2d ed. New York: Cambridge University Press, 1992.

PART THREE: THE RENAISSANCE THROUGH THE ROCOCO

GENERAL REFERENCES AND SOURCES

Campbell, L. *Renaissance Portraits: European Portrait-Painting in the 14th, 15th, and 16th Centuries.* New Haven: Yale University Press, 1990.

Chastel, A., et al. *The Renaissance: Essays in Interpretation.* London: Methuen, 1982.

Cloulas, I. *Treasures of the French Renaissance.* New York: Harry N. Abrams, 1998.

Cole, A. *Art of the Italian Renaissance Courts: Virtue and Magnificence.* London: Weidenfeld & Nicolson, 1995.

Gascoigne, B. *How to Identify Prints: A Complete Guide to Manual and Mechanical Processes from Woodcut to Inkjet.* New York: Thames & Hudson, 2004.

Grendler, P. F., ed. *Encyclopedia of the Renaissance.* 6 vols. New York: Scribner's, published in association with the Renaissance Society of America, 1999.

Gruber, A., ed. *The History of Decorative Arts: Vol. 1, The Renaissance and Mannerism in Europe. Vol. 2, Classicism and the Baroque in Europe.* New York: Abbeville Press, 1994.

Harbison, C. *The Mirror of the Artist: Northern Renaissance Art in its Historical Context.* New York: Harry N. Abrams, 1995.

Harris, A. S. *Seventeenth-Century Art and Architecture.* Upper Saddle River, NJ: Pearson Prentice Hall, 2005.

Hartt, F., and D. Wilkins. *History of Italian Renaissance Art.* 6th ed. Upper Saddle River, NJ: Pearson Prentice Hall, 2007.

Hopkins, A. *Italian Architecture: from Michelangelo to Borromini.* World of Art. New York: Thames & Hudson, 2002.

Hults, L. *The Print in the Western World.* Madison: University of Wisconsin Press, 1996.

Impey, O., and A. MacGregor, eds. *The Origins of Museums: The Cabinet of Curiosities in Sixteenth- and Seventeenth-Century Europe.* New York: Clarendon Press, 1985.

Ivins, W. M., Jr. *How Prints Look: Photographs with a Commentary.* Boston: Beacon Press, 1987.

Landau, D., and P. Parshall. *The Renaissance Print.* New Haven: Yale University Press, 1994.

Lincoln, E. *The Invention of the Italian Renaissance Printmaker.* New Haven: Yale University Press, 2000.

Martin, J. R. *Baroque.* Harmondsworth, England: Penguin, 1989.

Millon, H. A., ed. *The Triumph of the Baroque: Architecture in Europe, 1600–1750.* New York: Rizzoli, 1999.

Minor, V. H. *Baroque & Rococo: Art & Culture.* New York: Harry N. Abrams, 1999.

Norberg-Schultz, C. *Late Baroque and Rococo Architecture.* New York: Harry N. Abrams, 1983.

Olson, R. J. M. *Italian Renaissance Sculpture.* The World of Art. New York: Thames & Hudson, 1992.

Paoletti, J., and G. Radke. *Art in Renaissance Italy.* 3d ed. Upper Saddle River, NJ: Pearson Prentice Hall, 2006.

Payne, A. *Antiquity and Its Interpreters.* New York: Cambridge University Press, 2000.

Pope-Hennessy, J. *An Introduction to Italian Sculpture: Vol. 1, Italian Gothic Sculpture. Vol. 2, Italian Renaissance Sculpture. Vol. 3, Italian High Renaissance and Baroque Sculpture.* 4th ed. London: Phaidon Press, 1996.

Smith, J. C. *The Northern Renaissance.* Art & Ideas. London: Phaidon, 2004.

Snyder, J. *Northern Renaissance Art: Painting, Sculpture, the Graphic Arts, from 1350–1575.* 2d ed. New York: Harry N. Abrams, 2005.

Tomlinson, J. *From El Greco to Goya: Painting in Spain 1561–1828.* Perspectives. New York: Harry N. Abrams, 1997.

Turner, J. *Encyclopedia of Italian Renaissance & Mannerist Art.* 2 vols. New York: Grove's Dictionaries, 2000.

Vasari, G. *The Lives of the Artists.* Trans. with an introduction and notes by J. C. Bondanella and P. Bondanella. New York: Oxford University Press, 1998.

Welch, E. *Art in Renaissance Italy, 1350–1500.* New ed. Oxford: Oxford University Press, 2000.

Wiebenson, D., ed. *Architectural Theory and Practice from Alberti to Ledoux.* 2d ed. Chicago: University of Chicago Press, 1983.

Wittkower, R. *Architectural Principles in the Age of Humanism.* 5th ed. New York: St. Martin's Press, 1998.

CHAPTER 13. ART IN THIRTEENTH-AND FOURTEENTH-CENTURY ITALY

Bellosi, L. *Duccio, the Maestà.* New York: Thames & Hudson, 1999.

Bomford, D. *Art in the Making: Italian Painting Before 1400.* Exh. cat. London: National Gallery of Art, 1989.

Cole, B. *Studies in the History of Italian Art, 1250–1550.* London: Pindar, 1996.

Derbes, A. *The Cambridge Companion to Giotto.* New York: Cambridge University Press, 2004.

Kemp, M. *Behind the Picture: Art and Evidence in the Italian Renaissance.* New Haven: Yale University Press, 1997.

Maginnis, H. B. J. *The World of the Early Sienese Painter.* With a translation of the Sienese Breve dell'Arte dei pittori by Gabriele Erasmi. University Park: Pennsylvania State University Press, 2001.

Meiss, M. *Painting in Florence and Siena after the Black Death: The Arts, Religion, and Society in the Mid-Fourteenth Century.* Princeton, NJ: Princeton University Press, 1978, © 1951.

Norman, D., ed. *Siena, Florence, and Padua: Art, Society, and Religion 1280–1400.* New Haven: Yale University Press in association with the Open University, 1995.

Schmidt, V., ed. *Italian Panel Painting of the Duecento and Trecento.* Washington, DC: National Gallery of Art; New Haven: Dist. by Yale University Press, 2002.

Stubblebine, J. H. *Assisi and the Rise of Vernacular Art.* New York: Harper & Row, 1985.

———. *Dugento Painting: An Annotated Bibliography.* Boston: G. K. Hall, 1983.

White, J. *Art and Architecture in Italy, 1250–1400.* 3d ed. Pelican History of Art. New Haven: Yale University Press, 1993.

CHAPTER 14. ARTISTIC INNOVATIONS IN FIFTEENTH-CENTURY NORTHERN EUROPE

Ainsworth, M. W., and K. Christiansen. *From Van Eyck to Bruegel: Early Netherlandish Painting in the Metropolitan Museum of Art.* New York: Metropolitan Museum of Art, 1998.

Blum, S. *Early Netherlandish Triptychs: A Study in Patronage.* Berkeley: University of California Press, 1969.

Chapuis, J., ed. *Tilman Riemenschneider, Master Sculptor of the Late Middle Ages.* Washington, DC: National Gallery of Art; New York: Metropolitan Museum of Art; New Haven: Dist. by Yale University Press, 1999.

Cuttler, C. *Northern Painting from Pucelle to Bruegel.* Fort Worth: Holt, Rinehart & Winston, 1991, © 1972.

De Vos, D. *Rogier van der Weyden: The Complete Works.* New York: Harry N. Abrams, 1999.

Dhanens, E. *Hubert and Jan van Eyck.* New York: Alpine Fine Arts Collection, 1980.

Dixon, L. *Bosch*. Art & Ideas. London: Phaidon, 2003.

Friedländer, M. *Early Netherlandish Painting*. 14 vols. New York: Praeger, 1967–1973.

Koldeweij, J., ed. *Hieronymus Bosch: New Insights into His Life and Work*. Rotterdam: Museum Boijmans Van Beuningen: NAi; Ghent: Ludion, 2001.

Mâle, E. *Religious Art in France, the Late Middle Ages: A Study of Medieval Iconography and Its Sources*. Princeton, NJ: Princeton University Press, 1986.

Muller, T. *Sculpture in the Netherlands, Germany, France, and Spain, 1400–1500*. Pelican History of Art. Harmondsworth, England: Penguin, 1966.

Nuttall, P. *From Flanders to Florence: The Impact of Netherlandish Painting, 1400–1500*. New Haven: Yale University Press, 2004.

Pächt, O. *Van Eyck and the Founders of Early Netherlandish Painting*. London: Harvey Miller, 1994.

Panofsky, E. *Early Netherlandish Painting*. 2 vols. New York: Harper & Row, 1971. Orig. published Cambridge, MA: Harvard University Press, 1958.

Williamson, P. *Netherlandish Sculpture 1450–1550*. London: V & A; New York: Dist. by Harry N. Abrams, 2002.

CHAPTER 15. THE EARLY RENAISSANCE IN ITALY

Ahl, D. C. *The Cambridge Companion to Masaccio*. New York: Cambridge University Press, 2002.

Aikema, B. *Renaissance Venice and the North: Crosscurrents in the Time of Bellini, Dürer and Titian*. Exh. cat. Milan: Bompiani, 2000.

Alberti, L. B. *On Painting*. Trans. C. Grayson, introduction and notes M. Kemp. New York: Penguin, 1991.

———. *On the Art of Building, in Ten Books*. Trans. J. Rykwert, et al. Cambridge, MA: MIT Press, 1991.

Ames-Lewis, F. *Drawing in Early Renaissance Italy*. 2d ed. New Haven: Yale University Press, 2000.

Baxandall, M. *Painting and Experience in Fifteenth-Century Italy: A Primer in the Social History of Pictorial Style*. 2d ed. New York: Oxford University Press, 1988.

Blunt, A. *Artistic Theory in Italy, 1450–1600*. Reprint of 1940 ed. New York: Oxford University Press, 1983.

Bober, P., and R. Rubinstein. *Renaissance Artists and Antique Sculpture: A Handbook of Sources*. New York: Oxford University Press, 1986.

Borsook, E. *The Mural Painters of Tuscany: From Cimabue to Andrea del Sarto*. 2d ed. New York: Oxford University Press, 1980.

Cole, B. *The Renaissance Artist at Work: From Pisano to Titian*. New York: Harper & Row, © 1983.

Fejfer, J. *The Rediscovery of Antiquity: The Role of the Artist*. Copenhagen: Museum Tusculanum Press, University of Copenhagen, 2003.

Gilbert, C. E. *Italian Art, 1400–1500: Sources and Documents*. Englewood Cliffs, NJ: Prentice Hall, 1980.

Goldthwaite, R. *Wealth and the Demand for Art in Italy, 1300–1600*. Baltimore, MD: Johns Hopkins University Press, 1993.

Gombrich, E. H. *Norm and Form: Studies in the Art of the Renaissance*. 4th ed. London: Phaidon, 1985.

———. *Symbolic Images: Studies in the Art of the Renaissance*. 3d ed. London: Phaidon, 1972.

Heydenreich, L., and W. Lotz. *Architecture in Italy, 1400–1500: Rev. ed.* Pelican History of Art. New Haven: Yale University Press, 1996.

Humfreys, P., and M. Kemp, eds. *The Altarpiece in the Renaissance*. New York: Cambridge University Press, 1990.

———., ed. *The Cambridge Companion to Giovanni Bellini*. New York: Cambridge University Press, 2004.

Huse, N., and W. Wolters. *The Art of Renaissance Venice: Architecture, Sculpture, and Painting, 1460–1590*. Chicago: University of Chicago Press, 1990.

Janson, H. W. *The Sculpture of Donatello*. 2 vols. Princeton, NJ: Princeton University Press, 1979.

Joannides, P. *Masaccio and Masolino: A Complete Catalogue*. New York: Harry N. Abrams, 1993.

Kempers, B. *Painting, Power, and Patronage: The Rise of the Professional Artist in the Italian Renaissance*. New York: Penguin, 1992.

Kent, D. V. *Cosimo de' Medici and the Florentine Renaissance: The Patron's Oeuvre*. New Haven: Yale University Press, © 2000.

Krautheimer, R., and T. Krautheimer-Hess. *Lorenzo Ghiberti*. Princeton, NJ: Princeton University Press, 1982.

Lavin, M. A. *Piero della Francesca*. Art & Ideas. New York: Phaidon, 2002.

Murray, P. *The Architecture of the Italian Renaissance*. New rev. ed. The World of Art. New York: Random House, 1997.

Pächt, O. *Venetian Painting in the 15th Century: Jacopo, Gentile and Giovanni Bellini and Andrea Mantegna*. London: Harvey Miller, 2003.

Panofsky, E. *Perspective as Symbolic Form*. New York: Zone Books, 1997.

———. *Renaissance and Renascences in Western Art*. Trans. C. S. Wood. New York: Humanities Press, 1970.

Pope-Hennessy, J. *Donatello*. New York: Abbeville Press, 1993.

———. *Italian Renaissance Sculpture*. 3d ed. New York: Oxford University Press, 1986.

Randolph, A. *Engaging Symbols: Gender, Politics, and Public Art in Fifteenth-Century Florence*. New Haven: Yale University Press, 2002.

Rosenberg, C. *The Este Monuments and Urban Development in Renaissance Ferrara*. New York: Cambridge University Press, 1997.

Saalman, H. *Filippo Brunelleschi: The Buildings*. University Park: Pennsylvania State University Press, 1993.

Seymour, C. *Sculpture in Italy, 1400–1500*. Pelican History of Art. Harmondsworth, England: Penguin, 1966.

Turner, A. R. *Renaissance Florence*. Perspectives. New York: Harry N. Abrams, 1997.

Wackernagel, M. *The World of the Florentine Renaissance Artist: Projects and Patrons, Workshop and Art Market*. Princeton, NJ: Princeton University Press, 1981.

Wood, J. M., ed. *The Cambridge Companion to Piero della Francesca*. New York: Cambridge University Press, 2002.

CHAPTER 16. THE HIGH RENAISSANCE IN ITALY, 1495–1520

Ackerman, J., *The Architecture of Michelangelo*. 2d ed. Chicago: University of Chicago Press, 1986.

Beck, J. H. *Three Worlds of Michelangelo*. New York: W. W. Norton, 1999.

Boase, T. S. R. *Giorgio Vasari: The Man and the Book*. Princeton, NJ: Princeton University Press, 1979.

Brown, P. F. *Art and Life in Renaissance Venice*. Perspectives. New York: Harry N. Abrams, 1997.

———. *Venice and Antiquity: The Venetian Sense of the Past*. New Haven: Yale University Press, 1997.

Chapman, H. *Raphael: From Urbino to Rome*. London: National Gallery; New Haven: Dist. by Yale University Press, 2004.

Clark, K. *Leonardo da Vinci*. Rev. and introduced by M. Kemp. New York: Penguin, 1993, © 1988.

Cole, A. *Virtue and Magnificence: Art of the Italian Renaissance Courts*. Perspectives. New York: Harry N. Abrams, 1995.

De Tolnay, C. *Michelangelo*. 5 vols. Some vols. rev. Princeton, NJ: Princeton University Press, 1969–1971.

Freedberg, S. *Painting in Italy, 1500–1600*. 3d ed. Pelican History of Art. New Haven: Yale University Press, 1993.

———. *Painting of the High Renaissance in Rome and Florence*. 2 vols. New rev. ed. New York: Hacker Art Books, 1985.

Goffen, R. *Renaissance Rivals: Michelangelo, Leonardo, Raphael, Titian*. New Heaven: Yale University Press, 2002.

Hall, M. B. *The Cambridge Companion to Raphael*. New York: Cambridge University Press, 2005.

Hersey, G. L. *High Renaissance Art in St. Peter's and the Vatican: An Interpretive Guide*. Chicago: University of Chicago Press, 1993.

Hibbard, H. *Michelangelo*. 2d ed. Boulder, CO: Westview Press, 1998, © 1974.

Kemp, M. *Leonardo*. New York: Oxford University Press, 2004.

———., ed. *Leonardo on Painting: An Anthology of Writings*. New Haven: Yale University Press, 1989.

Nicholl, C. *Leonardo da Vinci: Flights of the Mind*. New York: Viking Penguin, 2004.

Panofsky, E. *Studies in Iconology: Humanist Themes in the Art of the Renaissance*. New York: Harper & Row, 1972.

Partridge, L. *The Art of Renaissance Rome*. Perspectives. New York: Harry N. Abrams, 1996.

Rowland, I. *The Culture of the High Renaissance: Ancients and Moderns in Sixteenth Century Rome*. Cambridge: 1998.

Rubin, P. L. *Giorgio Vasari: Art and History*. New Haven: Yale University Press, 1995.

Steinberg, L. *Leonardo's Incessant Last Supper*. New York: Zone Books, 2001.

Wallace, W. *Michelangelo: The Complete Sculpture, Painting, Architecture*. Southport, CT: Hugh Lauter Levin, 1998.

Wölfflin, H. *Classic Art: An Introduction to the High Renaissance*. 5th ed. London: Phaidon, 1994.

CHAPTER 17. THE LATE RENAISSANCE AND MANNERISM

Ackerman, J. *Palladio*. Reprint of the 2d ed. Harmondsworth, England: Penguin, 1991, © 1966.

Barkan, L. *Unearthing the Past: Archaeology and Aesthetics in the Making of Renaissance Culture*. New Haven: Yale University Press, 1999.

Beltramini, G., and A. Padoan. *Andrea Palladio: The Complete Illustrated Works*. New York: Universe; Dist. by St. Martin's Press, 2001.

Ekserdjian, D. *Correggio*. New Heaven: Yale University Press, 1997.

Friedlaender, W. *Mannerism and Anti-Mannerism in Italian Painting*. Reprint of 1957 ed. Interpretations in Art. New York: Columbia University Press, 1990.

Goffen, R. *Titian's Women*. New Haven: Yale University Press, 1997.

Klein, R., and H. Zerner. *Italian Art, 1500–1600: Sources and Documents*. Reprint of 1966 ed. Evanston, IL: Northwestern University Press, 1989.

Kliemann, J., and M. Rohlmann. *Italian Frescoes: High Renaissance and Mannerism, 1510–1600*. New York: Abbeville Press, 2004.

Murphy, C. *Lavinia Fontana: A Painter and Her Patrons in Sixteenth-Century Bologna*. New Haven: Yale University Press, 2003.

Partridge, L. *Michelangelo—The Last Judgment: A Glorious Restoration*. New York: Harry N. Abrams, 1997.

Rearick, W. R. *The Art of Paolo Veronese, 1528–1588*. Cambridge: Cambridge University Press, 1988.

Rosand, D. *Painting in Sixteenth-Century Venice: Titian, Veronese, Tintoretto*. New York: Cambridge University Press, 1997.

Shearman, J. K. G. *Mannerism*. New York: Penguin Books, 1990, © 1967.

Smyth, C. H. *Mannerism and Maniera*. 2d ed. Bibliotheca artibus et historiae. Vienna: IRSA, 1992.

Tavernor, R. *Palladio and Palladianism*. The World of Art. New York: Thames & Hudson, 1991.

Valcanover, F., and T. Pignatti. *Tintoretto*. New York: Harry N. Abrams, 1984.

Wundram, M. *Palladio: The Complete Buildings*. Köln and London: Taschen, 2004.

CHAPTER 18. EUROPEAN ART OF THE SIXTEENTH CENTURY: RENAISSANCE AND REFORMATION

Bartrum, G. *Albrecht Dürer and His Legacy: The Graphic Work of a Renaissance Artist*. Princeton, NJ: Princeton University Press, 2002.

Baxandall, M. *The Limewood Sculptors of Renaissance Germany*. New Haven: Yale University Press, 1980.

Eichberger, D., ed. *Durer and His Culture*. New York: Cambridge University Press, 1998.

Harbison, C. *The Mirror of the Artist: Northern Renaissance Art in Its Historical Context*. Perspectives. New York: Harry N. Abrams, 1995.

Hayum, A. *The Isenheim Altarpiece: God's Medicine and the Painter's Vision*. Princeton, NJ: Princeton University Press, 1993.

Hitchcock, H.-R. *German Renaissance Architecture*. Princeton, NJ: Princeton University Press, 1981.

Hulse, C. *Elizabeth I: Ruler and Legend*. Urbana: Published for the Newberry Library by the University of Illinois Press, 2003.

Hutchison, J. C. *Albrecht Dürer: A Biography*. Princeton, NJ: Princeton University Press, 1990.

Jopek, N. *German Sculpture, 1430–1540: A Catalogue of the Collection in the Victoria and Albert Museum*. London: V & A, 2002.

Kavaler, E. M. *Pieter Bruegel: Parables of Order and Enterprise*. New York: Cambridge University Press, 1999.

Koerner, J. *The Moment of Self-Portraiture in German Renaissance Art*. Chicago: University of Chicago Press, 1993.

———. *The Reformation of the Image*. Chicago: University of Chicago Press, 2004.

Mann, R. *El Greco and His Patrons: Three Major Projects*. New York: Cambridge University Press, 1986.

Melion, W. *Shaping the Netherlandish Canon: Karel van Mander's Schilder-Boeck*. Chicago: University of Chicago Press, 1991.

Moxey, K. *Peasants, Warriors, and Wives: Popular Imagery in the Reformation*. Chicago: University of Chicago Press, 1989.

Osten, G. von der, and H. Vey. *Painting and Sculpture in Germany and the Netherlands, 1500–1600*. Pelican History of Art. Harmondsworth, England: Penguin, 1969.

Panofsky, E. *The Life and Art of Albrecht Dürer*. 4th ed. Princeton, NJ: Princeton University Press, 1971.

Smith, J. C. *Nuremberg: A Renaissance City, 1500–1618*. Austin: Published for the Archer M. Huntington Art Gallery by the University of Texas Press, 1983.

Stechow, W. *Northern Renaissance Art, 1400–1600: Sources and Documents*. Evanston, IL: Northwestern University Press, 1989, © 1966.

Van Mander, K. *Lives of the Illustrious Netherlandish and German Painters*. Ed. H. Miedema. 6 vols. Doornspijk, Netherlands: Davaco, 1993–1999.

Wood, C. *Albrecht Altdorfer and the Origins of Landscape*. Chicago: University of Chicago Press, 1993.

Zerner, H. *Renaissance Art in France: The Invention of Classicism*. Paris: Flammarion; London: Thames & Hudson, 2003.

CHAPTER 19. THE BAROQUE IN ITALY AND SPAIN

Avery, C. *Bernini: Genius of the Baroque*. London: Thames & Hudson, 1997.

Bissell, R. W. *Masters of Italian Baroque Painting: The Detroit Institute of Arts*. Detroit, MI: Detroit Institute of Arts in association with D. Giles Ltd., London, 2005.

Blunt, A. *Borromini*. Cambridge, MA: Harvard University Press, 1979.

———. *Roman Baroque*. London: Pallas Athene Arts, 2001.

Brown, B. L., ed. *The Genius of Rome, 1592–1623*. Exh. cat. London: Royal Academy of Arts; New York: Dist. in the United States and Canada by Harry N. Abrams, 2001.

Brown, J. *Francisco de Zurbaran*. New York: Harry N. Abrams, 1991.

———. *Painting in Spain, 1500–1700*. Pelican History of Art. New Haven: Yale University Press, 1998.

———. *Velázquez: The Technique of Genius*. New Haven: Yale University Press, 1998.

Dempsey, C. *Annibale Carracci and the Beginnings of Baroque Style*. 2d ed. Fiesole, Italy: Cadmo, 2000.

Enggass, R., and J. Brown. *Italy and Spain, 1600–1750: Sources and Documents*. Reprint of 1970 ed. Evanston, IL: Northwestern University Press, 1992.

Freedberg, S. *Circa 1600: A Revolution of Style in Italian Painting*. Cambridge, MA: Harvard University Press, 1983.

Garrard, M. D. *Artemisia Gentileschi: The Image of the Female Hero in Italian Baroque Art*. Princeton, NJ: Princeton University Press, 1989.

Haskell, F. *Patrons and Painters: A Study in the Relations Between Italian Art and Society in the Age of the Baroque*. Rev. and enl. 2d ed. New Haven: Yale University Press, 1980.

Kubler, G., and M. Soria. *Art and Architecture in Spain and Portugal and Their American Dominions, 1500–1800*.

Pelican History of Art. Harmondsworth, England: Penguin, 1959.

Marder, T. A. *Bernini and the Art of Architecture*. New York: Abbeville Press, 1998.

Montagu, J. *Roman Baroque Sculpture: The Industry of Art*. New Haven: Yale University Press, 1989.

Nicolson, B. *Caravaggism in Europe*. Ed. L. Vertova. 3 vols. 2d ed., rev. and enl. Turin, Italy: Allemandi, 1989.

Posner, D. *Annibale Carracci*. 2 vols. London: Phaidon, 1971.

Smith, G. *Architectural Diplomacy: Rome and Paris in the Late Baroque*. Cambridge, MA: MIT Press, 1993.

Spear, R. E. *From Caravaggio to Artemisia: Essays on Painting in Seventeenth-Century Italy and France*. London: Pindar Press, 2002.

Spike, J. T. *Caravaggio*. Includes CD-ROM of all the known paintings of Caravaggio, including attributed and lost works. New York: Abbeville Press, © 2001.

Varriano, J. *Italian Baroque and Rococo Architecture*. New York: Oxford University Press, 1986.

Wittkower, R. *Art and Architecture in Italy, 1600–1750*. 4th ed. Pelican History of Art. New Haven: Yale University Press, 2000.

———. *Bernini: The Sculptor of the Roman Baroque*. 4th ed. London: Phaidon, 1997.

CHAPTER 20. THE BAROQUE IN FLANDERS AND HOLLAND

Alpers, S. *The Art of Describing: Dutch Art in the Seventeenth Century*. Chicago: University of Chicago Press, 1983.

———. *The Making of Rubens*. New Haven: Yale University Press, 1995.

Chapman, H. P. *Rembrandt's Self-Portraits: A Study in Seventeenth-Century Identity*. Princeton, NJ: Princeton University Press, 1990.

Fleischer, R., ed. *Rembrandt, Rubens, and the Art of Their Time: Recent Perspectives*. University Park: Pennsylvania State University, 1997.

Franits, W. E. *Dutch Seventeenth-Century Genre Painting: Its Stylistic and Thematic Evolution*. New Haven: Yale University Press, 2004.

Grijzenhout, F., ed. *The Golden Age of Dutch Painting in Historical Perspective*. New York: Cambridge University Press, 1999.

Hofrichter, F. F. *Haarlem: The Seventeenth Century*. Exh. cat. New Brunswick, NJ: Zimmerli Art Museum, 1982.

Kiers, J. and E. Runia, eds. *The Glory of the Golden Age: Dutch Art of the 17th Century*. 2 vols. Exh. cat. Rijksmuseum, Amsterdam: Waanders: 2000.

Logan, A. S. *Peter Paul Rubens: The Drawings*. Exh. cat. New York: Metropolitan Museum of Art; New Haven: Yale University Press, 2004.

Rosenberg, J. *Rembrandt: Life and Work*. Rev. ed. Ithaca, NY: Cornell University Press, 1980.

———, S. Slive, and E. ter Kuile. *Dutch Art and Architecture, 1600–1800*. 3d ed. New Haven: Yale University Press, 1997.

Salvesen, S., ed. *Rembrandt: The Master and His Workshop*. 2 vols. Exh. cat. New Haven: Yale University Press, 1991.

Schama, S. *The Embarrassment of Riches: An Interpretation of Dutch Culture in the Golden Age*. New York: Alfred A. Knopf, 1987.

Schwartz, G. *Rembrandt: His Life, His Paintings*. New York: Viking, 1985.

Slive, S. *Dutch Painting, 1600–1800*. Pelican History of Art. New Haven: Yale University Press, 1995.

———. *Frans Hals*. San Francisco: A. Wofsky Fine Arts, 1989.

———. *Frans Hals*. Exh. cat. Munich: Prestel-Verlag, 1989.

———. *Jacob van Ruisdael: A Complete Catalogue of His Paintings, Drawings, and Etchings*. New Haven: Yale University Press, 2001.

———. *Jacob van Ruisdael: Master of Landscape*. London: Royal Academy of Arts, 2005.

Stechow, W. *Dutch Landscape Painting of the Seventeenth Century*. Reprint of 1966 2d ed. Ithaca, NY: Cornell University Press, 1980.

Sutton, P. *The Age of Rubens*. Exh. cat. Boston: Museum of Fine Arts, 1993.

Vlieghe, H. *Flemish Art and Architecture, 1585–1700*. Pelican History of Art. New Haven: Yale University Press, © 1998.

Walford, F. *Jacob van Ruisdael and the Perception of Landscape*. New Haven: Yale University Press, 1992.

Westermann, M. *Art and Home: Dutch Interiors in the Age of Rembrandt*. Exh. cat. Zwolle: Waanders, 2001.

———. *Rembrandt*. Art & Ideas. London: Phaidon, 2000.

———. *A Worldly Art: The Dutch Republic 1585–1718*. Perspectives. New York: Harry N. Abrams, 1996.

Wheelock, A. K., ed. *Johannes Vermeer*. Exh. cat. New Haven: Yale University Press, 1995.

———., et al. *Anthony van Dyck*. Exh. cat. New York: Harry N. Abrams, 1990.

White, C. *Peter Paul Rubens*. New Haven: Yale University Press, 1987.

CHAPTER 21. THE BAROQUE IN FRANCE AND ENGLAND

Blunt, A. *Art and Architecture in France, 1500–1700*. 5th ed. Pelican History of Art. New Haven: Yale University Press, 1999.

———. *Nicolas Poussin*. London: Pallas Athene, 1995, © 1967.

Brusatin, M., et al. *The Baroque in Central Europe: Places, Architecture, and Art*. Venice: Marsilio, 1992.

Donovan, F. *Rubens and England*. New Haven: Published for The Paul Mellon Centre for Studies in British Art by Yale University Press, 2004.

Downes, K. *The Architecture of Wren*. Rev. ed. Reading, England: Redhedge, 1988.

Garreau, M. *Charles Le Brun: First Painter to King Louis XIV*. New York: Harry N. Abrams, 1992.

Kitson, M. *Studies on Claude and Poussin*. London: Pindar, 2000.

Lagerlöf, M. R. *Ideal Landscape: Annibale Carracci, Nicolas Poussin, and Claude Lorrain*. New Haven: Yale University Press, 1990.

Liechtenstein, J. *The Eloquence of Color: Rhetoric and Painting in the French Classical Age*. Berkeley: University of California Press, 1993.

Mérot, A. *French Painting in the Seventeenth Century*. New Haven: Yale University Press, 1995.

———. *Nicolas Poussin*. New York: Abbeville Press, 1990.

Röthlisberger, M. *Claude Lorrain: The Paintings*. 2 vols. New Haven: Yale University Press, 1961.

Summerson, J. *Architecture in Britain, 1530–1830*. Rev. 9th ed. Pelican History of Art. New Haven: Yale University Press, 1993.

Tinniswood, A. *His Invention So Fertile: A Life of Christopher Wren*. New York: Oxford University Press, 2001.

Verdi, R. *Nicolas Poussin 1594–1665*. London: Zwemmer in association with the Royal Academy of Arts, 1995.

Vlnas, V., ed. *The Glory of the Baroque in Bohemia: Essays on Art, Culture and Society in the 17th and 18th Centuries*. Prague: National Gallery, 2001.

Waterhouse, E. K. *The Dictionary of Sixteenth and Seventeenth Century British Painters*. Woodbridge, Suffolk, England: Antique Collectors' Club, 1988.

———. *Painting in Britain, 1530–1790*. 5th ed. Pelican History of Art. New Haven: Yale University Press, 1993.

Whinney, M. D. *Wren*. World of Art. New York: Thames & Hudson, 1998.

CHAPTER 22. THE ROCOCO

Bailey, C. B. *The Age of Watteau, Chardin, and Fragonard: Masterpieces of French Genre Painting*. New Haven: Yale University Press in association with the National Gallery of Canada, 2003.

Baillio, J. *Louise-Elisabeth Vigée-Lebrun 1755–1842*. Exh. cat. Fort Worth, TX: Kimbell Art Museum, 1982.

Brunel, G. *Boucher*. New York: Vendome, 1986.

———. *Painting in Eighteenth-Century France*. Ithaca, NY: Cornell University Press, 1981.

Cormack, M. *The Paintings of Thomas Gainsborough*. New York: Cambridge University Press, 1991.

Cuzin, J. P. *Jean-Honoré Fragonard: Life and Work: Complete Catalogue of the Oil Paintings*. New York: Harry N. Abrams, 1988.

François Boucher, 1703–1770. Exh. cat. New York: Metropolitan Museum of Art, © 1986.

Gaunt, W. *The Great Century of British Painting: Hogarth to Turner*. 2d ed. London: Phaidon, 1978.

Kalnein, W. von. *Architecture in France in the Eighteenth Century*. Pelican History of Art. New Haven: Yale University Press, 1995.

Levey, M. *Giambattista Tiepolo: His Life and Art*. New Haven: Yale University Press, 1986.

———. *Painting and Sculpture in France, 1700–1789*. New ed. Pelican History of Art. New Haven: Yale University Press, 1993.

———. *Painting in Eighteenth-Century Venice*. 3d ed. Pelican History of Art. New Haven: Yale University Press, 1993.

———. *Rococo to Revolution: Major Trends in Eighteenth-Century Painting*. Reprint of 1966 ed. The World of Art. New York: Thames & Hudson, 1985.

Links, J. G. *Canaletto*. Completely rev., updated, and enl. ed. London: Phaidon, 1994.

Mannings, D. *Sir Joshua Reynolds: A Complete Catalogue of His Paintings*. New Haven: Yale University Press, 2000.

Paulson, R. *Hogarth*. 3 vols. New Brunswick: Rutgers University Press, 1991–1993.

Penny, N., ed. *Reynolds*. Exh. cat. New York: Harry N. Abrams, 1986.

Pointon, M. *Hanging the Head: Portraiture and Social Formation in Eighteenth-Century England*. New Haven: Yale University Press, 1993.

Posner, D. *Antoine Watteau*. Ithaca, NY: Cornell University Press, 1984.

Rococo to Romanticism: Art and Architecture, 1700–1850. Garland Library of the History of Art. New York: Garland, 1976.

Rosenberg, P. *Chardin*. Exh. cat. London: Royal Academy of Art; New York: Metropolitan Museum of Art, 2000.

———. *From Drawing to Painting: Poussin, Watteau, Fragonard, David & Ingres*. Princeton, NJ: Princeton University Press, 2000.

Scott, K. *The Rococo Interior: Decoration and Social Spaces in Early Eighteenth-Century Paris*. New Haven: Yale University Press, 1995.

Sheriff, M. D. *The Exceptional Woman: Elisabeth Vigée-Lebrun and the Cultural Politics of Art*. Chicago: University of Chicago Press, 1996.

Wintermute, A. *Watteau and His World: French Drawing from 1700 to 1750*. Exh. cat. London: Merrell Holberton; New York: American Federation of Arts, 1999.

Credits

TEXT CREDITS

Pages 435-44 St. Benedict of Nursia. From *The Rule of St. Benedict*, by Anthony C. Meisel, tr. by M.L. del Mastro. Copyright © 1975 by Anthony C. Meisel and M.L. del Mastro. Used by permission of Doubleday, a division of Random House, Inc. Page 456 Inscriptions on the frescoes in the Palazzo Pubblico, Siena from *Arts of Power: Three Halls of State in Italy, 1300-1600* by Randolph Starn and Loren Partridge. Copyright © 1992 The Regents of the University of California. Reprinted by permission of the University of California Press. Page 486 Cyriacus of Ancona. From *Northern Renaissance Art 1400–1600: Sources and Documents*, ed. Wolfgang Stechow. Reprinted by permission of Northwestern Univ. Press. Page 492 Fray José de Sigüenza. From *Bosch in Perspective*, ed. by James Snyder. Copyright © 1973 by Prentice-Hall Inc. Reprinted by permission of Simon & Schuster Adult Publishing Group. Page 496 From the contract for the St. Wolfgang Altarpiece from *Northern Renaissance Art 1400-1600: Sources and Documents*, ed. Wolfgang Stechow. Reprinted by permission of Northwestern Univ. Press. Page 506 Lorenzo Ghiberti. From "The Commentaries" Book 2 from *Italian Art 1400-1500: Sources and Documents* by Creighton E. Gilbert (Evanston, IL: Northwestern Univ. Press, 1992). Reprinted by permission of the author. Page 511 Leon Battista Alberti. From "On Architecture" from *A Documentary History of Art*, Vol. 1, ed. by Elizabeth Gilmore Holt. Copyright © 1981 by Princeton University Press. Reprinted by permission of Princeton Univ. Press. Page 532 Domenico Veneziano. From *Italian Art 1400-1500: Sources and Documents* by Creighton E. Gilbert (Evanston, IL: Northwestern Univ. Press, 1992). Reprinted by permission of the author. Page 536 Giovanni Dominici. From *Italian Art 1400-1500: Sources and Documents* by Creighton E. Gilbert (Evanston, IL: Northwestern Univ. Press, 1992). Reprinted by permission of the author. Page 560 Leonardo da Vinci. From his undated mss. Reproduced from *The Literary Works of Leonardo Da Vinci*, ed. by Jean Paul Richter, Copyright © 1975 Phaidon Press Ltd. Reprinted with the permission of the publisher. Page 565 Michelangelo. From *Michelangelo: Life, Letters & Poetry*, ed. and tr. by George Bull. By permission of Oxford University Press. Page 568 From *The Poetry of Michelangelo: An Annotated Translation* by James M. Saslow. Copyright © 1991 by Yale University Press. Reprinted by permission. Page 598 Michelangelo. From *Michelangelo: Life, Letters & Poetry*, ed. and tr. by George Bull. By permission of Oxford University Press. Page 614 From a session of the Inquisition Tribunal in Venice of Paolo Veronese from *A Documentary History of Art*, Vol. 2, ed. by Elizabeth Gilmore Holt. Copyright © 1947, 1958, 1982 by Princeton University Press. Reprinted by permission of Princeton Univ. Press. Page 654 Carel van Mander. From *Dutch and Flemish Painters* by Carel van Mander, tr. by Constant Van de Wall (Manchester, NH: Ayer Company Publishers 1978). Page 692 Antonio Palomino. From *Italian & Spanish Art, 1600-1750: Sources & Documents*, ed. by Robert Enggass and Jonathan Brown. Reprinted by permission of Northwestern Univ. Press. Page 738 Nicolas Poussin. From *Nicolas Poussin* by Alain Merot, tr. by Fabia Claris. Copyright © 1990 by Thames & Hudson Ltd. Reprinted by kind permission of Thames & Hudson Ltd. Page 762 Jean de Jullienne "A Summary of the Life of Antoine Watteau" from *A Documentary History of Art*, Vol. 2, ed. by Elizabeth Gilmore Holt. Copyright © 1947, 1958, 1982 by Princeton University Press. Reprinted by permission of Princeton Univ. Press. Page 782 Giovanni Boccaccio. From *Decameron*, by Giovanni Boccaccio, tr. John Payne, rev. by Charles S. Singleton. Copyright © 1980, 1984 by the Regents of the University of California. Reprinted with the permission of the University of California Press. Page 782 From *Petrarch: The Canzoniere*, Sonnet 77, tr. by A.S. Kline. http://www.tonykline.co.uk, Copyright © 2002 by A.S. Kline. Used by permission of the author. Page 782 Dante Alighieri. From *The Divine Comedy*: Purgatory, from Canto Xl, tr. Mark Musa. Copyright © 1986 by Mark Musa. Reprinted with the permission of Indiana University Press. Page 783 Carel van Mander. From *Dutch and Flemish Painters* by Carel van Mander, tr. by Constant Van de Wall (Manchester, NH: Ayer Company Publishers 1978). Page 784 From Vasari's *The Lives of Painters, Sculptors, and Architects*, ed. by William Gaunt (1963 edition; first published 1927). By permission of Everymans' Library an imprint of Alfred A. Knopf. Page 785 Martin Luther. From *Luther's Works*, Vol. 40, tr. by Bernhard Erling, ed. by Conrad Bergendorff. Copyright © 1958 by Muhlenberg Press. Reprinted by permission of Augsburg Fortress, Publishers. Page 785 Giovanni Pietro Bellori. From *Italian & Spanish Art, 1600-1750: Sources & Documents*, ed. by Robert Enggass and Jonathan Brown. Reprinted by permission of Northwestern Univ. Press. Page 786 Filippo Baldinucci. From *Italian & Spanish Art, 1600-1750: Sources & Documents*, ed. by Robert Enggass and Jonathan Brown. Reprinted by permission of Northwestern Univ. Press. Page 786 Constantijn Huygens. From *Italian & Spanish Art, 1600-1750: Sources & Documents*, ed. by Robert Enggass and Jonathan Brown. Reprinted by permission of Northwestern Univ. Press.

Index